D0903116

DISCARDED
CONCORDIA UNIV. LIBRARY

A HANDBOOK OF GREEK ART

Free Standing Sculpture

A HANDBOOK OF

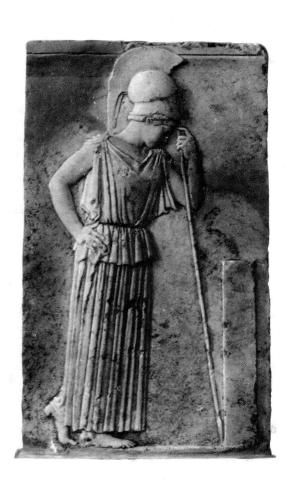

Phaidon

Gisela M. A. Richter

GREEK ART

London & New York

© 1959 Phaidon Press Ltd., 5 Cromwell Place, London SW 7
First Published 1959
Sixth Edition 1969 redesigned and with renumbered Illustrations

Phaidon Publishers, Inc., New York
Distributors in the United States: Praeger Publishers, Inc.
111 Fourth Avenue, New York, N.Y. 10003

Library of Congress Catalog Card Number : 68-18912

SBN 7148 05 C
SBN 714 1 6 P

Printed tria by Brüder Rosenbaum, Vienna

TO THE MEMORY

OF MY SISTER

CONTENTS

Τί οὖν ἐστιν, ὃ κινεῖ τὰς ὄψεις τῶν θεωμένων καὶ ἐπιστρέφει πρὸς αὑτὸ καὶ ἕλκει καὶ εὐφραίνεσθαι τῇ θέᾳ ποιεῖ; . . .
Λέγεται μὲν δὴ παρὰ πάντων, ὡς εἰπεῖν, ὡς συμμετρία τῶν μερῶν πρὸς ἄλληλα καὶ πρὸς τὸ ὅλον τό τε τῆς εὐχροίας προστεθὲν τὸ πρὸς τὴν ὄψιν κάλλος ποιεῖ καὶ ἔστιν αὐτοῖς καὶ ὅλως τοῖς ἄλλοις πᾶσι τὸ καλοῖς εἶναι τὸ συμμέτοις καὶ μεμετρημένοις ὑπάρχειν.

Plotinos, Enneads, I, 6, 1 (ed. Henry and Schwyzer, 1951).

What is it that attracts the eyes of those who behold a beautiful object, and calls them, lures them towards it, and fills them with joy at the sight? . . . Almost everyone declares that the symmetry of parts towards one another and towards the whole, with, besides, a certain charm of colour, constitutes the beauty recognized by the eye, that in visible things, as indeed in all else, universally, the beautiful thing is essentially symmetrical, patterned.

Translation by S. MacKenna, with slight changes.

PREFACE

The study of Greek art may be said to have begun in the Renaissance, the time of the revival of interest in Greek and Roman culture. It was then, however, chiefly based on the aesthetic appreciation of the single monuments that happened to be unearthed on Italian soil. Only gradually, as the material grew, were these monuments viewed as parts of a larger whole. The history of Greek art, therefore, as we know it today, is the work of scholars from the early eighteenth century onwards. Winckelmann (1717–68) and E. Q. Visconti (1751–1818) are among the earliest who tried to put order into a heterogeneous study. Excavations, first at Herculaneum and Pompeii, then all over Italy, Greece, Asia Minor, South Russia, North Africa, and Spain, brought to light more and more material of every kind. Private collections and museums were formed not only in the countries in which the objects were found, but throughout the civilized world. From this enrichment of our common patrimony grew the modern science of archaeology, that is, the *logos* of *archaia*, the study of things ancient. Inscriptions and the statements of ancient writers (especially Pausanias, Pliny, Quintilian, Philostratos, Lucian, and Vitruvius) have helped to clarify our studies, and the use of photography has lent them accuracy. This intensive research, in which scholars of all nations have participated, has resulted in the reconstruction of a consecutive history of Greek art. We can now view its unparalleled development from primitive beginnings through its manifold stages, each unfolding a new aspect of the Greek genius; we can differentiate the styles of some of the chief personalities in Greek art; and we can relate the succession of styles to historical events. Though the work still continues and every decade, every year almost, brings new discoveries that either establish or modify former conclusions, a reasonably reliable structure has by now been built.

It is the aim of this book to tell this intricate story in succinct form, so that it may serve as a general introduction for both the serious student and the intelligent amateur. Nowadays, when travel has been greatly facilitated and more and more people take an interest in Greek civilization, an informative account that supplies a background against which single monuments can be viewed should be useful; and, since the Greeks have produced many works of genius, contact with them will be stimulating.

Though Greek art, like all art, is a unity, it had many manifestations. In writing a history of it one can either present it as a consecutive whole, continually interrelating its various branches, or one can divide the subject into separate sections. In this book the latter method has been adopted, as was done, for instance, in the *Handbook of Greek Archaeology* by H. N. Fowler and J. R. Wheeler (1919), which has always seemed to me one of the clearest presentations. To the familiar subjects generally included in modern histories of Greek art, I have added short accounts of Furniture, Textiles, Glass, Ornament, and Epigraphy, for they too are part and parcel of the larger whole.

In each chapter I have tried to trace the development in a few salient examples. To describe all important objects of each period would of course have been impossible in the limited space of a handbook, and would, I think, have obscured rather than clarified the story. For the convenience of the student, however, I have added further material in a chronological table, with references to publications, as well as short bibliographies at the end of the book. Moreover in my text, when an object is not illustrated and not included in the chronological table, I have added a reference to a picture elsewhere. Technical terms are explained in a glossary. Architectural terms known in Greek are given in the Greek form, the others in the Latin. In transliterating Greek names I have retained the Greek forms, with some obvious exceptions.

I have many colleagues to thank for assistance. Mr. Bernard Ashmole and the late Arthur D. Nock had the kindness to read the entire text (in a somewhat early stage) and have made many valuable suggestions. Mr. William B. Dinsmoor has looked over my chapter on architecture, in the writing of which I have also constantly used his invaluable book *The Architecture of Ancient Greece*. Mr. A. D. Trendall has supplied me with the account of South Italian vases (pp. 358–364), embodying his latest researches. My chapter on Forerunners has been read by Mr. Carl W. Blegen, and I have discussed various aspects of this likewise continually changing story with the late Mr. Alan J. B. Wace, Mr. Doro Levi, and Mr. N. Platon. Mr. W. Schwabacher went over my chapter on coins and has saved me from a number of mistakes.

The sources of the photographs for the illustrations are given on p. 426. I want particularly to thank Miss A. Frantz, Miss Lucy Talcott, and the German Institute in Athens for their timely help in procuring some of these photographs.

Lastly I am much beholden to the Phaidon Press who have generously allowed me—as well as supplied—many illustrations, without which my discussions and descriptions would mean little.

1959 G. M. A. R.

Preface to the sixth Edition

A further number of corrections and additions have been made in this new edition, as in the previous ones. For especially now that this hand- book is to appear also in a paperback edition—and so will reach many more people—I have keenly felt the responsibility of keeping text and illustrations up to date. Besides some changes and additions in the text and illustrations, I have added several new notes, and new titles in the bibliography. Moreover, since the format, typography and style have been changed in this new edition, the numbers of the illustrations as well as of the notes have been made consecutive, eliminating a and b numbers.

1969 G. M. A. R.

THE FORERUNNERS

Long before the coming of the Greeks into Greece other peoples had dominated the Aegean world and had produced a civilization of high standing. Through archaeological research this 'prehistoric' age is gradually unfolding itself. Traces of palaeolithic habitation have been found in various places;[1] and abundant remains of the neolithic or Late Stone Age have come to light on the Greek mainland and on the Islands, dating from the sixth (?) to the fourth millenium B.C. It is not yet known from where these Neolithic people came. The beginning of the Bronze Age—when implements were no longer made of stone and not yet of iron, but were first of copper and then of bronze—has been placed around 3000 B.C. It was during the subsequent two thousand years that the brilliant Bronze Age civilization of the Eastern Mediterranean had its rise, culmination, and fall.

Our present knowledge regarding this civilization may be summarized as follows: Crete was at first the leader and centre, and in it a continuous evolution can be traced from neolithic times to the Late Bronze Age. This whole Bronze Age civilization has, therefore, been called Minoan, after the Cretan king Minos. The term Helladic, however, is now generally used to designate the related culture of the mainland, and the term Cycladic is applied to the marble statuettes and pottery of the third millennium B.C. that have been found in various Cycladic islands, as well as occasionally on the mainland; but these Cycladic objects bear no relation to the Minoan-Helladic culture and must belong to a civilization about which little is as yet known.

The Bronze Age civilization has been divided into three periods: Early (c. 2500–1900 B.C.), Middle (c. 1900–1500 B.C.), and Late (c. 1500–1100 B.C.), each of which has been further subdivided into three epochs. As a result of recent discoveries it is now thought that the Early Bronze Age, which antedates the first Palace of Knossos, was of much shorter duration than was previously thought; and, accordingly, some authorities now divide the Bronze Age in Crete into: the pre-Palace period, the First Palace period, and the Second Palace period. 'Similar theories have been propounded for the Early Bronze Age of the mainland, but have not been established'. (Blegen.)

The most important remains of the Early Minoan period have come to light in the eastern part of Crete—in the small towns of Gournia, Vasiliki, Palaikastro, and in the adjoining islands of Pseira and Mochlos.

Already then conditions were by no means primitive. Some of the people were prosperous and lived in comfortable houses, surrounded by artistic objects, and there was apparently communication with the outside world.

In the Middle Minoan period, which is about contemporary with the Middle Kingdom of Egypt, Cretan civilization reached its first climax. Palaces were built at Knossos, Phaistos, Mallia and Kato Zakro, there was active intercourse with foreign lands, and the arts flourished. This is when King Minos presumably lived, whose fame survived in Greek legends. (It is, however, possible that 'Minos' was a general word for king.) During the Late Minoan period, which runs parallel with the early part of the Empire of Egypt, came the second climax of Cretan civilization.

At its height this Minoan civilization is characterized by great splendour and wealth, at least for the upper classes. Large palaces with spacious courtyards, grandiose stairways, and a labyrinth of living-rooms, storerooms, and bathrooms with an advanced system of sanitation, have come to light. The gaily coloured paintings that decorated the walls have supplied information regarding the appearance and the customs of the people. And this knowledge has been supplemented by the many precious and ordinary objects found in the palaces, houses, and tombs—delicately wrought gold, silver, and bronze containers, large and small stone and terra-cotta vases, small sculptures in ivory, faience, terra cotta, and bronze, sealstones, and rings. They show us a prosperous people of buoyant spirit, fond of the chase and of sport, ruled over, it would seem, by a king, and worshipping, it is now thought, various deities, among which goddesses appear to have predominated. There was fruitful contact with the East, especially with Egypt and Syria, but the culture evolved was independent. The art had not the monumentality that characterizes much of the Egyptian, but it has a refreshing spontaneity and élan. Instead of depicting the homage of subjects to their kings, the Cretan artists found their inspiration chiefly in nature—in plants and animals and in the decorative forms which could be derived from them.

Naturally this civilization spread to the neighbouring islands and presently to the mainland of Greece. The history of this mainland civilization is gradually coming to light. In the Early Bronze Age, it is thought, there came an invasion by a people who were akin to the Cretans and islanders, that is, they were of non-European stock, and possibly came from South-western Asia Minor. Then, in the Middle Bronze Age, that is, soon after 2000 B.C., there apparently was a second invasion of the Greek mainland, presumably from the North, by a people of Indo-European race, now regarded as the first Greeks. They subdued and later amalgamated with their predecessors, the Neolithic and Early Bronze Age peoples. In the course of time these early Greeks

became the masters of the Aegean, established themselves at Knossos, and spread over the Islands, the coast of Asia Minor, Syria, Palestine, and Egypt. They even went westward, to the Lipari Islands, to Ischia, and to Southern Italy, and thus anticipated the Greek colonization of the eighth and seventh centuries B.C.

Inevitably these mainland peoples came under the influence of the mature Minoan culture of Crete. They adopted much of it, but gradually evolved an art of their own—intimately connected with the Cretan but in some essential ways different. Instead of the open, labyrinthine Minoan palaces they built citadels on a compact, orderly plan, fortified by strong walls. The palace of Mycenae with its famous Lion Gate, that of Tiryns with its stupendous galleries, and that of Goulas on Lake Copais are great engineering feats, and so are the beehive tombs, of which the 'Treasury of Atreus' at Mycenae is the most intricate. The other arts, however, the wall paintings, small sculptures, metalware, and particularly the pottery, show intimate contact with Crete.

This Mycenean civilization is concurrent with the Egyptian Empire of the XVIII to the XX dynasty (from soon after 1600 to about 1100 B.C.). To its last phase (about 1400–1100 B.C.) may be assigned the heroic age of Greece, when Mycenae under king Agamemnon was the dominant power, and when the Trojan expedition took place, of which Homer sang centuries later.

At the end of the Bronze Age the Mycenaeans were in their turn overthrown. Mycenae and many other sites were burned and destroyed. This destruction may have been due, at least in part, to the so-called Dorian invasion, that is, to the coming of fresh Greek tribes from the North. The later Greeks refer to it as the Return of the Herakleidai, a princely family descended from Herakles. 'The Isles were restless, disturbed among themselves' is the comment of Egyptian chroniclers.

This historical picture has been obtained by excavations and from the occasional statements of later writers. The invasions of the Greek mainland have been deduced from divisions in stratifications, sudden differences in architectural remains, for instance in the house plans and tombs referred to, and from the styles of the pottery. Particularly important have been the inscribed tablets found in Crete, and in recent years also on the mainland of Greece. Several different scripts could be recognized. First, in Crete, pictographs, consisting of primitive renderings of human beings, animals, objects, and ornaments, dating from the Early Bronze Age; then, also in Crete, hieroglyphs, in use during the Middle Bronze Age, of which a few—but only a few—resemble the Egyptian hieroglyphs; lastly, in the Late Bronze Age, two syllabic scripts known as Linear A and Linear B. Whereas Linear A was in general use throughout Crete, Linear B has so far been found only in Knossos and on the Greek mainland. Hundreds of clay tablets in

Linear B script have been found at Pylos and some at Mycenae; and vases with this script have been discovered elsewhere—at Orchomenos, Thebes, Eleusis, Tiryns, and Mycenae—showing the widespread use of this form of writing throughout the Greek mainland during the Mycenaean supremacy. The Linear B script is gradually being deciphered and it is thought to be an early form of Greek. This important discovery gives support to the theory that the Mycenaeans were Greek and that they dominated Knossos in the Late Bronze Age. A new chapter of Greek history has been opened.

If the Mycenaeans were indeed Greeks it might be thought that an account of Greek art should begin with the Mycenaean Age. If in this book the story nevertheless starts after the downfall of that civilization, the reason is that, though Mycenaeans and Greeks were racially akin, their arts were fundamentally different. Mycenaean art was, as we have seen, largely derived from the Cretan, both in form and almost entirely in content. On the other hand, when the Mycenaean age ended, a new art slowly emerged, with new forms and new subjects. In other words, though there was not the definite cultural break once envisaged by archaeologists, but rather a slow transformation, the unsettled conditions caused by the invasions produced at first a set-back in artistic production, and then the slow emergence of a new art. Instead of the curvilinear designs and the naturalistic representations of plant and marine life that had been popular with Minoans and Mycenaeans, a 'geometric' scheme with linear patterns was evolved; and when after a while animals and human beings were again represented they assumed schematized forms. Furthermore, the use of iron for implements instead of bronze created many changes. Hence the period from the eleventh to the eighth century B.C. is known as the Geometric or Early Iron Age.

It has seemed best, therefore, to restrict this account to the consecutive story of Hellenic art during the last millennium B.C. During that period—throughout Greek lands, ranging from Asia Minor and the Islands to Mainland Greece and westward to Sicily and Southern Italy—a homogeneous civilization was evolved. It passed through various epochs with changing styles in art, from primitive, to archaic, to developed, but basically it remained the same throughout. Though it borrowed here and there from other arts, chiefly from the old, mature cultures of Egypt and Mesopotamia, and occasionally from the Mycenaean (cf. p. 22), it transformed its borrowings into independent creations. And the civilization that was evolved is related to our own, for from it we in turn have borrowed and adapted. Culturally these Greeks are, therefore, our forerunners, and it is the art of these Greek people in the period of about 1100 to 100 B.C. that here concerns us.

ARCHITECTURE

Ｉt seems proper to begin an account of Greek art with architecture, for in ancient times sculpture was largely architectural, paintings decorated the walls of public and private buildings, and the 'minor' arts, such as pottery and furniture, served their chief functions in private houses. A study of Greek buildings is, therefore, essential for the proper understanding of other branches of Greek art. Moreover, in architecture one becomes at once acquainted with the intrinsic qualities of this art—the sober yet delicate forms, the interrelated proportions, and the feeling for the typical and the permanent rather than the accidental, the qualities in short that have given to Greek art its high place also in our civilization.

In spite of the devastations caused by earthquakes and wars throughout the centuries, enough Greek buildings have survived in sufficiently good preservation to show their general character and development.

Chief among the public buildings were the temples (*naoi*) for worship, which were sometimes set in spacious sacred areas (*temene*), containing not only several temples with their respective altars (*bomoi*), but treasuries (*thesauroi*), porticoes (*stoai*), votive monuments (*anathemata*), and elaborate gateways (*propylaia*). For athletic training and recreation there were gymnasiums, stadiums, theatres, and concert halls (*odeia*); they too sometimes formed part of the temenos, for religion, at least in early times, pervaded practically every phase of Greek life. The everyday activities of the people centred not only in the private house, but, even more so, in the market place (*agora*), with its colonnades, halls, and fountain houses. Votive and commemorative monuments played an important part, and so did funerary monuments, set up in both public and private cemeteries. Finally, each Greek city, being a unit in itself and often at war with its neighbours, had to be protected by fortifications.

Remains of these various structures have come to light all over the Greek world. Wherever the Greeks went they erected their temples, their theatres, gymnasiums, and market places. They were a basic part of Greek life. In addition there were special buildings characteristic of certain localities; for instance, the choregic monuments at Athens, erected to celebrate the victory of a chorus in a theatrical performance; the tholos, a small round building, of which examples have survived

at Epidauros, Delphi, and Athens; halls for the celebration of Mysteries, such as the *Telesterion* at Eleusis; and magnificent altars, like that at Pergamon. In a few places, for instance in the sanctuaries of Epidauros and Delphi, remains have been found of hotels (*katagogia*) in which visitors could be housed. A famous Hellenistic structure was the lighthouse at Alexandria.

Building Materials and Methods

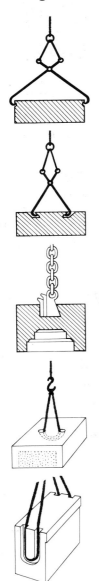

1. Methods of hoisting blocks: lifting tongs, a lewis, and ropes passed through cuttings.

The materials used by the Greeks for their buildings were sun-dried brick, wood, terra cotta, and stone. At first sun-dried brick and wood were mostly employed. This is indicated by a few statements of ancient writers and by certain elements in the Greek temple which seem to be derived from wood construction (for instance, triglyphs = the ends of cross-beams; metopes = the spaces between the beams; guttae = the pegs used for fastening). Later, stone became the chief material—hard limestone, conglomerate, and marble. The first two were generally coated with stucco to obtain a smooth surface. Marble was used from the sixth century B.C. in those regions where it was easily accessible, less so in places where it was not. The Eastern Mediterranean is rich in marble, and the quarries of Asia Minor, of Mainland Greece, including Athens, and particularly of the Islands (Naxos, Paros, and Thasos) were worked throughout antiquity. The cornice and roof tiles in early buildings were regularly of terra cotta, later often of marble.

Our information regarding building methods in stone is derived not only from actual remains of buildings and from old cuttings in quarries, but from a number of building inscriptions (about thirty of them have survived). These inscriptions are either records of expenses incurred during the erection of a building, or contracts and specifications. Another valuable source of information is the book on *Architecture* written by Vitruvius, who, though he lived in the time of Augustus, had Greek writings, now lost, to draw from.

The blocks were roughly worked in the quarries, if necessary lowered down the slope of a mountain on a chute, and transported in waggons. Cuttings on the stones indicate the methods employed for hoisting. There are three principal types: a loop cut in the middle of the stone, and grooves cut either at the end of the stone or around the stone (fig. 1). Such cuttings were employed chiefly for the softer stones. Marbles permitted the use of lifting tongs and the lewis. The holes for the tongs were placed on the lower or the upper surfaces, or on the sides near the top. A derrick with a complicated system of pulleys is represented on a relief of the second century A.D., now in the Lateran Collection. Since pulleys are mentioned in the fourth century B.C., the derrick must have been known also to the Greeks.

To shift the stones in position on a building, a crow-bar worked with shallow pry holes and deep shift holes was employed; and to bond the stones together iron and bronze dowels and cramps were used, the former for fastening the stones vertically, the latter horizontally; they were set in molten lead, sometimes poured through a channel. The shapes of the dowels and cramps varied at different periods (cf. fig. 2); those with ends bent at right angles were in use in the sixth and the early fifth century B.C.; the double T or H type with welded ends is characteristic of Periklean buildings; the hook cramp was employed periodically from the sixth century on; and the swallow-tail cramp was used for soft stones of all periods. The extensive use of these fastenings throughout antiquity was probably occasioned by the frequent earthquakes.

The tools were the standard ones still in use today: axe, hammer, mallet, and the pointed, toothed and flat chisels, in various sizes. Planes were tested with the straight-edge and square. No mortar was used in Greek times, and great care was taken to obtain tight-fitting contacts along the surfaces of the stones—along the whole of the horizontal ones, and generally along the edges only of the vertical ones, in which cases the central portion was sunk and left rough. (The process is called *anathyrosis*). The final polishing was done with smooth stones and a lubricant.

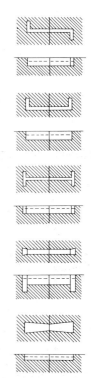

2. Cramps for fastening stones together.

The joints of the column drums received special treatment for accurate centring. A hole, about 4 to 6 inches square, was cut in the centre of each drum, top and bottom, and filled with a wooden plug; in the exact centre of this a circular hole was bored, and into it was inserted a wooden pin connecting the two adjoining drums. Bosses were left on the sides of the drums for convenient manipulation; and anathyrosis was employed to confine the contact surface along the edges. So perfect were the joints obtained in the best work that they were invisible at a short distance.

Stones were worked on the ground except for the last finishing. The flutes for the columns, for instance, were started on the ground at the top and bottom only and those in between were worked when the columns were in place. To set each block in its right position a system of lettering was sometimes employed.

Temples

In the temple the Greek feeling for artistic form found characteristic expression; and to many people today the Parthenon crowning the Akropolis hill still serves as the finest symbol of Greek genius. It is fitting, therefore, briefly to study the development of the Greek temple in its many forms, from century to century.

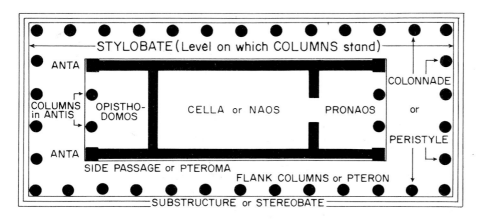

3. Ground Plan of a Greek Temple.

In primitive times an altar placed in an open space sufficed for worship; but when in time it was thought appropriate to house an image of the god inside a building, an adequate dwelling for the deity was required.

It may be asked what was the origin of the Greek temple? It is apparent that here, as in other forms of Greek art, the Greeks learned and borrowed from their predecessors. The ground plan was evidently derived from the *megaron* of the Mycenaean house, a rectangular hall with a frontal porch supported by columns. In Egypt the Greeks could see magnificent temples in which columns played a great part. Fluted columns occur there as early as the Middle Kingdom. Prototypes for the capitals, both Doric and Ionic, were furnished by the East—Egypt and Assyria, as well as Crete and Mycenae. The chief architectural ornaments used by the Greeks—the lotus, guilloche, palmette, spiral, and rosette—were also taken from the East; as were some of the architectural mouldings.

From these borrowings the Greek architect evolved something characteristically his own. After a period of experimentation a definite scheme was developed (cf. fig. 3) which remained more or less constant, except for endless variations in detail and proportions. A central hall (*cella*) was provided with a columned porch, practically always in front (*pronaos*) and often also at the back (*opisthodomos*); pilasters (*antae*) terminated the side walls of the cella. Rows of columns were placed in front, at the back, and sometimes all around to form a colonnade (*peristylion*); occasionally columns were added also in the interior to support the roof.

The decorations were confined to certain portions, plain and ornamented surfaces alternating according to a fixed design—a plain substructure, fluted columns, decorated capitals, a plain architrave, a decorated frieze, plain walls—and a roof enriched with pediments, antefixes, waterspouts, and akroteria. The shafts of the columns had no sculptural or painted decoration—as so often in Egypt—for they

were supporting members and had to appear as such (for an exception, cf. the columns of the temple at Ephesos, where, however, the decoration was confined to the bottom drum). Similarly, the walls of the cella were always left plain on the outside, not ornamented with reliefs as in Egypt; only on the interior were paintings sometimes added.

Refinements were introduced to give life to the design and to correct optical illusions. They are observable especially in the Parthenon (cf. pp. 33 f.). Curves take the place of straight lines. The stylobate and architrave curve upward. The walls of the cella and the outside columns lean inward. The abacuses and the faces of the cornice lean outward. The shafts of the columns taper upward and have a slight convex curve (*entasis*); their flutings are not as deep at the top as at the bottom.

Furthermore, the various parts of the building were obviously inter-related to one another and to the whole in height, width, and depth. What the principle of this interrelation was has given rise to much discussion. Some authorities favour an arithmetical, others a geometric proportion. Both have been claimed to exist. Thus, the lengths and widths of certain temples have been computed to be multiples of the different kinds of Greek feet ('Doric', 'Ionic', and Samian). The areas of certain temples have been found to correspond to the geometric ratios used also in Athenian pottery and later during the Renaissance ('the golden section', for instance). Since a building has length, breadth, and height, which can be computed arithmetically, and areas, which can best be analysed by geometry (i.e. by the 'measurement of land'), a twofold standard would not seem surprising. At all events, the known interest of the Greeks in geometry as well as in arithmetic, and their love of interrelations (cf. Plotinos, 1, 6, 1, and Vitruvius VII, Preface 14) make the use of a definite system probable.[1] And the resulting beauty of proportion in the extant buildings bears this out.

The temple as such was known to Homer (cf. e.g. *Iliad*, 1, 39), and foundations of temples datable in the late geometric period have come to light in various places (e.g. in Samos, Eleusis, Sparta, Perachora). Furthermore, fragmentary terra-cotta models of 'shrines' of geometric date, found at the Argive Heraion and at Perachora,[2] give some idea of the superstructure. Though many features of the developed Greek temple are still missing, there was already present a cella with a front porch supported by columns. The ground plan in the models is rectangular at one end, apsidal at the other; in the temple at Eleusis it was apsidal at least at one end, perhaps at both.

By the latter part of the seventh century the canonical Greek temple had been evolved. Enough examples of that period have been found to show its salient features. On a stone foundation (*stereobates*) either of irregular or roughly squared blocks, was first placed a levelling

course (*euthynteria*) and then a stepped platform (*krepidoma*). There were three orders of columns—Doric, Ionic, and Corinthian. The Doric column had no base but was placed immediately on the stylobate, that is, the top step of the krepidoma (cf. fig. 5). It had a fluted shaft, tapering towards the top, and a capital which consisted of a curved member (*echinus*) surmounted by a square block (*abacus*). The upper end of the shaft and the capital were cut in one block. At first a concave moulding served as the connecting member; later this was replaced by three or four projecting bands. The shaft was generally composed of several drums.

Upon the capital rested the entablature, comprising the architrave (*epistylion*), the frieze, and the cornice (*geison*). The architrave blocks, which reached from column to column, were left plain, except for a small moulding at the top (*taenia*), decorated at regular intervals with a panel (*regula*), from which six little knobs (*guttae*) projected downward.

The Doric frieze consisted of triglyphs (*triglyphoi*) with vertical groovings, alternating with metopes (*metopai*), which could be plain or painted or sculptured. There was generally a triglyph over each column and over the middle of each intercolumnation, and one was placed at the corners, an arrangement that necessitated various expedients, such as changing the widths of the intercolumnations. Above the frieze was the projecting cornice, inclined slightly downward to protect the face of the building from rain water. It consisted of a moulding, surmounted by a plain member (*corona*); along its soffit, over each triglyph and metope, was placed a slab or mutule (*mutulus*) with rows of drops (*guttae*).

The roof was generally not flat, as in Minoan Crete, but double pitched (saddle), with a ridge pole, and beams going lengthwise and rafters placed at right angles above them (fig. 4). The triangular space at each end, called pediment (*aetos*), was closed by a wall (*tympanon*) and protected by a raking cornice. On its floor were often placed groups of sculptures, fastened with dowels. Above the rafters were the tiles, both plain and cover, generally of terra cotta, sometimes of marble. Each row of cover tiles either ended at the sides in an antefix or terminated against the back of the gutter (*sima*). Waterspouts, generally in the form of lions' heads, provided openings to let out the rain water. Akroteria decorated the three angles of the pediment, in the form of either disks or sculptures.

The cella was completely walled in and was built as far as possible of uniform horizontal blocks, often resting on a kind of dado of vertical blocks (*orthostates*). Normally it had both a front and a rear porch (see above), with free-standing columns along the front and sides, and antae at the side walls. The entrance to the cella was through a large door, generally on the East; and in most cases this was the only source

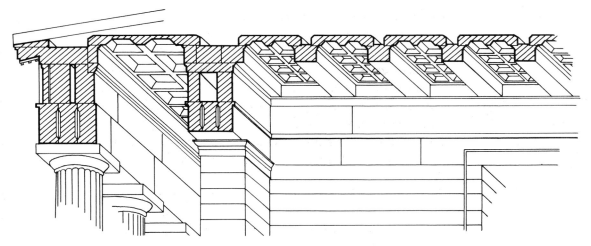

4. Roof of a Greek Temple.

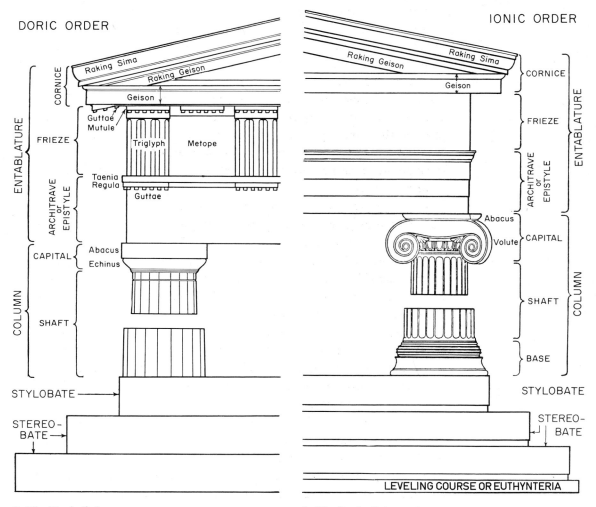

DORIC ORDER

IONIC ORDER

CORNICE
Raking Sima
Raking Geison
Geison
Guttae
Mutule
Triglyph Metope
Taenia
Regula
Guttae
CAPITAL
Abacus
Echinus
SHAFT

ENTABLATURE
FRIEZE
ARCHITRAVE or EPISTYLE

COLUMN

STYLOBATE
STEREO-BATE

Raking Geison Raking Sima
Geison
CORNICE
FRIEZE
ARCHITRAVE or EPISTYLE
Abacus
Volute CAPITAL
SHAFT
BASE

ENTABLATURE

COLUMN

STYLOBATE
STEREO-BATE
LEVELING COURSE OR EUTHYNTERIA

5. The Doric Column. **6.** The Ionic Column.

of daylight in the interior. Windows were exceptional. The cult statue was generally placed at the Western end of the cella, opposite the entrance. Encircling the cella and its porches was the colonnade (peristyle). If the cella was wide, interior supports of the roof were necessary, either in a single row of columns, lengthwise along the middle, or in two rows creating a central nave and two aisles. The columns were then often in two tiers, sometimes with a gallery approached by stairs. The ceiling was of wood, except that of the colonnade, which was often of marble with ornamented coffers.

The Ionic and Corinthian orders differ from the Doric chiefly in the forms of their columns. The shaft of the Ionic column, instead of rising directly from the stylobate, has a base in several tiers, and its capital, instead of an echinus, has a pair of volutes front and back, beneath which is generally an ornamented necking (fig. 6). The flutings of the shaft do not as in the Doric column meet at a sharp angle, but are separated from one another by a narrow flat band. The antae have special capitals consisting of carved mouldings, often repeated on the base and carried along the wall. Furthermore, the architrave is not plain, as in the Doric order, but is subdivided into projecting bands (usually three). And for the Doric triglyphs and metopes were substituted a row of dentils or a continuous sculptured frieze. The effect of the whole is less massive than in the Doric and more graceful.

The Corinthian column is allied to the Ionic in that it has a base and volutes on its capital, but the latter is further enriched with a single or double row of leafy—generally akanthos—scrolls, from which the volutes rise as if in organic growth.

The so-called Aeolic column, with a spreading, double-spiralled capital (fig. 7), is by many considered an early form of the Ionic and called Proto-Ionic. Typical examples have come from Neandria in the Troad, from Larisa near Smyrna, and from Lesbos—all apparently not earlier than the first quarter of the sixth century B.C. A late development of this form is seen in a capital used at Pergamon.

The chief mouldings employed in Greek temples were the astragal (convex), the cavetto (concave), the cyma (of double curvature) the torus (convex but larger than the astragal), and the hawksbeak (of multiple curvature). Each had its particular painted ornament—bead-and-reel, egg-and-tongue, leaf-and-dart, lotus-and-palmette, guilloche, and so on.

To judge by the somewhat scanty remains of colour, only certain parts of the Greek temple were regularly painted. Such were the backgrounds of the sculptured metopes, frieze, and pediments, which were red or blue, unless, as in most metopes, they were left white. The sculptures themselves were painted in varying shades (cf. p. 54). The mutules, triglyphs, and regulae were blue. By way of contrast the soffit

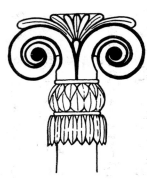

7. The 'Aeolic' Capital.

of the cornice, the top border of the metopes, and the taenia at the top of the architrave were generally red. The shafts of the columns and of course the exterior of the walls of the cella were left white, and so in most cases were apparently the capitals, except when covered with stucco. Painted ornaments were introduced on the sima, on the coffers of the ceiling, and on the mouldings. Thus colour was used like sculpture to accent various portions of the temple. It must have greatly enhanced the harmony and effectiveness of the whole.

The tendency in the evolution of the types was from massiveness towards slenderness. The early columns were relatively short with thick shafts and heavy capitals, whereas the later ones were higher and thinner, with lighter capitals. The profile of the echinus in the Doric capital changed from a bulbous to an elastic and then to a flat curve. The widths of the intercolumnations tended to increase as time progressed. The entablature was gradually reduced in height. The metopes, which in the earlier buildings often varied in size, later became square. And so on. These changes serve as evidence for a relative chronology, supplementing the few historical dates that supply an absolute chronology.

The earliest Doric temple of which a considerable part of the super- **ARCHAIC PERIOD,** structure survives is that of Hera at Olympia (*c.* 600 B.C. or earlier). **ABOUT 630–480 B.C.** It has the normal features of the Greek temple—cella, pronaos, opisthodomos, peristyle, and, in addition, two rows of columns inside the cella (fig. 9). It is long compared to its width, with six columns on the ends and sixteen on the sides. The columns, it is thought, were originally of wood and were gradually replaced in stone. At the time of Pausanias, in the second century A.D., there still remained one wooden column—in the opisthodomos. These replacements resulted in a great variety of styles. The extant columns date from the early sixth century B.C. to Roman times, and are all different in diameter, number of drums, number of flutes, methods of fastening, forms of echinus, and the kind of limestone used. The architrave was apparently of wood, as suggested by the wide intercolumnations, and the walls of the cella were of sun-dried brick on a stone foundation. Roof tiles and

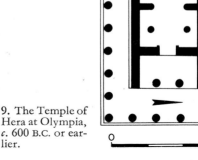

8. The Temple of Artemis at Korkyra, *c.* 600 B.C. Reconstruction.

9. The Temple of Hera at Olympia, *c.* 600 B.C. or earlier.

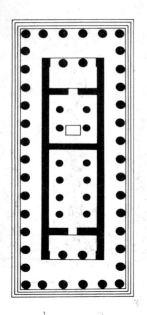
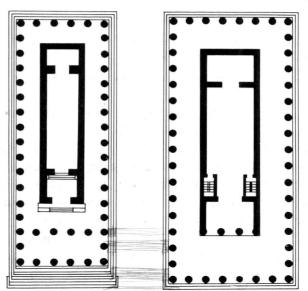

10. The Temple of Apollo at Corinth, *c.* 540 B.C.

11. Temple 'C' at Selinus, soon after 550 B.C.

12. The Temple of Hera at the Sele, near Paestum, *c.* 520–500 B.C.

revetment were of terra cotta. Inside the cella was found a large limestone base, probably for the cult statues of Hera and Zeus, for at the beginning the temple was dedicated to both these deities. Perhaps the colossal limestone head found near the temple belonged to the statue of Hera (see fig. 59). No other sculptures of the temple were found, but a fragment of a disk akroterion in terra cotta shows that the pediment was crowned with this feature.

Early Doric temples datable in the late seventh century and around 600 B.C. have also been discovered at Thermon, Korkyra (Corfu), Delphi, and Cyrene; but only foundations and a few architectural members remain, from which the ground plan at least has been deduced. In the case of Korkyra (fig. 8), however, parts of the pedimental sculptures have been found and they are among the most important early archaic examples extant (cf. pp. 62 f.).

To the second quarter of the sixth century may be assigned the small Doric temple of Hera near the mouth of the river Silaris (Sele), near Paestum. Only its foundations remain, which show that it had a pronaos with four columns, but no opisthodomos or peristyle. Fortunately much of the sandstone decoration was re-used in later buildings and so has survived. In addition to the triglyphs and metopes (carved together in one piece) which completely surrounded the building (cf. pp. 74 f.), there came to light Doric capitals with a hollow throat moulding and widely spreading echinus, and two anta capitals of the early 'Egyptianizing', cavetto type that appears also in Attic gravestones of the second quarter of the sixth century (cf. fig. 75).

The impressive temple of Apollo at Corinth provides a Doric example of about 540 B.C. The material was limestone, stuccoed. It had a pronaos and an opisthodomos, six columns at the ends and fifteen on the sides, as well as two rows of columns inside the cella (fig. 10). Now only

seven columns remain (monolithic and each with twenty flutes). An unusual feature was a cross-wall in the cella dividing it into two unequal parts. In the hall adjoining the opisthodomos a base was found, which perhaps served for a cult statue.

To this period can also be assigned the rebuilding of the ancient temple of Athena by Peisistratos and his sons (cf. p. 88).

Another Doric temple that may be placed soon after the middle of the sixth century is the so-called temple C at Selinus, among the oldest of the temples found there (figs. 11, 13). Like the temple at Corinth it had six columns at the ends, but it was longer in proportion to its width, with seventeen columns on the sides. There were two rows of columns in front of the pronaos. The opisthodomos was not open to the peristyle but formed a back chamber of the cella. The entablature was very high, the cornice consisting of two courses of stone, crowned with a terra-cotta gutter. The latter was decorated with guilloche, lotus, and palmette ornaments, and provided with piercings to allow the escape of rain water. Pieces of this magnificent, colourful sima have survived as well as three metopes now at Palermo (cf. pp. 74f.).

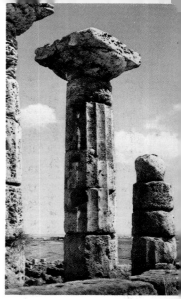

13. The Temple 'C' at Se-linus, soon after 550 B.C.

The temple of Zeus at Cyrene, built of limestone, with eight columns at the ends, seventeen on the sides, is also datable around 540 B.C.

In the East the grandiose conceptions of Egypt and Mesopotamia are reflected in three archaic temples of the Ionic order—at Ephesos, Samos, and Didyma. The temple at Ephesos had as many as twenty-one columns on the sides in a double colonnade like the later temple built on top of it (cf. fig. 14). The material was marble, except for the wooden roof and the terra-cotta tiles. The bottom drums of some of the columns were sculptured (cf. p. 74)—a feature evidently inspired by Egyptian and Mesopotamian prototypes. The temple was begun about 550 B.C., and an inscription records that Croesus of Lydia gave some of the columns; but like many of these undertakings it took a long time to build.

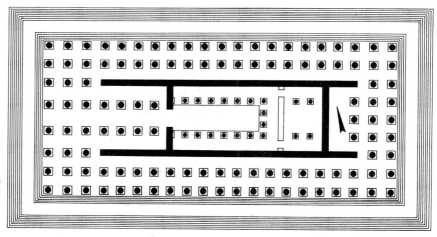

14. The Temple of Artemis at Ephesos, begun c. 550 B.C., rebuilt in the fourth century B.C.

0 40 M.

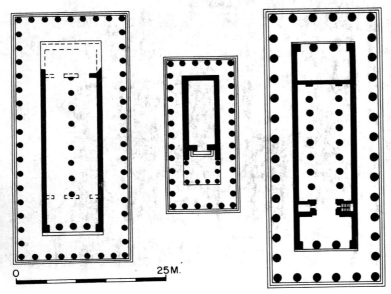

15–17. The Temples of Hera, c. 530
B.C., of Athena, c. 510 B.C., and of
Hera, c. 460 B.C., at Paestum.

0 25M.

The great dipteral temple at Samos was built by Rhoikos and Theo-doros. It was burnt about 530 B.C., and another, still larger, temple was erected on its site, begun by Polykrates, carried on with interruptions for several centuries, and never completed. The plan called for a high stylobate, approached by steps all round, a double colonnade of Ionic columns, and probably two rows of columns in the interior.

Of the early temple at Didyma, near Miletos, little remains. It was burnt by the Persians. To a later structure built on the same site may belong three large anta capitals, carved with egg-and-dart and palmettes.

A few architectural fragments and statuettes (cf. p. 197) have been found on the site of the early temple of Apollo at Naukratis; but of the superstructure nothing is preserved, and even the plan cannot be traced with accuracy.

In Paestum survive three of the best preserved Doric temples (figs. 15, 16, 17). One of these, formerly called the 'Basilica', now thought to have been dedicated to Hera, is datable around 530 B.C. The capitals show Ionic influence in the necking below the echinus. The anta capitals resemble those of the Heraion at the mouth of the river Silaris (cf. p. 31). The frieze probably had triglyphs and metopes, but none have come to light.

About twenty or thirty years later a considerably smaller temple was built not far from the 'Basilica', and dedicated to Athena (not to Demeter as was once thought[3]). As in the 'Basilica', the capitals rise from orna-mented neckings. The cornice was elaborately decorated. The pronaos had Ionic columns, of which some survive.[4] No sculptural members have been preserved.

The third Paestan temple is still later, datable around 460 B.C. (fig. 18). It used to be called the temple of Poseidon, but it has now been identified

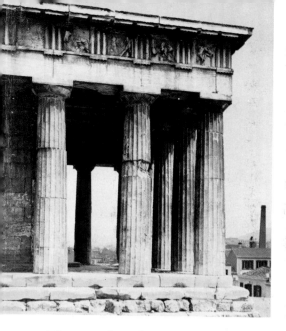

23. The Temple of Hephaistos in Athens, *c.* 449–444 B.C.

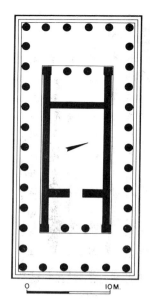

24. The Temple of Hephaistos in Athens, *c.* 449–444 B.C.

The temple of Hephaistos 'The Theseum'[5] (about 449–444 B.C.) in Athens, overlooking the ancient market place, is the best preserved Greek temple externally (cf. fig. 23). The material is Pentelic marble, except for the sculptures which are of Parian marble. The plan is normal, with six columns at the ends, thirteen at the sides, a pronaos, an opisthodomos, and an epistyle (fig. 24). Some of the pedimental statues have been tentatively identified in figures found in the Agora.[6] The continuous frieze above the porches—an unusual feature in a Doric temple—is still *in situ*, as are some of the metopes placed over the East end and the adjoining parts of the sides (cf. p. 134). The cult statues of Hephaistos (by Alkamenes, cf. Cicero, *De natura deor.*, I, 30) and Athena were not added before 421–415 B.C. (cf. *I.G*[2]., 370 371).

The Parthenon at Athens marks the climax of the Doric style. The harmony of its proportions, the refinements in its structure, and the fact that it is comparatively well preserved have established its fame (fig. 28). Moreover, its sculptural decorations—pedimental figures, metopes, frieze, waterspouts, antefixes, akroteria—have also partly survived and rank among the finest examples of their time (cf. pp. 113 ff.). The building is of Pentelic marble, except the foundation which is of local limestone. It was built over an earlier temple, which was perhaps started around 488 B.C. and ravaged by the Persians. Some of the charred, unfinished drums of this earlier building may be seen built in the fortification wall on the North side of the Akropolis. Other early blocks were re-used in the new building. Others again lie scattered on the site.

According to the building inscription, work on the Periklean Parthenon was begun in 447–446 B.C. and finished in 438, except for the sculptures which took another six years to complete. The architects were Iktinos and Kallikrates and they designed it on a magnificent scale. It was the largest Doric temple on the Greek mainland. In plan it was different

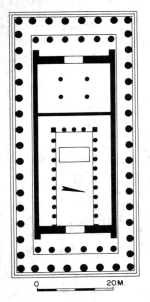

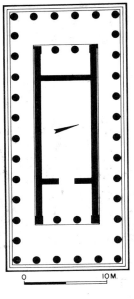

25. The Parthenon in Athens, 447–438 B.C.

26. The Temple of Poseidon at Sounion, c. 440 B.C.

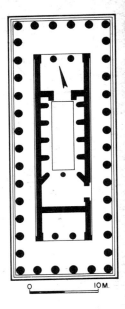

27. The Temple of Apollo Epikourios at Bassae, soon after 430 B.C.

from the older Parthenon (the substructure of which may still be seen projecting on the East and South sides). The peristyle had seventeen columns on the sides and eight at the ends (fig. 25). In addition to the cella and the two porches, there was a back chamber, which was entered only from the opisthodomos and was perhaps used as a treasury. The cella had interior columns in two storeys on the sides and rear, forming a colonnade that could be used by visitors for viewing Pheidias' chryselephantine Athena from all sides (cf. pp. 116 ff.). The poros foundation of the statue can still be seen on the cella floor. Though the temple is Doric, it has several Ionic features, such as a continuous frieze inside the colonnade, a Lesbian kymation above it, carved decorations on the anta capitals, and an astragal over the metopes. The building survived in a fairly complete state until 1687, when it was partly destroyed by an explosion during the Turko-Venetian war. Fortunately drawings of the sculptures, supposedly made by J. Carrey in 1674, have been preserved (cf. fig. 138).

Roughly contemporary with the Parthenon is the temple of Poseidon at Sounion, built on a promontory overlooking the sea and visible by the ships that passed beneath. An earlier temple dating from about 500 B.C. preceded it. The later temple is Doric, with six columns at the ends, thirteen on the sides, built of local marble (fig. 26). The columns are without entasis. The frieze, which ran across the pronaos and inside the front part of the peristyle, perhaps represented the combat of Centaurs and Lapiths (fragments have survived). A seated figure found in the vicinity may have belonged to the pedimental sculptures.

Here too belong the small Doric temples of Nemesis at Rhamnous, of Ares in the Athenian Agora, and of 'Concord' at Akragas. The latter owes its good preservation to the fact that it was converted into a church.

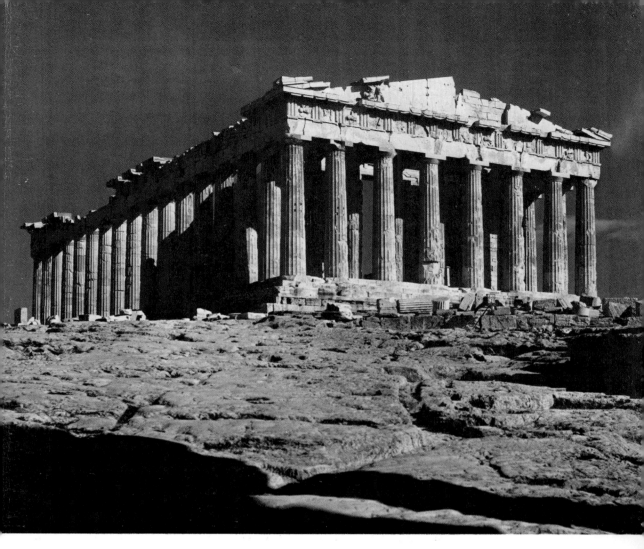

28. The Parthenon in Athens, 447–438 B.C.

The temple of Apollo Epikourios at Bassae, near Phigaleia, is situated on a lonely rocky hill amid the mountains of Arcadia. According to Pausanias, it was erected as a thank offering for relief from a plague (probably the famous one of 430 B.C.), and the architect was Iktinos. It was built of local limestone, except for the sima, the capitals of the interior columns, and the sculptures, which were of marble. There are several unusual features: a continuous frieze ran along the inside of the cella (cf. p. 134); a side door led from the peristyle into a chamber behind the cella; and in the cella itself were two rows of tall columns, three Corinthian, the other Ionic, attached (all but one) to the cella wall by short spur walls (fig. 27). The frieze has survived in fair condition and is now in the British Museum. From its many dowel holes and the fact that a few of the slabs overlap, it has been possible to reconstruct almost the whole animated composition. A few fragments of the akroteria and metopes also remain. They too are mainly in the British Museum.

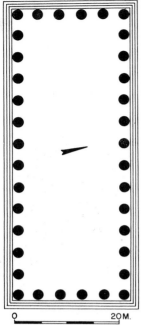

29. The Temple at Segesta, late fifth century B.C.

The temple at Segesta (Greek Egesta), in North-western Sicily, is one of the best preserved Greek temples, but was never finished (fig. 29). The columns were not fluted, the shell conglomerate was not stuccoed, the bosses for lifting were never removed, and the joints were never dressed. That the building was planned with great refinements can still be seen. Thus the stylobate and steps curve and the abaci are slightly tilted. Of the sculptural decoration only a palmette from the soffit survives. It is of graceful design, and somewhat later than those from the Parthenon. The reason for the unfinished state of the temple was apparently the Carthaginian invasion of 409–405 B.C.

Two famous Ionic temples in Athens, both of Pentelic marble, belong to the late fifth century B.C.—the little temple of Athena Nike (427–424 B.C.), built on the bastion at the South-west corner of the Akropolis, and the Erechtheion (421–406 B.C.), built opposite the Parthenon, on the North of the Akropolis hill. In each, the nearness of other buildings infringed on its territory, in one case the Propylaia and the sanctuary of Artemis Brauronia, in the other the Old Temple of Athena and the shrine of Athena and Erechtheus.

The temple of Athena Nike (fig. 30) was built on the site of an earlier temple. Diminutive in size, it yet had pedimental figures (traces of the fastenings remain) and golden akroteria, as well as a frieze. The latter is partly preserved and includes scenes of Greeks battling with Persians (cf. p. 134). The famous sculptured parapet surrounding the bastion on three sides was built towards the end of the century (cf. p. 137).

The plan of the Erechtheion is quite irregular (fig. 31). It consists of three chambers on separate levels, with a portico of six Ionic columns on the East side, a large doorway on the North side, and a porch with six karyatids instead of columns on the South (figs. 32, 33). For the Western façade the lower level necessitated the unusual treatment of partly engaged columns mounted on a high wall. The Eastern chamber is thought to have been the cella of Athena Polias. The central chamber

30. The Temple of Athena Nike in Athens, 427–424 B.C.

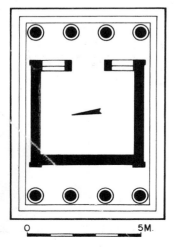

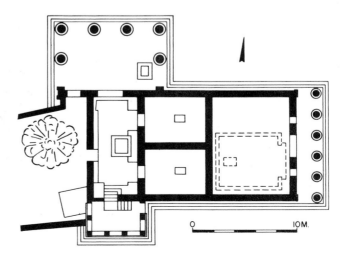

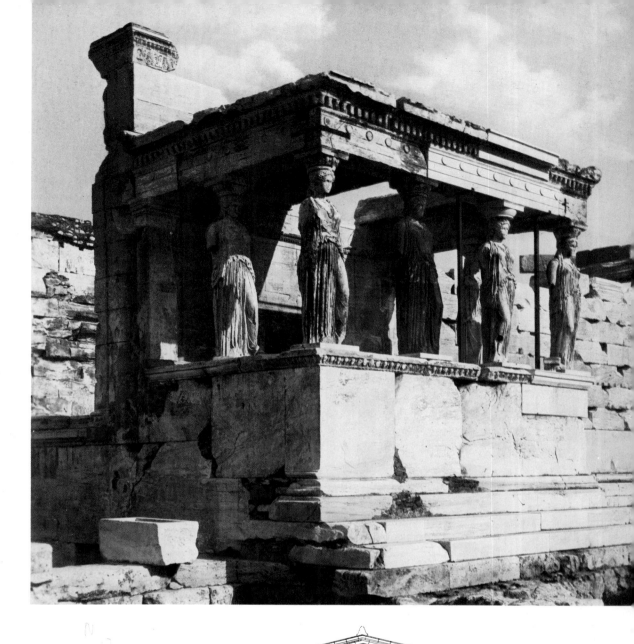

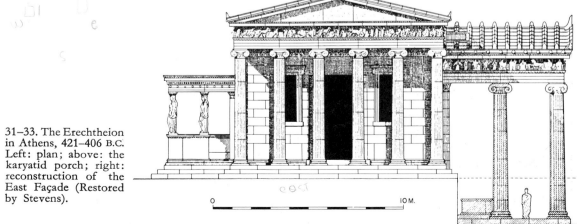

31–33. The Erechtheion in Athens, 421–406 B.C. Left: plan; above: the karyatid porch; right: reconstruction of the East Façade (Restored by Stevens).

0 10 M.

was subdivided longitudinally into two rooms. Certain traces have been interpreted to designate the cistern with the salt sea of Poseidon, and the marks produced by Poseidon's trident mentioned by Pausanias. Doors led from the North and karyatid porches and from the Western anteroom into the central sanctuary, and there were windows East and West.

The sculptured frieze which ran along the outside of the building consisted of marble figures attached to slabs of black Eleusinian limestone (cf. p. 137). The architectural decorations are exceptionally elaborate and were executed with great delicacy. Especially remarkable are those of the North portico—the guilloche patterns on the bases of the columns, the anthemion on the necking below the capitals, and the ornaments on the doorway. Gilding, gilt bronze, and glass beads in four colours were further enrichments. The work on the temple was interrupted by the Peloponnesian war. The building inscription of the second period of work (after 409) has been preserved. It gives the names of about 130 workmen (slaves, foreign residents, and full citizens), all, including the architect, receiving a daily wage of one drachma.

FOURTH CENTURY B.C. The temple of Asklepios at Epidauros may serve as an example of a Doric temple of the early fourth century B.C. It had six columns on the ends, and eleven at the sides, and it had a pronaos, but no opisthodomos (fig. 34). A ramp led up to the temple on the East end. The cult statue was chryselephantine, by Thrasymedes. Some of the sculptured decorations have survived (cf. pp. 138 f.), as well as the inscription giving the expense account.[7] From it we learn the name of the architect, Theodotos.

Another famous fourth-century temple was that of Athena Alea at Tegea, which Pausanias regarded as 'the most beautiful and largest of all those in the Peloponnese', and in which the Doric, Ionic, and Corianthian orders were combined. The architect is said to have been Skopas, and some of the battered pedimental figures that have been preserved may be by him (cf. p. 149).

The fourth-century temple of Apollo at Delphi, erected over earlier buildings, has already been mentioned (cf. p. 31).

Asia Minor has supplied several grandiose examples of Ionic temples of the second half of the fourth century B.C.—the great temple of Artemis at Ephesos, the temple of Athena Polias at Priene (begun about 340 B.C. and dedicated by Alexander the Great in 334), and the temple of Apollo at Didyma, of about 330 B.C.–A.D. 41 (fig. 35). The temple at Ephesos took the place of the archaic temple (cf. p. 29), which was burned in 356 B.C., and it duplicated the plan of its predecessor, even in the sculptured drums. The temple at Priene also had unusual features, such as square plinths for the columns.

The temple of Artemis at Sardis is probably contemporary with the Ephesian, which it closely resembles (cf. fig. 36). One of the capitals of its pronaos was acquired by the Metropolitan Museum of New York.

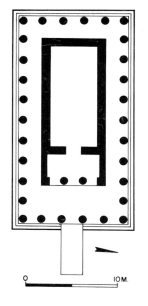

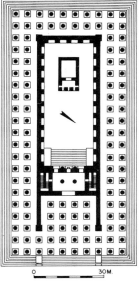

34. The Temple of Asklepios at Epidauros, early fourth century B.C.

35. The Temple of Apollo at Didyma, c. 330 B.C.–A.D. 40.

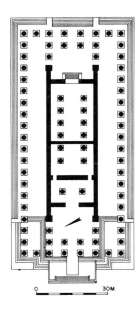

36. The Temple of Artemis at Sardis, c. 350–300 B.C.

Examples of Hellenistic architecture are to be found chiefly in Asia Minor; for Greece proper, after her loss of independence, had no longer the resources to erect great buildings, except when these were supplied by foreign potentates.

The temple of Artemis Leukophryene at Magnesia was reconstructed in the second century B.C. It follows old traditions, except that it is pseudo-dipteral with only one row of exterior columns, but this is set two intercolumnations from the wall of the cella. Like many Hellenistic buildings, it was raised on a high platform. Parts of its frieze, representing contests of Greeks and Amazons, in a rather coarse style, are now in Istanbul and in the Louvre (cf. p. 181).

The temple of Hekate at Lagina has also yielded extensive sculptural remains (cf. p. 181). It was short in proportion to its width, having eight columns on the ends and only eleven at the sides. It too was pseudo-dipteral.

The famous temple of Sarapis in Alexandria, erected under the Ptolemies, combined Oriental and Greek features. It stood on a lofty terrace, which was entered through a domed gateway leading into a courtyard with a basin of water. Connected with the temple was a library, and beneath the terrace were vaulted rooms in which the sacred ceremonies were performed.

The temple of Zeus Olympios at Athens (174 B.C.–A.D. 131) may conclude this short survey (fig. 37). The order is Corinthian. The stylobate measures about 41 by 188 metres. There was a double colonnade, with twenty columns on the sides and three rows of eight columns at the ends. The present temple stands on the bottom steps of an earlier, Doric structure of the sixth century which was never finished. The new building, of Pentelic marble, was begun by Antiochos IV Epiphanes of Syria (175–164 B.C.) from designs of the Roman architect Cossutius, on a lavish scale,

37. The Temple of Zeus Olympios in Athens, 174 B.C.–A.D. 131.

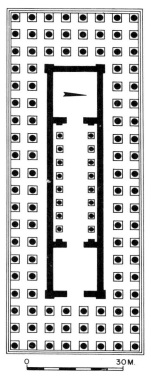

but not completed until Hadrian's time. The fifteen columns that are still standing are a conspicuous feature of modern Athens. Their slender shafts and elaborate capitals indicate the change in taste that had taken place since the time of the Parthenon.

Altars, Treasuries, Tholoi, Propylaia

The altar in an open precinct preceded the temple as a place of worship (cf. p. 22), and later remained an essential adjunct of the temple, being placed either inside it, or more commonly outside, facing the entrance. Generally it was a simple oblong or circular structure, occasionally of great size, and sometimes decorated with friezes of triglyphs and metopes and other elements.

Sumptuous altars of the archaic period have come to light in Ionia, for instance in Samos (120 feet square), and at Miletos, the latter with large volutes and palmettes rising like akroteria at the four corners.

The most famous altar of Hellenistic times is that of Zeus and Athena at Pergamon, built on one of the terraces of the citadel, probably by Eumenes II (197–159 B.C.). It consisted of an Ionic portico with two projecting sides (fig. 38), the whole set on a high podium which was decorated in high relief with the battle of gods and giants (cf. p. 175). The inner side of the back wall of the portico had a smaller frieze representing the story of Telephos and the foundation of Pergamon. Inside this three-sided structure stood the altar itself.

The largest known altar was found at Syracuse, built by Hieron II in the third century B.C. It was over 650 feet long and 74 feet wide, and it was divided, as was customary, into two parts, one for the sacrificial slaughter, the other for the actual burning of certain portions of the animals.

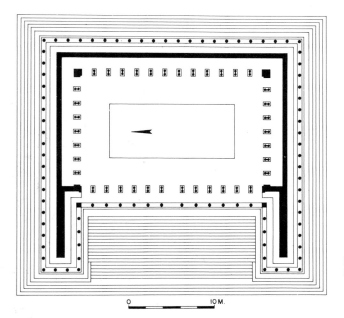

38. The Altar of Zeus and Athena at Pergamon, first half of second century B.C.

0 10 M.

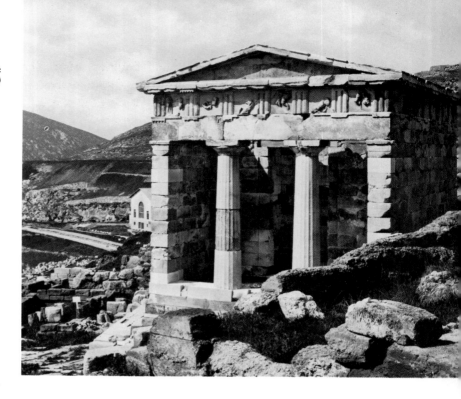

39. The Treasury of the Athenians at Delphi, *c.* 500 B.C.

Remains of treasuries (*thesauroi*), used to house public as well as in certain cases private offerings, have been found in a number of sanctuaries. Each community erected its own treasury, consisting generally of a smallish chamber, about 16 to 20 feet square, with a portico in front. A number of them have been discovered at Delphi and Olympia, some being Doric, others Ionic, and dating from the sixth century onwards. Like the temples, they were decorated with sculptures. The treasury of the Athenians at Delphi (about 500 B.C.) has been reconstructed and forms a conspicuous feature in the sanctuary (fig. 39). The sculptured metopes and akroteria of this treasury, and the pedimental figures, karyatids, and continuous friezes of the Siphnian Treasury (about 530–525 B.C.) are among the finest examples of their respective periods (cf. pp. 82, 88 f.). The treasury of Gela at Olympia (perhaps around 550 B.C.) was exceptionally large and had an elaborately decorated terra-cotta sheathing of its stone cornice which has survived in part.

Related to the temples are the circular buildings known as *tholoi*, which consist of chambers with concentric rings of columns, sometimes combining the different orders. Examples of such structures have been found in the sanctuaries of Delphi, Olympia, and Epidauros (cf. fig. 40), as well as one in the market place at Athens, where it served as a council chamber (cf. p. 46). What the function was elsewhere is uncertain. The tholos at Delphi was built by Polykleitos the Younger, who also designed the theatre at Epidauros (cf. p. 43). Its delicately carved metopes are partly preserved. The so-called Philippeion at Olympia was begun by Philip in 339 B.C. and completed by Alexander.

40. The Tholos at Epidauros, *c.* 350 B.C.

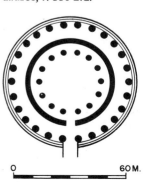

0 60 M.

The gateway of a sanctuary was sometimes a simple doorway (*propylon*), at other times an elaborate structure with several doorways (*propylaia*). The best known is at the entrance of the Athenian Akropolis built, after the destruction of an earlier building, by the architect Mnesikles in 437–432 B.C. It still stands, partly reconstructed—an impressive approach to the temples within. The central wall, with five doorways, was flanked West and East by a Doric portico and projected northward to form two chambers—one being the picture gallery mentioned by Pausanias. The corresponding area on the southern side was not available, being occupied by or reserved for other buildings. In the East and West porticoes Doric columns were used for the exterior, and taller Ionic ones for the interior, to allow for the rising ground. Throughout, Pentelic marble was employed, with additions here and there of black Eleusinian stone. The ceiling was famous for its beauty even in the time of Pausanias, and some of its marble coffers (originally decorated with golden stars on a blue ground) have been preserved. The approach was by a winding path and ramp, providing convenient access for processions and the sacrificial animals that passed through the wide central intercolumnations and gate. The building was never finished, evidently owing to the outbreak of the Peloponnesian war in 431 B.C. There is evidence of an additional large hall—which was intended to flank the Eastern portico on its North side—in a series of holes made for the insertion of roof beams and rafters; a similar hall was projected on the South, but likewise was never carried out. In the time of the Antonines the building served as a model for the grandiose propylaia at Eleusis; and similar hallways with temple-like façades have been found in the precincts of Priene and Samothrace.

Theatres, Stadia, Odeia

Next to the Greek temple, the Greek theatre has captured the popular imagination. Its form owes much to its origin—namely the choral dances associated with the worship of Dionysos. In 534 B.C. Thespis is said to have introduced an actor to these performances, Aischylos in 472 added a second actor, Sophokles in 458 a third (and each actor took more than one part); but the chorus always remained an essential feature. The Greek theatre, therefore, regularly consisted of a large circular orchestra (dancing place) with an altar in its centre and with a curved, generally semicircular auditorium (*theatron* or viewing place), situated generally on the slope of a hill. The actors, however, needed some structure to facilitate their entrances and exits and their changes of costume. A stage (*skene*) was therefore added, separated from the auditorium on either side by two passages (*parodoi*), giving access to the orchestra from the outside. At first the stage seems to have been level with the orchestra, but gradually it was raised and was provided with a colonnade; and in time stone struc-

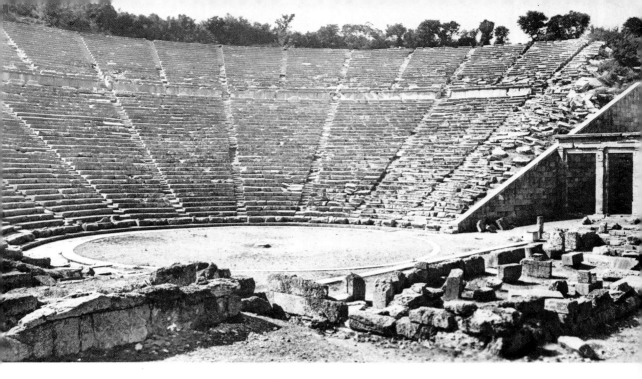

tures took the place of the earlier wooden ones. The various phases of this development have given rise to much discussion.

The earliest extant Greek theatre is that of Dionysos on the South slope of the Athenian Akropolis, which dates from the fifth century B.C. On this site the plays of Aischylos, Sophokles, Euripides, and Aristophanes were performed; but the actual remains date from various periods, principally from rebuildings in the time of Lykourgos (338–326 B.C.) and during the Roman Empire.

One of the best preserved theatres is that at Epidauros, erected by Polykleitos the Younger about 350 B.C. (cf. p. 41), by which time the theatre had assumed a monumental form. The orchestra is circular, 80 feet in diameter, with an altar to Dionysos in the centre (figs. 41, 42).

41. The Theatre at Epidauros, c. 350 B.C.

FIRSt
B 4fIL c.
south slopes of Akropolis

Orchestra

Par odos Paro dos

Ramp Ramp

Proskenion Skene

42. The Theatre at Epidauros, c. 350 B.C.

43

Behind it rose the auditorium, in shape a little more than a semicircle. It was divided by an ambulatory (*diazoma*) into two storeys and by radiating stairways into wedge-shaped sectors (*kerkides*), twelve in the lower storey, and about twice that number in the upper. All the seats were of stone. The seats of honour (*proedria*) had backs and arm rails (some, from other theatres, are decorated with reliefs); the others were backless, with hollowed-out front surfaces, so that their occupants could draw back their feet when people passed in front of them. The width of each seat was 2 feet 5¼ inches; the heights varied from 13 inches in the lower storey to 17 inches in the upper. The back parts of the actual seats were somewhat depressed. Thus everything was carefully calculated to accommodate as many spectators as possible in comparative comfort. Of the Polykleitan stage nothing remains except foundations.

Theatres of this general form have been found all over the Greek world. Most of them belong to the Hellenistic period. Some are well enough preserved—or have been sufficiently reconstructed—to allow Greek and Latin plays to be performed in them to this day. In listening to a play by Aischylos or Euripides, in the theatre of Syracuse for instance, one may imagine that the same play was once seen by Plato on the same spot; and one can realize how practical the plan was, the semicircular seating allowing several thousand people to sit within easy visual and vocal range of the performers.

The Greek race-courses (*stadia*) were, like the theatres, placed on the slope of a hill or in a valley, to allow the natural inclines being used for the seats of the spectators. The shape was elongated, with ends rounded or squared. Occasionally the starting and finishing lines are preserved, giving the exact length of the course, which varied from 600 to 700 feet.

The oldest stadium in Greece is that at Olympia, remains of which have been found beneath the later structures of the fifth and fourth centuries B.C. It was exactly a stade, or 600 Greek feet long, and was therefore called stadion. At first there were embankments only on three sides, and no division between stadium and precinct, which explains the many archaic offerings found during the recent excavations in that area. Not until the middle of the fourth century B.C. was a West embankment constructed to separate the stadium from the altar and temple of Zeus.

The stadium in Athens was constructed of limestone by Lykourgos in the fourth century B.C., reconstructed in marble by Herodes Atticus c. A.D. 140, and rebuilt, again in marble, for the first Olympic games in 1896. It can accommodate 70,000 spectators. Other stadia of which substantial remains survive are at Delphi, Epidauros, Miletos, and Priene.

For chariot and horse races a longer course was needed; but of these hippodromes few traces remain.

An imposing *odeion* (concert hall) was built in Athens, under the supervision of Perikles, near the theatre of Dionysos for the musical contests

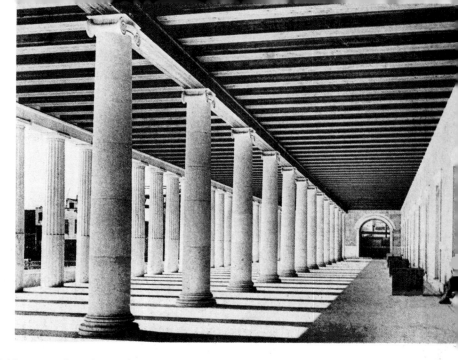

43. The Stoa of Attalos in Athens as reconstructed, *c.* 150 B.C.

that were introduced in 446 B.C., and perhaps also for theatrical rehearsals. It was a square structure with a roof supported by several rows of columns, and with porches East and West and perhaps also on the South. The remains now extant date from after Sulla's destruction of the Periklean hall, but follow the original design. The best preserved Greek odeion is on the South slope of the Athenian Akropolis, erected by Herodes Atticus about A.D. 161. Its form is like that of a small theatre. It has recently been reconstructed, and performances are given in it.

Assembly Places: Stoai, Leschai, Bouleuteria, Prytaneia, Fountain Houses

The colonnade (*stoa*), where people could find protection from rain or sun, was naturally needed wherever people assembled, and was accordingly built both in sanctuaries and market places. Remains of splendid archaic examples have come to light in Samos, and several have survived from the fifth and fourth centuries. That of Zeus (or Royal Stoa?), mentioned by Pausanias as being in the Athenian agora, has been identified by the American excavators. The Stoa Poikile ('painted Stoa') in Athens was famous for its painted decorations (cf. p. 277). The stoa of the Athenians at Delphi, set beneath the temple of Apollo on three steps of black limestone, has several columns still standing. A stoa in the sanctuary of Epidauros and one on the Southern slope of the Athenian Akropolis served for the housing of patients who hoped to be healed in the shrines of Asklepios. The large South stoa at Corinth facing the agora was used for commercial purposes besides shelter, as is shown by its row of shops and storerooms.

In the Hellenistic period porticoes were exceedingly popular, especially for the adornment of market places. That built by Attalos II of Pergamon

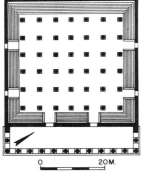

44. The Telesterion at Eleusis, after 445 B.C.

(159–138 B.C.) for the Athenian Agora has now been reconstructed by the American School of Classical Studies to serve as a Museum (fig. 43). It had two storeys with Doric, Ionic, and 'Pergamene' columns, a row of shops at the back, and storerooms below. The reconstruction, in Pentelic marble, enables one to realize the impressive, harmonious, and practical plan of these buildings.

The so-called *Leschai* were the Greek equivalents of the modern clubs, and served as informal meeting places. The best known is the Lesche of the Knidians at Delphi, an almost square chamber, divided into three aisles by two rows of columns. Polygnotos decorated its walls with scenes of the Trojan war (cf. p. 277).

As assembly places for specific purposes may be mentioned the council houses (*bouleuteria*), of which the most famous was that at Olympia where the contesting athletes are said to have sworn to obey the regulations of the games; the *prytaneia*, or meeting places of the Senate committee, such as the round structure or tholos unearthed in the Athenian agora (cf. p. 41); and the *Pnyx*, a kind of semicircular terrace cut on the slope of a hill North of the Akropolis to accommodate the citizen body of Athens.

The *Telesterion* at Eleusis, the Hall of Initiation of the Eleusinian Mysteries, consisted of a large enclosed hall, resembling an Egyptian hypostyle hall, with six rows of interior columns to support the roof (fig. 44). A similar assembly hall in Megalopolis was even larger.

The fountain houses with their porticoes were the daily meeting places of the women, as the stoai were of the men. The many representations of them on Attic vases, with women going to and fro with their water jars, give a vivid picture of this aspect of Greek life (cf. fig. 45). One of the earliest and most imposing of these fountain houses was that of Peirene at Corinth, consisting of four vaulted reservoirs, supplied by long galleries, into which the water filtered from above. The most famous of the Athenian fountains was the Enneakrounos (nine-mouthed), with nine lion's heads through which the water spouted. An attractive little

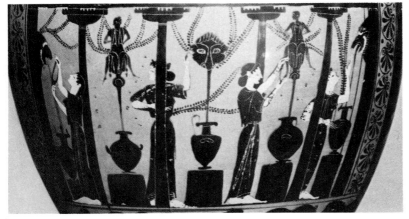

45. Fountain House. Detail from an Attic hydria of about 510 B.C. London, British Museum.

model of an early fountain house, tripartite, with a flat roof, has been found at Lemnos and is now in Athens.

In the Hellenistic period fountain houses became more elaborate, as exemplified by the expanded fountain of Peirene, at Corinth.

Gymnasia and Palaestras

Another important feature of Greek life was the gymnasium, where boys and young men exercised and were trained. A particularly fine example, dating from the fourth century B.C., has been discovered at Delphi. It was built on the slope of the hill below the sanctuary; on an upper terrace was a Doric portico with two racecourses, one covered, the other being open. On the lower terrace was a smaller structure, with baths, including a circular basin 33 feet in diameter.

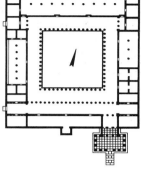

46. The Palaestra at Epidauros, Hellenistic period.

In Hellenistic times the gymnasium regularly included an open athletic ground for such outdoor exercises as running, jumping and throwing, whereas wrestling and boxing, which required less space, were practised in a partly enclosed structure called the *palaistra*. The Hellenistic palaestra at Olympia consisted of a large open court with a Doric peristyle and with rooms on all four sides—for indoor exercises, dressing rooms, baths, lectures, etc. Similar or even more elaborate structures have been found at Delos, Priene, Epidauros (cf. fig. 46) and Pergamon.

The famous 'Museum' built by the Ptolemies at Alexandria was really a development of the gymnasium; it included large gardens, fountains, stoai, a library, and a restaurant. Unfortunately its destruction was such that practically nothing remains.

Sepulchral and Votive Monuments

Greek sepulchral monuments passed through several stages of development and differed somewhat in various localities. The large terra-cotta vases of the geometric period and of the early seventh century B.C. (cf. pp. 291 ff.) were superseded in the later seventh and in the sixth century by stelai or shafts, generally decorated with reliefs and surmounted by finials; and they remained the normal gravestones for several centuries. The examples that have survived in large numbers form in fact a major part of the original Greek sculptures now extant. Some have been left standing in the ancient cemetery of Athens.

A form of early archaic tomb, apparently peculiar to Attica, was a quadrangular structure of sun-dried brick decorated with painted terra-cotta plaques[8]. The extant examples range from the last third of the seventh century to about 530 B.C. (cf. p. 233). The subjects are funerary. Actual structures of this type have been found in the Kerameikos of Athens, and may perhaps be represented on two kyathoi in the Cabinet

des Médailles. In addition, sepulchral statues were occasionally erected throughout archaic and classical times.

The sarcophagus was also used in Greek lands for inhumation burials, as it was later in Rome. Plain ones, corresponding to our coffins, were buried, decorated ones, in stone or terra cotta, were displayed in cemeteries and tomb chambers (cf. e.g. those from Klazomenai, Eretria, and Tarentum). Elaborate examples with sculptures in relief came to light in what must have been a royal necropolis at Sidon, in Syria, and are now in Istanbul. They date from various periods, the so-called Satrap sarcophagus[9] from *c.* 430 B.C., the so-called Lycian from *c.* 400, the one with the mourning women from *c.* 350, and the famous 'Alexander Sarcophagus' from the end of the fourth century B.C. (cf. pp. 131, 154). Extensive traces of colour remain, especially on the Alexander sarcophagus.

Other fine sepulchral structures have been found in Asia Minor. Early examples are the so-called Lion and Harpy Tombs from Lycia, of about 600 and 500 B.C. respectively, which consisted of a high, quadrangular pillar, surmounted by a tomb chamber in the form of a chest, and ornamented on its sides with reliefs (cf. pp. 62, 88).

From the late fifth century date two grandiose buildings—the Heroon at Gjölbaschi in the Troad, which was really a cemetery containing several tombs, and was surrounded by a wall, carved with reliefs in several tiers (cf. p. 137), and the Nereid Monument at Xanthos. The latter resembled an Ionic peripteral temple, except that it was set on a high base, and had figures of Nereids between the columns and sculptured friezes and statues in other parts (cf. p. 137).

The most sumptuous of these monuments, however, was the Mausoleum of Halikarnassos, begun by king Maussollos, continued by his wife Artemisia after his death in 353 B.C., and completed by Idrieus and Ada, their brother and sister. It stood on a square podium, was surrounded by a peristyle, and surmounted by a pyramid with a quadriga on top. Famous sculptors were employed in its decoration (cf. pp. 149 f.), and it ranked in antiquity as one of the Seven Wonders of the World. Its design was used as a model for many Hellenistic and Roman monuments.

Votive monuments in general resemble the sepulchral stelai, that is, they consist either of a slab decorated with reliefs and inscribed with a dedication, or of a statue mounted on a base. When they commemorated important events they sometimes assumed grandiose forms, as, for instance, Pheidias' statue of Athena Promachos, which was erected on the Akropolis after the battle of Marathon, and of which the large moulded base still remains; or the Ionic column surmounted by a sphinx, which was erected by the Naxians at Delphi and which had a total height of 47 feet (cf. p. 62). The decisive victory at Plataiai (479 B.C.) was commemorated by a stupendous monument consisting of a gold tripod supported by three intertwined bronze serpents. Parts of the latter survive and are in

Istanbul[10]. An attractive example of the early fourth century, found at Delphi, is in the form of a column decorated with acanthus leaves and karyatids; the occasion of its dedication is not known. Another type had the form of a semicircular or rectangular pedestal, which was placed in a niche and supported several statues of famous personages (e.g. the monuments of Daochos of Thessaly and of the Argive kings and queens, both at Delphi). The monument set up by Lysikrates in 335–334 B.C. to support the tripod that he won in a choral contest is still standing on its original site in Athens. It is a circular structure, placed on a high, square base, and surmounted by a roof on which the tripod was placed.

Lighthouses

A monumental lighthouse (*pharos*) built at Alexandria by Sostratos of Knidos for Ptolemy II (285–246 B.C.) ranked as one of the Seven Wonders of the World. It rose to a height of 440 feet, and consisted of three successive members—a square base with tapering sides, then, stepped back, an octagonal section, and on top a circular structure containing the beacon. Though only the lower part now remains (in the fort of Kait-Bey), the plan of the whole has been deducted from representations of it on coins, engraved gems, and a glass vase from Begram[11], as well as from ancient and Arabic inscriptions. The words *pharos* and *faro* are still the terms used for lighthouse in Greece and Italy today, and the plan served, it has been thought, as the prototype of the Christian campanile and the Mohammedan minaret.

Private Houses, Hotels, Fortifications, City Plans

Greek private houses were at first relatively simple. Sun-dried brick and wood seem to have been the materials regularly used for the walls. Little is in fact known of private dwellings of the early period; but that, by the late fifth century B.C., some houses had a certain elegance is shown, for instance, by the inscription relating to the furnishings of Alkibiades' house (cf. also Plutarch, *Alkibiades*, 16, 4).

The excavations at Olynthos have laid bare the foundations of more than a hundred houses dating from the late fifth and the first half of the fourth century B.C. They are usually almost square in plan, one-storeyed, with an entrance leading into a court, sometimes with a peristyle, one or more porticoes, and several living rooms, so arranged as to provide sunshine in winter (figs. 47-48). A similar plan was adopted for the Hellenistic houses found at Priene, Delos, Pella and Morgantina, but often in a more luxurious form. The basic features, however, remained: the court with connecting rooms, and the peristyle, serving as a kind of garden. A few windows, generally placed high, and a door faced the narrow streets.

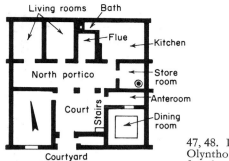

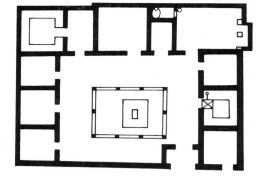

47, 48. Private Houses at Olynthos, late fifth or early fourth century B.C.

As a specially luxurious example of a Hellenistic house may be cited the summer palace near Palatitza in Macedonia, with a spacious entrance instead of the usual narrow corridor, large halls, porticoes, and a considerable number of rooms. It was in fact the palace of a king and not the dwelling of a private citizen in a democracy.[12]

In a few places, for instance in the sanctuaries of Epidauros and Delphi, remains of hotels (*katagogia*) have been found. There visitors could be housed, and, in the case of Epidauros, patients received awaiting to be cured. The building in Epidauros (fig. 49) had two storeys, and four peristyle courts, each surrounded by rooms, making a total of one hundred and sixty. The so-called Leonidaion, built by one Leonidas at Olympia, was intended chiefly for distinguished visitors and was correspondingly luxurious, with a colonnade surrounding it.

Apartment houses of several storeys belong to the Roman age.

A word may perhaps be said about the doors of Greek houses. The material was generally wood, which explains why so little is left of them; but the form is known from representations on vases (cf. fig. 50). It was two-winged, with transverse boards, studded with metal nails and appliques, including large rings serving as handles, and locks. A handsome example in white marble, 3.12 metres high, was found in a sepulchral chamber at Langaza, near Saloniki, and is now in the Museum of Istanbul

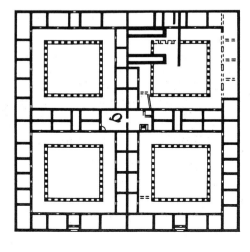

49. Hotel at Epidauros, fourth century B.C.

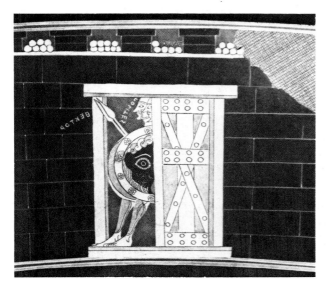

50. Door. Drawing after the François Vase. *c.* 570 B.C. Florence, Museo Archeologico.

51. Marble Door from Langaza. Fourth century B.C. Istanbul, Archaeological Museum.

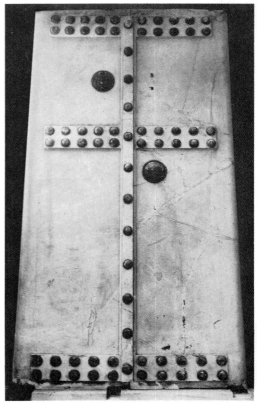

(fig. 51); and another of bronze belonged to the same chamber. Both can be dated in the late fourth century B.C. The one in bronze had a beautiful handle with elaborate palmettes on the attachments. Similar doors have come from other Macedonian tomb chambers, for instance those from Pydna and Palatitza, now in the Louvre (nos. 706, 707),[13] and painted false doors are represented on slabs in the Greek cemetery at Hadra near Alexandria.[14]

To guard against a neighbouring or distant enemy every Greek city had a city wall, with gates and projecting towers, and in most cases an akropolis which could serve as a last refuge. In addition, the passes which led from one city to another were protected by forts. A number of these fortifications have survived in good enough condition to show the original plan. In Athens the Dipylon (i.e. double) Gate consisted of an outer and an inner structure, connected to form a court and flanked by towers; thus, if the enemy forced the outer gate, the defence could be continued. The fortifications at Messene of the first half of the fourth century B.C. are exceptionally well preserved, and so is fort Euryelos at Syracuse which was built by the tyrant Dionysios (406–367 B.C.) against the Carthaginians. The latter consists of a large court with five towers, deep moats, and subterranean passages. Impressive remains of fourth-century fortifications have recently been found at Gela.

The Greeks apparently became interested in city planning at an early date. The impetus came from Ionia, where the founding of new colonies and the necessity to rebuild cities that had been destroyed afforded ample opportunities. The basic plan was the chequerboard or gridiron, invented, according to Aristotle (*Politics*, 11, 5, XVI, 2, 9), by Hippodamos of Miletos, who planned the city of Piraeus for the Athenians around the middle of the fifth century B.C.

The cities of Miletos, Priene, Pergamon, and Ephesos show plans in which several buildings play their part in an ordered whole. Colonnaded streets were introduced and have ever since been an attractive feature of Mediterranean towns. Great harbour works were added to the cities of the Aegean coast. And this Hellenistic architecture directly influenced Roman city plans.

LARGER WORKS OF SCULPTURE

It seems best to begin an account of Greek sculpture with the larger figures and groups, even though some Greek statuettes and small reliefs in bronze and terra cotta are earlier by several centuries (cf. p. 186); for in the larger sculptures one can trace in greater detail than in any other medium the development of Greek plastic art through its various phases.

Sources of Information

Naturally, after more than two thousand years, a large part of Greek sculpture has disappeared; but enough remains to reconstruct its history along broad lines. Moreover, in the Roman period, Greek originals were extensively copied and adapted, and famous Greek sculptures survive in such Roman reproductions. Much additional information is derived from ancient writers on Greek art, especially from the Elder Pliny (A.D. 23–79), who in his *Natural History* included accounts of Greek sculptors and painters (mostly taken from earlier writers), and from Pausanias, who wrote a *Description of Greece* in the second century A.D. Furthermore, inscriptions have supplemented our knowledge. They consist mostly of temple inventories, of dedications, and of signatures on bases of statues and reliefs.

Uses, Subjects, Materials, Techniques

Greek sculptures mostly served a religious purpose, at least in the earlier periods. They were used for the decoration of temples—for pedimental groups, friezes, akroteria—for the cult statues placed inside the cella, and for the votive monuments erected in the sanctuaries. A large proportion of the surviving original Greek sculptures are architectural.

Commemorative sculptures also played an important part. A significant victory would be celebrated by the erection of a statue or group, a triumph in an athletic contest with the statue of the young victor, a treaty made between two cities with the erection of a stele.

In addition, there was a large private demand for grave monuments. They consisted of stelai or slabs ornamented with reliefs or paintings and crowned with finials, of statues worked in the round, and of large

stone vases decorated with reliefs. They stood in the open, in family burial plots, or sometimes combined in public cemeteries (e. g. in the Kerameikos of Athens).

The subjects chosen in Greek sculpture, as well as in the other branches of Greek art, may be divided into two chief categories. They either illustrate the manifold myths of the Greeks, the picturesque stories of their gods and goddesses and the valiant deeds of their heroes; or they depict the daily life of the time—athletes contesting, warriors fighting, women with their children and maids, and mourners at the tombs. Historical scenes and battles, which played so large a part in Egyptian and Assyrian, and later in Roman, art were rarely directly represented in Greece; more commonly they were suggested by mythical contests—of gods and giants, or Greeks and Amazons, or Lapiths and Centaurs.

The erection of portraits of prominent individuals, either by their relatives or the state, apparently began in the fifth century B.C. Such statues were set up in public places rather than in private houses, at least until Hellenistic times.

The chief materials used by the Greeks for their larger sculptures were stone (limestone and marble), bronze, terra cotta, wood, a combination of gold and ivory, and occasionally iron (cf. e. g. Pliny, XXXIV, 141). Only stone examples have survived in any quantity. In the damp climate of Greece, wood has mostly disintegrated; gold and ivory were too precious to survive; bronze was melted down in times of emergency; and iron has corroded.

Though stylistically the sculptures in these various materials show the same evolution, their techniques naturally differed.

In the earlier periods stone sculptures were produced by direct carving. Not until the Roman age was the so-called pointing process introduced, by which a model could be copied mechanically from a cast many times (cf. p. 183). The standard tools used by the Greeks were the punch or point, the drill, and the various chisels—claw, drove, flat, and gouge— all manipulated with the mallet. The running drill was apparently introduced in the fifth century B.C., whereas the saw was known from early times.

Transportation of heavy blocks of stone naturally presented a problem. Large statues were, therefore, cut to their approximate shape in the quarries. Several that for some reason were never finished can still be seen on Mount Pentelikon and in Naxos. There was no objection to piecing. Heads and outstretched arms were often made separately and attached with metal dowels and stone tenons, generally set in molten lead. Smaller pieces could be fastened with cement.

All stone sculpture, whether of limestone or marble, was painted, either wholly or in part. Though much of the original colour has now disappeared, enough traces remain to make its general use certain, as indeed

it had been in Egypt (even for coloured stone) and as was desirable in the brilliant light of Greece. Another general Greek practice was the addition of accessories in different materials. Eyes were sometimes inlaid in coloured stone, glass or ivory; metal curls, diadems and wreaths were added, and even earrings and necklaces; likewise metal spears, swords, and the reins and bridles. Only the holes for attachment now generally remain.

Bronze was throughout Greek history a favourite material for statues. The earliest bronze sculptures were plated, that is, they were made of hammered sheets of bronze, riveted together over a wooden core. Later, casting was introduced. Solid casting, though appropriate for statuettes (cf. p. 186), is not suitable for large statues; and so hollow casting—which had been practised in Egypt from early times—was introduced during the seventh century B.C., as actual examples show, and became common in the sixth century. The lost-wax (*cire-perdu*) and sand-mould processes were both employed. In the former, a wax model (solid or modelled over a core) was surrounded by a mantle of clay and sand, heated until the wax melted away, whereupon the molten metal was poured into the empty spaces, and the core, which had been kept in place by bars, was removed. In the sand-mould process the figure was generally made in sections; but the principle of casting was the same as in the lost wax process, except that the model was of wood instead of wax, and was inserted into a box filled with moist sand, producing a mould for the molten metal.

Greek bronzes were left in their natural, golden yellow colour; the patinas with which they are now generally covered are due to the action of time.

Terra-cotta statues and large reliefs have been found in considerable numbers in Cyprus, Etruria, Sicily, and Southern Italy, where marble was scarce. But also in Asia Minor and Greece—where marble was easily available—terra cotta was sometimes used for the decoration of temples and occasionally for votive and cult figures.

In the earlier periods terra-cotta statues were built up in coils and wads of clay, with thick walls. To prevent distortion and diminish shrinkage during the firing, the clay was mixed with sand and grog (particles of fired clay). In Hellenistic and Roman times moulding instead of building was often used.

Recently light has been thrown on the technique of the famous chryselephantine (gold and ivory) statues of Greece. The terra-cotta moulds, found in 1955–56 in Olympia in a fill adjoining the very site that had been identified as Pheidias' workshop, show that the gold drapery of the statue of Zeus (cf. pp. 117 f.) had been hammered into piece moulds of terra cotta (the larger ones reinforced with iron bars) and that the gold was diversified with inlay of glass.[1] The life-size heads of ivory found under the Sacred Way at Delphi presumably came from chryselephantine statues.[2]

The Sculptures

EARLY ARCHAIC
PERIOD,
ABOUT 660–580 B.C.

According to the evidence at present available, substantive stone sculpture, that is, statues and reliefs approximately life-size and over, were not produced in Greece before about the middle of the seventh century B.C. Before that time even cult images were apparently more or less small in size and mostly of wood. It evidently was contact with the East that initiated the making of large stone sculptures in Greece. Egypt had conquered Assyria in 672 B.C. and from then on the East was opened to Greek trade. Herodotos (II, I, 54) states that the Egyptian king Psammetichos (*c.* 660–609 B.C.) gave the Ionians and Carians 'places to dwell in . . . on either side of the Nile' and that they were 'the first men of alien speech to settle in Egypt'. As this and other statements of ancient writers tally more or less with the scanty archaeological evidence that exists for the chronology of this period, it seems safe to take *c.* 650, or a little earlier, as the upper limit for Greek substantive sculpture.

The earliest known large statues of Greece testify to the inspiration she received from the East. They are not, it is true, in the hard, coloured stones used by the Egyptians, for the Greeks had at hand abundant stores of white marble, which they quickly learned to utilize; but in the stances and general appearance the borrowings from Egypt and Mesopotamia are evident. A few types were adopted and repeated again and again. Chief among them was the standing youth (*kouros*) in a strictly frontal pose, the left foot a little advanced, the arms generally held close to the sides, occasionally bent at the elbows, the hands either clenched (with the superfluous stone left inside them) or laid flat against the body. The scheme is the same as that used in Egypt, and the general shape, with broad shoulders, narrow waist, and small flanks, is also similar. An important difference, however, is that whereas the Egyptian stone statues generally have a supporting pillar behind them and mostly wear at least a loin cloth, the Greek kouros is represented without any support and is usually entirely nude. For exceptions cf. p. 63.

The female standing type (*kore*) in this period is, on the other hand, regularly shown covered with drapery, which is foldless and adheres closely to the body.

Another popular archaic Greek type is the seated figure, male and female. It too bears a striking resemblance to its Egyptian prototype, that is, it was represented sitting in a stiff frontal attitude, with feet placed close together, both forearms laid on the lap, hands generally held downward, one sometimes clenched. It was regularly enveloped in drapery, which is practically foldless, with an arched lower edge above the feet, as in Assyrian sculpture.

The striding figure also had antecedents in Egyptian art. It was represented much like the standing type, with the left foot advanced, but the

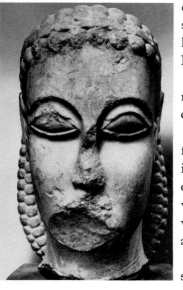

52. Head of a Kouros from the Dipylon, *c.* 615–590 B.C. Athens, National Museum.

legs were placed wider apart and the upper part of the body was made to lean forward. It was utilized chiefly in friezes representing battles, as it had been in Egyptian reliefs.

To represent a figure in rapid motion—flying or running—the Greeks developed a conventional rendering of a half-kneeling stance, with one knee placed on or near the ground, the other slightly bent, and with arms stretched upward, downward, and sideways. In these figures, as well as in the half-reclining ones, the upper part of the torso was turned to the spectator, whereas the legs were shown sideways, entailing a strong torsion at the waist. To represent this turn of the body the Greek artist adopted the Oriental scheme of showing the upper part of the body in full front view, the legs in profile, and of generally covering the waist with drapery.

But though the Greeks owed much to their Oriental predecessors and freely adopted what appealed to them, they soon showed a fundamentally different approach. Instead of endlessly repeating the same conventions, they evolved something entirely new that has changed the conception of art ever since. They were not content to represent a human being according to a formalized scheme, but with their inquisitive minds they discovered, step by step, the true nature of appearance. Within a century or two the formalized shapes which had held good in the Orient for several thousands of years were changed into figures that were true to nature and functioned anatomically. For the first time in history a sculptured human shape was made to reproduce the complex mechanism of the human body. This was achieved in a gradual evolution by working within the framework of a few accepted types; for just as Greek poets 'avoided the appearance of originality' and 'treated a traditional theme in a conventional style and form',[3] so Greek artists used certain accepted types for the expression of their thought. No sculptor, however, merely reproduced the work of another; each renovated the familiar theme, continually advancing on the path of naturalism.

Let us watch this evolution in a number of specific sculptures representing various types.

Many examples of the standing type, both male and female, have been found in Attica, the Peloponnese, Boeotia, and the Islands. Two of the earliest, unfortunately in a mutilated state, have come from Delos; Attica has yielded an impressive series which has been provisionally assigned to the end of the seventh century. It consists of parts of four figures from the sanctuary of Poseidon at Sounion (fig. 53); a head and a hand from the cemetery of the Dipylon (cf. fig. 52); some fragments found in the old Athenian market place;[4] a hand in a private collection in Athens; and an almost complete statue in the Metropolitan Museum, New York (fig. 54). In Delphi may be seen the famous twins, Kleobis and Biton (cf. figs. 55, 56); in Thasos the tall, slim Ram-bearer; in Delos the great Colossus, which had fallen to the ground, it would seem, already in the

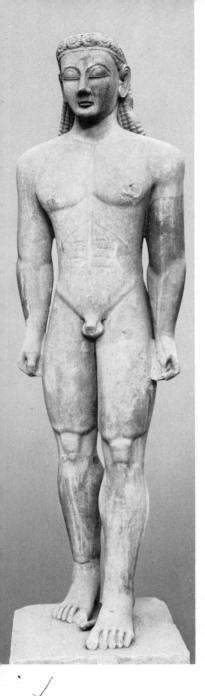
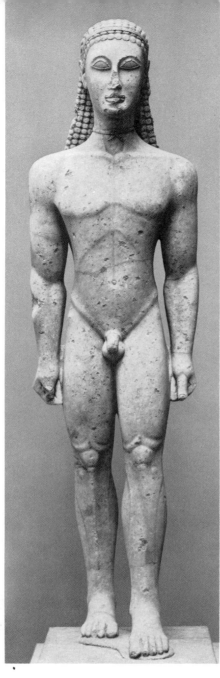
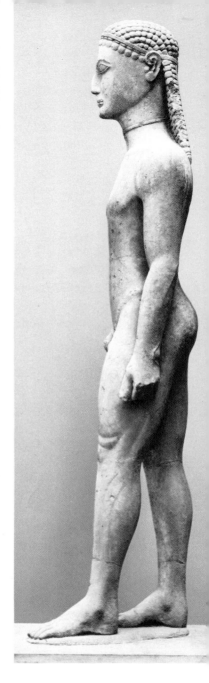

53. Kouros from Sounion, *c.* 615–590 B.C. Athens, National Museum.

54. Kouros, *c.* 615–590 B.C. New York, Metropolitan Museum.

time of Plutarch (*Nikias*, 3); in Thera and Samos fragments of other colossal kouroi. From Boeotia has come a group of two figures inscribed Dermys and Kittylos.

Here, then, we have examples of the earliest large sculptures wrought by the Greeks in sparkling white marble. In all a similar scheme is adopted, in which the derivation from the quadrangular block is evident. The head is cubic, with the features—eyes, ears, and mouth—carved in flat planes and stylized. The body is four-sided. The vertebral column is practically

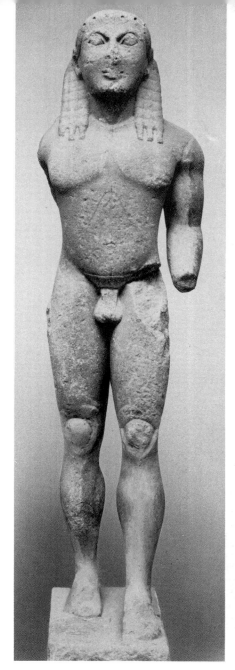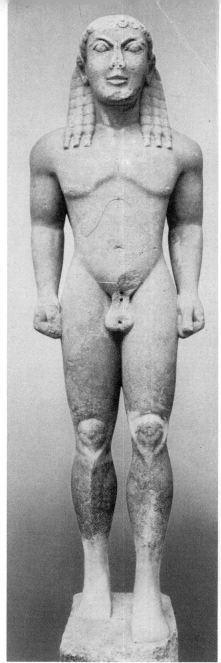

55, 56. Kleobis and Biton, *c.* 600–590 B.C. Delphi, Museum.

straight. The greatest protrusion of the back is higher than that of the chest. The forearm is turned forward, while the clenched hand is twisted towards the body. Anatomical details are indicated on the surface of the block by grooves, ridges, and knobs. In the abdominal muscle three or more transverse divisions are marked above the navel, instead of only the two visible in nature. The protrusion at the flanks is not indicated. The knees reproduce the more or less symmetrical arrangement current in Egypt. The shins are vertical, the malleoli level. The feet stand squarely

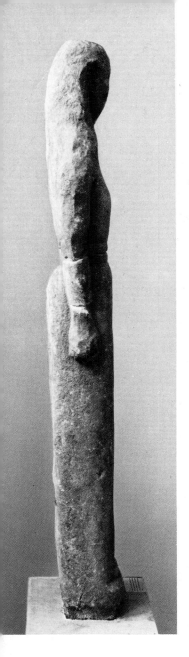
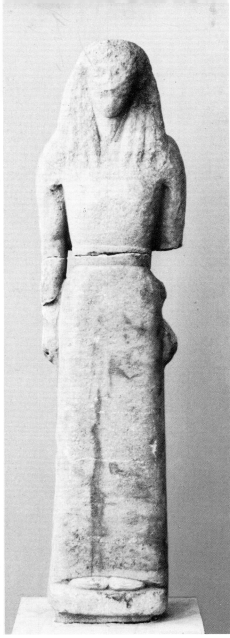
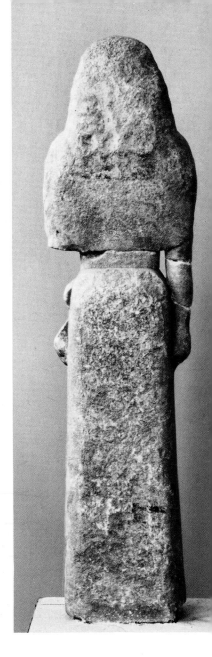

57. Statue from Delos, dedicated by Nikandre, *c.* 660–650 B.C. Athens, National Museum.

on the ground, with long toes, the ends of which recede along one continuous curve and often turn downwards. The human shape, in other words, was conceived as a compact, solid structure, in which essentials were emphasized and generalized into expressive patterns. A monumental quality not unlike that of Egyptian sculpture was thereby achieved.

The same conception is observable in the other sculptures that can be assigned to this early period; for instance, in the female statues standing in a stiff, frontal attitude and enveloped in practically foldless drapery, such as the marble statue dedicated by Nikandre at Delos, now in Athens (fig. 57), and a figure once at Auxerre now in the Louvre (fig. 58). It is

58. Female Statue, formerly at Auxerre. *c.* 630–600 B.C. Paris, Louvre.

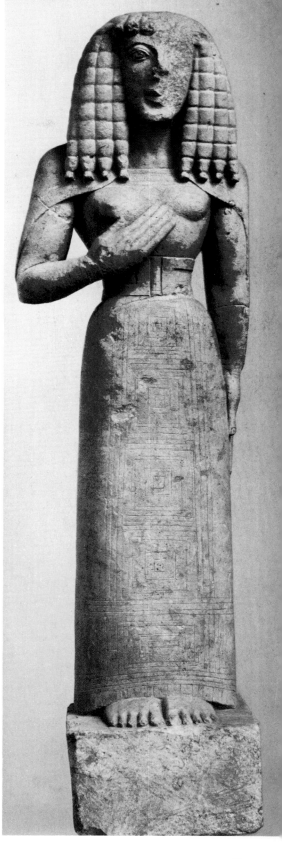

59. Head of Hera (?), *c.* 600 B.C. Olympia, Museum.

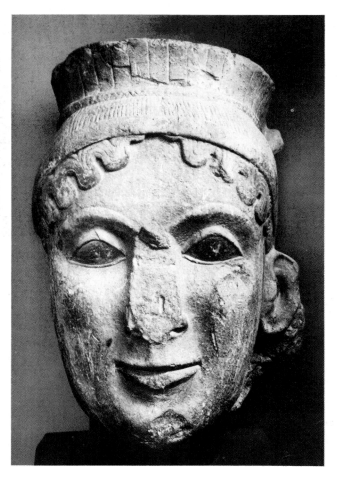

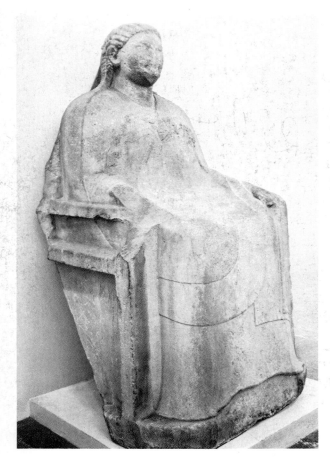

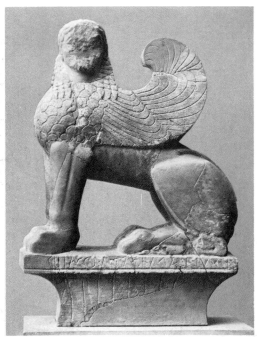

60. Seated Statue from Didyma, *c.* 600–580 B.C. London, British Museum.

61. Sphinx from a sepulchral Stele, *c.* 600 B.C. New York, Metropolitan Museum.

62. Gorgon from the pediment of the Artemis ▶ Temple at Korkyra, *c.* 600–580 B.C.

evident in the earliest seated statues that lined the sacred way leading to the temple at Didyma (cf. fig. 60); in the seated statues from Prinias and Gortyna; and in the colossal limestone head from Olympia (fig. 59, cf. p. 28), almost cubic in shape, which perhaps once belonged to the cult statue of Hera. And it characterizes the seated lions found on the terrace near the sacred lake at Delos, as well as the sphinxes that crowned the sepulchral stelai of the time (cf. fig. 61), and the reliefs of the imposing Lion Tomb from Xanthos, now in London (cf. p. 88). In all, the composition is simple and compact, with anatomical forms translated into decorative patterns.

The architectural sculptures from the early temples are in the same style. Foremost among them are the lioness downing a bull, from a pedimental group on the Athenian Akropolis, and the sculptures from the temple of Artemis at Corfu, the ancient Korkyra (fig. 62, cf. p. 28). In the latter the problem of fitting the figures into the triangular space of the pediment is solved by placing a majestic Gorgon in the centre, flanking it with two large lions, symmetrically composed, and putting smaller

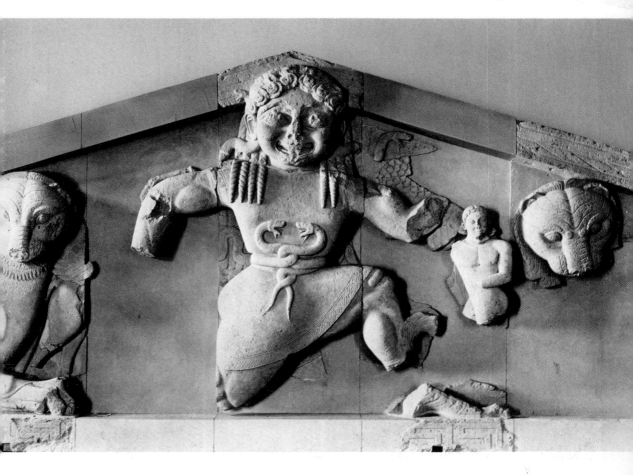

figures at the angles. There is no concerted action or co-ordination, but the simplified forms of the figures impart grandeur to the overall design.

As examples of the next stage in the evolution of Greek sculpture may serve, first of all, four standing youths (kouroi) found in different localities—Thera, Tenea, Volomandra, Melos, and Rhodes (cf. figs. 63–65). In these statues, though the derivation from the four-sided block is still evident, the corporeal quality of the figure is more strongly felt than before. More details are seen in the round and indicated as modelled shapes. The feeling for design is still strong, but, instead of linear patterns, volumes are co-ordinated. Shoulders, pectorals, flanks, thighs, and arms form interrelated shapes; so do the muscles of the arms and legs; while the head, with its undulating mass of hair and decorative features, forms an effective crowning member. In this general period appear also a few draped male figures, evidently intended to represent not athletes but important personages. They have come to light in Samos and elsewhere and show marked Ionic influence.

MIDDLE ARCHAIC PERIOD, ABOUT 580–535 B.C.

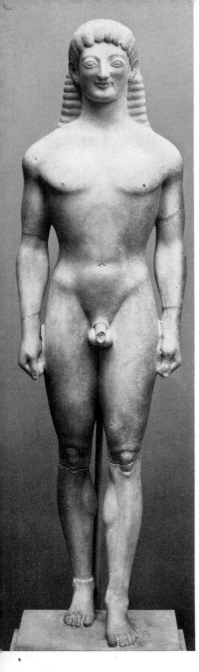
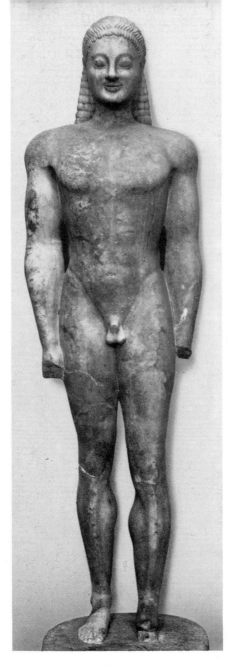
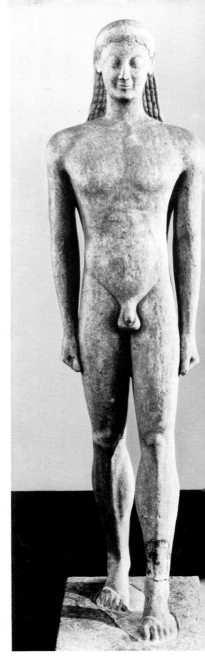

63. Kouros from Tenea, *c.* 575–550 B.C. Munich, Antikensammlung.

64. Kouros from Volomandra, *c.* 575–550 B.C. Athens, National Museum.

65. Kouros from Melos, *c.* 555–540 B.C. Athens, National Museum.

The well-preserved standing Maiden of Berlin (fig. 66), said to be from Attica, is the female counterpart of these kouroi. Here too, though the figure retains the compactness of the early kouroi, the modelling is more rounded. Features and drapery are still rendered in a schematic manner, but they have more depth. In other words, a new conception has been injected into the early monumental structure; a step forward has been taken in the direction of naturalistic representation.

A headless female statue from Samos, now in the Louvre (fig. 67), in-scribed with a dedication to Hera by Cheramyes, is an Eastern, more gracious counterpart of the Berlin kore. She is shown standing, as rigid

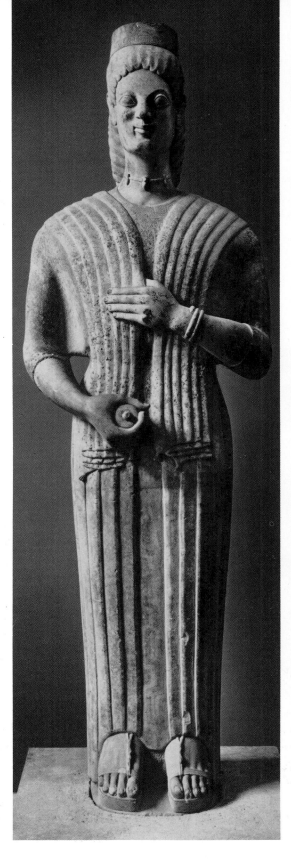
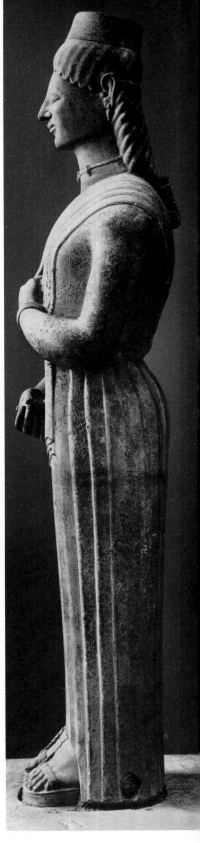

66. Maiden from
Attica, *c.* 580–570
B.C. Berlin, Museum.

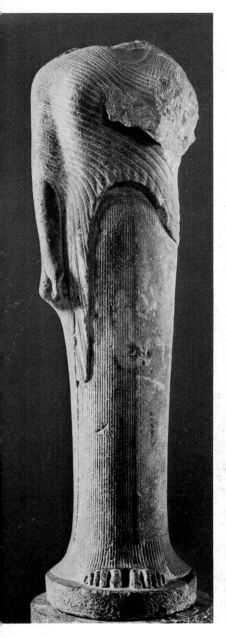

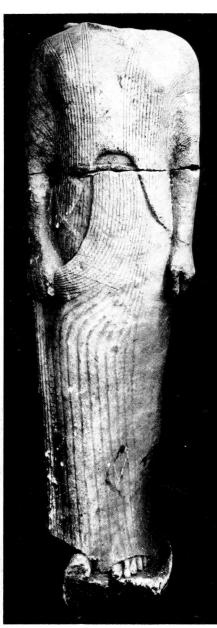

67. Statue from Samos, dedicated by Cheramyes, *c.* 575–550 B.C. Paris, Louvre.

68. Statue of Philippe, from Samos, *c.* 560 B.C. Vathy Museum, Samos.

as a tree, but the fluid contours and subtle differentiations in the enveloping drapery give her a lifelike quality. Another headless statue from Samos, also with a dedicatory inscription by Cheramyes, is now in Berlin. And part of a similar figure, with head preserved, has been found on the Athenian Akropolis (no. 677).

A group of draped statues, also from Samos, belongs to the same general period. They are represented seated, reclining, or standing. One is inscribed 'Philippe' (fig. 68); another 'Ornithe'; still another 'Phileia'

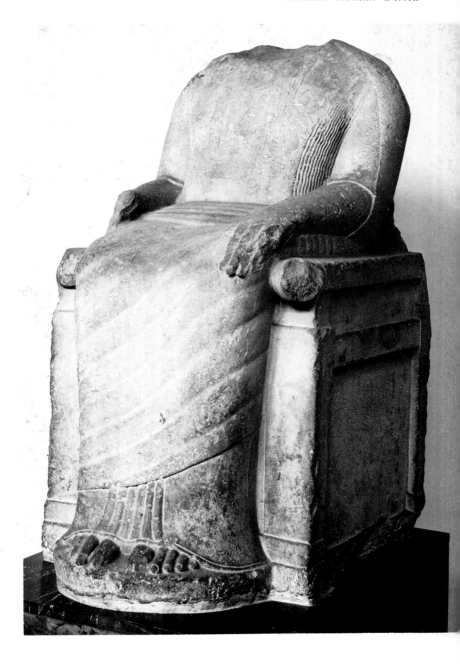

69. Statue from Didyma,
c. 560–550 B.C. London,
British Museum.

and 'Geneleos made us'; a fourth has part of the name of the dedicator:
'I am . . . oche who has dedicated it also to Hera.' The group is perhaps
the earliest non-architectural Greek ensemble that has survived. The
figures stood all in a row, without any concerted action. The only varia-
tion was in the attitudes and in the rendering of the draperies.

Several of the statues which lined the Sacred Way to the temple of
Apollo at Didyma (cf. fig. 69) resemble Geneleos' Phileia. Here too the
drapery begins to be broken up by a tentative indication of folds.

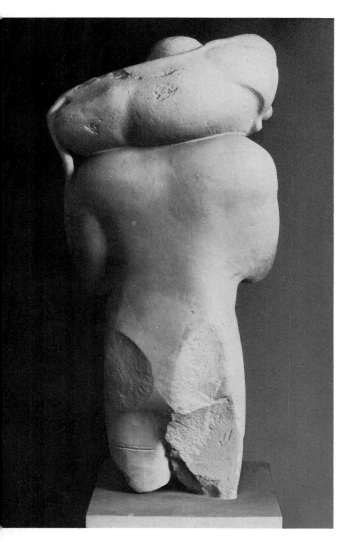
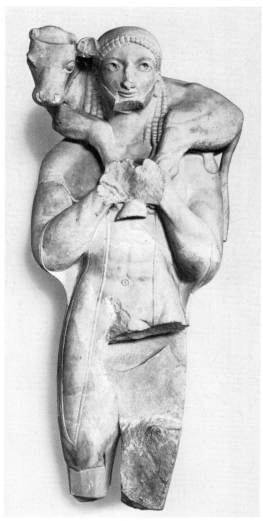

70. The Calf-Bearer, *c*.575–550 B.C. Athens, Akropolis Museum.

One of the statues is signed by the sculptor: 'Eudemos made me'; another is inscribed 'I am Chares, son of Kleisis, ruler of Teichioussa'. Chares was evidently a local potentate during the reign of Croesus. The first person is regularly used in these early inscriptions, for the statue was conceived as speaking to the spectator.

The famous Calf-Bearer from the Akropolis at Athens (fig. 70) is a close relative of the Berlin Kore. It shows the same powerful compactness, stocky proportions, and separate accentuation of volumes. According to the inscription, it was dedicated by one (Rh)ombos.

Another remarkable dedicatory group from the Athenian Akropolis of this period is the so-called Rampin Horseman (fig. 71), the head of which once belonged to Monsieur Rampin and is now in the Louvre, while what remains of the figure is in Athens. Originally there were perhaps

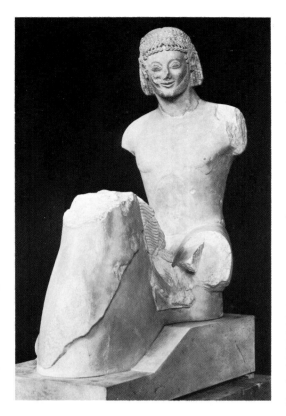

71. Horseman, *c.* 575–550 B.C. Paris, Louvre (head) and Athens, Akropolis Museum (body).

72. Nike from Delos, *c.* 550 B.C. Athens, National Museum.

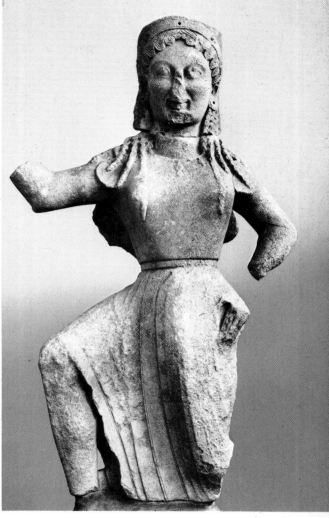

two riders, forming a symmetrical group, and representing the Dioskouroi, to judge from some additional fragments which may have belonged.

The half-kneeling stance adopted in the preceding period for the representation of rapid motion was retained also in this epoch. Though the upper part of the body remained rigid, the forward movement was suggested by a more animated action of the limbs. The Nike from Delos in Athens (fig. 72) shows this new buoyancy both in expression and pose. If an inscribed base found near the statue belonged to it, it was the work of Mikkiades and of his son Archermōs of Chios.

The Attic grave monuments of the middle archaic period reflect the opulence of the wealthy class during Peisistratos' rule. The general composition is the same as in the preceding epoch—a tall shaft, placed on a rectangular base and crowned by a cavetto capital, which in turn is

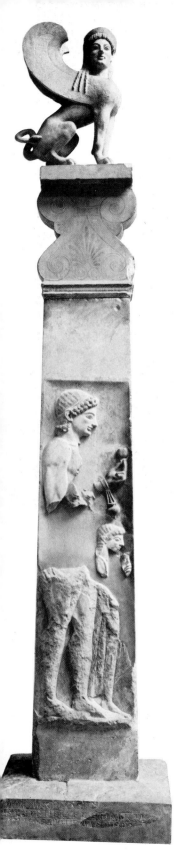

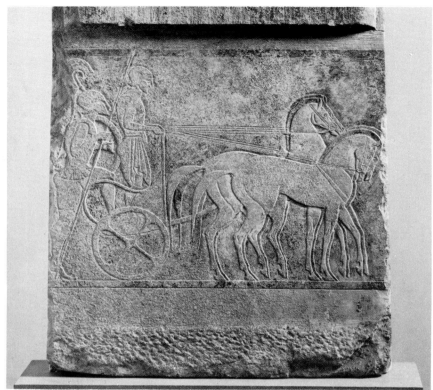

73. Stele (the sphinx from a cast), *c.* 540–530 B.C. New York, Metropolitan Museum.

74. Lower part of a Stele, *c.* 540–530 B.C. New York, Metropolitan Museum.

surmounted by a sphinx; but there is now greater animation (cf. fig. 75). The sphinx is shown crouching instead of seated; the cavetto capital is at first made higher than before and then is changed into one of double-volute form; and the sculptured (or painted) decoration on the shaft shows more freedom.

The most complete example that has survived of this stupendous design is in New York[5] (fig. 73). With its crowning sphinx, shaft, and supporting base it stands over 13 feet high, an eloquent witness to imaginative enterprise. A sphinx from a similar monument is in Boston (fig. 76); and the lower part of another (or the same?), with a 'predella' representing a chariot scene, in incuse relief, is in New York (fig. 74).

Several kouroi of this period may have served as sepulchral statues; likewise some figures of lions, for instance three from Perachora which are now in the Museums of Boston and Copenhagen. A lion as the guardian of a tomb was a characteristic Greek conception.

The many architectural sculptures that can be attributed to the second quarter and the middle of the sixth century testify to ambitious building

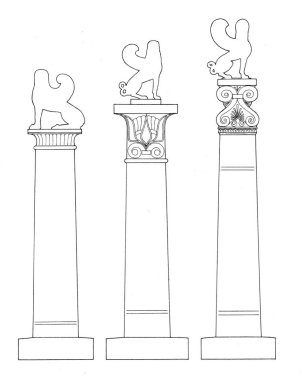

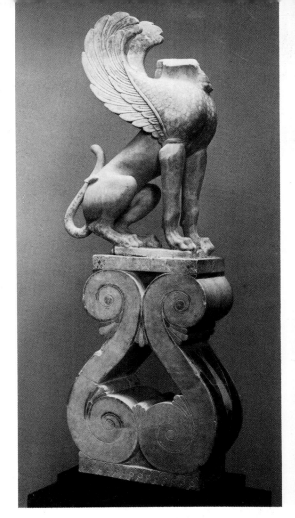

75. Early Attic grave stelai.

76. Sphinx, from a grave stele, c. 540–530 B.C.
Boston, Museum of Fine Arts.

operations all over the Greek world at that time. From the Athenian
Akropolis come several pedimental groups, including an impressive
composition which included a three-headed 'Typhon' (cf. figs 78, 79),
Herakles struggling with the Triton, and—according to some authorities—
even two lions attacking a bull. The figures are carved in limestone, and
copious traces of the original polychromy remain. In the rendering of
the features, bodies and draperies, the same stage in naturalism has been
reached as in the free-standing sculptures of that time. Here too there is a
new sense for rounded shapes. And in the compositional scheme a less
staccato effect has been obtained, though there is not as yet any unity
of action.

The metopes from the so-called Sikyonian Treasury at Delphi (cf. p. 41)
with their four-sided forms, rigid stances, and almost foldless draperies,
may be assigned to the second quarter of the sixth century. The subjects
include the Dioskouroi and the sons of Aphareus (Idas and Lynkeus)
driving oxen home from a raid; the hunt of the Kalydonian boar; the
ship Argo; Phrixos and the ram; and Europa and the bull.

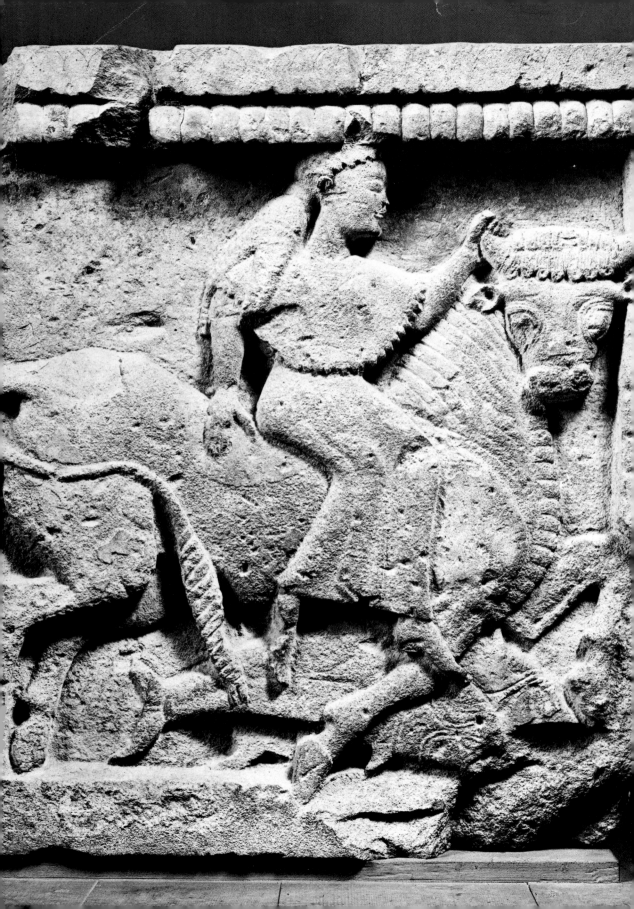

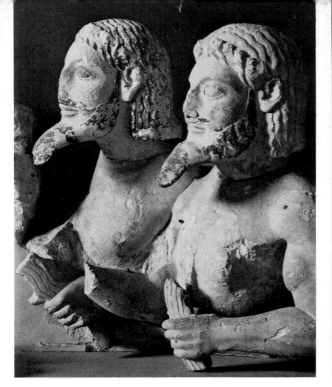

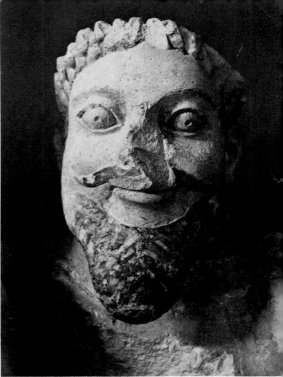

78–79. Three-headed 'Typhon,' from a pediment, *c.* 560–550 B.C. Athens, Akropolis Museum.

◀ 77. Europa and the Bull, *c.* 560 B.C. Metope from Temple Y at Selinus. Palermo, Museo Civico.

80. Herakles and the Kerkopes, *c.* 540 B.C. Metope from Temple C at Selinus. Palermo, Museo Civico.

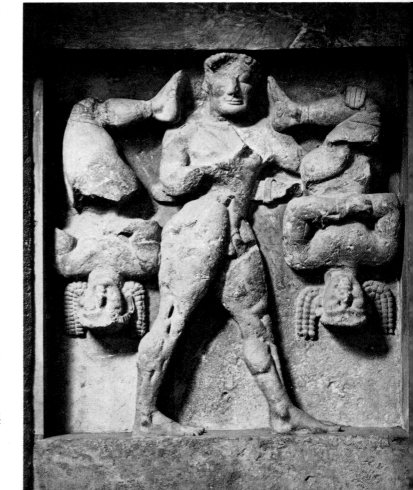

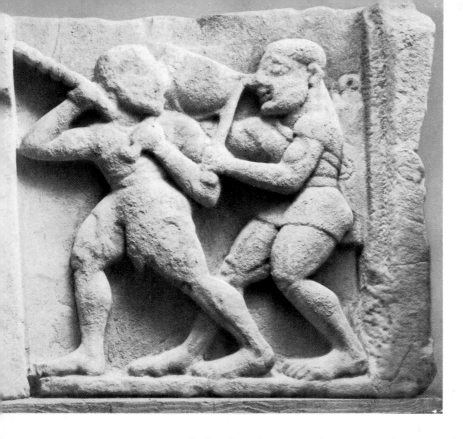

81. Herakles and Apollo, *c.* 575–550 B.C. Metope from the Temple of Hera at Foce del Sele. Paestum, Museum.

82. Head of a Kouros from ▶ Attica, *c.* 540–515 B.C. Copenhagen, Ny Carlsberg Glyptotek.

83. Head of Aristodikos, ▶ *c.* 510–500 B.C. Athens, National Museum.

Related to these in style are several metopes from temple Y at Selinus, with similar angular compositions, representing Apollo, Leto, and Artemis; a sphinx; Herakles and the Cretan Bull; and Europa on the bull (fig. 77).

Another series of metopes, from temple C at Selinus, are somewhat later (*c.* 540 B.C.). They represent a chariot scene, Perseus cutting off the head of Medusa, and Herakles carrying the Kerkopes (cf. fig. 80), in a rather farouche but powerful style.

Splendid metopes have come from a sanctuary of Hera at the mouth of the river Silaris (cf. p. 28). There are in all about forty carved in sandstone, in an extraordinarily vivid, rounded style bespeaking Ionian influence. The subjects show great variety and include such familar themes as the labours of Herakles (cf. fig. 81) and feats of the Trojan war, as well as less well-known myths. Some catastrophe must have overtaken the sanctuary while the metopes were still being carved, for several are unfinished.

Important architectural sculptures of the middle archaic period have been found in Asia Minor, especially at Ephesos, Assos, Kyzikos, and Larisa. They show the soft, rounded modelling characteristic of the Eastern Mediterranean. The decorated column drums from the temple of Artemis at Ephesos (cf. p. 29) include part of a dedication by Croesus; but the figures that have survived range in date through the second half of the sixth century.

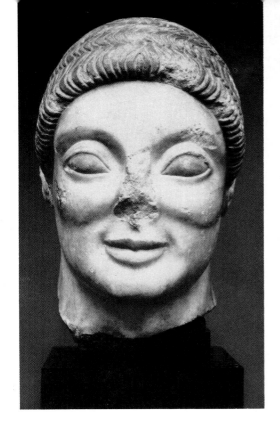 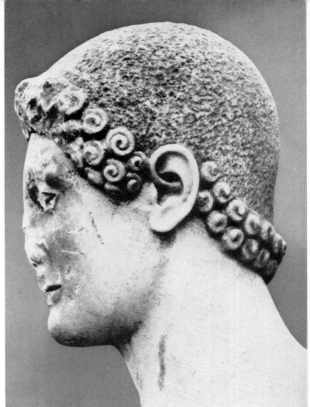

During the second half of the sixth century the persistent struggle of Greek artists to attain naturalistic form bore fruit. The stances become less rigid and the anatomy of the human figure is better understood. The combination of the old decorative sense with the new naturalism gives to the products of this epoch a suavity and grace that make them perhaps the most appealing of all Greek sculptures. Fortunately many examples have been preserved, especially from Attica, for, after the sack of the Athenian Akropolis by the Persians in 479 B.C., the Athenians on their return buried the old broken statues in trenches, to be rediscovered by modern excavators.

Several statues of kouroi from various parts of Greece illustrate successive stages in this epoch-making evolution. The best preserved are—in chronological order—a statue from Attica, now in Munich (fig. 84), statues from Anavysos (fig. 85), Keos, the Piraeus (fig. 88), Boeotia (fig. 86), the Aristodikos (fig. 83), all in Athens, and the 'Strangford Apollo' in London. Eastern versions have come from Asia Minor, Rhodes, and Samos. Several have been found in South Italy and Sicily, including an excellent example from Agrigentum and a bronze statue found in the sea off Piombino and now in the Louvre[6]. A superb head, the so-called Rayet head (fig. 82), is said to have come from Attica and is in Copenhagen. Compared with the earlier kouroi, several significant changes are apparent. The plank-like shape has been definitely overcome by imparting more volume to the thorax and by making the greatest protrusion of the

LATE ARCHAIC PERIOD, ABOUT 540—480 B.C.

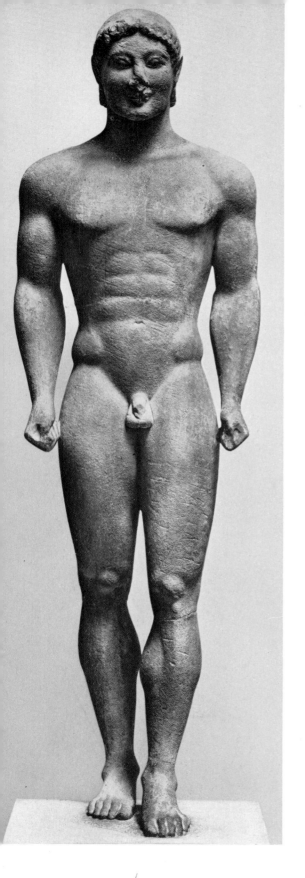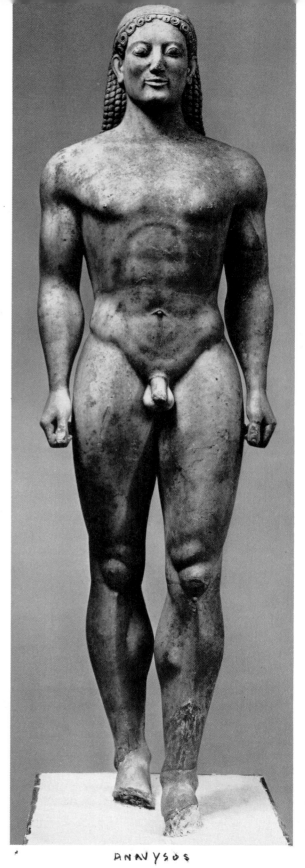

ANAVYSOS

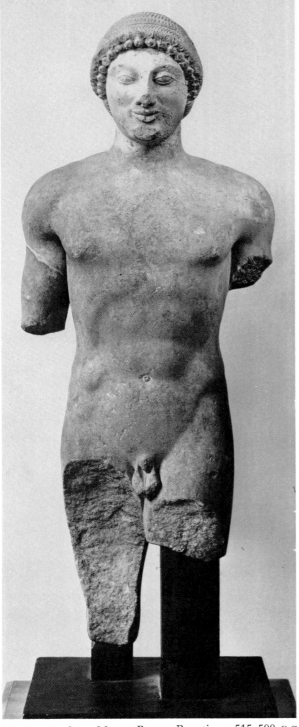

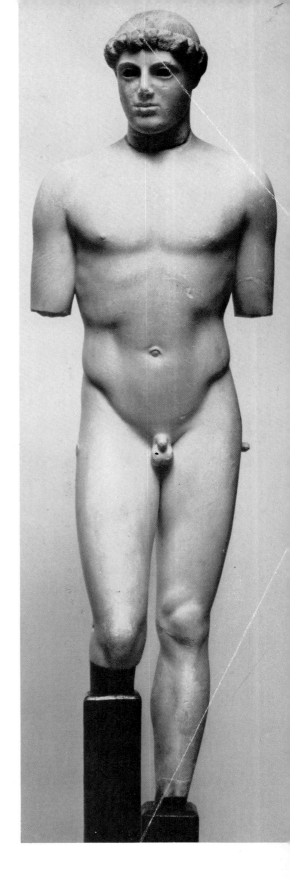

86. Kouros from Mount Ptoon, Boeotia, *c.* 515–500 B.C.
Athens, National Museum.

87. 'Kritios' Boy, *c.* 490–480 B.C. Athens, Akropolis
Museum.

◄ 84. Kouros from Attica, *c.* 540–515 B.C. Munich, Antiken-
sammlung.

◄ 85. Kouros from Anavysos, *c.* 540–515 B.C. Athens,
National Museum.

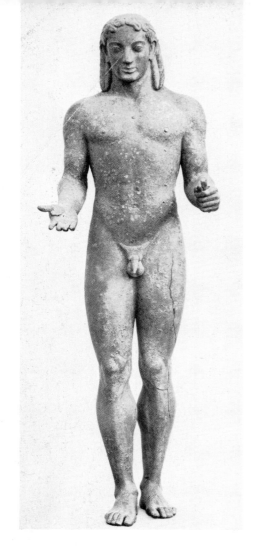

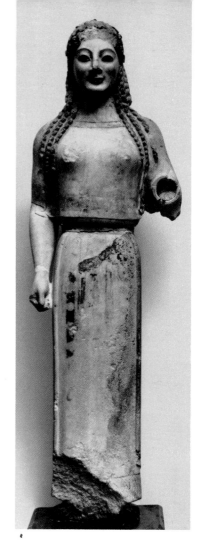

88. Apollo, found at the Piraeus, 530–520 B.C. Athens, National Museum.

89. The 'Peplos Kore', c. 540–530 B.C. Athens, Akropolis Museum.

back correspond to that of the front; in consequence the vertebral column assumes its characteristic S-shaped curve. The forearm is no longer twisted forward but is in a more natural position, with the palm of the hand directed towards the body. The legs are well shaped, with the inner malleolus higher than the outer, and with the toes no longer receding along one line. The flanks are made to bulge from the waist.

As time went on further important observations were made. Instead of three transverse divisions being shown above the navel in the abdominal muscle, only two were indicated, the third (top) division being incorporated into the semicircular arch of the thorax, as it is in nature. The muscles of the neck were more correctly rendered; and the clavicles were given their S-shaped curve and made to disappear beneath the shoulder. The swelling of the trapezium was indicated. The features also assumed more natural forms, with various details rendered that had not been observed before, for instance the antitragus of the ear and the inner recess of the eye.

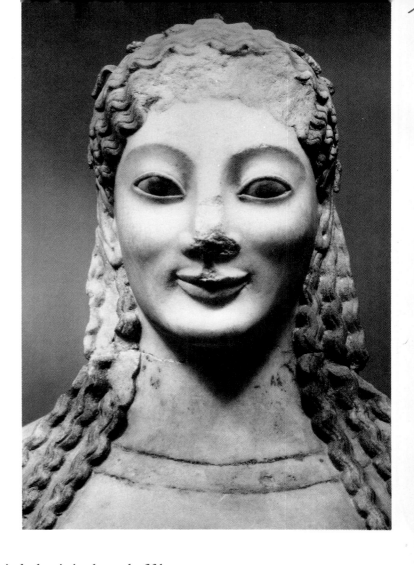

90. Detail from 89.

Finally, at the end of the period, that is in the early fifth century B.C., a certain movement was imparted to the figure. Though the shoulders remained frontal, the flanks were no longer rendered symmetrically, the flank over the advanced leg being placed forward and lower than in the receding leg, which was now correctly shown as carrying the weight of the figure (cf. fig. 87). A slight turn was given to the head and the upper part of the body. This marked the beginning of the dissolution of the frontality and the symmetrical construction which had characterized ancient art for thousands of years.

In addition to the kouroi, other sculptures from all over the Greek world illustrate the same evolution. Among the free-standing statues, the Maidens from the Athenian Akropolis occupy a prominent place. The Peplos kore (figs. 89–90), so called from the woollen peplos that she is wearing over her Ionic chiton, is a successor of the Berlin kore (cf. fig. 66). Her quiet but no longer rigid stance, the expressive face, and the subtly varied drapery give her distinction. The majority of the

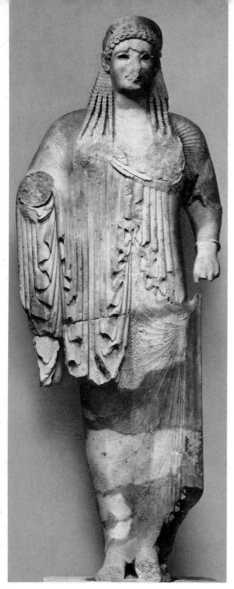

91. Kore probably before Antenor, c. 530–525 B.C. Athens, Akropolis Museum.

92. Kore, c. 510–500 B.C. Athens, Akropolis Museum No. 674.

other Maidens may be assigned to about 530–500 B.C. They illustrate the decorative rendering of drapery in this late archaic period. The heavy folds of the mantle and the soft, crinkly folds of the chiton are effectively contrasted, and their various directions follow the action of the figure. The long hair descending in radiating tresses, or looped up behind, and the diadems, earrings, necklaces, and bracelets add to the impression of dainty elegance. On the base of one of the statues is the signature of the sculptor Antenor (fig. 91). Shortly afterwards comes the kore no. 675 (fig. 93), one of the best preserved and most engaging examples of the series. The famous kore no. 674 (fig. 92) shows the combination of stylization and naturalism at its best. The so-called Boudeuse (no. 686) may be placed a little before 480 B.C.

We must imagine these Maidens perched on high pedestals, standing on the Akropolis hill, radiant in their rich polychromy, of which extensive

93. Kore, c. 530–515 B.C. Athens, Akropolis Museum No. 675. ▶

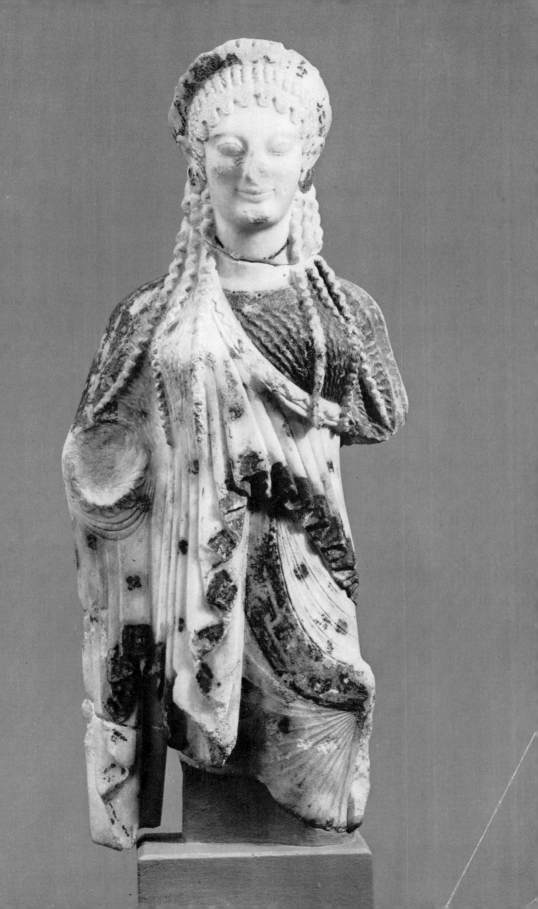

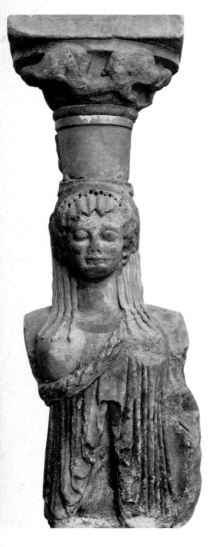

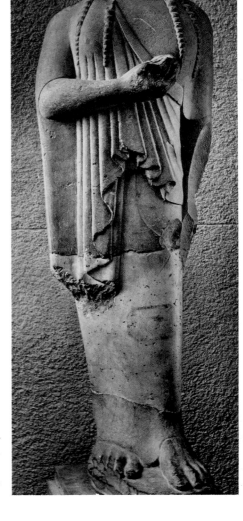

94. Karyatid from the Treasury of the Siphnians at Delphi, *c.* 530–525 B.C.

95. Kore from Klazomenai, 540–525 B.C. Paris, Louvre.

traces remain. Similar standing Maidens, both in the round and in relief, have been found elsewhere—in Delphi, Delos, Cyrene, and Asia Minor (cf. fig. 95), and the two karyatids (cf. fig. 94) serving as columns of the pronaos in the Treasury of the Siphnians at Delphi (cf. p. 41) are of the same type. Since this Treasury can be dated by literary evidence to shortly before 525 B.C. (cf. Herodotos, III, 57–58; Pausanias, X, II, 2), we have here welcome support for the chronology of the series.

As examples of the seated type during the second half of the sixth century may be cited a statue of Athena found on the Athenian Akropolis (fig. 97), perhaps the very one seen by Pausanias (I, 26, 4) and said by him to be by the sculptor Endoios; and a statue from Samos (fig. 96), which, according to an inscription, was dedicated by Aiakes, perhaps a relative of Polykrates. Compared with the earlier seated statues (cf. fig. 69), they show a marked advance in naturalism. The figure has

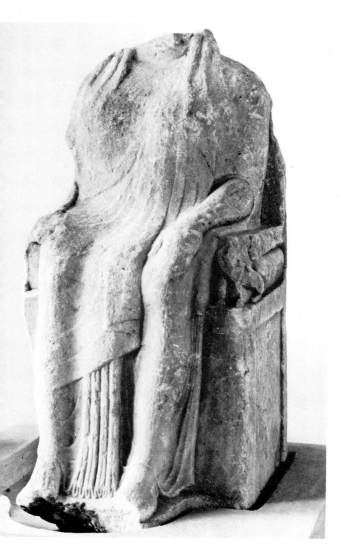

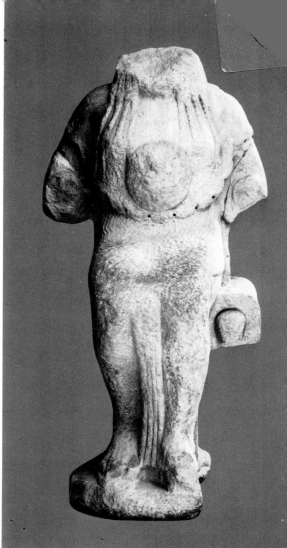

now assumed a separate entity from that of the chair on which it sits, and the folds are less massive and reveal the forms of the body.

Finally, as a climax to the series, comes the goddess from Tarentum in Berlin (fig. 101), datable around 480 B.C. She is shown seated on a finely carved throne, a cushion at her back, her feet resting on a high, voluted footstool. The dignified pose, delicately carved features, finely composed hair, and still schematized folds show archaic art in its final phase. And there is a new grandeur in the composition heralding a new era.

In a relief of a helmeted runner in Athens (fig. 98) of the late sixth century the motion is still indicated by the old convention of a half-kneeling posture, with frontal shoulders and profile legs. An important innovation, however, is an attempt at foreshortening by placing the abdominal muscle obliquely. The turn of the body is thereby suggested and more swing is imparted to the composition. A few decades later,

96. Statue from Samos, dedicated by Aiakes, c. 525–500 B.C. Samos, Tigani Museum.

97. Athena, perhaps by Endoios, c. 525–500 B.C. Athens, Akropolis Museum.

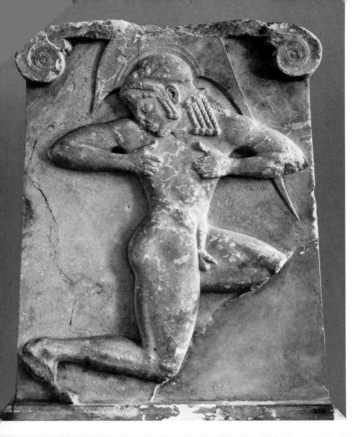

98. Helmeted Runner, *c*. 510–500 B.C. Athens, National Museum.

99. Running Maiden from Eleusis, *c*. 480 B.C. Eleusis, Museum.

100. Nike, soon after 490 B.C. Athens, Akropolis Museum.

101. Seated Goddess from Tarentum, *c*. 480 B.C. ▶ Berlin, Museum.

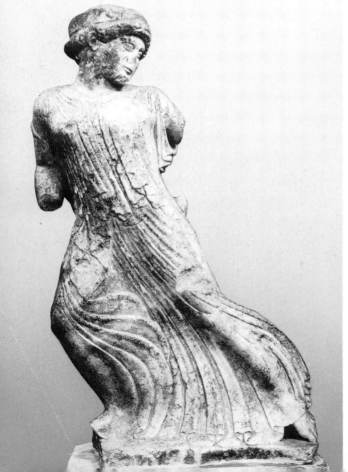

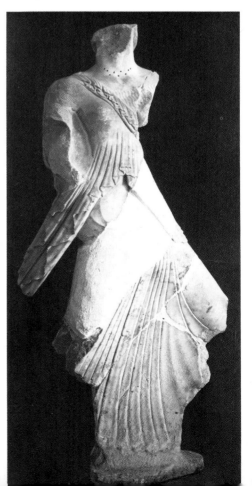

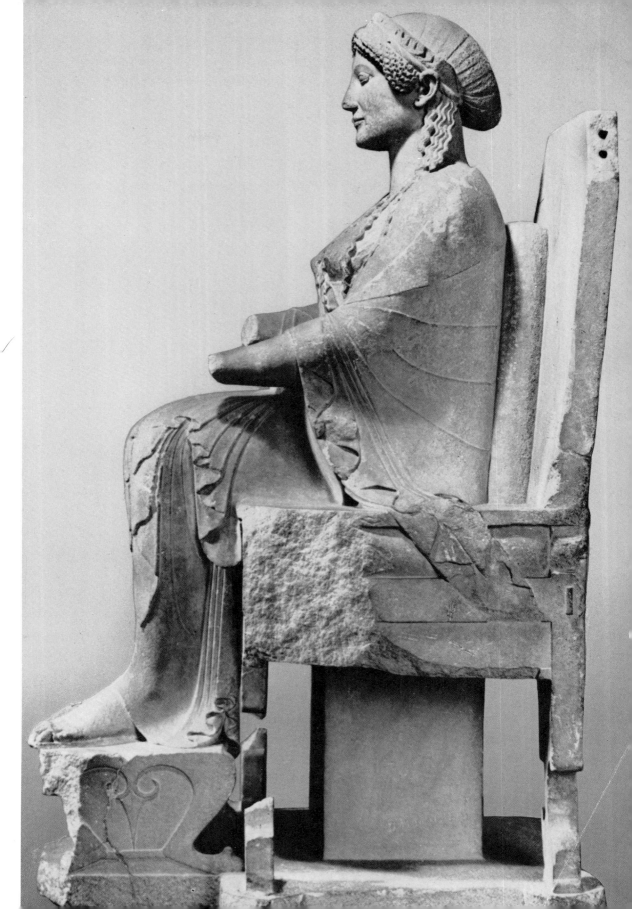

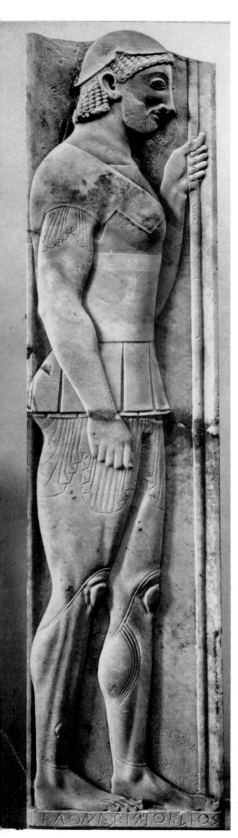

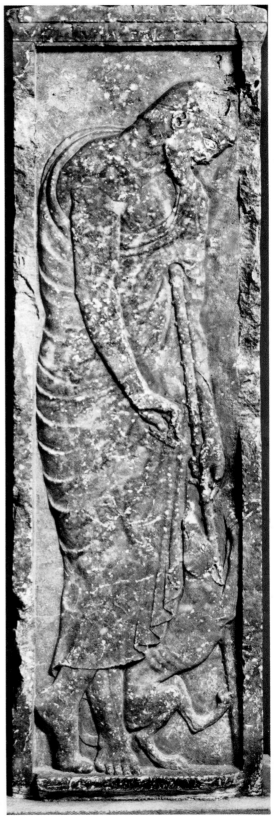

102. Stele of Aristion, by Aristokles, *c.* 510–500 B.C. Athens, National Museum.

103. Stele from Orchomenos, by Alxenor, *c.* 500–490 B.C. Athens, National Museum.

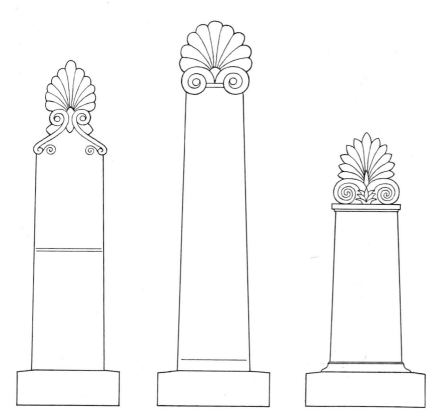

104. Attic Grave Stelai, after 530 B.C.–c. 450 B.C.

105. Incised Stele: Youth holding a flower, c. 520 B.C. Paris, Louvre.

in the Nike from the Akropolis (fig. 100), perhaps dedicated after the battle of Marathon, and in the Running Maiden from Eleusis (fig. 99) —perhaps a fleeing companion of Persephone—the kneeling stance is abandoned and a more natural posture is obtained, with both legs only slightly flexed and the trunk no longer perpendicular.

Around 530 B.C. there came a change from the elaborate type of gravestone of the middle archaic period (cf. fig. 75) to a simpler form. It consisted of a relatively low shaft, surmounted by a finial in the form of a palmette, at first with a double volute (similar in design to that used on capitals of the preceding period), later with a single one (cf. fig. 104). Outstanding examples are a stele in the Louvre (fig. 105) with a youth holding a flower (incised and painted) and the well-known stele of Aristion in Athens by Aristokles, decorated with the relief of a warrior (fig. 102). They are among the last archaic Athenian grave-stones that have come down to us.

Several stelai of the early fifth century have been found in the Islands and Northern Greece. Like the Athenian examples of the same epoch, they consist of a high, narrow, sculptured shaft, with a palmette finial. An especially interesting example from Orchomenos shows a bearded man, clothed in a mantle, playing with his dog (fig. 103); it is signed by the Naxian sculptor Alxenor.

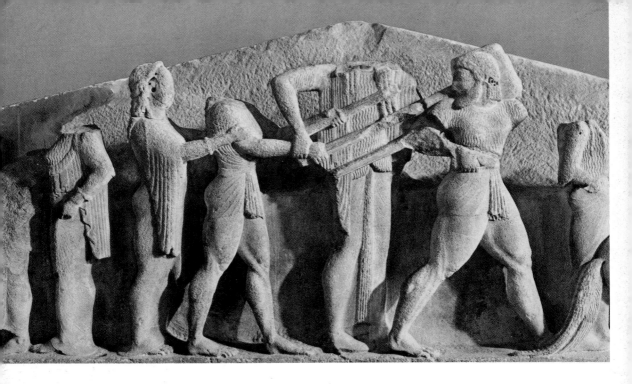

106. Apollo and Herakles, from the pediment of the Siphnian Treasury at Delphi, c. 530–525 B.C.

From Xanthos has come one of the most interesting sepulchral monuments that have survived. Like the earlier Lion Tomb (cf. pp. 48, 62), it is in the form of a chest, decorated with reliefs on its four sides, and was once mounted on a high pillar. The subjects consist of male and female figures bringing offerings to deities and heroized ancestors, and of Harpies or Sirens carrying away the 'souls of the dead'. The soft modelling and gracious attitudes bespeak an East Greek origin.

A number of architectural sculptures exemplify the development in composition during the late archaic period and the variety of stances attempted. The Treasury of the Siphnians at Delphi, of which the exact date can, as we saw, be placed shortly before 525 B.C., has supplied a well preserved pedimental group, representing the contest of Apollo and Herakles for the tripod (fig. 106). The pedimental sculptures of the temple of Apollo at Delphi (cf. p. 31) are somewhat later. From a temple on the Athenian Akropolis come splendid, over-life-size figures of Zeus and Athena battling with giants (cf. fig. 107), datable c. 525–520 B.C.; and from the Megarian Treasury at Olympia (c. 510 B.C.) a small limestone pediment with the same subject.

A number of reliefs illustrate the successive stages in the rendering of foreshortening. In the friezes from the Siphnian Treasury at Delphi representing battles of gods and giants (cf. fig. 108), chariot scenes, and an assembly of deities, the three-quarter view is still rendered by placing a frontal trunk on profile legs. Some decades later, however, for instance in some of the metopes of the Athenian Treasury at Delphi (cf. p. 41) with exploits of Herakles and Theseus, and in the statue bases from Athens with reliefs of a cat-and-dog fight and a ball game

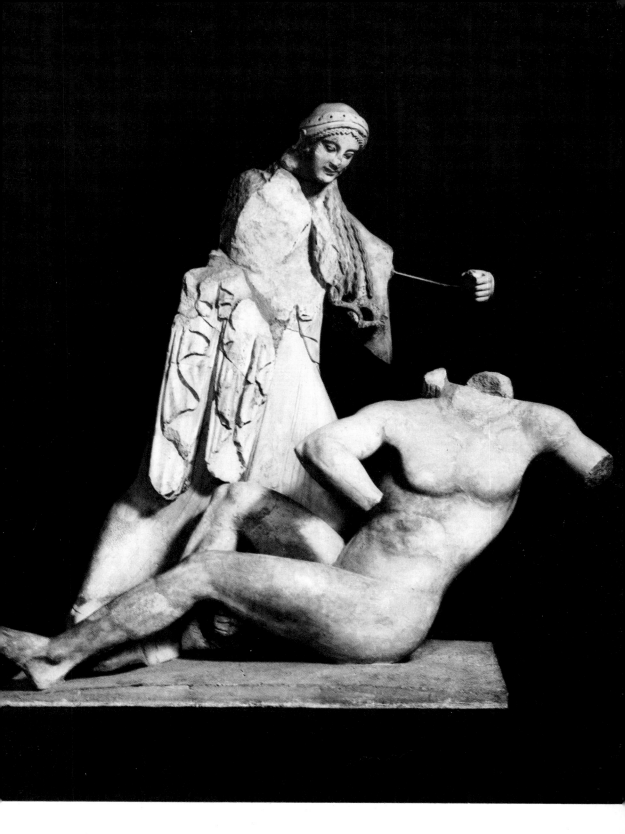

107. Athena and Giant, from a Temple of the Athenian Akropolis, *c.* 525–520 B.C. Athens, Akropolis Museum.

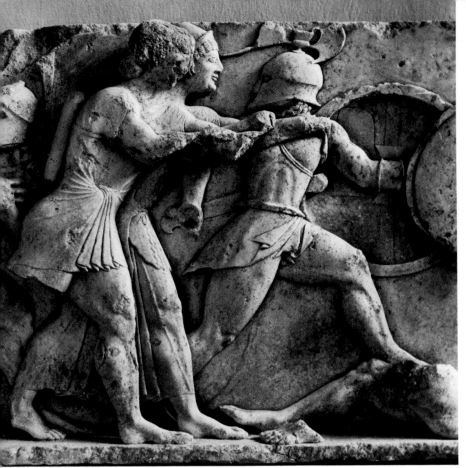

108. Battle of Gods and Giants. Slab from the frieze of the Treasury of the Siphnians, *c.* 530–525 B.C.

109. Ball game. Statue Base, *c.* 510–500 B.C. Athens, National Museum. ▶

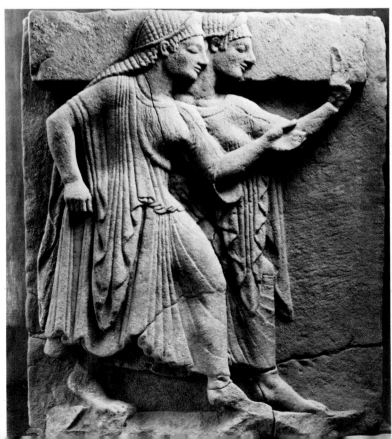

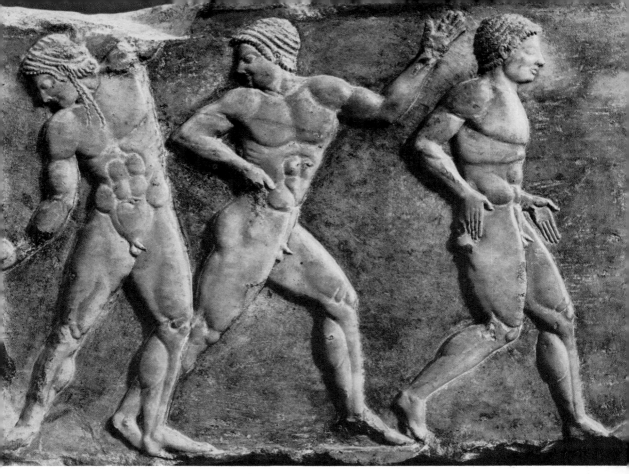

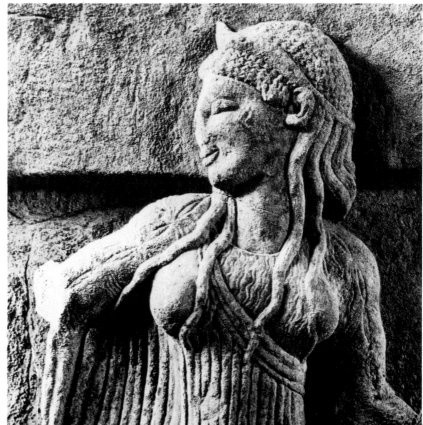

110, 111. Running Nereids (?) Metopes from the Temple of Hera at Foce del Sele, *c.* 510–500 B.C. Paestum Museum.

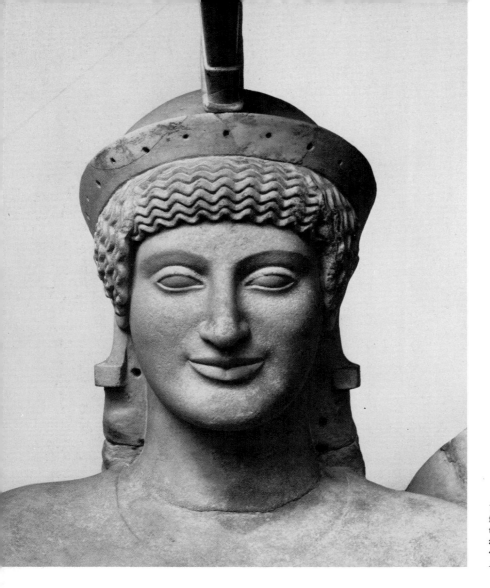

112. Head of Athena, from the pediment of the Temple of Aphaia at Aegina, *c.* 500–480 B.C. Munich, Antikensammlung.

(cf. fig. 109), attempts at foreshortening are apparent in the placing of the abdominal muscle obliquely; in the running maidens on the metopes of the Heraion at Foce del Sele (cf. p. 31), in some figures a single breast is shown slightly foreshortened (fig. 110), while in others both breasts are still viewed frontally (cf. fig. 111). Though these attempts are not yet wholly successful, they testify to the realization of the problem involved. From the temple F at Selinus (*c.* 500 B.C.) have come the lower parts of two metopes, one with a dying giant—a remarkably realistic rendering for this period.

Finally in the first two decades of the fifth century may be placed the pediments of the temple of Aphaia in Aegina (cf. pp. 31 f.). In spite of the fragmentary state of some of the figures, it has been possible to reconstruct the whole of both compositions. They show subtly inter-related schemes. In the centre of each pediment stood a stately Athena

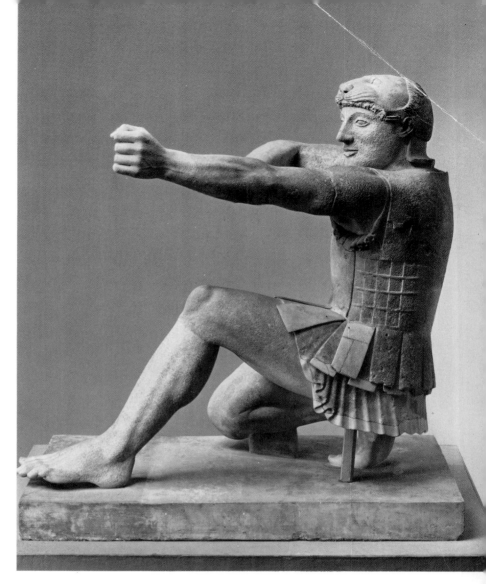

113. Herakles, from the East pediment of the Temple of Aphaia at Aegina, c. 500–480 B.C. Munich, Antikensammlung.

(cf. fig. 112), and on either side were symmetrical groups of Greeks fighting Trojans, in which the active poses of the fighters were contrasted with the reclining and falling ones of the wounded. One of the best preserved and finest of the figures is the Herakles (fig. 113) from near the corner of the East pediment, shown crouching, in the act of shooting off an arrow, the whole forming an effective and harmonious design. The statues from this Eastern pediment are somewhat later in style than those of the Western, perhaps due to its having been substituted for a pediment injured during the Persian wars, of which several figures seem to have survived.

From the first half of the fifth century are also preserved a number of terra-cotta sculptures, found in Olympia, Corinth, Thebes, and elsewhere. They evidently served as ornaments of small buildings and as votive offerings. Foremost among them are a standing warrior, a group

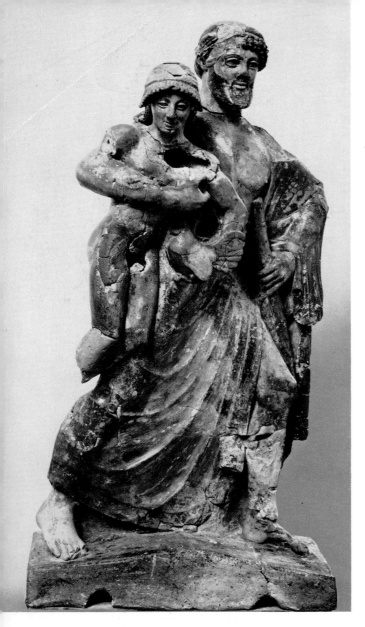

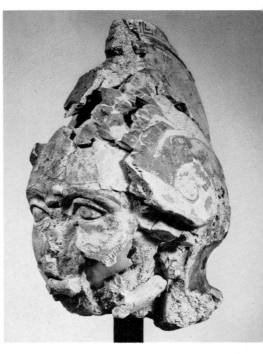

115. Terra-cotta head from the Athenian Agora.
c. 460 B.C. Athens, Agora Museum.

114. Zeus and Ganymede, terra-cotta group,
c. 475–470 B.C. Olympia, Museum.

of Zeus carrying away young Ganymede (fig. 114), and fragments of
an Athena combined with warriors, all from Olympia. A terra-cotta
helmeted head of *c.* 460 B.C. was found in over sixty fragments in the
Athenian Agora (fig. 115); and from Sicily and South Italy, where the
absence of marble favoured sculptural work in clay, have come a number
of comparable examples.

The close connection between Greece and Italy in this branch of art
is suggested by Pliny's statement (XXXV, 151–52) that Boutades of
Sikyon was the inventor of terra-cotta sculpture and that Damaratos
of Corinth, when he left his native city for Etruria, was accompanied
by the modellers (fictores) Diopos, Eugrammos, and Eucheiros, who

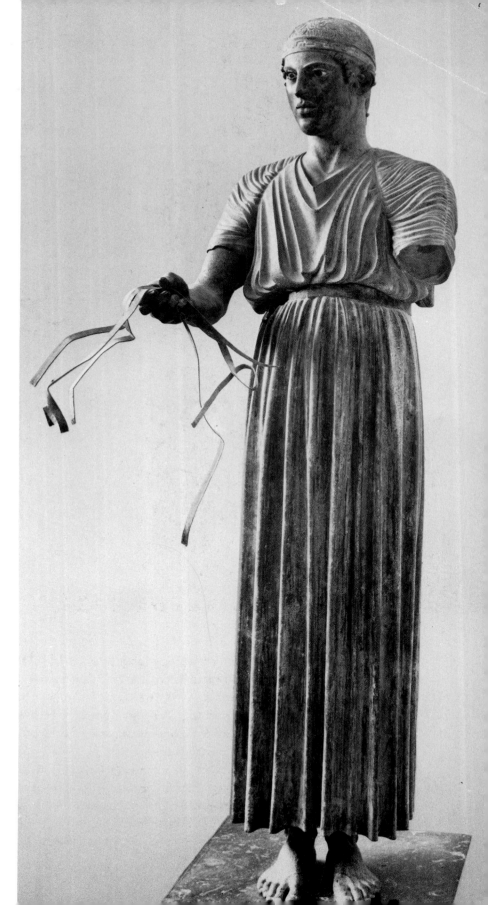

116. Charioteer, bronze,
c. 475–470 B.C. Delphi.

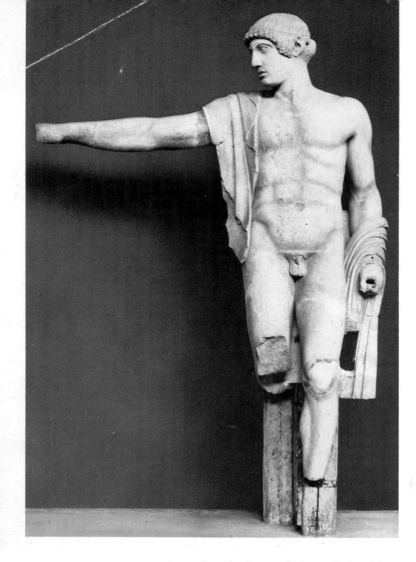

117. Apollo, from the West pediment of the Temple of Zeus at Olympia, 465–457 B.C.

introduced the craft into Italy. The marked Greek influence of the Etruscan terra-cotta sculptures of this period bears out the literary evidence.

EARLY CLASSICAL PERIOD, ABOUT 480–450 B.C. The second quarter of the fifth century marks the beginning of the so-called classical style. After a sustained effort of more than a century the Greek sculptor had attained full knowledge of the complicated structure of the human figure and was able to represent it as a co-ordinated whole. The next step was to use this new knowledge in various directions—in the representation of action and feeling, in the rendering of drapery, and in composition. Though in all these directions the artists gradually achieved naturalistic forms, they imparted to their figures a certain quality—one might call it serenity—that removed it from realism.

Let us watch this interesting development in a number of specific examples, first in the various stances of the human figure.

We saw that at the end of the archaic period there were attempts to distribute the weight unequally, but that the shoulders remained frontal.

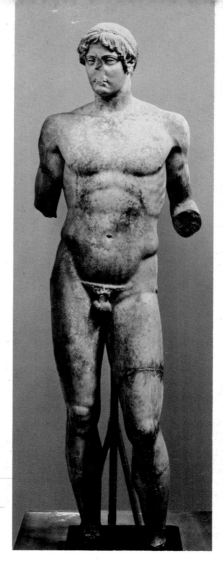
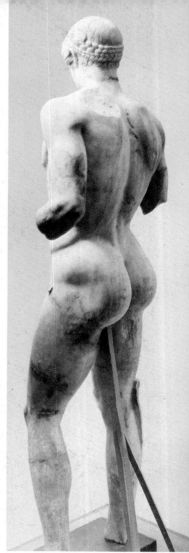

118. The 'Omphalos Apollo', *c.* 460–450 B.C. Roman copy. Athens, National Museum.

Soon afterwards, however, the unequal distribution of weight was made to affect the whole figure. A turn was given to the upper part of the body, often in an opposite direction from that of the pelvis, whereby a sense of movement and easy balance was imparted. Moreover, this new knowledge could be applied to other stances. A new world of forms was thus opened to the Greek artist.

Examples of the standing male figure in this epoch are furnished both by Greek originals, such as the famous bronze charioteer at Delphi (*c.* 475 B.C., cf. fig. 116), erected as a votive offering after a race, and the Apollo (fig. 117) and Zeus from the pediment of the temple of Zeus at Olympia (465–457 B.C., cf. p. 32), and by figures preserved in good Roman copies—for instance the Apollo from Cherchel, the Apollo in Mantua, and the so-called Omphalos Apollo in Athens (fig. 118). The last, datable near the middle of the fifth century, illustrates the final stage in this progression. Perfect balance has been obtained. The weight of the figure is now boldly poised on one leg, and the

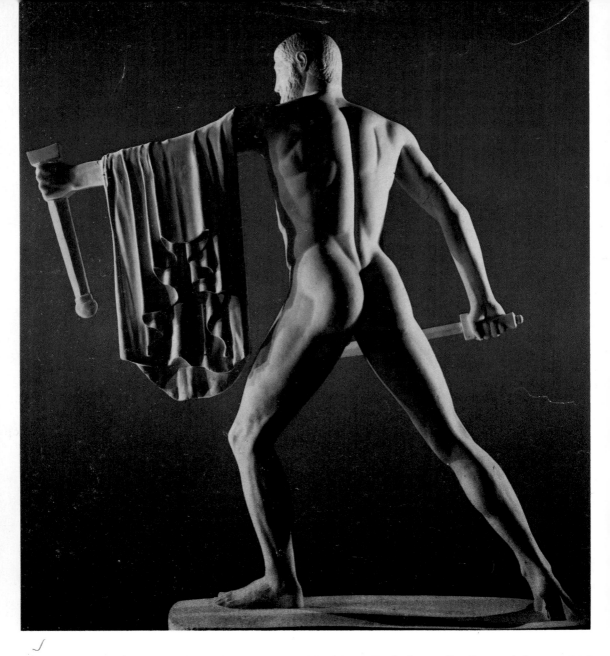

119. Aristogeiton, from the group by Kritios and Nesiotes, 477–476 B.C. Cast of a reconstructed Roman copy. Naples, National Museum.

resulting asymmetry is ably shown. Both the median line and the vertebral column have a sideward turn; shoulders, hips, and knees are no longer horizontal, but incline upward and downward in alternating rhythm. The head too is slightly turned and the eyes and mouth are no longer in a strictly horizontal line; moreover each feature is modelled in a naturalistic manner. Nevertheless the early monumental quality is not entirely lost. The derivation from the geometric scheme is apparent in a subtle play of proportions, and a quiet grandeur pervades the figure.

Outstanding examples of the striding type are preserved in the statues of Harmodios and Aristogeiton (cf. fig. 119), the heroes who slew the tyrant Hipparchos, and for whom commemorative statues were set up

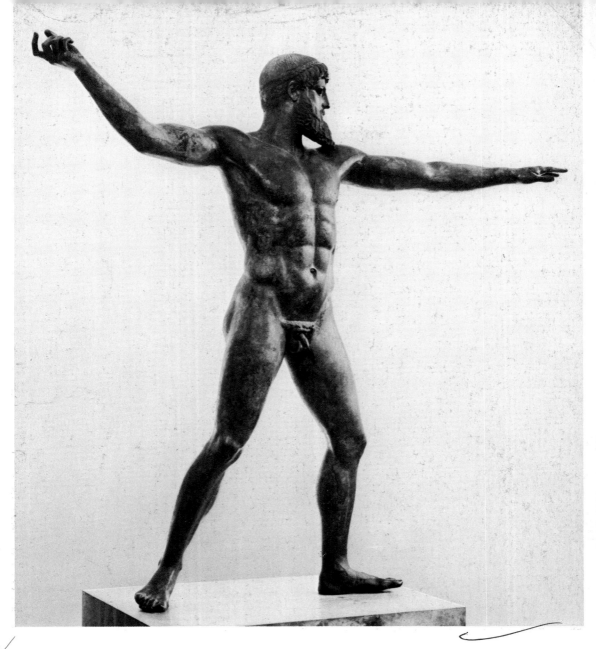

120. Poseidon (or Zeus?), bronze, c. 470–450 B.C. Athens, National Museum.

in the Athenian marketplace. The originals have disappeared, but a number of Roman reproductions survive—in Naples, Rome, and elsewhere. They are apparently all copies of the second group, by Kritios and Nesiotes, which was erected in 477–476 B.C. after the first group, by Antenor, had been carried away by the Persians in 480–479. When properly reconstructed—with the right arm of Harmodios brought over his head—the composition shows great vigour. The modelling of the trunk is convincingly rendered in violent action for the first time in Greek art.

Some decades later comes the striding Poseidon, one of the finest Greek original statues in bronze that have survived (figs. 120, 121).

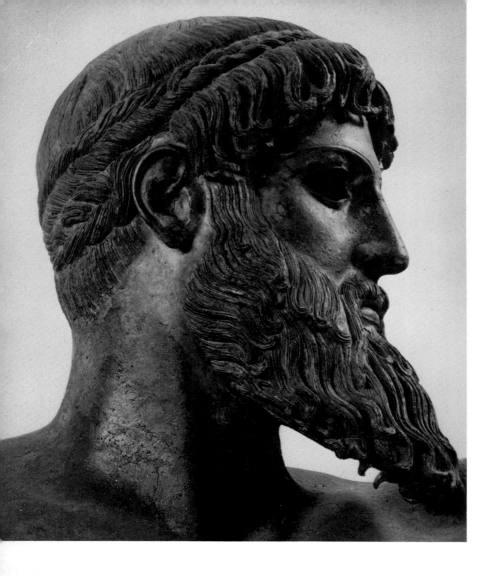

121. Detail from 120.

He is represented in the traditional pose, with his right arm raised to hurl the trident, but now with all parts co-ordinated and with a new majesty. The statue was found in the sea, off Cape Artemision, and must once have formed part of a shipload of sculptures bound elsewhere.

Furthermore, several crouching, striding, seated, and reclining figures (cf. fig. 123), ably composed in the new manner, come from the pedimental sculptures of the temple of Zeus at Olympia. The former stiffness has been transformed into easy balance.

At this time there may also be observed a new interest in depicting emotion, not only in the attitudes of the figures, as mostly heretofore, but also in the features. Thus pain, surprise, fear and exaltation are occasionally shown in an astonishingly realistic way both in sculpture and vase-painting (cf. pp. 343 f.). It is natural, therefore, that in this epoch individualized portraiture began. A remarkably vivid head of Themistokles (fig. 122) found at Ostia is evidently a Roman copy of

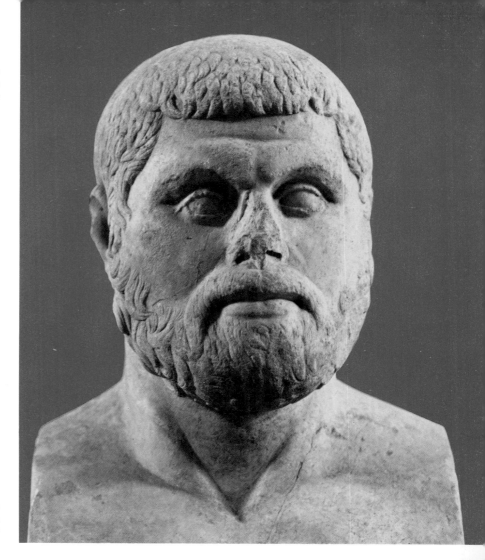

122. Head of Themis-
tokles, *c.* 470–450 B.C.
Roman copy. Ostia,
Museum.

123. Kladeos, from the
West pediment of the
Temple of Zeus at
Olympia, 465–457 B.C.

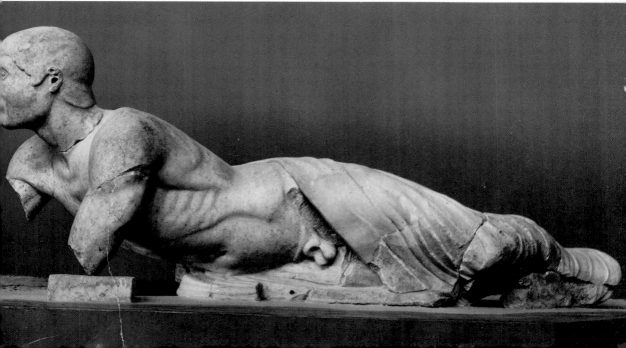

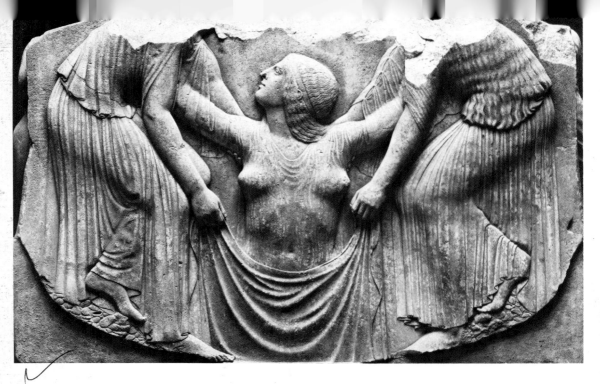

124. The Birth of Aphrodite (?), *c.* 470–460 B.C. Rome, Terme Museum. Front of a three-sided relief known as 'Ludovisi Throne'.

a work of this period. The Greek prototype must have been a whole statue, for Greek portraits in the earlier periods invariably show the whole figure, not merely the head or bust.

An important development took place during this epoch in the rendering of drapery. The folds, instead of being schematically arranged, assume more natural shapes. Instead of the thin chiton and short Ionic himation with their multitudinous folds, the heavier peplos is favoured. Particularly pleasing are the quietly standing female figures. They exist both in Roman copies, such as the so-called Hestia Giustiniani and Aspasia (cf. fig. 126), and in Greek originals, for instance, the statues from the Olympia pediments, from Xanthos, now in the British Museum (cf. fig. 125), and from Thrace. The general scheme is the same in all, but there is constant variation of detail, so that no two figures are alike. And all have a statuesque quality reminiscent of their antecedents.

The rendering of hair likewise underwent a change. In the male figures it is now shown either short, with spiral curls framing forehead and temple, or long but rolled or looped up behind.

Two three-sided reliefs, one in Rome, the other in Boston, are examples of relief sculpture in the style of *c.* 470 B.C. Their original purpose is not known; perhaps they served as screens on a large altar. In the central portion of the relief in Rome a woman appears to be rising from the sea (indicated by a pebbly beach), supported by two female figures (Horai?) (cf. figs. 124, 127). On either side is a seated woman; one is nude and is playing the flute, the other is draped and is sprinkling incense. The subjects have been interpreted as the Birth of Aphrodite and her attendants.

125. Kore from Xanthos, Lycia, *c.* 470–450 B.C. London, British Museum.

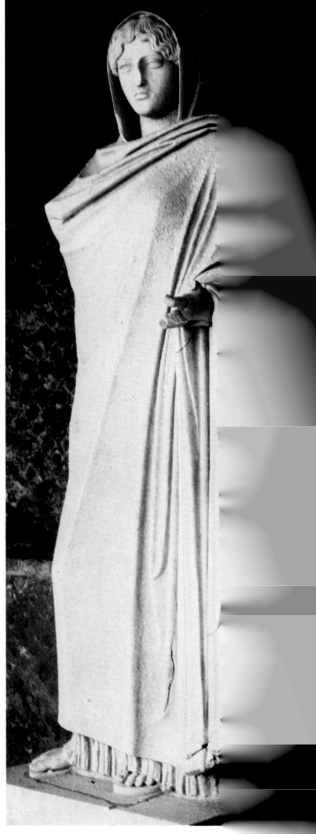

126. 'Aspasia', *c.* 470–450 B.C. Roman copy. Baiae.

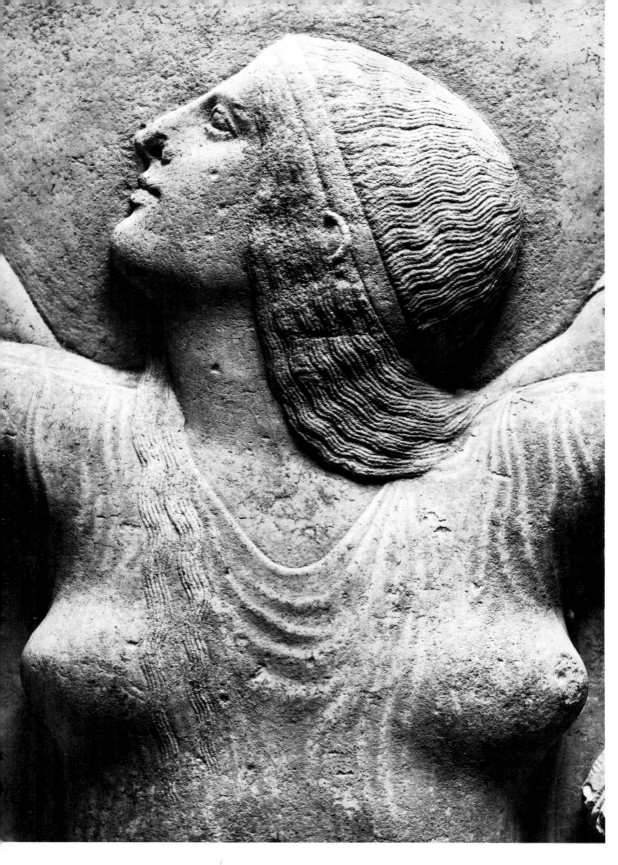

127. Detail from 124.

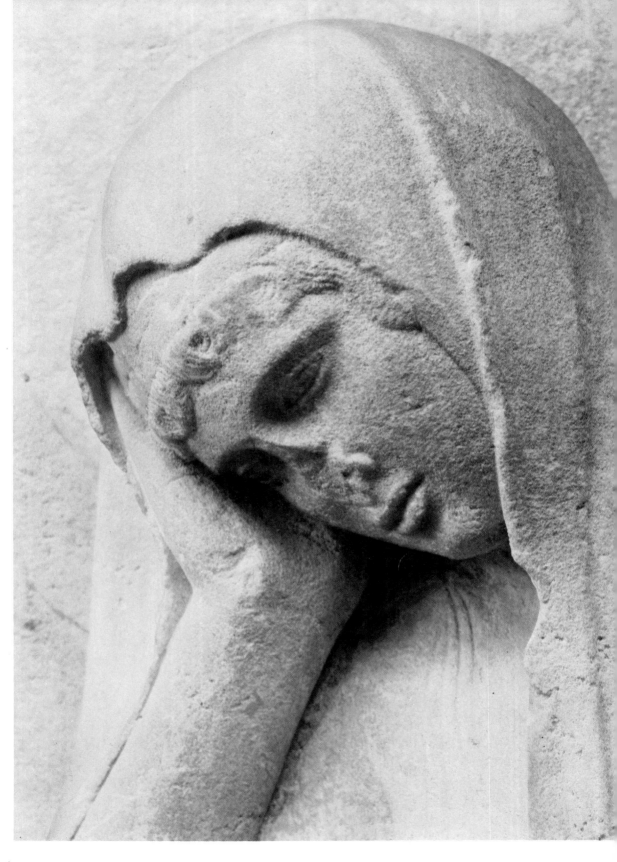

128. Head of a Mourning Woman. Detail from a three-sided relief. Boston, Museum of Fine Arts.

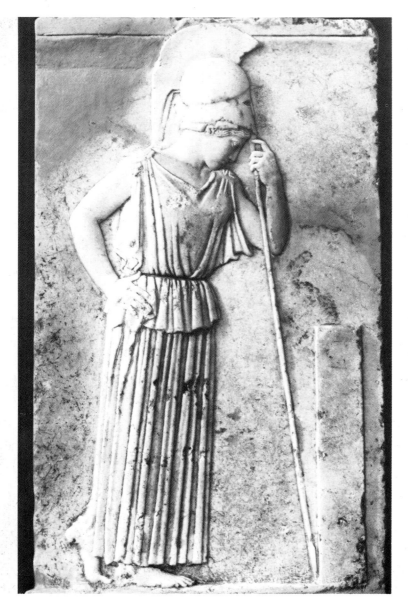

129. 'Mourning Athena', *c.* 470–450 B.C. Athens, Akropolis Museum.

In the Boston relief the central part shows a young boy (Eros or Thanatos?) weighing two small figures, presumably Achilles and Memnon, in the presence of their mothers, Thetis and Eos (cf. fig. 128); on the sides are a youth playing the lyre and an old woman. There are signs of reworking on the sides of both reliefs, perhaps made to render less conspicuous certain injuries suffered during the transport in Roman times from the original location, perhaps from South Italy to Rome. (On the authenticity or later date of the Boston reliefs cf. references on p. 394, note 7). These sculptures show a great advance in the rendering of foreshortening over the preceding epoch. The figures are shown in gradually retreating depth, so that the arms of the three women in the scene with the birth of Aphrodite appear convincingly

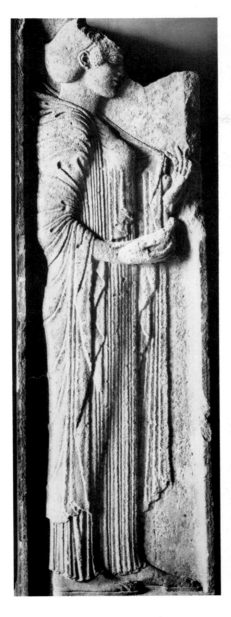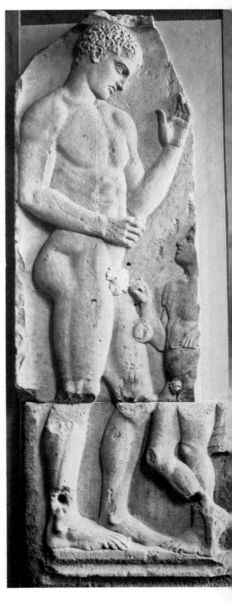

130. Grave Stele: Woman holding a Bird, *c.* 470 B.C. Rome, Conservatori Museum.

131. Grave Stele: Athlete with Slave Boy, *c.* 460 B.C. Vatican Museum.

one behind another. The rhythmical design of the folds, especially in the sorrowing Eos and in the two Horai, and the undulating contours of the figures give these reliefs great attraction.

An outstanding votive relief of this period (*c.* 460 B.C.) is the famous Mourning Athena from the Athenian Akropolis (fig. 129). Though small, it has the quiet majesty of the Olympia sculptures.

Several sculptured gravestones of this time have come to light in Italy, Thessaly, Nisyros, Delphi, and elsewhere. One of a woman holding a bird was found on the Esquiline (fig. 130), another of an athlete with his slave boy was unearthed near the Vatican (fig. 131).[8] In the latter there is a skilful foreshortening of the body. These two stelai, like other Greek sculptures found in central Italy, must have

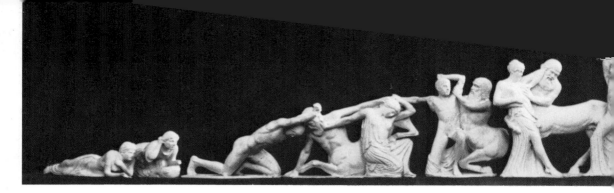

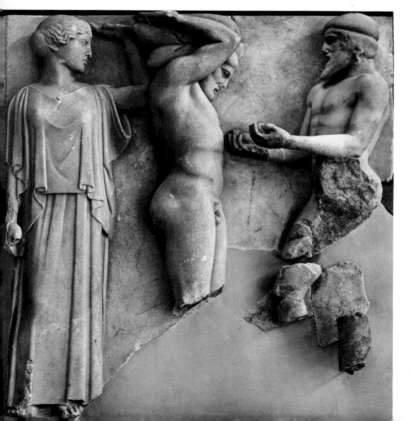

132. Reconstruction of the West pediment of the Temple of Zeus at Olympia.

been taken by the Romans after their conquest of Southern Italy and Greece.

The pediments and metopes from the temple of Zeus at Olympia (cf. p. 32) are among the most important examples of architectural sculptures that have survived. They furnish not only a number of single statues in various stances (cf. p. 97), but are well enough preserved to show the compositional schemes. In the East pediment are represented the preparations for the race of Pelops. In the centre stands Zeus, flanked on either side by male and female standing figures; then come chariots with attendants; and lastly seated and reclining spectators. In the West pediment the central figure of Apollo dominates the scene; right and left are three groups of fighting Centaurs and Lapiths, and at each corner are two reclining women. The whole forms a subtly interrelated design (fig. 132).

In the metopes there is a similar juxtaposition of quiet and animated scenes, of majestic calm and stately tumult. The subjects are the exploits

133. Herakles and Atlas. Metope from the Temple of Zeus at Olympia, 465–457 B.C.

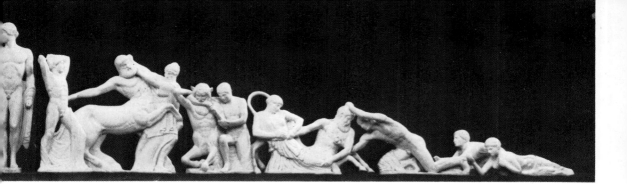

of Herakles: Herakles with Atlas and with Athena (fig. 133); fighting the Nemean lion, the Cretan bull, and the Stymphalian birds; and cleaning the Augean stables.

The metopes from the temple E at Selinus in Sicily date from about 470 B.C. In their spacious compositions, especially in that of Zeus and Hera and of Artemis and Aktaion (fig. 134), the new style is evident.

The outstanding sculptors of this period, according to ancient writers, were Kalamis, Pythagoras, and Myron. Only in the case of Myron has it proved possible to attribute extant works with confidence. One is his Diskos-thrower, which has been recognized in several copies from a detailed description by Lucian (*Philopseud.*, 18). The most complete is that in the Terme Museum in Rome, formerly in the Lancelotti Collection (fig. 135). A youth is shown in the act of throwing a diskos, turning head and body in a twisted yet harmonious pose. Another work, likewise preserved in Roman copies, is a Marsyas, represented in the act of starting back (fig. 136). The original formed a group with Athena (also

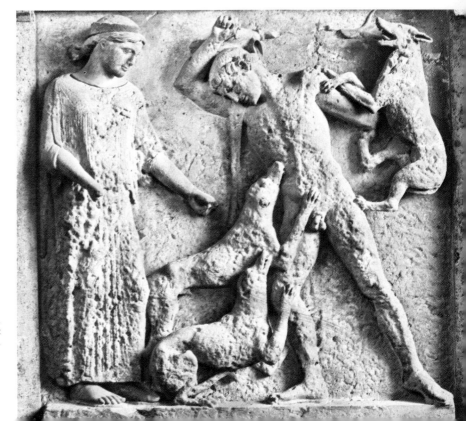

134. Artemis and Aktaion. Metope from Temple E at Selinus, *c.* 470–460 B.C. Palermo, Museo Civico.

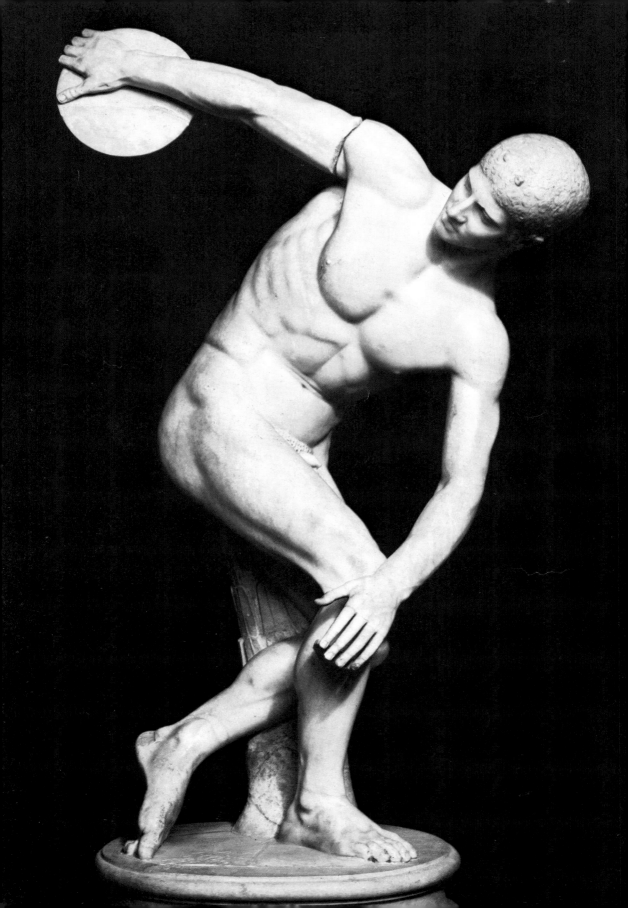

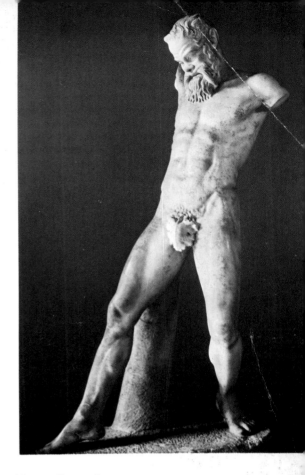

135. Diskobolos by Myron, *c.* 460–450 B.C. Roman copy.
From a reconstructed cast. Rome, Terme Museum.

136. Marsyas by Myron, *c.* 460–450 B.C. Roman copy.
Rome, Lateran Collection, now in the Vatican Museum.

preserved in Roman copies), which stood on the Akropolis and was seen there by Pausanias (I, 24, I). Representations of it appear on coins of Athens, on a red-figured oinochoe in Berlin, and on a marble base in Athens. Recently in the Heraion of Samos has been found what may have been the base of Myron's colossal group of Zeus, Athena, and Herakles mentioned by Strabo (XIV, 1, 14).[9] A Herakles preserved in a small marble statue in Boston[10] may recall the Herakles of this group.

In the Diskobolos and Marsyas, Myron shows his interest in novel stances, which was a characteristic of the time; at least a number of figures in what may be called arrested motion (falling, about to run, drawing a bow) are known.

Many other sculptors active in this period are mentioned by ancient writers—Kanachos and Aristokles of Sikyon, for instance, and Kallon and Onatas of Aegina; and other names are preserved in signatures on bases. In fact, the large number of prominent sculptors of this period—as well as later—known to us only by name makes attributions to individual artists hazardous. It is equally difficult to distinguish schools; for sculptors travelled widely, as their signatures and the statement of ancient writers testify. One has to be content in most cases with nameless sculptures, from which, however, can be obtained a clear picture of the stylistic development of the time.

137. 'Theseus'. From the East pediment of the Parthenon, *c.* 438–431 B.C. London, British Museum.

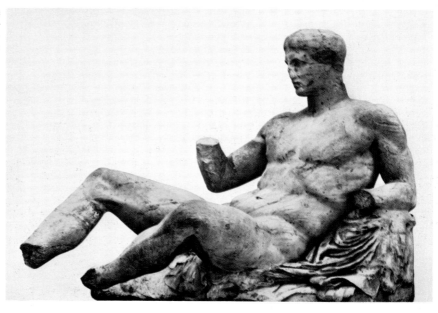

THE SECOND HALF
OF THE FIFTH
CENTURY B.C.

After Greece had recovered from the havoc of the Persian invasion and from the effort demanded by her defence and victories, followed a time of prosperity and elation. As head of the Delian League, Athens had large resources at her disposal. During the administration of Perikles (449–429 B.C.) an extensive building plan was initiated. New temples and porticoes arose to take the place of those destroyed in the war. To this

138. The West pediment of the Parthenon in Athens, *c.* 438–431 B.C. Drawing perhaps by J. Carrey, 1674. Facsimile in London, British Museum.

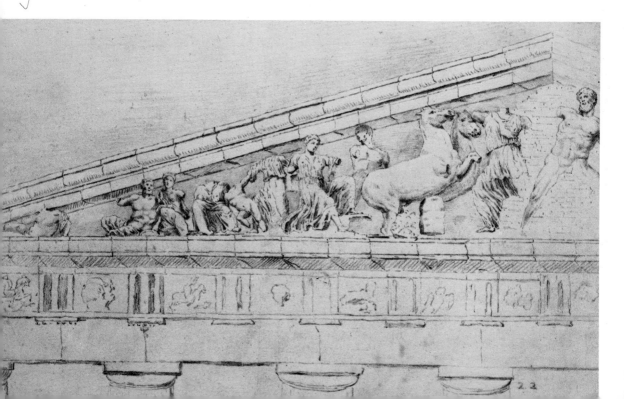

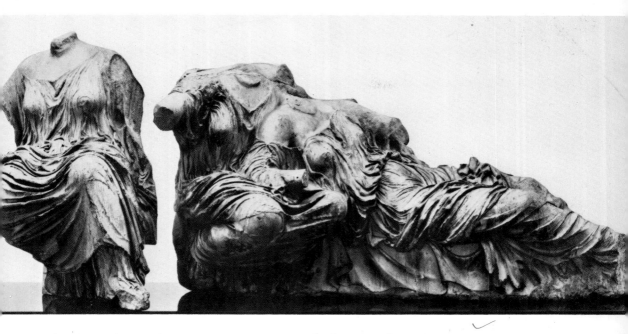

period belong the Parthenon (447–432 B.C.) and the Propylaia (437–432 B.C.) on the Akropolis (cf. p. 33), the Hephaisteion (*c.* 450–440 B.C.) overlooking the ancient market-place (cf. p. 33), and the Hall of Mysteries at Eleusis (cf. p. 46). This activity naturally acted as a stimulus to artists, and fortunately great men arose to meet the occasion.

139. The 'Three Fates'. From the East pediment of the Parthenon, *c.* 438–431 B.C. London, British Museum.

The Athenian sculptor Pheidias was appointed by Perikles chief overseer of all artistic undertakings. Plutarch (*Perikles*, XIII, 41) gives a graphic description of the work on the Akropolis: 'As the buildings rose stately in size and unsurpassed in form and grace, the workmen vied with one another that the quality of their work might be enhanced by its artistic beauty. Most wonderful of all was the rapidity of construction. Each one of them, men thought, would require many successive generations to complete it, but all of them were fully completed in the heyday of a single administration.'

The sculptures which decorated the Parthenon—two pedimental groups, a long continuous frieze, and metopes on the four sides, as well as antefixes, akroteria, and waterspouts—have survived in part, and are now in London, Athens, Paris, and Rome. On the Western pediment was represented the contest of Athena and Poseidon for the domination of Athens; on the Eastern pediment the Birth of Athena. Though large portions were destroyed by a bomb in 1687 during the Turkish-Venetian war, drawings made shortly before this catastrophe give an idea of the original compositions (cf. fig. 138). The standing, seated, reclining figures formed rhythmical designs (cf. figs. 137, 139). In the East pediment a bold, new device was introduced for the filling of the corners. Instead of reclining figures as heretofore, there appears at one end Helios,

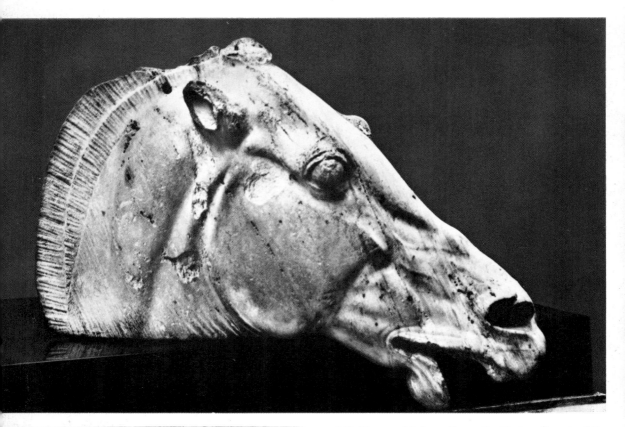

140. Horse of Selene. From the East pediment of the Parthenon, c. 438–431 B.C. London, British Museum.

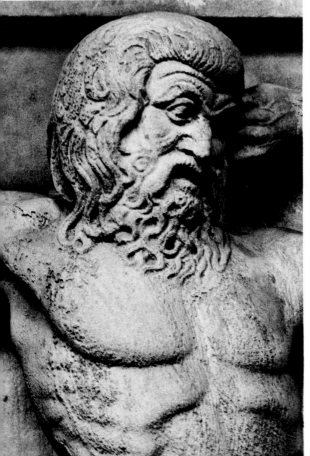

141. Head of a Centaur. From a metope of the Parthenon, c. 447–443 B.C. London, British Museum.

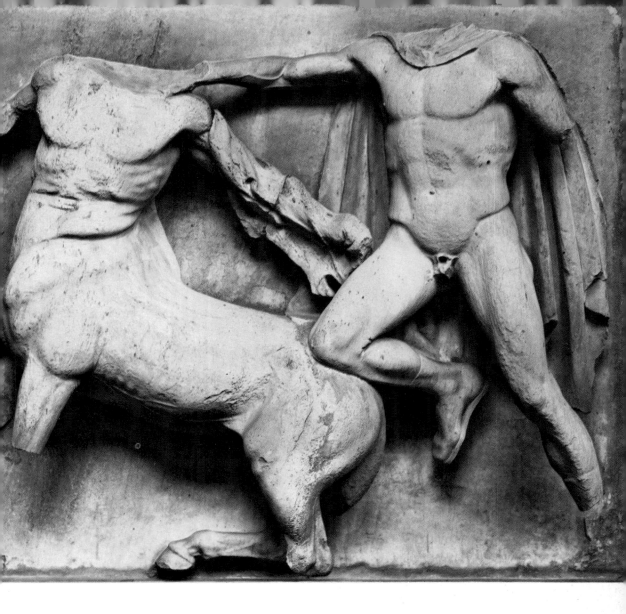

the Sun, with his horses, rising from the sea, at the other Selene, the Moon, descending with her horses (cf. fig. 140).[11]

142. Lapith and Centaur. Metope from the Parthenon, *c.* 447–443 B.C. London, British Museum.

The quadrangular spaces of the metopes were occupied mostly by single combats—Lapiths struggling with Centaurs (cf. fig. 142), gods overcoming giants, Greeks fighting Amazons. A fourth series, of which little remains, depicted the Fall of Troy. The scenes perhaps symbolized, it has been thought, the recent victory over Persia. The realistic expressions in some of the Centaurs (cf. fig. 141) exemplify the vivid interest in the representation of emotion.

The frieze, like the metopes, ran along the four sides of the building, but inside the colonnade. The subject was the procession of the Panathenaia, the great Athenian festival; at least the various incidents represented correspond more or less with what is known of that cere-

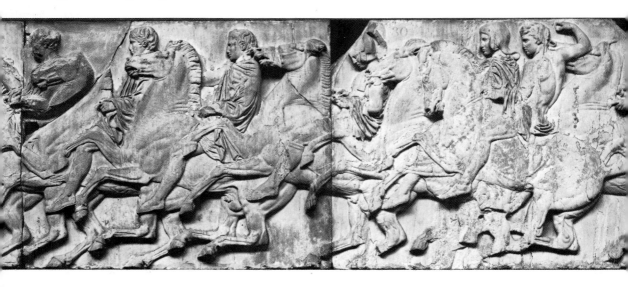

143. Horsemen. From the frieze of the Parthenon, *c.* 442–438 B.C. London, British Museum.

monial. [12] The start was shown at the South-west corner with the mounting of the riders; then, along the North and South sides, came lively cavalcades of horsemen (cf. fig. 143) and charioteers, men bearing trays and leading animals to sacrifice; and on the East side was the solemn procession of maidens, received by magistrates (cf. fig. 144), and as a climax of the ceremony the handing over of the peplos for the cult statue of Athena in the presence of an assembly of deities (fig. 145). In this long composition of advancing figures there is never any monotony, lively and quiet poses being effectively intermingled.

Foreshortening was now perfectly understood; the further parts of the figures are contracted and carved in gradually receding planes. Moreover, though a uniform front plane is everywhere observed, variation in the depth of the relief where the different shapes cut across one another conveys the impression of figures standing or moving alongside one another. Thus, in the cavalcades a number of horsemen are convincingly shown advancing in a row. The old two-dimensional conception has given place to a three-dimensional one with the illusion of depth successfully conveyed.

Though Pheidias could not have executed all these sculptures himself, and there is indeed evidence that many sculptors were at work, he, as overseer, doubtless directed the work and perhaps sketched the designs. At all events, they supply the best material by which to judge his style; for his single statues, which ancient writers praised in the highest terms, have all perished, and survive only in Roman copies. Foremost among them were the colossal bronze statue of Athena erected on the Akropolis, between the Propylaia and the Erechtheion (cf. p. 48); the Athena in gold and ivory which stood inside the cella of the Parthenon; and the colossal statue of Zeus, likewise in gold and ivory, made for the temple

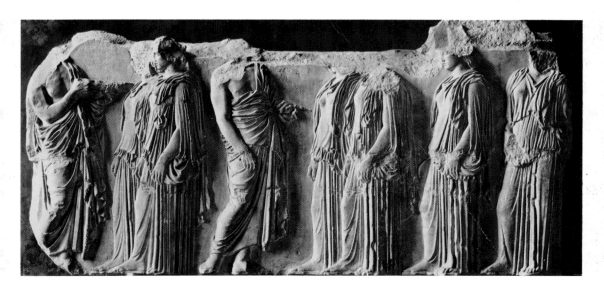

144. Maidens. From the frieze of the Parthenon, *c.* 442–438 B.C. Paris, Louvre.

145. Deities. From the frieze of the Parthenon, *c.* 442–438 B.C. Athens, Akropolis Museum.

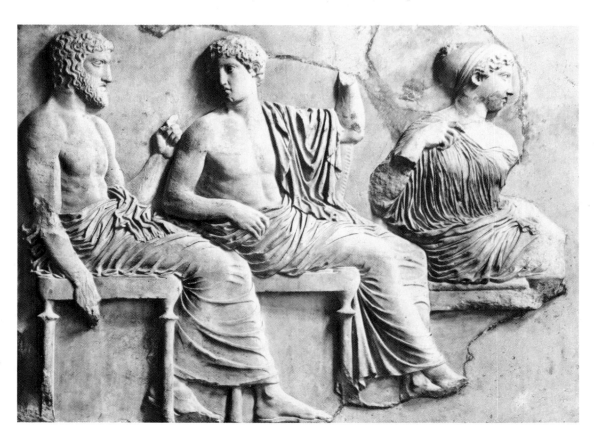

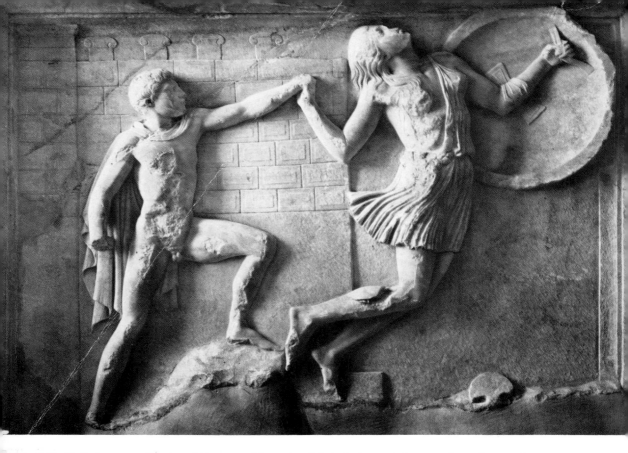

146. Fight between Greek and Amazon. Roman marble copy from the shield of the Athena Parthenos by Pheidias (*c.* 447–439 B.C.). Piraeus Museum.

of Zeus at Olympia. Of the bronze Athena only perhaps minute representations on Roman coins and part of the base survive. Of the Athena Parthenos several marble copies in various sizes are preserved (cf. figs. 152, 153,), as well as diminutive representations on gems and coins (figs. 148–9), and large marble reliefs reproducing the figures on the shield (cf. fig. 146). Of the Zeus only the copies on Roman coins and engraved gems remained (cf. figs. 150, 151) until the discovery of the terra-cotta moulds used for the gold drapery (cf. p. 55).

Several other statues that exist in Roman copies have been attributed to Pheidias on more or less reliable evidence—the so-called Athena Lemnia (fig. 154), for instance, an Amazon (cf. p. 126), and a youth tying a fillet round his head.

From these sculptures and from the descriptions by ancient writers of Pheidias' works, one may gain some idea of his style. Quiet attitudes, serene expressions, and a certain majesty of conception were the chief characteristics; and to these were added, we are told (by Demetrius, *De Elocut.*, 14), precision in workmanship. According to Quintilian (*Inst. orat.* XII, 10, 9), the beauty of the Olympian Zeus 'could be said to have added something to traditional religion, so adequate to the divine nature was the majesty of his work'. Evidently Pheidias was the chief exponent of the idealizing, classical style that became the dominant quality of Greek sculpture during his lifetime and later.

147

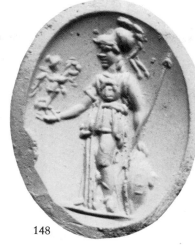

148

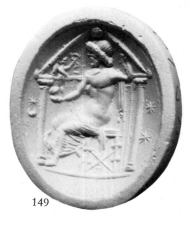

149

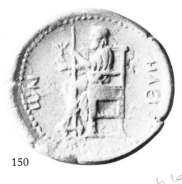

150

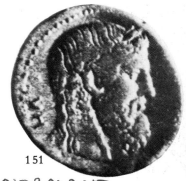

151

de la guerre

VERAKEION? LENORMANT

147–151. 'Athena Promachos', after the colossal bronze statue (*c*. 460–450 B.C.) by Pheidias on the Athenian Akropolis, Roman coin. 148. Athena Parthenos, after the gold and ivory statue by Pheidias in the Parthenon (*c*. 447–439 B.C.), Carnelian ringstone. 149–51. Zeus, after the colossal gold and ivory statue by Pheidias at Olympia (*c*. 435 B.C.), Carnelian ringstone and two Roman coins.

vierge

152–3. Athena Parthenos, Roman marble copies after the gold and ivory statue by Pheidias in the Parthenon (*c*. 447–439 B.C.). Athens, National Museum.

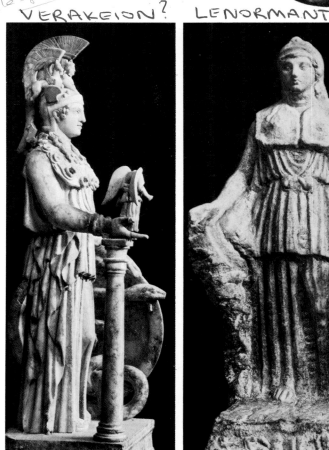

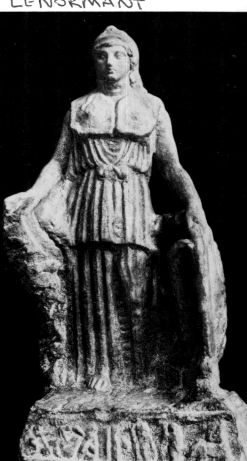

In the sculptures of the Parthenon, which took about fifteen years to complete, one may observe a certain development. It is particularly apparent in the renderings of the drapery in the metopes (*c*. 447–443 B.C.), the frieze (*c*. 442–438), and the pedimental statues (*c*. 438–432). The folds gradually multiply, become more variegated and transparent, and above all gain in depth. The same trend is evident in other sculptures of the time, until in the last quarter of the century the chiton is often made so transparent as to completely reveal the forms of the body (cf. p. 137).

Another prominent sculptor of this epoch was Polykleitos of Argos. Though he too made statues of deities, including a chryselephantine Hera for her temple at Argos, he was above all a sculptor of athletes. Pliny (xxxiv, 55) describes one of his works as 'a boy of manly form bearing a lance, called the Canon by artists, who drew from it the rudiments of art as from a code'. From this description a figure that has survived in a number of Roman copies could be identified as one of his works (cf. fig. 155). A broad-shouldered youth is represented resting his weight on one leg, while the other is placed sideways and backwards; in one hand he grasps a lance, whereas the other is lowered. Even in the somewhat hard versions of the Roman age, the beauty of proportion for which the original was famous is evident. There is a harmony of design, a poise and relaxation in the attitude, never before attained in Greek sculpture. It is not surprising that artists of the succeeding generations took the figure as their model.

Another work of Polykleitos that has been identified in Roman reproductions is the so-called Diadoumenos, a youth binding a fillet round his head (fig. 156). The pose of the body, the clear demarcation of the various planes and the square build are the same as in the Doryphoros. But the raising of the arms and a slight inclination of the head to one side give greater animation to the composition.

These two figures of Polykleitos form the climax of the long struggles by the Greek artists to attain naturalistic form. Not only are the individual shapes rendered according to nature, but a balanced, harmonious whole has been achieved. A subtle play of proportion has taken the place of the interrelated patterns of the early age. Polykleitos is known to have written a book on proportion, entitled the Canon. Had it survived we should know more about the principles that governed the rhythmical design of his figures.

Of Polykleitos' most important work—his chryselephantine statue of Hera for the Heraion near Argos—only representations on Roman coins and the detailed description by Pausanias (II,17, 4) can convey some idea.

Pheidias and Polykleitos had many distinguished contemporaries and followers. Chief among them were: Kresilas, among whose works Pliny mentions a wounded Amazon, perhaps preserved in a Roman copy in the

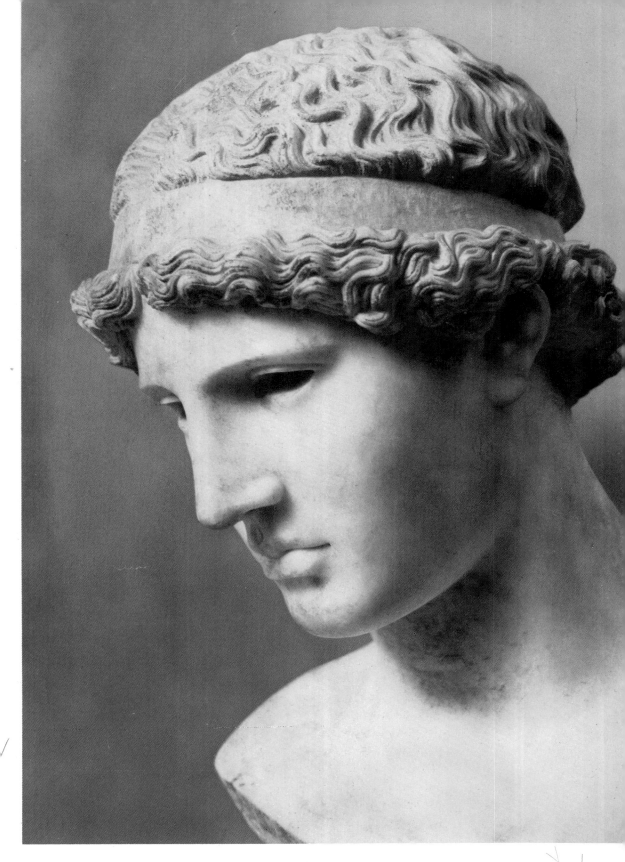

154. Head of the Athena Lemnia by Pheidias, *c.* 440 B.C. Roman copy. Bologna, Museo Civico.

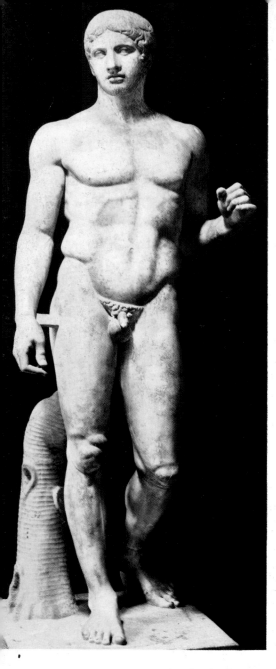

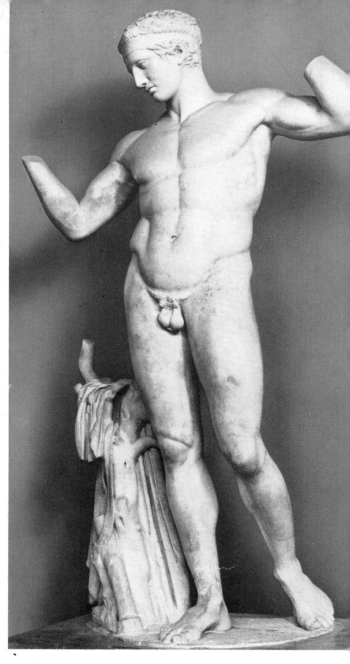

Capitoline Museum (cf. p. 127), and a portrait of Perikles on the Akropolis—possibly preserved in several copies (cf. fig. 157); Alkamenes, whose name may be seen on two Roman herms found at Pergamon (fig. 158) and Ephesos, and to whom has been attributed a group of Prokne and Itys from the Akropolis[13]; Agorakritos, who carved a statue of Nemesis for a temple at Rhamnous, of which a fragment of the head is in the British Museum; Kallimachos, who probably made the prototypes of the reliefs representing ecstatic Maenads in rhythmical poses and diaphanous draperies (fig. 160); Paionios, whose flying Victory, perched on a high, triangular pedestal, has been found at Olympia (fig. 159); Strongylion,

155. The Doryphoros by Polykleitos, *c*. 450–440 B.C. Roman copy. Naples, Museo Nazionale.

156. The Diadoumenos by Polykleitos, *c*. 440–430 B.C. Roman copy. Athens, National Museum.

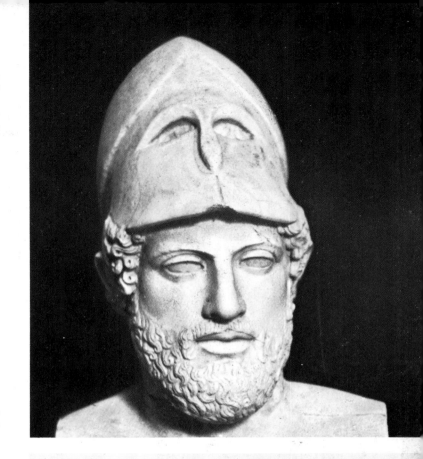

157. Portrait of Perikles by Kresilas (?) *c*. 440 B.C. Roman copy. Vatican, Museum.

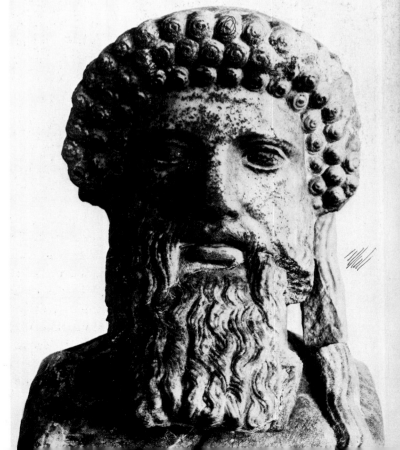

158. Hermes by Alkamenes, *c*. 450–430 B.C. Roman copy. Istanbul, Museum.

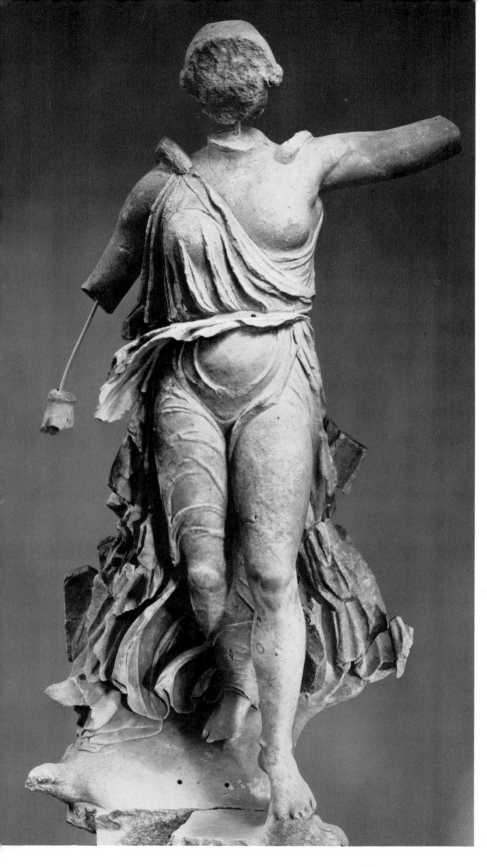

159. Nike by Paionios, *c.* 420–410 B.C. Olympia, Museum.

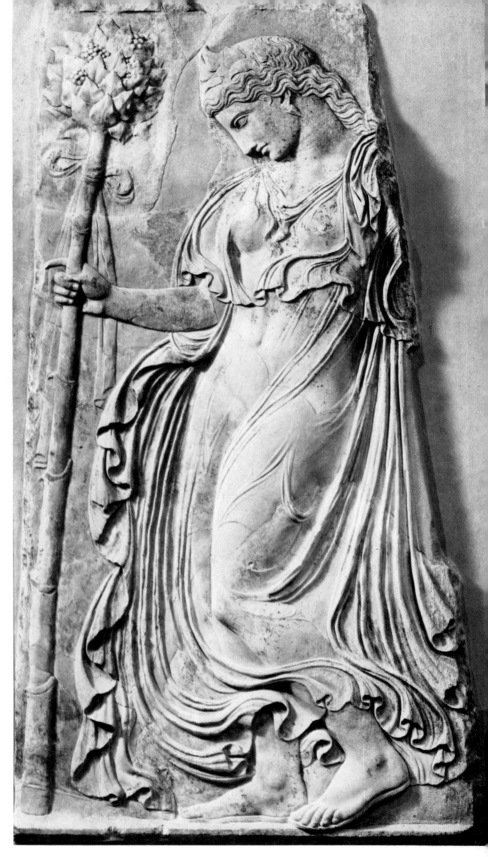

160. Maenad, after Kal-
limachos (?), *c.* 420–
410 B.C. Roman copy.
New York, Metro-
politan Museum.

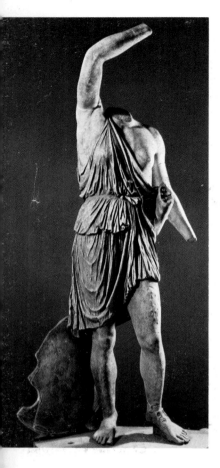

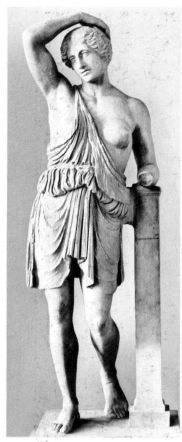

161–163. Amazons. 161. Probably by Pheidias, *c.* 440–430 B.C. Roman copy. Hadrian's Villa, near Tivoli; 162. Perhaps by Polykleitos, *c.* 440–430 B.C. Roman copy. New York, Metropolitan Museum; 163. Perhaps by Kresilas, *c.* 440–430 B.C. Roman copy. Rome, Capitoline Museum (r. arm restored).

164. 'Venus Genetrix', *c.* 430–400 B.C. Roman copy. Paris, Louvre.

165. The 'Idolino', *c.* 420 B.C. Roman copy. Florence, Museo Archeologico.

renowned for his representations of animals, and whose statue of the Wooden Horse of Troy stood on the Athenian Akropolis, where part of the base remains; and Naukydes, the brother of Polykleitos, to whom a standing diskobolos has been attributed.

According to Pliny (XXXIV, 53), several artists—Pheidias, Polykleitos, Kresilas, and two others named Kydon and Phradmon—competed in making a statue of an Amazon for the temple of Artemis at Ephesos. The sculptors themselves were to decide which work should win the prize, and this proved to be the one 'which each artist placed second to his own', namely that of Polykleitos. The statue of Pheidias was second, that of Kresilas third, that of Kydon fourth, and that of Phradmon fifth. As three distinct types occur in many replicas, and two others exist each in one copy and so were evidently less popular, and since stylistically these statues belong to the same period, some credence may be given to the story.

There has been much discussion as to which one of the existing reproductions should be assigned to which artist. The attribution to Pheidias of the 'Mattei' type, best represented in an almost complete statue found in Hadrian's Villa (fig. 161),[14] is rendered likely by its close correspondence to the figure on a gem showing an Amazon grasping

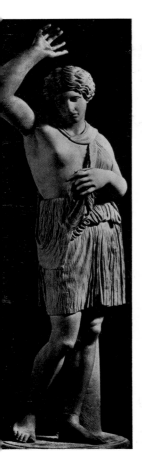
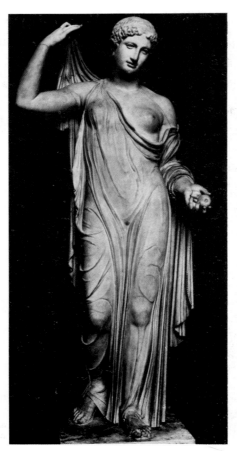
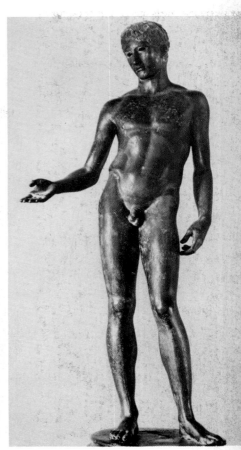

a lance with both hands, the right one high above her head, and Lucian's testimony (*Eikones*, 4): 'Which of the works of Pheidias do you praise most highly? The Amazon who is leaning on her spear.' The type preserved in the statues in Berlin, Copenhagen, and New York (fig. 162) may reproduce the Polykleitan Amazon, for it is the most rhythmical of the four, and Polykleitos, as we have seen, was known for his harmonious creations. Moreover, the fact that a statue of this type was used by Hadrian in his villa as a pendant to the Pheidian statue would seem to reinforce the attribution, for it would have been characteristic of Hadrian to have selected works of the two most famous Greek sculptors. The Capitoline type (fig. 163) would then reproduce Kresilas' Amazon, which Pliny specifically calls *volneratam*, and where indeed the wound is the dominant note. And the fourth and fifth types (reproduced in statues at Ephesos and in the Villa Doria Pamfili) might be those by Kydon and by Phradmon.[15] However, these attributions are still only surmises, since no clinching evidence has come to light. Many authorities indeed attribute the Capitoline type not to Kresilas but to Polykleitos, owing to its squarish form, which is thought to resemble that of the Doryphoros.

There are also many fine works that have survived in Roman copies, but which cannot be attributed to specific sculptors; for instance the

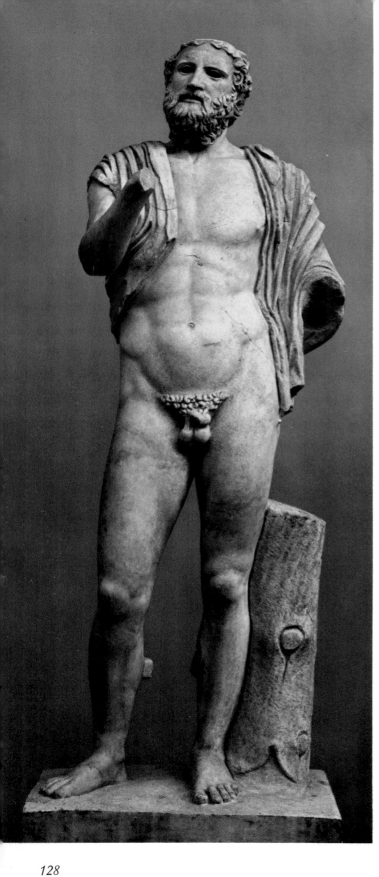

166. Anakreon, *c.* 450–430 B.C. Roman copy.
Copenhagen, Ny Carlsberg Glyptotek.

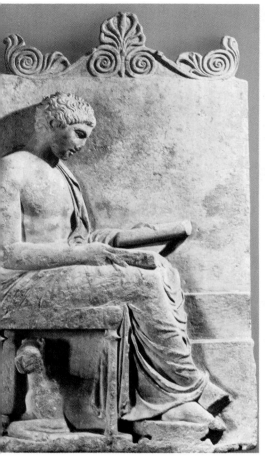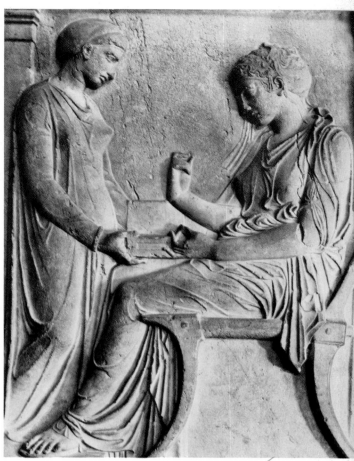

so-called Venus Genetrix (fig. 164), which must have been very popular in Italy, for many copies survive, and the Idolino in Florence (fig. 165), a softened version of Polykleitos' figures.

Several portraits assignable to the second half of the fifth century have been preserved in Roman copies. Besides the Perikles mentioned above, the most interesting is the Anakreon, which survives in a herm in Rome, inscribed 'Anakreon lyrikos', and in a full-size statue in Copenhagen (fig. 166). The latter is an excellent example of how the Greek portraitist conveyed character not only in the face but in the attitude of the figure.

There are references by ancient writers to a sculptor, Demetrios of Alopeke, and to his extraordinarily realistic portraits. As no identification of his works has proved possible, we cannot judge the degree of this 'verism'; it was presumably only relative.

During the second half of the fifth century Athens again became a centre for the production of sculptured gravestones. The shaft now became wider and less high than before, which made it possible to represent a seated figure or more than one figure without any effect of crowding. On account of the greater width of the shaft, the finial, instead of being in the shape of a single palmette, was often given the

167. Stele of a Youth, c. 420 B.C. Grottaferrata, Abbey.

168. Stele of Hegeso, c. 400 B.C. Athens, National Museum.

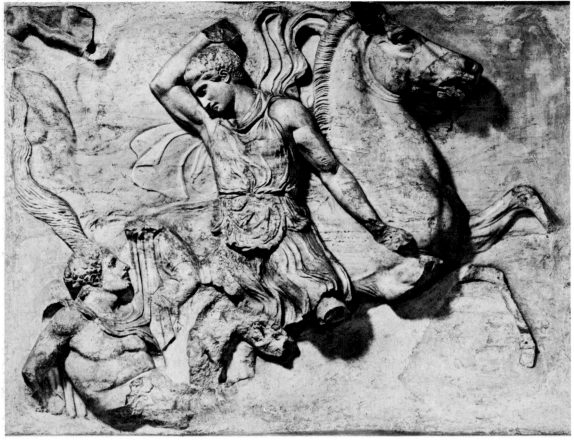

169. Horseman and enemy, *c.* 430–420 B.C. Rome, Villa Albani.

170. 'Lycian' Sarcophagus, *c.* 420–400 B.C. Istanbul, Museum.

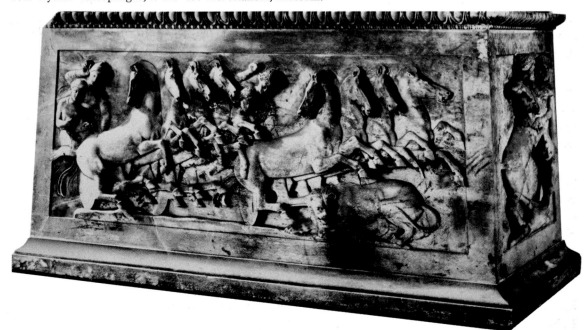

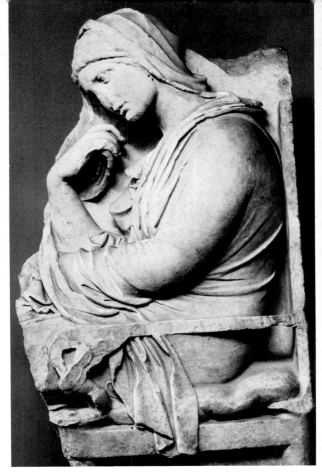
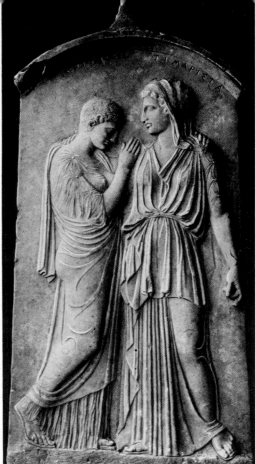

form of a pediment with palmettes as akroteria and with antae at the sides. The stelai of Hegeso in Athens (fig. 168) and of a youth at Grottaferrata (fig. 167) may serve as examples of the harmonious designs achieved. A relief of a horseman downing an enemy (fig. 169), now in the Villa Albani, was perhaps also a grandiose sepulchral monument.

To the very end of the fifth century, or the beginning of the fourth, may be assigned several large slabs with figures carved in such high relief that they are practically in the round. The stele of Phainerete and that of Phrasikleia in Athens, and one from Lowther Castle now in New York (fig. 171) are imposing examples of this type.

Similar gravestones have come to light in other Greek lands—for instance in Northern Greece, Boeotia, and the Islands. Chief among them is that of Krito and Timariste from Rhodes (fig. 172), dating from about 420 B.C. Also to this period may be assigned the so-called Satrap sarcophagus, found at Sidon, with scenes from the life of a Persian satrap, and the 'Lycian' sarcophagus, of about 400 B.C. (fig. 170), with chariot scenes like those on silver phialai and on Syracusan coins (cf. pp. 219, 259).

In addition to gravestones, votive reliefs dedicated in sanctuaries became common in the fifth century. The relief with a representation of Echelos and Basile, and that from Eleusis with figures of Demeter,

171. Stele of a Woman, c. 400 B.C. New York, Metropolitan Museum.

172. Stele of Krito and Timariste, c. 440–420 B.C. Rhodes, Museum.

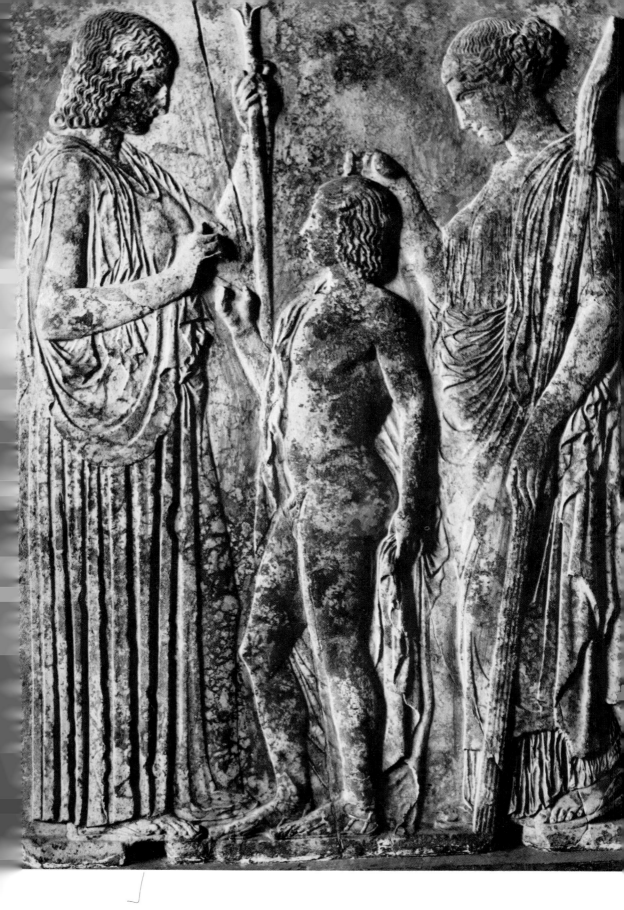

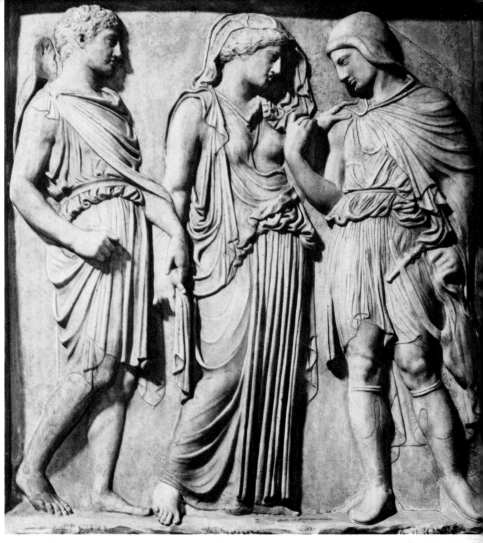

173. Demeter, Tripto-
lemos and Persephone.
Votive relief from Eleu-
sis, *c.* 440 B.C. Athens,
National Museum.

174. Hermes, Orpheus
and Eurydike, *c.* 425–
420 B.C. Roman coup.
Rome, Villa Albani.

Persephone, and Triptolemos (fig. 173), are outstanding examples. The
latter is one of the few extant Greek sculptures of which a Roman copy
also exists, enabling one to compare the two renderings. Here, as in the
case of the karyatids of the Erechtheion (see below), the greater delicacy
of execution in the originals—with soft transitions from muscle to muscle,
and from fold to fold—contrasts with the harder, more mechanical
carving in the copy.

Several large reliefs which may have been votive or architectural have
survived in a number of Roman copies. The subjects are mythological
and, on each, three figures are represented in harmonious compositions—
Hermes, Orpheus, and Eurydike (fig. 174); Herakles, Theseus, and
Peirithous; Medea and two daughters of Pelias; Herakles and two
Hesperides. The style is that of the last quarter of the fifth century,
perhaps around 420 B.C.

Over twenty fifth-century reliefs have survived, at least in part, with
inscriptions recording treaties and other historical happenings. They

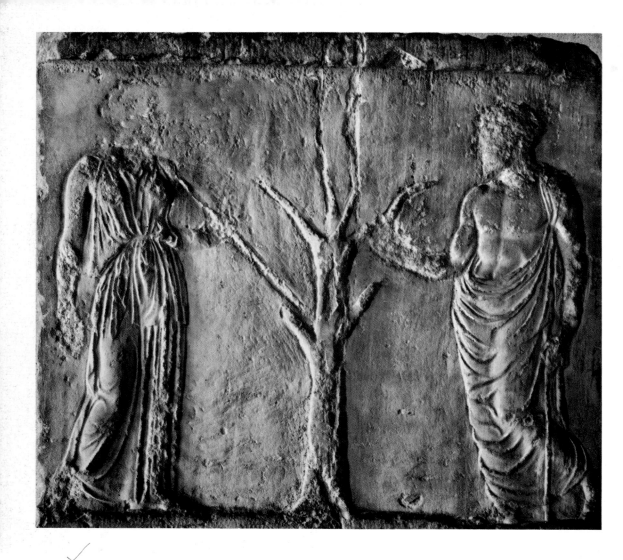

supply valuable chronological data. One of the finest is the relief of Athena and Erechtheus in the Louvre, dated 410–409 B.C. (fig. 175).

Furthermore, many architectural statues and reliefs of this period are preserved—in addition to those of the Parthenon. A progressive development can be observed. In Athens the pedimental figures, metopes, and frieze of the Hephaisteion (cf. pp. 33f.) must date from about 445 B.C.; likewise the splendid pedimental figures of Niobids found in Rome and now in Rome (fig. 176) and Copenhagen. The frieze of the little temple of Athena Nike on the Akropolis (cf. p. 36), with its quietly standing figures and animated battle scenes, may be assigned to about 425 B.C. The frieze and metopes of the temple of Apollo at Phigeleia in Arcadia (cf. p. 35), with representations of Greeks and Amazons (fig. 177), and of Lapiths and Centaurs in boldly designed groups and with flying draperies creating deep shadows, are outstanding works of about 425–420 B.C. The karyatids of the Erechtheion (cf. fig. 178), of which practically complete Roman copies have recently been found in Hadrian's Villa (cf. fig. 179),

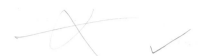

175. Record relief of Athena and Erechtheus, dated 410–409 B.C. Paris, Louvre.

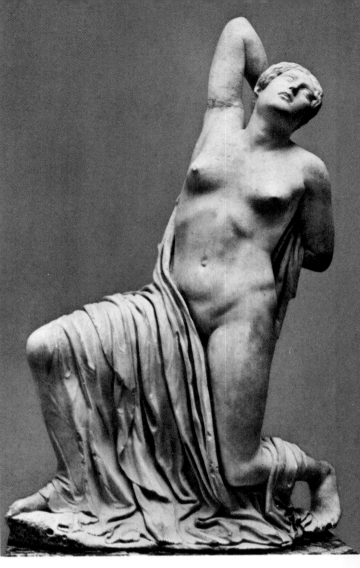

176. Niobid, from a pediment, *c*. 440 B.C. Rome, Terme Museum.

177. Greeks and Amazons, from the Temple of Apollo at Phigaleia, *c*. 425–420 B.C. London, British Museum.

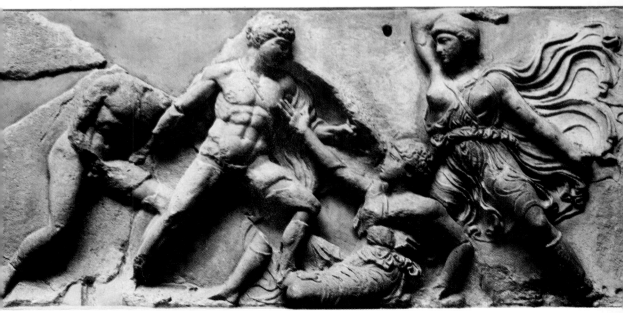

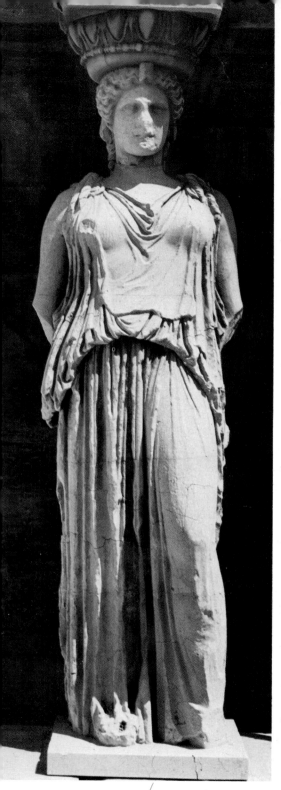

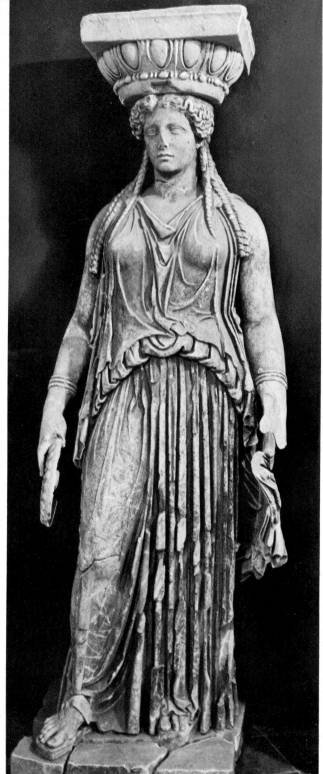

178. Karyatid from the Erechtheion in Athens, *c*. 420–413 B.C. London, British Museum.

179. Karyatid from the Erechtheion in Athens, *c*. 420–413 B.C. Roman copy. Hadrian's Villa, near Tivoli.

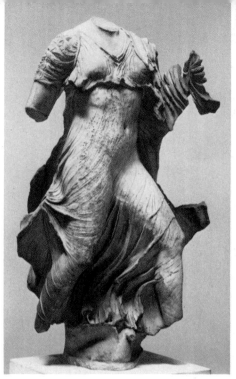

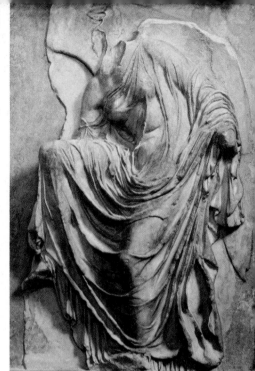

180. Nereid from the Nereid monument at Xanthos in Lycia, *c.* 400 B.C. London, British Museum.

181. Nike from the parapet of the Temple of Athena Nike, *c.* 410–407 B.C. Athens, Akropolis Museum.

may be dated shortly afterwards (420–413). Finally, the scanty remains of the frieze of the Erechtheion (409–406) and the delicately carved Nikai from the parapet of the Nike temple (*c.* 410 B.C.) (fig. 181) illustrate the style of the end of the century, when the draperies have become so transparent that they no longer hide but rather accentuate the forms of the body.

The sculptures of the Gjölbaschi and Nereid monuments (cf. fig. 180), both from Asia Minor (cf. p. 48), may also be assigned to the end of the fifth century. Here, too, transparent draperies are combined with deeply carved, agitated folds. In the Gjölbaschi frieze one may note an important innovation. In the battle scenes, which include massed formations of soldiers (cf. fig. 182), there is conveyed for the first time in Greek art a sense of something extending beyond the actual representation, a feeling that what is represented is merely part of a larger whole. Heretofore the Greek sculptor had confined himself to showing a limited number of figures in his reliefs. Even in the Parthenon frieze the various groups are complete in themselves, with a definite number of participants. The knowledge of perspective now opened up new possibilities. Not until later times, however, was this knowledge effectively and consistently utilized (cf. pp. 278 f.).

Mention must be made of a peculiar style that began some time in the fifth century B.C. and which is called archaizing, being a mannered imitation of the archaic, in strong contrast with the prevailing developed style.[16] In time this harking back to early conceptions became more and more common, and was especially popular in the Roman period.

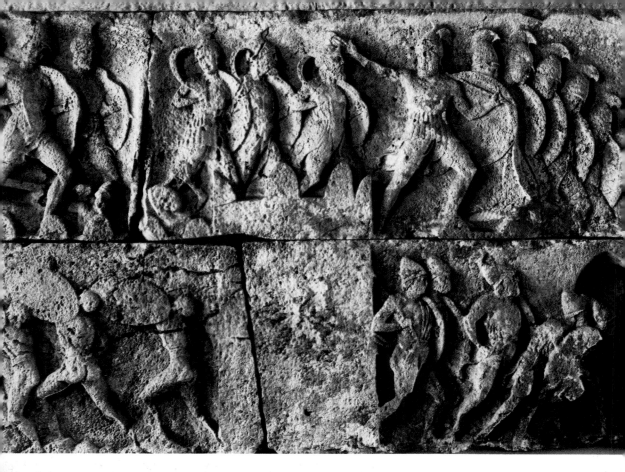

182. Battle. Relief from the Heroon at Gjölbaschi-Trysa, *c.* 420–410 B.C. Vienna, Kunsthistorisches Museum.

One must, therefore, distinguish between straight Roman copies of Greek archaizing sculptures and Roman adaptations of them (generally called archaistic). Archaizing mannerisms occur in vase-paintings as early as the Pan Painter (cf. p. 347).

A well-known instance in sculpture of this archaizing style from the fifth century B.C. is the Hermes by Alkamenes (cf. fig. 158), where especially the rows of ringlets above the forehead are reminiscent of sixth-century renderings. Attractive examples of the fourth century showing schematized folds in imitation of the archaic are the votive reliefs representing Hermes and the nymphs (cf. fig. 219).

FOURTH CENTURY B.C.

The art of the early fourth century B.C. is a continuation of that of the later fifth. Similar conceptions prevailed. The faces have the same serene expressions, the stances have the same easy balance, and the drapery has transparency often combined with heavier, agitated folds. So similar in fact are the renderings that the creations of the two epochs are sometimes difficult to distinguish.

Among the prominent sculptors of the first two decades of the fourth century were Hektoridas, Timotheos, and Thrasymedes, who worked on the temple of Asklepios at Epidauros (cf. p. 38). The pedimental statues, akroteria, and reliefs from that building (cf. figs. 183–185), representing Amazons, Nereids, and the seated Asklepios,

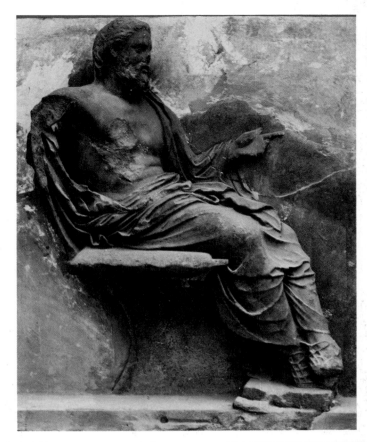

183. Asklepios. Relief from the Temple of Asklepios at Epidauros, c. 400–380 B.C. Athens, National Museum.

184–5. Statues from the Temple of Asklepios at Epidauros, c. 400–380 B.C. Athens, National Museum.

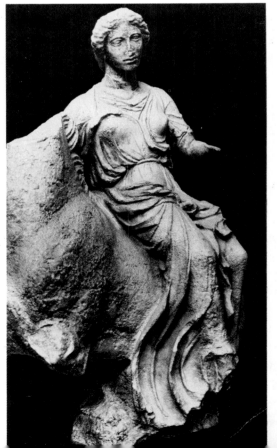

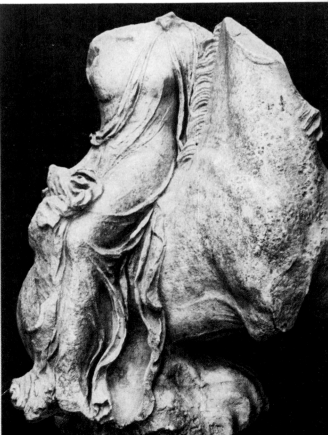

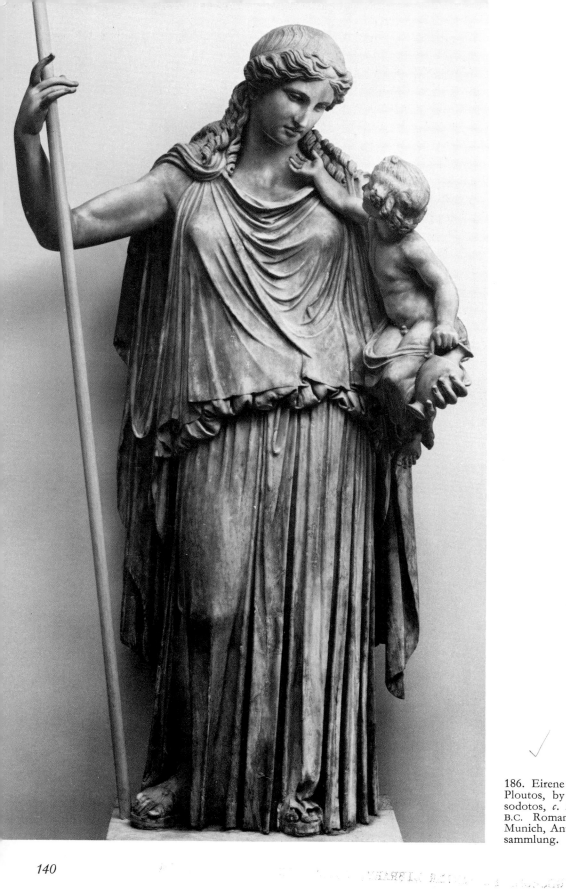

186. Eirene and
Ploutos, by Kephi-
sodotos, *c.* 375–370
B.C. Roman copy.
Munich, Antiken-
sammlung.

have been preserved in part, and they show the same delicacy of execution as the reliefs on the parapet of the temple of Athena Nike (cf. p. 36 and fig. 180). To some of these figures newly identified fragments have recently been joined, greatly adding to their general effect.[17] A statue of Leda of similar style, which survives in several Roman copies, can be associated with these sculptures.

Gradually, however, there came a change. The sufferings caused by the Peloponnesian War (431–404 B.C.) and the teachings of poets and philosophers like Euripides, Sokrates, and the Sophists were transforming the outlook of the people. A greater interest in the individual was taking the place of the former impersonal ideal. In art this is reflected by what may be called a more human quality. A soft graciousness now becomes the chief characteristic. The expressions of the faces show a dreamy gentleness, often with an emotional note; the poses become more sinuous; the drapery is rendered in a more naturalistic manner without exaggerated transparency or violent contrasts.

According to Pausanias (IX, 16, I), Kephisodotos made a statue of Eirene ('Peace') bearing the child Wealth in her arms. Roman copies of this work have been recognized in several extant statues, the most complete of which is in Munich (fig. 186). Though there is a superficial likeness to fifth-century creations, the intimate relation between woman and child, the tender expression of Eirene, and the massive folds of the drapery herald a new style. The original statue was probably erected soon after Athens' victory over Sparta in 375 B.C. A statue of Hermes with the infant Dionysos, which is mentioned by Pliny (XXXIV, 87) as a work of Kephisodotos, has been persuasively identified in Roman copies (cf. fig. 187). Its composition is a direct precursor of Praxiteles' Hermes (cf. p. 144).

187. Hermes with the infant Dionysos, by Kephisodotos, *c.* 375-370 B.C. Engraving after a Roman copy.

After this period of transition there arose three great sculptors, who dominated the art of the fourth century as Pheidias and Polykleitos had that of the fifth. They are Praxiteles of Athens, Skopas of Paros, and Lysippos of Sikyon.

The most famous work of Praxiteles was the Aphrodite which he made for Knidos and which has survived in many Roman copies (cf. fig. 188). She is represented nude, standing in a graceful pose, one hand in front of her, with the other holding her drapery. Pliny (XXXVI, 20) called it the finest statue 'not only by Praxiteles but in the whole world'. It was placed in an open shrine and was visible from all four sides, and from all four sides, Pliny says, it was equally admired. Lucian (*Eikones*, 6) speaks of 'the smile playing gently over her parted lips' and of 'the melting gaze of the eyes with their bright and joyous expression'.

Other sculptures that can be attributed to Praxiteles on more or less convincing evidence and of which Roman reproductions are known

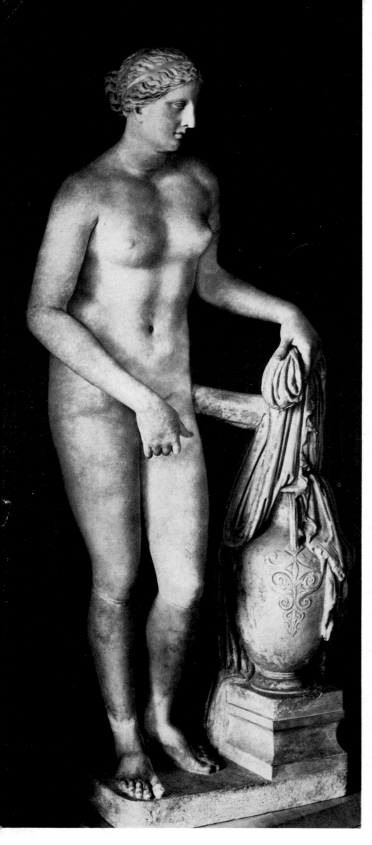

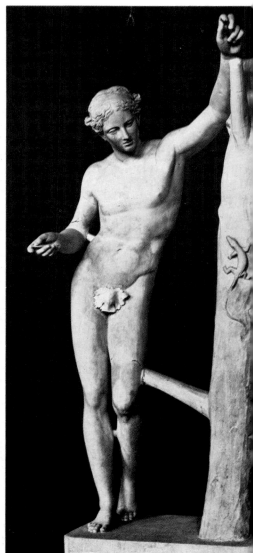

188. The Aphrodite of Knidos by Praxiteles, *c*. 350–330 B.C. Roman copy. Vatican Museum.

189. Apollo Sauroktonos, by Praxiteles, *c*. 350–330 B.C. Roman copy. Vatican Museum.

191. The Aphrodite from Arles, attributed to Praxiteles, c. 350–330 B.C. Roman copy. Paris, Louvre.

190. Artemis from Gabii, attributed to Praxiteles, c. 350–330 B.C. Roman copy. Paris, Louvre.

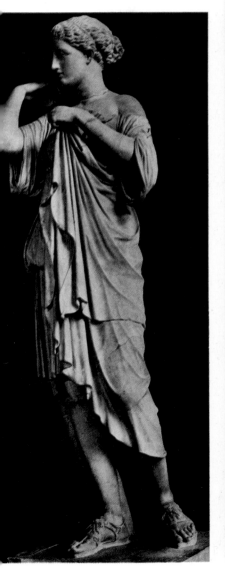

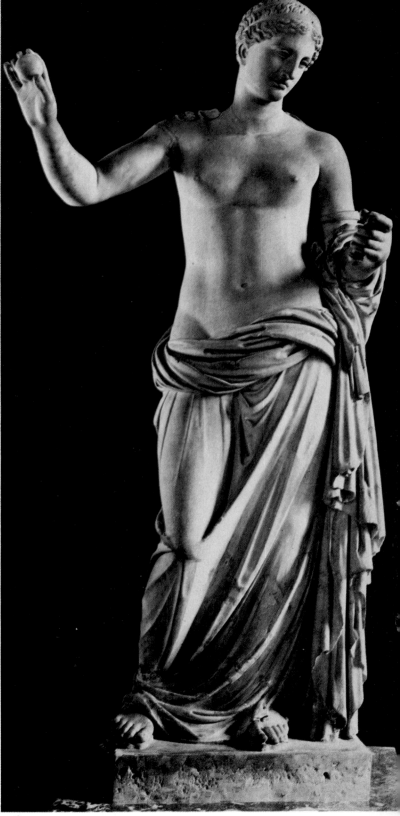

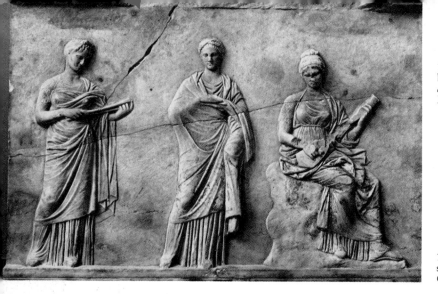

192. Three Muses, from a Statue base probably by Praxiteles, *c.* 350–330 B.C. Athens, National Museum.

193. Hermes with the infant Diony- ►
sos, by Praxiteles, *c.* 350–330 B.C. Olympia, Museum.

are the so-called Apollo Sauroktonos or Lizard-Slayer (fig. 189), the Aphrodite of Arles (fig. 191), the Eros of Thespiai, the Eros of Parion, the Apollo Lykeios, the Artemis of Gabii (fig. 190), and various satyrs. In addition, there are two works which are accepted by most authorities as original works by Praxiteles himself. One is a statue base, of which three slabs have been found at Mantineia, decorated with Apollo, Marsyas, and the Muses (fig. 192), and which has been thought to be the very base seen by Pausanias at Mantineia. Pausanias (VIII, 9, 1) does not specifically say that the base 'on which were represented the Muses and Marsyas playing the flute' was the work of Praxiteles, only that the statues of Leto, Apollo, and Artemis which it supported were by him. But it seems probable that Praxiteles at least designed the compositions. Though the execution of the reliefs is somewhat perfunctory, the dainty charm of the figures is in keeping with what we know of Praxiteles' style.

Whether the statue of Hermes with the infant Dionysos (figs. 193, 194), which was found in the Heraion at Olympia (cf. p. 27) in 1877, is an original work by the great Praxiteles, or by a second-century sculptor of that name, or a Roman copy has been much discussed.[18] The evidence for the attribution to the famous fourth-century artist appears eminently sound. There is first the statement by Pausanias (V,17, 3): 'In later times other offerings were dedicated in the Heraion. Amongst these was a Hermes of marble bearing the infant Dionysos, the work of Praxiteles.' Added to this testimony, there is the composition of the statue, which is a direct descendant of Kephisodotos' group (cf. p. 141), and which is intimately related to the design of the Knidian Aphrodite of Praxiteles. Above all, there is the quality of execution which is much superior to that of the many existing Roman copies. The delicacy of the modelling with its soft transitions, and the 'melting gaze of the eyes'—to use Lucian's expression—can in fact supply a

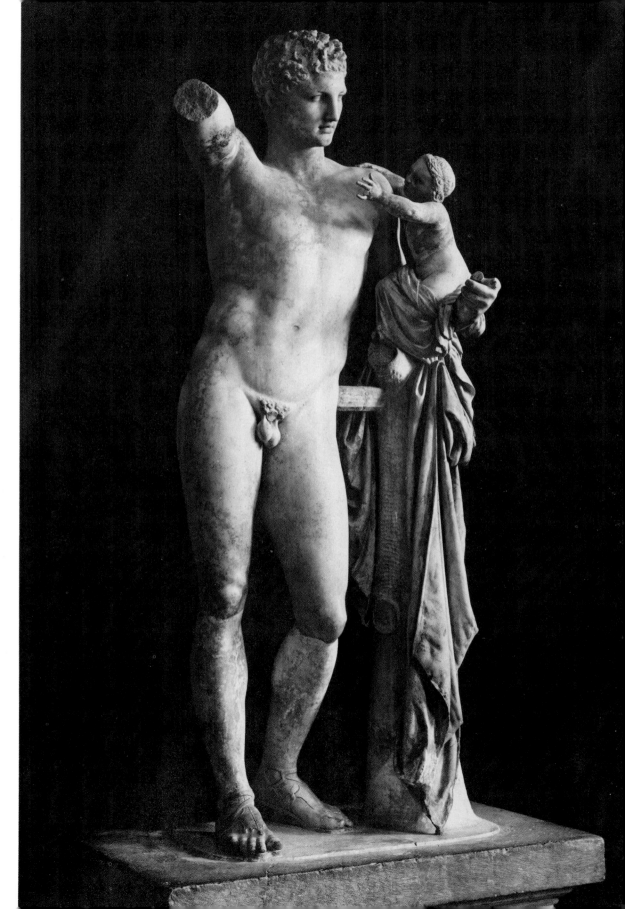

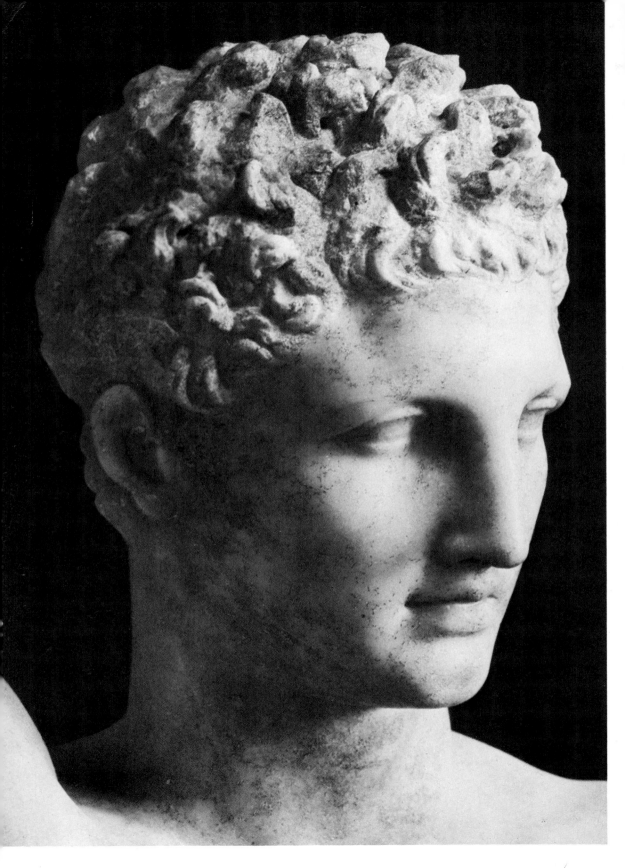

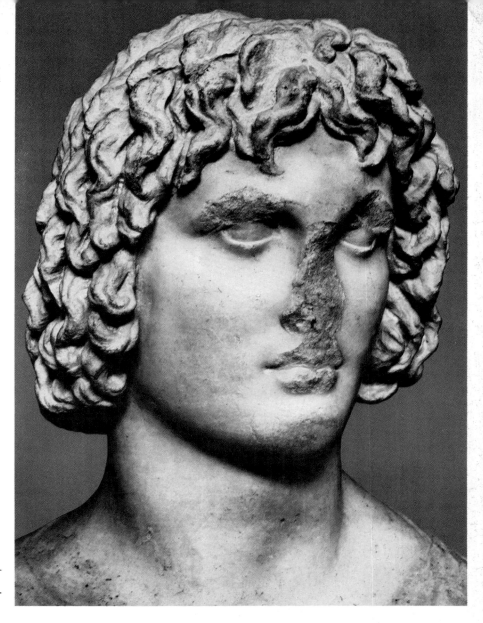

194. Head of Hermes. Detail from 193.

195. 'Eubouleus' from Eleusis, *c*. 350–330 B.C. Roman copy? Athens, National Museum.

standard by which to judge copies of the Roman age. To the forms accurately transmitted in the copies one can add in one's imagination the sensitive finish imparted to the Hermes. With regard to the other possibility—that the Praxiteles mentioned by Pausanias was not the famous one, but a later sculptor of that name—would not Pausanias in that case have mentioned this important fact, and perhaps speculated on the question, according to his wont? Nor does the statue correspond stylistically to second-century creations.

The influence of Praxiteles on the art of his time was profound. It is reflected in many a major and minor work of his and subsequent generations. The Leconfield Aphrodite, the 'Eubouleus'[19] (fig. 195), the Aberdeen Herakles, the bronze statue of a youth found in the Bay

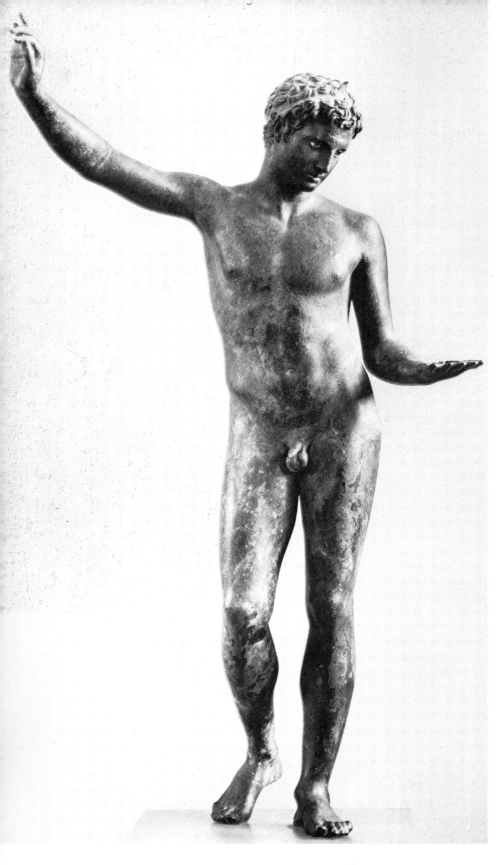

196. Bronze statue of a boy, from the Bay of Marathon, *c*. 340–300 B.C. Athens, National Museum.

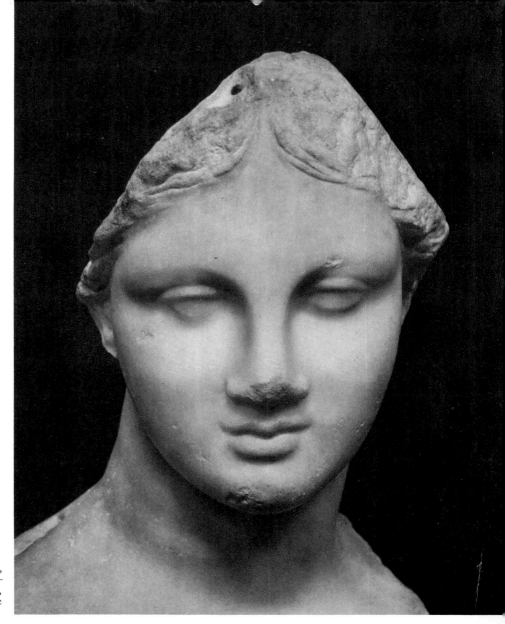

197. Head of a girl, from Chios, *c.* 320–280 B.C. Boston, Museum of Fine Arts.

of Marathon (fig. 196), the head from Chios in Boston (fig. 197), and many works of the so-called Alexandrian style (cf. p. 167) are all directly derived from Praxiteles' creations. And his conception of Aphrodite, embodied in the Knidian statue, inspired many a later work. The Aphrodite of Capua, the Townley, the Ostia, the Capitoline, the Medici, and even the Anadyomene, are all variations of the peerless Knidian.

According to the statements of ancient writers, Skopas worked on three important monuments of the first half and middle of the fourth century B.C.: the temple of Athena Alea at Tegea, the temple of Artemis at Ephesos, and the Mausoleum of Halikarnassos (cf. pp. 38, 48). Sculptural remains of all three buildings have survived and some have been tentatively associated with Skopas. Especially important are several

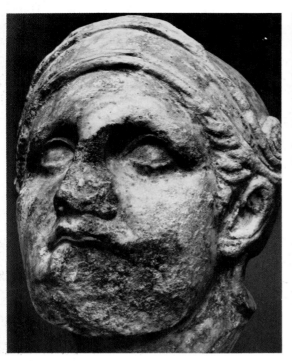
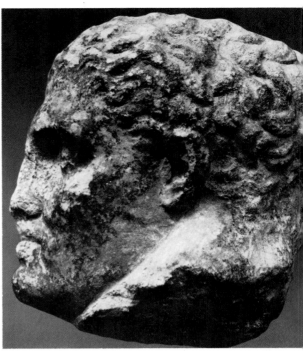

198–9. Heads from the pediment of the Temple of Athena Alea at Tegea, perhaps by Skopas, *c.* 370–350 B.C. Athens, National Museum.

battered heads from the pediments of the temple at Tegea (cf. figs. 198, 199), which in their square forms, deep-set eyes, and furrowed brows suggest the work of a prominent artist. But that they are by Skopas we have unfortunately no certain evidence; for Pausanias only says that Skopas was the architect of the temple and that the two statues of Asklepios and Hygieia inside the cella were by him (VIII, 45, 5; VIII, 47, I).[20]

According to Pliny (XXXVI, 30), the sculptures on the East side of the Mausoleum of Halikarnassos (cf. fig. 200) were executed by Skopas; but there is diversity of opinion among modern scholars as to which of the extant reliefs should be attributed to him (cf. p. 154); and the same applies to the scanty remains of the decorated columns from Ephesos, one of which is said by Pliny (XXXIV, 95) to have been carved by Skopas.

Among the non-architectural sculptures attributed to Skopas that have been preserved in Roman copies, perhaps the most attractive is the so-called Pothos, 'Longing' (cf. Pausanias I, 43, 6), a figure of a youth standing with crossed legs, leaning on a pillar or a thyrsos, a goose at his feet (fig. 201). The upward inclination of the head, the melting gaze, the marked curve of the body place it in the fourth century B.C., and the many Roman copies testify to its popularity. It is noteworthy that the style of this figure is not very close to that of the Tegea heads.

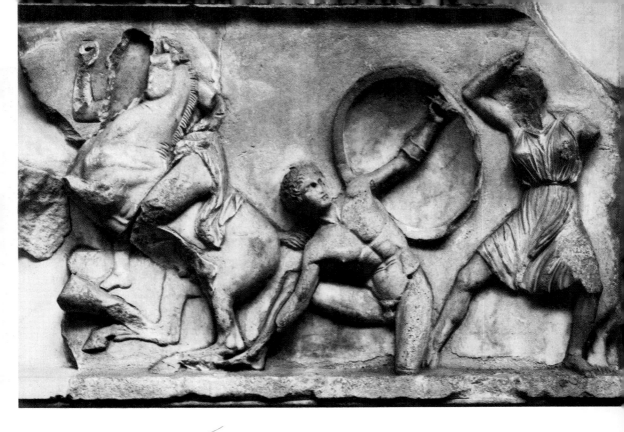

200. Fight between Greeks and Amazons, from the Mausoleum of Halikarnassos, attributed to Skopas, *c.* 355–330 B.C. London, British Museum.

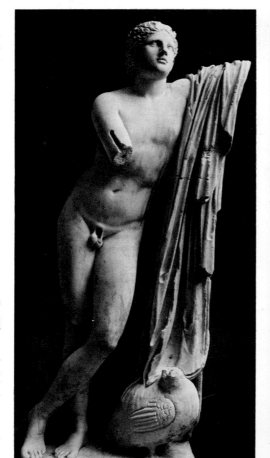

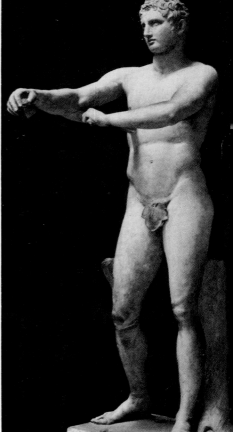

201. Pothos, *c.* 350 B.C. Roman copy. Rome, Conservatori Museum.

202. The Apoxyomenos, by Lysippos, *c.* 325–300 B.C. Roman copy. Vatican Museum.

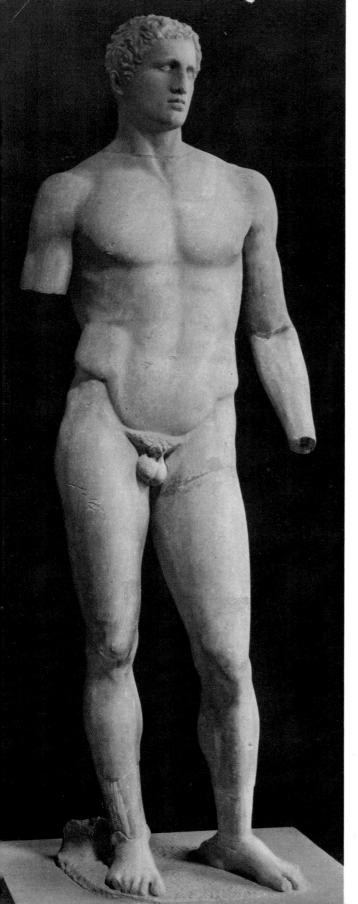

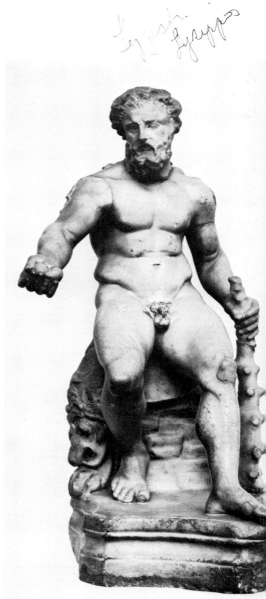

204. Herakles Epitrapezios, by Lysippos, *c.* 325–300 B.C. Roman copy. London, British Museum.

203. Agias, after Lysippos (?), *c.* 325–300 B.C. Delphi, Museum.

Among the other statues thought to show Skopasian characteristics the most important are the Meleager, preserved in many Roman reproductions, and the Lansdowne Herakles which is now at Malibu, California.

An inscription found at Delphi cites Lysippos as active soon after 370 B.C., and, according to another inscription, he made a portrait of king Seleukos (who assumed the royal title in 312 B.C.). Lysippos, therefore, had a long career, and he is indeed referred to as 'an old man' in the Anthology (Agathias, A. 22). Several statues preserved in Roman copies may be attributed to him. Among them is the so-called Apoxyomenos, the youth scraping himself, in the Vatican (fig. 202). It bears out Pliny's statement (XXXIV, 65) that he introduced a new system of proportion, in which, in contrast to earlier sculptors and especially to Polykleitos, he made the head smaller and 'the body slenderer and drier' (corpora graciliora siccioraque), thus imparting to his figures an appearance of greater height. In addition, there is a new sense of movement. Trunk, head, and limbs all face in different directions, suggesting that the action may be changed at any moment.

Other attributions to Lysippos, based on various evidence, are the Herakles Farnese, signed by the copyist Glykon, in Naples, of which an apparently more faithful version is preserved in a statue in the Uffizi (cf. also the large bronze statuette in Paris, fig. 284, and one recently found at Pergamon, *Arch. Anz*. 1966, p. 441, figs. 22a, 22b); the Herakles Epitrapezios (fig. 204), thought to have served as a table decoration (cf. Martial, IX, 44) but of which a colossal replica has now been found, which may have been a straight copy of the original[21]; and the Agias (fig. 203). The last, which formed part of the monument erected at Delphi by the Thessalian Daochos to his forefathers, has been thought to be a contemporary copy of a lost bronze original made by Lysippos for Thessaly; for the inscriptions on the bases of the two statues are the same, except that in the case of the Thessalian inscription the signature of Lysippos is added. It must be admitted, however, that the Agias does not bear out Pliny's description of Lysippos' style, as does the Apoxyomenos, and that in the fourth century B.C. faithful copies were not yet current. It seems more likely, therefore, that the Delphian Agias was a new creation, though perhaps related in general type to Lysippos' Thessalian statue.

At Olympia was found part of a pedestal which once supported a statue of the athlete Poulydamas by Lysippos (cf. Pausanias VI, 5, I). If Lysippos was responsible also for the base, the reliefs on it, which represent athletic feats, would be original works by the artist. Unfortunately they are considerably battered.

Lysippos was also a successful portraitist. He is known to have made not only the portrait of king Seleukos above mentioned, but several of

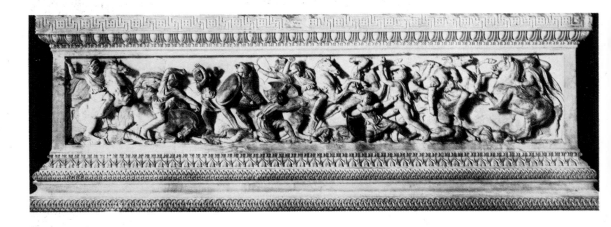

Alexander the Great. And he was famous for his large compositions, his colossal statues, and his figures of animals.

Though few of his works have been reliably identified, it is evident, even from the little that has survived, that Lysippos was a highly original artist. His new system of proportions, his realism, and the grandiose scale of his compositions left their mark on the art of his time and the succeeding centuries. To mention only one instance, in the famous Alexander Sarcophagus (cf. fig. 205) the new sense of movement in a many-figured composition seems to be inspired directly by Lysippos' creations.

In addition to Praxiteles, Skopas, and Lysippos, there were naturally many other prominent sculptors active in the fourth century. Among them were two sons of Praxiteles, named Kephisodotos and Timarchos, who decorated an altar at Kos, fragments of which have survived, and who made a seated statue of Menander for the theatre of Athens, of which the inscribed base has been found. Probably the sensitive head of which more than forty Roman copies are known (cf. fig. 206)—and which moreover resembles a head inscribed Menandros on a relief once in Marbury Hall and one on a late Roman mosaic from Mytilene—reproduces this portrait.

According to Pliny (XXXVI, 30), Bryaxis, Leochares, and Timotheos, as well as the great Skopas (cf. p. 150), were engaged in the decoration of the Mausoleum of Halikarnassos; but though many slabs of the frieze and other sculptures of the building have survived, some in excellent condition, it has proved difficult to apportion the various pieces to the artists named, for we know too little of their individual styles. All we have, for instance, by which to judge Bryaxis' work is a sculptured base which bears his name (fig. 207), but this signature may have referred only to the statue which surmounted the base, and which no longer exists. Of his famous colossal Hades-Sarapis only some reduced copies and adaptations survive. And of his other works no trace remains, except possibly the representations on coins of the Apollo he made for Daphne, near Antioch.

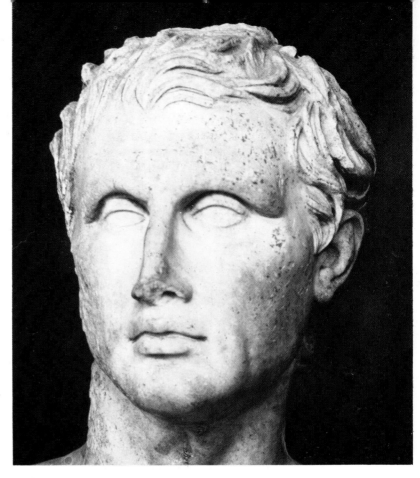

205. Alexander the Great fighting the Persians. Relief on the 'Alexander Sarcophagus' from Sidon, c.325–300 B.C. Istanbul, Museum.

206. Menander (?), c. 300 B.C. Roman copy. Boston, Museum of Fine Arts.

To Leochares has been attributed the prototype of a group in the Vatican representing Zeus' eagle carrying the boy Ganymede in its claws (fig. 208). But here too the evidence is not conclusive. It only consists of Pliny's mention that he made such a group, 'in which the eagle is said to use its talons gently, though the boy's garment protects him' (XXXIV, 79), and that the style of the Vatican statue seems to fit Leochares' time (though some have thought it Hellenistic).

Timotheos is known to have worked on the temple of Asklepios at Epidauros, for he is cited in a building inscription recording the various

207. Base for a statue by Bryaxis, c. 340–330 B.C. Athens, National Museum.

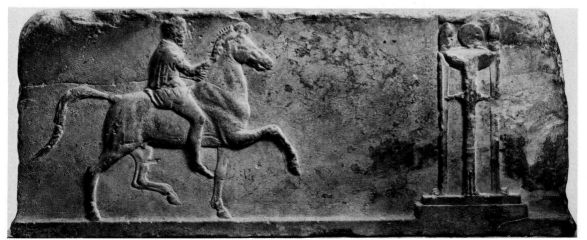

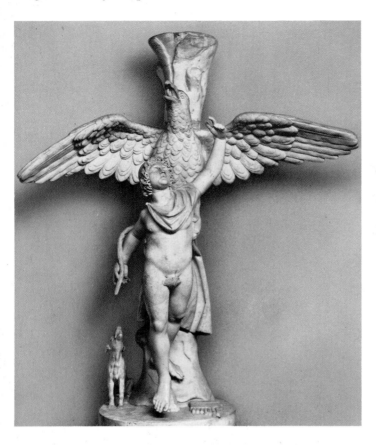

208. The eagle and Ganymede, perhaps by Leochares, *c.* 350–320 B.C. Roman copy. Vatican, Museum.

contracts. As most of the extant sculptures from that building (cf. p. 138), particularly the akroteria, are carved in a delicate style with transparent draperies, it is natural to think that Timotheos worked in that manner. But none of the Mausoleum slabs are markedly similar to the Epidauros sculptures, and delicate carving was a general characteristic of the period.

Euphranor is mentioned by ancient writers as one of the most prominent sculptors of the fourth century. According to Vitruvius (VII, praef., 14), he wrote on the theory of art. Except for the headless, stately statue of his Apollo Patroos mentioned by Pausanias (I, 3, 3), and found on the Athenian Agora not far from his temple (cf. fig. 210), no extant sculptures can with certainty be attributed to him.

Silanion made a portrait of Plato, dedicated by Mithradates (Diog. Laert. III, 25) and this may have survived in several Roman copies (cf. fig. 209). He too is known to have written on art and specifically on proportion.

Lysistratos, the brother of Lysippos, is said to have been the first to have taken plaster casts of statues (cf. Pliny XXXV, 153), an invention which later had important consequences (cf. p. 183).

Of the many other fourth-century artists whose names are preserved, either in signatures or through the mention of ancient writers, nothing

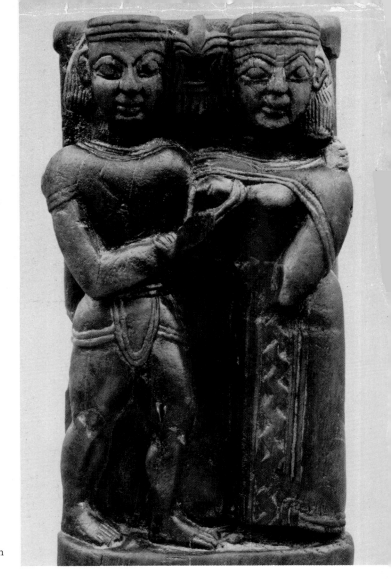

263. Zeus and Hera. Wooden group from
Samos, *c.* 625–600 B.C.

seventh century from the same find, now in Athens; it was joined to
the body (now missing) by a tong. Recently other early wooden
figures have come to light in Samos, among them an imposing Hera
wearing a high polos.[3]

All these figures in various materials and from different localities
indicate widespread sculptural activity throughout the seventh century.

From the sixth century there has survived a splendid series of bronze SIXTH
statuettes which can be correlated with the statues of that time. They CENTURY B.C.
have been found throughout Greece, Asia Minor, and Southern Italy,
and they show the same variety of stances and the same steady evolution
towards, naturalistic form.

As an early example of the standing youth a statuette from Samos
may be cited (fig. 264), and, as a late archaic one, a fine statuette from
the Akropolis (fig. 265). The first is related to the stone kouroi of the

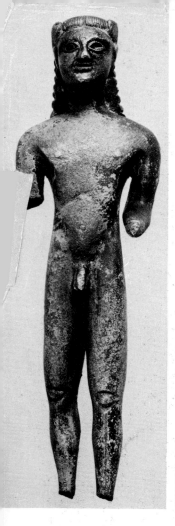

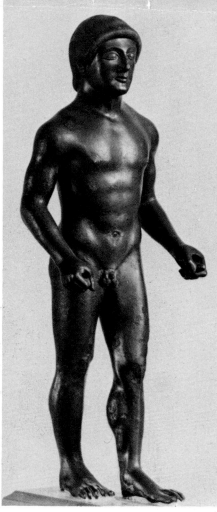

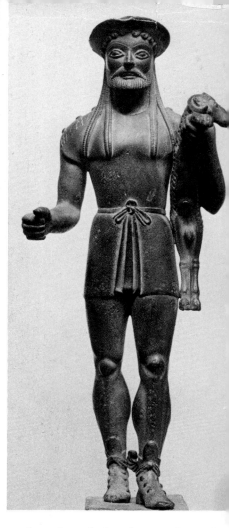

267. Runner. Bronze statuette from Samos, c. 520–500 B.C. Vathy, Museum.

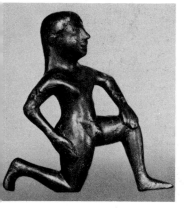

first half of the sixth century, the second to those belonging to the end of that century (cf. fig. 85). To about the same time also belongs a figure of Hermes wearing a short tunic, hat, and shoes (fig. 266), a masterpiece of late archaic art.

The evolution of the female standing type can be realized by comparing a bronze figure from Samos (fig. 268), of the second quarter of the sixth century, with a bronze figure in Berlin of about 540 B.C. (fig. 269), in which the drapery shows the stylized folds of the later Akropolis maidens.

Several fine statuettes are in the posture of attack, popular also in the larger sculptures. We may illustrate here a sturdy Herakles, found in Arcadia and now in New York (fig. 270), of about 530 to 520 B.C., and a Herakles brandishing his club, found at Perachora and now in Athens (fig. 271).

The half-kneeling stance was used to indicate flying or running in statuettes as in the larger sculptures. Good examples of such flying figures are in Athens and Berlin, and a particularly vivacious one, of the late archaic period, was found at Samos (fig. 267).

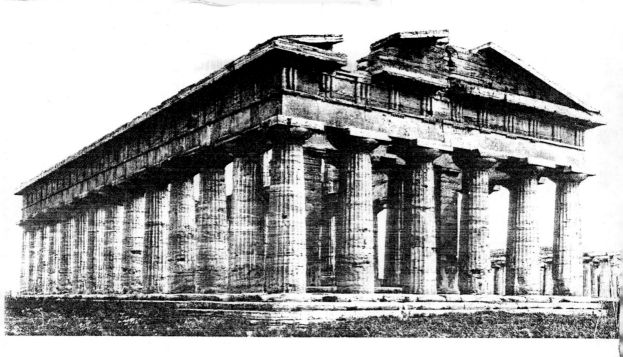

as a Heraion. It is the only Greek temple in which part of the second tier of columns inside the cella still stands. There are remains of a stairway at the eastern end of the cella, probably for reaching an attic. A large altar to the east of the temple is still partly preserved.

About five miles away from Paestum, at the mouth of the river Silaris (Sele), yet another temple of Hera has come to light (fig. 12). It is much larger than the earlier temple on this site (cf. p. 28), having seventeen columns at the sides. The cella had a deep pronaos, a chamber at the back instead of an opisthodomos, and a peristyle. It, too, was decorated with sculptured, sandstone metopes (cf. p. 92). The date must be about 520–500 B.C.

To the latter part of the sixth century belongs the Doric temple of Apollo at Delphi, which was built—after a great fire had destroyed an earlier edifice—with the aid of subscriptions from the whole Greek world. According to Herodotos (V, 62), the Alkmaionidai, a noble Athenian family exiled by Peisistratos, undertook to build the temple and, though they had contracted to erect it all in limestone (*poros*), they used Parian marble for the front. Several pedimental sculptures of limestone from the Western and of marble from the Eastern façade have survived (cf. p. 88). This temple was the scene of Euripides' Ion, the sculptures of which were admired by Creusa's handmaids (ll. 184 ff.). It, too, was destroyed, this time by an earthquake. It was replaced in the fourth century B.C. by another temple, which is the one now standing on the site. An enclosed room behind the cella is thought to have been where the priestess pronounced the oracles (cf. fig. 19).

The importance of Aegina in the early fifth century B.C. is indicated by the temple of Aphaia that still stands today on a promontory in the Eastern part of the island (fig. 20). The material is local limestone,

18. The Temple of Hera at Paestum, *c*. 460 B.C.

19. The Temple of Apollo at Delphi, *c*. 520 B.C.

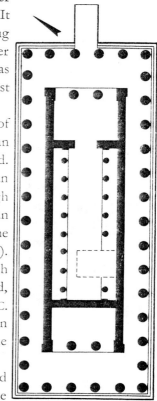

0 20 M.

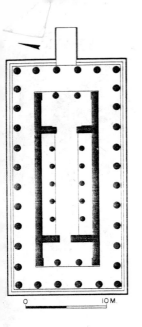

20. The Temple of Aphaia at Aegina, early fifth century B.C.

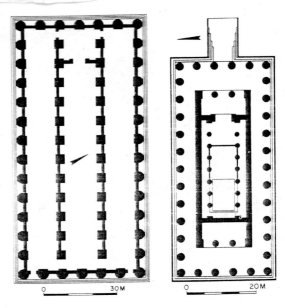

21. The Temple of Zeus at Akragas, begun c. 500 B.C.

22. The Temple of Zeus at Olympia, c. 470–460 B.C.

stuccoed, except for the simas, the lowest row of the roof tiles, the akroteria, and the pedimental sculptures, which were of marble (cf. pp. 92f.) In addition to the usual features, it had two rows of columns in the cella, built in two storeys. The east façade was entered by a sloping ramp.

EARLY CLASSICAL PERIOD, ABOUT 480–450 B.C.

One of the most imposing Doric temples still extant is that of Zeus Olympios at Akragas (Agrigentum). It was unusual in plan (fig. 21). There were two rows of piers in the interior, no pronaos, only a narrow opisthodomos. The columns of the peristyle are engaged, set along a continuous wall. In addition, a series of colossal figures of giants were used for support, each probably placed between the exterior columns. The temple was the largest in Sicily, the stylobate measuring about 53 by 110 metres, and it took a long time in building. Though it may have been begun about 500 B.C., the extant sculptures can hardly be earlier than about 470.

To the second quarter of the fifth century belongs also the famous temple of Zeus at Olympia. It had a pronaos, an opisthodomos, a peristyle, and two rows of columns in the cella (fig. 22). Stairs led to a gallery, and, as in the temple of Aphaia at Aegina, the level of the temple floor was reached by a ramp on the East side. The material was the local shell conglomerate, covered with stucco; but the tiles and the sculptural decoration were of marble. A large part of the latter has survived. It includes most of the pedimental figures and the metopes from the porches; also some of the waterspouts in the form of lions' heads (a few of the original ones and a number of the later substitutions). The stylistic date (cf. pp. 97, 108 f.) conforms with the statement by Pausanias that the cost of the building was defrayed by the booty obtained in the conquest of Pisa (c. 470 B.C.). The cult statue of Zeus by Pheidias, however, must be later (cf. pp. 116, 118).

For the Heraion at Paestum, dated c. 460 B.C., cf. pp. 30 f.

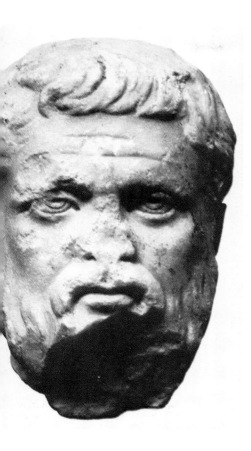

209. Portrait of Plato, perhaps by Silanion,
c. 355–330 B.C. Roman copy. Athens, National
Museum.

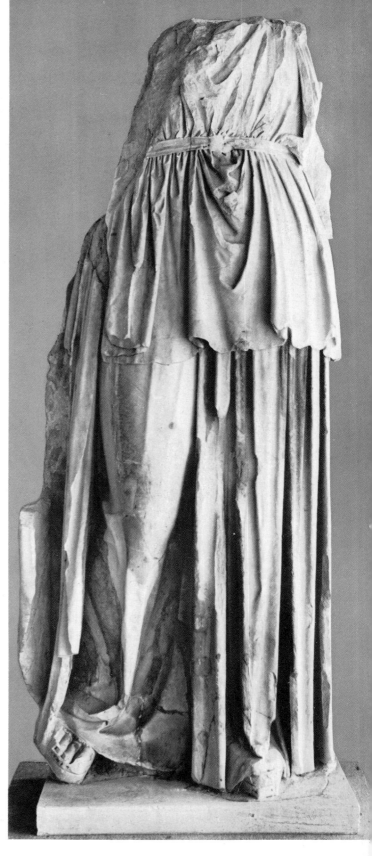

210. Apollo Patroos, by Euphranor, c. 350–330
B.C. Athens, Agora Museum.

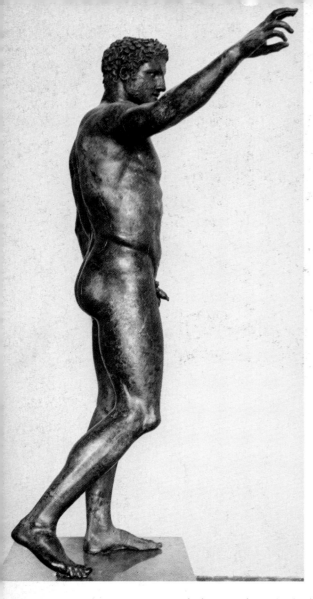

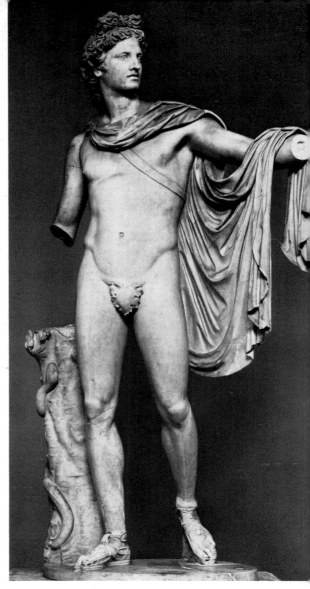

is known by which their style can be even tentatively visualized. On the other hand, a number of fine Greek originals have been preserved, which enable us to judge the style of the period; for instance the Demeter of Knidos, sitting serenely on her crushioned, high-backed chair (fig. 213); the lovely head from the South slope of the Akropolis; the impressive Asklepios from Melos; and the radiant bronze youth from Antikythera (fig. 211). In addition, there are good Roman copies of what must have been famous works of the time, among them the Apollo of Belvedere (fig. 212), the Capitoline Aphrodite (fig. 214), and the Artemis of Versailles.

Portraiture, that is the making of a more or less realistic likeness of a certain individual, had begun, as we saw, in the fifth century B.C. (cf. p. 100). During the fourth century there was an increased interest in this art, as shown in the many examples that are attributable to this

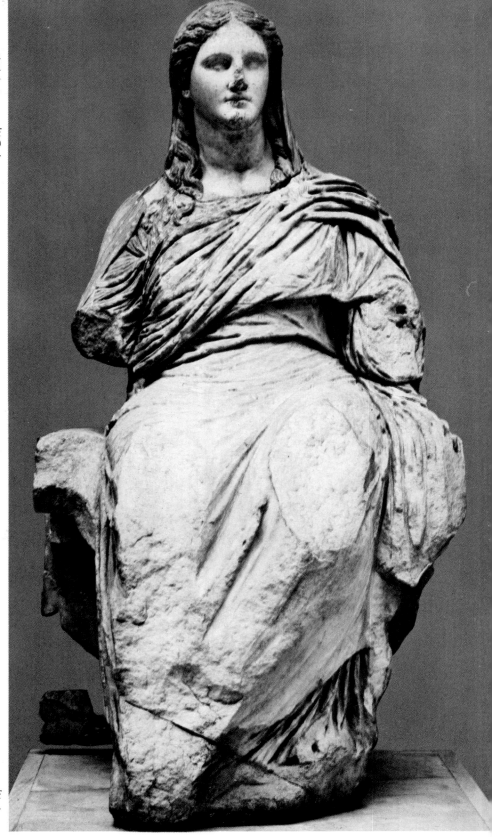

211. Bronze statue of a youth ('Paris'), found in the sea off Antikythera, *c.* 350–330 B.C. Athens, National Museum.

212. The Apollo of Belvedere, *c.* 350–320 B.C. Roman copy. Vatican, Museum.

213. The Demeter of Knidos, *c.* 350 B.C. London, British Museum.

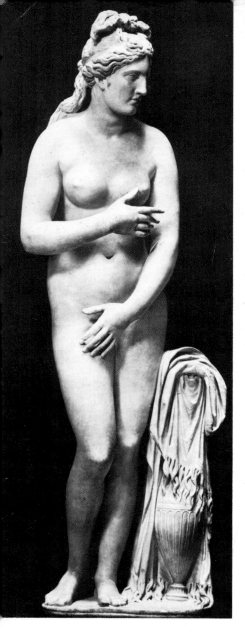
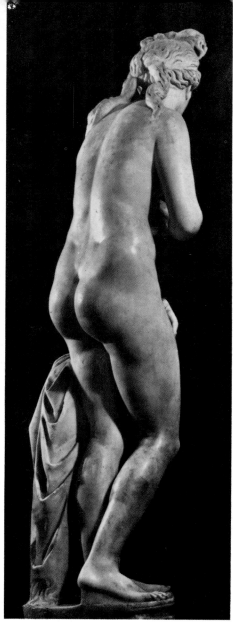

214. The 'Capitoline Aphrodite', c. 320–280 B.C. Roman copy. Rome, Capitoline Museum.

period. A few are Greek originals, for instance, the statue of Maussollos from the Mausoleum of Halikarnassos (cf. pp. 48, 154), most of them are Roman copies in the form of busts and herms, or of whole statues reproducing the original compositions.

It is recorded that statues of Aischylos, Sophokles, and Euripides were dedicated in the theatre of Athens by Lykourgos (c. 340 B.C.). The standing figure of Sophokles in the Lateran (fig. 215) has been peruasively identified as reproducing one of these statues. An inscribed herm in Naples gives us the distinguished features of Euripides (fig. 216). The seated Sokrates, perhaps by Lysippos, and the Plato, perhaps by Silanion (cf. p. 156), have been tentatively reconstructed. All are expres-

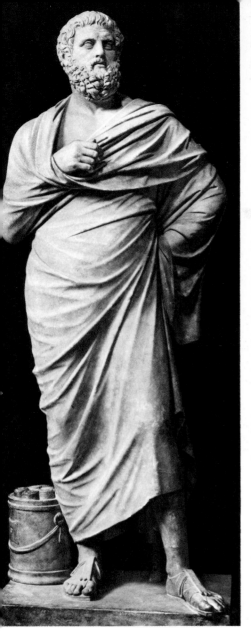

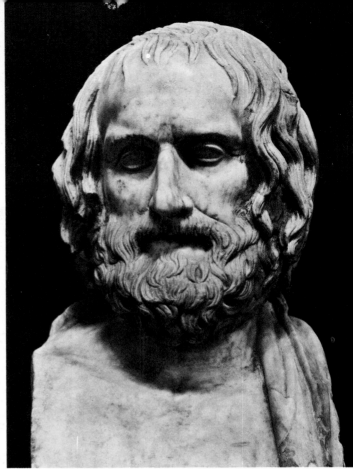

216. Portrait of Euripides, *c.* 340–330 B.C. Roman copy. National Museum, Naples.

215. Portrait of Sophokles, *c.* 340-330 B.C. Roman copy. Rome, Lateran Collection, now in the Vatican Museum.

sive of the individuals portrayed, though still in a somewhat generalized manner. The great age of realistic Greek portraiture was not to come until later (cf. p. 177).

The majority of extant Greek gravestones belong to the fourth century B.C. There seems indeed to have been a mass production in Athens at that time. The late-fifth-century form of a decorated slab surmounted by a pediment and flanked by antae (cf. p. 131) now became standardized. Occasionally a simulated tiled roof with antefixes was substituted for the pediment. Other common forms were a tall, narrow slab crowned by an akroterion, and a marble vase—a lekythos or a loutrophoros. The name of the deceased—and occasionally of members of his family—were regularly

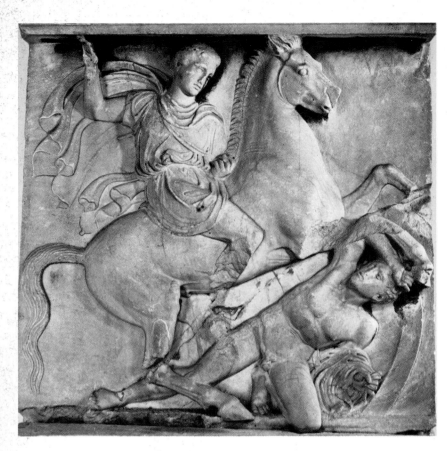

217. Stele of Dexileos, c. 394 B.C. Athens, Kerameikos Museum.

218. Stele of a father and son, c. 350–330 B.C. Athens, National Museum.

inscribed. Statues in the round were also used for sepulchral monuments, as they had been earlier.

Many of the reliefs on these tombstones are but cursorily worked, others are outstanding, and it is known that Praxiteles executed one of them (cf. Pliny, XXXVI, 20). Favourite subjects are figures in quiet poses, engaged in the ordinary activities of life, but, so to speak, heroized. Other representations include horsemen, combats, women in childbirth, and vases. The stele of the young horseman Dexileos (fig. 217) can be definitely dated around 394 B.C., for an inscription states that he fell in the Corinthian war. It is instructive to compare it with that of another horseman in a similar composition, of a few decades earlier (fig. 169). Something of the fifth-century force and stateliness has already vanished.

Several of the later monuments are in the form of deep niches, with a number of figures in high relief. Among the finest is one in Athens representing a father mourning the death of his son (fig. 218)—a masterly rendering of restrained emotion. These large gravestones mark the increase of luxury in this form of art that was presently curbed by an anti-luxury decree forbidding the erection of sculptured gravestones in Attica (enacted by Demetrios of Phaleron between 317 and 307 B.C.). By this arbitrary action one of the most pleasing artistic creations was stopped in Athens for a considerable time.

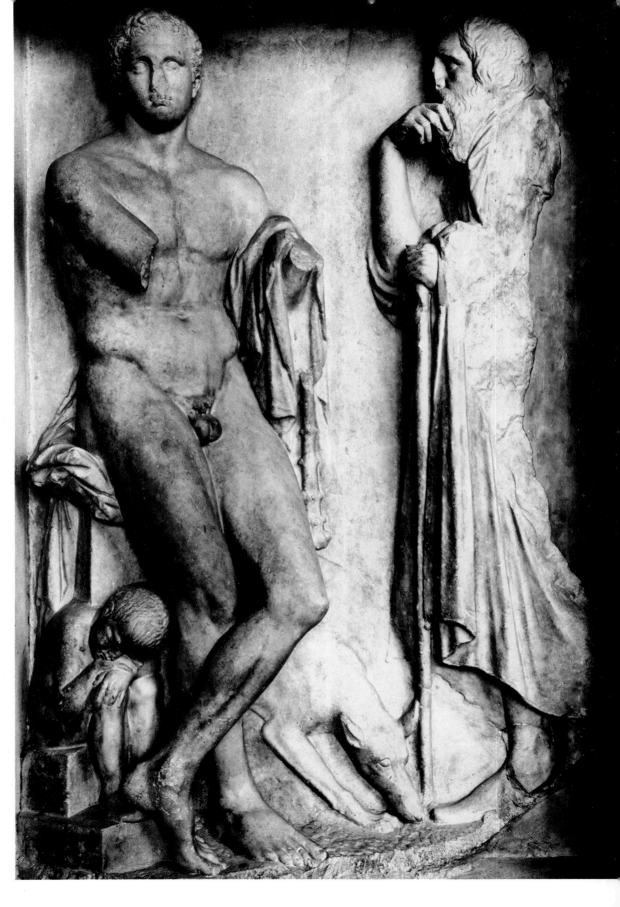

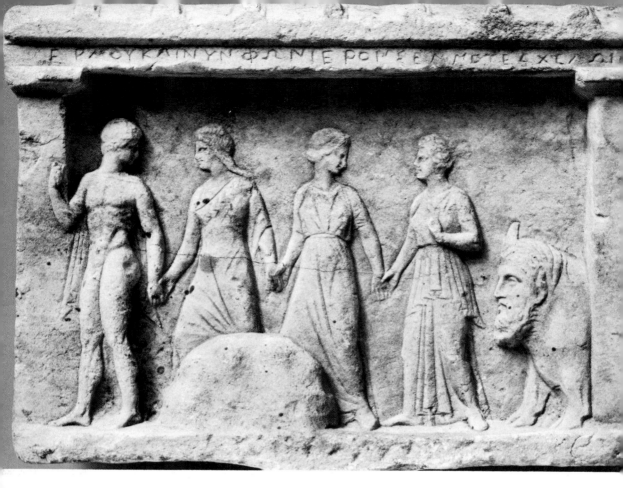

219. Hermes and Nymphs. Votive relief, c. 320–300 B.C. New York, Metropolitan Museum.

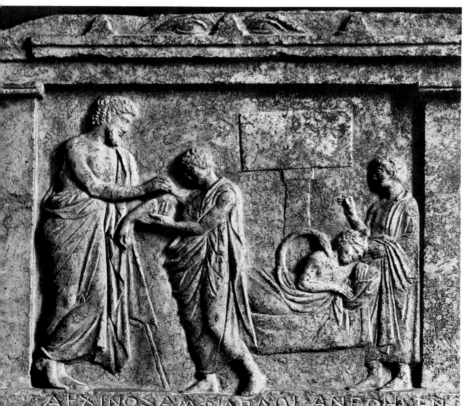

220. Votive relief dedicated to Asklepios, c. 380–350 B.C. Athens, National Museum.

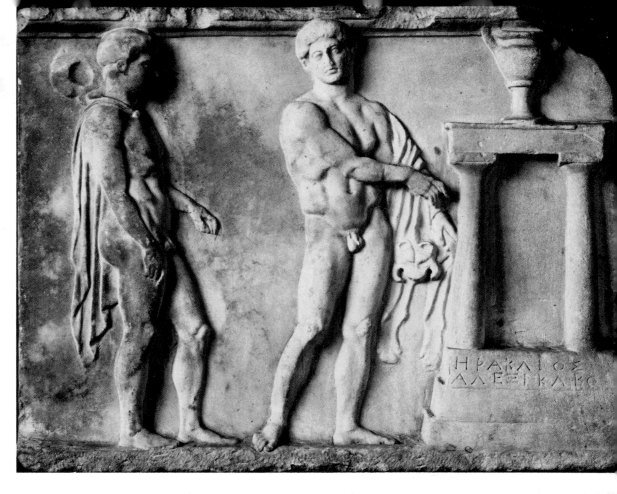

221. Votive relief dedicated to Herakles, c. 400–380 B.C. Boston, Museum of Fine Arts.

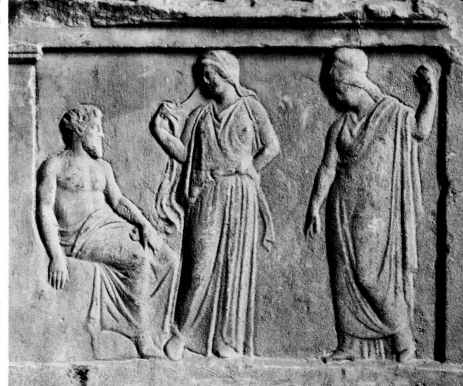

222. Relief commemorating the treaty between Athens and Korkyra, 375–374 B.C. Athens, National Museum.

Besides Attica, Tarentum was an important centre for the production of sepulchral reliefs and statues not in marble but in local limestone.

Another class of reliefs of which many original Greek examples of the fourth century have been preserved is the votive. Like their fifth-century predecessors, they generally show the deity to whom the dedication was made approached by votaries, the latter often considerably smaller, as becomes their humbler status. Sometimes a heroized youth is shown on horseback, singly or with attendants, or a man is seen reclining on a couch, with his wife and perhaps a servant in the offing. Inscriptions give the name of the dedicator and of the hero or deity. A favourite offering, especially in grottoes, was to Pan and Hermes and the Nymphs (fig. 219). Generally Hermes is shown escorting three nymphs clothed in tunics, which are often rendered in an archaizing style (cf. pp. 137 f.). Especially interesting are the reliefs representing some cure, which were presumably dedicated by grateful patients to Asklepios (fig. 220). Fig. 221 shows a relief in Boston, dedicated to Herakles Alexikakos, 'Averter of Evil', of early fourth-century style; in the centre stands Herakles with the lion's skin; to his left is another figure, by some interpreted as Hermes, but perhaps simply the youth who brought the offering.

Important also are a number of so-called record reliefs, erected to commemorate specific events, and therefore precisely dated (cf. p. 133). Over fifty belonging to the fourth century are known, some with well preserved reliefs. Among the finest are those in Athens (fig. 222), commemorating the treaty between Athens and Korkyra in 375–4, and in Copenhagen, erected in honour of Euphyes and Dexios in 329–8.

In the middle of the century may be dated the Sarcophagus of Mourning Women from Sidon in Istanbul. On its sides are eighteen figures, placed between columns, each in an attitude of grief and all different.

HELLENISTIC PERIOD, ABOUT 330–100 B.C. The conquests of Philip and Alexander of Macedon and the principalities created by their successors vastly extended the boundaries of the Greek world and spread Hellenic civilization throughout an Eastern, Hellenistic empire. It was inevitable that this enlargement should bring with it fundamental changes also in art. Many of these changes had, as we saw, been initiated by Lysippos, but they were further developed during the two succeeding centuries. All were in the direction of increased realism—realism in modelling, in movement, in expression, and in the scope of the subjects treated. To represent the variety of planes in the human body, its movement in different contrasting directions, the texture and multiple folds of drapery, human character and emotion, and to reproduce these in a naturalistic manner became the great ambition of artists. This deepened interest in realism showed itself also in the subjects selected. Old age, childhood, deformity, anger, despair, drunkenness, racial differences, though occasionally represented in the preceding periods, were now studied with new insight.

This development was not confined to a few localities. It spread over the whole Hellenistic world. A number of styles can be distinguished. One is the so-called *sfumato* style, with delicate modelling, soft transitions from plane to plane, and serene expressions. It has been associated with Alexandria, where a good many examples of this type have been found. Another, more vigorous, style shows marked contrasts in the various planes, closely knit groups, lively action with frequent contortions, and emotional expressions. It has been called Pergamene, for it is exemplified by the sculptural dedications of the kings of Pergamon. A third, the so-called traditional style, has been thought to be characteristic of the Greek mainland, where the traditions of the past were supposedly firmly rooted, and the old subjects, stances and compositions often retained. Frequently there is a trend toward the picturesque, manifested, for instance, in the introduction of landscape.

Such local designations are convenient as describing familiar, frequently recurring types; but it must be remembered that these styles were by no means confined to Alexandria, Pergamon, and mainland Greece. They are observable all over the Greek Hellenistic world—Asia Minor, the Islands, Greece, Northern Africa, and Southern Italy. Artists then, as before, travelled extensively. They went where their commissions took them, that is, all over the far-flung Hellenistic empire, and when one

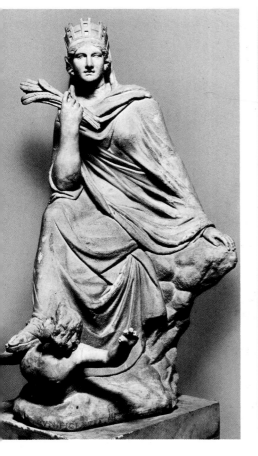

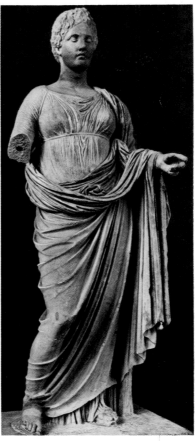

223. The Tyche of Antioch, by Eutychides, after 300 B.C. Roman copy. Vatican Museum. (Right forearm restored, head alien.)

224. Themis, by Chaire-stratos, *c.* 300–250 B.C. Athens, National Museum.

undertaking was finished they went to the next. This circumstance, certified by ancient writers and inscriptional evidence, explains the similarity of styles in sculptures found in different localities. There were, therefore, not, as was once thought, specific schools located in particular regions, but rather various tendencies that characterize Hellenistic sculpture in general.

This is one of the reasons why, in spite of the many Hellenistic sculptures that have survived, it is difficult to trace in them a detailed, consecutive development. In general terms, however, one might say that in the late fourth and the first half of the third century B.C. the classical traditions of the preceding periods were still strong, whereas in the second half of the third and the first half of the second century B.C. a vigorous realism was evolved. Then, from the middle of the second century on, in the wake of the Roman conquests, there was a diminution of strength; originality waned, and artists began to feed more and more on the achievements of their great past.

A few examples, in tentative chronological sequence, may serve to bring out the chief characteristics of Hellenistic art in contrast to those of the preceding periods.

A figure of Tyche or 'Personification' of the city of Antioch by the sculptor Eutychides (mentioned by Pausanias, VI, 2, 6) is preserved in

225. Niobid. *c*. 300 B.C. Roman copy. Rome, Conservatori Museum.

226. Aphrodite, by Doidalsas, *c*. 250–240 B.C. Roman copy. Rome, Terme Museum.

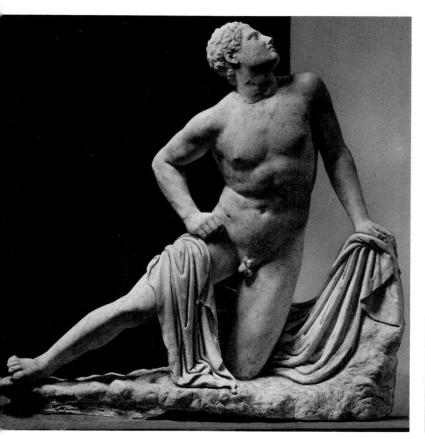

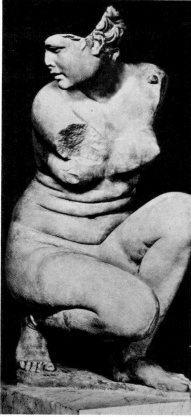

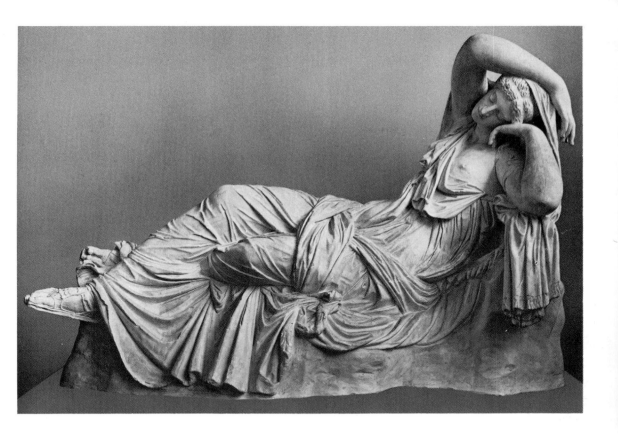

Roman copies (cf. fig. 223) and must date after 300 B.C., the time when
Antioch was founded. She is represented seated on a rock, one foot
resting on the shoulder of a youth, who is shown swimming beneath
her and who personifies the river Orontes. The contrasting directions
of the folds, head, trunk, and limbs in the Tyche give animation to a
seemingly quiet pose.

227. Ariadne, *c*. 240 B.C.
Reconstructed cast. Rome,
Museo dei Gessi.

Also in the first quarter of the third century B.C. must belong the
Themis from Rhamnous (fig 224), signed by Chairestratos, which is
directly derived from fourth-century creations.

The group of Niobids in Florence and elsewhere (cf. fig. 225) was
evidently copied from an original of *c*. 300 B.C., for the influence of
Lysippos is still strong. It must have been composed for hilly ground,
with the figures designed in a variety of postures, in which the frontal
view of the torso predominated.

The statue of 'Aphrodite washing herself', mentioned by Pliny
(XXXV, 35) as a work by Doidalsas of Bithynia, and preserved in many
Roman copies as a Crouching Aphrodite (cf. fig. 226), may be assigned
to the middle of the third century. The lower part of the body and the
legs face in one direction, there is a twist to the body, and the head is
turned sharply to her right.

The Sleeping Ariadne in the Vatican (fig. 227). supplies a reclining
figure of *c*. 240 B.C., and the Nike of Samothrace (*c*. 200 B.C.), standing

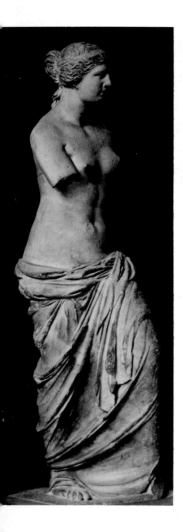

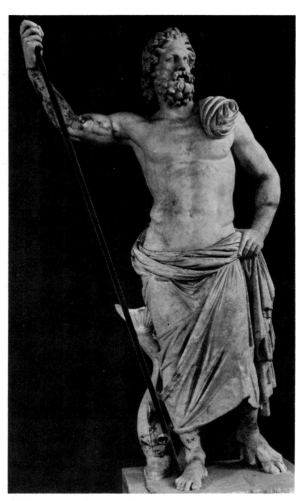

on the prow of a ship, with her drapery swept backward by the wind, is the embodiment of triumph in victory (fig. 230).

With the statue of Poseidon, found in the island of Melos and now in Athens, we reach late Hellenistic art (fig. 229). The different directions given to the various parts of the body and the strong contrasts in the folds of the drapery impart a restless impression to what at first sight appears a stationary stance. Likewise the famous Aphrodite of Melos in the Louvre (cf. fig. 228), in spite of her statuesque pose, conveys a feeling of movement through the different directions of torso and limbs and the variegated folds of the drapery.

If we compare these statues with those in the same stances in the earlier periods, the different conception of the Hellenistic artist becomes evident. An animated, sometimes almost theatrical, quality has taken the place of the former serenity. The contrast is even more marked in the larger compositions, especially when stress of combat or suffering are represented. Foremost among these are the Pergamene sculptures. They consist of: (1) the over-life-size statues of a Dying Gaul in the Capitoline

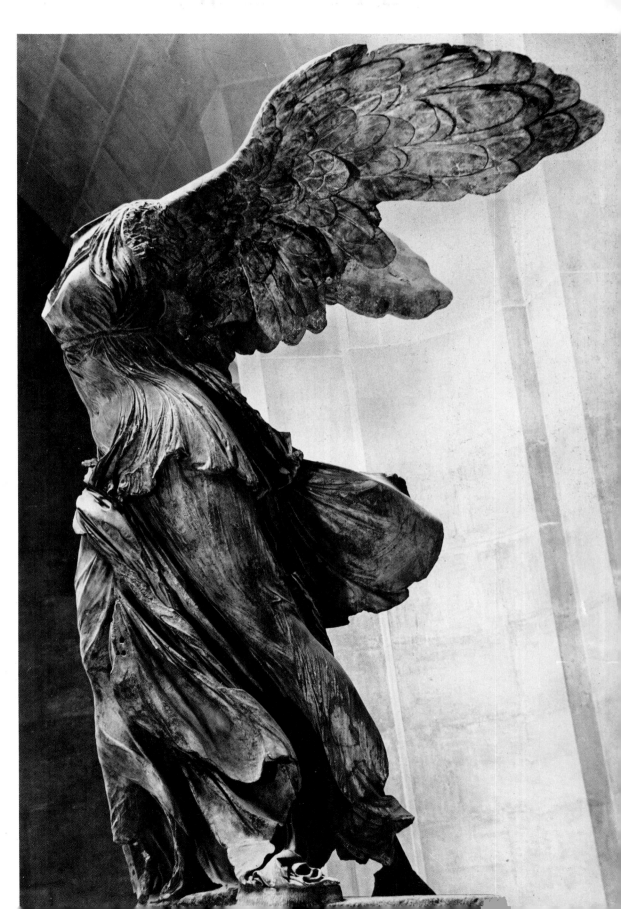

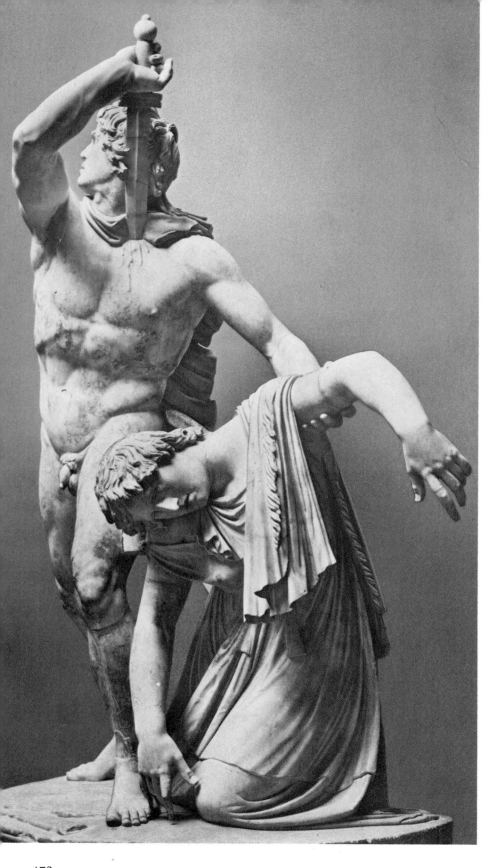

231. Gaul killing himself and his wife, *c.* 240–200 B.C. Roman copy. Rome, Terme Museum.

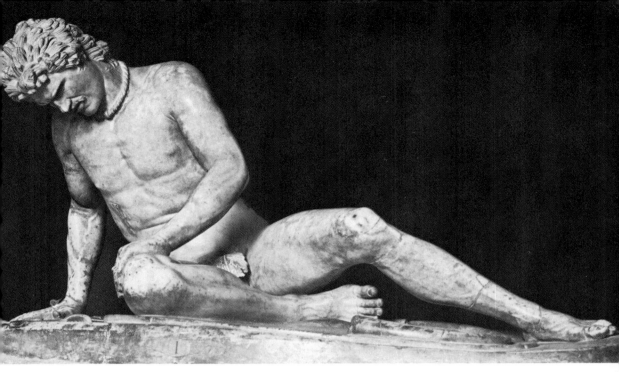

232. Dying Gaul, *c.* 240–200 B.C. Roman copy. Rome, Capitoline Museum.

233. Gaul, *c.* 200 B.C. Roman copy. Naples, Museo Nazionale.

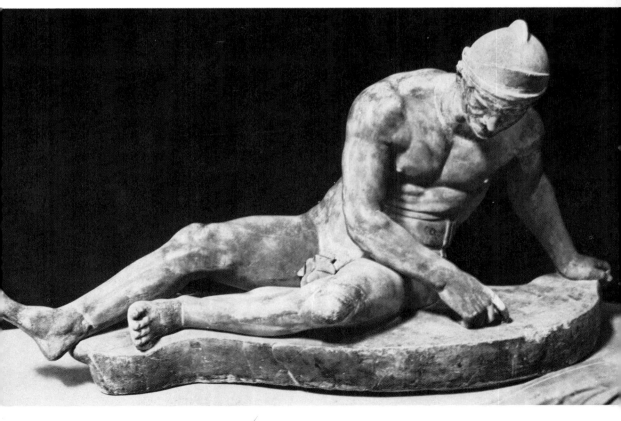

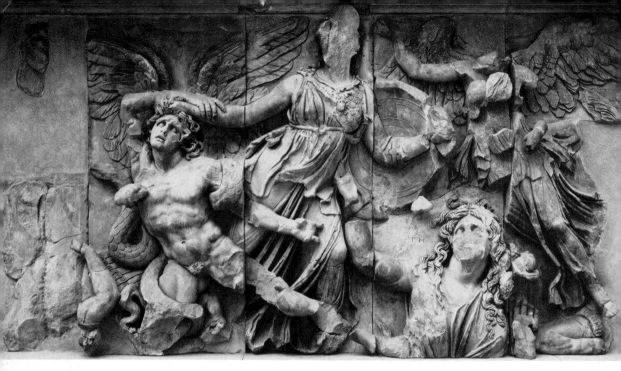

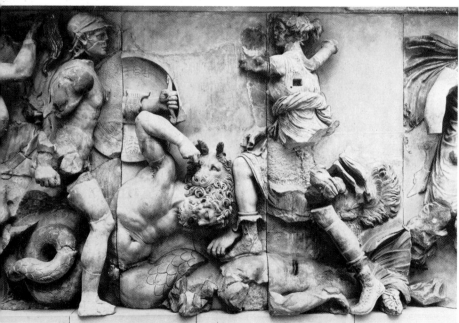

234–235. Fight between gods and giants. From the frieze of the altar of Zeus and Athena at Pergamon, c. 180–150 B.C. Berlin, Museum.

236. Laokoon, by Hagesandros, Polydoros and Athanodoros, c. 175–150 B.C. Vatican Museum.

Museum (fig. 232) and of a Gaul killing himself and his wife in the Terme Museum (fig. 231), which have been identified as copies of the bronze groups dedicated by Attalos I of Pergamon (241–197 B.C.) after his victories over the Gauls; (2) the marble statues, two-thirds life-size, in various Museums, of Gauls (cf. fig. 233), Amazons, Persians, and giants, which reproduce in all probability the bronze figures set up by the same Attalos on the Akropolis of Athens in 200 B.C.; and, above all, (3) the

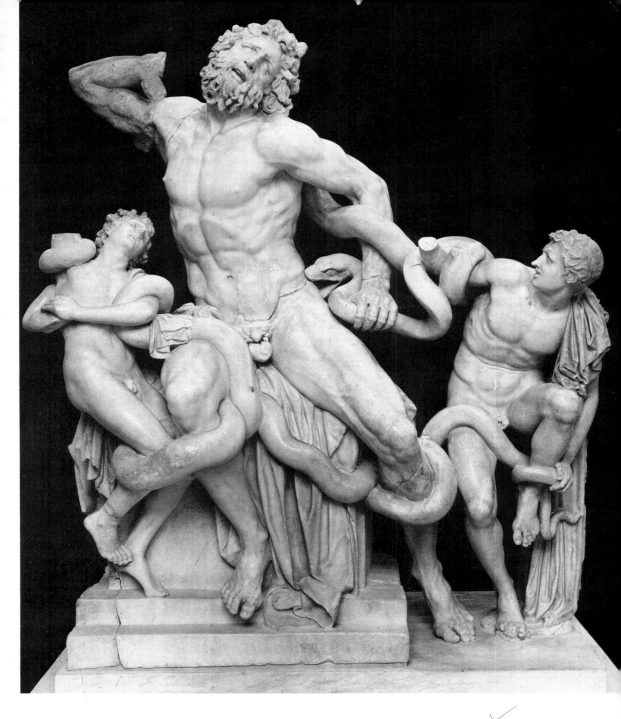

stupendous frieze of gods fighting giants (cf. figs. 234, 235) from the
Altar of Zeus and Athena at Pergamon (cf. p. 40), built probably by
Eumenes II (197–159 B.C.). They form the climax of Greek realistic
representations—in modelling, composition, and expression of emotion.

Closely allied to these great Pergamene creations are powerful statues
from other localities—the half-reclining Satyr in Munich, shown in the
complete abandonment of sleep, the Laokoon in the Vatican[22] (fig. 236),

237. The 'Belvedere Torso', by Apollonios, *c*. 150 B.C. Roman copy. Vatican Museum.

writing in an agony of pain, the comparable statues from Sperlonga (cf. fig. 239), the Belvedere Torso in the Vatican (fig. 237), the two Centaurs in the Capitoline Museum (cf. fig. 240), and the 'Gladiator' in the Louvre. All have the swelling muscles and restless poses favoured in late Hellenistic art.

The variety of subjects attempted in this period is almost endless. Dancing satyrs, old fishermen, old market women, sleeping children and Erotes (cf. fig. 238), a hanging Marsyas, a jockey on his horse (fig. 241), wrestlers, all appear in life-size statues, as well as in statuettes and in relief (cf. p. 203).

It is natural that this age of heightened individualism was distinguished also for its portraits. Outstanding early examples are those of Ptolemy I (305–284 B.C.), preserved on Hellenistic coins (cf. p. 260) and in Roman marble heads; the statue of Demosthenes, shown standing with clasped hands (cf. fig. 243), of which the Greek prototype may be attributed to Polyeuktos of Athens and dated about 280 B.C.; and a seated Epikouros (about 270 B.C.), which can be reconstructed from the surviving heads (cf. fig. 244) and torsos. A seated figure of Chrysippos (reconstructed in the Louvre, cf. fig. 242), which evidently reproduces the statue by

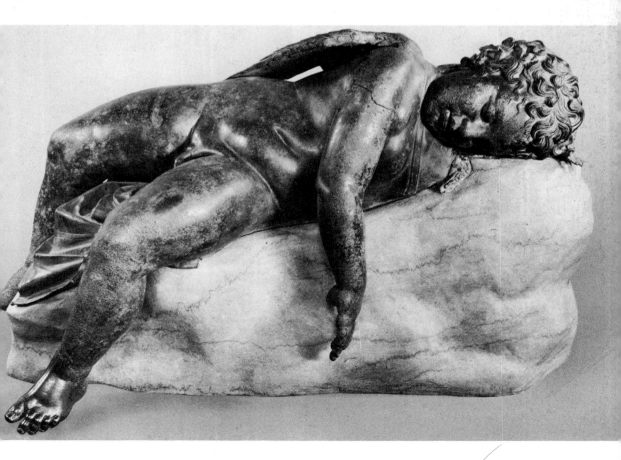

238. Eros, *c.* 240–200 B.C. Greek original (?). New York, Metropolitan Museum.

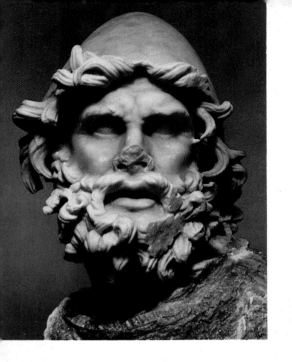

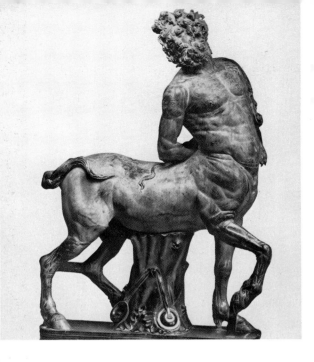

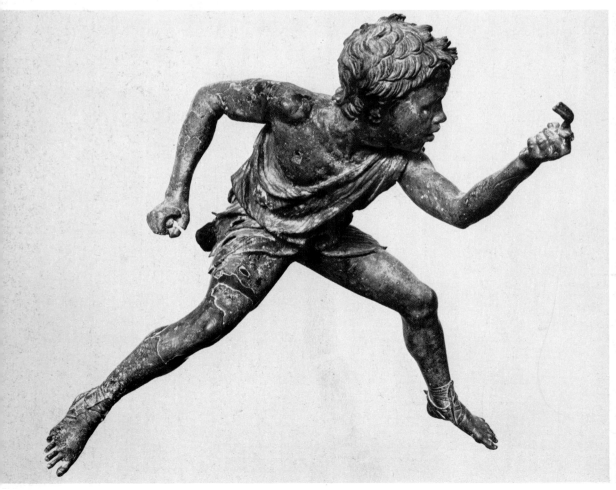

239. Head from Sperlonga, *c.* 175–150 B.C. Sperlonga, Museum.

240. Centaur, *c.* 150 B.C. Roman copy. Rome, Capitoline Museum.

241. Jockey, *c.* 240–200 B.C. Athens, National Museum.

243. Portrait of Demosthenes, attributed to ▶ Polyeuktos, *c.* 280 B.C. Roman copy. Copenhagen.

242. Portrait of Chrysippos, by Euboulides (?), *c.* 200 B.C. Reconstructed Roman copy. Paris, Louvre.

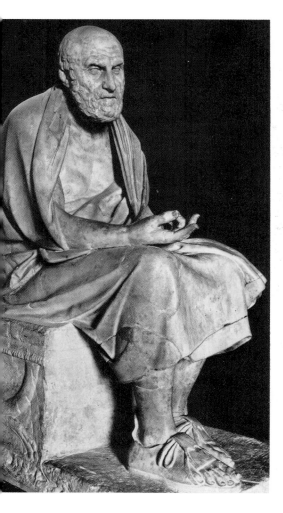

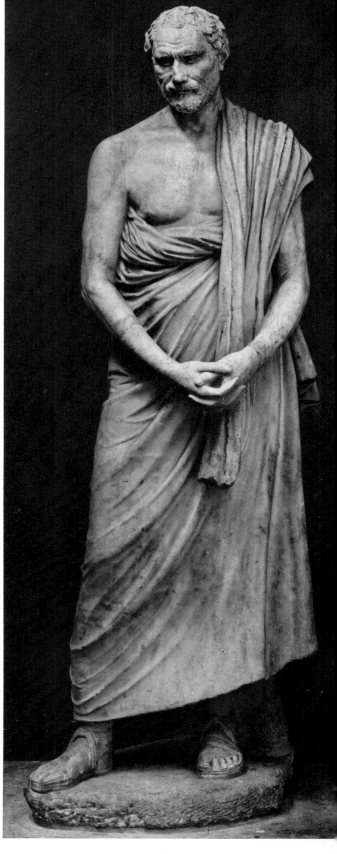

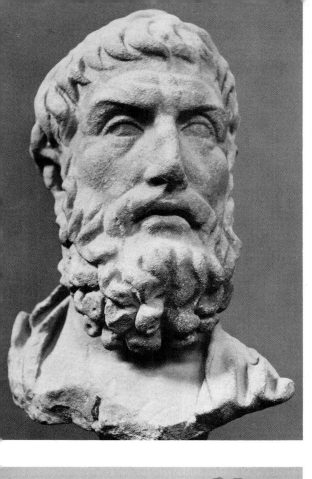

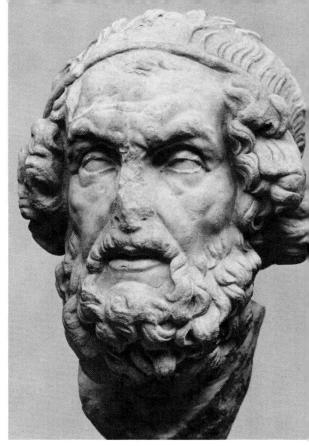

244. Portrait of Epikouros, *c.* 270 B.C. Roman copy. Rome, Barracco Museum.

245. Homer, *c.* 150 B.C. Roman copy. Boston, Museum of Fine Arts.

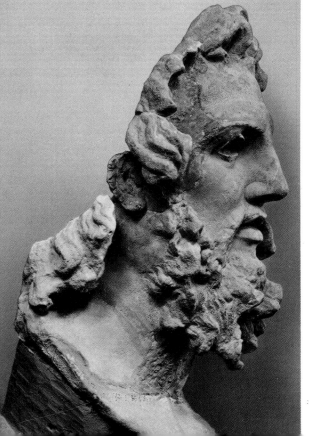

246. Anytos, by Damophon, from the Temple at Lykosoura, *c.* 180–140 B.C. Athens, National Museum.

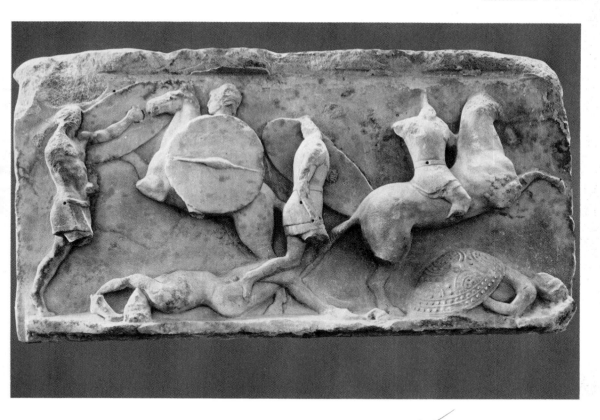

Euboulides erected shortly after the philosopher's death in 206 B.C. (cf. Pliny xxxiv, 88), illustrates the heightened realism of that time. The final stage was reached in the blind Homer (fig. 245), stylistically connected with the Pergamene Altar, in a head identified as Euthydemos I of Bactria from its similarity to the coin types, and in the pseudo-Seneca which survives in many Roman copies.

247. Fight between Romans and Macedonians. Base of a statue of Aemilius Paulus at Delphi, *c.* 167 B.C.

Several important monuments datable in the first half of the second century B.C. further enlarge our knowledge of late Hellenistic art. One is the colossal group of Demeter, Despoina, Artemis, and the giant Anytos (cf. fig. 246), made for the sanctuary of Despoina at Lykosoura by Damophon, the same Damophon who repaired the ivory plaques of the Pheidian Zeus at Olympia (Paus. IV, 31, 6). Another is a sculptured base at Delphi (fig. 247), which Aemilius Paulus erected after his victory at Pydna (167 B.C.) for a statue of himself; it shows Romans fighting Macedonians in a spirited style. The friezes from the temple of Hekate at Lagina in Asia Minor, and of the temple of Artemis Leukophryene at Magnesia also belong to the second century (cf. p. 39); in both, earlier motifs are utilized in new, somewhat stilted compositions. A relief in the British Museum, representing the Apotheosis of Homer (fig. 248) and signed by Archelaos of Priene, is now dated *c.* 220–170 B.C.

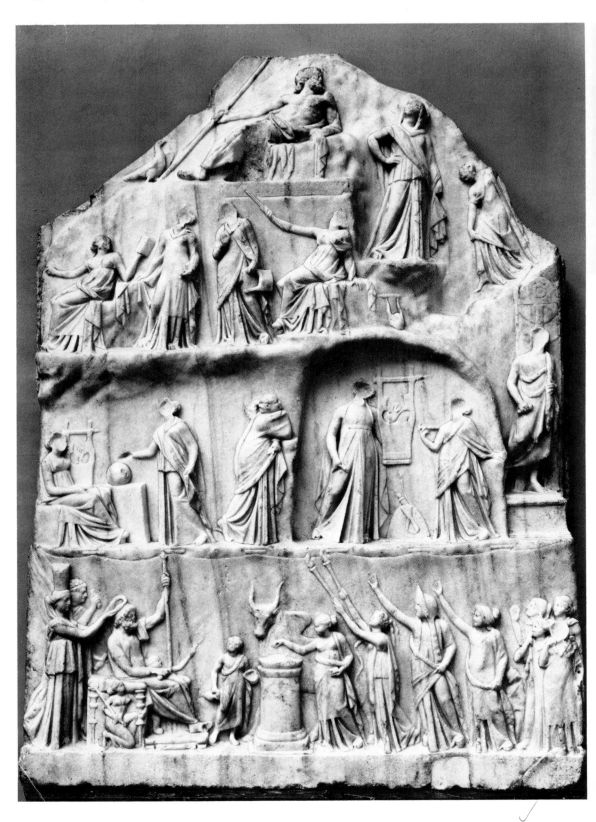

248. The Apotheosis of Homer, by Archelaos of Priene, third to second century B.C. London, British Museum.

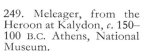

249. Meleager, from the Heroon at Kalydon, *c.* 150–100 B.C. Athens, National Museum.

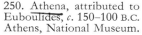

250. Athena, attributed to Euboulides, *c.* 150–100 B.C. Athens, National Museum.

In the second century B.C. began the copying of former masterpieces. Outstanding examples are the Athena Parthenos found at Pergamon and the medallions from the Heroon of Kalydon, which include busts of the well-known types of the fourth-century Meleager (fig. 249) and of the Herakles Farnese. A head of Athena (fig. 250), attributed to the sculptor Euboulides, harks back to the Athena Velletri of the fourth century B.C. The torso of a portrait statue from Delos, representing the Roman magistrate Gaios Ophellios (fig. 251) and signed by Dionysios and Timarchides of Athens, recalls the Hermes of Praxiteles. These same artists, according to Pausanias (X, 34, 7), made a copy of the shield of Pheidias' Athena Parthenos for Elateia. Philiskos of Rhodes, who made a group of Muses, later exhibited in Rome (Pliny, XXXV, 34), and whose signature survives on a base from Thasos,[23] also evidently utilized former creations.

All these sculptures, however, are free copies which only approximate their prototypes. It was not until the very end of the second or the beginning of the first century B.C. that, stimulated by the widespread Roman demand for famous Greek sculptures, mechanical copying by the pointing process was introduced (a process still in use today). From a cast of a Greek statue or relief many marble copies could be made with considerable accuracy by transferring points from cast to marble block. Greek artists, in the service of Rome, produced such copies in vast numbers for the adornment of public places and private houses. It is possible that Pasiteles and Arkesilaos, two sculptors mentioned by Pliny (XXXIII, 130, 156, etc.) as prominent in the first century B.C., invented or at least popularized this process. A new era in sculptural art was thereby introduced.

251. Portrait of Gaios Ophellios, by Dionysios and Timarchides, *c.* 100 B.C. Delos, Museum.

Even more accurate than such marble reproductions were those in bronze, for they could be cast directly from moulds taken from the original statues, and their forms were, therefore, identical with those of the originals. No final 'modelling' of the surface by the master sculptor was needed, only the chasing of locks and other details. That is why statues in bronze of the Roman Age are sometimes difficult to distinguish from Greek originals.

In cases when no cast or mould could be taken of the original statue or relief, in chryselephantine statues for instance, or when a piece of sculpture was inaccessible (as in the Nike parapet), the copying had to be made freehand. It then became a mere adaptation. The same applies to the many reproductions of Greek sculptures, sometimes in reduced scale, that became parts of new compositions on marble vases, funerary altars, candelabra, and sarcophagi.

Whatever one may think of these reproductions—and they vary in quality, some being mediocre, others excellent, depending on the final finish imparted by the sculptor—it is well to remember that, were it not for these copies and adaptations, our knowledge of Greek sculpture would be meagre indeed; for the majority of Greek originals, be they of marble or bronze, have disappeared in the lime kiln and melting pot.

STATUETTES AND SMALL RELIEFS

(Exclusive of Terra Cottas)

Greek statuettes and small reliefs do not merely repeat the story of the large sculptures on a smaller scale. They form a separate branch of Greek art. Their uses were different from those of the larger works, for they were often parts of complex ensembles and were designed with these ends in view. Moreover, their small dimensions, which enable one to hold and turn them round in one's hands, make for intimate relationship. Hence they are among the most popular products of Greek art.

As in substantive sculpture, so in these statuettes and small reliefs, the Greeks used a variety of materials. In addition to stone (marble, lime-stone, and alabaster) and metal (gold, silver, bronze, lead, and iron), they employed ivory, bone, amber, wax, wood, and especially terra cotta. (The terra cottas, being so numerous, will be discussed in a separate chapter.) On account of the perishable or precious nature of some of these materials, relatively few specimens have survived. Only bronze statuettes have been preserved in any quantity. Their small dimensions and the fact that many were buried in antiquity saved them from being melted down, as were the bronze statues. Lead was used for cheap dedications, especially in early times—to judge by the many small, stamped figures found in the sanctuary of Artemis Orthia at Sparta; but their unattractive surface and the softness of the metal prevented any widespread use.

This account, therefore, will deal chiefly with bronzes; but small sculptural works in other materials will occasionally be mentioned to prevent giving a one-sided picture of the original output.

Many of the bronze statuettes extant today once served as decorative features on tripods, and as handles, feet, and ornaments on vases, mirrors, and other utensils. Some were dedicated in sanctuaries, and these occasionally have inscriptions giving the name of the deity to whom the offering was made and of the dedicator. The bases were either cast in one piece with the statuettes, or the feet of the figure were provided with tangs and inserted into a separate base.

The consistency of the metal varies from almost pure copper in the earliest periods to a mixture of copper and tin, generally with the addition of some impurities. A few of the earlier examples were hammered in

separate sheets and fastened together on a wooden core. The large majority, however, were cast solid, not hollow, for the material saved by that process was not sufficient to compensate for the additional labour entailed.

Bronze statuettes of every period have survived in considerable quantity and so present a continuous picture of the evolution of Greek sculptural art. In the following account only a few outstanding examples, in chronological sequence, can be mentioned, enough, however, to show the high quality of some of the output.

GEOMETRIC PERIOD, NINTH TO EIGHTH CENTURY B.C.
Many bronze statuettes and small reliefs of the geometric period antedate the extant statues by a century or two, and so illustrate Greek sculptural work in its earliest phase. They are cast solid and consist chiefly of the human and animal figures—horses, oxen, deer, birds, etc.— that once decorated the rims, handles, legs, and feet of tripods and vases. Some have designs under their bases, and were evidently used as seals[1]; others have holes or loops for suspension and must have been dedicatory offerings in sanctuaries. Occasionally, especially towards the end of the eighth century, a figure in action or a group was attempted. Attacking warriors and charioteers have come from the Akropolis of Athens, from Olympia (cf. fig. 253), and elsewhere; statuettes of a helmetmaker (fig. 252) and of a man with a centaur are in New York; a man stretching his bow is in Würzburg; and so on.

In all these figures the forms are generalized and little attention is paid to anatomical structure. The effect depended on a flowing contour and the design as a whole. Today, when simplified forms are again appreciated, these little ornaments have a special appeal.

In a tomb in Athens there came to light remains of several ivory statuettes, together with pottery datable, it is thought, 750 B.C. or later. They represent nude female figures in stiff, erect poses, with hands held against the thighs. The forms are more rounded than in the contemporary bronze figures, and presage the later, Orientalizing sculptures.

SEVENTH CENTURY B.C.
The generalized statuettes of the geometric age were followed during the seventh century by more formalized renderings in which an interest in anatomical structure is evident. An example of about 700 B.C., now in Boston, represents a standing youth in the attitude of the early kouros (fig. 254); it bears the inscription 'Mantiklos dedicated me to the Far-Darter of the silver bow, as part of his tithe, do thou, Phoebos, grant him gracious recompense'. The various parts of the figure are accentuated, the thighs bulge from the waist, the shoulders protrude, the thorax has expanded. To the early seventh century may be assigned several statuettes of warriors in an attitude of attack, from Olympia. The stance is still rigid, but the forms are less angular.

A large statuette from Dreros, Crete (fig. 255), of about 650 B.C. shows a slightly more advanced stage with even an attempt to render

252. Helmetmaker. Bronze statu-
ette, eighth century B.C. New
York, Metropolitan Museum.

253. Charioteer. Bronze statuette
from Olympia, eighth century B.C.
Athens, National Museum.

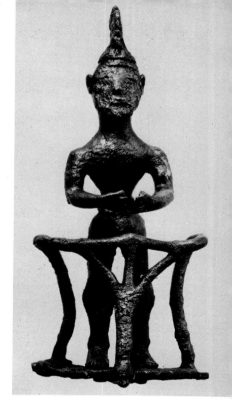

254. Bronze statuette of a youth,
c. 700–680 B.C. Boston, Museum of
Fine Arts.

255. Kouros. Bronze statuette
from Dreros, *c.* 650 B.C. Heraklion,
Museum.

256. Youth carrying a ram. Bronze
statuette from Crete, *c.* 640–610
B.C. Berlin, Museum.

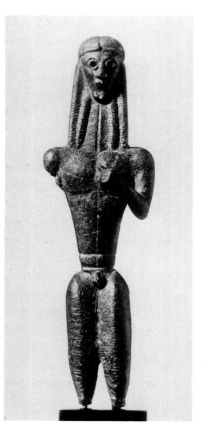

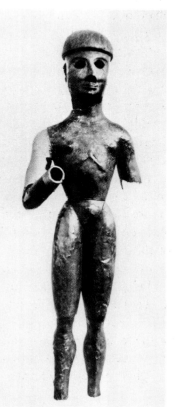

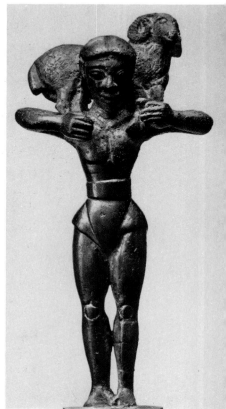

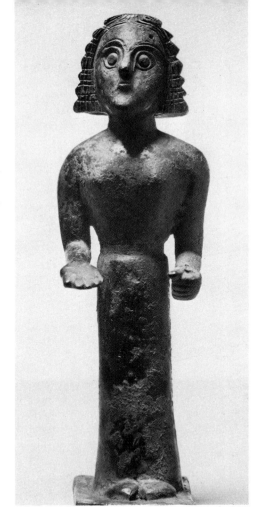

257. Bronze statuette of a girl, *c.* 650 B.C. Baltimore, Walters Art Gallery.

muscles and bones. A youth carrying a ram, found in Crete and now in Berlin (fig. 256), illustrates the stage reached in the stone kouroi of the later seventh century B.C. (cf. figs. 53–56), except that in the bronze statuettes the action of the arms is freer.

As female counterparts of these male figures may be cited a statuette in Baltimore (fig. 257), the two female statuettes found with the Dreros youth, fig. 255, and the marble karyatids supporting vessels (cf. fig. 258) discovered at Olympia, Isthmia and elsewhere. They are reduced versions of the statues shown in figs. 57 and 58. A little later, early in the sixth century, should come the earliest of the statuettes found in a deposit beneath the floor of Croesus' temple (fig. 259).

These statuettes are all cast solid, except those from Dreros, which are worked in the so-called *sphyrelaton* technique, in which hammered plates of bronze are nailed to a wooden core. Though it is now known from actual examples that hollow casting was introduced fairly early in the seventh century (cf. fig. 296), solid casting was continued for large statuettes, as shown, for instance, by a bird (fig. 260) and lion from Perachora, and a horse from Olympia (the last cast in several pieces).

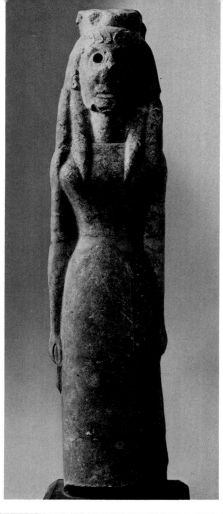

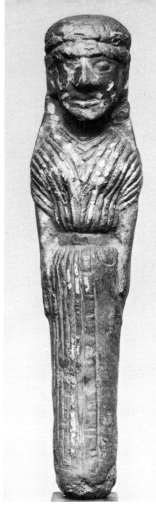

258. Marble karyatid from Olympia, c. 640–620 B.C. Olympia, Museum.

259. Bronze statuette of a girl, from Ephesos, c. 600–580 B.C. Istanbul, Museum.

260. Bronze figure of a bird from Perachora, c. 620–600 B.C. Athens, National Museum.

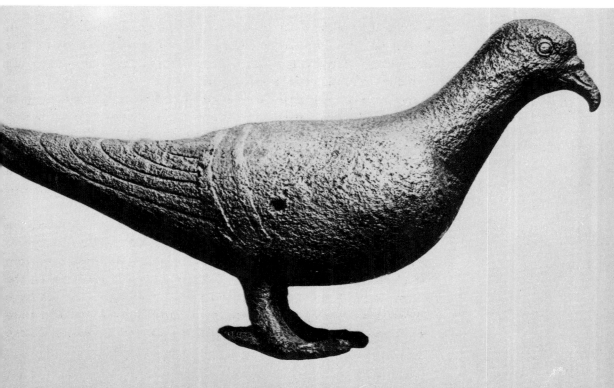

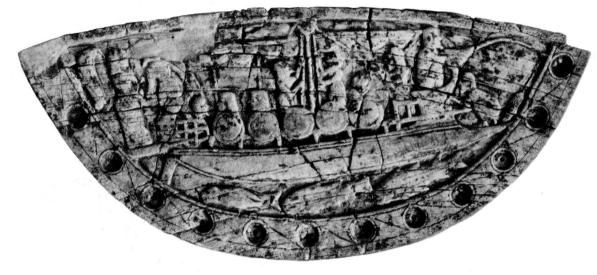

261. Warship. Ivory relief from Sparta, late seventh century B.C. Athens, National Museum.

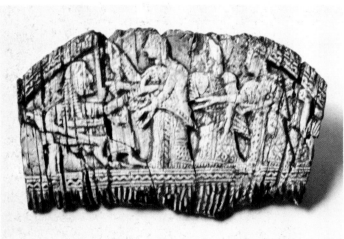

262. The Judgment of Paris. Ivory comb from Sparta, late seventh century B.C. Athens, National Museum.

In addition to these bronze examples, figures in other materials have been discovered. Many ivory statuettes and reliefs dating from the late eighth and the seventh century B.C. have come to light in the sanctuary of Artemis Orthia in Sparta. Especially noteworthy are two vivacious reliefs, one depicting a warship about to depart (fig. 261), the other, on a comb, the Judgment of Paris (fig. 262) (late seventh century).

An ivory plaque with two female figures in relief, now in New York, once perhaps decorated a chest,[2] for there are two holes for rivets. The style points to the third quarter of the seventh century.

A remarkable group in wood of perhaps around 625 to 600 B.C. has been found in Samos (fig. 263). It shows Zeus and Hera with arms intertwined in the manner of Dermys and Kittylos (cf. p. 58). Unfortunately the wood has disintegrated, so only illustrations now exist. There remains, however, a small head of a kouros, of the end of the

264. Kouros. Bronze statuette from Samos, early sixth century B.C. Vathy, Museum.

265. Kouros. Bronze statuette from the Akropolis, late sixth century B.C. Athens, National Museum.

266. Hermes. Bronze statuette, late sixth century B.C. Boston, Museum of Fine Arts.

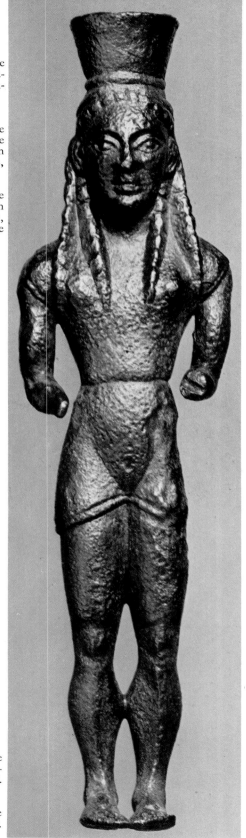

268. Bronze statuette of a girl, from Samos, c. 575–550 B.C. Vathy, Museum.

269. Bronze statuette of a girl, c. 540 B.C. Berlin, Museum.

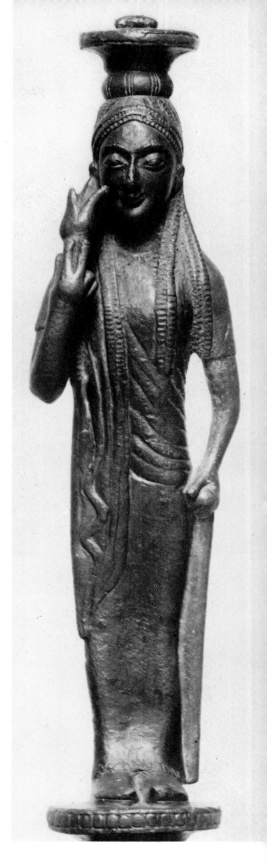

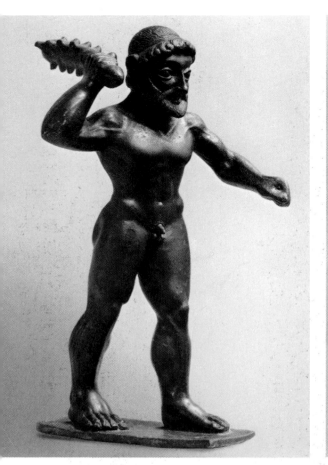
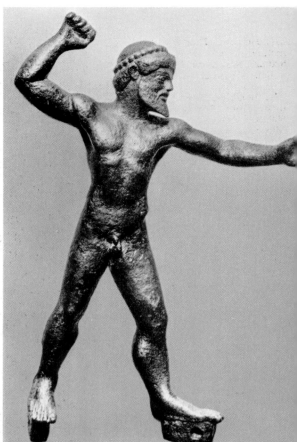
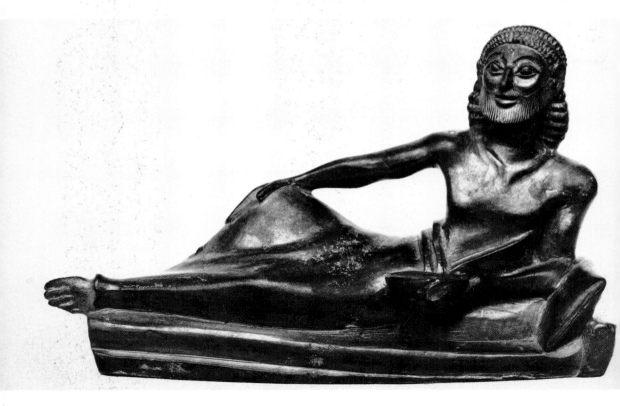

270. Herakles. Bronze statuette from Arcadia, *c.* 530–520 B.C. New York, Metropolitan Museum.

271. Herakles. Bronze statuette from Perachora, *c.* 500 B.C. Athens, National Museum.

272. Banqueter. Bronze statuette from Dodona (?), *c.* 530 B.C. London, British Museum.

273. Lady holding ewer and basin. Ivory statuette from Ephesos, before 550 B.C. Istanbul, Museum.

274. Wooden statuette from Klazomenai, *c.* 600–550 B.C. Munich, Antiquarium.

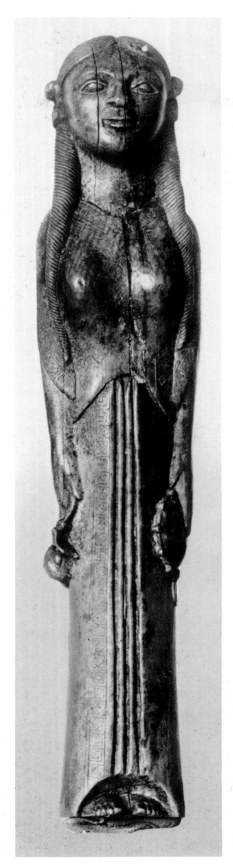

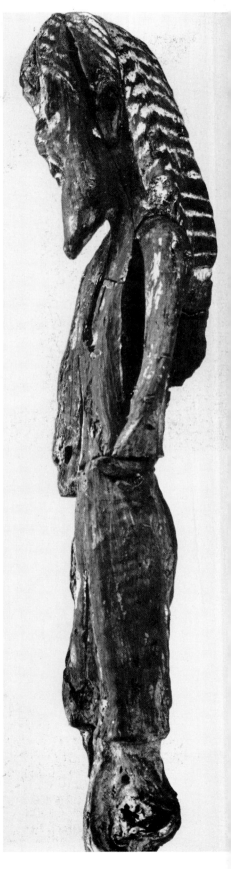

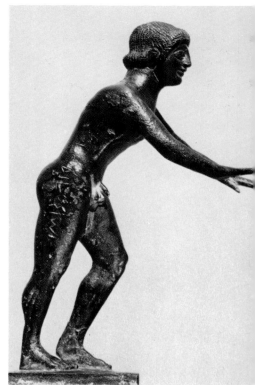

The statuette of a banqueter (fig. 272), a recent acquisition of the British Museum, shows a figure in the conventional attitude of half reclining—legs outstretched, trunk erect, head turned—beautifully stylized and yet singularly alive. A similar example, less carefully executed, is in the National Museum, Athens (no. 16353).

There are a few exceedingly instructive instances of archaic wooden statuettes of this period. At Palma di Montechiaro in Sicily, for instance, were found three female statuettes in that material, one perhaps still of the seventh century (cf. p. 190), the two others of the first half of the sixth. They stand erect, in stiff attitudes, each wearing a long tunic and a headdress. The missing forearms were extended and doubtless held offerings; they were made in separate pieces and attached with tenons. Traces of paint remain. Another wooden statuette of about this time has been found at Klazomenai (fig. 274). These wooden survivors (cf. p. 54) bring to mind the extensive use of this material for sculpture—in antiquity as nowadays.

Ivory statuettes were found in a deposit beneath the floor of Croesus' temple at Ephesos (cf. p. 188). The most attractive is a little lady holding a ewer and a basin, full of Eastern grace and suavity (fig. 273).

Another interesting series of ivory figures have come from Samos. A relief of the early sixth century shows Perseus cutting off the head of Medusa (fig. 275). The Medusa recalls the Gorgon of the pediment of Korkyra, and the Perseus the Chrysaor of the same pediment (cf. fig. 62).

275. Perseus and Medusa. Ivory relief from Samos, early sixth century B.C. Athens, National Museum.

276. Runner. Bronze statuette from Olympia, early fifth century B.C. Olympia, Museum.

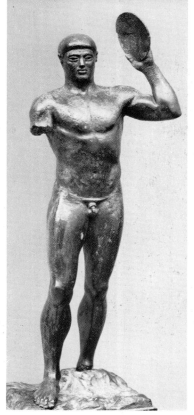

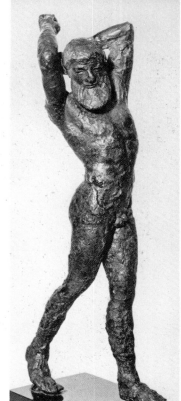

277. Discus-thrower. Bronze statuette, early fifth century B.C. New York, Metropolitan Museum.

278. 'Hephaistos'. Bronze statuette, c. 460 B.C. Washington, Dumbarton Oaks.

The discovery of a treasure trove at Delphi has supplied a mass of dainty ivory figures. Many were evidently used as inlays, perhaps on wooden thrones. Others were parts of statues (cf. p. 54). The style suggests Greek workmanship around the middle of the sixth century.

A number of limestone and alabaster statuettes assignable to *c.* 600–540 B.C. have come to light on the sites of early sanctuaries at Naukratis, Rhodes, Knidos, etc. They represent male and female figures, standing and seated, some holding offerings. Their purpose was evidently votive.

Small amber statuettes and groups have been found in Etruria. Two, in late archaic Greek style—a woman carrying a child, and Aphrodite with Adonis—are in New York.[4] Many others are in the Museo Preistorico in Rome. Several specially fine examples, from Sala Casalina, are in the Petit Palais in Paris.

The art of the early fifth century is well illustrated in a bronze statuette FIRST HALF of a striding Herakles in the Benaki Museum[5] and in a dainty runner OF THE FIFTH in Olympia (fig. 276), inscribed: 'I belong to Zeus'. As in the approxi- CENTURY B.C. mately contemporary pedimental sculptures from Aegina, the forward motion is no longer suggested by a half-kneeling stance, but is expressed in a naturalistic manner. To about the same epoch belongs the splendid athlete, in New York (fig. 277), raising his discus above his head, preparatory for the throw. The bronze statuette of a youth holding his right hand to his lips, in an attitude of prayer,[6] also in New York, may be assigned to about 470 B.C. In its quiet dignity it heralds the

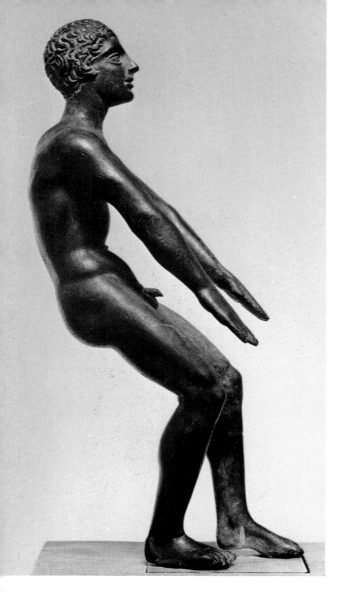

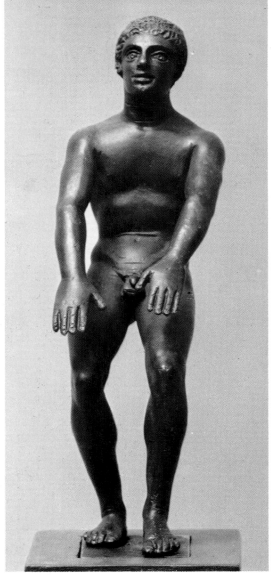

279. Bronze statuette of a youth, *c.* 450 B.C. New York, Metropolitan Museum.

classical style. The 'Hephaistos' statuette in Dumbarton Oaks (fig. 278) is a splendid example of a striding figure of around 460 B.C.

A large statuette of a horse, about 8¾ in. high (cf. fig. 280, is also a product of this period; it once formed part of a chariot group dedicated at Olympia. A little later, perhaps around 450 B.C., should come a statuette of a youth, apparently finishing a jump (fig. 279). The momentary pose recalls the works of Myron and his circle. Two statuettes of goats in the British Museum (cf. fig. 281) are likewise products of the first half of the fifth century—a period famed for its animal sculpture in ancient times.

A series of draped female figures standing in quiet poses belong to the second quarter of the fifth century. They are clothed in the heavy woollen peplos, arranged in a few folds, all seemingly alike, but in reality infinitely varied. Many acted as supports of standing mirrors

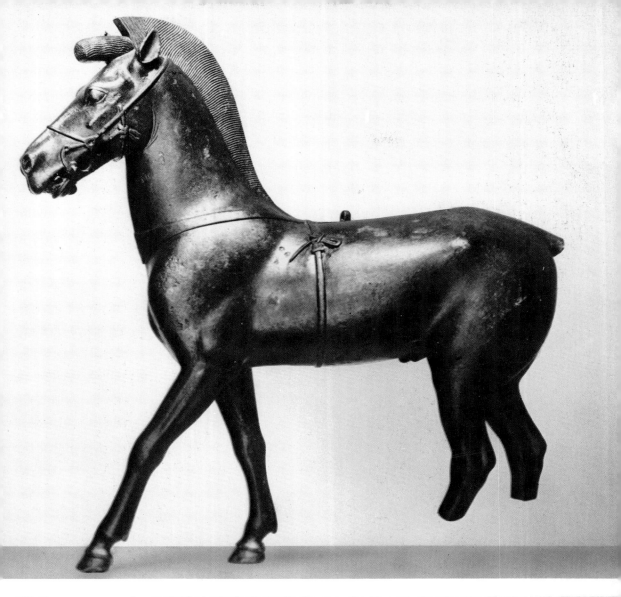

280. Bronze statuette of a horse from Olympia, *c.* 470–460 B.C. Olympia, Museum.

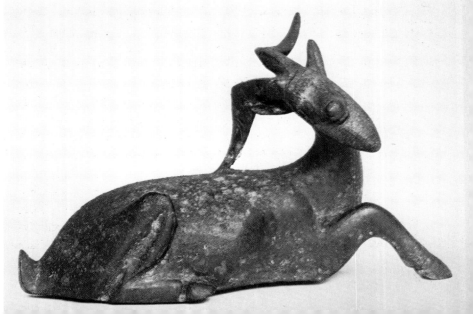

281. Bronze statuette of a goat, *c.* 500–450 B.C. London, British Museum.

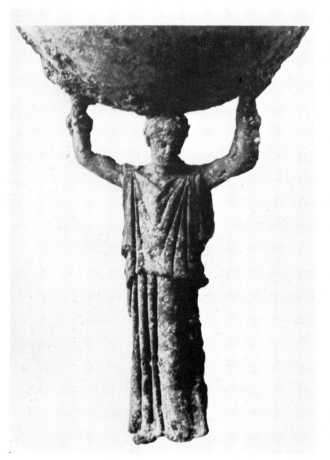

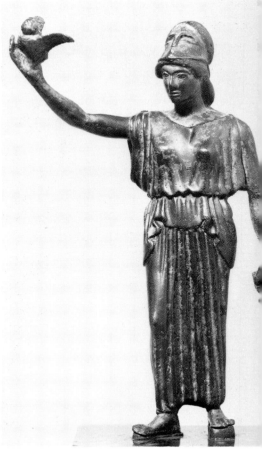

(cf. p. 221), or of incense burners (cf. fig. 282), or formed parts of utensils; others, for instance the Athena of the Elgin Collection in New York (fig. 283), and the 'spinning' girl in Berlin (now interpreted as in the attitude of an adorans in the act of sacrificing)[7] were apparently made as single statuettes. Their style approximates that of the pedimental figures from the temple of Zeus at Olympia (cf. p. 108).

ABOUT 450−330 B.C. Comparatively few Greek bronze statuettes of the classical period, that is, of the second half of the fifth and of the fourth century B.C., have been preserved. As conspicuous examples may be cited two youths, in the Louvre (fig. 285) and in Athens, shown standing in the attitude favoured by Polykleitos, with the weight resting on the right leg and the left flexed. Polykleitan influence is seen also in the precise demarcation of the various planes and in the interrelation of the parts to the whole. A large statuette of Herakles, also in the Louvre (fig. 284), a reproduction of the Lysippian Herakles (cf. p. 153), illustrates the change in conception a century or so later. Stance and modelling are closer to nature, but something of the earlier grandeur is lost.

282. Bronze incense burner from Delphi, *c.* 475–450 B.C. Delphi Museum.

283. Bronze statuette of Athena, *c.* 475–450 B.C. New York, Metropolitan Museum.

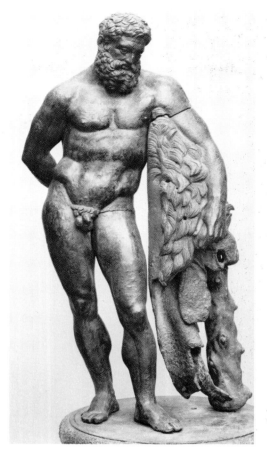

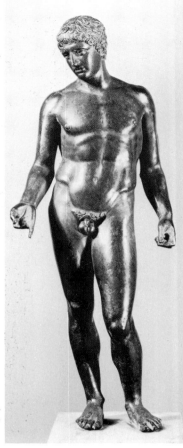

284. Bronze statuette of Herakles, *c.* 325 B.C. Roman copy. Paris, Louvre.

285. Bronze statuette of a youth, *c.* 450–440 B.C. Paris, Louvre.

A large statuette of a nude girl, from Beroea in Macedonia and now in Munich, has relatively severe forms and must still date from the fifth century. On the other hand, the so-called Pourtalès Aphrodite in London[8] and the Haviland Aphrodite (fig. 286) in New York (named after their former owners) illustrate the Praxitelean style in its full development. Here too the change from fifth-century monumentality to fourth-century grace is clearly shown.

The statuette of a cow in Paris[9] is an outstanding example of animal sculpture belonging to this time. It recalls the praises bestowed by ancient writers on the cow that stood on the Akropolis in Athens and which, according to Pausanias, 'appeared to have breath inside her and seemed about to bellow'. But in addition to naturalism the figure has a monumental quality. The same applies to the deer from Sybaris in the Louvre, standing as if listening.[10]

Lastly—though not strictly a sculptural work—may be cited a superb engraving on ivory of a charioteer, found in South Russia.[11] It is of late-fifth-century style, comparable to the metal engravings of that time.

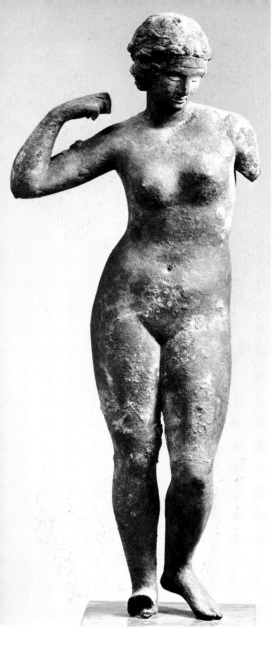

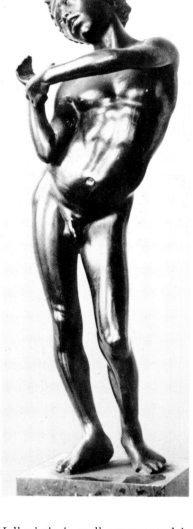

286. Bronze statuette of
Aphrodite, fourth century
B.C. New York, Metro-
politan Museum.

287. Bronze statuette of a
negro, perhaps *c.* 200 B.C.
Paris, Bibliothèque Natio-
nale.

HELLENISTIC
PERIOD,
ABOUT 330–100 B.C.

In contrast to the classical age, the Hellenistic is well represented in
bronze statuettes. They show the naturalistic modelling and the variety
of subjects that appear also in the larger sculptures.

The realistic portrayal of human beings in a variety of aspects, lofty
and lowly, became of absorbing interest to the artist, and his deepened
understanding is shown in many remarkable examples. Among them
may be mentioned in particular: a young negro musician (fig. 287) with
a lithe body and sad, sensitive face (Paris); a hunchback (New York);[12]
an emaciated man (Dumbarton Oaks, fig. 290); a dancer enveloped in
drapery (Walter Baker Collection, fig. 291); a beggar (Berlin);[13] an
old peasant woman (Vienna);[14] and an archer (London).[15] The indivi-

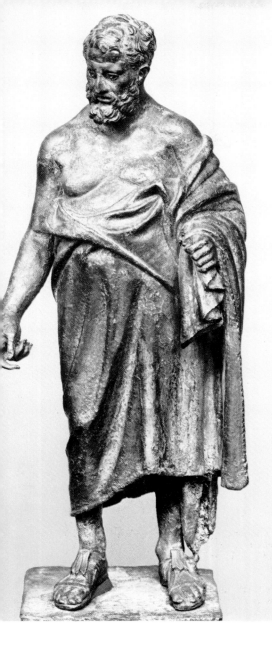

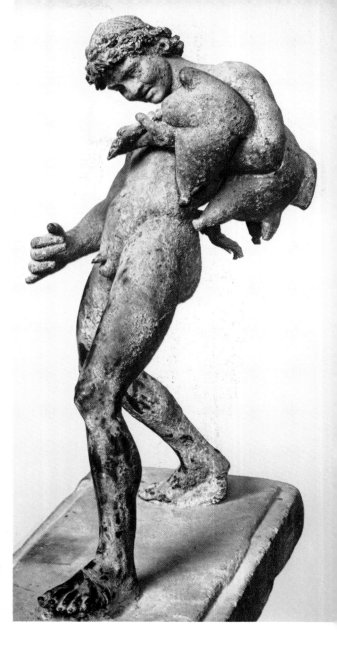

duality of each is ably conveyed both in expression and attitude. A statuette of a philosopher in New York (fig. 288), preserved almost entire, shows the realism that portraiture had attained in the Hellenistic Age.

The mythological themes so popular in former days were naturally continued. They differ, however, from the earlier representations in a new feeling for movement. The lively Satyr from Pergamon defending himself from an assailant,[16] and the group from Aphrodisias of Theseus struggling with the Minotaur[17] are typical examples. The Satyr shouldering a wineskin and leaning far back under its weight, in Naples (fig. 289), is an attractive example of late Hellenistic art; the difficult pose is achieved in masterly fashion. Finally, the striding Poseidon in the

288. Bronze statuette of a philosopher, *c.* 280 B.C. New York, Metropolitan Museum.

289. Satyr with wineskin. Bronze statuette, second century B.C. Naples, Museo Nazionale.

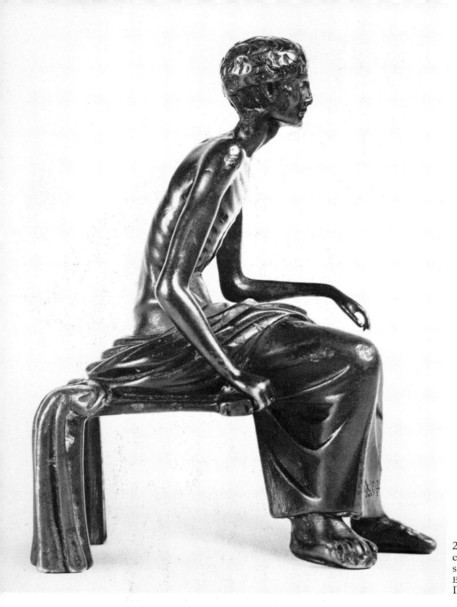

290. Bronze statuette of an emaciated youth, from Soissons, third to second century B.C. Roman copy. Washington, Dumbarton Oaks.

Louvre (fig. 293) forms an eloquent contrast with the fifth-century statue from Cape Artemision (figs. 120, 121) and sums up better than many words the difference of conception in the two epochs.

A few statuettes in other materials besides bronze have been preserved also of this period. A figure of a three-sided Hekate,[18] now in New York, is a precious specimen in wood. The goddess is represented in three, almost identical, contiguous figures, each wearing a baldric and a quiver. A coating of gesso, painted and gilded, once covered the surface. The provenance is said to be Alexandria. In a general way the group probably reproduces the triple Hekate by the fifth-century sculptor Alkamenes. A statuette in gilt wood of Alexander the Great, in the Louvre, shows him standing in a characteristic, somewhat restless pose, with head turned to one side (fig. 292).

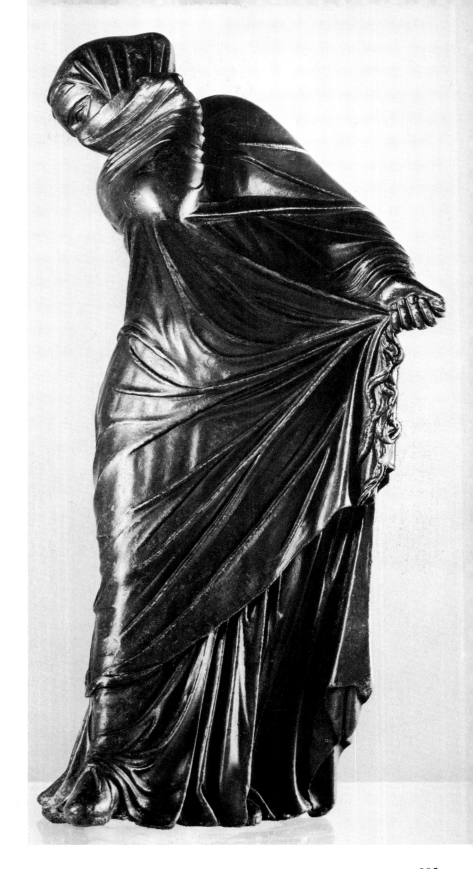

291. Bronze statuette of
a dancer, perhaps *c.* 200
B.C. New York, Walter
Baker Collection.

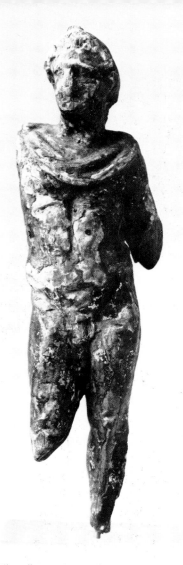

292. Alexander the Great. Statuette in gilt wood, third century B.C. Paris, Louvre.

293. Bronze statuette of Poseidon, perhaps second century B.C. Paris, Louvre.

That beeswax was once a common material for sculpture is noted by Plato and later writers, who mention the keroplasts (modellers in wax) as parallel to the koroplasts (makers of terra-cotta statuettes). The products of the wax makers consisted chiefly of statuettes for votive and household use, children's toys, counters for table games, decorative fruits, human figures for use in magic spells, and so forth. In spite of the perishable nature of the material, a few specimens survive. A female head, 4¾ inches high, said to be from Alexandria and now in New York,[19] was once perhaps part of a largish statuette of Aphrodite of Hellenistic date. Traces of dark paint are still visible.

FIRST CENTURY B.C. AND LATER The copying of former Greek masterpieces that became current in Roman times from the later second century B.C. onwards (cf. p. 183) was of course not confined to large sculptures. To possess a famous Greek work, albeit in reduced form, became a desideratum of Roman collectors. For us this was a fortunate circumstance. Many a celebrated statue, now lost or known only in a fragmentary state, is preserved in

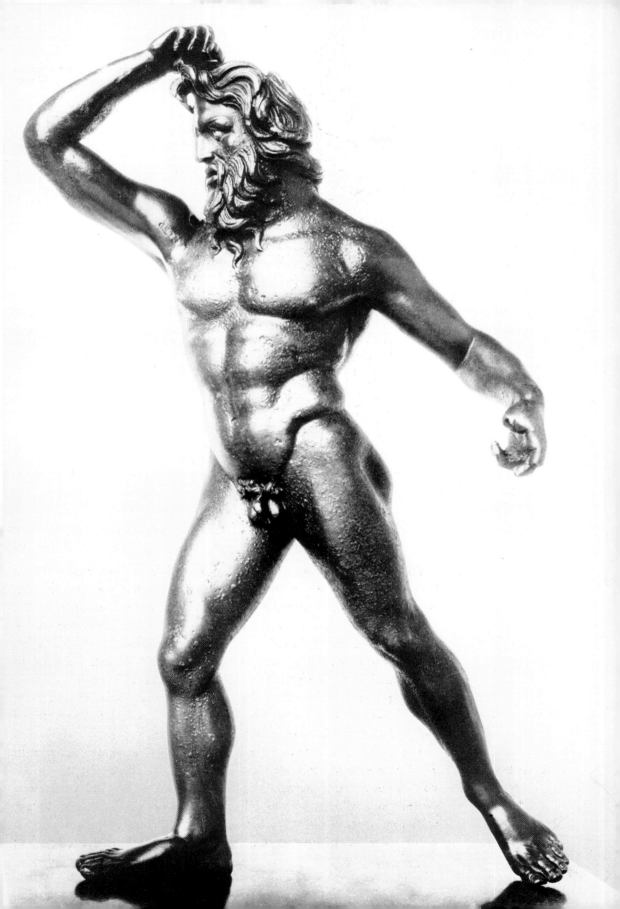

complete form in a bronze or stone statuette of Roman date. Thus Lysippos' famous statue of Herakles resting on his club exists entire in the bronze statuette in the Louvre mentioned above (cf. p. 201). The Hermes with the child Dionysos by Kephisodotos (cf. p. 141) is preserved in a statuette in the Louvre of which only part of the right arm is missing. The Knidian Aphrodite of Praxiteles (cf. p. 141) and the Crouching Aphrodite by Doidalsas (cf. p. 169) survive in small, practically complete bronze and marble statuettes which convey the harmony of the composition better than do the fragmentary or badly restored statues. A sleeping Eros in a relaxed pose reproduces an evidently famous composition preserved also in marble and bronze statues (cf. fig. 238).

Furthermore, famous Greek works, such as the Zeus by Pheidias and the Hermes by Polykleitos, appear with slight modifications as the Roman Jupiter Capitolinus or as Mercurius, the god of commerce, a seated Athena served as the personification of Roma, a flying Nike as a Victoria, and a standing Ares as a Mars. Thereby the composition, at least, of several famous Greek sculptures has been perpetuated.

DECORATIVE METALWORK

The term 'decorative metalwork' covers a large field. Metal was used in ancient times for many purposes for which nowadays other materials are preferred; and these metal objects, most of which served some practical purpose, were often ornamented with statuettes, reliefs, and incised designs, and so became works of art. (When such ornaments have been found singly they are mentioned in the preceding chapter.)

The chief metals used by the Greeks for their decorative work were bronze (in different alloys), silver, and gold. When the Romans brought back works of art from Greek lands, embossed metalwork formed an important part of the loot. Pliny (XXXIII, 148) says that Scipio, after his victory over Antiochos III, carried off to Rome chased silver and gold vases weighing thousands of pounds. Livy (27, 16, 7) and Cicero (*Verr. Or.,* II, 50–52) speak of the enormous plunder of silver and of Corinthian bronzes taken from Tarentum and Sicily. Famous silversmiths of the fifth century B.C. and later are listed by Pliny (XXXVII, 154). Pheidias and Polykleitos are said to have been proficient in this art. Mentor was an outstanding silversmith. In the Greek temple inventories silver and bronze utensils are constantly listed (cf. *I.G.*², 1394).

Naturally such precious materials as gold and silver and even bronze, which could be conveniently melted down in times of stress, had little chance to survive to our time. Nevertheless, enough examples remain to give an idea of the variety and excellence of this branch of Greek art. They consist mostly of armour (helmets, shields, cuirasses, and greaves), parts of harness, tripods, and household articles (vases, mirrors, kitchen utensils, chests, furniture). The decorations are in relief, or incised, or in the round. Often only the decorated parts have been preserved, the object itself having disappeared. This is for instance the case with bronze vases, which were mostly hammered in thin sheets, whereas the applied handles and feet were cast and more durable.

Several different techniques can be distinguished: repoussé, hammering over a mould, stamping with a die, and casting. In repoussé, a sheet of metal was placed on a pitch foundation and worked into shape, alternately from the front and the back. In hammered work, the metal sheet was beaten into a mould on which the design was in reverse. In stamping, the design on the die was impressed on the metal. The casting of metal reliefs was similar to that of casting metal statues and

statuettes (cf. p. 55). In the early periods no mould seems to have been taken of the original model for multiple production. Not until Hellenistic times are exact replicas found even in the several handles of a vase.

In all these techniques the graving tool was often used for the chasing of details. Moreover, some decorations were entirely engraved. The incisions were made with variously shaped tools—runners, pearls, and flats. Inlay was also practised, the chief materials used being coloured stones, glass, bone, ivory, copper, niello, gold, and silver. The primary purpose was to impart a rich polychrome effect.

Greek metalware has been found on many different sites—in Greece and the East, in Bulgaria, Jugoslavia, and South Russia, in Southern Italy and Sicily, and in the North. In addition to original Greek works, many copies made in Roman times have been found, for instance at Boscoreale and Pompeii, Hildesheim (Germany), Bernay (France), and Denmark. A number have come from 'treasures', i.e. ensembles buried by their owners when some danger threatened.

A few specific examples of this ancient decorative work will show its wide range and the identity of style with the other products of the time.

EIGHTH AND SEVENTH CENTURIES The geometric tripods and vases decorated with statuettes have already been mentioned (cf. p. 186). Geometric fibulae, found mostly in Attica and Boeotia, often have engraved designs, in the angular style then current. They depict human and animal figures, singly or in groups, sometimes in recognizable mythological scenes.

Several shields found in the Idaean cave in Crete are conspicuous examples of early Orientalizing art (*c.* 700 B.C.?); they are decorated

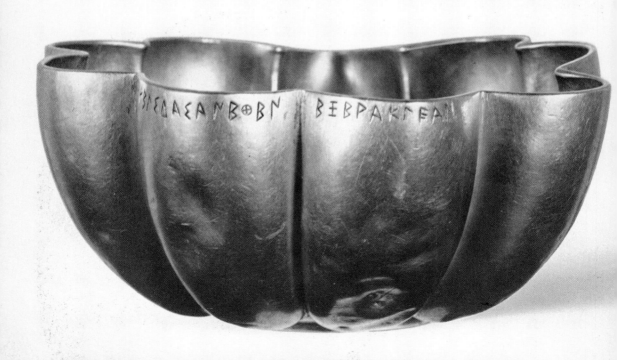

in embossed relief with monsters and animals in so marked an Eastern style that they are thought by many to be importations; and the same applies to the embossed and incised bowls from Cyprus and Italy, some with scenes of Egyptianizing type.[1]

Many specimens of early metalware have come to light in the various sanctuaries of Greece. Some formed part of armour dedicated to a deity after a victory. The back of a breastplate, found in the river Alpheios at Olympia and now in a private collection, is engraved with animals and monsters and with a group perhaps to be interpreted as Zeus greeting Apollo (fig. 295). It may be assigned to the mid-seventh century B.C. Magnificent hammered and cast griffin heads (figs. 296, 297), which once projected from the rims of the early bronze cauldrons (called Argive by Herodotos IV, 152), have been discovered at Olympia and elsewhere. They convey the fierce Oriental spirit inherent in some seventh-century products. The same designs are continued during the succeeding century, but the griffins gradually become gentler and less monumental. Bronze helmets likewise offered fields for decoration—on their cheek-pieces, frontals, and neck-pieces. A fine seventh-century example in the Louvre has an engraved sphinx of Proto-Corinthian type.[2]

A hammered gold bowl (fig. 294), said to have been found at Olympia and now in Boston, is inscribed 'The sons of Kypselos dedicated (this bowl) from Herakleia'. It was, therefore, a thanks-offering by the sons of the Corinthian tyrant after a successful expedition some time in the second half of the seventh century.

294. Hammered gold bowl, *c.* 620 B.C. Boston, Museum of Fine Arts.

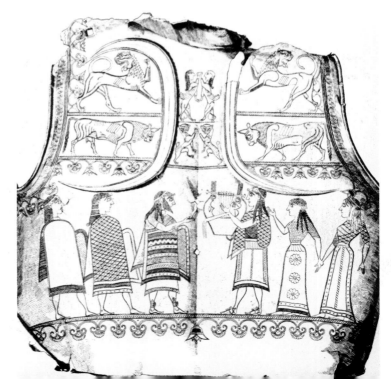

295. Back of a breastplate, found at Olympia, *c.* 650 B.C. Private Collection.

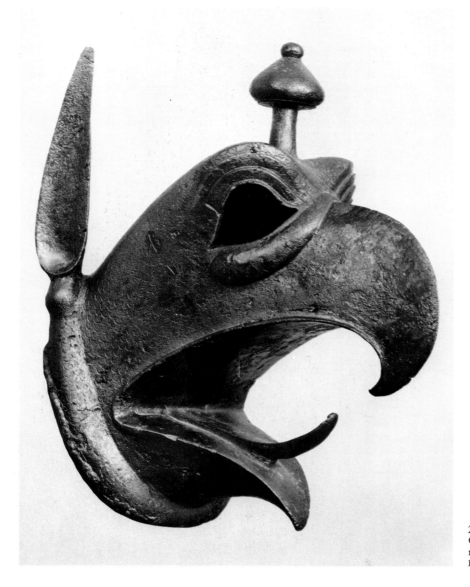

296. Griffin head from Olympia. Cast bronze, mid-seventh century B.C. Olympia, Museum.

SIXTH CENTURY B.C. Much beautiful metalware has survived from the sixth century B.C. A large number of embossed shield bands have come to light in recent excavations at Olympia (cf. fig. 298)—and previously elsewhere—ranging in date from about 610 to 460 B.C. The scenes represent incidents from the Trojan and Theban cycles, the labours of Herakles, the stories of Theseus and Perseus, and various monsters; only occasionally are they taken from daily life. Many are about contemporary with the reliefs on the metopes found at the mouth of the river Silaris, near Paestum (cf. p. 74), which show a similar variety of themes. In the shield bands there are many repeats, for they were hammered into moulds, and the same mould was used a number of times.

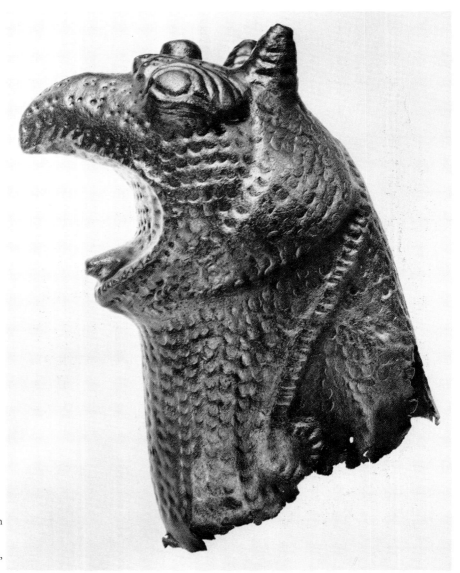

297. Griffin head from Olympia. Hammered bronze, mid-seventh century B.C. Olympia, Museum.

A pair of bronze greaves (cf. fig. 299), said to have come from Ruvo and now in the British Museum, are splendid examples of decorated armour. On each is represented a flying Gorgon, in repoussé relief and chased; protruding tongue and teeth are in ivory; the eyes once sparkled with inlaid stones. The date must be around 540 B.C. Sixth-century helmets are sometimes beautifully decorated. A fine array, some with dedicatory inscriptions, have been found at Olympia.[3]

A goodly number of archaic bronze vases have survived—kraters, hydriai, jugs, amphorae, as well as cups, plates, and bowls. Well preserved and expertly executed specimens of the late sixth century have come from South Italy—from Randazzo, Sicily (now in Berlin),[4] from Sala

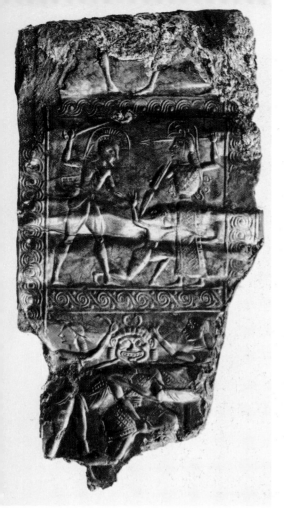

298. Embossed shield band from Olympia, sixth century B.C. Olympia, Museum.

299. Bronze greave, c. 540 B.C. London, British Museum.

300. Bronze hydria from Sala Consilina, late sixth century B.C. Paris, Petit Palais.

301. Bronze hydria from Paestum, late sixth century B.C. Paestum, Museum.

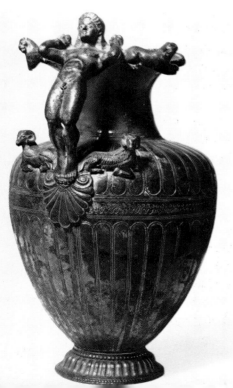

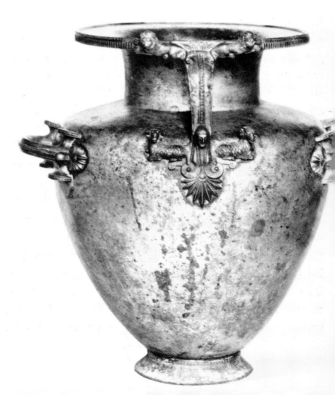

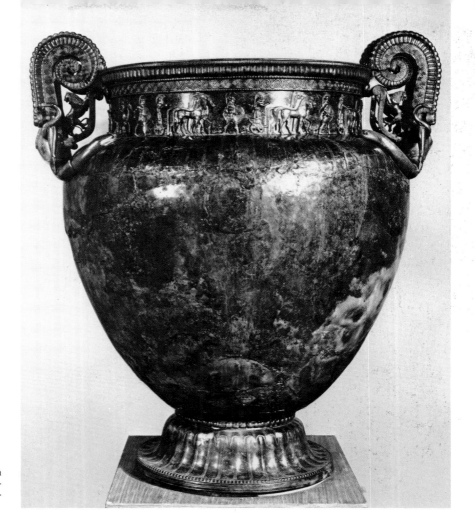

302. Bronze krater from Vix, *c.* 500 B.C. Châtillon, Musée Archéologique.

Consilina, Lucania (now in the Petit Palais, cf. fig. 300),[5] and more recently from Paestum (now in the Museum there, cf. fig. 301).[6] They present similar features in their decoration, the favourite motifs being recumbent lions and rams, female busts, foreparts of horses, palmettes, and a youth bending backwards. All, however, are separately cast, and each is a fresh creation, slightly different from the others.

But the most spectacular of all the bronze vases that have survived to our time is the volute krater recently found at Vix, near Châtillon-sur-Seine, in France (figs. 302, 303).[7] It is over 5 feet high and over 4 feet in diameter, and is ornamented with (cast) figures of warriors and chariots on the neck, and with Medusas, lions, and other features at the handles; a female statuette is perched on a cone in the centre of the lid. The whole is carefully executed in the late archaic style of about 500 B.C. Shape and decorations recall two kraters found at Trebenischte in Bulgaria,[8] and a hydria found at Grächwyl in Switzerland.[9] All may have been imported from a common centre—whether from Greece or Southern Italy or elsewhere is not known. In the same tomb as the krater from Vix were found two Attic Little-Master cups and a gold

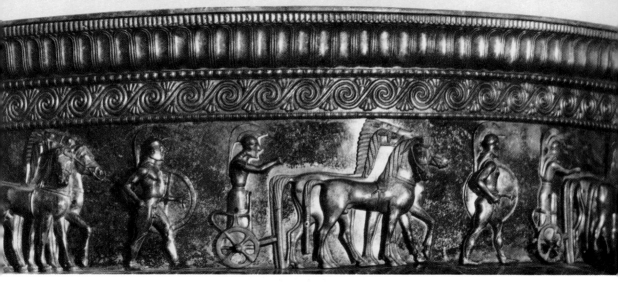

303. Detail from 302.

304. Bronze mirror, *c.* 550–525 B.C. New York, Metropolitan Museum.

305. Bronze mirror, *c.* 500 B.C. Athens, National Museum.

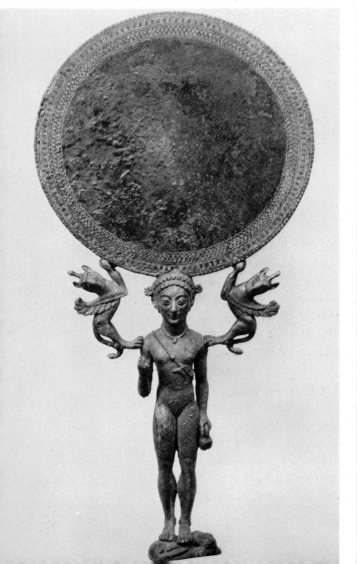

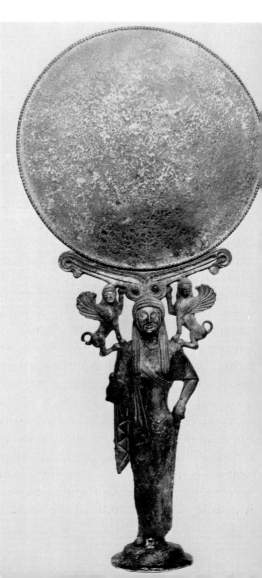

torque-like diadem, of non-Greek shape but decorated with little Pegasoi in Greek style (cf. fig. 379). The tomb must have belonged to a woman of a prominent local family who prized Greek art.

The Vix vase puts one in mind of Herodotos' tales (I, 70; III, 47) of the gigantic krater that the Spartans intended to present to Croesus of Lydia but which instead went to Samos; and of the large silver krater on an iron stand, a work of Glaukos of Chios, made for Alyattes of Lydia (*c.* 580 B.C.), and called 'the most notable of all the offerings at Delphi'.

In Greece, as in Egypt, discs of polished bronze (rarely of silver) served women as mirrors. In archaic times the disc had a handle, which was either in the form of a statuette, generally of a nude girl standing on a stool or an animal (cf. fig. 304); or the handle was flat and decorated with a figure in relief.[10] These mirrors were evidently intended to be laid down when not in use, like the hand mirrors of Egypt and our own, for they do not stand up. In the late archaic period, however, the statuette that served as a handle began to be provided with a stand, and was no longer represented nude, but clothed in chiton and mantle, like the marble korai of that time (cf. p. 102). Several fine examples are in Athens (cf. fig. 305) and London. Comparable are the archaic paterae with handles in the form of statuettes of youths with arms raised and holding animals.[11]

Three well preserved bronze water jars now in New York exemplify FIFTH the progressive changes in shape and decoration from the fifth to the AND FOURTH fourth century. The earliest has an inscription stating that it served as CENTURIES B.C. a prize at the Argive games (fig. 306). At the upper end of the vertical handle is the bust of a woman, the style of which recalls the sculptures from the temple of Zeus at Olympia (cf. fig. 133). The sturdy shape is also characteristic of that robust epoch. The second hydria has a relief of Artemis and a stag on the lower attachment of the vertical handle (fig. 307). Style and proportions place it at the end of the fifth century, about the time of the reliefs on the parapet of the Nike temple of *c.* 410 B.C. (cf. p. 137). Inlays of silver enliven the effect. The third example has on its handle attachment an Eros looking at himself in a mirror (fig. 309, 310). The pronounced curve of the figure recalls the Praxitelean statues, and the form of the jar, with the high neck and elongated body, is also characteristic of that time.

A bronze fifth-century footbath (fig. 308), said to be from South Italy and now in New York, consists of a low tripod base and a two-handled, shallow bowl, beautifully proportioned. Similar examples have been found at Trebenischte, and the same general form appears in foot-washing scenes on Greek vases and terra-cotta reliefs (cf. p. 237). A bronze krater with volute handles ending in swans' heads, from Locri, is now in London. Similar examples are in the Louvre and elsewhere.

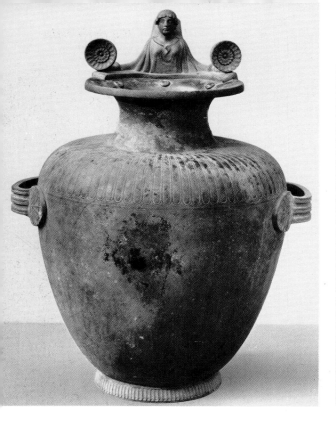

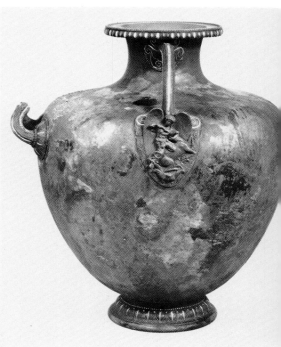

306. Bronze hydria, *c.* 470–450 B.C. New York, Metropolitan Museum.

307. Bronze hydria, late fifth century B.C. New York, Metropolitan Museum.

Several silver libation bowls, in London and New York, show the expert work practised at the end of the fifth century B.C. That in London (cf. fig. 311) was found at Èze, in Southern France;[12] those in New York[13] are said to have come from Italy. Practically the whole surface of the bowls is decorated with embossed reliefs, representing the apotheosis of Herakles. The hero is shown in a chariot, driven by Nike, and is accompanied by Athena, Ares, and Dionysos, also riding in chariots. The composition is similar to that on the Calene bowls of the third century B.C. (cf. p. 366), which evidently reproduce fifth-century prototypes. The two bowls in New York have in addition an inner, narrower

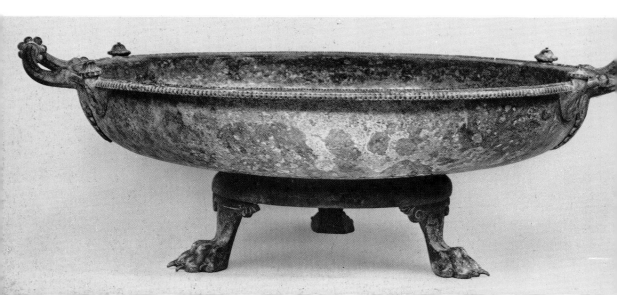

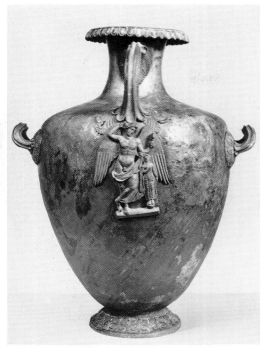

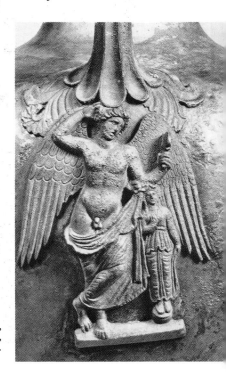

309, 310. Bronze hydria, *c.* 350 B.C. New York, Metropolitan Museum. 310. Detail.

frieze consisting of figures reclining at a banquet, in a composition that recurs on a Calene bowl in Leningrad. The two New York bowls are identical and must have been hammered into the same mould; the marks left by double striking can be detected, and they are different in the two bowls. The general style, especially of the chariot groups, recalls that of Sicilian coins of the late fifth century B.C. (cf. p. 259), and of the 'Lycian' sarcophagus from Sidon in Istanbul (cf. p. 131).

A finely worked bronze bridle of a horse, decorated with scrolls and swans' heads,[14] in open-work and in the round, further exemplifies the precision of workmanship in the classical period.

308. Bronze footbath, fifth century B.C. New York, Metropolitan Museum.

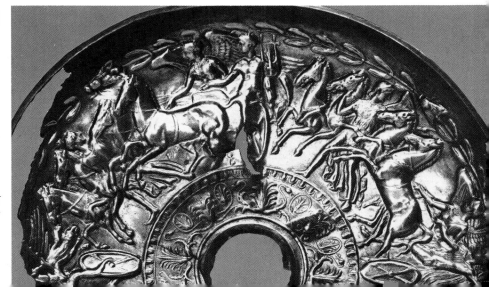

311. Silver libation bowl, late fifth century B.C. Detail. London, British Museum.

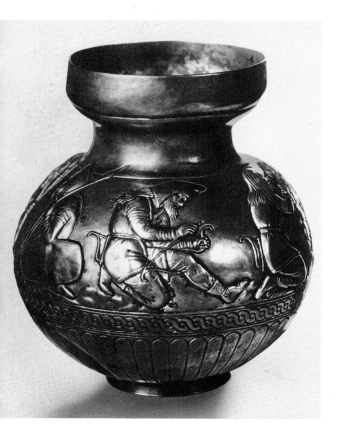

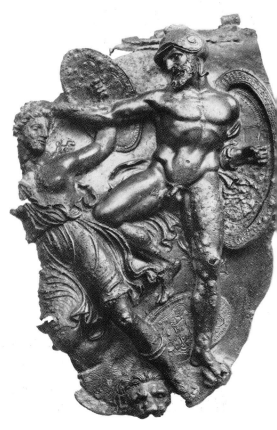

312. Electrum jar from South Russia, *c.* 410–380 B.C. Leningrad, Hermitage.

313. Embossed shoulder-piece of a bronze cuirass, *c.* 400–370 B.C. London, British Museum.

Two embossed reliefs representing Greeks battling with Amazons once decorated the shoulder-pieces of a cuirass; they were found in the river Siris in South Italy and are now in the British Museum (cf. fig. 313). In the modelling of the figures and in the rendering of the transparent drapery they recall the pedimental statues from Epidauros of the early fourth century B.C. (cf. p. 138).

A late-fifth-century bronze pail, also from Southern Italy, now in Berlin, has two spirited reliefs of a Nike in a chariot drawn by a lion and a panther.[15] Exceptionally here the reliefs are on the body of the utensil, and cast in one piece with it.

To the late fifth and the fourth century B.C. belong also some gold and silver objects found in the Scythian tombs of South Russia. Among them are gold plates for sword sheaths and quiver cases, ornamented with various scenes in relief comprising Greeks fighting Amazons and contests of animals. A gold comb from Solokha is surmounted by a spirited combat of horsemen, worked in the round; and a large silver vase from Nikopol has on its body embossed reliefs of Persians fighting Greeks. Among the finest is an electrum jar with Scythian warriors in lifelike postures (fig. 312). The subjects and forms of the objects are mostly Scythian, the style of the decorations is pure Greek. They, like

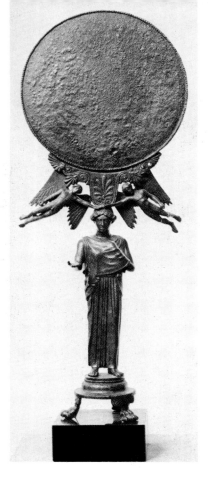

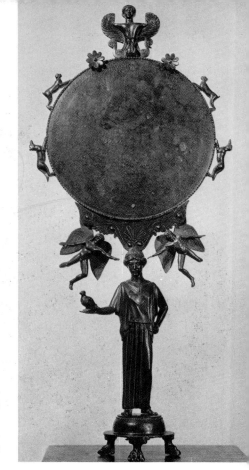

314. Bronze mirror, c. 460–450 B.C. Athens, National Museum.

315. Bronze mirror, c. 470–450 B.C. New York, Walter Baker Collection.

the krater found at Vix, must have been imported, unless Greek artists went to Russia to work for Scythian chieftains.[16]

Furthermore, fine examples of Greek metalware have come to light in the sepulchral mounds of Bulgaria; notably—from Baschova Mogila—a silver phiale with a chariot scene, and a kylix with Selene on horseback, both exquisitely incised in late-fifth-century style;[17] and—from Golemata Mogila—a silver kantharos with incised Dionysiac scenes datable near the middle of the fifth century B.C.[18] (All are now in the Museum of Plovdiv.) In this case shapes, subjects, and style are pure Greek, so that one may suppose that the objects were imported by Thracian chieftains.

Fifth- and fourth-century bronze mirrors are of several types. The form prevalent during the first half of the fifth century is similar to that of late archaic times, except that the statuette forming the handle is now regularly represented as wearing not the chiton and Ionic mantle, but the peplos, arranged in simple folds, like the statues of the Olympia pediments (cf. fig. 132). A few of these mirrors—in New York, Athens, London, and Paris—are preserved entire, with disc, handle, and stand, as well as with the little animals attached round the rim and the flying Erotes right and left of the female figure (cf. figs. 314, 315[19]). One side of the disc is regularly concave, the other convex, enlarging and diminish-

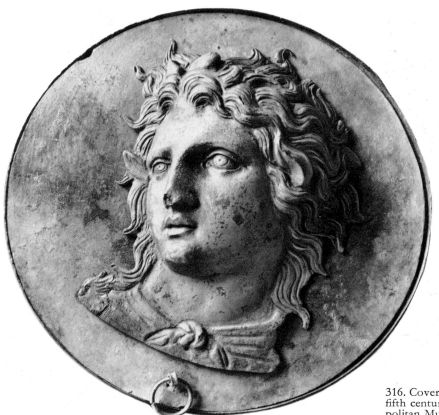

316. Cover of a mirror, second half of fifth century B.C. New York, Metropolitan Museum.

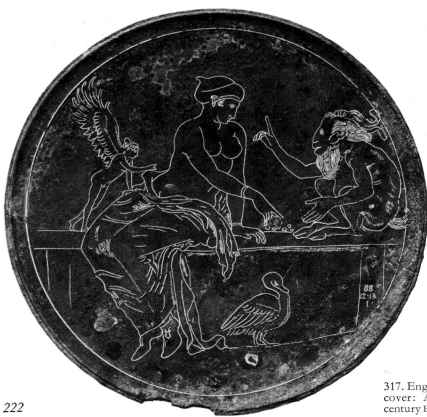

317. Engraved under-side of a mirror-cover: Aphrodite and Pan. Fourth century B.C. London, British Museum.

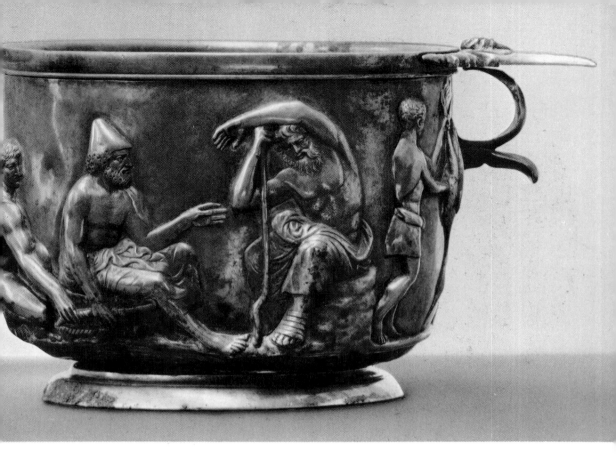

ing according to need. As they stood in the chamber of its owner, the rich and harmonious design must have added a note of splendour.

In the second half of the fifth century and in the fourth a new type of mirror became current—a round disc, without handle, but with a cover attached to the disc by a hinge. The cover was regularly ornamented with a repoussé relief either of a female head (cf. fig. 316), or a mythological scene, or a simple palmette design. The subjects include Aphrodite and Eros, Dionysos and Ariadne, a fight of two Pans, Marsyas and a Scythian slave, Nike, Nereids, and Ganymede carried off by the eagle, all presumably considered appropriate decorations for women's use. Occasionally the under-side of the mirror cover has an engraved scene. One of the fifth century in New York shows Atlas shouldering the weight of the heavens and Herakles standing by.[20] On another, of the fourth century, in London, are Aphrodite and Pan engaged in playing a game (fig. 317). The figures were often silvered, and so stood out effectively against the golden colour of the bronze.

A third, simpler type of mirror had a plain handle, either cast in one piece with the disc, or provided with a tang for insertion in a bone or ivory or wooden handle. The decoration was generally restricted to volutes and palmettes of elegant design. Women are often represented holding such mirrors on fifth-and-fourth-century vases and reliefs.

318. Silver cup from Hoby. Roman copy in fifth century B.C. style. Copenhagen, National Museum.

Two silver cups, found at Hoby in Denmark and now in Copenhagen, are Roman copies of Greek embossed metalwork.[21] On one is represented Philoktetes (cf. fig. 318), on the other Achilles receiving Priam. The form of the cups and the inscribed signature by Cheirisophos point to a late date, but the style is fifth- to fourth-century Greek.

HELLENISTIC PERIOD AND LATER The metalware of the Hellenistic period reflects the variety of styles and the enlarged repertoire current at that time. Realistic renderings and many different subjects, including Eastern scenes and landscapes, are now favoured.

Several discs, with heads of satyrs in relief, in a remarkably lifelike style, belong to the late fourth or the early third century B.C. They were found at Elis and are now in London and New York.[22] Their purpose has been identified from a bridle found in South Russia with similar discs still attached.

Several bronze mirrors, with covers decorated in repoussé as in the preceding period, can be assigned to the third century B.C. One, in New York, shows a chubby Eros.[23] The type with tang for insertion in a handle now sometimes has an openwork plaque with a figured representation between disc and handle. An exceptionally elaborate example, of perhaps the early third century, is in the British Museum. On the plaque (fig. 319) are two figures variously interpreted as Aphrodite and Adonis, or as Eos and Kephalos; and on the top of the rim are Erotes and scrolls; silver inlay enlivens the border of the disc.[24] Like most of the mirrors of this type, it comes from South Italy;[25] the dates of the others range from the fourth to the third century B.C.

A relief from the shoulder-blade of a cuirass represents warriors in violent combat.[26] The contortion of the figures and their realistic

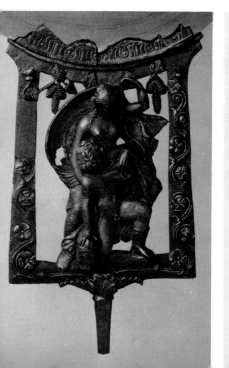

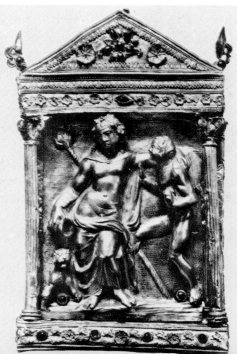

319. Lower part of bronze mirror, third century B.C. British Museum.

320. Gold shrine: Dionysos and satyr, perhaps 250–200 B.C. Collection of Mrs. Hélène Stathatos, Athens, National Museum.

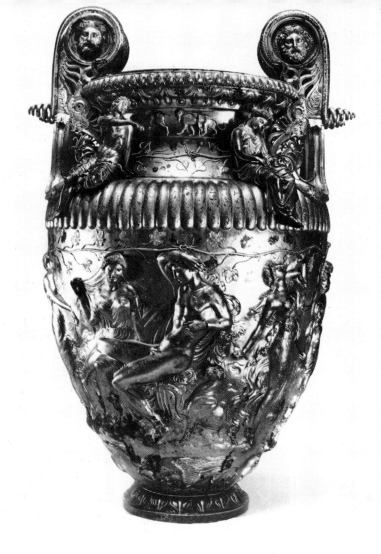

321. Bronze krater found at Derveni,
third or second century B.C. Saloniki,
Museum.

expressions contrast with the quieter renderings in the reliefs from the
river Siris with similar subjects (cf. p. 220).

As an example of Hellenistic metalware may also be mentioned a
small gold shrine (fig. 320) found in Thessaly and then in the collection
of Mrs. Hélène Stathatos.[27] Inside the shrine is a figured representation,
expertly modelled in high relief, of Dionysos, drunk, supported by a
little satyr, a favourite theme in late Greek art. It is a unique object
of which the purpose is not yet known.

A large bronze krater found in 1962 at Derveni near Saloniki ranks
as one of the most grandiose products of Hellenistic art. Handles, neck
and body are decorated with Dionysiac scenes in exuberant style and
expert technique (fig. 321).[28]

Many examples of Hellenistic silverware are included in the treasures
found at Boscoreale and Pompeii. Most of them are Roman copies, a
few perhaps are Hellenistic originals. Among the latter are cups with
repoussé reliefs representing storks and cranes in lifelike attitudes,

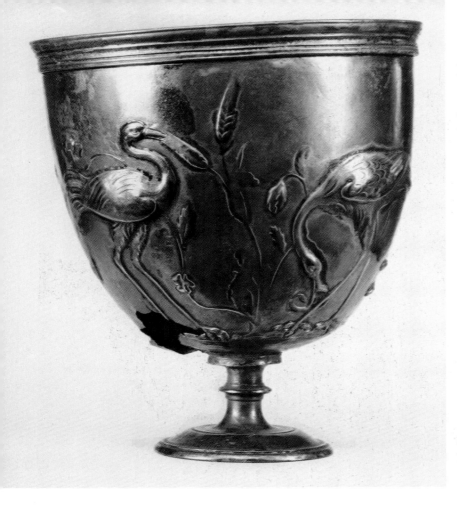

322. Silver cup, perhaps second century B.C. New York, Pierpont Morgan Library.

323. Silver patera with seated Athena, from Hildesheim, Roman period. Berlin, Staatliche Museen (formerly Hildesheim, Museum).

looking for food and bringing worms to their fledgelings (cf. fig. 322). Among the Roman specimens is a libation bowl from Boscoreale of which the central boss is in the form of a bust symbolizing the city of Alexandria. These emblemata as they are called have often been found separately. Some, of Greek workmanship and especially fine execution, have come from Tarentum, which was indeed famous for its metalware. One may recall Cicero's mention in his Verrine speeches of the removal of such emblemata from Greek bowls to serve as the prized possessions of Roman collectors.

The sumptuous silverware found at Hildesheim in Germany and at Bernay in France, consisting of plates, platters, cups, bowls, and jugs, can give an idea of the rich appointments of Roman households described by Latin writers. A patera has as its central ornament a seated Athena, with helmet, shield, and aegis (fig. 323). Two others have medallions with heads of Attis and Kybele. Two cups are ornamented with masks and theatrical symbols.

Mention must also be made of a remarkable gold treasure that came to light at Panagurishte, in Southern Bulgaria, in 1949.[29] It consists of

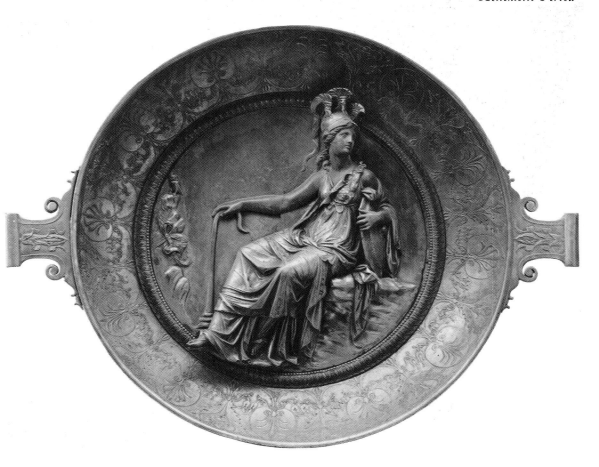

four rhyta, three jugs, an amphora, and a phiale, all elaborately decorated with embossed designs representing mythological scenes—except the phiale which has negro heads arranged in three concentric circles. Many of the figures have their names inscribed in punctured Greek letters, which have by some been dated in the late fourth or third century B.C. And this is the date assigned to the ensemble by Končev in his publication.

The discovery at Mit Rahne (Memphis) in Egypt and at Begram in Afghanistan[30]—as well as here and there elsewhere—of plaster casts taken from metal reliefs throws light on the ancient technique of copying Greek metalware. Moulds were evidently taken from various objects —vases (especially emblemata of bowls), armour, mirror covers, jewellery, and so forth—and then cast in plaster. The subjects comprise Dionysiac scenes, sacrifices, shrines, personifications of cities, a bust of Athena (cf. fig. 324), Homeric heroes, etc. The style ranges from archaic to Hellenistic, the latter predominating, but the actual casts are of Roman date. They bear out the references by ancient writers to the mania of Roman collectors for Greek metalware, the extravagant prices paid for

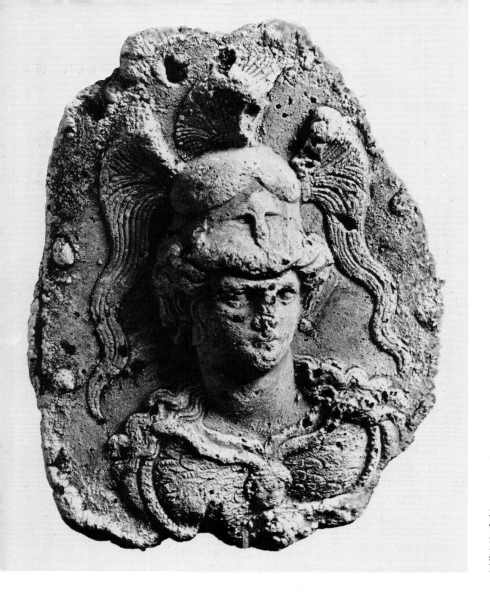

324. Roman plaster cast of a metal bust of Athena, from Egypt. Berlin, Staatliche Museen (formerly Hildesheim, Museum).

such old pieces, and the copying of them by means of impressions. These little plaster casts, in fact, taken directly from Greek originals, are precious relics of this Greek metalware, once so widely practised and now surviving in relatively few specimens.

A further enlargement of our knowledge of Greek metalware may be derived from the reliefs on pottery moulded from metal originals. The practice was particularly common among the South Italian potters of the Hellenistic period (cf. p. 366). Unfortunately the black glaze that regularly covers the surface of this ware obscures many a detail.

TERRA-COTTA STATUETTES AND
SMALL RELIEFS

Clay was extensively used by the Greeks for sculptural purposes, not only for statues (cf. p. 94), but for statuettes and small reliefs. They show the same development of style—from primitive to archaic to naturalistic—as do the larger sculptures; and this applies to all examples from whatever locality. To appreciate their original appearance one must remember that all were once painted. The colours have mostly disappeared, but when preserved they make one realize the original gay effect, so different from the drab appearance of unpainted terra cotta.

The chief function of these small terra cottas, especially in the earlier periods, was votive; and so the deity of a specific sanctuary was often represented. Particularly popular were Demeter, Persephone, and Dionysos, who could give protection in the nether world.

Though similar types and techniques recur throughout the Mediterranean, different classes can occasionally be associated with specific centres. In this short survey, therefore, attention will sometimes be called to such specific classes though the chief emphasis will, as in the other chapters, be placed on chronological development and outstanding specimens.

Terra-cotta statuettes were common in the Mycenaean age, but they do not seem to reappear, at least in considerable numbers, until the ninth to eighth century B.C. From then on, however, there is a continuous output throughout the Greek world; for clay could be found in many localities and lends itself to sculptural treatment. The large number of such statuettes that have survived is explained by their having been frequently buried in trenches when discarded, to make room for fresh offerings. Excavations at the Argive Heraion, Sparta, Perachora, Corinth, Attica, Boeotia, Euboea, Crete, Tarsus, Rhodes, South Italy and Sicily have yielded a host of specimens; and they present a wealth of different types indicative of the fertile imagination of the artists.

The geometric and sub-geometric terra cottas found in sanctuaries ABOUT 900—550 B.C. and tombs have the same summary forms as the other geometric products. Most of them are modelled by hand, but occasionally they have a moulded head, and sometimes they are moulded throughout. Horses, riders, birds are the prevalent motifs. Sometimes they served as handles on the lids of vases.

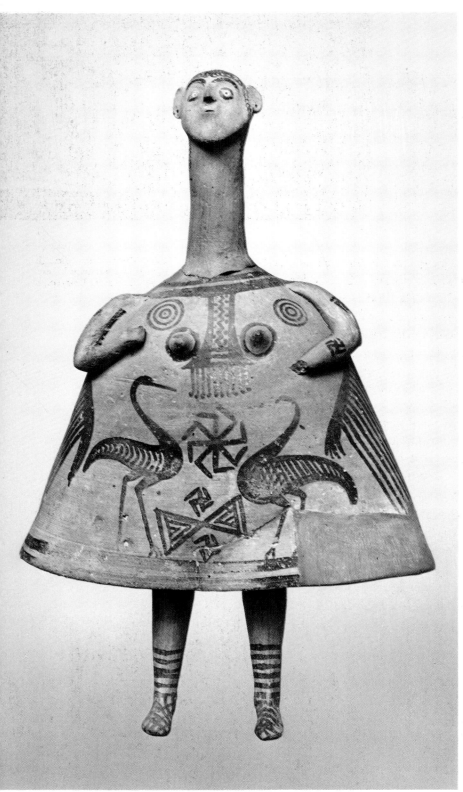

325. Terra-cotta statuette from Boeotia, eighth century B.C. Boston, Museum of Fine Arts.

326. Terra-cotta chariot from Boeotia, seventh century B.C. Athens, National Museum.

328. Terra-cotta horsecart with amphorae, from Euboea, seventh century B.C. Athens, National Museum.

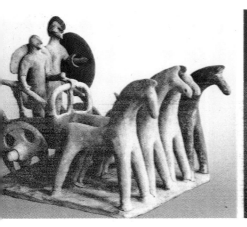

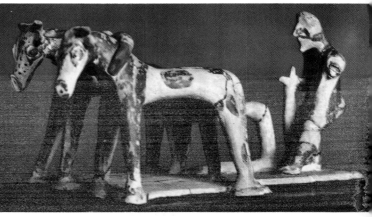

As a specific early class of geometric terra cottas may be mentioned the figures from Boeotia with bell-shaped bodies, long necks, flat faces, and stumpy legs (cf. fig. 325). The bodies were thrown on the wheel, the rest of the figure was modelled by hand. Ornaments, including birds and animals, were occasionally painted on the body.

In the seventh century there was an active output of terra-cotta figures in Boeotia, as there was in pottery (cf. pp. 309 f.). As two remarkable examples may be mentioned a four-horse chariot now in Athens (fig. 326), containing two warriors, one acting as charioteer—as described in the Iliad—and a workman with his plough, drawn by two oxen, found in Thebes and now in the Louvre (fig. 327). Likewise distinctive of Boeotia, though also found elsewhere, are the bird-faced statuettes, so called from their pinched faces, and the 'pappades' with high polos-like headdresses resembling those of modern Greek priests. In spite of their primitive appearance, most of them are hardly earlier than the first half of the sixth century.

327. Terra-cotta plough from Boeotia, seventh century B.C. Paris, Louvre.

329. Funeral wagon. Terra-cotta group found at Vari, *c.* 600 B.C. Athens, National Museum.

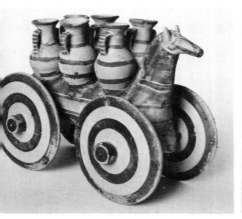

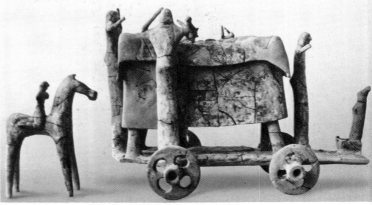

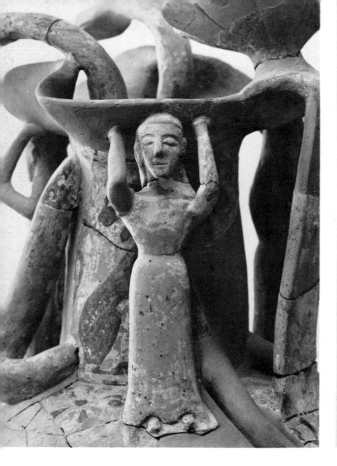

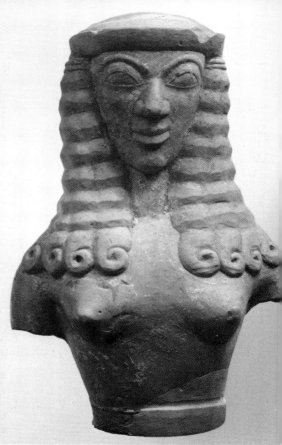

330. Terra-cotta statuette on a Proto-Attic jug, *c.* 650–630 B.C. Athens, Kerameikos Museum.

Excavations in Cyprus have yielded many terra cottas of this early time. The majority are hand-modelled. Some have columnar bodies made on the wheel, with the upper part modelled by hand. Warriors, horsemen, musicians, water-carriers, and animals are favourite subjects, as well as figures holding offerings—a flower, a cup, or an animal. Linear patterns are used as decorations.

A cart and horse laden with six amphorae, found in Euboea and now in Athens (fig. 328), shows the skilful way in which elaborate groups were modelled. One of the most remarkable groups of this early period, however, was found at Vari, Attica (fig. 329); it consists of a funeral wagon, on which the dead person lies, covered with a cloth and surrounded by mourning women, and with a small running figure and a bird lying on top, evidently signifying the soul of the departed.[1] The date is perhaps around 600 B.C.

Occasionally terra-cotta statuettes were introduced on vases, as on a Proto-Attic jug of *c.* 650–630 B.C. from the Kerameikos (cf. fig. 330).

Crete has yielded a large number of early terra-cotta plaques with figures in relief, chiefly warriors and female deities, most of them crudely worked.

Standing apart from the prevalent products are the large terra-cotta masks found at Tiryns,[2] interpreted by some as representing Gorgons

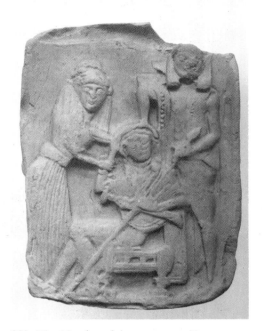

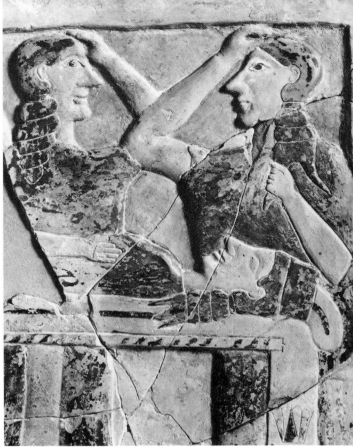

332. The Murder of Agamemnon. Terra-cotta relief. Both from Gortyna, seventh century B.C. Heraklion, Museum.

331. Terra-cotta figure.

and worn in cult dances. They have been dated around 700 B.C.

The so-called Daedalid type of the seventh century—with flat face, low skull, and hair arranged at the sides in horizontal layers—is prevalent also in terra cottas. It appears in different localities—Crete (cf. fig. 331), Corinth, Laconia, Argos, Boeotia, Rhodes, and elsewhere, as did the similar examples in the contemporary larger sculptures (cf. fig. 58). The figures are either in the round or in relief. Many different subjects are represented—standing and seated deities, the *potnia theron* (goddess of animals), and even mythological groups. One of the most remarkable is a relief from Gortyna depicting the killing of Agamemnon by Clytemnaestra and Aigisthos (fig. 332).

The terra-cotta plaques that lined the quadrangular tombs of Attica in the later seventh century (cf. p. 47) were often decorated with reliefs. A common subject is the prothesis, i.e. the lying-in-state of the dead, surrounded by mourners tearing their hair (cf. fig. 333).

From Lemnos have come large statuettes with columnar bodies, raised arms, long necks, large heads, and staring expressions. They wear tunics decorated with spirals and other motifs (seventh century). Also distinctive of Lemnos are reliefs representing Sirens, with bodies shown in profile and heads frontal, surmounted by a polos (early sixth century).[3]

333. Mourners at a bier. Terra-cotta relief from an Attic tomb, *c.* 630–600 B.C. Detail. New York, Metropolitan Museum.

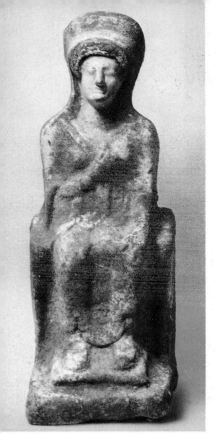

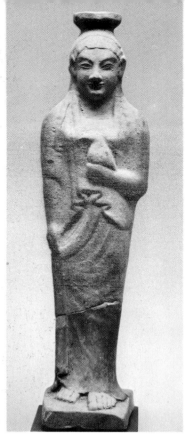

334. Terra-cotta seated woman, *c.* 525–500 B.C. New York, Metropolitan Museum.

335. Standing woman. Terra-cotta jug from Sicily, late sixth century B.C. New York, Metropolitan Museum.

ABOUT 550—475 B.C. In the second half of the sixth century B.C. the types become more restricted and the expressions more gracious and animated. They consist mostly of seated and standing female figures in dignified poses and with stylized draperies (cf. fig. 334), comparable to the larger sculptures of that period (cf. pp. 78 ff.). Some hold a bird, fruit, or flower in one hand, others a child on the lap. Animals are also popular.

The technique of moulding now became almost universal. Many moulds of all periods from many different sites have survived. The procedure was as follows: after the making of the original model (in clay or wax), a clay mould of it was taken—generally only of the front, rarely of both front and back—and fired. Clay was then pressed into the mould in several applications and, after drying, when shrinkage made separation easy, the figure was removed. While still in leather-hard condition, the back (which was mostly left smooth and provided with a vent hole for evaporation), and the base (generally of rectangular form) were attached with slip, and finishing touches were given with modelling tools. Lastly, apparently before firing,[4] the whole surface was covered with a slip of white, peptized clay. After firing to a temperature ranging from 750 to 950 degrees Centigrade, the surface was painted with tempera colours in different shades of red, blue, and yellow, the white slip acting as a base. Even when the tempera colours have disappeared, the white slip often remains. In contrast to the bronze statuettes, there

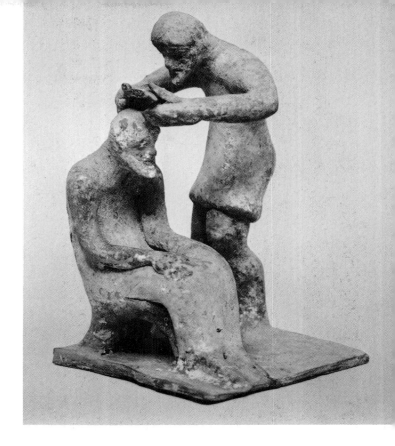

336. A barber. Terra-cotta group from Boeotia, late sixth century B.C. Boston, Museum of Fine Arts.

are many repeats in terra-cotta figures. The same mould was evidently used repeatedly.

The Akropolis of Athens has yielded a series of these moulded statuettes, found buried in trenches, evidently after the Persian sack of 480 B.C.; and similar statuettes have come from many other sites. A number, for instance, have been found in Rhodes, Cyrene, and Asia Minor; others in recent excavations near the temples of Hera at Paestum and at the mouth of the river Silaris. A seated figure, with one or more children on her lap (*kouro-trophos*), was evidently a popular offering to the goddess Hera. Specially fine examples of seated and standing women, serving as jugs, have come to light in Sicily (cf. fig. 335), Rhodes and Samos. Large protomes of female goddesses, used as votive offerings, have been unearthed in Rhodes, Sardis, and elsewhere. Sphinxes, sirens, satyrs, animals and jointed dolls are also common. From tombs in Southern Italy (Capua, Ruvo) have come delicate little gorgoneia and masks of a river-god and of Dionysos and his circle. Some have their colours fairly well preserved (black, white, red, blue).

A particularly engaging class of late archaic terra cottas may be connected with Boeotia. It consists of statuettes and groups representing men and women engaged in every-day occupations—cooking or kneading bread, making music, looking after children, cutting wood, or acting as barbers (fig. 336). The figures are mostly modelled by hand in attrac-

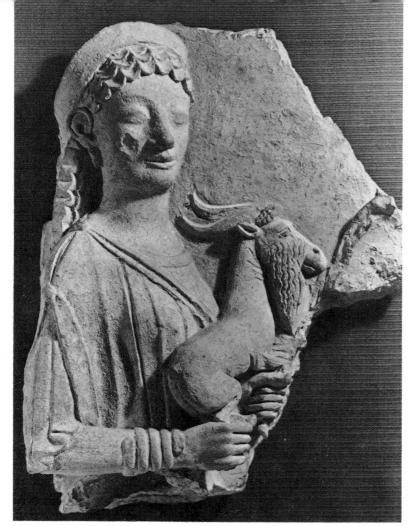

337. Aphrodite holding a goat. Terra-cotta relief from Gela, *c.* 500 B.C. Oxford, Ashmolean Museum.

338. Bellerophon. Melian terra-cotta relief, *c.* 475–450 B.C. London, British Museum.

tively life-like poses, without much detail. Animals also appear. A dog, in New York, is shown carrying a piece of meat in his mouth. Two dogs, in the Louvre, together carry a ram.

In addition to statuettes, small reliefs are not uncommon. They too were pressed into moulds, but of course they are not hollow, but solid, with a smooth back. The subjects show considerable variety; on a small plaque from Sardis, of the early fifth century, is a warrior dragging a female captive by the hair.[5] Several examples from the Akropolis of Athens show Athena mounting a chariot.[6] On a fragmentary relief from Gela of about 500 B.C. is seen a regal figure of Aphrodite holding a goat (fig. 337).[7]

ABOUT 475–400 B.C. In the second quarter of the fifth century, female draped statuettes still predominate. In style they resemble the marble and bronze figures of the period. The peplos, arranged in a few, simple folds is the favourite garment. Occasionally figures in action are represented, for instance, Europa riding on the bull. Many fine heads and busts have been found in South Italy, especially in Locri and Tarentum.

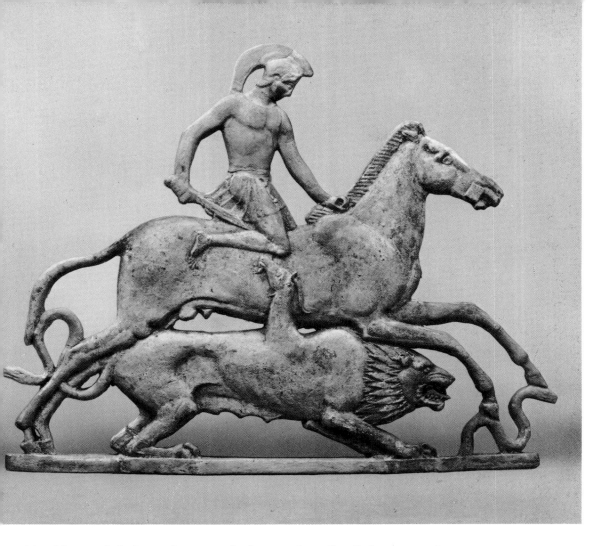

To this epoch belong also several classes of small reliefs, some of high quality. The Melian reliefs (*c.* 475–450 B.C.), so called because many were found in the island of Melos, must have served as decorations (they have holes for suspension or fastening) either, as has been thought, of wooden caskets, or, as has recently been persuasively suggested, of the interior of houses.[8] All the extant examples are moulded, and there are several repeats. The subjects are mostly mythological, but some are taken from daily life. The return of Odysseus, Phrixos on the ram, Bellerophon (fig. 338), Aktaion attacked by Artemis' hounds, a girl dancing to the music of the flute with a youth watching her, are some of the scenes represented in examples in London, Paris, Berlin, and New York. Traces of the original colouring remain here and there.

Another class of small reliefs has come from Locri. They evidently served as votive offerings to Persephone, in whose sanctuary practically all were found. Most of the subjects relate to myths associated with that goddess. One of the most frequent is the rape of Persephone, in three episodes: the actual capture, generally by a youth; the journey

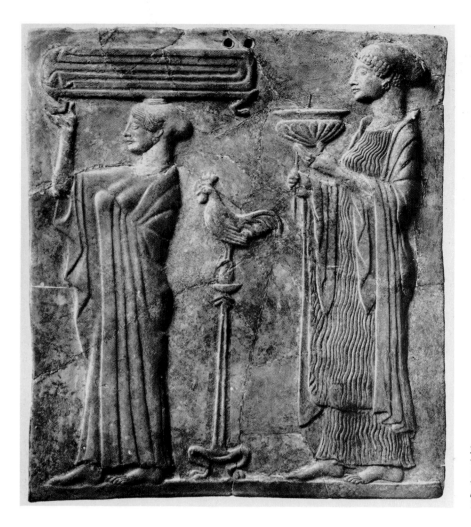

339. Preparation for the wedding of Persephone (?) Detail of a terra-cotta votive relief from Locri, *c*. 470–450 B.C. Reggio, Museum.

through the air in a chariot drawn by horses or Pegasoi; the arrival in the nether world where Hades presides; and finally the celebration of the marriage of Hades and Persephone, who are shown seated on a sumptuous throne—either together or Persephone alone—while deities approach with gifts. Fig. 339 illustrates, it would seem, the bringing of the wedding dress to the bride.

A remarkable feature of these Locrian reliefs is that the moulds were not used entire, but in separate parts, so that constant variations occur. Differences may be observed not only in details such as are caused by retouching with modelling tools, but in the actual figures represented, as is the case in the later statuettes (cf. p. 241). The colours that covered the surface are occasionally well preserved; some are rather crudely contrasted, others are harmoniously interrelated. The workmanship is often of great delicacy, testifying to a high skill.

Another important centre for the production of terra-cotta reliefs in South Italy was Tarentum. Rich deposits of figures ranging from the sixth century to the Hellenistic period have been found there, many

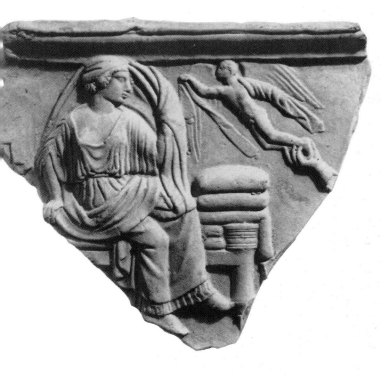

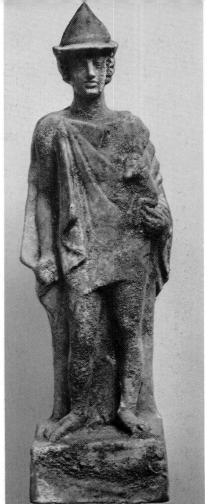

340. Eros visiting a bride. Terra-cotta plaque from Tarentum, late fifth century B.C. Oxford, Ashmolean Museum.

341. Hermes. Terra-cotta statuette, *c.* 450–400 B.C. Collection of Mrs. Hélène Stathatos, Athens, National Museum.

datable in the fifth century B.C. They are mostly votive offerings, dedicated to the heroized dead. Male figures reclining at banquets, Dionysos, and the Dioskouroi on horseback are popular subjects. Characteristic also are moulds for discs, presumably votive, decorated with various emblems, and small plaques with reliefs. One of the most attractive shows a young bride sitting on her couch and visited by Eros (fig. 340).

Compared with the rich output of the preceding and succeeding epochs, the extant terra-cotta statuettes of the second half of the fifth century are relatively few; but they are often fairly large and of good workmanship. There is indeed a certain grandeur in these little figures that bespeaks the influence of the great sculptors of the time. The favourite subject is a deity in a statuesque pose. A particularly interesting example, in Mrs. Hélène Stathatos' collection in Athens, represents Hermes (fig. 341). The colours are still well preserved: the flesh parts are in brownish red, the chlamys is white, with flying birds in blue, evidently reproducing a woven or embroidered pattern. A similar figure,

less well preserved, is in the Louvre. From Boeotia, Lokris, and other sites have come a series of protomes with handsome female busts and half-length figures, similar to those from Rhodes (cf. p. 235), but later in style.

FOURTH CENTURY B.C. AND LATER From the fourth century B.C. onwards terra-cotta statuettes enjoyed great popularity. Many sites throughout Greek lands have yielded hundreds of specimens. The best known are those from Tanagra in Boeotia, which belong mostly to the last third of the fourth and to the third century B.C. That the little town of Tanagra became an important centre for the manufacture of these figures is perhaps explained by the Macedonian destruction of Thebes and other Boeotian cities in 338 and 335 B.C. On the other hand, it is now thought that the centre of production was Attica, and this seems historically and artistically probable.[9]

342–44. Terra-cotta statuettes from Tanagra, *c.* 300 B.C. London, British Museum, and New York, Walter Baker collection.

The figures reflect the individualized spirit of the time. No longer are stately divinities or votaries represented; the people of the time

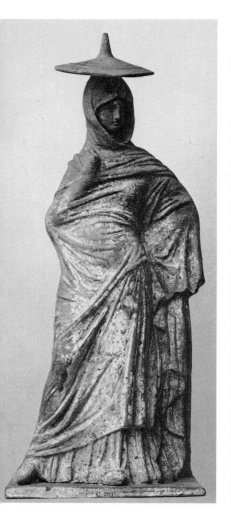
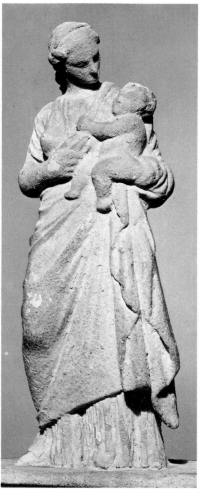
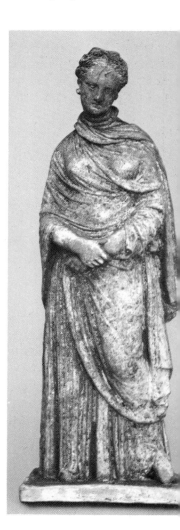

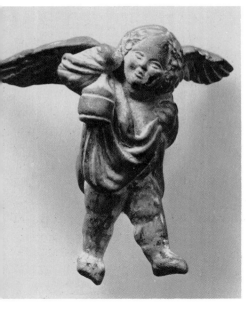

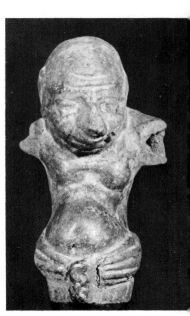

345. Eros. Terra-cotta figure from Tanagra, c. 300 B.C. New York, Metropolitan Museum.

346. Grotesque terra-cotta figure from Myrina, perhaps second century B.C. Alexandria, Benaki collection.

furnish the favourite themes. Most of the statuettes represent women, quietly standing or sitting, wearing tunic and mantle and broad-brimmed hat, and holding a child or a fan or a fruit (figs. 342–344). Now and then a youth or an old woman appears, or a child playing ball, or a flying Eros (fig. 345). There is a Praxitelean grace and gentleness in these figurines which give them a singular charm. They seem simple, but the simplicity is subtle and difficult to imitate. Many forgers have tried, but they have caught only the outward form, not the serene spirit.

The figures are moulded, like the earlier examples, but to ensure variety multiple moulds were employed; that is, different heads were attached to the same type of body, the arms were placed in various ways, and the attributes were changed. The method adopted in the Locrian reliefs (cf. p. 238) was continued here with equal success. Moreover, the same type was varied by retouching or by applying different colour. There is, therefore, never any monotony in these statuettes, for each is a fresh creation.

Other sites have yielded similar figures; especially Attica, and it is possible that the large output found in the little Boeotian town of Tanagra was stimulated by immigrant Attic artists, or was actually imported from Attica (cf. supra).

The question of the original purpose of these statuettes is difficult to answer. The majority have been found in tombs; but they have no obvious sepulchral meaning. It is also difficult to believe that they had some religious significance. Only occasionally the meaning seems clear. A company of actors was found in one tomb, presumably as offerings to an actor.

The Hellenistic terra cottas carry on the tradition of the fourth century. The Agora of Athens has yielded a mass of such figures

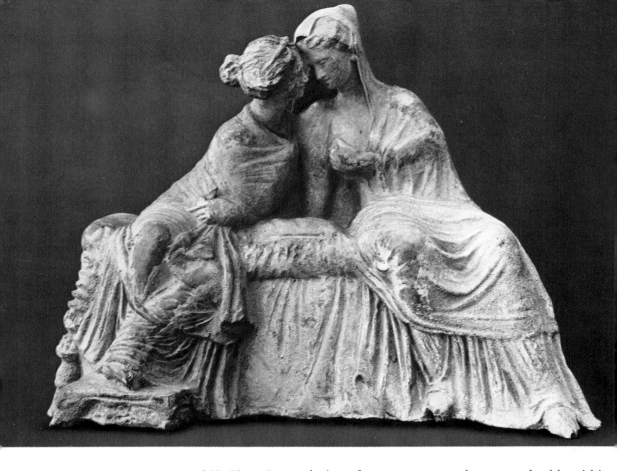

(*c.* 350–50 B.C.), mostly in a fragmentary state, but many datable within fairly narrow limits, and therefore valuable for absolute chronology. Besides the traditional themes, ritual subjects, jointed dolls, caricatures, and actors reciting occur.

One of the great centres for the manufacture of terra-cotta statuettes in later Hellenistic times was Myrina in Asia Minor, where French excavators in 1880–82 found hundreds of examples. A comparison between them and the Tanagra figures often shows marked differences. Lively poses are now popular, and deities, especially Aphrodite, Eros, and Nike, are popular subjects. Grotesque figures (cf. fig. 346) and actors reciting are common. Even when every-day people are represented, a new restlessness is observable in the attitudes and in the rendering of the drapery. The statuettes reflect, in fact, the new style introduced in the sculpture of the time. The dates assigned to the Myrina statuettes range from the late third century through the second into the first century B.C. Fig. 347 shows a life-like group of two women gossiping.

Myrina is of course not the only site that has yielded late Greek terra cottas. In Smyrna, Tarsus, Pontos, Cyrene, Greece itself, Sicily, and South Italy many examples have been found; some served as decorations of vases (cf. p. 364). From Egypt comes a special class, reddish brown in colour, and often representing Egyptian deities.

347. Two women gossiping. Terra-cotta group from Myrina, perhaps second century B.C. London, British Museum.

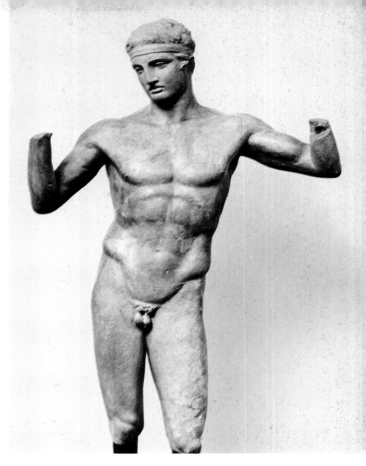

348. The Diadoumenos. Terra-cotta copy of the statue by Polykleitos (cf. fig. 154), first century B.C. New York, Metropolitan Museum.

The types evolved in the Hellenistic age continued into Roman times, and are, in fact, sometimes difficult to distinguish from the earlier specimens. In these late times, however, there was rarely much retouching after the figures were extracted from the moulds. They therefore have a mechanical look.

To the first century B.C. belongs a group of terra-cotta statuettes which reproduce famous works of the preceding epochs. They are larger than the average terra-cotta figurines, and are not mechanically made, but free copies. Originally they were gilded to approximate the appearance of bronze. A number have been found at Smyrna. One of the best preserved, now in New York, represents the Diadoumenos of Polykleitos (fig. 348).

A special use of terra cotta must be mentioned—that of taking moulds from decorations on metalware. Many Greek reliefs in bronze, silver, and gold of the fifth century and later have survived in these terra-cotta reproductions. They have been found in different localities, especially of late in the Athenian Agora. Their purpose is not certain. Perhaps the artist kept an impression of his work, not of course for reproduction, for such copying was not practised in the classical period as it was later (cf. pp. 183, 206), but to serve as a record.

For terra-cotta reliefs on pottery taken from metalware cf. pp. 366 ff.

CHAPTER 7

ENGRAVED GEMS

The art of engraving stones to serve as seals goes back to Babylonia in the fourth millennium B.C. and had a long history in Minoan and Mycenaean times. The Greeks, as usual, learned and borrowed from their predecessors what appealed to them, and then evolved something new.

The Greek engraved stones—or gems as they are commonly called—give a comprehensive view of Greek art in miniature. The various styles, from geometric to archaic and from developed to Hellenistic, are shown there in continuous succession. The subjects also are similar to those current in sculpture and painting; and the quality of the work is sometimes of the highest order. It is indeed extraordinary how monumental is the conception in some of these small representations, and how finished the workmanship.

Greek gems served primarily as seals and identification marks, and in the ancient world, when many people could not write, sealing played an important rôle; but it was naturally practised chiefly by the upper classes for safeguarding their possessions. Relatively few gems of the earlier periods are preserved; later, however, especially in the Roman period, when engraved gems were worn not only for sealing but also as ornaments and amulets, they became very common.

Sometimes Greek sealstones were also employed officially; such a use is mentioned in inscriptions and by ancient writers (cf. e.g. Aristotle, *Constitution of Athens*, 44, 1; Strabo, 9, 31), and the design on a gem is occasionally almost identical with one on a coin (cf. p. 248).

How greatly a fine gem was appreciated in Greek times is shown by Herodotos' famous story (III, 40, 41). When the tyrant Polykrates (d. 522 B.C.) was advised by Amasis, king of Egypt, to forestall the envy of the gods at his good fortune by casting away his most valued possession, he chose among his many treasures his signet, 'encased in gold and made of an emerald stone, the work of Theodoros, the son of Telekles, of Samos'; and after Polykrates had thrown the ring into the sea and returned to his house, 'he mourned for his loss'. Furthermore, in the treasure lists of temples of the fifth and fourth centuries B.C., of the Parthenon and Hekatompedon for instance, gems are frequently mentioned as offerings by votaries.

It is not definitely known whether ancient gem cutters made use of the magnifying glass. The general principle of magnification by con-

centrating rays was known to Aristophanes (*Clouds*, 766 ff.); Pliny (XXXVI, 67, and XXXVII, 10) mentions balls of glass or crystal brought in contact with the rays of the sun to generate heat; and Seneca (*Quaestiones naturales*, I, 6, 5) speaks of the principle applied for magnifying objects. It is, therefore, possible that some device for magnification was employed in the minute, eye-straining work of gem engraving. On the other hand, even nowadays, when strong lenses are available, gem engravers often work without them, at least in their youth; so perhaps the Greeks did likewise.

Not only the styles in gem engraving, but the materials, the forms of the stones, and the choice of subjects, vary from period to period.

The gems of the geometric age reflect the primitive character of that civilization. Instead of the lively, naturalistic representations of the preceding Mycenaean epoch, linear patterns predominate, and the designs are no longer carved on hard stones with the help of the wheel, but by hand on soft steatites. There were no standard shapes. As a rule the conical, domed, angular, and rounded beads common in Syria were adopted, as well as occasionally the cylinder. All were perforated, to be worn suspended from a string. Towards the end of the period, during the eighth century B.C., plants, animals, and human beings appear; but they are formalized into linear patterns. Compared to the rich output of Mycenean times, the geometric gems are few in number.

GEOMETRIC PERIOD, TENTH TO EIGHTH CENTURY B.C.

In the late eighth and in the seventh century B.C. the same transformation took place in engraved gems as in the other products of Greek art. The angular designs became more rounded, and Oriental elements intruded. Moreover, the use of hard semi-precious stones worked with the wheel was gradually reintroduced, and the gem engraver's art was greatly stimulated thereby. The shapes of the stones still show great variety, Eastern forms being specially common. Occasionally metal rings with engraved bezels occur.

SEVENTH AND SIXTH CENTURIES B.C.

349. Winged horse. Steatite, seventh to sixth century B.C. New York, Metropolitan Museum.

An interesting revival of Mycenaean traditions appears in the 'Island gems', found chiefly at Melos and datable in the seventh and the early sixth century B.C. They have the same lentoid and glandular shapes as the Mycenaean stones, and like them are engraved with animals and monsters in rhythmical compositions (cf. fig. 349). Griffins, sphinxes, winged horses and goats, flying birds, and fish are common representations. Sometimes mythological subjects occur, for instance the suicide of Ajax on a steatite in New York.[1] The most common stone is the soft steatite.

Oriental influence is observable in the so-called Graeco-Phoenician gems[2] which have been found chiefly in the Carthaginian cemeteries of Sardinia and in the Balearic islands. They date from the period of the Carthaginian supremacy, that is, from the middle of the sixth century B.C. into the fourth century B.C. The shape is almost exclusively the scarab (with beetle back), and the favourite material is the green jasper, though the coloured quartzes also occur, and occasionally glass. The Egyptian deities Bes and Isis, as well as monsters, animals, and fantastic combinations of human heads with animal bodies are favourite representations; but Greek heroes, primarily Herakles, are also common, especially in the later stones. A border regularly surrounds the design.

Another special class of early seal engravings occur on gold rings with long, oval bezels, resembling the Egyptian cartouche.[3] They have been found almost exclusively in Etruria, especially at Vulci and Caere. The bezels are engraved in intaglio, occasionally in relief, in archaic Ionic style, resembling that on the so-called Pontic vases. Monsters and scenes with chariots form the commonest representations. It is now thought that these rings were probably made by Etruscans in Italy in the late seventh to the middle of the sixth century B.C.

The practice of sealing became fairly general throughout Greece in the course of the sixth century B.C.; at least a larger number of sealstones have survived of that epoch than of the preceding one. The usual shape is the scarab. Occasionally the back, instead of being carved in the form of a beetle, is shaped as a mask, or a negro's head, or a lion, a siren, and so forth. Before long the scaraboid (with plain, generally convex back) makes its appearance. Both scarab and scaraboid were regularly perforated and set in metal hoops. The latter are sometimes quite thick and are provided with swivel sockets that turn on the pointed ends of the hoop as on pivots. Later, the settings were soldered to the hoops, which then became correspondingly lighter. Rarely, the old Oriental forms of perforated cone and cylinder appear, to be worn suspended from a string.

The most common materials are the coloured quartzes; glass was used occasionally. The human figure is the most popular representation. Warriors, horsemen, archers, athletes and hunters are shown again and again in varying postures; and sometimes they can be identified with

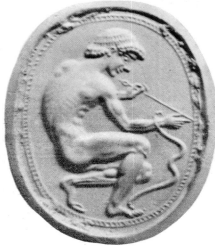

a mythological personage. Herakles is particularly popular. Gods and goddesses are comparatively rare; but satyrs, sirens and gorgons, as well as sphinxes occur often. Animals appear singly, or in combat, or associated with a human being. The design is mostly encircled by a border.

In these representations the same development from stylization to naturalism can be observed as in the other branches of Greek art. The structure of the human figure was evidently of absorbing interest to the artist and he tried to render it in varying postures, often in three-quarter views. The drapery was stylized in the manner current at the time.

Occasionally a name is inscribed, either in the nominative or in the genitive. It may refer to the owner of the seal, or to the artist who carved it. In the latter case it is generally written quite inconspicuously. The greatest artist of the time whose name has been preserved is Epimenes, who signed a stone, now in Boston, with the figure of a youth holding a horse.[4] Other names of archaic gem engravers known by their signatures are Onesimos, Syries, and Semon. Of these only Semon's work—a woman at a fountain, engraved on a stone in Boston—is outstanding. As in vase-painting, so in gem engraving, a signature does not necessarily signify the best work, and masterpieces are often not signed. Among the latter, are a Hermes, in the Berlin Museum,[5] and a winged figure carrying a girl (fig. 350), in New York. An archer in three-quarter back view, engraved on a stone in New York (fig. 351), has been attributed to Epimenes on stylistic grounds, since it resembles the signed example in Boston.

The Etruscan scarabs of the late archaic period are sometimes executed in a style that closely resembles the Greek. Only external characteristics, such as the decorated vertical border, which was regularly employed in Etruria but not in Greece, furnish a clue. It seems likely, therefore, that these stones were engraved by Greek artists for Etruscan patrons. In the course of time, however, an Etruscan flavour is observable.

350. Winged figure carrying a girl. Carnelian, early fifth century B.C.

351. Archer. Chalcedony, attributed to Epimenes, c. 500 B.C. Both in New York, Metropolitan Museum.

Greek gems of the developed period, especially those of the fifth century B.C., are comparatively rare; for the possession of a personal seal was still restricted to the wealthy. Aristophanes (*Ekklesiazousai*, 632), for instance, couples 'grandees' with people who wear sealrings.

The scarab at first retained its popularity, the back being carved either in the form of a beetle, or lion, or some other animal. Presently the scaraboid with plain convex back became the prevalent form. Four-sided beads and cones are not uncommon.

By far the commonest material is the chalcedony—especially in the Ionian stones from East Greece. Less frequent are the carnelian, agate, rock crystal, jasper, lapis lazuli, and glass. Metal rings with engraved bezels become increasingly common, and are especially frequent in the fourth century B.C. The bezel is either oval, or a pointed oval, or round.

The favourite subjects are now no longer mythological heroes, but the daily life of women. They are represented making music, playing with their children and with animals, taking a bath, and so forth. Animals appear either singly or attacking each other. Deities are more or less restricted to Aphrodite, Eros, and Nike. Fantastic creatures are comparatively rare. The encircling border, which was in regular use in the preceding period, still frequently occurs in the older examples, but by the fourth century it has practically disappeared. Instead, a ground line is often added, and occasionally a decorated exergue; but in Ionian stones both border and ground line are regularly omitted, lending spaciousness to the composition.

A close connection between coins and gems may be observed at this time. Perhaps the same person sometimes practised both arts. This is definitely known of Phrygillos, who signed an Eros on a gem and coins of Syracuse of the second half of the fifth century B.C. A chalcedony scaraboid in Naples signed by Sosias[6] has a female head which resembles the heads on coins by Eumenes and his contemporaries (cf. p. 257).

Other excellent engravers of the fifth and fourth centuries known to us by name are Onatas, who signed a Nike erecting a trophy, on a stone in London;[7] Atheniades, who signed a man in Persian dress, on a gold ring in Leningrad;[8] and Pergamos, who signed the head of a youth with a Phrygian cap, on a stone in Leningrad.[9]

But the greatest artist of the time was Dexamenos. In his work the high-water mark of gem engraving is reached. His signature is preserved on four representations: a woman with her maid, in Cambridge (fig. 352), probably an early work before he reached his maturity; a heron with a grasshopper, in Leningrad;[10] a flying heron, also in Leningrad;[11] and the portrait of a bearded man, in Boston (fig. 354). The last three show a delicacy of line that is beyond compare.

In addition, there are many unsigned masterpieces, for instance the Hades and Persephone in New York (*c.* 460–450 B.C., fig. 353); a woman

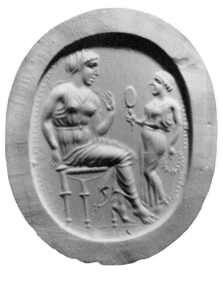

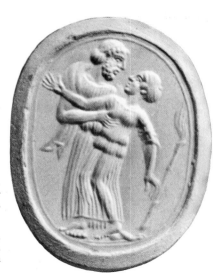

352. Woman and maid. Chalcedony, by Dexamenos, *c.* 420 B.C. Cambridge, Fitzwilliam Museum.

353. Hades and Persephone. Chalcedony, *c.* 460.450 B.C. New York, Metropolitan Museum.

balancing a stick, in Berlin;[12] and a wounded Centaur, in London[13] (the last two datable in the second half of the fifth century B.C.). Some of the representations of animals are likewise outstanding. Even insects are rendered with extraordinary ability. A grasshopper in Berlin,[14] and a fly[15] of unknown location remind one of the tradition that Pheidias, in addition to his colossal Olympian Zeus, carved such tiny things as a grasshopper, a bee, and a fly (cf. Julian Imperator, *Epist.*, 8; Nicephor. Gregor. *Hist.* VIII, 7). Among the many attractive compositions on gold rings of the late fifth and the fourth century B.C. may be mentioned a Kassandra in New York (fig. 355) and a young rider in London,[16] the latter comparable to the horsemen on the coins of Taras.

A special class of Greek fifth- and fourth-century gems are the so-called Graeco-Persian, probably engraved by Greek artists for Persian clients. They closely resemble the gems found in Ionia, except for the subjects

GRAECO-PERSIAN GEMS

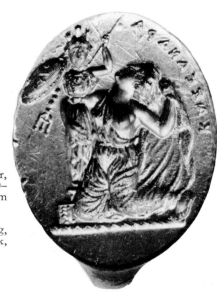

354. Head of a man. Jasper, by Dexamenos, *c.* 420–400 B.C. Boston, Museum of Fine Arts.

355. Kassandra. Gold ring, *c.* 400–380 B.C. New York, Metropolitan Museum.

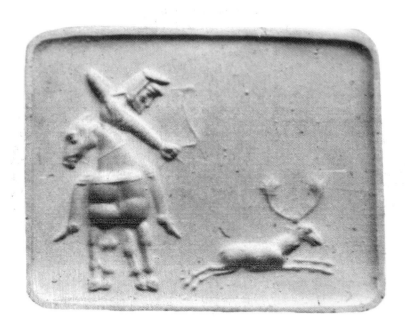

356. Persian hunting. Graeco-Persian chalcedony, second half of fifth century B.C. New York, Metropolitan Museum.

which are Persian. Persian nobles in hunting scenes (cf. fig. 356) or in combats with Greeks, single figures of Persian men and women, Eastern animals, and occasionally monsters are executed in the broad, spirited, facile style characteristic of Ionia, with occasional foreshortening. A certain Oriental flavour in the representations may be explained by the fact that the stones were made for Persians and so had to suit the taste of the owners.

The chief form of these Graeco-Persian gems is, as in Ionia, the scaraboid. A rectangular stone with one side faceted, and an oblong four-sided stone also occur. Bluish chalcedony is the favourite material. These gems have been found over a large area—in Persia, Asia Minor, Lydia, Anatolia, Southern Russia, Greece, and even as far East as India. This wide distribution is explained by the fact that Persians travelled extensively, taking their sealstones with them, and by the active commerce of the time. The majority of the stones were doubtless executed in Persia, for the representations show an intimate knowledge of Persian life and dress—more so than do the Persians depicted on Attic vases; and it is known that many Greeks resided in Persia during this period. Occasionally helpful comparisons can be made between gems and coins, and they again suggest Greek workmanship.

Another class of gems of the developed period related to the Greek is the Etruscan. But, although in the archaic period Etruscan scarabs closely resembled the Greek (cf. p. 247), in the second half of the fifth century and later, the difference between the two is more marked. They now, in fact, form a distinct class, dependent on Greek models, but evidently executed by local artists.

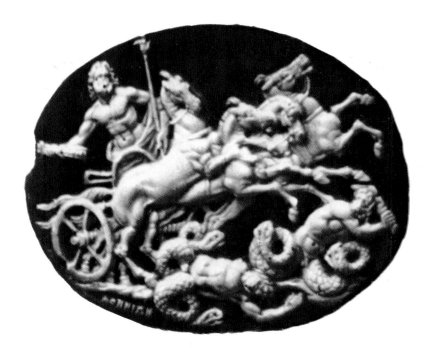

357. Zeus downing giants. Sardonyx cameo by Athenion, third to second century B.C. Naples, Museo Nazionale.

The gems of the Hellenistic period show the variety of styles and subjects current in the sculptures of the time. Some display strong realism, others almost exaggerated softness; still others imitate the archaic style. The artists of that epoch had a great wealth of materials at their disposal, for the resources of the East had been made available by the conquests of Alexander the Great. The favourite stones are the hyacinth, garnet, beryl, topaz, amethyst, rock crystal, carnelian, sard, agate, and sardonyx. Chalcedony still occurs, but is no longer common. Glass was popular. The stones are occasionally quite large and the design is often cut on the strongly convex side of the gem. Metal rings with engraved bezels are more frequent than before.

Among mythological subjects, Dionysos and Aphrodite and their followers—Satyrs, Maenads, Eros, Psyche, and Hermaphrodite—are the most popular. Egyptian divinities, like Isis and Sarapis, now make their appearance. The head of Medusa is another favourite. Representations of vases and utensils, animals, masks, and symbols also occur. Subjects taken from daily life are less common than in the preceding period, except portraits, which now assume importance.

An innovation of this epoch was the cameo, in which the design was worked in relief instead of in intaglio. The material generally employed was the sardonyx, the various layers of which were utilized with great ability. Occasionally, semi-precious stones were employed for works in the round—statuettes, busts, and vases. They, as well as the cameos, became common in Roman times.

The names of several Hellenistic gem engravers are known from their signatures. One of the foremost is Athenion, who engraved a

HELLENISTIC PERIOD, ABOUT 300—100 B.C.

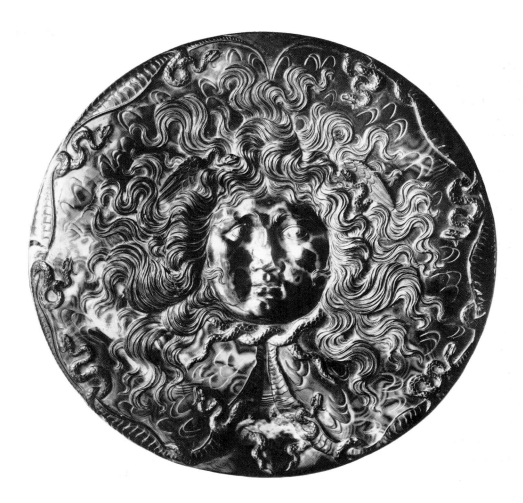

358. Medusa. Sardonyx cameo, third to second century B.C. Naples, Museo Nazionale.

sardonyx cameo, in Naples, with Zeus in his chariot downing giants (fig. 357). Boethos signed a stone with an emaciated Philoktetes;[17] Gelon an Aphrodite arming;[18] Onesas an Athena, a Muse tuning a lyre, and a head of Herakles.[19] Among the portraitists Herakleidas and Agathopous are outstanding, the former for the head of a Roman on a gold ring in Naples.[20] An artist named Pheidias represented a youth putting on his greave and gave him the features of Alexander the Great.[21] No stone signed by Pyrgoteles, who according to Pliny was the favourite engraver of Alexander, has been preserved.

Several superb cameos can be attributed to the Hellenistic period. Two, in Vienna and Leningrad, show portraits perhaps of Alexander and his mother Olympias.[22] Another masterpiece is the so-called Tazza Farnese in Naples, which has on one side a mask of Medusa (fig. 358), on the other Nile and other figures, the whole executed in sardonyx.[23] A large two-handled cup in Paris, cut entirely in sardonyx, has reliefs representing the paraphernalia of a banquet.[24]

A special class of Hellenistic gems was produced in Italy. They are called Italic to differentiate them from the purely Greek. Two styles can be distinguished; one carries on the Etruscan tradition, the other

the Greek. The Etruscanizing gems show their dependence on Etruscan art in both style and subjects. The archaic and developed styles of Etruria are copied in a somewhat dry manner. Among the subjects Greek heroes are particularly common; also warriors, horsemen, and artisans. In addition, religious ceremonies play an important part, especially sacrificial scenes and the consultation of oracles.

The Hellenizing group resembles the Greek Hellenistic products in style and content. Erotic and Bacchic figures are popular, as well as scenes from daily life. The execution is generally facile, but rarely of great artistic merit. In a few cases the same design occurs on a gem and on a coin of the period.

Engraved gems enjoyed a great popularity in the late Republican and FIRST Roman imperial periods. In fact, more gems of this epoch have survived CENTURY B.C. than of any other. And since the great majority of the designs are of Greek origin—Greek deities, heroes, and myths, as well as portraits of Greek philosophers and orators (cf. fig. 359)—Roman gems have become an important source for our knowledge of Greek art. Of special interest are the reproductions of Greek statues that have survived also in marble copies. The representations on the gems often have the advantage of showing the figure complete instead of fragmentary, as so often in marble sculptures. For instance, the Athena Parthenos by Pheidias (fig. 148), the Doryphoros and Diadoumenos by Polykleitos, the Diskobolos by Myron, the Sauroktonos by Praxiteles, the Pothos by Skopas, and the Apoxyomenos by Lysippos are all shown on Roman gems in complete and reliable compositions.

It is also sometimes possible to recognize famous Greek paintings or reliefs in the compositions on Roman gems. Thus the Rape of the Palladion by Diomedes and Odysseus—represented also on plaster casts from Begram (cf. p. 227), on a Roman sarcophagus, and on the gem signed by Felix[25]—must reproduce a Greek composition, possibly the embossed relief by Pytheas mentioned by Pliny (XXXIII, 156), or a sculptural group.[26]

Furthermore, Roman gems constitute an important source for our knowledge of Roman portraits. Excellent examples are preserved, ranging from the late Republican and the Julio-Claudian epochs to the later imperial. They are sometimes signed, and the names of the artists are practically always Greek—Agathangelos, Aspasios, Epitynchanos, Euodos, Dioskourides, Hyllos, and so forth. Some of the portraits occur in cameos, in elaborate compositions comprising several figures. Augustus and the goddess Roma appear seated side by side on two large cameos in Vienna,[27] one in a composition with other members of the imperial family.

Thus the continuation of Greek art into Roman times is made specially clear in this branch of art.

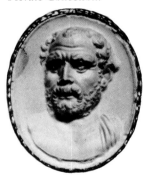

359. Head of Demosthenes. Amethyst ringstone. Private Collection.

CHAPTER 8

COINS

The coins of Greece are in some ways her most characteristic product. The independence and at the same time interdependence of her many city states are reflected in the variety of the designs and in the similarity of their successive styles. Coinage was a Greek invention. Egypt and Mesopotamia had indeed used metal bars (ingots) for purposes of exchange; but to stamp a piece of metal with a specific mark guaranteeing its purity, weight, and value was introduced, it seems, by the Ionian merchant cities in the seventh century B.C.—probably after 650 B.C.[1] At first a simple mark, such as an incuse square, served the purpose; but it is typical of Greece that these simple pellets were soon transformed into artistic emblems. Each city chose an appropriate design—at first generally the symbol of its local deity—an animal, a plant, or other object—later the head or figure of the deity itself, of a favourite hero, or a mythological group.

The figured design appeared at first only on the obverse of the coin, but before long (around 500 B.C.) both sides were so decorated. The technique needed considerable skill. An intaglio design was carved on a thick metal disk which was fitted into a corresponding depression on the top of the anvil. A blank disk of the correct weight was then heated until sufficiently malleable and placed over the die on the anvil. A punch with the other intaglio design on its lower face was adjusted on the heated disk and hammered in, producing the two-faced coin. Reverse and obverse often do not correspond with each other in direction, and sometimes, when the disk or punch had not been properly adjusted, the design came out only in part. Since considerable wear was involved in this technique, especially in the punch with the reverse, new dies frequently had to be made. This circumstance has been our gain, since it afforded an opportunity for constant variations reflecting the development of Greek art.

In addition to the chief emblems or 'types', accessory symbols were used, each of which had a specific meaning; sometimes it referred to an official, or, when a similar emblem was adopted by several cities which had entered into a monetary union, a characteristic symbol was used as a distinguishing mark by the individual cities.

The chief materials employed for Greek coins were electrum (a natural alloy of gold and silver), gold, silver, and bronze. Greek coins are thick compared to modern ones, and too irregular for stacking.

Different cities used different denominations. Thus, in Athens the unit of value was the drachma, divided into obols; in Corinth and other communities it was the stater, divided into drachmas. Cities which were closely connected by commerce generally used the same weight-standard. The chief standards for the silver coinage were the Aeginetan and the Euboic; in addition, there were many local ones.

Inscriptions, generally in abbreviated form, often make it possible to assign coins to specific cities. They give the name of the people by whom the coins were issued, and, in some cases, of the official responsible for the issue. A few coins can be dated by historical events, for instance, the Syracusan demareteion of 480–479 B.C., struck after the victory over Carthage (fig. 360), and the decadrachms of Syracuse, struck to celebrate the victory over Athens in 413 B.C. Occasionally, as in the gems, artists added their signature, either entire or the initial letters, with or without 'made it'. Kimon, Euainetos, Eumenes, Herakleidas, Eukleidas, Myr(on), Polykrates, Phrygillos, Sosion, Theodotos are some of the eminent artists whose names have survived.

Many thousand Greek coins have come down to our day, and one may ask why, since the metal was precious and could have been re-used. The answer is that the ancient Greeks, not having bank accounts, were in the habit of burying their savings. These hoards, brought to light in modern times, have yielded many of the coins known to us today; and they have furnished us with original Greek designs of all periods. Some are of great beauty, skilfully adapted to the circular field. Moreover, they can teach a useful lesson. Though each city had its individual emblem, the various representations follow the common evolution from archaic to naturalistic; and, except for the broad divisions of East Greece, Mainland Greece, and the West—observable also in sculpture—the style is in most cases markedly similar.[2]

A few typical examples, in chronological sequence, may serve to illustrate this.

The lion's head on an electrum stater of Asia Minor[3] (c. 650 B.C.), large-eyed, open-mouthed, and with teeth and tongue showing, recalls the fierce seventh-century lions by the Nessos Painter (cf. p. 327), and the statues from Corfu, Samos, Miletos, and Delos (cf. fig. 62). The city which minted the design is not definitely known, for, as is mostly the case in the early archaic period, no inscription indicates the origin. Some numismatists attribute the coin to Smyrna.

The mid-sixth-century staters introduced by Croesus of Lydia, with foreparts of a lion and of a bull facing each other,[4] were the first pure gold coins to be minted. The lion has become tamer than his seventh-century precursor, and may be compared with the lions on the François vase and on vases by Sophilos (cf. pp. 330ff.). It was the time of the tyrant Peisistratos whose encouragement of commerce is reflected in

ARCHAIC PERIOD, ABOUT 650–480 B.C.

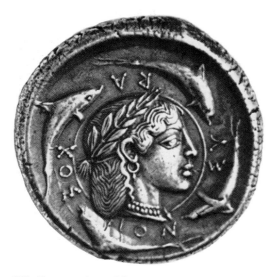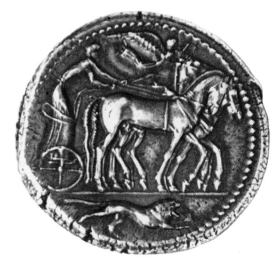

360. Demareteion of Syracuse, *c.* 479 B.C. London, British Museum.

the sudden abundance of Athenian coinage bearing the head of Athena and an owl as emblems. These two emblems remained constant on Athenian coinage, even somewhat in style, for in the later issues there is a tendency to archaize—as was natural in a community with a far-flung commerce. A few landmarks, however, exist, as, for instance, the head of Athena with a laurel wreath and palmette scroll on the helmet, issued probably after the battle of Marathon in 490 B.C.

The silver staters of Kaulonia and Poseidonia (cf. figs. 361, 362) present a series of striding figures in which the evolution of the profile and three-quarter views in the late archaic epoch can be paralleled to those on the stone reliefs and vases of the time. Particularly significant is the rendering of the abdominal muscle, first with three transverse

361. Silver Stater of Poseidonia, *c.* 525.515 B.C. London, British Museum.
362. Silver Stater of Kaulonia, *c.* 500 B.C. London, British Museum.

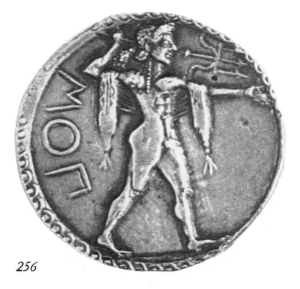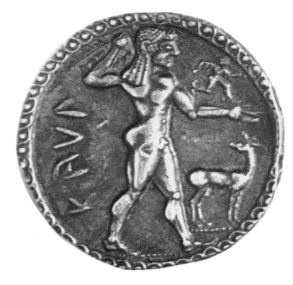

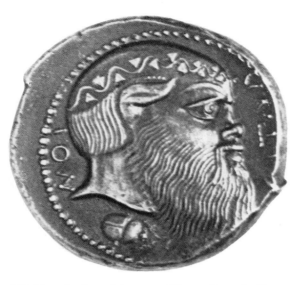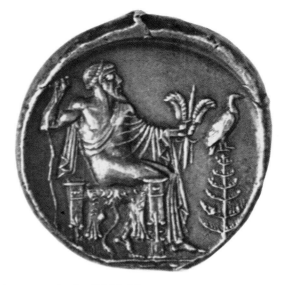

363. Tetradrachm of Aetna, *c.* 470 B.C. Brussels. From an electrotype in the British Museum.

divisions above the navel, then with two, at first placed in full front view, then shifted to one side (cf. p. 92).

In the early classical period the tetradrachms of Aetna (*c.* 470 B.C.) recall in stateliness the Olympia pedimental figures. On one side is the head of a silenos, on the other the enthroned Zeus and, in front of him, a pine tree with an eagle perched on it (fig. 363).

A decade or so later, Sicilian Naxos struck the tetradrachm with the head of Dionysos on one side and a squatting silenos on the other (fig. 364)—another Sicilian masterpiece. The composition of the silenos with trunk in almost full front view, but with some foreshortening, recalls the audacious compositions in contemporary sculptures (cf. pp. 111 ff.).

CLASSICAL PERIOD, ABOUT 480—330 B.C.

364. Tetradrachm of Naxos, Sicily, *c.* 460 B.C. London, British Museum.

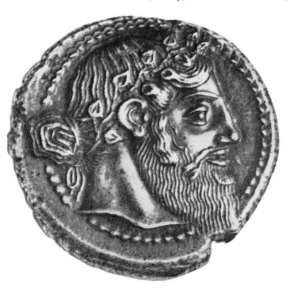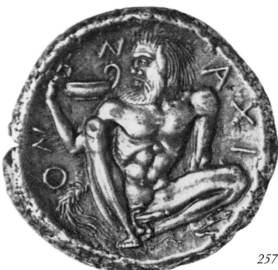

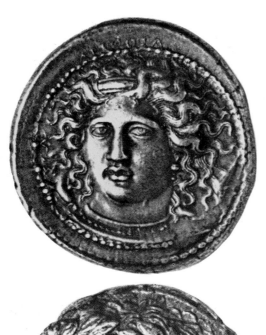

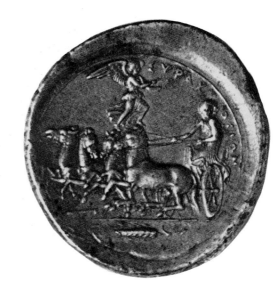

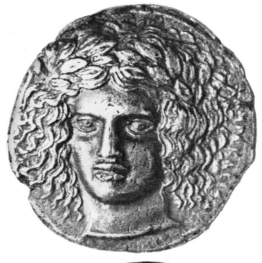

365. Tetradrachm of Syracuse by Kimon, *c*. 415–400 B.C. London, British Museum.

366. Tetradrachm of Katane, by Herakleidas, *c*. 415–400 B.C. London, British Museum.

367. Decadrachm of Syracuse, by Euainetos, *c*. 413–400 B.C. London, British Museum.

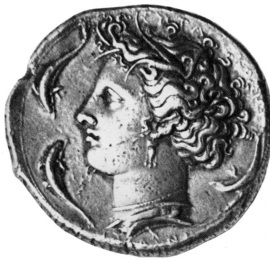

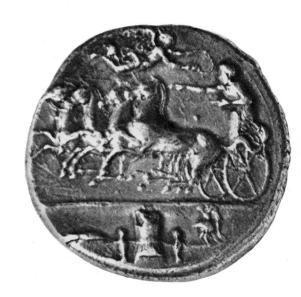

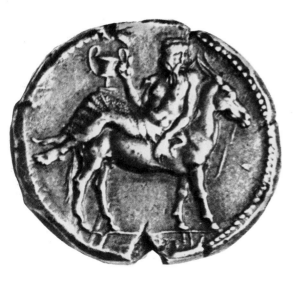 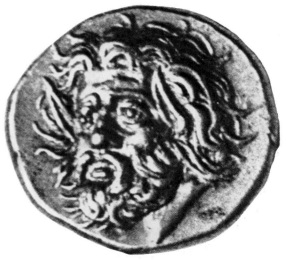

The splendid series from Sicilian and South Italian cities with a head on the obverse and a chariot on the reverse begins around 480 and continues to the end of the century. Several of the later coins are signed by their makers—Herakleidas, who put his name on a tetradrachm of Katane with a frontal head of Apollo (fig. 366) and a quadriga (*c.* 415 B.C.); Eukleidas, who signed a tetradrachm of Syracuse with a quadriga and the head of Athena in three-quarter view (*c.* 412 B.C.), perhaps reproducing the Athena Parthenos; Kimon, who made the magnificent head of Arethusa in three-quarter view and the galloping quadriga on a tetradrachm of Syracuse (410 B.C.), (fig. 365); and Euainetos, the maker of one of the famous decadrachms of Syracuse with the head of Arethusa in profile on one side, and an advancing quadriga on the other (fig. 367). The armour in the exergue of some of the chariot scenes represents, it is thought, the prizes given at the games instituted to celebrate the victory over Athens in 413 B.C. Here too belong the decadrachms of Akragas with a youth driving his chariot on the obverse, signed by Myr(on), and the eagles and hare on the reverse, signed by Polykrates (*c.* 408 B.C.). The signatures are affixed in inconspicuous places, just as on the engraved gems (cf. p. 247). The compositions are enriched by subsidiary figures— Nike crowning the charioteer, dolphins surrounding the head of Arethusa, an eagle flying above the chariot, a grasshopper in the field with the two eagles. Each has a specific meaning, and at the same time plays its part in the composition.

These coins mark the acme of the power of Sicily and Greek Southern Italy before the defeats inflicted by Carthage. Concurrently, beautiful designs were produced in Northern and Eastern cities, such as the Dionysos riding an ass (fig. 368) on the tetradrachms of Mende in Macedonia, and the almost frontal head of Helios on tetradrachms of Rhodes.[5]

368. Tetradrachm of Mende, Macedonia, *c.* 450–425 B.C. London, British Museum.

369. Coin of Pantikapaion, Crimea, *c.* 350 B.C. London, British Museum.

259

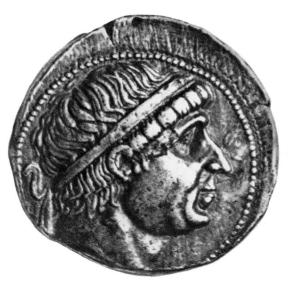
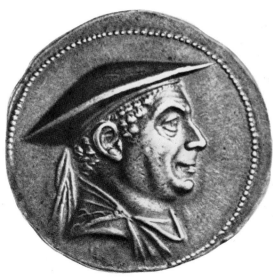

370. Antiochos I of Syria, *c.* 280–260 B.C. London, British Museum.

371. Antimachos of Bactria, *c.* 185 B.C. London, British Museum.

A high standard of workmanship continued into the fourth century B.C., as exemplified by the seated Pan and the head of Zeus on the coins of the Arcadian Confederacy of 370 B.C.,[6] as well as by the remarkable head of a satyr in three-quarter view (fig. 369) on the coins of Pantikapaion in the Crimea, comparable to heads on vase-paintings.[7]

HELLENISTIC
PERIOD
In the latter part of the fourth century a new chapter opens. In the East the conquests of Philip and of Alexander of Macedon ended the independence of many of the Greek city states. Vast territories now came un!er the rule of a single government; and though after Alexander's death the empire he had created was broken up into three large divisions, they too were controlled by royal houses—the Antigonids in Macedonia, the Seleucids in Syria, and the Ptolemies in Egypt. In many cases the various states continued to use their characteristic types on the reverses of their coins, but they are often only pale reflections of those of former days. There is, however, one development that lends special interest to Hellenistic coinage. On the obverses there begin to appear portraits of the rulers—first of Alexander, then of his successors. It was the first time that this had happened, except for a few heads of Persian satraps, struck in Asia Minor toward the end of the fifth century B.C.[8] It now became a regular practice, especially in the Asiatic kingdoms. The heads on these coins present us with original Greek portraits during more than two centuries. Moreover, since they can often be precisely dated, they shed light on the development of Greek portraiture. The heads of some of these able rulers, of Philetairos of Pergamon,[9] for instance, of Antiochos of Syria (fig. 370), of Perseus of Macedon (fig. 372), and especially of Euthydemos and Antimachos of Bactria (fig. 371)

and of Mithradates III of Pontos, represent the best that was achieved by Greek artists in realistic portraiture.[10]

In Greece proper these regal coins were not used. A semblance of independence was retained, and in the Peloponnese there is the interesting phenomenon of a federal currency used by all the members of the Achaean League, with the head of Zeus on the obverse of the silver coins, and the Achaean monogram on the reverse, and with the name, initial, or symbol of the individual city which struck the coin.

In Italy the successive defeats inflicted by Rome on the Greek cities of the South had the same effect which the Macedonian conquests had in the East. One by one the independent cities were absorbed by Rome. The same fate befell Greece herself in 146 B.C. Athens and a few other cities were allowed for a time to continue their coinages. With the establishment of the Roman empire in 30 B.C., however, Greek coinage came to an end. Nevertheless, it left its mark on its successor; not only was the custom of placing the head of the ruler on the obverses retained —which is responsible for a series of excellent portraits of Roman emperors—but there often appear reproductions of Greek sculptures on the reverses. Some of the most famous Greek statues, such as the Zeus at Olympia by Pheidias, are known to us solely through the medium of Roman coins and gems (cf. figs. 149–151).

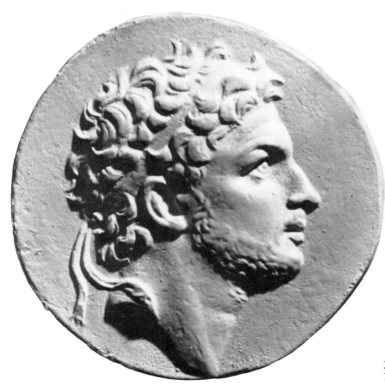

372. Perseus of Macedon, *c.* 178–168 B.C. London, British Museum.

CHAPTER 9

JEWELLERY

Like engraved gems and coins, jewellery forms, so to speak, part of the sculptural arts; for here too the Greek love for plastic decoration is evident. Instead of relying on coloured stones for effect, Greek jewellers worked the gold itself into all manner of shapes. This ductile material, which in antiquity was obtained chiefly from the river beds of Asia Minor, Thrace, and Russia, and was often used in its soft, pure state, offered indeed many opportunities for artistic work. Modelling, casting, repoussé, cutting, granulation (decoration with tiny balls, set either in a pattern or over the whole surface), filigree (decoration with thin wire), plait work, inlay, and chasing were all practised with great skill. In many of these techniques Egyptian and Mesopotamian jewellers had been proficient before the Greeks, and the Greeks doubtless learned much from them.

Gold was of course not the only metal used by the Greeks in their jewellery. Silver was also employed, but much has by now disappeared, or survives only in a corroded state. Gold, on the other hand, is not affected by dampness, and has often been preserved practically intact. Only the enamel that was once introduced as a discreet colour note is generally missing; when well preserved, as in some examples from the Crimea and now in Leningrad, it adds much to the general effect. Electrum, a natural alloy of gold and silver, was popular in early jewellery, as it was in coins (cf. p. 254). In addition, less precious materials, such as bronze, lead, and iron, were used, especially for rings and bracelets; and in tombs gilt terra-cotta jewellery is sometimes found, as a cheap substitute for the genuine article.

Our knowledge of Greek jewellery is derived first and foremost, of course, from the actual pieces that have been found in tombs and sanctuaries—the diadems, necklaces, earrings, bracelets, pins, buttons, and other objects. The jewellery sometimes represented on sculptures and in paintings has shown how these various pieces were worn, and has supplied evidence for dating. Occasional references to jewellery by ancient writers have supplemented this knowledge. Further helpful information has been gleaned from inscriptions, especially the inventories of temples and the accounts of priests, that have been found in Athens, Delos, and Rhodes. They mention among other precious objects: gold and silver crowns; gold crowns of laurel, myrtle, ivy, olive, oak, vine; finger rings of silver or gilt iron, of bronze, silver, and gold, either

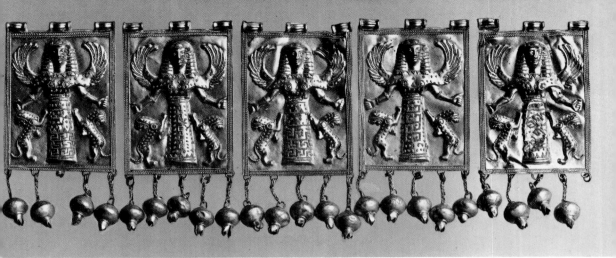

plain or set with stones; bracelets of gold and silver; pins; buttons of gold, silver, bronze, and iron; earrings; diadems; necklaces with pendants of different forms; and so forth. It was evidently customary to offer to the gods precious ornaments together with gold and silver metalwork (cf. p. 209). Even when the people themselves were comparatively poor and did not themselves wear rich jewellery—as was undoubtedly mostly the case on the Greek mainland in early times—the gods received their due. Moreover, temples in ancient times often served as treasuries where valuable objects were placed; though many were later melted down in times of stress.

The decorations on Greek jewellery show the same development from period to period as do the other classes of Greek art. Human and animal figures are represented first in generalized form, then according to fixed conventions, and finally naturalistically. Moreover, the repertoire also changes. The compositions are simple at first, gradually they become more complex, a wealth of motifs being sometimes combined in a single, sumptuous design.

Comparatively little jewellery of the geometric period has been found. It consists chiefly of strips with embossed decorations, fibulae with incised ornaments on bow and quadrangular catch, pins, and necklaces with simple pendants. They have come from Attica, the Peloponnese, and elsewhere.

In the seventh century, on the other hand, there was a rich output, both in Greece proper, and especially in the wealthy communities of Asia Minor and the Islands. In Rhodes (and elsewhere) have been found decorated gold and silver plaques, some with loops along the top, apparently parts of necklaces and diadems. Among the embossed decorations favourite motifs are a Centaur and a winged goddess (fig. 373) in a frontal position, wearing a foldless, belted garment, and with hair arranged in 'Daedalid' fashion, like the sculptures of the period (cf. fig. 58). She is the great goddess of beasts—a primitive Artemis—and

373. Gold plaques from Rhodes with winged goddess, seventh century B.C. London, British Museum.

ABOUT 900–600 B.C.

374. Electrum rosette from Melos, seventh century B.C. Athens, National Museum.

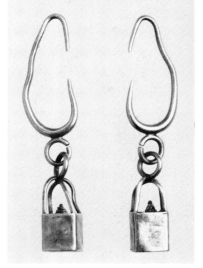

375. Earrings, seventh to sixth century B.C. New York, Metropolitan Museum.

so is holding in both her hands lions or birds of prey. The hawk and the bee were sacred to her and sometimes accompany her.

From the Islands of Thera, Melos, Delos, and Rhodes have come delicately worked electrum and silver rosettes (cf. fig. 374), perhaps originally parts of diadems, necklaces, or earrings, or ornaments sewn on garments. Each petal is decorated with a smaller rosette, on which is perched another ornament, and in the centre is a griffin's head or bird or still another rosette. Disk earrings, with long, looped pendants terminating in griffin's heads, have been found in Melos and Rhodes; also attractive pins with decorated heads, not unlike our modern hatpins. More elaborate and larger pins ending in a knob, with one or more disks beneath, have come to light on a number of early sites, for instance, at the Argive Heraion, at Perachora, on the Athenian Akropolis, and at Ephesos.

Earrings in the form of a crescent, with a large hook and a long pendant ending in a cage-like member (cf. fig. 375), are datable in the seventh to sixth century. Examples have been found in Sardinia, as well as in Cyprus, Rhodes, and Carthage. They are, therefore, generally referred to as Phoenician.

The tombs of Etruria and of Cyprus, Iberia, and other non-Greek localities have yielded sumptuous jewellery of this period, testifying to the wealth of their peoples during the seventh century B.C. Here too the Orientalizing influence apparent in the Greek art of this time is observable. Whether it came to Etruria through contact with Greece, through commerce, or through direct relations with the East is still a moot question.

ARCHAIC PERIOD, ABOUT 600—475 B.C. Relatively few examples of jewellery of the archaic period of the sixth and the early fifth century have been found in Greece, though on the sculptures and vases of that time diadems, necklaces, earrings, and bracelets are often represented. Perhaps the looting during the Persian wars may explain this lack to some extent. The examples that have

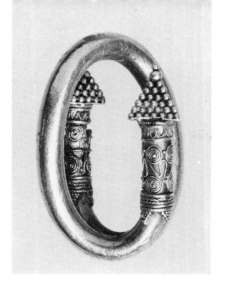

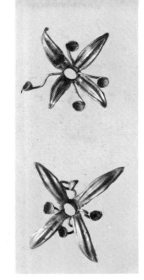

376. Earring, *c.* 500 B.C. New York, Metropolitan Museum.

377. Gold flowers from Delphi, sixth century B.C. Delphi, Museum.

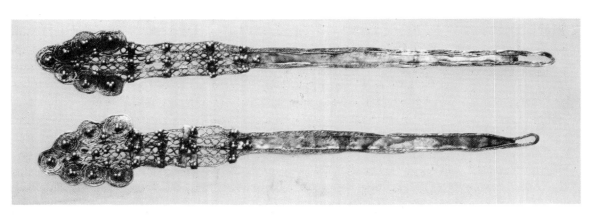

378. Ornamented gold bands, from Chalkidike, perhaps sixth century B.C. Collection of Mrs. Hélène Stathatos, Athens, National Museum.

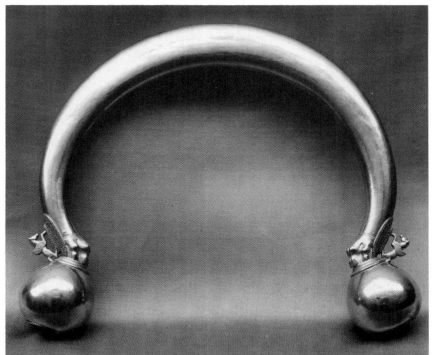

379. Gold diadem from Vix, *c.* 500 B.C. Châtillon, Musée archéologique.

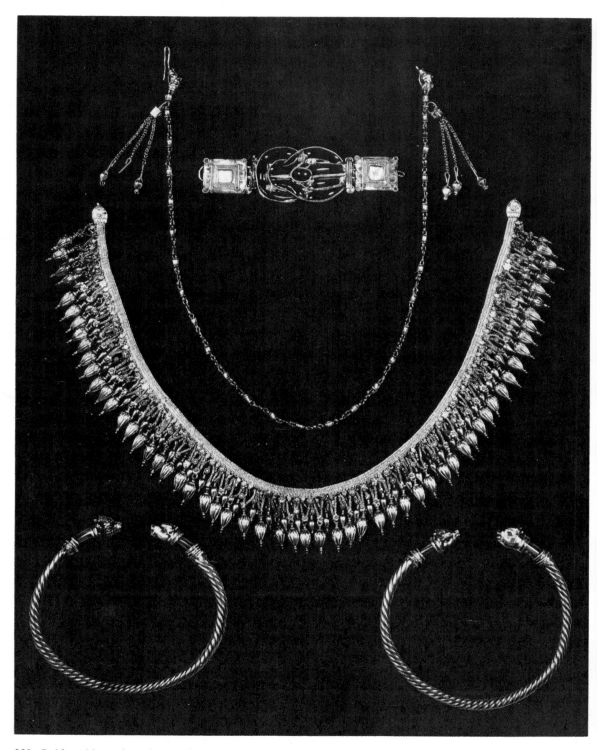

380. Gold necklaces, bracelets, and a clasp. Fourth to third century B.C. London, British Museum.

survived consist chiefly of plaques with stamped ornaments, not unlike
those of the seventh century, and of earrings of sturdy forms. Among
the latter a common type is a spiral terminating at both ends in human
or animal heads, or knobs, or pyramids of granules (fig. 376). The
collars are sometimes decorated with filigree. As the spiral is generally
too thick to pass through the lobe of the ear, it must have been suspended
from a ring or hook. Another earring current at this period is boat- or
leech-shaped with a large hook and sometimes with box-like pendants,
decorated with filigree and granulation. Heavy bracelets ending in
animals' heads and various fibulae have come to light on various sites.
Delicate little gold ornaments in the form of flowers (fig. 377) formed
part of the treasure trove found at Delphi (cf. p. 55).

Several unusual pieces from outside Greece proper have also been
assigned to this period. A number of gold bands, ornamented with
openwork filigree spirals and other motifs (cf. fig. 378), are said to
have come from Chalkidike and are now mostly in the collection of
Mrs. Stathatos in Athens. They have by some been interpreted as
bracelets but were more probably decorations (on uniforms?).[1] A gold,
torque-like diadem terminating in large globules and with Pegasoi at
the junctures (fig. 379) was found at Vix, in the same tomb as the large
krater (cf. fig. 302). The type of diadem is foreign to Greece, whereas
the Pegasoi seem to be of Greek workmanship.

In the jewellery of the fifth century and especially in that of the fourth CLASSICAL
and third centuries B.C. Greek taste shows itself in developed form. AND HELLENISTIC
The tombs of Northern Greece (Thessaly, Macedonia, Thrace), Southern PERIODS,
Russia, and Southern Italy have yielded abundant material in the form ABOUT 475–100 B.C.
of crowns (including wreaths and diadems), necklaces, bracelets, earrings,
finger rings, pins, and plaques (cf. fig. 380).

The chief characteristic of this jewellery is the frequent use of human
and animal motifs, and of filigree work in elaborate, minutely worked
designs. As always in Greek art, a few basic forms were adopted and
constantly varied in detail. The chief were:

(1) Crowns and wreaths, either simulating naturalistic forms of leaves
and flowers—such as oak, laurel, ivy, and myrtle—or stylized and consisting
of flat bands with embossed patterns. The crowns were used as prizes
(*I.G.* I, no. 59), were worn in processions (cf. Demosthenes, *c. Meid.*,
522), and were dedicated in tombs and sanctuaries (*I.G.* II, 645).
The leaves are mounted on hollow tubes, reinforced with pitch or wax
(materials mentioned in temple inventories).

(2) The earrings present great variety. Several of the earlier types
were retained, but were now often richly decorated. Thus the spiral
earrings end in human and animal heads, and the leech form is elaborated
by the addition of pendants, or is converted into a crescent, ornamented
with filigree, figures in the round, and pendants. To the early disk

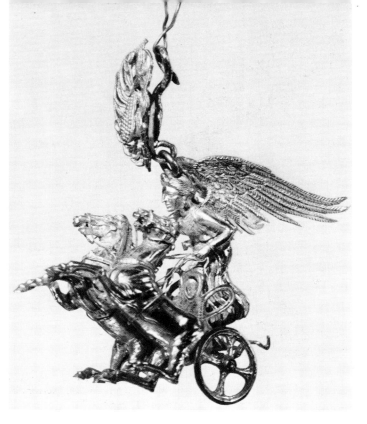

381. Gold earring, *c.* 350–325 B.C. Boston, Museum of Fine Arts.

382. Gold earrings, fourth century B.C. New York, Metropolitan Museum.

383. Gold earrings, *c.* 350–325 B.C. New York, Metropolitan Museum.

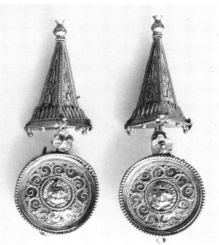

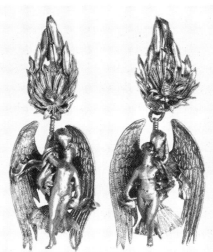

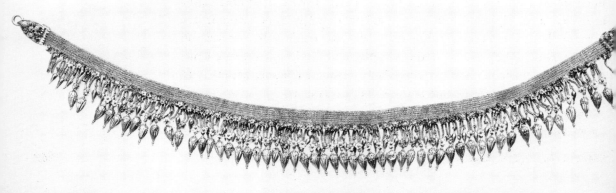

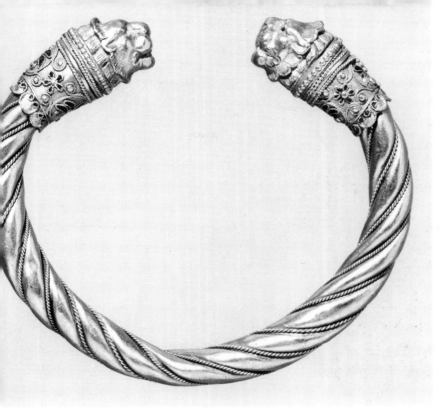

385. Bracelet, *c.* 350–325 B.C. New York, Metropolitan Museum.

type are likewise added all sorts of pendants, pyramidal (fig. 382), human and animal; Erotes, Nikai, and birds are especially common. A pair of disks from Kerch have an embossed head of the Athena Parthenos, from which hangs a network of chains with pendants and rosettes.[2] Each disk is 7.3 centimetres in diameter.

Sometimes the disk and leech forms are combined into one composition comprising figures in the round, pendants, and filigree work. Or the disk is changed into a palmette from which are suspended elongated members or minute sculptural groups. Outstanding among the latter is a Nike driving a two-horse chariot, now in Boston (fig. 381), and a group of Ganymede with the eagle, in New York (cf. fig. 383 and p. 271).

Especially common is the ring type of earring with one end in the form of a human or animal head, the other attenuated into a hook; the hoop itself is either plain or spirally wound.

(3) The necklaces fitted snugly round the neck and consisted of a finely plaited ribbon, or 8-shaped links, or beads, with decorated clasps at the ends (cf. fig. 384). Often they are encircled with pendants in the form of heads or other motifs; the joints are masked by rosettes, in the petals of which traces of the original blue, red, and green enamel sometimes remain. Among the pendants elongated beads, acorns, and amphorae are common; some perhaps were talismans.

(4) The most common type of bracelet is a massive hoop terminating at either end in an animal's head, often with a decorated collar (fig. 385).

384. Necklace, *c.* 350–325 B.C. New York, Metropolitan Museum.

The motifs favoured are heads of lions, bulls, and rams. Specially fine examples from Kerch have foreparts of sphinxes.[3] The hoop might be gold or silver or bronze (gold- or silver-plated), or crystal (see p. 271), and is either plain, or consists of spirally wound wires, or of a string of plaques. Sometimes the bracelet is so large that it must have been worn on the upper arm—as often represented in sculptures and vase paintings.

(5) Greek finger rings have been discussed in the chapter on engraved gems, for their gold and silver bezels were often engraved with a design. The forms of the rings went through several stages of development.

(6) Pins are another common article of classical Greek jewellery. Some are plain, others have decorated knobs in the form of a head or a statuette or a fruit. An exceptionally elaborate one, now in Boston, is shaped as a capital, enriched with rampant lions, plants, and bees, all worked with great delicacy (fig. 386). The pin itself (now mostly missing) terminates above in two round knobs, which have taken the place of the former disks.

The safety-pin, so popular in early times, became less frequent in the postarchaic period; but beautifully wrought examples of the fifth and fourth centuries B.C. have been found in South Italy; they consist of a semicircular bow and an elongated catch decorated with filigree

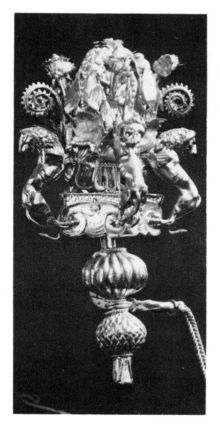

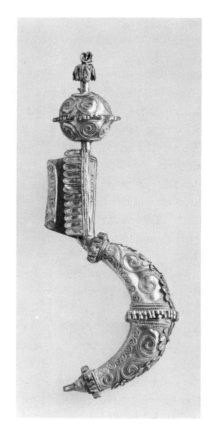

386. Gold pin head, fifth century B.C. Boston, Museum of Fine Arts.

387. Safety-pin from South Italy, fourth to third century B.C. New York, Metropolitan Museum.

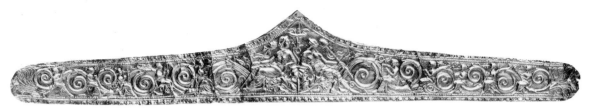

(cf. fig. 387), and sometimes terminating in a human head. Still other pins are in the form of brooches with rounded disks, used for fastening garments.

(7) A large number of small gold plaques of various forms have occasionally been found in tombs. They have holes at the corners and had evidently been fastened to garments which have disappeared.

In addition to single examples of Greek jewellery, a number of ensembles have come to light in various localities. A set, said to have come from a tomb on the Hellespont and now in New York, includes a diadem, a necklace, a pair of earrings, and a finger ring. The diadem is especially noteworthy. It has an embossed design composed of several figures—Dionysos and Ariadne in the centre, flanked by arabesques and female figures making music—executed in late fourth-century style (cf. fig. 388).

Another set in New York, said to be from Macedonia, consists of a necklace, two bracelets with crystal hoops, a finger ring, four fibulae, and two earrings (cf. fig. 383). The latter are remarkable. Each consists of a palmette, with two layers of leaves and a central fruit, from which is suspended a minute sculptural group of the eagle of Zeus carrying off young Ganymede. The figures are cast solid; Ganymede's drapery, the wings and tail of the eagle are made of hammered sheets; the feathers are chased. Each leaf of the palmette is edged with a beaded wire, and the fruit is covered with granulation. All the techniques perfected by long experience have here been combined to form a goldsmith's master-piece. The date may be computed from the fact that a necklace similar to that in this set was found at Corinth with coins assignable to about the time of Alexander's death (323 B.C.).

Other sumptuous parures have come to light in Southern Italy (Cumae, Ruvo, Taranto), Thessaly, and South Russia. An ensemble from Thessaly is particularly remarkable. It consists of a number of largish medallions, with busts of deities, framed by ornamental bands, to which is attached a network of small chains (cf. fig. 389). Their purpose is not certain; it is thought that they served as lids of round boxes. In the same set was a little shrine, with a sculptural group of Dionysos and a satyr in high relief (cf. fig. 320). Most of these objects are in the Stathatos and Benaki collections in Athens.

The pieces described above belong to the early Hellenistic period of the late fourth and the first half of the third century B.C., when the types evolved in the preceding epoch were continued. As time went on, however, came a significant change. With the help of the coloured stones that the conquests of Alexander had made easily available, pleasing effects could be obtained without the minute working of the metal itself. At first their use was restrained. A clasp in the British Museum with a 'Herakles knot' filled with strips of garnet, and a diadem in the Benaki Museum[4] are undoubtedly effective. But in the course of time, stress was laid more and more on multi-coloured stones, and inevitably the gold work deteriorated. Consequently, in the Roman period, when the Hellenistic Greek forms were largely retained, the workmanship is generally flimsy, though the colours of the inserted stones lend gayness to the general effect.

389. Medallion with chains, from Thessaly, third century B.C. Hélène Stathatos Collection. Athens, National Museum.

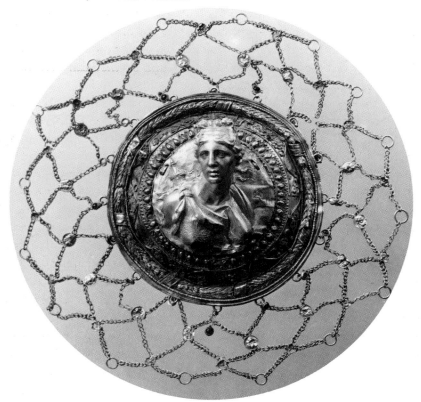

PAINTINGS AND MOSAICS

Paintings

In contrast to Greek sculptures, of which many important examples have been preserved, the major art of Greek painting, at least of the archaic and classical periods, has mostly disappeared. It is, nevertheless, possible to reconstruct its development, to some extent at least, from a number of sources. Chief of these are the painted decorations on pottery (described in the following chapter), which exist in quantity, and which often present subjects similar to those used in the larger paintings. They show the evolution of Greek drawing through its many phases from two-dimensional to three-dimensional representation in unbroken succession. Their technique, however, is entirely different from that of murals and panels, and so they can give only a limited visualization of what is lost.

Fortunately other evidence supplements our knowledge: (1) First of all, there exist after all a number of Greek painted decorations, mostly of the archaic and Hellenistic periods, such as scraps of archaic wall paintings, archaic wooden plaques, marble tombstones, terra-cotta metopes and pinakes, and Hellenistic murals from various sites. There have survived, furthermore, many mosaics with compositions similar to those in the paintings, though of course executed in a different technique (cf. pp. 289 f.). (2) The paintings from Etruscan tombs, many of which date from the sixth and fifth centuries B.C., and from Lucanian tombs of the fourth century, show strong Greek influence, and some were perhaps executed by immigrant Greek artists—a supposition which is now borne out by the recent discovery near Paestum of Greek paintings markedly like those found in the Etruscan tombs (cf. infra). (3) The colourful paintings on Hellenistic vases, particularly those from Centuripe, Canosa, and Hadra (cf. pp. 364 f.), can convey an idea of contemporary Greek wall paintings. (4) The murals and mosaics found in Rome, Pompeii, Herculaneum, Stabiai, and the near-by villas, as well as in Alexandria, dating from the first century B.C. and later, are many of them copies and adaptations of Greek originals. (5) Ancient writers often mention Greek paintings and painters and give accounts of them. Plato and Aristotle, for instance, occasionally furnish useful information, though in general terms. The Elder Pliny (d. A.D. 79) in his *Natural History* has given a consecutive account of the chief Greek painters. Pausanias in the second century A.D. still saw

many Greek murals in the public buildings and temples of Greece, and described some of them at length. Lucian's references to specific Greek paintings are sometimes of considerable value. And so on.

From this heterogeneous evidence the following evolution can be reconstructed: In the earlier periods Greek paintings were two-dimensional, like those of Egypt, with no attempt at foreshortening or linear perspective. The range of colours was limited—red (in various shades), black, blue, green, white, and yellow—and they were applied in flat, undifferentiated washes, without any attempt at modelling by light and shade. A decorative silhouette predominated, and emphasis was laid on beauty of line and rhythmic composition. In the course of the fifth century B.C. a more naturalistic scheme was gradually evolved. Foreshortening was introduced, as well as tentative perspective. Toward the end of the century the representation of the third dimension was further developed, the colours began to be mixed, and the forms modelled. These changes led to the realistic schools of the fourth and succeeding centuries.

This is the all-over picture. A few specific examples, in chronological sequence, will serve to illustrate it.

SEVENTH AND SIXTH CENTURIES B.C. The early terra-cotta metopes from Thermos can give an idea of late-seventh-century painting. The subjects are mythological, mostly single figures, painted in black, red, orange, and white, on a yellowish slip. Among the best preserved is the picture of a hunter shouldering his game, and Perseus running off with the head of Medusa (fig. 390).

A number of terra-cotta plaques with painted scenes of the prothesis or lying-in-state of the dead, found in Attica, provide examples of Greek pictorial art of the late seventh and early sixth century B.C. (cf. p. 233).

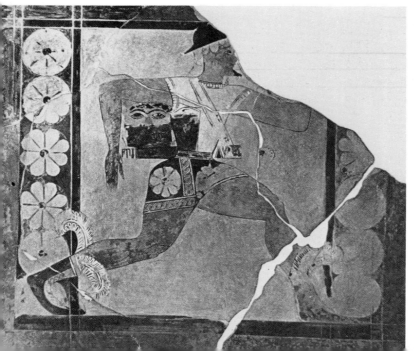

390. Perseus with the head of Medusa. Terra-cotta metope from the Temple at Thermos, late seventh century B.C. Athens, National Museum.

The terra-cotta plaques from Corinth, with representations of potters and miners,[1] are in the black-figured technique of the sixth century B.C. Here belong also the terra-cotta Clazomenian sarcophagi, with sometimes elaborate compositions in black-figure and red-figure.

The colours employed on the painted archaic Attic tombstones of the sixth century (cf. pp. 70, 86) are red, blue, and black, and sometimes green.[2] The figures were first traced in black outline (now mostly faded) and the background was regularly red. No colour has remained on the nude parts. Particularly interesting is the panel of a stele in New York, with an incised representation of a warrior mounting his chariot (cf. fig. 74), on which there were enough traces of colour preserved for a reconstruction; the colour scheme was red and black, as in Attic vase-painting.

The four little wooden plaques discovered in a cave at Sikyon constitute the only Greek panel paintings that have survived. Their style indicates a date in the second half of the sixth century. The figures that remain include women conversing, parts of garments, and —on the best preserved example—a procession of votaries carrying offerings to an altar, all delicately drawn in a harmonious design. Inscriptions in Corinthian letters give the names of the votaries and a dedication to the nymphs. The colours are red, brown, blue, black, and white.

The remains of wall paintings found at Gordion in Phrygia are precious examples of the late sixth century.[3] They come from a room once decorated with brilliantly coloured paintings, now reduced to a heap of fragments. Especially noteworthy is what appears to have been a gymnasium scene, with boys exercising to the music of the flute.

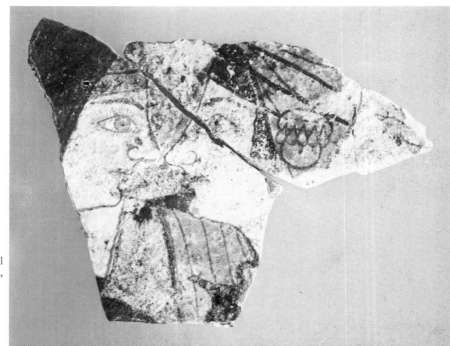

391. Two heads. From a wall painting at Gordion in Phrygia, late sixth century B.C.

Other subjects include griffin heads, birds, and flowers (perhaps part of an embroidered garment), and a procession of figures. The prevailing colours are blue, red, and green, applied in tempera technique. Fig. 391 shows two vivid heads in profile view. These murals in pure Greek style found in far-off Phrygia demonstrate the wide range of Greek influence in the art of the time.

The archaic tombs of Etruria present us with wall paintings and terra-cotta plaques ranging from the seventh century B.C. (Campana tomb, near Veii), through the sixth (the tombs of bulls, of augurs, of inscriptions, of hunting and fishing, of the painted vases; also plaques from Caere), to the first third of the fifth century B.C. (the tombs of leopards and those of the Triclinium). They show the same development in drawing as do the contemporary vase paintings. The dancers and banqueters of the tomb of the Triclinium exemplify the freedom and grace attained at the end of the archaic period; and recently there have actually been found five Greek paintings of this type. They have come to light in a tomb near Paestum, as decorations of a sarcophagus and are in excellent condition. The subjects consist of daily-life scenes, including banquet scenes, similar in style to the Etruscan examples of circa 480 B.C.[4]

All these paintings are executed in uniform washes.

The few remarks by Pliny on the subject of archaic Greek painting (XXXV, 15) bear out in a general way the archaeological evidence. He assigns its invention to Corinth or Sikyon and says that it arose from outlining shadows. One may surmise that he is referring to the early silhouette and outline drawing known from geometric and seventh-century vases. He also gives (XXXV, 56) a few names of early painters—Philokles, 'an Egyptian' (perhaps a Greek from Naukratis), Kleanthes of Corinth, Aridikes of Corinth, and Telephanes of Sikyon. Nothing further is known of them. The first personality one can perhaps grasp is Kimon of Kleonai, who is said to have represented the features in different positions, looking backward and upward and downward, to have marked the attachments of limbs . . . and to have discovered the wrinkles and folds of drapery. He belongs to the last quarter of the sixth century, and the 'inventions' with which he is credited correspond to the innovations in the drawing of early red-figure (cf. pp. 335 f.).

FIFTH CENTURY B.C. AND LATER Virtually no original examples of Greek pictorial art of the classical period of the fifth and the first half of the fourth century remain, except the decorations on vases. On the other hand, ancient writers devote most of their comments and descriptions to the painters and paintings of that time, and from them we can glean a good deal of information.

Polygnotos, a native of Thasos, and active in Athens after the Persian wars, was regarded as the real 'inventor' of painting. Among his chief works were the murals in the Lesche of the Knidians at Delphi (cf. p. 46)

and those that he and his associate Mikon painted in the Stoa Poikile of Athens (cf. p. 45). His Ilioupersis (the fall of Troy) and Nekyia (Odysseus' visit to Hades) were still seen by Pausanias when he visited Delphi in the second century A.D., and he has given us a long description of them (X, 25, 31).

The salient points of Polygnotos' art seem to have been the nobility of his types, the expression of emotion in the faces, and the introduction of spatial depth, that is, foreshortening and the disposition of the figures on different levels. According to Aristotle (*Poetics*, 6), Polygnotos, in contrast to Zeuxis, was 'a skilful delineator of character'. We may deduce from this that, as in the Ilioupersis by the Kleophrades Painter on a hydria in Naples (cf. p. 343), Polygnotos showed not only the triumph of the victors, but the tragedy of defeat—in the same way as did his contemporary Aischylos in his *Persai*, and to an even greater degree Euripides some fifty years later, in his *Trojan Women*. Significant also is the fact that in the period of Polygnotos was created the first individualized Greek portrait so far known—the statue of Themistokles, of which the head has survived in a Roman herm found at Ostia (cf. fig. 122).

Vitruvius (VII, praef. II) states that Agatharchos of Athens, when Aischylos was bringing out a tragedy, made the scenery and left a commentary on it, and that this led Demokritos and Anaxagoras to write on the same subject, explaining the principles of perspective, so that 'though all is drawn on vertical and plane surfaces, some parts may be seen withdrawing into the background, and others to be protruding in front'. The painter Apollodoros (*c.* 430–400 B.C.) was called 'shadow painter', that is, 'he mimicked form through shading and colour' (Hesychios, s.v. Σκιά). Pliny (XXXV, 60, 61) says that he was the first to give his figures 'the appearance of reality' and 'to have opened the gates of art which Zeuxis entered'. Specifically his inventions seem to have been the use of shadows and perspective, and of mixed instead of pure colours (cf. Plutarch, *De glor. Ath.*, 346a).

Apollodoros' younger contemporaries, Zeuxis of Herakleia and Parrhasios of Ephesos, seem to have expanded these discoveries. Quintilian (*Inst. Orat.*, XII, 10, 4) says that the former discovered the principles of light and shade, while the latter discovered greater subtleness of line. Thereby the realistic schools of fourth-century Greek paintings were initiated. It was an age of panel painting rather than of murals. The leading men were first Eupompos, who belonged to the concluding years of the fifth century B.C., then the Macedonian Pamphilos and his pupil Pausias of Sikyon, who developed the technique of encaustic painting, Aristeides of Thebes, and Nikias of Athens. The last was a contemporary of Praxiteles and painted some of his statues. He was known for paying special attention to light and shade, and for 'making the figures stand out from the background'.

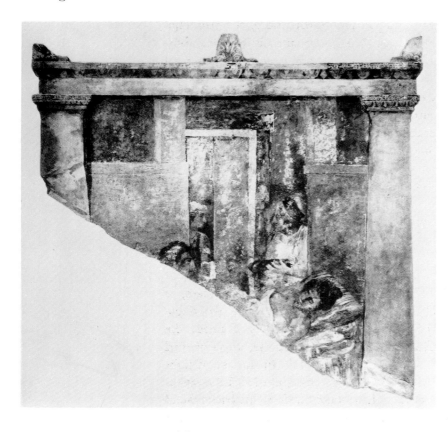

392. Stele of Hediste, third century B.C. Volo, Museum.

The greatest of these artists was the Ionian Apelles, the favourite painter of Alexander the Great, whose portrait he painted. His most famous work was an Aphrodite at Kos 'emerging from the waves and pressing the sea-foam from her hair', evidently a pictorial counterpart of the statue of Aphrodite Anadyomene (cf. p. 149).

The realistic ideal of the time is illustrated by the well-known anecdotes related by Pliny and others of the painted grapes by Zeuxis at which birds flew, and of Apelles' picture of a horse at which live horses neighed. They show the *trompe-l'oeil* ideal of that time. It was attained not only by successful foreshortening, which by now had become the order of the day, but by the use of mixed instead of pure colours.

Some of the third-century painted stelai from Alexandria and Sidon, and especially those from Pagasai (Volo), in Thessaly, can give some idea of this developed phase of Greek painting. Among the finest is the stele of Hediste (fig. 392) in which an interior is depicted with a dead woman lying on a couch, her husband seated at the foot of it, and in the background an old nurse holding a child in her arms; through an open door at the back a young girl is seen. The various depths at which the figures are placed are suggested by intersecting lines and by a slight diminution of the figures in the farther distance. Besides pure colours—such as reds, yellow, and blacks—mixed colours appear, for

instance, violet (for the wall and pillars). Furthermore, the paintings on the vases from Centuripe (cf. pp. 363f.)—executed in tempera technique in rose, mauve, blue, yellow, black, and white, and now assigned to the third century B.C.,—can, when well preserved, show both the colour scheme and to some extent the compositions current at the time.

Vitruvius' statement regarding the discovery of perspective during the fifth century B.C. (see above) is borne out by the vase-paintings of the time (cf. p. 325). One can watch there the development in the rendering of the third dimension step by step. It is important, however, to realize that, whereas foreshortening was perfectly understood as early as the second half of the fifth century B.C., linear perspective always remained partial—even in late Greek, Roman, and mediaeval times. Instead of one vanishing point to which all parallel receding lines converge, several vanishing points were used with varying points of sight. This conception is well illustrated in the furniture, altars, and buildings that occasionally appear on Attic and South Italian vases, as well as in the more ambitious compositions in Pompeian paintings. Though some degree of co-ordination was sometimes attained, the space of the picture was never realized as a unity, that is, never viewed from a single point of sight.⁵ And this applies also to the use of light and shade. Though the figures were no longer depicted in flat surfaces, as in the earlier periods, but were made to stand out from the background in modelled shapes, they were not conceived as occupying one space illumined by one light. It was not until the Renaissance of the fifteenth century that linear and aerial perspective, as we understand them, were systematically explored.

How much the paintings of the Roman age can give a realization of Greek painting has been much discussed. That the figures in the murals from Pompeii and elsewhere were mostly copied from Greek originals there can be no doubt. Such Greek originals were available in Italy, having been brought there as loot by the Roman conquerors, and that copying from Greek paintings was a familiar practice is known from literary sources (cf. e.g. Pliny, XXXV, 125; Lucian, *Zeuxis*, 3–8). Moreover, there is the evidence of the paintings themselves. They show no consistent development in the style of the figures during the several centuries in which they were produced, only a variety of Greek styles, ranging from the fifth to the second century B.C. The different 'repeats' —groups, or extracts from groups recurring in different paintings of varying dates—point in the same direction.

It is even possible now and then to recognize in some Roman murals and mosaics specific Greek paintings of the fourth and third centuries B.C. mentioned by ancient writers. Thus, the Andromeda and Perseus in Naples (fig. 395) may represent the Andromeda cited by Pliny (XXXV, 132) as a work by Nikias. The famous Alexander mosaic in Naples

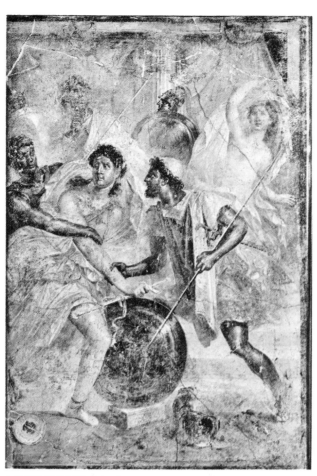

◄ 393. Achilles at Skyros. Wall painting from Pompeii. Naples, Museo Nazionale.

394. Doves, after Sosos of Pergamon. Mosaic. Rome, Capitoline Museum.

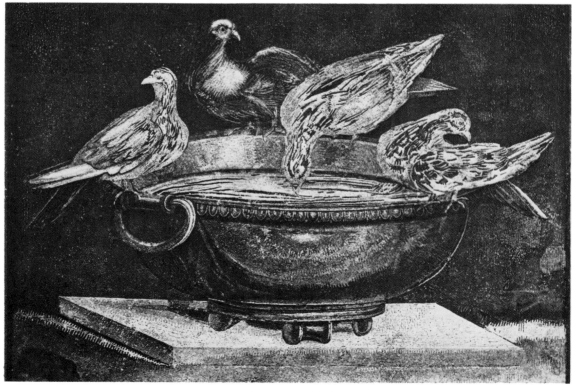

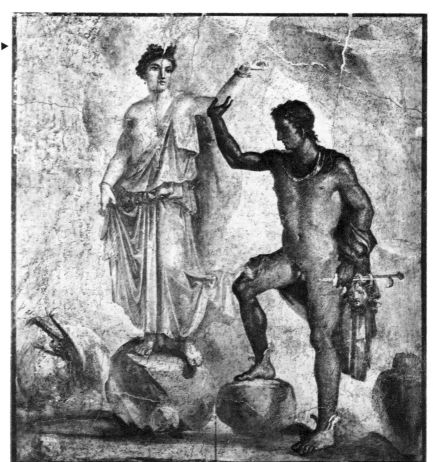

395. Andromeda and Perseus, perhaps after Nikias. Wall painting from Pompeii. Naples, Museo Nazionale. ▶

396. Darius from the mosaic of Alexander and Darius, perhaps after Philoxenos of Eretria. Mosaic from Pompeii. Naples, Museo Nazionale.

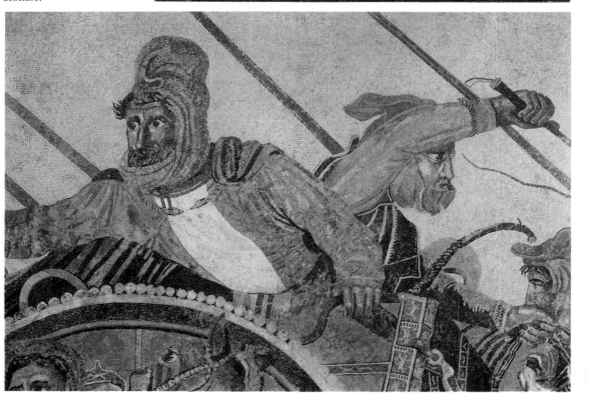

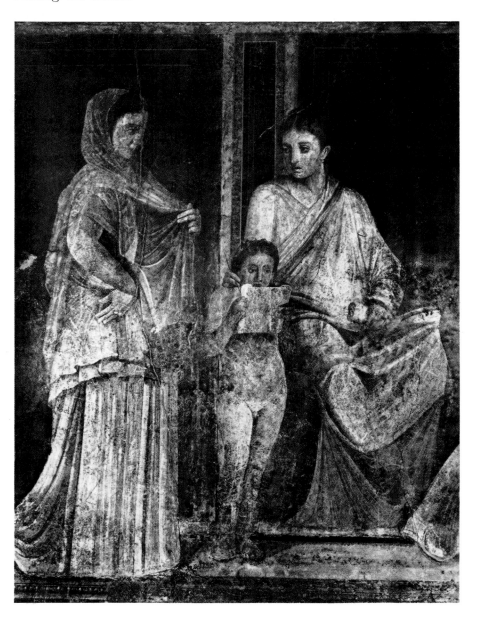

397. Detail from the wall paintings in the Villa Item, Pompeii. In situ.

(fig. 396) may reproduce a painting of Alexander and Darius by Philoxenos of Eretria. The victor with the palms in the Palazzo Rospigliosi in Rome[6] may hark back to Eupompos' painting of that subject. The mosaic of doves in the Capitoline Museum (fig. 394), and the mosaic of the 'Unswept floor' in the Lateran[7] evidently reproduce a large composition by Sosos of Pergamon (cf. p. 291). And so on.

The Roman copies of Greek paintings, however, were not mechanically reproduced as were the statues. They were free copies which, moreover, had to be adapted to new locations. One must, therefore, allow for

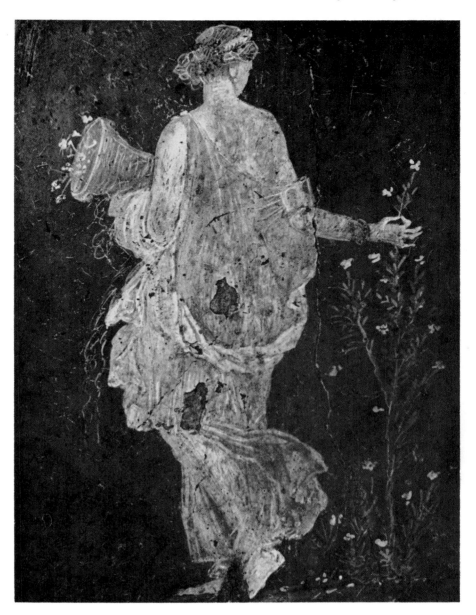

398. Flora. Wall painting from Stabiae. Naples, Museo Nazionale.

variations in composition, and above all take into account the difference in quality between original and copy. Now and then, however, the best examples doubtless bring us near to the Greek—for instance the beautifully composed picture of Achilles at Skyros from Pompeii (fig. 393), the elaborate decoration of the walls of the Villa Item at Pompeii,[8] (cf. fig. 397), the ethereal Flora from Stabiae (cf. fig. 398), and the Achilles and Briseis, from Pompeii (cf. fig. 399).

It was in the Hellenistic period, it would seem, that landscape painting was first developed. Vitruvius (VII, 5, 2–3) specifically mentions that

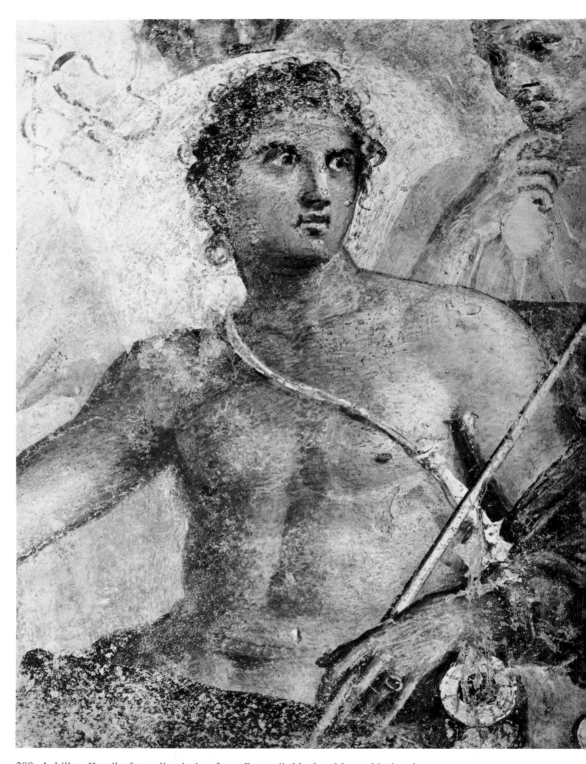

399. Achilles. Detail of a wall painting from Pompeii. Naples, Museo Nazionale.

'ancient artists' painted 'harbours, headlands . . . groves, hills . . . and the wanderings of Odysseus'. And this statement is now borne out by the plaster casts found at Begram, Afghanistan, which evidently reproduce reliefs from Hellenistic metalware and in which landscapes are frequently introduced (cf. p. 253). Perhaps we have Roman copies of such Greek landscapes in the well-known Odyssey paintings in the Vatican (cf. fig. 400). They show, better even than the picture of a garden from the villa of Livia at Primaporta (cf. fig. 402), both the achievements and the limitations of the ancient artists in this field. They were able to represent successfully atmospheric effects, but not aerial perspective with a unified light. Light was always introduced from various sides. That landscape painting had great appeal also for the artists of the Roman age is shown in the charming idyls from Pompeii representing shrines (cf. fig. 401) and maritime scenes.

The statements of Pliny (XXXV, 112) and Vitruvius (VI, 7, 4) that late Greek artists depicted 'humble' subjects as well as important figured scenes suggest that genre and still-life compositions were included in the Hellenistic repertoire. This branch of painting was also developed by Pompeian artists, who often included flowers, fruits, and birds in their pictures.

To what extent the technique of Roman paintings resembled the Greek is not definitely known, as so little of the latter is preserved; but one may assume that the two were not dissimilar. According to recent research, the technique of the Pompeian wall paintings must have been as follows: First two or three carefully prepared layers of limestone, mixed with sand and calcite, were applied to the walls. The background of the picture was painted first and left to dry, whereupon the figures and ornaments were added. The colours were mixed with soapy limestone and some kind of glue to act as a medium, and were rendered shiny by waxing. By these means the paintings acquired great durability and brilliance.

The pigments employed in antiquity were chiefly the earth colours (such as ochres), mineral colours (such as carbonate of copper), and vegetable and animal dyes. Long lists and descriptions of them are given by Pliny (XXXIII, 158–163, XXXV, 30–50) and Vitruvius (VII, 7–14).

Encaustic painting, in which the colours were mixed with melted wax and applied with a spatula or some pointed instrument, was practised in both Greek and Roman times. On a South Italian vase of the early fourth century B.C. (fig. 403) and on a sarcophagus from Kerch, artists are depicted engaged in painting in that technique.[9] Actual examples are provided by the many fine, well preserved portraits on Egyptian mummy cases of the Roman period. And one can learn something regarding the technique from the paintings of warriors on Boeotian

400. Odyssey landscape. Wall painting from the Esquiline. Vatican Museum.

401. Rural Shrine. Wall painting from Boscotrecase. New York, Metropolitan Museum.

402. Garden. Wall painting from the Villa of Livia at Primaporta. Rome, Terme Museum.

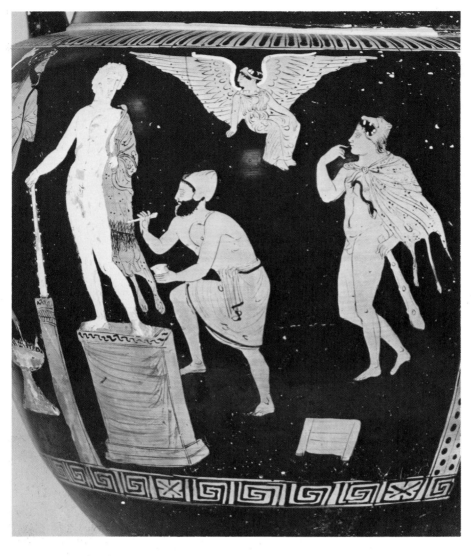

403. Artist painting
in encaustic. From a
South Italian vase
of the early fourth
century B.C. New
York, Metropolitan
Museum.

stelai of dark marble, datable *c.* 400 B.C. and later, where, however,
only the incised preliminary sketch remains.[10]

We may conclude this brief sketch of the development of Greek
painting with a quotation from Dionysios of Halikarnassos, who wrote
at the time of Augustus, when there were still to be seen many famous
paintings of the earlier days: 'In ancient paintings the scheme of colouring
was simple and presented no variety in the tones; but the line was rendered
with exquisite perfection, thus lending to these early works a singular
grace. This purity of draughtsmanship was gradually lost; its place was
taken by a learned technique, by the differentiation of light and shade,
by the full resources of the rich colouring to which the works of the
later artists owe their strength' (tr. K. Jex-Blake and E. Sellers). Fortu-
nately 'the exquisite perfection' of line drawing that appealed to Dionysios
of Halikarnassos in earlier Greek pictorial art is preserved for us in
Attic vase-painting.

Mosaics

Greek mosaics of the fifth and fourth centuries B.C. have been found in considerable numbers at Olynthos, and similar ones have come, for instance, from Olympia, Alexandria, and Macedonia (at Palatitsa and at Pella, the birthplace of Alexander the Great, cf. fig. 407).[11] In contrast to most later mosaics they are worked not in cut cubes, but in natural pebbles, either in black and white, or multi-coloured. The subjects are those current in the other branches of Greek art, that is, animals and monsters, mythological scenes, and floral motifs. Especially noteworthy examples are representations of Nereids and of Bellerophon spearing the Chimaira (fig. 404), both from Olynthos and dating from the first half of the fourth century B.C.

The cube technique seems to have been introduced from the East, after Alexander's conquests. Specimens of Hellenistic date have been found at Olynthos, Delos, and elsewhere. In Roman times it was almost exclusively employed, and the custom of having mosaic floors in houses became widespread. Many examples ranging from the first century B.C. to the fourth century A.D. have come to light throughout the Roman empire.

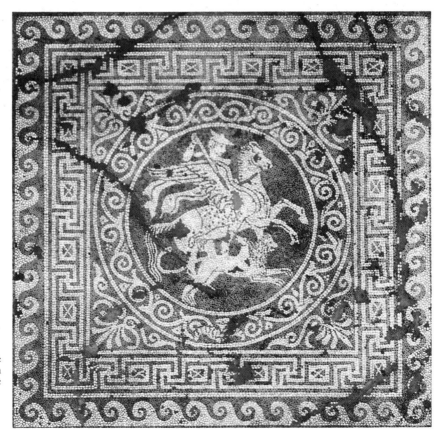

404. Bellerophon and the Chimaira. Mosaic from Olynthos, first half of the fourth century B.C.

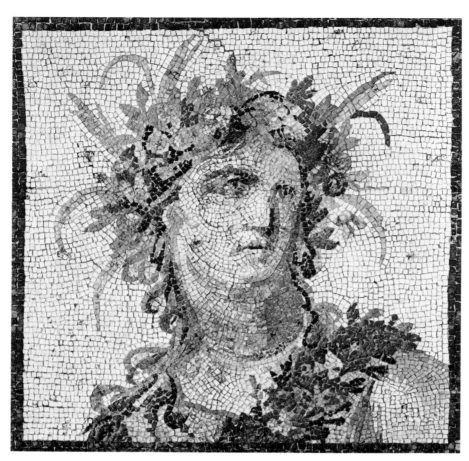

405. Dionysos. Mosaic from Antioch. New York, Metropolitan Museum.

406. Street musicians, by Dioskourides. Mosaic from Pompeii. Naples, Museo Nazionale.

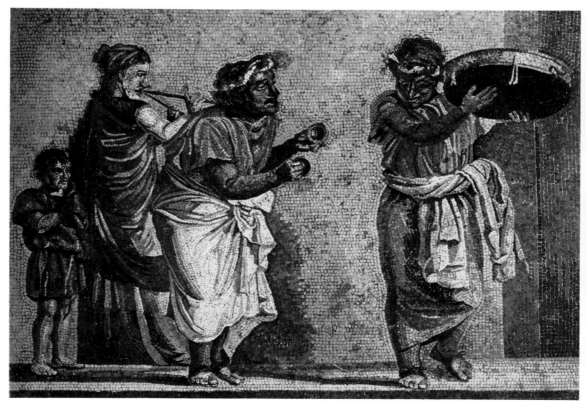

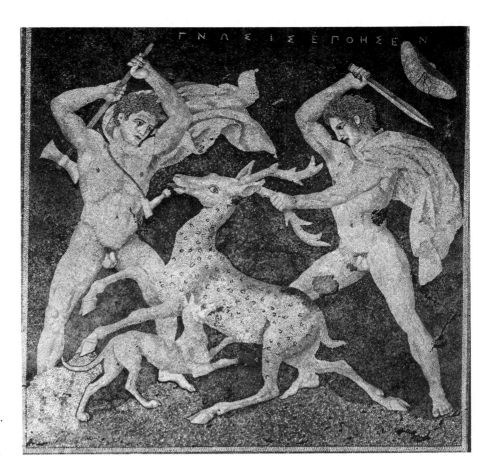

407. Stag hunt,
signed by Gnosis.
Mosaic from Pella.
About 300 B.C.
Archaeological
Museum, Salonike.

As in the paintings of the Roman age, so in the mosaics, it can some-
times be determined that they are copies of famous Greek originals.
In addition to those mentioned above (cf. p. 282) may be cited the small
panels in Naples signed by Dioskourides, representing street musicians
(fig. 406) and old women, which presumably reproduce Hellenistic
originals. They are executed in many-coloured stones of astonishingly
small size. The Dionysos mounted on a tiger, from Delos, and many
of the mosaics from Antioch (cf. fig. 405) and North Africa likewise
show the close relation between mosaics and paintings. The art continued
to flourish until the fourth century A.D. (cf. especially the examples
from Piazza Armerina) and then developed into the great mosaics of
the Early Christian and Byzantine periods.

CHAPTER 11

POTTERY AND VASE-PAINTING

In the absence of significant examples of the major art of Greek painting, pottery has assumed an importance even beyond its own great intrinsic value. During certain periods and in certain localities the vase-painter was not content to decorate his pots with simple lines and plant motifs. He took his themes from mythology and the life around him, as did the panel and mural painters. Moreover, occasionally these vase-paintings are of the highest quality, and this is especially the case in the Attic pottery of the sixth and fifth centuries. In spite of the difference in technique and colour scheme, they can, therefore, give a realization of the extraordinary feeling for line, contour, and composition of Greek artists in general; and in adding these qualities in one's imagination to the colourful Roman murals, one can gain some perception of Greek pictorial art. Furthermore, Greek terra-cotta vases have survived in large numbers, for, once fired, they may be broken, but are otherwise practically indestructible. They have been found in sanctuaries and tombs, where they had been placed as offerings, and in or near private dwellings, where they had been thrown on dumps or in unused wells when discarded. They, therefore, present a continuous story from geometric to Hellenistic times.

As in sculpture, so in painting, the Greeks gradually solved the many problems of representation. They emancipated the art of drawing from a conventional system of two-dimensional formulas and learned how to represent on a flat surface three-dimensional figures as they appear to the eye. They mastered the problem of foreshortening, imparted volume to their figures, and introduced spatial relations into their compositions. This evolution can be observed step by step in Greek vase-painting.

Naturally, Greek pottery offers much apart from what it can teach regarding the lost larger paintings. The Greek sense of form can here be studied to advantage; for in the well preserved examples the subtle interrelation of the parts to one another and to the whole can be fully appreciated. Technically, also, the Greek potter was a master. And the inscriptions he sometimes added have shed light on many an ancient custom.

Various Fabrics

Pottery is an ancient art; it was practised in Greek lands from the stone age on. At first the vases were built with coils and wads of clay. By about 1800 B.C. the art of throwing on the wheel was introduced and was henceforth practised with great skill by the Minoan and Mycenaean artists. After the break-up of the Mycenaean civilization (cf. p. 17) there is at first no definite change observable in the pottery; but after a while the conceptions of a new age found expression in pottery as they did in other branches of Greek art. By the tenth and ninth centuries B.C. the curvilinear patterns and the representations of plant and marine life popular with Minoans and Mycenaeans had been transformed into geometric designs. Zigzags, shaded triangles, chequers, network, tangent and concentric circles, semi-circles, wavy lines, rosettes, wheel ornaments, the swastika, and, later, the meander became the prevalent motifs. The Minoan artistic stock gradually disappeared.

Several periods can be distinguished: the sub-Mycenaean (eleventh century B.C.), in which the curvilinear elements are still in evidence; the proto-geometric (tenth century, cf. fig. 408), of sober appearance, in which the geometric style is in formation; and the full-fledged

GEOMETRIC PERIOD, ABOUT 1000—700 B.C.

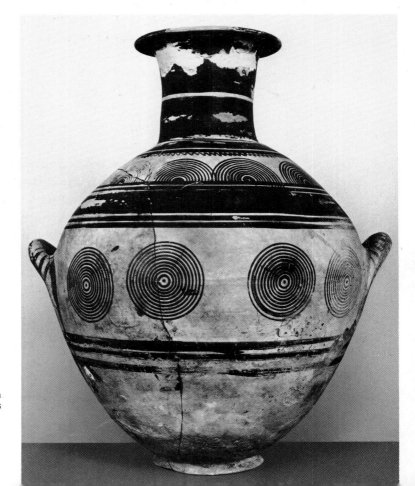

408. Proto-geometric vase, tenth century B.C. Athens, Kerameikos Museum.

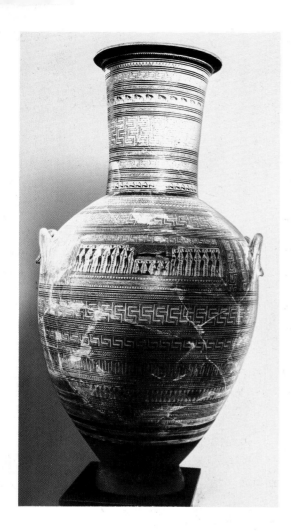

409. Geometric vase with Prothesis, eighth century B.C. Athens, National Museum.

410. Geometric vase with Prothesis and funeral procession, eighth century B.C. New York, Metropolitan Museum.

geometric (ninth to eighth century), characterized by a profusion of ornaments and the introduction of animal and human figures (cf. fig. 409). The decorations are painted in lustrous brown 'glaze' (cf. p. 316) on the light surface of the clay, and the same dark glaze is used as a wash to cover the undecorated areas. Occasionally a touch of white is added. The human figures are painted first entirely in silhouette, later occasionally also in outline with inner lines added—an outline head, for instance, with a dot for the eye. Statuettes of horses and birds or miniature vases served as handles of lids; or human figures were attached to handles.

According to the locality in which the vases were found (Attica, Corinth, Boeotia, Argos, Crete, the Cyclades, Cyprus, Samos, Rhodes, Italy, etc.), they differ somewhat in appearance. On the whole, however, the style is remarkably uniform. Attica evidently played a leading part.

The subjects range from single figures to elaborate groups, some perhaps with mythological import, as, for instance, the scene on a vase in London which is usually interpreted as Helen and Paris about to depart from Greece.

In the late eighth and the seventh century B.C. the schematized geometric art was gradually transformed. It was a period of change all over the Mediterranean world (cf. p. 56). Colonies were being founded east and west; intercommunications were improved; and contact with the ancient Oriental civilizations—Egypt, Mesopotamia, Syria, and Phoenicia—was established. The resultant Oriental influence is shown by the adoption of Eastern floral motifs, such as the lotus and palmette, and of Oriental monsters and beasts, such as sphinxes, panthers, and lions.

ORIENTALIZING AND ARCHAIC PERIODS, ABOUT 720—550 B.C. AND LATER

The pottery of this epoch presents a varied picture. There were a number of important centres, each with its individual style and technique, but they divide geographically into two chief classes—Mainland and East Greek.

On the Mainland the most important centres were Attica and Corinth.

In ATTICA two different epochs have been distinguished. The first (about 720–650 B.C.)—by some authorities called Idaean from its resemblance to the reliefs on the shields found on Mount Ida (cf. p. 210)—is characterized by an exuberant style, with emphasis on bold, curvilinear ornaments, and with imposing compositions of wild animals and human figures. The geometric abnormal proportions are retained but vitalized. The drawing is partly in silhouette, partly in outline.

MAINLAND-GREECE

A hydria found at Analatos in Attica stands midway between the geometric period and the seventh century, with ornaments typical of both periods; whereas an amphora in New York, of the second quarter of the seventh century, shows the new style in developed form (fig. 412). It is 3½ feet high. On the neck are depicted a lion and a spotted deer; on the shoulder grazing horses; on the body Herakles and the centaur Nessos, with, it would seem, Deianeira awaiting the outcome in the chariot. Ornamental motifs appear above and below, and over the whole surface of the back. The decoration is in brownish-black glaze, with a generous use of white and occasional incisions. The figures are partly in outline, partly in silhouette, with trunks drawn in profile or in full front view, and with rounded limbs. In spite of their crudity they have a life and force absent in the systematized and orderly geometric compositions.

An amphora showing the same farouche power has come to light at Eleusis; on its neck is depicted the blinding of Polyphemos (fig. 413), on the body Perseus and the Gorgons (fig. 414). It too should date from *c.* 675–650 B.C.

A similar exuberance is noticeable in the vases found in Aegina that have been recognized as Attic products.

In the second epoch (*c.* 650–600 B.C.)—by some called Daedalid (cf. p. 233)—a more sober spirit prevails, and the forms of animals and human beings become more normal. It is the period of the first monumental sculpture in Greece, and some of the designs on the vases have

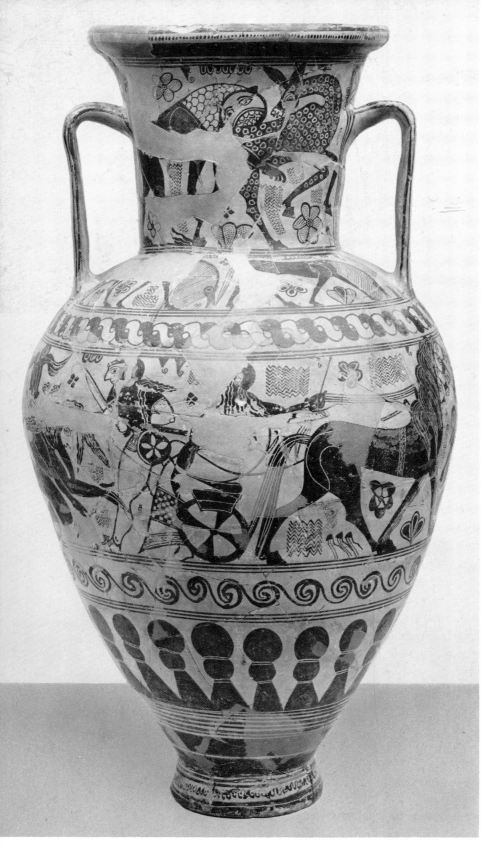

412. Proto-Attic amphora with Herakles and Nessos, *c.* 675–650 B.C. New York, Metropolitan Museum.

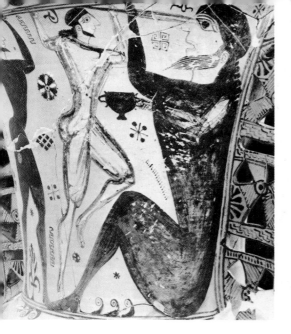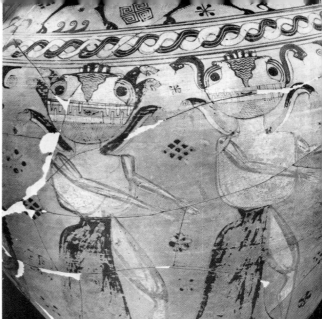

the same grandeur as the early kouroi (cf. pp. 57ff.). Technically this epoch is also important. It marks the adoption of the black-figured style, in which the figures are no longer drawn partly in outline, but are entirely in silhouette, with details incised and with red and white accessory colours. Early examples of this class are the so-called Kynosarges amphora (*c.* 650 B.C.), and several terra-cotta plaques depicting the dead man laid out on a bier, surrounded by mourning women (*c.* 630 B.C., cf. p. 233). Then come such masterpieces as the amphora from the Piraeus (fig. 415) and several vases found at Vari with representations of Prometheus and Bellerophon, as well as large monsters and wild animals. They are followed by the famous amphora (*c.* 610–600 B.C.) with Herakles, Nessos, and the Gorgons (fig. 416), the sphinx from the Agora (cf. fig. 417), and the amphorae with horses' heads painted in panels, all in full black-figure. The favourite shapes are the large, capacious kraters, lebetes, hydriai, and amphorae, the generous areas of which allowed for large-scale compositions and grandiose forms.

One generation later, that is, in the first quarter of the sixth century, the compositions become relatively smaller. The narrative style, with themes taken from mythology and daily life, has become firmly established. The monstrous creatures dominant in the preceding epoch are relegated to second place. A remarkable product of this epoch is a large lebes in the Louvre with a representation of Perseus and the Gorgons (cf. fig. 439). Then, in the second quarter of the century, come the so-called Tyrrhenian vases with lively mythological scenes and rows of animals arranged in tiers. To the first half of the sixth century belong also the komast and Siana cups, which are followed in the third quarter by the Little-Master cups, named after the miniature style of their decoration.

(For the artists of this early period cf. pp. 326ff.)

413–4. The blinding of Polyphemos; two Gorgons. From a Proto-Attic amphora found at Eleusis, *c.* 675–650 B.C. Eleusis, Museum.

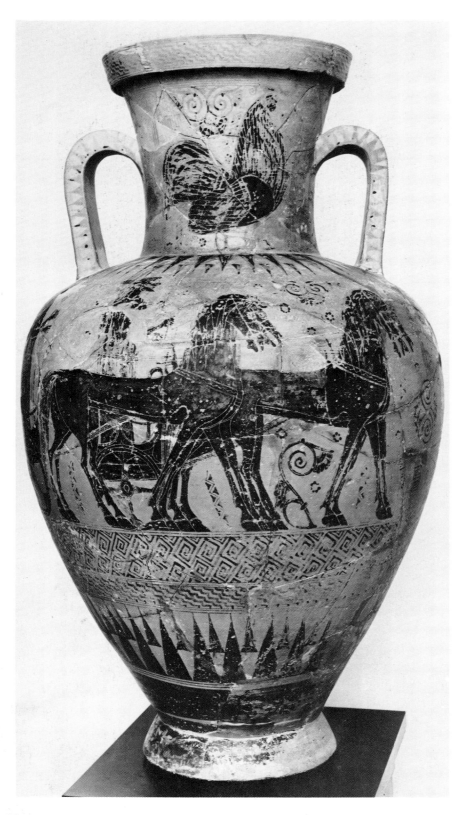

415. Attic amphora with chariots, from the Piraeus, *c.* 620 B.C. Athens, National Museum.

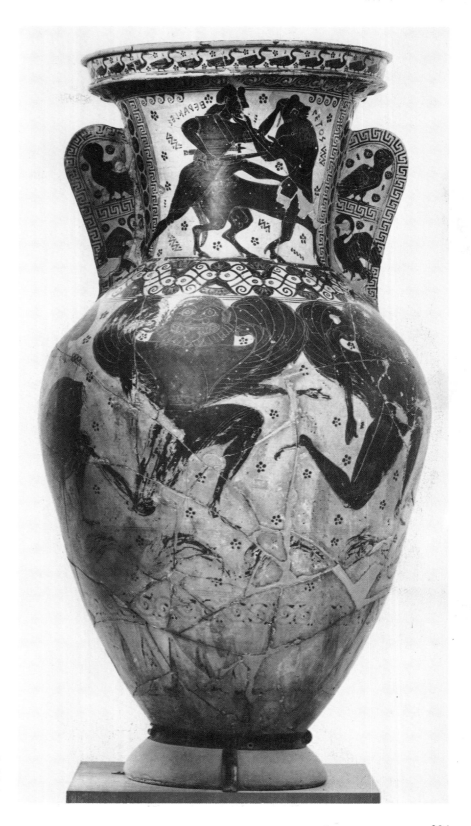

416. Attic amphora with Herakles killing Nessos, and Gorgons, *c.* 610–600 B.C. Athens, National Museum.

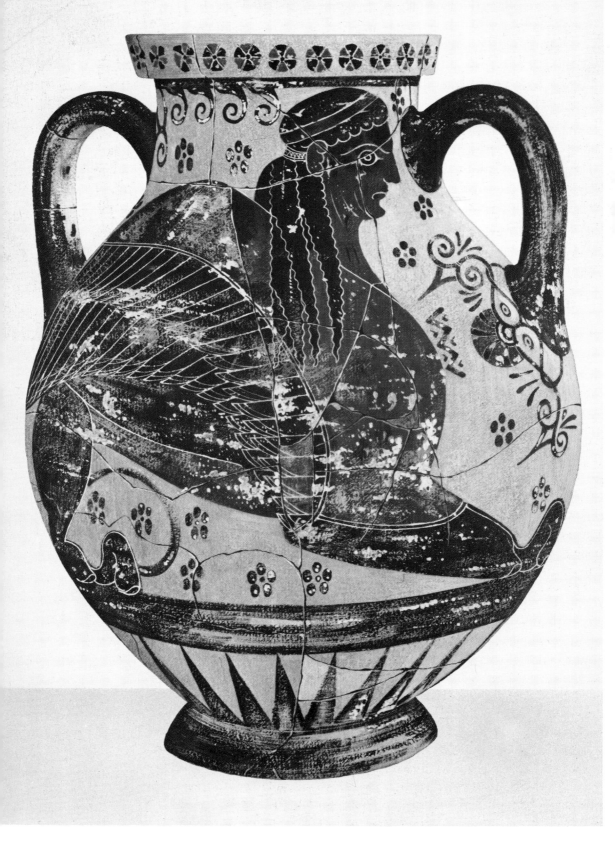

417. Attic amphora with sphinx, from the Agora, late seventh century B.C. Athens, Agora Museum.

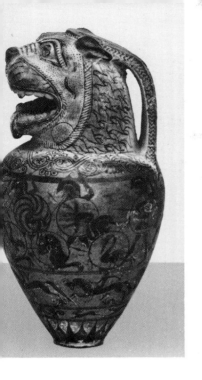

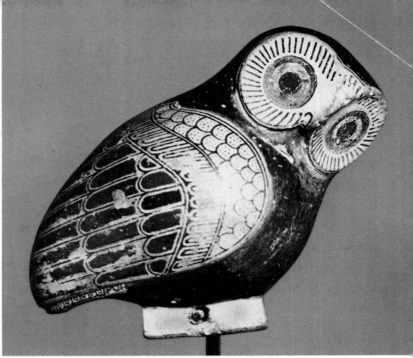

Some of these Attic products have been found in Delos, Rhodes, Egypt, Troy, Southern Russia, Etruria, Southern Italy, Sicily, and Marseilles. Attica had by this time evidently developed a flourishing export trade. Soon she was to eliminate her commercial rival Corinth, and become the chief ceramic centre of the Mediterranean world (cf. pp. 315 ff.).

CORINTH in the seventh and early sixth century was politically and commercially the most powerful Greek state. Her influence spread east and west. She had become one of the chief outposts of Phoenician traders. Corinthian pottery has accordingly been found in quantity, not only all over Greece, but in Italy and the East, including Egypt.

The so-called Proto-Corinthian vases, which are now assumed to be Corinthian, consist chiefly of two-handled cups (skyphoi), jugs, and small, dainty perfume pots. They began to be produced in the geometric age and were then decorated with geometric patterns. In the late eighth century animal and human figures appear, and occasionally Eastern curvilinear ornaments. The figures are no longer angular abstractions, but have rounded contours and considerable animation. Both outline drawing and silhouette are used and there is occasional incision; white occurs as an accessory colour.

This change becomes more marked in the first half and the middle of the seventh century. Co-ordinated scenes appear, with human figures shown in definite action. Intricate floral designs are added. The vases still consist of cups, jugs, and small perfume bottles, and the decoration is in black silhouette, in a miniature style, with red and white as accessory

418. Proto-Corinthian jug, mid-seventh century B.C. London, British Museum.

419. Proto-Corinthian perfume bottle, c. 650–625 B.C. Paris, Louvre.

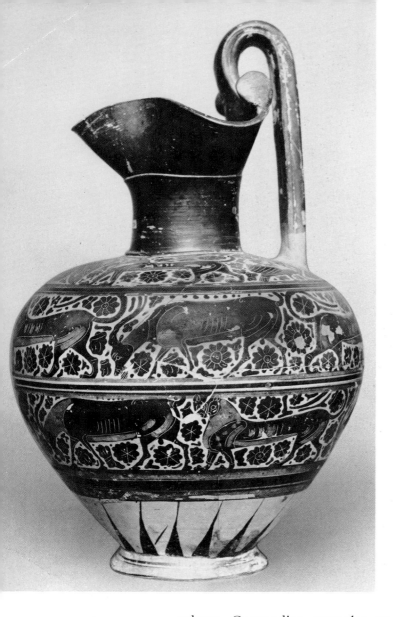

420. Corinthian oinochoe, *c*. 625–600 B.C.
London, British Museum.

colours. Outstanding examples are the so-called Macmillan (fig. 418) and Chigi[2] vases in the British and Villa Giulia Museums. Occasionally the vases were made in the shape of animals and human beings. A man wrapped in a cloak, with hair arranged in 'Daedalid' fashion, in New York, and a little owl, with head turned to one side (fig. 419), in Paris,[3] are such attractive sculptural examples.

Out of this dainty Proto-Corinthian style was developed the Corinthian of the second half of the seventh and the first half of the sixth century—the period of the tyrants Kypselos and Periander. The decoration is arranged in friezes covering most of the surface and the vases are now considerably larger. The designs are in a bold style, with an Oriental flavour (cf. figs. 420, 421). The chief motifs are animals and monsters, with rosettes, dots, and other ornaments scattered all over the back-

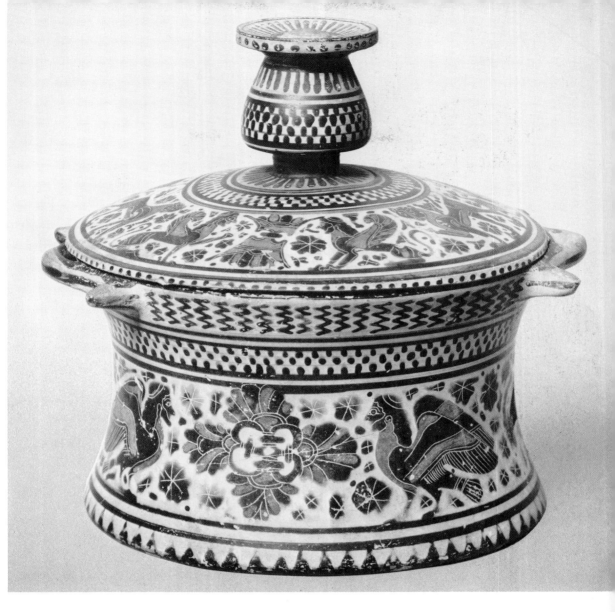

ground, perhaps in imitation of Eastern textiles. Scenes with human figures are fairly common; they include padded dancers, armed horsemen, and scenes from the legends of Troy. Odysseus, Polyphemos, and Herakles are favourite heroes. The decoration is in black-figure, on a light terra-cotta background, with much incision and copious accessory red and white. The prevalent shapes are the krater, hydria, oinochoe, perfume vases, plates, and toilet boxes. Plastic vases also occur.

421. Corinthian pyxis, late seventh century B.C. New York, Metropolitan Museum.

The popularity of this ware is attested by its wide distribution. There were four distinct phases: a transitional period (about 640–625 B.C.), and the so-called Early, Middle and Late Corinthian, to each of which a quarter of a century has been assigned. The strong, incisive drawing on the Eurytos krater (Early Corinthian; Louvre) and the vivacity of the departure of Amphiaraos (Late Corinthian I; Berlin) gradually

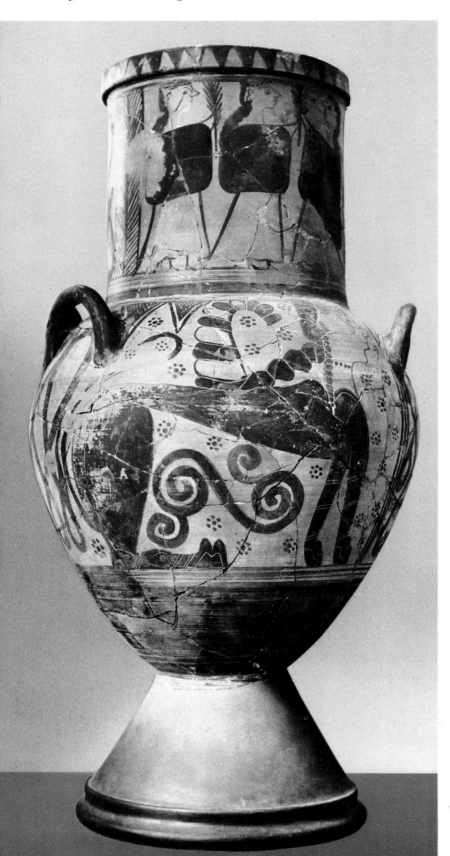

422. Eretrian amphora, first half of the seventh century B.C. Athens, National Museum.

became weak and stereotyped. By 550 B.C. the great days of Corinth were over. Her pottery practically ceased as a flourishing export commodity and continued only as a local ware.

Among the other mainland potteries the most important were those of Euboea (Eretria and Chalkis), Boeotia, Argolis, and Laconia.

In ERETRIA have been found a series of colossal, high-stemmed vases of the first half of the seventh century B.C. with large-scale compositions, executed partly in outline, partly in silhouette (cf. fig. 422), in the bold style characteristic of that period. They are followed *c.* 500 B.C. by vases of similar form, with decoration in developed black-figure.

That CHALKIS was a great power in the eighth century B.C. is shown by the colonies she founded in the West, such as Pithekoussai on Ischia, Cumae, and Sicilian Naxos (cf. Strabo, 247; Livy, VIII, 22). No distinctive eighth- to seventh-century Chalcidian ware has as yet been recognized in excavations on those sites. The pottery found there is either pre-Hellenic Italic (e.g. at Cumae), or imported from the East —Crete, Rhodes, Cyprus, and especially Corinth—or it consists of

423. Chalcidian psykter-amphora, with battle of Greeks and Trojans, *c.* 540 B.C. Melbourne, National Gallery of Victoria.

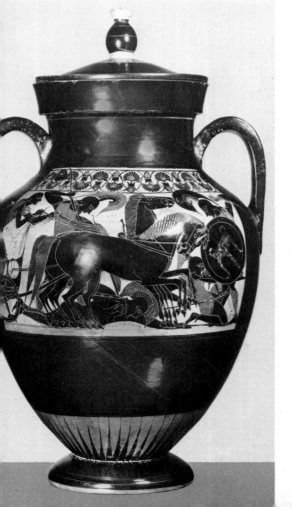

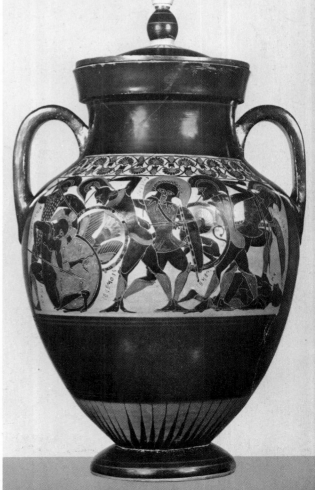

local imitations of those wares. The well-known Chalcidian vases, painted in developed black-figure, date from *c.* 550–510 B.C. The best examples, such as the psykter-amphora recently acquired by Melbourne[4] (fig. 423), approach the Attic in excellence of drawing and quality of glaze. Vigorous battle scenes, horsemen, chariots, and elaborate floral motifs are favourite themes. Mythological scenes are not infrequent. The rows of animals popular in early days are often retained. The frequent inscriptions are in the Chalcidian alphabet, and in recent excavations at Chalkis there have been found not only sherds of that style, but remains of potteries. So Euboea must have been a centre of production; but, since most extant examples have been found in Etruria, it is possible that some Chalcidian potters went to Etruria and practised their art there.

A splendid series of large and small vases, decorated with floral motifs and assignable to the seventh and the first half of the sixth century, have come from BOEOTIA. Among them are colossal pithoi,

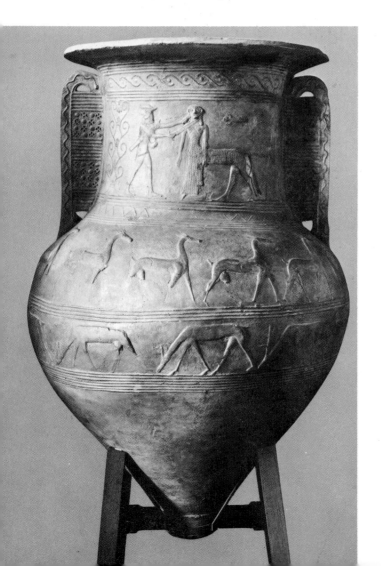

424. Boeotian pithos with Perseus and Medusa, seventh century B.C. Paris, Louvre.

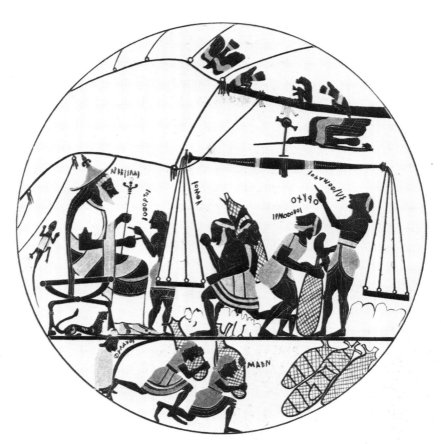

425. King Arkesilas supervising the weighing of silphium(?). Drawing after a Laconian kylix, first half of the sixth century B.C. Paris, Bibliothèque Nationale.

decorated with figures in relief, often of mythological content (e.g. Perseus and Medusa [fig. 424], and Europa on the bull). Another distinctive Boeotian class consists of kylikes, decorated mostly with floral motifs and flying birds, occasionally with animals and human figures, in a spirited style, without much detail. Boeotian potters also worked in black-figure. A jug in the Louvre with a shepherd and his flock bears the signature 'Gamedes made it'.

The painted terra-cotta shields from TIRYNS,[5] with their ill-proportioned, uncouth, lively figures belong to the first half of the seventh century.

The LACONIAN vases passed through various phases, starting around 600 B.C. and continuing until 550 B.C. and later. The decoration is in black-figure, sometimes on a white slip. Among the floral motifs, bands of pomegranates, lotus buds and palmettes, as well as a net pattern predominate. These vases were formerly called Cyrenaic, for in a scene depicting the weighing of silphium (?), on a kylix found at Vulci, is a figure inscribed Arkesilas (fig. 425), evidently an important personage, and so presumably the king of Cyrene of that name who reigned *c.* 568–550 B.C.; and on another kylix found at Tarentum is the nymph Cyrene. Excavations at Sparta, however, have shown that

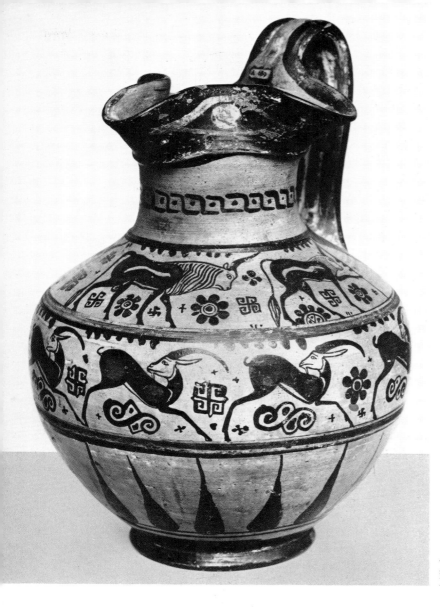

426. Rhodian oinochoe, late seventh century B.C. London, British Museum.

EAST GREECE
AND THE ISLANDS

the ware was produced there in continuous sequence, from geometric to later archaic, and the occasional inscriptions are in Laconian script. Seventh- and early sixth-century vases have been found on many sites—Thera, Samos, Rhodes, Crete, Chios, Paros, Melos, Klazomenai, Naukratis, etc. The best known are the so-called Rhodian or 'Camirian'. They consist mostly of jugs, bowls, and plates (stemmed and stemless), and are decorated on a creamy white slip with rows of wild goats, deer, bulls, birds, and occasionally sphinxes, in dark brown glaze (cf. fig. 426); the figures are drawn partly in outline, partly in silhouette, with accessory colours, but generally without incisions. They are mostly not borrowed from Oriental art, as are the Corinthian, but observed from nature, for in spite of obvious conventions they are full of life. Floral patterns are used in effective combinations. In the later examples

of the middle and second half of the sixth century (generally called Fikellura after the cemetery in Rhodes where many of them were found), network, scales, and rows of crescents are the distinctive patterns.

Related to these Rhodian pots, but standing apart, is a group of vases of which the most noteworthy example is a plate in the British Museum with the combat of Menelaos and Hektor over the dead body of Euphorbos.

The plastic vases in the form of heads of helmeted warriors, women, monsters, and animals, or of sandalled feet, are perhaps also Rhodian, at all events East Greek. And there are East Greek versions of Attic Little-Master cups (cf. p. 334), generally with neatly drawn concentric circles on the inside (fig. 427). Exceptionally there is a more ambitious composition, such as a bird-nester in a tree, on a kylix in the Louvre (c. 550 B.C., cf. fig. 428).

Amphorae and hydriai, some of large dimensions, have been unearthed in the island of MELOS; the decoration consists of floral motifs, busts of women, and figured scenes, sometimes placed in panels. They are painted partly in outline, partly in silhouette, in a bold, luxuriant style. Two magnificent specimens, one of the middle, the other of the third

427. Interior of an East Greek Little-Master cup, c. 560–510 B.C. Oxford, Ashmolean Museum.

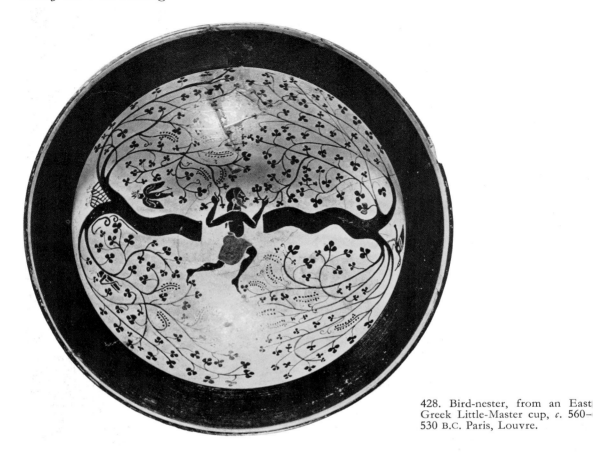

428. Bird-nester, from an East Greek Little-Master cup, *c*. 560–530 B.C. Paris, Louvre.

quarter of the seventh century, are in the National Museum, Athens (cf. figs. 429, 430). On the earlier are depicted Apollo in a four-horse chariot and Artemis holding a deer; on the later Herakles is shown departing with his wife Deianeira. The progression of style in the two representations, especially in the rendering of the horses, is very evident.

Another distinctive ware has been found in the island of LEMNOS. Large cuplike vases with openwork volutes could not have served a practical purpose and must have been votive. Another form is a stemmed bowl, with helmeted heads on the rim. Two kraters are decorated with mythological scenes, painted in outline.

A remarkable vase belonging to the Tean-Boeotian group was found in 1961 in Mykonos.[6] It consists of a large amphora, 1.34 m. high, with scenes from the Ilioupersis, arranged in metope-like panels, on the body, and a representation of the Trojan Horse on the neck, all executed in relief in seventh-century style (fig. 431). The Trojan Horse is shown mounted on rollers and provided with seven 'windows' on body and neck, inside each of which is drawn the head of a Greek soldier. Seven other Greeks have already dismounted and are preparing for combat. It is the earliest detailed representation of this famous legend.

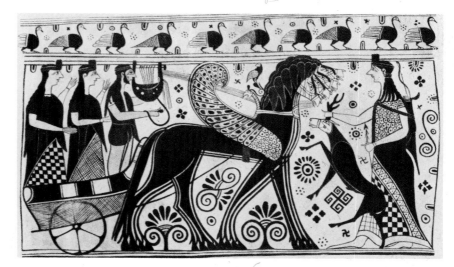

429. Apollo, Muses and Artemis. Drawing after an amphora from Melos, mid-seventh century B.C. Athens, National Museum.

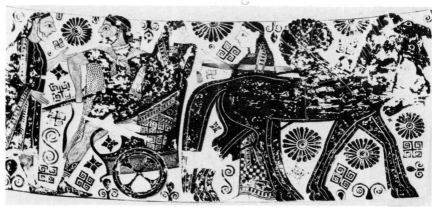

430. Herakles and Deianeira. Drawing after an amphora from Melos, c. 650–625 B.C. Athens, National Museum.

The so-called NAUKRATITE or CHIAN ware is an attractive East Greek product current in the late seventh century to the middle of the sixth century. The best examples have a creamy white background on which the design is painted in dark red, various shades of brown, and white, without incisions. Both outline drawing and silhouette are used. Cups of chalice shape are common.

Aryballoi in the form of heads and animals, covered with blue alkaline glaze, show the influence of Egypt and may stem from Naukratis.

The DAPHNE ware, so called from the locality in which most of the vases were found, also has an Eastern flavour. The decoration is in black-figure, with human beings in lively postures (c. 600–550 B.C.).

The CLAZOMENIAN vases of the sixth century have considerable distinction. They are ornamented in black-figure with human figures, animals, and monsters—chiefly sphinxes and sirens—in a graceful style, without apparent narrative content. Especially noteworthy are the terra-cotta sarcophagi, found in a cemetery at Klazomenai (cf. p. 48). Their rims and covers are often elaborately decorated with battle scenes and handsome animals and monsters. The technique is in developed black-figure, combined occasionally with outline drawing; white lines

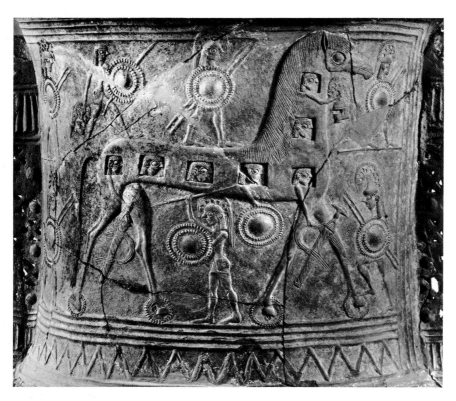

431. Detail of terracotta pithos from Mykonos, first half of seventh century B.C.

are sometimes substituted for incisions. The production lasted a considerable time, and the latest examples show the introduction of the red-figure technique.

The CAERETAN hydriai, though found at Cervetri, the ancient Caere, in Etruria, hence their name, were probably all painted by an Ionian Greek artist around 530 B.C. The scenes, executed in black-figure, show animation, originality, and humour. Herakles performing his mighty deeds is a prevalent subject; fig. 432 illustrates a hydria in the Villa Giulia Museum, with a picture of the blinding of Polyphemos by Odysseus and his companions.

Two classes of Eastern vases stand apart. One comes from Sardis and has, therefore, been called LYDIAN. They show a variety of techniques: Some are fired blackish or greyish (like the Etruscan bucchero) and have no painted decorations; others are covered with black glaze, with occasional ornaments in white; or they have a white slip with ornaments in blackish or reddish glaze (cf. fig. 433); and still others have blackish brown or white decorations added directly on the reddish colour of the clay. The shapes are also different from those prevalent in Mediterranean countries. High-stemmed dishes, small jars with conical feet, bowls with spouts, and lekythoi with concave bodies are the chief forms. Occasionally kraters of Corinthian design occur. This pottery belongs to the seventh and the first half of the sixth century, before the advent of king Croesus, and so before increased contact with the Greek communities. Hence its individual character.

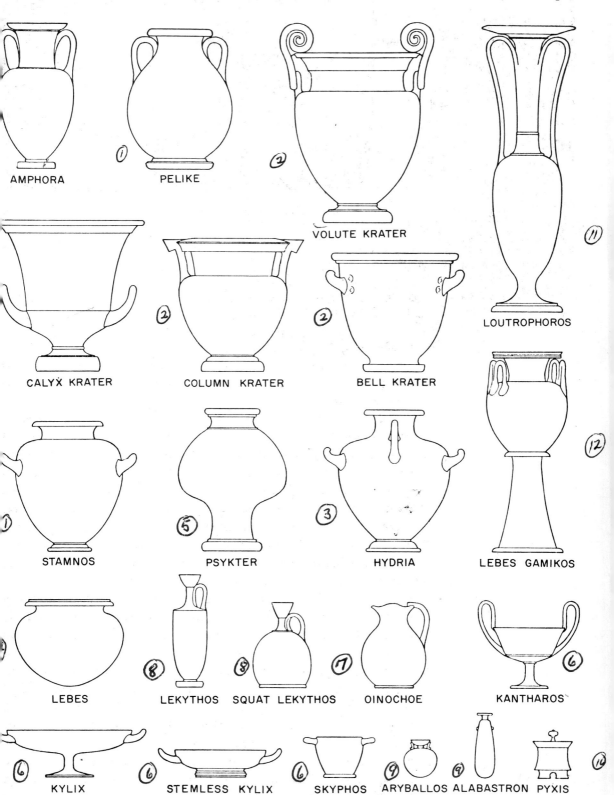

437. Shapes of sixth- to fifth-century Attic vases.

the Greeks did not drink their wine neat; there were four varieties, called, after the forms of handles and body—column krater, volute krater, calyx krater, and bell krater. The handle-less lebes also served as a wine vessel; it had a round bottom and was placed on a stand. The psykter, with body drawn in towards the base and with a high foot, was used for cooling the wine. The kylix, skyphos, kantharos, mastos, all with two handles, and the vases in the form of heads, mostly with a single handle, were the chief drinking cups. The kyathos, with a single, high handle, served for ladling the wine out of the krater.

The oinochoe, with one handle and a round or trefoil mouth, was the standard wine-jug, and the one-handled, narrow-necked lekythos was the oil-jug. The aryballos and alabastron were ointment and oil jars, used in the palaestra and the home. The askos, with convex top and arched handle, was also an oil-jug. The pyxis served as a box for toilet articles; it had no handle, but a lid with a central knob, or, in the late fifth century, with a bronze, ring-shaped handle. The lekanis, a bowl with lid, base, and mostly two handles, was used to contain various things, chiefly for women's use. The phiale was the libation bowl; it had no handle, but instead a central boss for inserting the fingers while pouring. The kothon was apparently a water bottle.[9] The plates and small stands were evidently for table use.

In addition to these standard shapes there were several that were used for special occasions. The Panathenaic amphora, with broad body tapering sharply downwards and with a relatively thin neck, was given as a prize at the Panathenaic games and was regularly decorated with an Athena on one side, and with the contest at which the prize was won on the other. The loutrophoros, a tall vase with high neck and flaring mouth, was employed for bringing water from the fountain Kallirrhoe for the nuptial bath, and was placed on the tomb of an unmarried person; there were two varieties, one with two handles resembling an amphora, another with three handles like a hydria. The lebes gamikos, with high flaring foot, body in the shape of a lebes, and double handles on the shoulder, was a marriage bowl, given as a present to the bride. The plemochoe, with high foot, turned-in rim, and knobbed lid, was a perfume vase used after the bath and in ritual ceremonies. An onos was an implement placed on the knee while carding wool. A number of these vases, the amphorae for instance, were regularly provided with lids; but few of them have survived. When they have, they add much to the general effect.

Most of these shapes were adhered to for several centuries, others had a comparatively short life. Each shape changed in the course of time, but retained its essential characteristics. In the hydriai and lekythoi, for instance, the shoulder is at first rounded, then offset, and then again rounded. The early kylikes have a low, conical foot and a deep bowl

with offset lip; gradually the bowl becomes shallower and the foot high-stemmed, until a superb form is evolved with a continuous curve from lip to stem. In the earlier amphorae the neck is in one line with the body, in the later it is mostly offset. Speaking generally, the sturdy shapes of the early sixth century gradually became refined into the harmonious forms of the late sixth and early fifth century; then became slighter and more elongated; finally they changed into the weaker, but still graceful forms of the fourth century. Many of the shapes mentioned occur also in miniature, evidently having served as toys. Especially popular was the oinochoe decorated with scenes of children at play.

To study the carefully designed shapes and to appreciate their subtle distinctions is an introduction to Greek art. The handles, in particular, are revealing of the Greek mind. Shape, size, and position are nicely calculated for convenient use and artistic effect. A Greek handle never has the appearance of being stuck on. The slight swelling imparted at the juncture suggests growth and adds solidity.

The decoration consisted of two chief elements—the ornamental DECORATION motifs and the figured scenes.

The ornaments, which in the preceding period had often been scattered over the whole surface of the vase, now became systematized and were relegated to definite areas. They served to accent the component parts—mouth, neck, shoulder, body, handles; they acted as borders or frames for the figured scenes; or they occupied the backs of the vases; and occasionally they formed the sole decoration. Moreover, they were reduced to a few standard motifs. The lotus, the palmette, the simple and multiple meander, sometimes alternating with a crossed square, ivy and laurel wreaths, rays, scrolls, tongues, and horizontal bands were used again and again in different combinations. Many of these ornaments were survivals from former epochs, but all now became designs of sober elegance.

The figured scenes were at first taken chiefly from mythology. The favourite deities were Zeus, Apollo, Athena, Hermes, and Dionysos with his retinue; the favourite heroes were Herakles, Theseus, and Perseus. Scenes from the Trojan war, Amazons fighting Greeks, Centaurs, and Lapiths were popular representations. As time went on, however, artists became more and more interested in depicting the life around them—the youths exercising in the gymnasium, riding, arming, departing for battle, fighting, being wounded, dying; the gay banquets with men reclining on couches, drinking, singing, having their cups refilled by the boys, and listening to the music of the flute girls; women busy with their household tasks: fetching water, spinning, weaving, dressing, dancing, and attending to their children; children playing with their toys; household animals; rituals, marriage ceremonies, burials, and

438. Altar with receding sides. Drawing after an Apulian krater, fourth century B.C. Naples, Museo Nazionale.

mourners at graves; actors performing in plays, both tragic and comic. All these subjects appear on the vases in a series of vivid scenes, and constitute one of the chief sources for our knowledge of Greek life.

The rendering of the figures reflects the epoch-making changes that took place in Greek drawing during this period. Until about the middle of the sixth century the representations were still purely two-dimensional. The figures were drawn either in full profile, or a full-front trunk was attached to profile legs and arms; an eye in front view was drawn on a profile head; draperies were stiff and foldless. Depth was suggested merely by the overlapping of forms. In furniture and architecture only the front planes were indicated.

Around 530 B.C. came the beginning of a change. From then on attempts were made to show a figure not in a combination of full front and profile views, but in actual three-quarter views. The farther side of abdomen, chest, and back contracts, so does the farther side of a clavicle, shoulder blade, foot, and hand. The folds of draperies were first drawn as differently coloured areas, presently by oblique lines with zigzag edges. At first such renderings appear only occasionally, for the old two-dimensional concept was slow to die. Gradually they occur more frequently. By the second quarter of the fifth century B.C. the feeling for space becomes pronounced. Three-quarter views become increasingly popular. In the profile rendering of the eye the iris is first moved to the inner corner, presently the inner corner is drawn open. The old schematic drapery is abandoned; the folds assume natural

shapes, and go in a number of directions. The old tradition of putting all the figures along one line in the front plane is not always followed; some are occasionally placed higher than others to suggest a farther plane, and the feet are no longer put along one and the same line. Muscles and folds are occasionally drawn in thinned glaze for contrast with the black contours of the figures, suggesting depth.

By the second half of the fifth century three-quarter views no longer present difficulties. The rendering of the eye in profile has been mastered. The hair is not always painted as a compact black mass, but its strands are differentiated. The draperies are drawn in flowing lines varying in direction, suggesting the round forms of the body beneath. A discreet use of white, red (often on white), and gilding gives variety to the colour scheme. Linear perspective makes its appearance. Shrines, altars, and furniture are drawn not always in front view, but with receding sides (cf. fig. 438 and pp. 278 f.).

By the fourth century B.C. the attainment of depth was fully realized. Though vase-painting no longer occupied the prominent place it had in former days, it reflects the achievements in contemporary paintings to some extent. Three-quarter views and even violent foreshortenings, which a century ago had been merely attempted, are now convincingly rendered. The black-glaze lines become thin and attenuated. White, pink, gold leaf, and occasionally even blue and green are used in the more carefully executed pictures to enrich the colour scheme.

The inscriptions occasionally added in vase paintings are of great INSCRIPTIONS interest. They are of various kinds:

(1) They give the names of the figures represented, generally in the nominative (Ajax, Herakles), or in the genitive, with 'likeness' understood (of Aphrodite). Sometimes a horse is named (Xanthos), or an object is described (a seat, a waterjar, a fountain).

(2) They explain the subject represented ('games in honour of Patroklos') or the action of a figure ('he is about to jump').

(3) What a person is saying is written as if issuing from his mouth ('look, a swallow').

(4) Sometimes a phrase is addressed to the person looking at the vase ('I greet you').

(5) A widespread custom was to call a youth or girl fair—not necessarily the one represented in the picture, but a favourite beauty of the time. The regular formula is 'so and so (he or she) is fair' (kalos, kale). Generally boys rather than girls are praised. Since the same name sometimes occurs on a number of vases, valuable chronological evidence is thereby supplied.

(6) There are many meaningless inscriptions—letters strung together which make no apparent sense. They were evidently added for decorative effect.

(7) On the under-sides of the feet of the vases, rarely elsewhere, appear sometimes a few letters or marks or ligatures or numerals, either painted or incised, generally before firing. They were in some cases, at least, memoranda of transactions between seller and purchaser.

(8) A piece of a broken pot served as a voting ticket, and the name of an individual to be ostracized was incised on it. Names of several prominent persons appear on such potsherds; Themistokles, for instance.

(9) The most important inscriptions are the signatures of artists—of the potters and painters who made and decorated the vases. They appear in two forms: 'So and so made it' (*epoiesen* or *epoiei*), and 'so and so decorated it' (*egraphsen* or *egraphe*). Sometimes the same man both fashioned and decorated the pot and signed 'so and so painted and made it'. A few times a double signature occurs: 'so and so made it and so and so painted it'. 'Made it' is the commonest form. Now and then the same name occurs on different vases, sometimes with 'made it', sometimes with 'painted it'. On two black-figured Little-Masters cups two men signed with *epoiesen*. In a few cases the same name occurs with the verb 'painted' on vases that are different in style, evidently because two different artists had the same name.

Considering the large numbers of vases preserved, signatures are rare. Most of the extant ones belong to the second half of the sixth century and the early fifth. The custom continued through the fifth century and into the early fourth. By the later fourth it had practically disappeared; the only Athenian signatures of that time so far known are on the special class of Panathenaic amphorae (cf. p. 353).

Up to about 490 B.C. the letters are in Attic script, after 480 B.C. Ionic letters begin to appear. Evidently the Ionic forms were in general use in unofficial writing long before they were adopted by the state (cf. p. 389).

Most signatures are painted in the fields of the vases before firing; occasionally they are placed on handles, feet, or rims. Rarely they are incised. In one or two instances the signature was incised on the glaze, before firing.

THE ARTISTS OF ATTIC BLACK-FIGURE AND RED-FIGURE

Though few actual names of Attic vase-painters are known, many different styles can be recognized. Through the intensive work of the last fifty years—by many archaeologists, but especially by Sir John Beazley—the chief personalities of Attic black-figure and red-figure have become known. To those not known from signatures invented names have been assigned, derived from the subject or location of the artist's chief work (Nekyia Painter, Berlin Painter), or from a kalos name that he used (Euaion Painter), or from the name of the potter with whom he collaborated (Brygos Painter), etc.

The differentiation of these many styles has greatly increased the interest of Greek vase-painting, and has made it equal in many respects

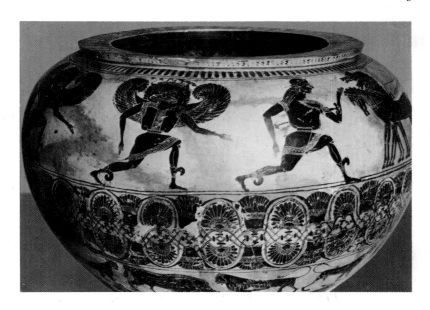

439. Attic bowl with Perseus and the Gorgons, early sixth century. Paris, Louvre.

to that of the paintings of the Renaissance. But there is no Vasari to tell us about the lives of the painters. They are known solely by their works. Only a few of the foremost artists can here be mentioned, in chronological sequence, from *c*. 620–350 B.C.

About 620–530 B.C. One of the best artists of the beginning of Attic black-figure, that is, towards the end of the seventh century B.C. was the NESSOS PAINTER who decorated the amphorae with Herakles, Nessos, and the Gorgons, and with the sphinx, mentioned above (cf. figs. 416, 417, p. 299). His figures are large in scale, with big features

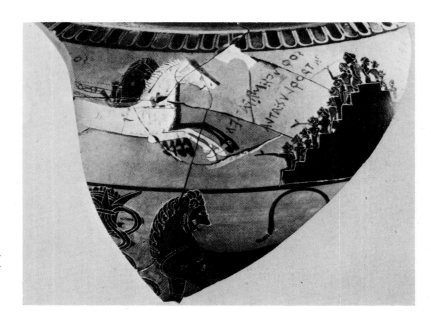

440. Games at the funeral of Patroklos, on the fragment of a bowl painted by Sophilos, early sixth century. Athens, National Museum.

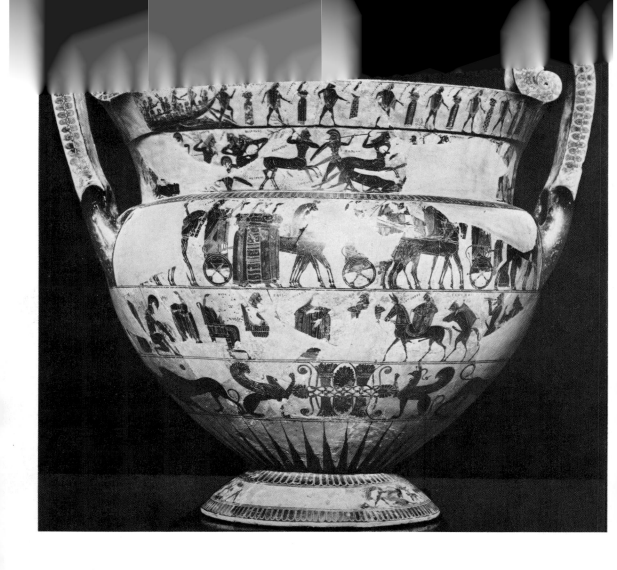

441 a, 442 a, b. Krater made by Ergotimos and painted by Kleitias ('François vase'), *c.* 570 B.C. Florence, Museo Archeologico. Side showing (fig. 442 a) a mythological animal and (fig. 442 b) the return of Hephaistos to Olympos.

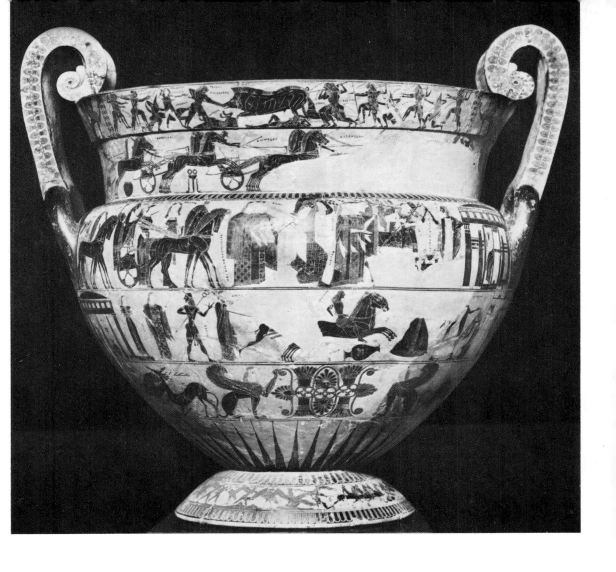

441b, 442c. Krater made by Ergotimos and painted by Kleitias ('François vase'), *c.* 570 B.C. Florence, Museo Archeologico. Side showing (fig. 442c) the Kalydonian boar hunt.

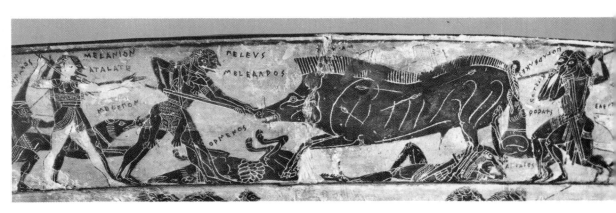

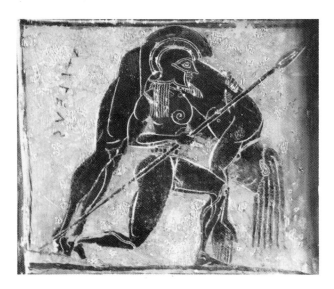

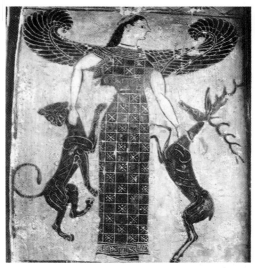

443. Ajax with the body of Achilles; Artemis. Details from the François Vase.

and serious expressions. They, and the sturdy vases on which they are painted, express the same spirit as the early Attic kouroi (cf. p. 60). Monsters and friezes of animals, so conspicuous during the preceding epochs, still loom large, and artists seem to have enjoyed depicting their fierceness.

The GORGON PAINTER is the chief representative of the succeeding generation (cf. p. 299). Among his works is a bowl on a stand, decorated with the story of Perseus and the Gorgons (fig. 439), and with rows upon rows of animals. The expressive gestures, the careful drawing, the filling of the whole available space with decorations are characteristic features. The elaborate articulations of the stand were evidently inspired by metalwork. Their harmonious interrelations suggest interest in rhythmical composition.

Closely related in style to the Gorgon painter (and perhaps even identical with him) is SOPHILOS, whose signature is preserved on three fragmentary vases. In one, from Pharsalos, he signed with both *egraphsen* and *epoiesen*; so he was a potter as well as a painter. The scene represents the games at Patroklos' funeral, being watched by excited onlookers on a stepped platform (fig. 440); among them was Achilles (only the inscribed name now remains). Without use of perspective the illusion of a crowd watching a chariot race is successfully conveyed. Below is a row of animals.

KLEITIAS is the chief painter of the second quarter of the sixth century. He and the potter ERGOTIMOS signed the magnificent François krater in Florence (fig. 441–443), twenty-six inches high, and decorated with more than two hundred neatly drawn, vivacious figures, arranged in six superimposed rows (the lowest on the foot), and in two small panels at the handles. The subjects are chiefly mythological—

444. Stand made by Ergotimos and painted by Kleitias, second quarter of the sixth century B.C. New York, Metropolitan Museum.

the Kalydonian boar hunt, a dance of the youths and maidens rescued from the Minotaur by Theseus, the chariot race at the funeral games of Patroklos, the arrival of deities after the wedding of Peleus and Thetis, the pursuit of Troilos by Achilles, the return of Hephaistos to Olympos, a row of animals and monsters, the battle of pygmies and cranes, and, on the handles, Ajax carrying the dead body of Achilles, and Artemis as queen of wild beasts. The interest in story-telling is further shown in the many inscribed names that serve to identify the figures. The vase was found at Vulci, in an Etruscan tomb, and is called after its excavator.

The same two artists, Kleitias and Ergotimos signed a little stand with a delicately drawn gorgoneion (fig. 444), now in New York, as well as Little-Master cups.

The PAINTER OF AKROPOLIS 606, a contemporary of Kleitias, was one of the ablest artists of his time. The lebes in Athens, after which he is named, could serve as an illustration of the Iliad, so vividly drawn is the Homeric turmoil of the battle. His gifted contemporary NEARCHOS was both painter and potter, and, like other artists of the time, produced large as well as small pots.

On a fragmentary bowl in Athens is preserved the signature of LYDOS, 'the Lydian painted it', an outstanding artist of the middle and third quarter of the sixth century. He decorated also one of the largest terracotta kraters that have survived, with the return of Hephaistos to Olympos, escorted by his retinue of Satyrs and Maenads (fig. 445). The large scale of the figures, placed continuously round the whole vase, their lively gestures, and the rhythmical composition make the vase an impressive piece. The same vigorous style is found on Lydos' terracotta plaques with mourners raising their hands as they sing the funeral

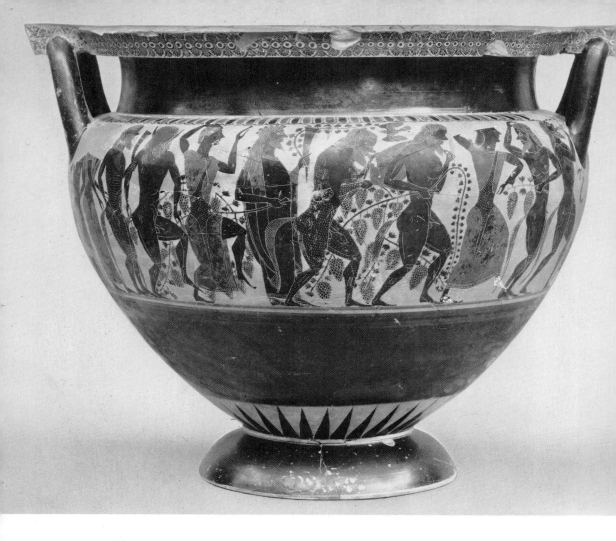

445. Krater with Hephaistos returning to Olympos, painted by Lydos, c. 550–540 B.C. New York, Metropolitan Museum.

dirge. Such plaques once decorated, it seems, quadrangular tombs of sun-dried brick of a type found in the Athenian Kerameikos and perhaps represented on two kyathoi in Paris (cf. p. 47).

EXEKIAS was both potter and painter. Twice he signed with *egraphse kapoiese me*, 'decorated and made me': on an amphora in Berlin and on an amphora in the Vatican decorated with Archilles and Ajax playing draughts (fig. 446), and with the Dioskouroi welcomed home. The scenes are painted with a wealth of detail in an elegant yet forceful style. The same quiet distinction pervades many of his other works (cf. fig. 451). Like Lydos he decorated not only vases but plaques.

Eight signatures of AMASIS as potter are known, all on highly finished specimens of the potter's craft. The decorator of these vases, the Amasis Painter, imparted to his figures a mannered grace, even when he worked cursorily. He painted both large and small pots, including a number of Little-Master cups. Among his most attractive pieces are two lekythoi in New York, one showing women engaged in

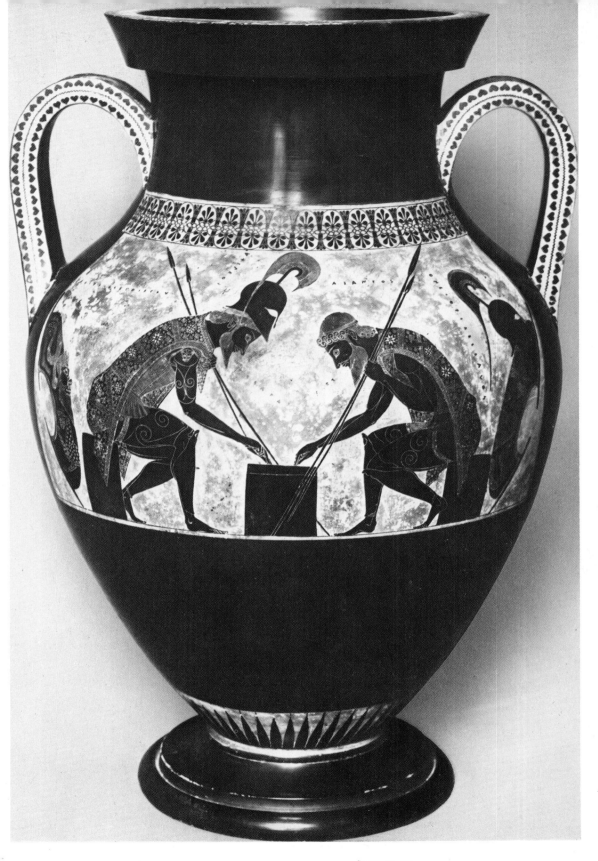

446. Amphora with Ajax and Achilles playing draughts, painted by Exekias, c. 550–540 B.C. Vatican, Museum.

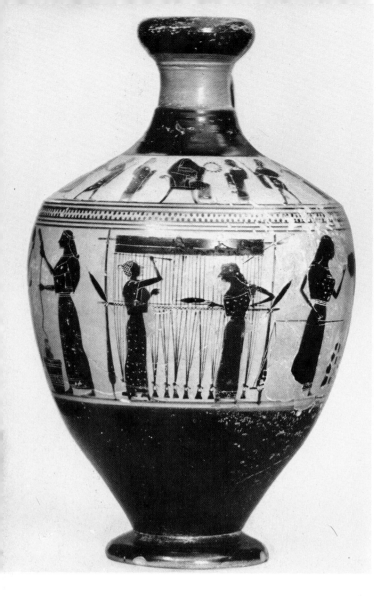

447. Lekythos with women working wool, by the Amasis painter, *c.* 540 B.C. New York, Metropolitan Museum.

working wool (fig. 447)—weighing it, carding it, spinning, and weaving—the other a wedding procession[10] (cf. fig. 448). Not only the style of the pictures but also the pots are markedly similar.

The so-called AFFECTER carried the mannerism still further, creating stylized, elongated figures, with lively gestures, but strung together with little concerted action.

NIKOSTHENES was a prolific potter (his signature appears on some hundred extant vases) who liked to experiment with new forms in imitation of metalware. The artist who decorated most of his pots (the N painter) produced mostly conventional pictures, cursorily executed.

The TLESON PAINTER, who decorated the Little-Master cups signed 'Tleson, son of Nearchos, made it', is the chief representative of a large class of miniature painters. His little figures are drawn with grace and precision.

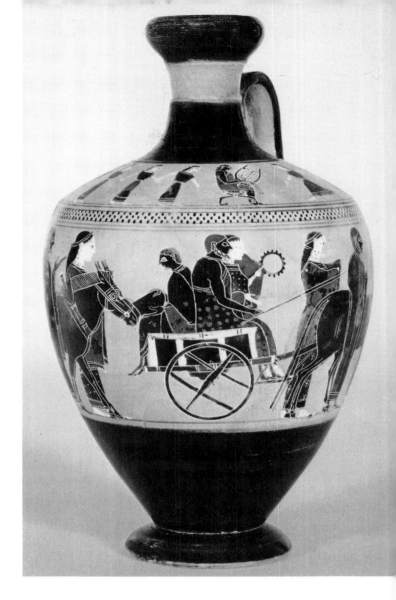

448. Lekythos with wedding procession, by the Amasis Painter, *c.* 540 B.C. New York, Metropolitan Museum.

In the concluding years of the reign of the tyrant Peisistratos (d. 527 B.C.) red-figured painting was introduced. The two techniques continued side by side until the end of the century and beyond. Some painters indeed used the two methods on the same vase. One of the earliest artists who worked in red-figure was the ANDOKIDES PAINTER. He continued the tradition of Exekias in a strong, broad style, but with a dainty, almost affected grace, reminding us that he lived during the luxurious Peisistratid days. His kitharist and two listeners holding flowers, and his dancing Maenad on amphorae in Paris and New York[11] (fig. 449) bring to mind the late archaic Maidens from the Akropolis (cf. pp. 79 f.).

PSIAX signed, as painter, two alabastra potted by HILINOS. He decorated both large and small vases, in a highly finished, meticulous style, with a wealth of detail; and he, like the Andokides Painter, was

449. Maenad, from an amphora painted by the Andokides Painter, *c.* 520 B.C. New York, Metropolitan Museum.

450. Trumpeter, from a plate painted by Psiax, *c.* 520 B.C. London, British Museum.

an experimenter. He worked in black-figure (cf. fig. 450), red-figure, black on white, white on red, and used such devices as applied clay on spear shafts, and heads in the round on oinochoai. One of his most important works is an amphora in Philadelphia potted by Menon (hence he was formerly called the Menon Painter).

About 530–400 B.C. In a decade or two, red-figure was securely established. For the next fifty years painters of the highest calibre decorated vases, and their manifold styles show the lively activity in the Attic potteries of that period. It is the time of the fall of the Peisistratid tyranny, the reforms of Kleisthenes, and the early days of the Athenian democracy.

Names of vase-painters and potters that stand out among a host of gifted artists are first EPIKTETOS—who signed with both *epoiesen* and *egraphsen.* His neat, spruce figures, drawn in flowing lines with few interior markings, form harmonious designs and yet have an extraordinarily living quality. The medallions on plates in the Cabinet des Médailles and the British Museum representing a man on his way home from a banquet, and a youth with his horse (fig. 452) are typical examples.

OLTOS signed two kylikes with *egraphsen,* and from their style over a hundred other cups have been attributed to him. Some are carefully painted, others hastily. His figures are thick-set and drawn with strong incisive lines. One of his masterpieces is the large kylix in Tarquinia with deities on Olympos.

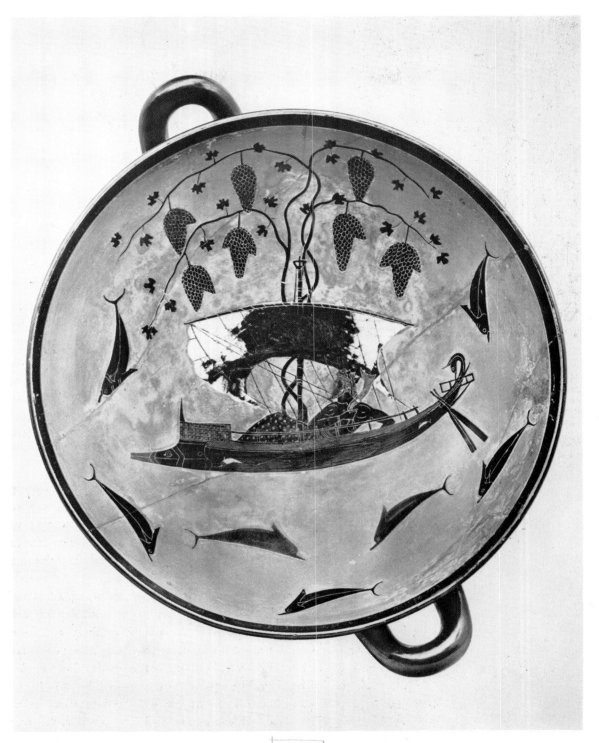

451. Dionysos sailing (on red-glazed ground), by Exekias, mid-sixth century B.C. Munich, Antikensammlung.

525

Kilix

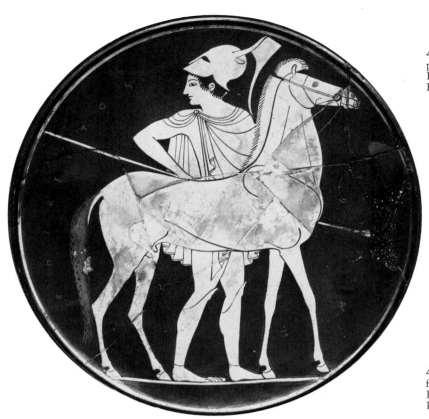

452. Youth with horse, from a plate made and painted by Epiktetos, c. 510 B.C. London, British Museum.

453. Herakles and Antaios, from a calyx krater painted by Euphronios, c. 510–500 B.C. Paris, Louvre.

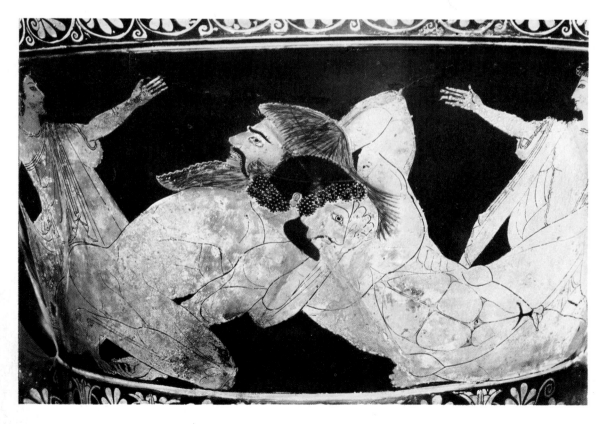

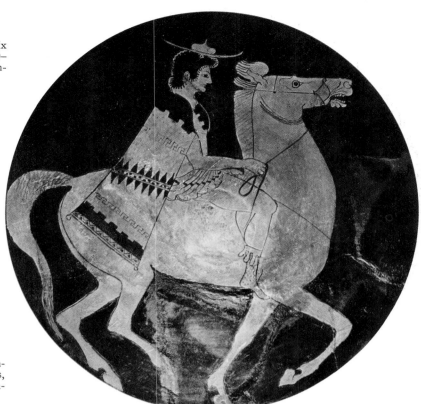

454. Young rider, from a kylix painted by Euphronios, c. 510–500 B.C. Munich, Antikensammlung.

455. Revellers, from an amphora painted by Euthymides, c. 510–500 B.C. Munich, Antikensammlung.

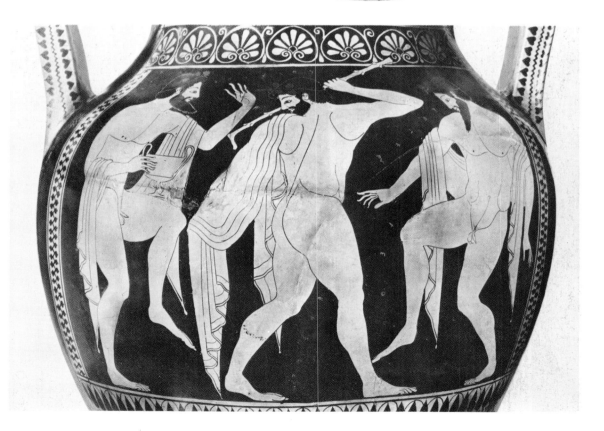

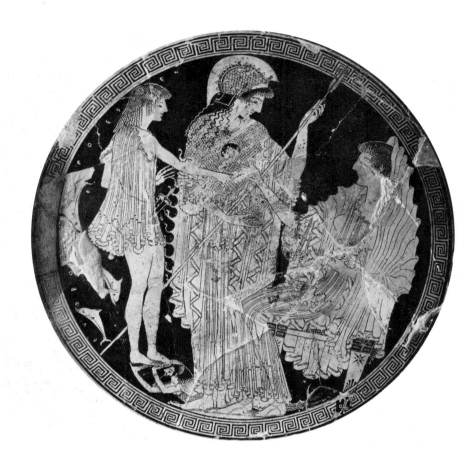

The full power of this epoch is shown in the work of EUPHRONIOS. The name appears on ten vases with *epoiesen*, on five with *egraphsen*, and all are distinguished examples (but perhaps there were two artists of that name). The calyx krater in the Louvre with a scene of Herakles and Antaios (fig. 453), signed by Euphronios as painter, is magnificently drawn, and the large kylix in New York, signed by Euphronios as potter, is an outstanding example of the craft. One of his most attractive paintings is the aristocratic young rider, with the inscription Leagros kalos, on a kylix in Munich (fig. 454). It is painted on a coral red instead of a black ground, in the effective technique only occasionally employed (cf. p. 319).

EUTHYMIDES' signature—with *egraphsen* or *egraphe*—has survived on six vases. He was a contemporary of Euphronios and of the same stature. His statuesque figures are drawn with sureness of touch, and some show a special interest in what at this time began to occupy Greek draughtsmen—foreshortening. On an amphora in Munich (fig. 455) the revellers are drawn in successful three-quarter front and back views; and that he was proud of his achievement is shown by the inscription he added: 'Euphronios never did anything like it.'

Other great figures of this time are PHINTIAS, whose monumental yet winsome paintings have survived on six vases signed with *egraphsen*,

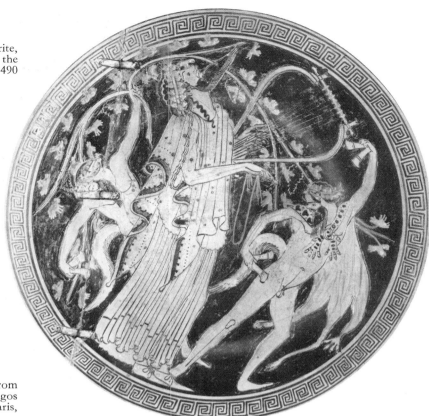

456. Theseus and Amphitrite, from a kylix painted by the Panaitios Painter, *c.* 500–490 B.C. Paris, Louvre.

457. Dionysos and satyrs, from a kylix painted by the Brygos Painter, *c.* 500–480 B.C. Paris, Bibliothèque Nationale.

three with *epoiesen*; the SOSIAS PAINTER, who drew the remarkable picture of Achilles tending the wounded Patroklos, on a kylix in Berlin; and PEITHINOS, who signed the elaborate, somewhat affected tondo of Peleus and Thetis, on a kylix in Berlin.[12]

Around the turn of the century a form of kylix of great elegance was created—with a high stem, adequate standing base, shallow bowl, and an unbroken curve from foot to lip. It was a difficult shape to pot and to decorate, and it invited the best talent of the time. The great Euphronios affixed his signature to six of these kylikes, which were decorated by a master draughtsman called the PANAITIOS PAINTER (= ONESIMOS?). The work of this artist shows an extraordinary combination of power, vitality, and refinement. Among his best extant works are the delicately drawn Theseus and Amphitrite, on a large kylix in the Louvre (fig. 456); the impetuous Herakles and Eurystheus, on a kylix in the British Museum;[13] and the youth reading aloud to two listeners, on a kyathos in Berlin.[14]

Three other names stand out among the many cup-painters of the time—the Brygos Painter, Makron, and Douris.

The BRYGOS PAINTER decorated five kylikes signed by Brygos as potter, and his highly individual style has been recognized on over one hundred and seventy vases, chiefly cups. He, like the Panaitios

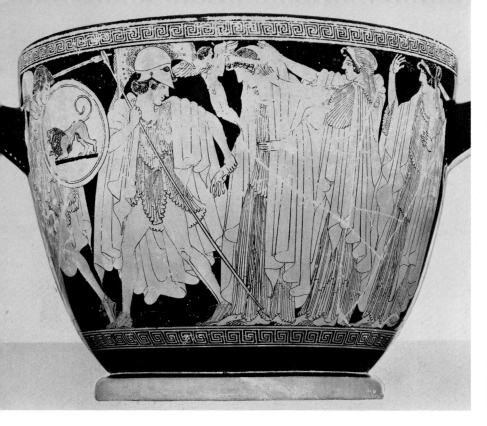

458. Skyphos with the rape of Helen, made by Hieron and painted by Makron, *c*. 500–480 B.C. Boston, Museum of Fine Arts.

459. Dancing satyrs, from a psykter painted by Douris, *c*. 500–480 B.C. London, British Museum.

Painter, liked violent movement, and his favourite subjects were scenes of pursuit, revels, and battles; but occasionally he produced a stately goddess or a woman sitting quietly at home working wool. His early work is characterized by a strong, incisive line and an abundant vitality. The Dionysos and satyrs in Paris (fig. 457), the ecstatic Maenads in Munich,[15] and the wild satyrs attacking Iris and Hera, in the British Museum,[16] are examples of such animated pictures. His later works are more attenuated. The old joie de vivre is gone, the lines have become thin, the figures are almost ethereal.

MAKRON painted all except three of about thirty extant vases signed by HIERON as potter, and over three hundred works have been attributed to him. On a skyphos, in Boston, with a picture of Menelaos and Helen (fig. 458), he signed jointly with Hieron: 'Hieron epoiesen, Makron egraphsen'. His paintings are notable for delicacy of drawing, especially in the rendering of women's garments, and for harmony of composition. Favourite subjects are banquet scenes; satyrs and maenads; and women, boys and youths, arranged in groups of three or two. In these 'conversation scenes' there is much repetition, but variety is created by the paraphernalia that are introduced—couches, stools, cushions, wreaths, sticks, sponges, strigils, and baskets. That the works of the Brygos Painter and Makron were prized also in ancient times is suggested by the fact that vases decorated by them were found in a tomb at Capua with pots

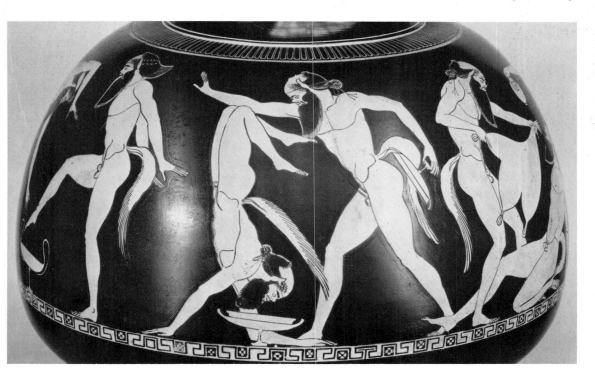

painted by artists of the next generation (the Sotades and the Deepdene Painters[17] (cf. p. 347).

Of DOURIS about forty signatures are preserved and over 200 vases have been attributed to him on grounds of style. A kantharos in Brussels is signed by him both as painter and potter. He was active from about 500 to 470 B.C., and an early, a middle, and a late period have been distinguished. The moving picture of Eos carrying her dead son Memnon in her arms (an ancient Pietà), painted as a tondo on a kylix in the Louvre,[18] the animated school scene on a kylix in Berlin,[19] and the rhythmical satyrs on a psykter in the British Museum (fig. 459) rank among the masterpieces of his middle period. Much of his work is academic, but in his later period he acquired a monumental quality. The women putting away clothes, on a kylix in New York,[20] is a harmonious composition of large-scale figures successfully adjusted to the circular field.

A number of first-rate artists of this epoch seem to have specialized in the making and decorating of large pots instead of kylikes. The KLEOPHRADES PAINTER, who decorated a large cup in Paris signed *Kleophrades epoiesen*, painted over a hundred extant vases, chiefly amphorae and hydriai, in a virile, highly individual style. A firm, flowing line, spaciousness of composition, and above all a monumental quality are his chief characteristics. Two large calyx kraters,[21] in Tarquinia and

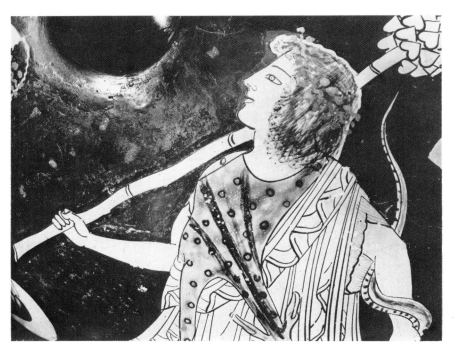

460. Maenad, from an amphora painted by the Kleophrades Painter, *c.* 500–490 B.C. Munich, Antikensammlung.

462. The destruction of Troy, from a hydria painted by the Kleophrades Painter, *c.* 500–490 B.C. Naples, Museo Nazionale.

461. Achilles and Hektor, from a volute krater painted by the Berlin Painter, *c.* 500–480 B.C. London, British Museum.

New York, with youths arming, a pointed amphora with ecstatic Maenads, in Munich (cf. fig. 460),[22] and the Ilioupersis, on a hydria in Naples (fig. 462), are among his best works. In the last he successfully conveyed not only the fierceness of battle and the triumph of victory, but the pathos of defeat. In his late period his strength waned and he produced conventional pictures on relatively small vases. One of these is signed *Epiktetos egraphsen*; so we know his real name—the same as that of a painter of the preceding generation (cf. p. 336).

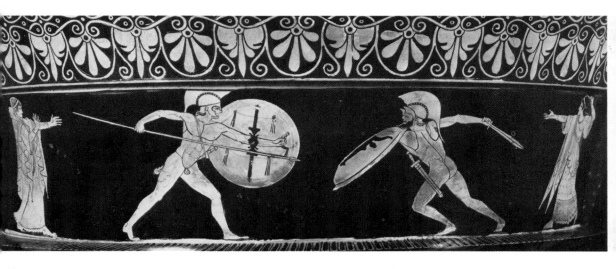

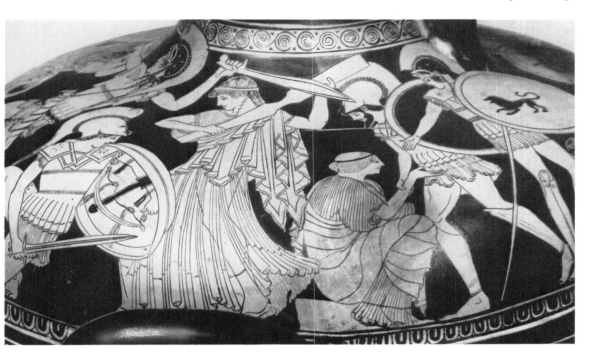

The BERLIN PAINTER derives his name from a tall amphora in Berlin with Hermes and two satyrs. More than two hundred vases have been attributed to him. None of them is signed.[23] His lithe, graceful figures are drawn in flowing lines, often with much anatomical detail, in spacious compositions. An early example is the picture of Achilles and Penthesileia on a hydria in New York.[24] The contests of Achilles and Memnon, and of Achilles and Hektor (fig. 461), on a volute krater in London, are among his masterpieces. The Homeric joy of battle in the

463. Fight between Lapiths and Centaurs, from a krater, *c.* 460–450 B.C. New York, Metropolitan Museum.

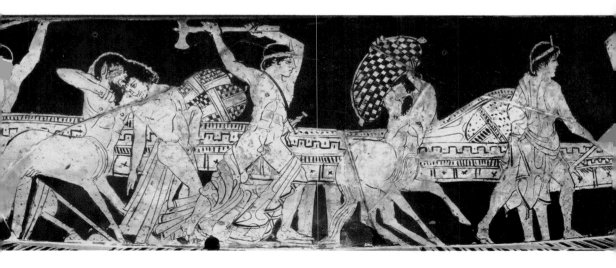

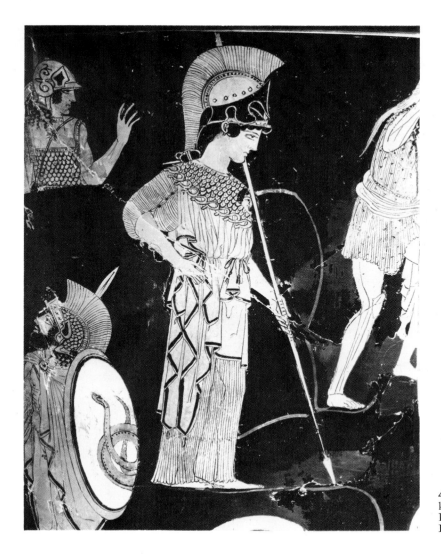

464. Athena, from a calyx krater painted by the Niobid Painter, *c.* 460–450 B.C. Paris, Louvre.

two heroes and the anxiety of the two women watching the fight are finely contrasted.

Throughout this period, indeed until the middle of the fifth century, black-figure was retained as a secondary technique, mostly for small lekythoi, neck-amphorae, and oinochoai. The SAPPHO PAINTER, the DIOSPHOS PAINTER, the THESEUS and ATHENA PAINTERS are some of the artists to whom these vases have been attributed. Some of them doubtless also worked in red-figure.

In the period of the early free style (*c.* 475–450 B.C.) a new spirit is observable in vase-painting as in the other branches of Greek art. Several trends can be distinguished. Some artists, evidently inspired by the murals of Polygnotos and his associates (cf. p. 277), produced ambitious compositions on large vases with figures placed on different levels in hilly landscapes. Combats of Lapiths and Centaurs (cf. fig. 463) and of Greeks and Amazons are favourite themes. Foremost among

these artists is the NIOBID PAINTER, who decorated a magnificent calyx krater in the Louvre with the Argonauts and the Death of the Niobids. Statuesque poses (cf. fig. 464) and contorted attitudes appear *crispées* side by side on these vases, as they do in the sculpture of the time.

Other artists specialized in quiet compositions, foreshadowing the classicism of the next epoch. Among them is the VILLA GIULIA PAINTER, who decorated a calyx krater in the Villa Giulia Museum with women in a stately dance.[25] His able pupil the CHICAGO PAINTER combined statuesqueness with winsome grace.

By way of contrast, the Mannerists harked back to the style of the preceding period, using archaic conventions side by side with free renderings. Their most gifted representative is the PAN PAINTER, named after one of his chief works, an exuberant Pan pursuing a goatherd.

Still another group of painters is distinguished by individualistic treatment of familar subjects. Such are the PENTHESILEIA PAINTER and his many followers. The Achilles and Penthesileia on a kylix in Munich[26] shows this well-known subject treated with a new emotional note. On a white-ground pyxis in New York is represented the Judgement of Paris, with Paris depicted as a shepherd boy sitting on a rock, receiving Hermes (fig. 465).

To the same general group of artists belong the PISTOXENOS PAINTER, whose masterpiece is the regal Aphrodite riding a goose, on a kylix in the British Museum;[27] the SOTADES PAINTER who decorated a vase in the form of a knucklebone with floating figures symbolizing clouds;[28] and the DEEPDEENE PAINTER who painted two scenes from the Danae legend on a stamnos in New York.[29]

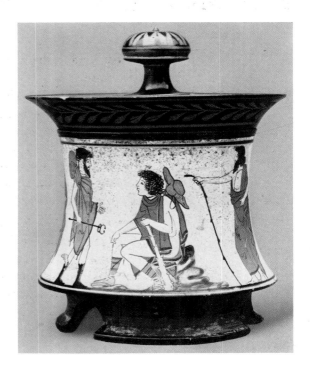

465. Pyxis with the Judgement of Paris, painted by the Penthesileia Painter, *c.* 460–450 B.C. New York, Metropolitan Museum.

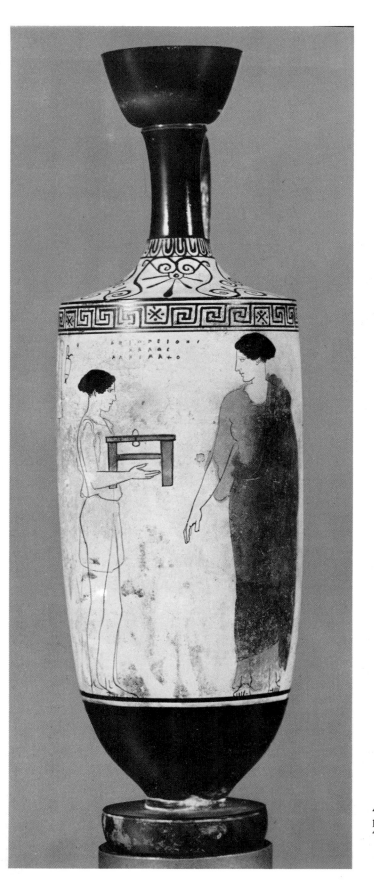

466. Lekythos with woman and maid, painted by the Achilles Painter, *c.* 450–440 B.C. Boston, Museum of Fine Arts.

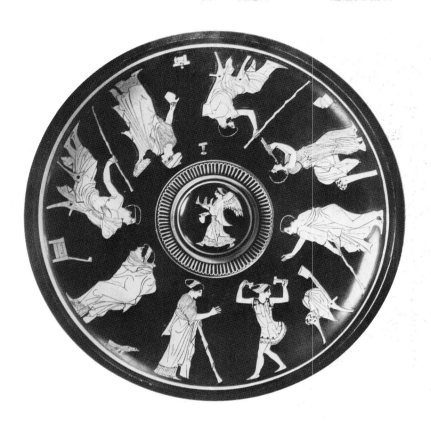

467. Phiale with visit to a school of music, painted by the Phiale Painter, *c.* 440–430 B.C. Boston, Museum of Fine Arts.

The period of the free style (about 450–420 B.C.) coincides with the administration of Perikles and the sculptures of the Parthenon (cf. pp. 112 ff.). At this time of great activity in the major arts of sculpture, architecture, and mural painting, the best talent tended to work in those fields. There are, therefore, fewer outstanding vase-painters than before. Nevertheless, the quiet grandeur that characterizes the sculptures of this epoch is reflected in many a vase-painting, especially in the work of the ACHILLES PAINTER, named after the stately amphora with Achilles and Briseis in the Vatican. His distinctive style has been recog-

468. Alkestis and her friends. Drawing after an onos painted by the Eretria Painter, *c.* 420 B.C. Athens, National Museum.

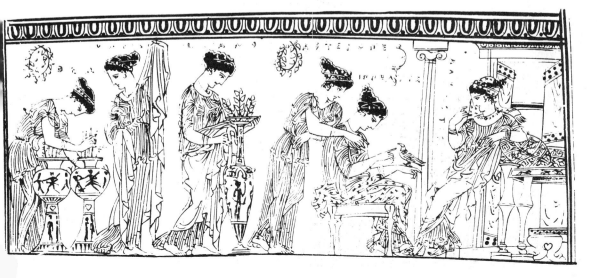

nized in more than 200 vase paintings. He particularly favoured the white-ground lekythos, and some of his finest paintings are in that technique. Among them are a girl bringing a casket to her mistress, in Boston (fig. 466), a youth departing for battle and bidding farewell to his wife, in Athens,[30] and two Muses on Mount Helikon, in a private collection.[31] In the last the colours are exceptionally well preserved. The yellow, vermilion, wine-red, reddish brown, and black appear to be consciously interrelated, playing their part in the harmony of the design.

The PHIALE PAINTER, perhaps a pupil of the Achilles Painter, introduced a lively spirit into the Periklean serenity. One of his most attractive pictures is the Visit to a School of Music, on a phiale in Boston (fig. 467)—which has given the artist his name.

A vase-painter named POLYGNOTOS is another outstanding artist of the second half of the fifth century. His figures are rounder and more fleshy than those of the Achilles Painter, and he favoured the larger vases—stamnoi, kraters, and amphorae. He had many followers, among them the LYKAION PAINTER, called after the name he gave to the departing warrior, on a pelike in London.[32]

Among the painters who favoured the smaller pots was the ERETRIA PAINTER, The refinement of his line is apparent in the delicate profiles of his figures, in their beautifully drawn hands, and in their clinging draperies. He has been named after one of his best works—a picture of Alkestis and her friends, on an onos from Eretria, now in Athens (fig. 468).

The MEIDIAS PAINTER, who decorated a hydria in London with the rape of the Leukippidai and with Herakles in the garden of the Hesperides (figs. 469, 470), carried on the tradition of the Eretria Painter. His graceful figures with rich, clinging draperies are the counterparts of the marble reliefs on the parapet of the Athena Nike temple (cf. p. 137)—both, curiously enough, produced during the agonizing last stages of the Peloponnesian war. His style, but not his fine drawing, was adopted by many followers.

The KLEOPHON PAINTER and the DINOS PAINTER may be called late followers of Polygnotos. Their work shows a broad treatment, with round, fleshy forms, loose draperies, and a developed spatial sense. They favoured the larger vases and Dionysiac subjects. A potsherd decorated by the Kleophon Painter was found in Pheidias' workshop at Olympia, together with the moulds used for the gold drapery of the statue of Zeus (cf. p. 55).

Here may also be mentioned the artist who decorated several oinochoai —in polychrome on an unglazed surface—with scenes connected with the theatre and the worship of Dionysos in a highly individual, burlesque style. His pots are, in fact, the counterparts of the South Italian phlyax

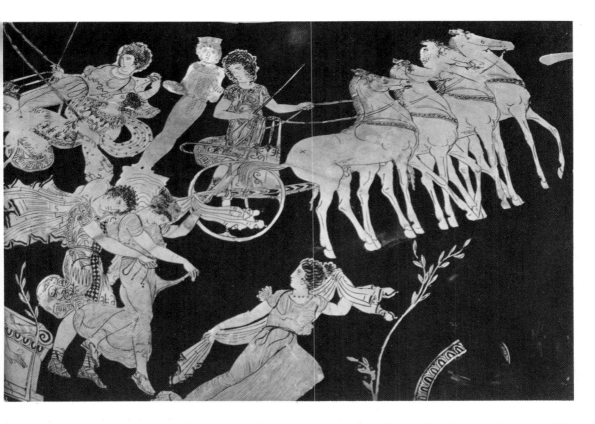

469, 470. The Rape of the Leukippidai and Herakles in the garden of the Hesperides, from a hydria painted by the Meidias Painter, *c.* 410 B.C. London, British Museum.

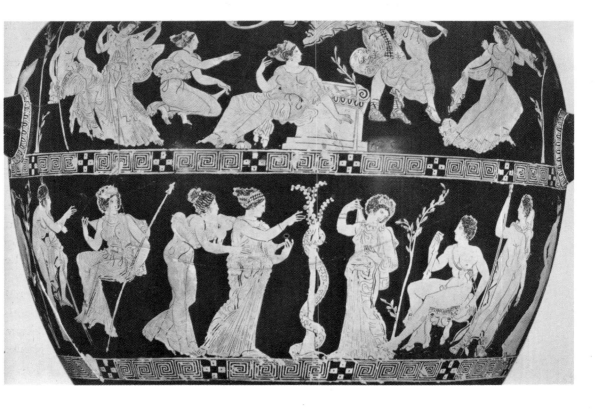

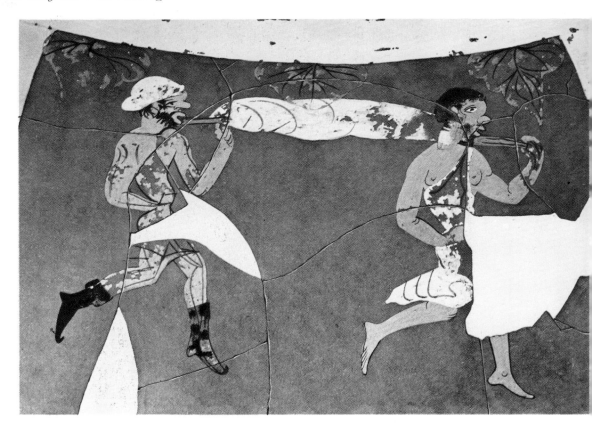

471. Two men carrying a cake. Drawing after an oinochoe, *c.* 400 B.C. Athens, Agora Museum.

vases and the Boeotian Kabeiroi ware (cf. pp. 357, 363). Fig. 471 illustrates a typical scene with two figures carrying what has been interpreted as an Obelian cake on a spike. The date is around 400 B.C. (cf. p. 319).

During the last quarter of the fifth century, that is the concluding years of the Peloponnesian war, a number of artists specialized in the decoration of white-ground lekythoi for sepulchral use. Foremost among them are the WOMAN PAINTER, the REED PAINTER, and the TRIGLYPH PAINTER. The disillusion of the time is reflected in the brooding expressions of their figures.

Presently, around 400 B.C., a highly ornate style was developed, characterized by thick lines, dark patterns on garments, and a copious use of white and yellow. Crowded compositions and figures drawn chiefly in three-quarter views became the vogue. The TALOS PAINTER, the PRONOMOS PAINTER, and the SUESSULA PAINTER (cf. fig. 472) are the chief exponents of this style. In the early fourth century the style was further developed, with much added colour, gilding, and applied clay. The MELEAGER PAINTER and the XENOPHANTOS PAINTER rank among the chief artists of this time. The latter signed a pair of lekythoi, from Kerch, now in Leningrad, with scenes of Persians hunting.[33]

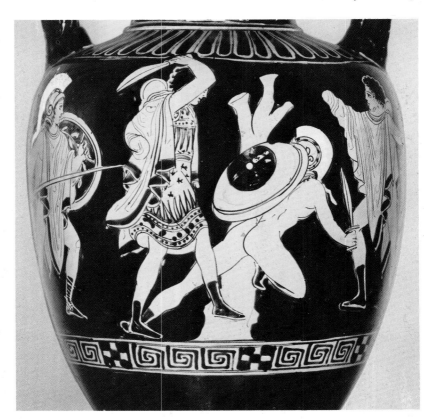

472. Combat scene, from an amphora painted by the Suessula Painter, *c.* 400 B.C. New York, Metropolitan Museum.

Side by side with these florid paintings a simpler style persists, in which the red-and-black colour scheme, with only slight touches of accessory colours, is retained. It is found chiefly on the smaller vases, and the decoration generally consists of only one or two figures. The ERBACH PAINTER, the JENA PAINTER, and the DIOMED PAINTER (cf. fig. 474) belong here.

The two red-figured styles, florid and simple, continued well into the fourth century B.C., until they developed, in the second quarter of the century, into the Kerch style, so called from the city in South Russia where many examples have been found. It lasted until about 320 B.C. and represents the last phase of Athenian red-figure. Subjects from the life of women and cult scenes are especially popular. Dionysos, Apollo, and Aphrodite are the chief deities represented, and Herakles is the favourite hero. The figures are drawn in short, thin, black lines, enriched with pink, gold leaf, and sometimes blue and green. Much of the work is cursory, but occasionally a masterpiece was produced, for instance the Dionysos and Pompe (Procession) on an oinochoe, now in New York (fig. 473), the name piece of the POMPE PAINTER.

Painting in black-figure was retained during the fourth century for a special class of vases—the Panathenaic prize amphorae (cf. p. 322).

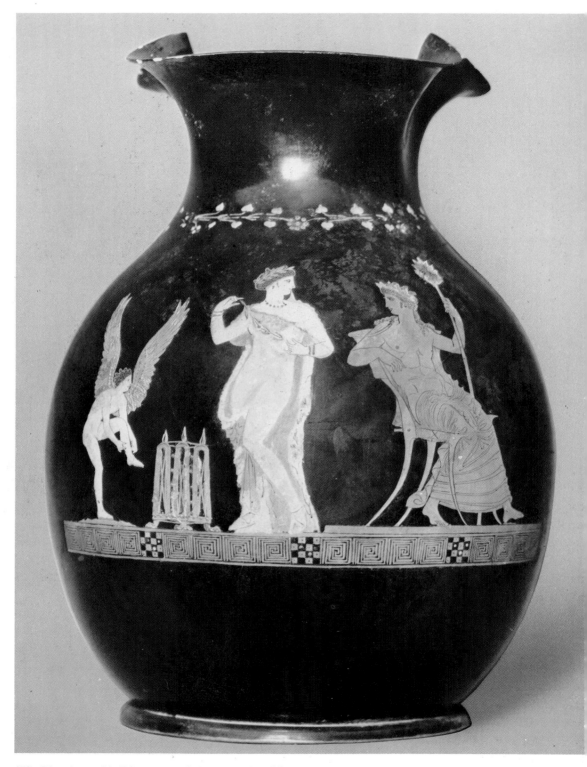

473. Oinochoe with Dionysos and Pompe, painted by the Pompe Painter, *c.* 350 B.C. New York, Metropolitan Museum.

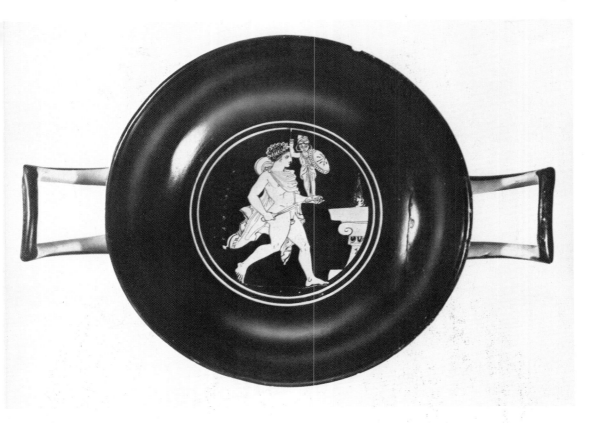

The form of the amphora is more elongated than before, the figure of Athena is drawn in archaizing style, whereas the representation of the contest is in the free manner of the period (fig. 475). A number of these amphorae are inscribed with the name of the archon of the year in which the prize was won, and so supply chronological data.

474. Kylix with Diomedes carrying the Palladion, painted by the Diomed Painter, *c.* 400–380 B.C. Oxford, Ashmolean Museum.

An interesting development in Attic ware which may be assigned to the late fourth century was the addition of reliefs or figures in the round to vases. Relief decoration was nothing new in Greek ceramics. It had been used in the archaic period in various places, especially in Crete, Boeotia, and Laconia; and it occurs occasionally also in the fifth and the early fourth century side by side with red-figure. Furthermore, the gradual development of the third dimension had introduced the use of applied clay for minor objects. The next step was to employ applied clay, first for single figures, then for the whole decoration. One of the finest examples is a lekythos found at Kerch and now in the Louvre (CA 2190), decorated with a group of Eleusinian deities. More modest is a little oinochoe in New York with a charming scene of Erotes learning to fly (fig. 476). Often a simple laurel wreath round the neck sufficed as decoration.

VARIOUS
ATHENIAN FABRICS
PREVALENT
DURING
THE FOURTH
CENTURY B.C.

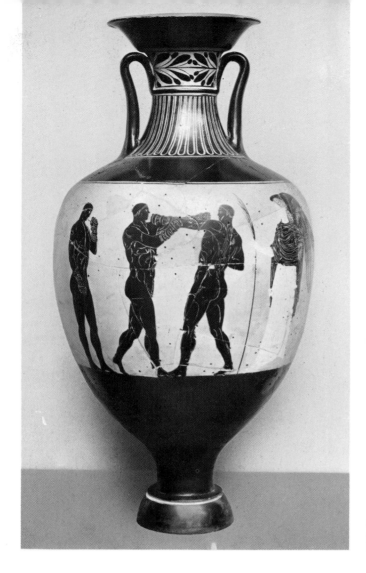

475. Panathenaic prize amphora with boxing contest, fourth century B.C. London, British Museum.

Another common device was to attach a statuette to the body of a lekythos or a jug, or to fashion the whole body of the vase in the form of a statuette. The figures were painted in tempera over white slip. Relief decoration on vases had, as we shall see, a long subsequent history (cf. pp. 366 ff.).

Yet another technique practised in Athens during the fourth century was that of stamped decoration on vases entirely covered with black glaze. Though the earliest examples date from the fifth century (cf. p. 319), the technique continued for a considerable time.

Belonging also to the fourth century, but continuing later, is the 'West Slope ware' first found in quantity on the West slope of the Athenian Akropolis, hence its name, but later in many other localities. As in the South Italian Gnathian vases (cf. p. 362), floral and other ornaments are painted in red, white, and yellow, on an all-black surface, with occasional stamped and incised decorations.

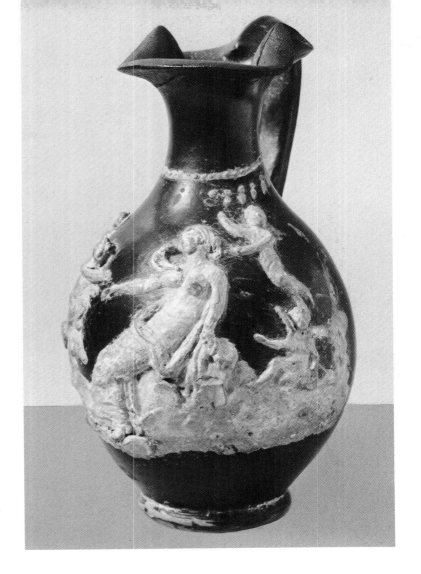

476. Oinochoe with clay relief of Erotes learning to fly, fourth century B.C. New York, Metropolitan Museum.

Boeotian Vases, Fifth and Fourth Centuries B.C.

Though Attic pottery dominated the Mediterranean from the middle of the sixth to the fourth century B.C., naturally other wares were created for local needs. Among these may be mentioned the Boeotian vases. Black-figure, red-figure, and especially all-black, were used, chiefly on bowls and cups. The figures are usually cursorily worked and lack the incised lines customary in Attic black-figure. Occasionally, however, in the midst of this secondary output, a little masterpiece appears, such as the picture of two youths with lyre and flute, on an oinochoe in New York.[34]

The so-called Kabeiroi vases, found in the sanctuary of the Kabeiroi near Thebes, constitute a special class. The prevalent form is the skyphos with horizontal handles. The decoration, in black silhouette against a pale terra-cotta ground, consists mostly of burlesque scenes, in which

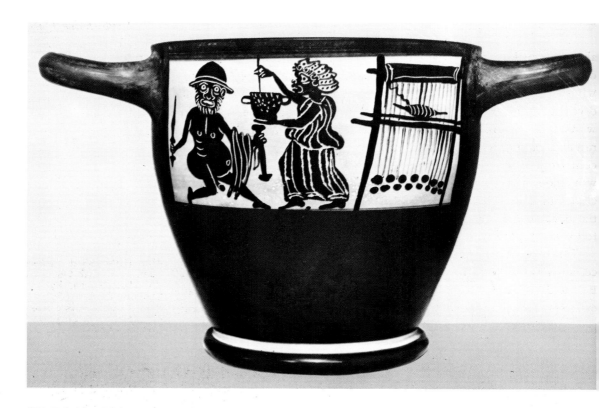

477. Kabeiric skyphos with Odysseus and Circe, fourth century B.C. Oxford, Ashmolean Museum.

gods and heroes are caricatured with Aristophanic humour. The majority belong to the fourth century, a few are earlier. A skyphos in the Ashmolean Museum has a scene of Odysseus with Circe (fig. 477). The deeds of Herakles are a favourite subject. The drawing is able and individual; it is evident that in burlesque the Boeotian artist found a natural expression. In the more conventional scenes, for instance in the Nereids carrying off the weapons of Achilles, the style closely resembles contemporary Attic red-figure.

South Italian Vases, Fifth and Fourth Centuries B.C.

BY A. D. TRENDALL

'A more serious rival to Attic pottery was the red-figured ware which began to be produced in Southern Italy from about 440 B.C. and continued through the fourth century to supply local needs. The earliest examples closely reflect the contemporary Attic style, especially that of the Achilles Painter, Polygnotos, and their followers; but by the turn of the century local schools were developing, in which an increasing divergence is shown. South Italian glaze is not such an intense black nor so lustrous as Attic, the shapes are more varied but less precise, and the decoration tends to be more florid. The scenes attract, however, by a sense of movement and often have a special interest in their representation of rare myths or lost plays.

'Two distinct fabrics may be observed during the fifth century—one leading to Lucanian, the other to Apulian—and the fourth century sees

also the development of Campanian, Paestan, and Sicilian. At the head
of the first school stand the PISTICCI and AMYKOS PAINTERS, from
whose workshop some three hundred vases have survived, mostly
decorated with rather monotonous scenes depicting the pursuit of
women, departure of warriors, athletes and Victory, or silens and
maenads, and only occasionally rising to more imaginative subjects and
compositions on the grand scale (cf. fig. 478). The location of this
workshop is still undetermined, but the line of stylistic succession is
clear and leads on (through the CREUSA and DOLON PAINTERS) to
the developed Lucanian style of the CHOEPHOROI PAINTER and his
followers in the middle and second half of the fourth century.

'The other Early South Italian fabric, which may with reasonable
certainty be assigned to Taranto, seems to have begun about 430–420
B.C. and adopts from the start a more monumental style, which finds
expression in a fondness for large vases decorated with elaborate com-
positions, sometimes in several registers. This group remained in close

478. Early South Italian
calyx krater with Odysseus
and the Cyclops, by the
Cyclops Painter (Pisticci-
Amykos group), last quar-
ter of fifth century B.C.
London, British Museum.

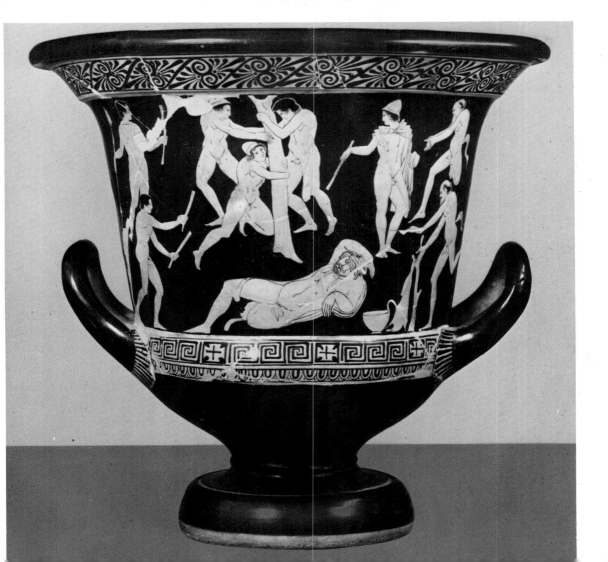

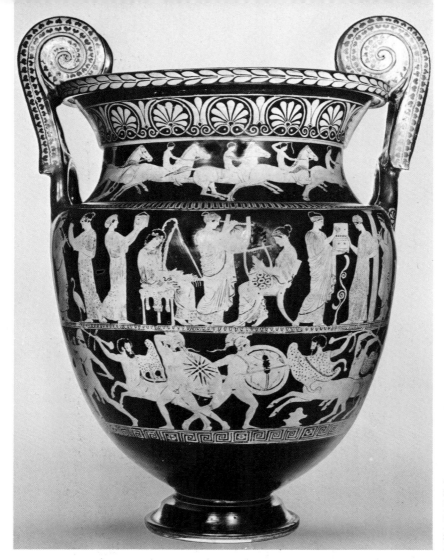

479. Early South Italian volute krater with women making music and Centaur fight, by the Sisyphus Painter, last quarter of the fifth century B.C. Munich, Antikensammlung.

480. Darius in council before his expedition against Greece. Apulian volute krater painted by the Darius Painter, third quarter of fourth century B.C. Naples, Museo Nazionale.

contact with the Attic tradition and its work never has that provincial and even barbaric quality which characterizes most other Italiote fabrics in their latest stages. Its great failing is the inability to compose on the grand scale, with the result that, while individual figures are often excellent, the compositions as a whole are heavy and lifeless. It is significant that once the new school was firmly established the import of vases into Apulia from the other centre virtually ceased. The chief artist is the SISYPHUS PAINTER, whose somewhat statuesque style shows the influence of the Parthenon and Phigaleia sculptures; he paints not only monumental kraters such as his namepiece, decorated with large-scale mythological scenes (cf. fig. 479), but also smaller vases with less pretentious compositions. He may, therefore, be said to stand behind both the main lines of Apulian vase-painting in the fourth century—the rich or 'ornate' style which culminates in the huge, elaborately decorated vases of the DARIUS PAINTER (cf. fig. 480) and his followers, and the plain style of the humbler vases which is continued by the TARPORLEY

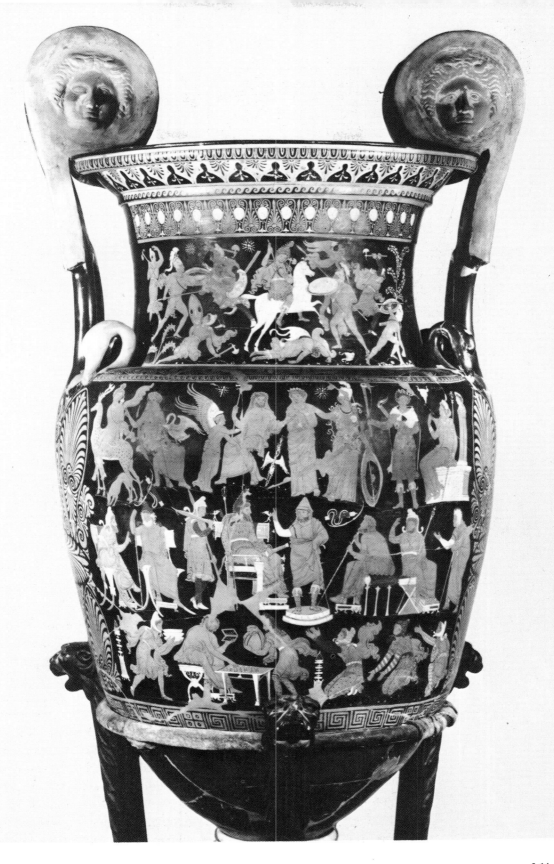

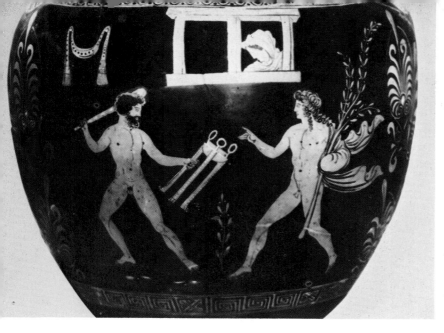

481. Apollo and Herakles, from a Lucanian volute krater by the Primato Painter, third quarter of the fourth century B.C. Naples, Museo Nazionale.

482. Symposium, from a Campanian bell krater, Cumae group, third quarter of the fourth century B.C. Naples, Museo Nazionale.

PAINTER and his school, and lasts until late in the century, with a steady increase in output and a corresponding decrease in quality. The 'Ornate' style makes great use of added white and red, and sometimes vases are found decorated only with these added colours. This style, often referred to as Gnathian from the site where examples of it were first found, comes in just before c. 350 and continues until the early third century. For an Attic parallel cf. the so-called West Slope ware (p. 356).

'The influence of both the main Apulian schools is to be seen also in the work of contemporary Lucanian vase-painters. The ROCCANOVA GROUP reflects the plainer style of the mid-fourth century, but takes it further in the direction of barbarism, the PRIMATO GROUP the richer style, with a preference for mythological and funerary scenes in the Apulian tradition (cf. fig. 481). Isolated, however, in Lucania and cut off from the main currents of artistic development, the PRIMATO PAINTER lapses gradually into a provincialism, which with his followers descends almost to barbarism, and it is hard to believe that the latest Lucanian products from the end of the fourth century are in fact the work of Greeks.

'Apart from some fifth-century imitations of Attic vases, the local manufacture of red-figure in the west does not seem to have begun until the first quarter of the fourth century. Two main fabrics are well established—Campanian and Paestan, both having their origins in a small group of vases, mostly of Sicilian provenience, which is strongly influenced by late-fifth-century Attic. Both fabrics remain closely related in style throughout, though Campanian is more varied. The latter falls into three main divisions—the CASSANDRA-ERRERA GROUP, perhaps made at Capua, consisting largely of smaller vases decorated with

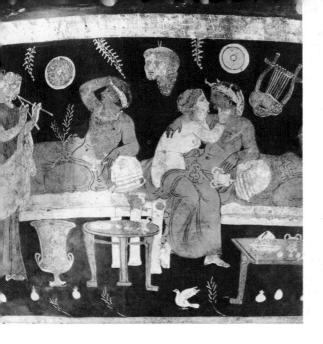

483. Sicilian polychrome pyxis from Lipari, late fourth century B.C. Lipari, Museo Archeologico.

warriors, women, youths, etc., and only occasionally rising to large-scale compositions, the AV GROUP named after Avella, where some of the vases belonging to it were found, but perhaps also based on Capua, and the CUMAE GROUP. The last is by far the most important and comprises more than a thousand vases, frequently decorated with scenes showing warriors in Samnite armour, or symposia (cf. fig. 482), with a rich use of added yellow and white, sometimes with green, red and other colours as well. It is from this group that Sicilian red-figure descends. Recent excavations at Gela, Lentini, and Lipari have brought to light a large number of vases, and it is now certain that schools existed locally, probably arising after the Timoleontic revival *c.* 340 B.C. The MANFRIA GROUP is to be closely associated with one of the better Cumaean painters, whose style, composition and use of added colour are all carefully imitated, though the Sicilian artist shows more originality in his choice of subjects, often representing with much life and verve scenes from popular comedy. A more elaborate style develops in the last quarter of the century, in which considerable use is made of added blue for drapery and other details, and this in turn leads on to the richly polychrome style of vases from Lipari (cf. fig. 483), on which blue, green, red, pink, white and yellow are applied to a rather pale clay to produce an effect quite different from that of any other red-figure and clearly leading up to the fully polychrome style of the Centuripe vases of the third century (cf. p. 366).

'The fabric of Paestum is dominated by the workshop of ASTEAS and PYTHON, two artists known to us by name from signed vases. They mostly depict Dionysiac, cult, or genre scenes; from time to time they paint rather heavy mythological compositions but appear to best advantage in the representation of phlyax plays (cf. fig. 484), which are

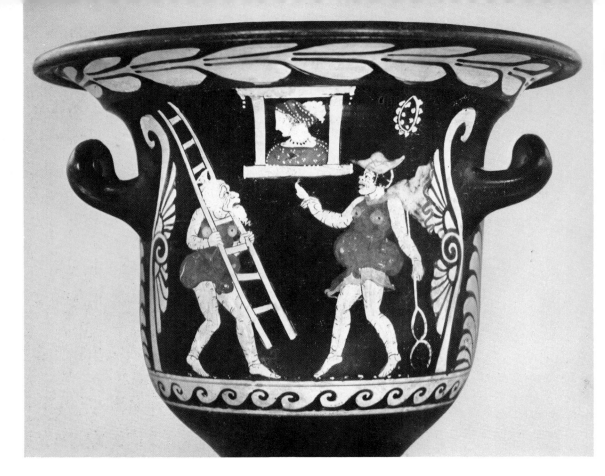

shown with considerable animation and rustic humour. Their style is continued by their successors, especially the PAINTERS OF NAPLES 1778 and 2585, with progressive deterioration in the drawing and less originality in the choice of subjects. Recent excavations have brought to light many examples of the work of another school of late Paestan vase-painters, contemporary with these, but showing more strongly the influence of the latest Apulian, and the fabric comes to an end about 300 B.C. at a stage when its products are almost barbarized.'

Vases of the Hellenistic Period

With the Hellenistic age came fundamental changes in the decoration of pottery. The black- and red-figured styles that had prevailed for more than three centuries were practically abandoned and replaced by other techniques.

In several of these Hellenistic vases the surface was covered with white slip, and ornaments were added in tempera colours. Many of the Hadra vases (so called from the cemetery of Hadra, near Alexandria, where most of them have been found) are in that technique; so are the sumptuous Canosa vases (mostly found at Canosa in South Italy), which combine painted with plastic decoration; and above all the

484. Zeus and Hermes. Scene from a phlyax play on a Paestan bell krater painted by Asteas, third quarter of the fourth century B.C. Vatican, Museo Gregoriano Etrusco.

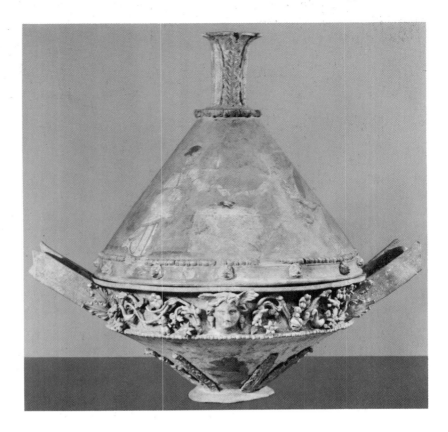

485. Lekanis from Centuripe, third century B.C. New York, Metropolitan Museum.

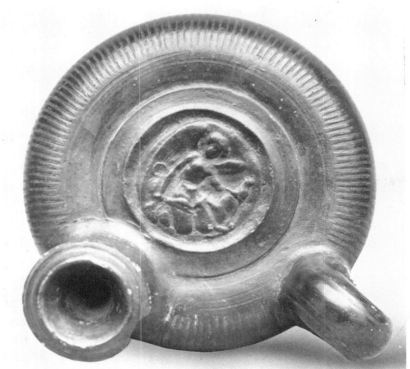

486. Calene guttus (lamp feeder), third century B.C., with relief of Nike sacrificing a bull. London, British Museum.

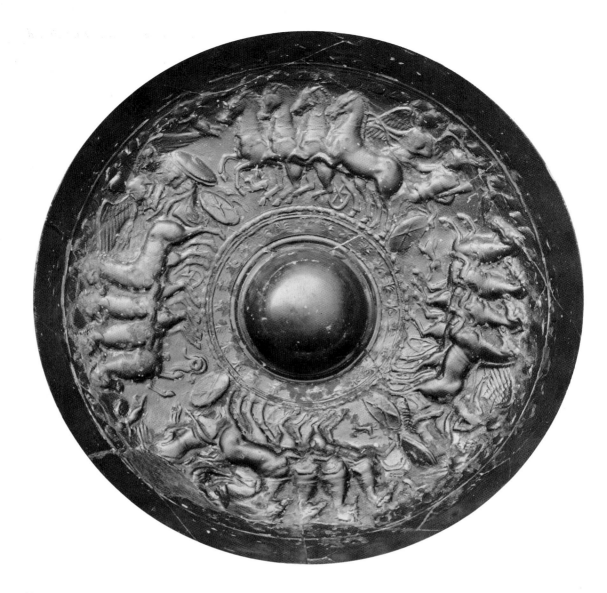

Centuripe vases (cf. p. 363), found in the little town of Centuripe in
Sicily, which often have scenes consisting of several figures painted in
various colours, occasionally approximating in style the murals from
Pompeii and Herculaneum (cf. fig. 485). Here, too, ornaments in relief
were added.

But in the majority of Hellenistic vases the painted ornaments are
dispensed with altogether and reliefs take their place. The inspiration
evidently came from embossed metalware. The chief classes are the
Calene, the Megarian, and the Pergamene.

The Calene ware—so called because many examples were found at
Cales in South Italy, and because some bear signatures of Calene potters—
consists of lamp feeders (cf. fig. 486), cups and bowls decorated with
reliefs. The favourite subject on the bowls is the apotheosis of Herakles
(cf. fig. 487). The reliefs are taken from moulds, reproducing Hellenistic

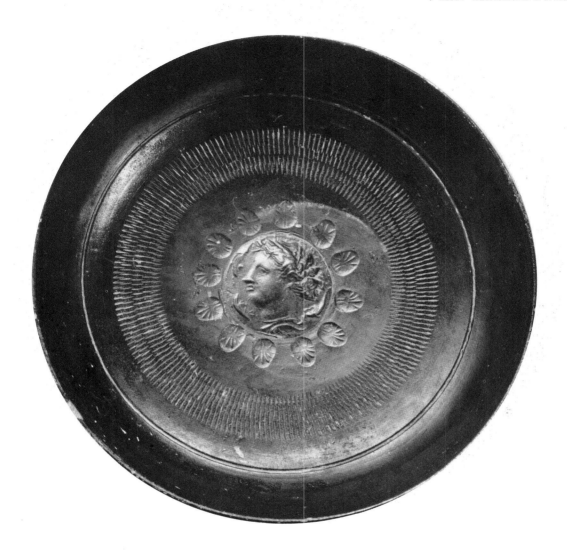

and, occasionally, earlier metal prototypes, as for example on the kylikes with medallions reproducing fifth-century Syracusan coins (cf. fig. 488 and p. 228). The surface is entirely covered with black glaze. The earliest specimens belong to the late fourth century, the majority to the third.

488. Interior of a kylix with medallion moulded from a fifth-century Syracusan coin. Third century B.C. New York, Metropolitan Museum.

Appliqué reliefs taken from metalware were also added to other black-glazed vases—to amphorae (cf. fig. 489), kraters, hydriai and skyphoi—found chiefly in continental and East Greece. Moreover, a large quantity of plain black-glazed pots—either entirely undecorated or merely with palmettes and other ornaments impressed in the clay— has been found both East and West. They represent the common household ware of the time.

The Megarian ware—at first found at Megara, but later in many other places, including Attica—consists almost entirely of bowls with relief

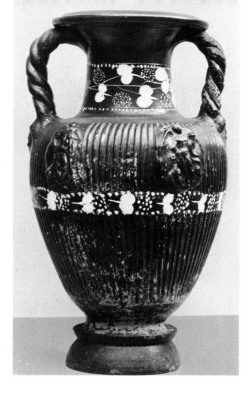

489. Black-glazed amphora with
appliqué reliefs, *c*. third century
B.C. New York, Metropolitan
Museum.

decoration on the exterior. Like the Etruscan bucchero ware, it was
produced by a combination of wheel work, stamping, and moulding;
that is, the bowls were thrown in fired terra-cotta moulds, into the
interior of which stamps had been impressed while in leather-hard
condition. The surface here, too, is covered with glaze, which has some-
times fired blackish, at other times reddish. The decoration consists of
floral ornaments and occasionally of figured scenes. The latter include
some from the epic cycle and from well-known tragedies, for instance,
the plays of Euripides; the extant examples date from the third and
second centuries B.C. Fig. 490 illustrates Euripides' Iphigeneia in Aulis,

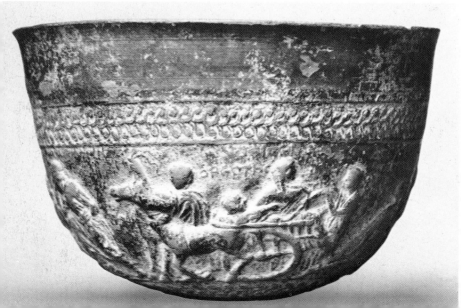

490. Megarian bowl with
relief of Clytemnestra's ar-
rival in Aulis, after Euri-
pides. Third or second
century B.C. New York,
Metropolitan Museum.

with Clytemnestra arriving with Iphigeneia from Mycenae, to the consternation of Agamemnon.

The Pergamene ware, perhaps actually made in Pergamon, lasted probably from about 150 to 50 B.C. It too has a blackish-reddish glaze, but the reliefs were separately moulded and attached to wheel-thrown vases. The same figures recur in different combinations. Eros and Herakles are favourite motifs.

In the Roman period relief decoration on pottery was continued. The Arretine vases and the later terra sigillata show the same technique as the Megarian, but the glaze was now a uniform bright red, having been fired wholly under oxidizing conditions.

In another class, also dating from the first century B.C. and later, the reliefs were moulded with the vase and covered with a blue-green glaze, alkaline or lead, approximating that used in Egypt, and for a limited time in East Greece (cf. p. 313). Like the modern glazes, it must have been applied on a fired surface.

Lamps

Greek lamps of the sixth to the fourth century B.C. form, so to speak, a branch of pottery. They consist of small, round, terra-cotta receptacles, with an opening in the middle for pouring in the oil, a spout for the wick, and sometimes a handle, horizontally or obliquely placed (figs. 491, 492). The technique is the same as in the vases; that is, they were thrown and turned on the wheel, and glazed black with some parts reserved. There is no figured decoration, but the harmonious shape and the effectively contrasted colouring often make of them works of art. They had a long subsequent history in Hellenistic and Roman times, when the spout was lengthened and moulded reliefs were added.

491, 492. Terra-cotta lamps, fifth century B.C. Private collection, and British Museum.

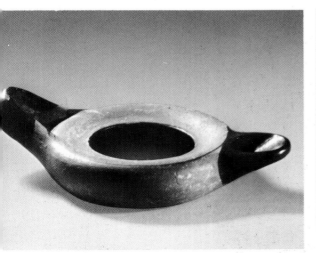
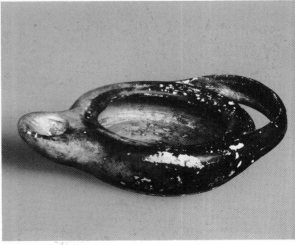

CHAPTER 12

FURNITURE

Greek furniture was mostly of wood, which is apt to disintegrate —except in such dry climates as Egypt and the Crimea—and of bronze, much of which was melted down. Little, therefore, survives. Nevertheless, it is possible to know a great deal about Greek furniture; for it is often represented on Greek vases and reliefs, sometimes articles of furniture form part of terra-cotta and bronze statuettes, and even of larger stone sculptures, and occasionally they are mentioned in inscriptions and by ancient writers.

One can, therefore, trace the derivation and development of the various types from period to period in the same way as in other branches of Greek art. As in architecture and pottery, so in furniture, the Greeks, instead of continually inventing new designs, confined themselves to a few and developed and perfected these. Each became more or less constant; only occasionally was a new form introduced and then it took the place of the old one. There was no mass production, and so there could be constant variety of detail—in the swing of the curves, in the interrelation of the parts, and in the ornaments. These subtle changes prevented monotony. Some of the forms—in particular those of the throne, couch, and chest—were evidently inspired by Egyptian prototypes, but they were developed into new creations.

The methods of manufacturing furniture in ancient Greece were much the same as they were in Europe and America before the widespread use of machinery. The tools were the obvious ones—the axe, saw, plane, hammer, and lathe. Pseudo-Plato (Theages, 124 B), in referring to carpenters, speaks of 'those who saw and bore and plane and turn'. There was a large choice of woods—maple, beech, willow, citron, cedar, oak, etc.

For joining the various parts wooden dowels and tenons, metal nails, and glue were used. γόμφος, a wooden tenon, is described by Hesychios in his *Lexikon* as 'joining pieces of wood'. The tenons were round, rectangular, or dovetailed. Veneering did not become popular until Roman times; but inlay was extensively practised by the Greeks. Each piece of furniture was hand-made and its composition and execution could make of it a work of art. Accordingly, in early times at least, a carpenter was highly esteemed. In the *Odyssey*, XVII, 382 ff., he is mentioned among the men who 'are welcomed the world over'.

Greek furniture before the Hellenistic and Roman ages consisted of relatively few forms. Chairs, stools, couches, tables, and chests were practically all that was needed.[1] The couches served the double purpose of a bed and a sofa, and the chests, large and small, took the place of our closets and wardrobes (cf. pp. 377ff.). Books were few, at least in the early epochs, so there were no bookcases or desks; and there was no bric-a-brac as such, so display cases were not needed. Instead of upholstery the Greeks used loose covers, hangings, and pillows which consequently became necessary and important adjuncts of furniture.[2]

Chairs and Stools

The chairs were of three types and each had a different name—the *thronos*, the *diphros*, and the *klismos*. The THRONOS was the stately chair used by gods, the heroized dead, princes, and other important people. It mostly had a back, low or high, and sometimes arm-rails; the legs were carved to resemble those of animals (cf. fig. 493), or they were turned (cf. fig. 494), or they were rectangular, with voluted incisions placed about half way up (fig. 495). The seat was generally plaited, or of leather, and cushions and coverings were added for comfort. Decorative motifs were applied here and there—finials on the back in the form of a palmette, or a volute, or an animal's head; and sometimes an ornamented panel beneath the seat, as in Egyptian thrones, or a central support in the form of a figure; and the arm-rail often terminated in a ram's head supported by a sphinx, or small pillar, or some other device (on the Harpy Tomb a Triton is added).

In addition, all sorts of ornaments were occasionally painted or inlaid in different materials and in various places. The throne of Pheidias' Zeus at Olympia, which is described at length by Pausanias (V, II, 2), was 'adorned with gold and precious stones,[3] also with ebony and ivory'; and it had 'figures painted and images wrought on it'. The throne of Asklepios at Epidauros had the deeds of the Argive heroes carved in

493–495. Three types of *thronos*.

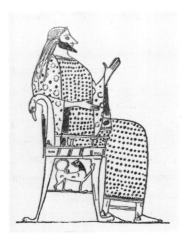 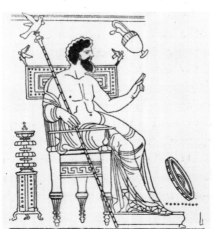 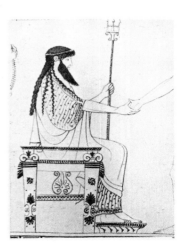

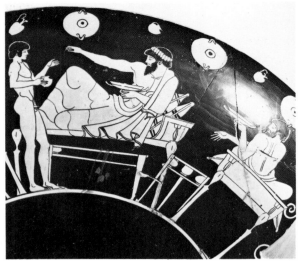

496, 497. Three-legged tables, and couches with turned legs; diphros okladias. From vase-painting in the British Museum. Fifth century B.C.

relief on it (Pausanias II, 27, 2). The 'throne' of Apollo at Amyklai by Bathykles was also elaborately decorated (Pausanias, III, 18, 9 ff.). In the representations on vases and in terra-cotta statuettes painted decorations are often added. The tradition of elaborately decorated furniture indeed goes back not only to Egyptian but also to Mycenaean times, as shown, for instance, by inscriptions on the tablets from Pylos;[4] and richly ornamented chairs, tables, and couches are often described in Homer.

The development of the throne can be followed in the representations on vases and reliefs. In the scenes of the lying-in-state of the dead (prothesis) depicted on eighth- and seventh-century vases, the legs of the thrones are either straight, or they taper, or they are turned and have large, rather clumsy swellings. On a prothesis scene in New York a throne is shown with a back which has crossed stretchers (cf. fig. 410).

In the sixth century B.C. the throne became gradually standardized into the three types mentioned above, that is, with legs either animal, turned, or rectangular. From then on the various parts were more and more harmoniously interrelated, until the design reached its climax in the course of the fifth century. Black-figured and red-figured Attic vases and terra-cotta and bronze statuettes, as well as full-size marble examples tell the story in detail. The throne of the seated goddess in Berlin, for instance (cf. fig. 101), shows the construction clearly—the panelled back with palmette finials, the arm-rail, the cushioned seat, the rectangular legs with voluted incisions, and the tenons for fastenings. The reliefs on marble gravestones supply further handsome examples.

In the fourth century B.C. the forms tend to become more slender and more elaborate, and often have exaggeratedly broad back boards, as illustrated in South Italian vase-paintings.

A fourth type of throne—with solid sides, carved in one piece with a rectangular or curved back—makes its appearance in the archaic period but becomes popular only in the Hellenistic, when it often served

as the seats of important personages in Greek theatres—at Athens, Epidauros, and Priene—and it is occasionally represented on marble reliefs. Sometimes it is ornamented with scenes in relief.

Besides the throne, there were various types of simpler chairs. The DIPHROS was a stool without back and with four turned legs (fig. 499). It was easily transportable and so in common use. Gods are shown sitting on diphroi on the Parthenon frieze (cf. fig. 145); women use them in their home. In the classical period there are relatively few turnings on the legs;[5] in the Hellenistic epoch they multiply, as seen in vase-paintings and on Ptolemaic coins. Sometimes a stool appears which is quite low and has straight, unturned legs. This was a favourite form for artisans at work.

Another variant of the diphros was the DIPHROS OKLADIAS, in which the legs, instead of being perpendicular, cross, as in the modern folding stool. It too was a practical, light seat (fig. 497). Whether it was collapsible, like its descendant, is not certain, for the ancient representations do not make this clear; but it is probable that at least some of the examples could be folded, for the joints where the legs cross or connect with the seat are often marked by concentric circles, suggesting the presence of a pivotal pin. Moreover, the Egyptian precursors actually fold. And, after all, the chief reason for making the legs cross is that the stool should fold.

Still another form of stool is represented on Greek vases—a simple, rectangular, BOX-LIKE SEAT. No hinges and no feet are indicated, so it could not be a chest. Moreover, on the François vase (cf. p. 330), Priam is sitting on such a box, inscribed *thakos*, 'seat'. The sides are sometimes ornamented either with linear designs or figured motifs.

Both the throne and the diphros had Egyptian antecedents. The KLISMOS with curving back and legs was a characteristically Greek creation—light, comfortable, and graceful (cf. figs. 498, 499). At about

498, 499. Klismos; klismos and diphros. From vase-paintings in the British Museum. Fifth century B.C.

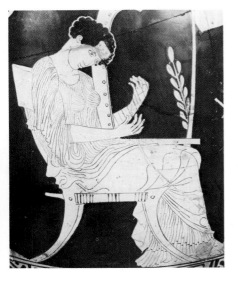
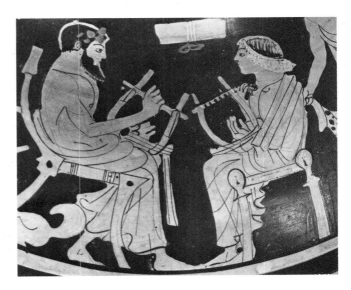

the height of the shoulders the back had a board, which was supported by three uprights. The seat was plaited, and a cushion was generally placed on it. The same development took place as in the throne. The climax, with parts beautifully interrelated, is reached in the fifth and the early fourth century. The gravestone of Hegeso (cf. fig. 168) supplies a typical example of that epoch. In some red-figured Attic vases the back of the klismos is shown placed at a very oblique angle, evidently for comfort in lounging.

Footstools

The footstools depicted on geometric vases and on the François vase are plain, with four straight legs, like the Egyptian. Two wooden geometric footstools found at Samos have solid sides, shaped to resemble a horse and decorated with incised designs[6] (fig. 500). The footstool of the fifth and fourth centuries as well as later had curving legs ending in animal paws (cf. figs. 101, 167, 168). It served not only for resting one's feet while sitting on a throne or chair, but also for stepping on a high couch.

500. Wooden footstool from Samos. Probably late eighth century B.C. (The wood has disintegrated and the footstool no longer exists.)

Couches

The Greek couch (*kline*) was used not only for sleeping and reposing but during meal times; for the Greeks, the men at least, usually reclined while eating. The legs of couches, like those of thrones, were in the form of animal legs, or turned, or rectangular with incisions of voluted design. An important distinction between Egyptian and Greek couches is that the former have foot-boards, but no head-boards, whereas Greek couches regularly have head-boards and often also low foot-boards—resembling modern beds, in fact. Fig. 501 shows a boy carrying a couch and table on his back, evidently for a dinner party.

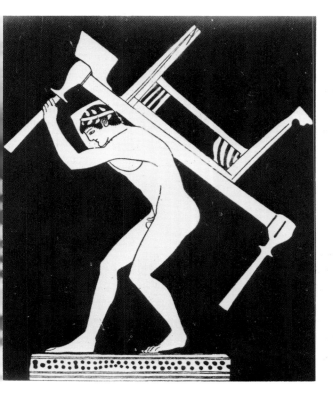

As in the thrones, decorations—painted, inlaid, or in the round—were added on the more sumptuous couches at appropriate places. The filling of the frames consisted of interlaced cords on which mattresses, covers, and pillows were placed. Sheets are never represented in the numerous representations of beds on Greek vases and reliefs; nor are they mentioned in the occasional descriptions of beds by ancient writers, except perhaps by Homer (cf. *Iliad*, IX, 661; *Odyssey*, XIII, 73, 118, where λίνον seems to mean sheet). Nevertheless, as Egyptian sheets have survived, it is likely that they were known to the Greeks also, even if they were not in common use. To judge by the many representations of couches on Greek vases, a bed was not 'made up' as nowadays, with sheets and covers tucked in. Instead, the covers are merely laid on top of the bed. Mattresses, however, were substantial.

On the vases and elsewhere, couches are often represented too short to permit stretching out at full length. That this was merely an artistic convention is shown by the fact that when the occupant is depicted lying down, the bed is adequately long. Moreover, the stone sepulchral couches found at Tarentum, in Euboea, and elsewhere, are sometimes 6 or 7 feet long.

The development of the three forms of couches closely resembles that of the corresponding thrones. Vase-paintings and reliefs again furnish many representations, ranging from archaic to Hellenistic. In addition, several miniature examples in terra cotta, and fairly large ones on marble

501. Boy carrying a couch and a table. After a vase by the Pan Painter, second quarter of the fifth century B.C. Oxford, Ashmolean Museum.

502. Limestone statuette of a man carrying a table, from Cyprus. Sixth century B.C. London, British Museum.

reliefs are preserved; also a few actual (wooden) legs (cf. p. 398, note 5). The designs with which they were painted occasionally survive and give an idea of the general effect. A number of bronze appliqués which once decorated the head-boards of Hellenistic couches (and their Roman derivatives) have also survived.[7] They are in the forms of human busts and heads of horses, mules, and dogs, with lively expressions, and often enriched with silver inlay.

Tables

Tables with the Greeks had fewer uses than with us. Today almost every room contains several tables to display our many possessions. The Greeks had few books, no magazines or newspapers, little bric-a-brac not in actual use, and small lamps which stood on special stands. When a mirror, or drinking cup, or flute-case was put away, it was generally hung up on the wall, as shown in the representations on vases. The chief use of a table was during meals, for the support of dishes and the food. It was put alongside the couch on which the person reclined, and when dinner was over it was carried away or pushed under the couch. Each person had his own individual table. It was accordingly light, plain, and low. The top is mostly oblong and rests on three legs— two at one end, placed nearest the head of the couch, one in the middle of the other end. The legs are perpendicular or oblique, and taper downwards, ending sometimes in lion's paws; occasionally they are curved. They are fastened to the table top with tenons or dowels, and are connected with each other for further support by stretchers. Occasionally consoles are added. The table top regularly projects beyond the legs at the upper end, whereas at the lower end it is flush with the leg.

This is the regular form, and one can see that a three-legged table would be convenient, especially on uneven ground. Four-legged tables, however, also existed, and they are occasionally depicted on vases, and are mentioned by Greek writers (cf. Athenaios, II, 49a).

A few actual pieces help one to visualize these Greek tables. Handsome bronze legs, of the classical period, are in the Palermo Museum[8] and the Louvre. They have scrolled consoles at the top and end below in lion's paws. In the numerous banquet scenes on Greek vases and reliefs, tables are shown laden with bread and meat, just as Homer describes (*Odyssey*, IX, 8; cf. Plato *Republic*, 390b). Two bronze statuettes (in Paris and London) with dancers performing on tables,[9] and a stone group from Cyprus in London, in which a three-legged table is being carried on a man's shoulders (cf. fig. 502), give a clear idea of the construction.

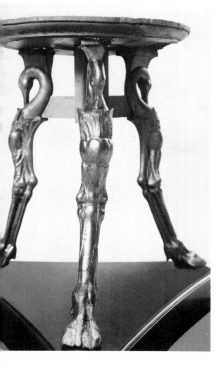

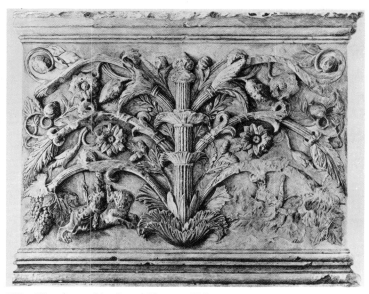

503. Wooden table from Egypt. Hellenistic period. Brussels, Musées Royaux des Beaux-Arts.

504. Marble table support from Pergamon. Second century B.C. Etching.

In the later Greek period a new type of table was invented and used side by side with the other. It had a round top and three legs of animal form. It is frequently represented in vase-paintings from Kerch and South Italy, and an actual example from Egypt is in the Brussels Museum (fig. 503); several miniature terra-cotta ones are in Athens and elsewhere.

Two large marble slabs (cf. fig. 504), which evidently served as table supports, have come to light at Pergamon. They can be dated in the second century B.C. from the resemblance of their akanthos decorations to those on the altar of Eumenes, and are, therefore, precursors of the type of table found frequently in Roman times, especially at Pompeii.

Chests

Chests served for putting away one's clothes, jewellery, and other articles. As the clothes worn by the Greeks were mostly rectangular pieces of cloth, they could be neatly folded and put away in a chest better than hung up in a wardrobe. The size of chests naturally varied according to use. Chests for clothes were large, those for jewellery and toilet articles were small and dainty.

The chief form in use was, like its Egyptian prototype, a rectangular box with panelled sides and a slightly projecting, horizontal lid, working on hinges. There were generally four low feet, formed by the prolongation of the corner posts, and often ending in lion's paws. The sides were plain or decorated. For fastening, there were corresponding knobs on lid and box round which a string was tied. The most famous chest

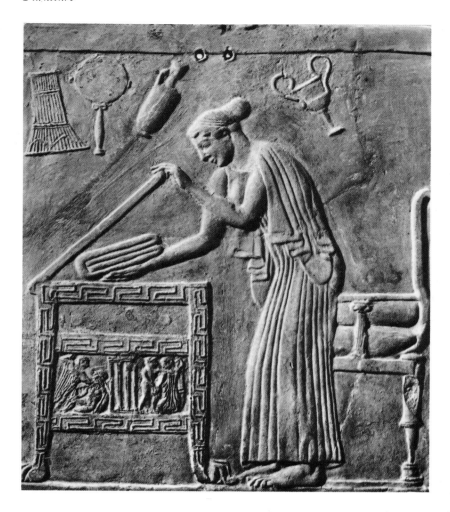

505. Woman placing a garment in a chest. Locrian terra-cotta relief, *c.* 460 B.C. Reggio, Museum.

of antiquity was that of Kypselos of the seventh century B.C., which Pausanias saw in the temple of Hera at Olympia. He gives a long description of it (V, 17, 2). It was 'made of cedar wood, and on it were wrought figures, some of ivory, some of gold, and some of the cedar wood itself'. No details of the form or construction are given, only a long list of the decorations; but it was doubtless of the same shape as that current in Egypt and used throughout Greek times.

The forms of the chests of the sixth to the fourth century B.C. are illustrated on many reliefs and vases. Especially interesting are those depicted on the Locrian terra-cotta reliefs (*c.* 460 B.C.), where they sometimes appear richly decorated with various patterns and figured panels (cf. p. 237). The legs regularly end in lion's paws. On one relief a woman is shown holding the lid open while she places a neatly folded garment inside (fig. 505); and on an Attic red-figured lekythos is depicted a large chest with open lid and a woman putting a bundle of clothes into it.[10] Often the chests are large enough to be sat on or to accommo-

date two people, like those on which the goddesses are sitting on the East pediment of the Parthenon and the ones represented on vases of the Danae legend.[11] Two bronze miniature examples in the round are in the Berlin Museum,[12] and an actual wooden chest, from Olbia, is in Odessa.[13]

Our knowledge of chests of the fourth century is further increased by the wooden coffins in the form of chests from Egypt and the Crimea.[14] They generally have gabled tops, and the panelled sides were embellished with floral and figured decorations, either painted or in gaily coloured reliefs of wood, plaster, or terra cotta.

Cupboards, Wardrobes, Shelves

What we call wardrobes or cupboards—with doors opening in front—were apparently not known in Greece until Hellenistic and Roman times.[15] There is no Greek name for cupboard, only the Latin name *armarium*; nor are cupboards represented on Greek vases and reliefs. The regular receptacle for clothes, jewellery, etc. was, as we saw, the chest, large and small (cf. p. 377); and many articles that we should put in cupboards or chests of drawers were hung up on the wall (cf. figs. 496, 505).

Only occasionally a shelf or bracket is represented with some object resting on it—a vase or a greave[16]—and once or twice there appears a set of shelves,[17] but without the doors characteristic of cupboards. In Hellenistic times, with the introduction of libraries, etc., more complicated shelving must have been used; and from it the cupboard with doors was probably developed.[18]

Roman armaria are quadrangular receptacles, provided with low feet, flat or gabled tops, and doors reaching from top to bottom and working on hinges.[19] They are often represented on Roman reliefs, especially on sarcophagi; sometimes the doors are depicted open, displaying the contents within—books in the form of scrolls, masks, bottles, shoes, and so forth; not clothes, for the proper receptacle for clothes remained the chest.

The standard forms of Greek furniture—of chairs, couches, footstools, tables, and chests—were transmitted to the Etruscans and the Romans, who adopted them with occasional slight changes in design. On this heritage furniture makers have built down to our time.

CHAPTER 13

TEXTILES

The long list of epithets given by Pollux (X, 42) to bed covers alone—delicate, well-woven, glistening, beautifully coloured, of many flowers, covered with ornaments, purple, dark green, scarlet, violet, with scarlet flowers, with a purple border, shot with gold, with figures of animals, with stars gleaming upon them—makes one realize what a loss to our artistic heritage the almost total disappearance of Greek textiles must be. There are, however, frequent representations of ornamented garments, bed covers, and pillows, on Greek vases from the seventh to the fourth century B.C. Some of the marble maidens from the Akropolis of Athens and a few other sculptures have coloured designs on their garments fairly well preserved. And terra-cotta statuettes amplify this picture. There are also occasional descriptions of covers, hangings, and garments by ancient writers and in inscriptions.[1] Finally, a few actual specimens have come to light in the Crimea,[2] Mongolia,[3] and recently at Koropi, in Attica.[4] From these sources the appearance of Greek textiles can to some extent be visualized.

The chief materials used were wool and linen. Silk is mentioned by Aristotle (*Hist. anim.* V, 19, p. 551b, 13ff.), and there are possible references to the mulberry in Aischylos and Sophokles. Moreover, the

506. Embroidered fabric from the Crimea. Leningrad, Hermitage.

507, 508. Painted fabric and woven fabric with geometric design, both from the Crimea. Leningrad, Hermitage.

509. Woven fabric from the Crimea. Leningrad, Hermitage.

510. Linen embroidered in silver-gilt with diaper pattern and lions. Perhaps late fifth century B.C. From Koropi. London, Victoria and Albert Museum.

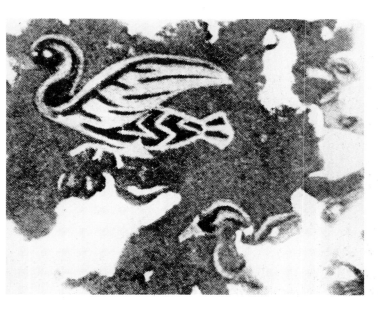

amorgina mentioned by Aristophanes (*Lysistrate*, 150 ff.) as 'transparent' may refer to silk.⁵ Cotton was apparently not used until much later.

The working of these materials was of course done in the home and constituted one of the chief occupations of the women. There are representations in vase-paintings of the various processes. The sheep's wool was washed, beaten, carded (either on the bare leg or on a terracotta implement that fitted the upper leg and was called *onos* or *epinetron*, cf. p. 322), spun on the spindle, and woven on a vertical loom (cf. fig. 447). The preparation of linen was not unlike that of today, and it was spun and woven like the wool. The woollen garments were as a rule coloured, the linen ones white. The decoration for men at least was generally confined to borders, but for women it sometimes formed a frieze or an all-over pattern; figured scenes as well as linear ornaments were used. The designs were either woven into the material, or embroidered on it, or painted. The fragments of textiles that have been preserved in the Crimea show all three techniques—a scroll pattern with palmettes, in embroidery (fig. 506); figures reserved in yellow against a black painted background with details painted red (fig. 507); geometric designs (fig. 508), and ducks (fig. 509) woven into the material as an

511–512. Hera, Ourania and the Horai. Drawing after the François vase, cf. fig. 432 b.

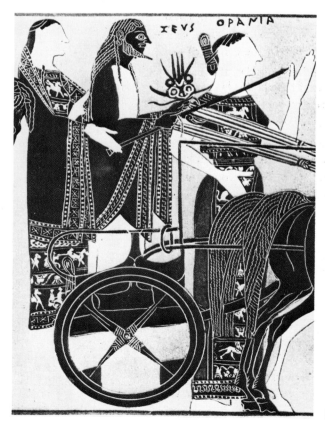
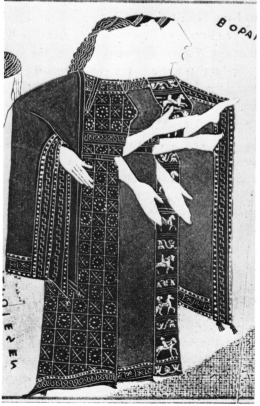

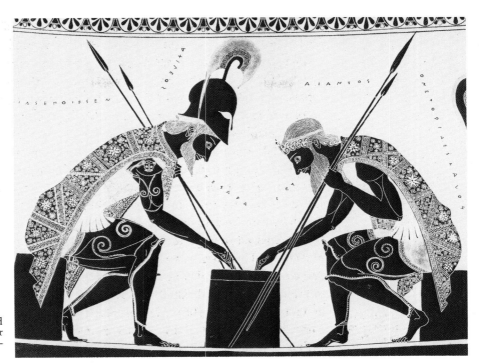

513. Achilles and
Ajax. Drawing after
the amphora by Exe-
kias, cf. fig.446.

all-over pattern in yellow, black, and green. A piece from Koropi, said
to have been found in a bronze vase, is of linen and is embroidered in
silver-gilt with a diaper pattern and a walking lion in the centre of each
unit (fig. 510). It has been dated at the end of the fifth century.

From these scraps one can learn something of the methods employed,
but a better idea of the magnificence of Greek textiles is obtained from
representations on vases—of the garments, for instance, of Hera,
Ourania (fig. 511), and the Horai (fig. 512) on the François vase (cf.
p. 330), adorned with rows of chariots, horsemen, animals, and flowers;
or the mantles of Achilles and Ajax on the amphora by Exekias (fig. 513
and p. 332). They recall passages in ancient literature, of Helen described
as weaving 'many battles of the horse-taming Trojans and the brazen-
coated Achaeans' on a purple cloth (*Iliad* III, 125 ff.), and of Andromache
'weaving an all-over pattern of flowers of varied hues' (*Iliad*, XXII, 441),
or of Creusa's handmaids trying to make out the subjects on the friezes
of the temple of Apollo at Delphi and wondering whether they were the
same as those they were using in their own embroideries: 'Who is it?
Who? On my embroidery is the hero's story told?' (Euripides, *Ion*, 184 ff.).

To visualize these coloured, decorated garments, one must imagine
them as free-hanging, not close-fitting like ours, for they consisted mostly
of rectangular pieces of cloth, which assumed beautiful folds both when
at rest and in motion, and so became expressive of the persons who
wore them.

CHAPTER 14

GLASS AND GLAZE

In addition to metal and clay, the Greeks used glass for vessels and some other objects; but it was a restricted use. The invention of glass-blowing was not made until the second or first century B.C. Before that, glass was mostly laboriously modelled by hand in a technique evidently current in Egypt; for Egypt seems to have been a great centre for glass-making throughout antiquity. Glazed beads occur there at least as early as the fourth millennium B.C., and in the early dynasties glaze is commonly found on tiles, figurines, and beads. Glass vessels occur from the eighteenth dynasty (*c.* 1500 B.C.) on. Moreover, remains of glass factories have been discovered on various Egyptian sites ranging from the eighteenth to the twenty-second dynasties (*c.* 1500–900 B.C.). There can be no doubt, therefore, that Egypt manufactured her own glass.

The theory advanced by Pliny (XXXVI, 26) that the Phoenicians invented glass is hardly credible. According to him, Phoenician merchants encamped on the shore and, resting their cooking pots on blocks of natron, afterwards found glass produced by the union of the natron (i.e. alkali) and the sand at a high temperature. But neither glass factories nor deposits of glass earlier than the fifth century B.C. have as yet been unearthed in Phoenicia.

514. Glass alabastron. Hellenistic period. New York, Metropolitan Museum.

Glass vases similar to the Egyptian have been found in Greek and Etruscan tombs of the sixth to the fourth century B.C., and Hellenistic examples have come to light in Cyprus and other places. They must either have been produced in Egypt and exported, or made elsewhere in imitation of the Egyptian. The technique was as follows: The glass vase was modelled in a fluid state over a core; while it was still hot, threads of coloured glass were applied on the surface and incorporated by rolling, various patterns being produced by dragging the surface in different directions with a sharp instrument.

The shapes adopted by the Greeks were different, however, from the Egyptian; they were the same in fact as those in use for the smaller Greek terra-cotta vases—the alabastron, aryballos, oinochoe, and little pointed amphora (fig. 515). Furthermore, the colours—mostly yellow, red, blue, and white—are not as bright and pure as in the earlier Egyptian examples. So the two are easily distinguishable.

In the Hellenistic period the technique remained the same, but the shapes and decorations changed somewhat. The necks of the alabastra

became longer, the forms lost their former compactness, and the handles were often large and elaborate (cf. fig. 514).

The dainty elegance of these colourful glass vases made them suitable for ointment bottles, and that seems to have been their chief function.

Beads were fashioned in the same way as the glass vases and with the same brilliant colours. They are of various types—plain, 'eyed', with drops of glass protruding, with spiral and zigzag patterns, and in the form of grotesque masks.

There also is now evidence of moulded, transparent glass as early as the seventh century B.C. (e.g. at Gordion in Phrygia, Fortetsa in Crete, and in the Bernardini tomb); and it seems to have continued through the classical and Hellenistic periods.

In addition, glass sealstones, moulded from stone ones, were in use during all Greek and Roman periods (cf. pp. 246, 248); and glass inserts were employed in architectural decoration (for instance on the Erech-theion, cf. p. 38) and in sculpture (for instance in the chryselephantine Zeus of Pheidias, cf. p. 55). Glass at this time was evidently a precious material, and since it was fusible and so could be moulded into various forms, it served as an appropriate addition to marble and metal, enhancing the general effect by its variegated colours—just as did coloured stones. In fact, the Greek word ὕαλος was used both for glass and such transparent stones as alabaster and rock crystal (cf. p. 398, chapter 12, note 3).

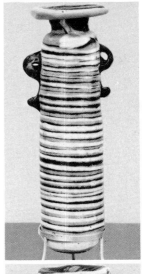

As was pointed out (cf. p. 316), the black used by the Greeks on their pottery is not a true glaze in the modern sense. A real, alkaline, blue glaze, however, occurs for a limited period during the archaic period in East Greece, evidently in imitation of the Egyptian. It was applied chiefly on aryballoi and small vases in animal and human form, made not of ordinary clay, but of a white composed body, like the Egyptian 'faïence'. Examples have been found in various localities, including Italy; but the centre of their manufacture was doubtless in the East, perhaps in Naukratis and Rhodes. Later the production stopped, submerged by Attic black- and red-figure, as were so many other wares. Similar blue alkaline glazes, however, reappear in the late Hellenistic and Roman periods, together with green, yellow, and colourless lead glazes, in a ware similar in shape and technique to the Arretine (cf. p. 369).

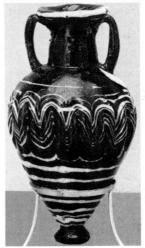

The invention of the blowing tube—in the second or first century B.C.—caused a revolution in the use of glass. With this easy and rapid means of manufacture, glass vessels of considerable size and in all sorts of shapes could be produced. Their use became widespread, and many different techniques were evolved—plain blown, blown in moulds, mosaic (millefiori), onyx, grooved, spiked, with threads of glass applied plastically, painted, gilt, and incised. Specimens in these various techniques have been found all over the Roman empire, and belong specifically to Roman art.

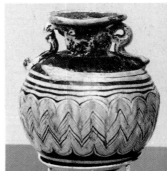

515. Four glass vases, sixth to fourth century B.C. New York, Metropolitan Museum.

CHAPTER 15

ORNAMENT

Ornament played an essential part in the artistic creations of the Greeks. It survives mostly in architecture, finials of gravestones, metalwork, and vase-paintings, and has been discussed in the chapters dealing with those branches of art. Originally, however, it was an important feature also in other products of which little now remains, for instance in textiles and furniture.

In contrast to Minoan and Mycenaean ornament, the classical Greek was not naturalistic, but formalized. Not only were individual motifs conventionalized, but their position was systematized. They were assigned to definite places with precise functions (cf. e.g. pp. 27, 323). In this respect, as in many others, classical Greek art owes much to the geometric epoch, during which the spontaneous, sprawling ornaments of the Minoans and Mycenaeans were gradually schematized into orderly designs.

The characteristic of the Greeks that we observed in other branches of art, of taking over from their predecessors what appealed to them and changing their borrowings into new creations, can be clearly seen in their ornament. The motifs as such had mostly been used by others. The lotus, palmette, guilloche, rosette, spiral, and various leaf forms and scrolls had long been current in Egypt, Assyria, and Crete, but all were transformed into typically Greek designs of singular lightness and grace, and, though systematized, they retain the living quality of plant forms. When they had once become part of the artistic repertoire they remained constant, change being confined to detail and composition. Only occasionally was a new element introduced, like the akanthos.

A certain development in some of the forms can be observed, especially in the palmette and the lotus (cf. p. 387). As was the case elsewhere, the progression was from sturdy to elegant, to attenuated, to luxuriant, but naturally these changes are less obvious than in the figured representations. It may be said without exaggeration that Greek ornament at its best—as seen, for instance, in the finials of archaic and classical gravestones (cf. fig. 516), on sixth- and fifth-century vases (cf. fig. 517), and on the North porch of the Erechtheion, has never been excelled in refinement and harmonious composition; and that some Hellenistic decorations, for instance the akanthos on a table support (fig. 504) and on the altar from Pergamon, have an exuberance and vitality rarely equalled elsewhere.

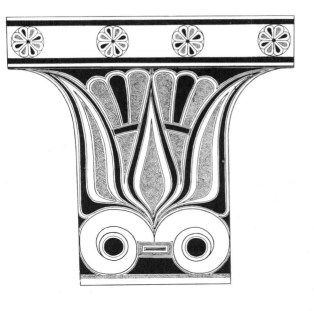

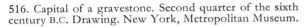

516. Capital of a gravestone. Second quarter of the sixth century B.C. Drawing. New York, Metropolitan Museum.

517. Amphora by the Eucharides Painter, *c.* 490 B.C. Paris, Louvre.

The Greek motifs and compositions, like the Greek architectural forms, were transmitted to succeeding generations and are current even today. The following is a list of the principal ornaments that appear in the various periods:

Geometric Period: Horizontal bands, concentric circles and semi-circles, wavy lines, zigzags, net pattern, simple and shaded triangles, lozenges of various forms, meanders, the swastika, chequers.

Orientalizing Period: lotus, rosettes, scrolls, spirals, concentric circles, leaf patterns, palmettes, wheels, zigzags, chequers, meanders, scales, volutes, guilloche, various plant forms.

Sixth and fifth centuries: Meanders (plain and alternating with crossed squares, stars, and other motifs), net pattern, rosettes, scales, chequers, scrolls, spirals, guilloche, tongues, eggs, rays, leaves (laurel, ivy, with or without berries), lotus flower and bud, palmettes (enclosed, double, and oblique, bead-and-reel, leaf-and-dart). Palmettes, lotus flowers, and scrolls are combined in endlessly varied combinations.

Fourth and third centuries: Many of the motifs current in the preceding period are continued, but particularly popular are the wave pattern, the laurel wreath, and the palmette in a late form; also various forms of rosettes.

EPIGRAPHY

At certain periods, especially during the second half of the sixth and the fifth century B.C., the letters in Greek inscriptions are so beautifully formed and spaced that they constitute works of art. A short mention of them must, therefore, here be included.

The earliest inscriptions written in Greek characters so far known date from the eighth century B.C. (Future excavations may, however, bring to light earlier examples.) The language of the Mycenaean script—known as Linear B—was, it is now thought, an early form of Greek (cf. p. 17). This Mycenaean script was, however, not alphabetic, but pictographic and syllabic. The Greek alphabet was apparently borrowed from Semitic sources.

Most of the extant Greek inscriptions are on stone and consist of contracts, decrees, treaties, building specifications, dedications, epitaphs, and signatures (cf. figs. 518, 519). They also occur on terra-cotta vases, or parts of vases (*ostraka*), coins, metalwork, and wood. The commonest writing material in antiquity—besides presumably wooden tablets—was papyrus (from which our word paper is derived). It was a product of Egypt, and was used there from the third millennium B.C. on. In Greece it

518. Epitaph for the Athenians who fell in the battle of Potidaia, 432 B.C. London, British Museum.

519. Inscribed base of the stele of Dexileos (fig. 217), *c*. 394 B.C. Athens, Kerameikos Museum.

was known at least as early as the fifth century B.C. A large number of Greek papyri have come to light in Egypt, ranging from the fourth century B.C. to Hellenistic and Roman times. In the damp climates of Greece and Italy they have mostly disappeared, though special circumstances have produced some exceptions (cf. the discoveries in a villa at Herculaneum). A papyrus roll, carbonised but not completely consumed, was found by Mr. Makaronas near Salonike. It can be dated in the second half of the fourth century B.C. and is thus 'one of the earliest known Greek papyri and the only one ever found in Greece'[1] (fig. 520). Parchment (pergamena), the prepared skin of certain animals, apparently became common in Greek lands from the time of Eumenes II of Pergamon. It was in its turn ousted by the comparatively modern paper, made out of rags.

The forms of the letters in Greek inscriptions and the spelling vary according to locality, for there was diversity of alphabet and dialect in the various Greek states; that is, there were minor differences within the larger groups of Doric, Ionic, and Western. Moreover, the letters changed from period to period, and often help to place an object chronologically. In fact, in epigraphy, as in other branches of Greek art, the independence of individual states, as well as their common Hellenism, is apparent.

After about 400 B.C., however, the Ionic forms of letters were adopted by many Greek states, including Athens, and distinctions were largely obliterated. This is particularly true in Hellenistic times.

520. Papyrus roll from near Salonike. 350–300 B.C.

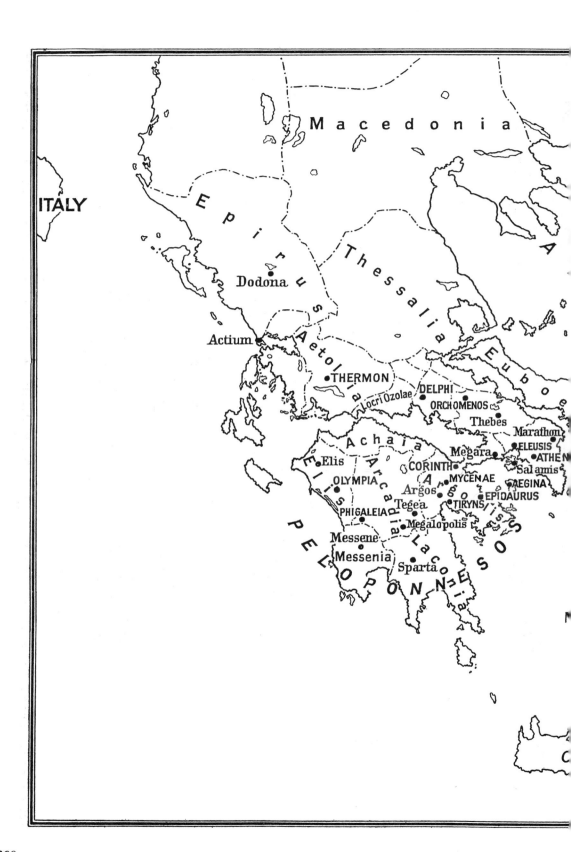

Macedonia

ITALY

E p i r u s

Dodona

Thessalia

Actium

Aetolia

Euboe

THERMON

DELPHI

Locri Ozolae

ORCHOMENOS

Thebes

Marathon

Achaia

Megara

ELEUSIS

ATHEN

Elis

CORINTH

Salamis

OLYMPIA

Arcadia

MYCENAE

AEGINA

Elis

Argos

EPIDAURUS

PHIGALEIA

Tegea

TIRYNS

Megalopolis

Messene

P E L O P O N N E S O S

Laconia

Messenia

Sparta

390

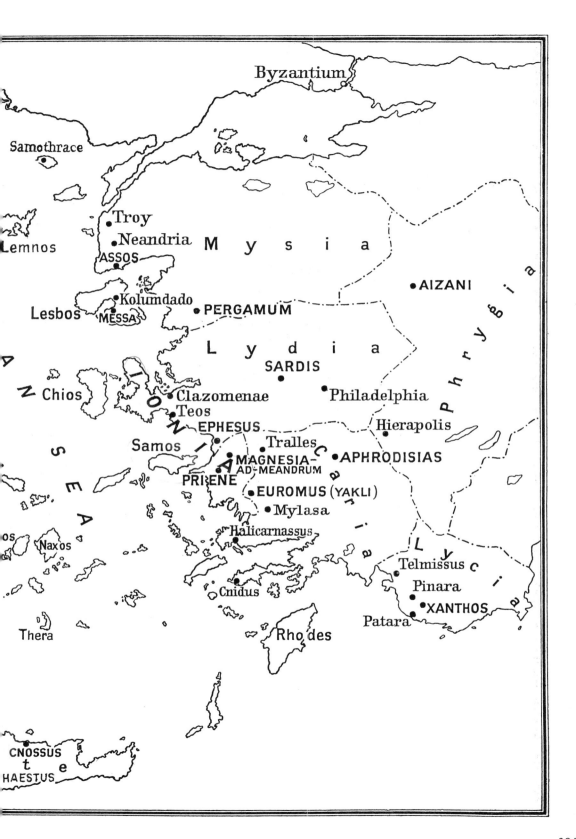

Byzantium

Samothrace

Lemnos

Troy
Neandria
ASSOS

M y s i a

AIZANI

Kolumdado
MESSA
Lesbos

PERGAMUM

L y d i a

SARDIS

Philadelphia

Chios

Clazomenae
Teos
EPHESUS

Samos

Tralles

Hierapolis

APHRODISIAS

MAGNESIA-
AD-MEANDRUM

PRIENE

EUROMUS (YAKLI)

Mylasa

Halicarnassus

Naxos

Cnidus

Telmissus

Pinara

XANTHOS

Patara

Thera

Rhodes

CNOSSUS
t e
HAESTUS

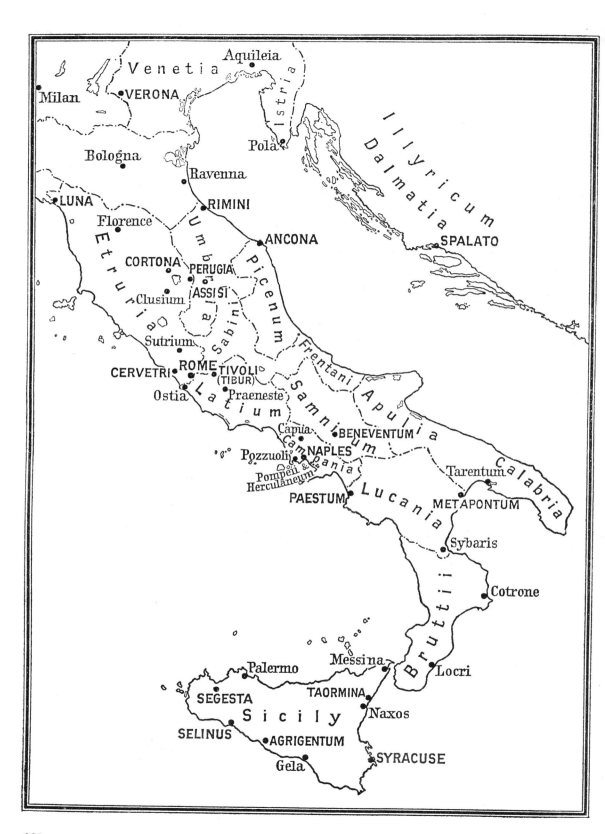

ABBREVIATIONS OF PERIODICALS CITED

A. J. A.	American Journal of Archaeology.
Annuario	Annuario della scuola archeologica di Atene e delle Missioni Italiani in Oriente.
Arch. Anz.	Archäologischer Anzeiger, Beiblatt zum Jahrbuch des Deutschen Archäologischen Instituts.
Ath. Mitt.	Mitteilungen des Deutschen Archäologischen Instituts, Athenische Abteilung.
B. C. H.	Bulletin de la correspondance hellénique.
Boll. d'Arte	Bolletino d'arte del Ministero della Pubblica Istruzione.
B. S. A.	Annual of the British School at Athens.
Eph. arch.	Ephemeris archaiologike.
I. G.	Inscriptiones graecae.
J. d. I.	Jahrbuch des Deutschen Archäologischen Instituts.
J. H. S.	Journal of Hellenic Studies.
J. R. S.	Journal of Roman Studies.
M. M. A. Bull.	Bulletin of the Metropolitan Museum of Art.
Mon. Piot	Monuments et Mémoires publiés par l'Académie des Inscriptions et Belles Lettres (Fondation Eugène Piot).
Mus. Helv.	Museum Helveticum.
Not. d. Scavi	Notizie degli Scavi di antichità, comunicate all'Accademia dei Lincei.
Oest. Jahr.	Jahreshefte des Oesterreichischen Archäologischen Instituts.
Rev. arch.	Revue archéologique.
Röm. Mitt.	Mitteilungen des Deutschen Archäologischen Instituts, Römische Abteilung.

NOTES

CHAPTER 1
Forerunners

1. In the Copaic basin (cf. Stampfuss, *Mannus*, XXXIV, 1942, pp. 132 ff.), and elsewhere (cf. *J.H.S.*, Archeological Reports, 1957, p. 15; Daux, *B.C.H.*, 1963, p. 690).

CHAPTER 2
Architecture

1. It is also known that several fifth- and fourth-century artists wrote books on proportion, e.g. Polykleitos, Pollis, Euphranor, Silanion, and the architect Pythios.
2. K. Müller, *Ath. Mitt*, XLVIII, 1923, pp. 52 ff.; Payne, *Perachora*, I, pp. 34 ff.
3. Cf. *A.J.A.* LVII, 1953, pp. 212 ff.
4. F. Krauss, *Mitt. d. Deutschen Arch. Inst.*, 1948, pp. 11 ff.
5. Whether the temple was dedicated to Theseus or to Hephaistos has recently been again discussed by Koch, *Studien zum Theseustempel*, 1955, and Wycherly, *J.H.S.*, LXXIX, 1959, pp. 153 ff.
6. H. A. Thompson, *Hesperia*, XVIII, 1949, pp. 241 ff.; Gottlieb, *A.J.A.*, LXI, 1957, p. 161 ff.
7. *I.G.* IV, 1484; Cavvadias, *Fouilles d'Epidaure*, no. 241, pp. 78 ff.
8. On these tombs and plaques cf. now Boardman, *B.S.A.*, L, 1955, pp. 51 ff.
9. Now published in detail by I. Kleemann, *Der Satrapen-Sarkophag aus Sidon*, 1958.
10. Devambez, *Grandes bronzes du Musée de Stamboul*, pp. 9 f., and the references there cited.
11. Hackin and others, *Nouvelles recherches archéologiques à Begram*, figs. 359–362.
12. On the recent excavations on this site cf. Vanderpool, *A.J.A.*, LXI, 1957, pp. 284 f., pl. 86, figs. 14–16.
13. On all these doors cf. Mendel, *Catalogue des Sculptures*, under no. 138.
14. Cf. B. R. Brown, *Ptolemaic Paintings and Mosaics*, 1957, pp. 33 ff. pl. XXII.

CHAPTER 3
Larger Works of Sculpture

1. Kunze, *Gnomon*, XXVII, 1955, pp. 222 f., XXVIII, 1956, pp. 318 ff.; in *Neue Deutsche Ausgrabungen im Mittelmeer . . .*, 1959, pp. 278 ff. Pausanias speaks of inlay of stone, but glass in that early period was precious and regarded as a sort of stone (cf. p. 385).
2. Amandry, *B.C.H.* LXIII, 1939, pp. 86 ff.
3. J. A. K. Thomson, *The Greek Tradition*, p. 22.
4. E. Harrison, *Hesperia*, XXIV, 1955, pp. 290 ff.
5. The recently identified fragments belonging to this stele (found in the reserve collection of the National Museum of Athens) have not yet been published and so could not be added here.
6. For a theory that this statue dates from the first century B.C. cf. B.S. Ridgway, *Antike Plastik*, VII, 1967, pp. 43 ff.
7. On this question, cf. especially E. Nash, in *Röm. Mitt.* LXVI, 1959, pp. 104 ff.; Jucker, *Museum Helveticum*, XXII, 1965, fasc. 2, p. 120; Ashmole, *Boston Museum Bull.*, LXIII, 1965, pp. 59 ff.; W. J. Young and B. Ashmole, *Boston Museum Bull.*, LXVI, 1968, pp. 124 ff.
8. Magi, in *Studies presented to D. M. Robinson*, I, 1951, pp. 615 ff.
9. Buschor, *Ath. Mitt.*, LXVIII, 1953, pp. 51 ff.
10. Cf. L. D. Caskey, *Catalogue of Greek and Roman Sculpture, Museum of Fine Arts*, no. 64, where other reproductions are listed; to these can now be added a marble statuette in the Ashmolean Museum, *Guide*, 1951, pl. XXXVIII.
11. On the identification of the head of Helios, cf. Marcadé, *B.C.H.*, LXXX, 1956, pp. 161 ff., and on that of Selene, *ibid.* 1957, pp. 76 ff.
12. For different interpretations see Holloway, *Art Bull.*, XLVIII, 1966, pp. 223 ff. and the references there cited.
13. The attribution of the Prokne and Itys group in the Akropolis Museum to Alkamenes is not certain, for Pausanias (I, 24, 3) merely says that the group was dedicated by Alkamenes. On the possibility that Alkamenes' cult statue of Hephaistos in the Hephaisteion (p. 24) is represented on a Roman lamp, cf. Papaspyridi-Karousou, *Ath. Mitt.*, LXIX–LXX, 1954–55, pp. 67 ff.
14. Aurigemma, *Boll. d'Arte*, XXXIX, 1954, pp. 7 ff.
15. As a fifth type, one could now take that published by Eichler, *Oest. Jahr.* XLIII, 1956–58, pp. 7 ff., and so restore Pliny's original text. Cf. Richter, *Archaeology*, XII, 1959, pp. 111 ff.
16. Cf. on this style especially Bulle, 'Archaisierende griechische Rund-

plastik', *Abhandlungen der Bayerischen Akademie der Wissenschaften*, philos., philolog., und hist. Klasse, XXX, 2, 1918; C. Karousos, 'Archaistika', *Archaiologikon Deltion*, X, 1926, pp. 91 ff.

17. The fragments were found and identified by N. Yalouris in the reserve collection of the National Museum, Athens; cf. Daux, Chronique, *B.C.H.*, 1966, pp. 783 f., figs. 1–8.

18. On this question cf. especially 'Who carved the Hermes of Praxiteles?', *A.J.A.*, XXXV, 1931, pp. 249 ff. (R. Carpenter, Casson, Blümel, Richter, V. Müller, Dinsmoor); Blümel, *Der Hermes eines Praxiteles*, 1948; Kreuzer, *J.d.I.*, LVIII, 1943, pp. 133 ff.

19. Now thought by some to be a Roman copy and to represent Alexander the Great; cf. E. B. Harrison, *Hesperia* XIX, 1960, pp. 382 ff.; Bieber, *Alexander the Great in Greek and Roman Art* (1966), p. 26.

20. On the stele found at Tegea not far from the temple of Athena Alea with the names of Ada and Idreus (sister and brother of Maussollos and Artemisia) inscribed, cf. my *Sculpture and Sculptors of the Greeks* (1950), p. 271, note 107.

21. Cf. De Visscher, *Heracles Epitrapezios*, 1962, and Richter, *Revue belge de philologie et d'hist.*, XLI, 1963, pp. 137 ff.

22. On the much discussed date of the Laokoon cf. my *Three Critical Periods in Greek Sculpture* (1951), pp. 66 ff.; Jacopi, *Arch. cl.* X, 1958, pp. 160 ff.; Magi, *Mem. Acc. Pont. Arch.*, 1961, pp. 39 ff; and the forthcoming new edition of my *Sculpture and Sculptors of the Greeks*.

23. The signature, to which the lower part of a figure found near this base may belong, has been assigned to about 100 B.C. Cf. Lippold, *Griechische Plastik*, pp. 333 f., 383, and Bieber, *The Sculpture of the Hellenistic Age*, p. 130.

CHAPTER 4
Statuettes and Small Reliefs

1. Experiments made by Mr. Denys Haynes and myself in the British Museum (in 1957) showed this to be perfectly possible. The designs resemble those on geometric sealstones.

2. Mr. R. J. H. Jenkins has suggested to me that the relief may once have decorated the Chest of Kypselos (cf. p. 378) — as part of the Judgment of Paris scene — since period, dimensions, and material would fit.

3. Cf. Daux, *B.C.H.*, 1962, pp. 854 f., fig. 16, pl. XXIX.

4. Richter, *Handbook of Etruscan Art*, Metropolitan Museum, figs. 97–98, 104–105.

5. Payne, *J.H.S.*, LIV, 1934, pp. 163 ff., pl. VII.

6. *M.M.A., Handbook*, 1953, pl. 59, c.

7. Lamb, *Greek and Roman Bronzes*, pl. LV, b. For a theory that it was originally intended for a mirror support cf. Blümel, *Arch. Anz.* 1955, col. 313.

8. Walters, *Catalogue of Bronzes*, no. 1084.

9. Richter, *Animals in Greek Sculpture*, fig. 98.

10. De Ridder, *Les bronzes antiques du Louvre*, no. 196.

11. Swindler, *Ancient Painting*, p. 187, fig. 337; Rumpf, *Malerei u. Zeichnung*, pl. 37, 2; Pfuhl, *Malerei und Zeichnung der Griechen*, fig. 627.

12. Lamb, pl. LXXVII, b.

13. *Ibid.* pl. LXXVII, c.

14. *Ibid.* pl. LXXVIII, a.

15. *Ibid.* pl. XC, a.

16. *Ibid.* pl. LXXIV, b.

17. Neugebauer, *Berlin, Museum, Führer, Die Bronzen*, pl. 49.

18. *M.M.A. Handbook*, 1953, pl. 109, f.

19. *M.M.A. Handbook*, 1953, pl. 109, i.

CHAPTER 5
Decorative Metalwork

1. Lamb, *Greek and Roman Bronzes*, pp. 55 ff. (shields); Myres, *Cesnola Handbook*, pp. 457 ff. (bowls).

2. *B.C.H.*, LXXIII, 1949, p. 438.

3. Cf. Kunze, VIII. Olympiabericht, 1967, pp. 111–183.

4. Lamb, pl. XLVI, b.

5. Lamb, p. 134; *Not. d. Scavi*, 1897, p. 164; *Arch. Anz.*, 1925, pp. 191 ff. On the handles of such vases cf. D. K. Hill, *A.J.A.*, LXII, 1958, pp. 193 ff.

6. Sestieri, *Boll. d'Arte*, XL, 1955, pp. 53 ff.

7. Joffroy, *Le Trésor de Vix* (Mon. Piot, XLVIII, 1).

8. Filow, *Die archaische Nekropole von Trebenischte*, 1927; Joffroy, *op. cit.*, pp. 22 ff., pls. XIX–XXI.

9. Lamb, pl. XLVIII, b.

10. Lamb, pl. XLIV, a, c.

11. Lamb, pl. XLIV, d.

12. Walters, *Catalogue of Silver Plate*, no. 9, pl. 11 (there numbered 8 by mistake).

13. Richter, *A.J.A.*, XLV, 1941, pp. 363 ff., LIV, 1950, pp. 357 ff.

14. De Ridder, *Les bronzes antiques du Louvre*, no. 1518.

15. Lamb, pls. LXXII, LXXIII, a.

16. On this South Russian metalware, cf. Minns, *Scythians and Greeks*, pp.

155 ff.; Rostovtzeff, *Iranians and Greeks*, pls. XIX–XXII; Richter, *Metropolitan Museum Studies*, IV, 1932, pp. 109 ff.; and the references to Russian publications there cited.

17. Filow, *Die Grabhügelnekropole bei Duvanlij*, pls. IV, V.
18. *Ibid.* pl. VII.
19. Von Bothmer, *Greek, Etruscan, and Roman Antiquities, Baker Collection, Exhibition*, Century Association, New York, 1950, no. 30; Hanfmann, *Ancient Art in American Private Collections*, 1954, no. 215.
20. Richter, *Catalogue of Bronzes*, no. 760.
21. *Arch. Anz.*, 1937, cols. 237 ff.
22. Lamb, pl. LXX, b.
23. *M.M.A.* Handbook, 1953, pl. 105, g.
24. My illustration shows the ornamented tang of the mirror as recently cleaned, and is here reproduced with the kind permission of Mr. Haynes.
25. Iantzen, *Bronzewerkstätten in Grossgriechenland und Sizilien*, pp. 21 ff., pls. 6, 7.
26. *M.M.A.* Handbook, 1953, pl. 105, h.
27. Amandry. *Collection Hélène Stathatos, Les bijoux antiques*, no. 232, pl. XXXV.
28. Cf. Daux, *B.C.H.* LXXXVII, 1963, pls. XVI–XX.
29. Končev, *Archaeology*, VIII, 1955, pp. 218 ff.; Svoboda and Končev, *Neue Denkmäler antiker Toreutik*, p. 162.
30. Cf. Rubensohn, *Hellenistisches Silbergerät*, and Hackin, *Nouvelles recherches archéologiques à Begram;* Richter, *A.J.A.*, LXII, 1958, pp. 369 ff.

CHAPTER 6
Terra-Cotta Statuettes and Small Reliefs

1. Cf. Vanderpool, *A.J.A.*, LXI, 1957, p. 281, pl. 84, fig. 9.
2. Karo, *Führer durch Tiryns*, 2nd edn., 1934, fig. 17.
3. On the statuettes from Lemnos, now in Athens, cf. *B.C.H.*, LIII, 1929, p. 517; *Arch. Anz.*, 1930, col. 140; Lippold, *Griechische Plastik*, p. 72.
4. On this white being a clay slip cf. Bimson in Higgins, *Catalogue of the Terracottas in the British Museum*, I, 1954, p. viii. In other experiments, however, made on Cypriote material, it is claimed that the white was 'essentially calcium carbonate, and therefore a lime wash', cf. Young, *Terracotta Figurines from Kourion*, p. 189.
5. Richter, *M.M.A.* Handbook, 1953, pl. 52, j.
6. Brooke, in Casson, *Catalogue of the Acropolis Museum*, II, no. 1333.
7. P. Gardner, *Mél. Perrot*, p. 121, pl. II.
8. Graham, *A.J.A.*, LXII, 1958, pp. 315 ff.
9. Thompson, *A.J.A.*, LXX, 1966, pp. 51 ff.

CHAPTER 7
Engraved Gems

1. Richter, *Catalogue of Engraved Gems*, *M.M.A.*, 1956, no. 13.
2. *Ibid.* pl. IV.
3. Furtwängler, *Antike Gemmen*, pl. VII, 1–10.
4. Beazley, *Lewes House Gems*, no. 28.
5. *A.G.*, pl. VIII, 37.
6. Richter, *A.J.A.*, LXI, 1957, p. 263, pl. 80, fig. 1.
7. *A.G.*, pl. XIII, 37.
8. *A.G.*, pl. X, 27.
9. *A.G.*, pl. XIII, 2.
10. *A.G.*, pl. XIV, 4.
11. *A.G.*, III, p. 137, fig. 94.
12. *A.G.*, pl. XIII, 10.
13. *A.G.*, pl. XIII, 30.
14. *A.G.*, pl. XI, 42.
15. *A.G.*, pl. X, 53.
16. *A.G.*, pl. IX, 39.
17. *A.G.*, pl. LVII, 3.
18. Beazley, *Lewes House Gems*, no. 102.
19. *A.G.*, pls. XXXIV, 43, XXXV, 23, 26.
20. *A.G.*, pl. XXXIII, 15.
21. *A.G.*, pl. XXXIV, 18.
22. *A.G.*, pl. LIII, 1, 2.
23. For a recent interpretation of the figures cf. Charbonneaux, *Mon. Piot*, L, 1958, pp. 85 ff.
24. *A.G.*, III, p. 157, figs. 108, 109.
25. *A.G.*, pl. XLIX, 4.
26. A statue of Diomedes of this type has recently been found in Athens, cf. *A.J.A.*, LXI, 1957, pl. 83, fig. 2.
27. *A.G.*, pl. LVI, and vol. III, p. 315, fig. 158.

CHAPTER 8
Coins

1. For a recent suggestion that coinage was primarily introduced for the payment of mercenaries by the Lydian kings, cf. R. M. Cook, 'Speculations on the Origins of Coinage', *Historia*, VII, 1958, pp. 257 ff.
2. Mr. Schwabacher has pointed out to me that the coins of Northern Greece, especially those of Macedonia, during the archaic period, show special stylistic features.
3. Richter, *Archaic Greek Art*, fig. 304.
4. *Guide to the Principal Coins of the British Museum*, 1932, pl. 1, 20.
5. *Ibid.* pl. XIX, 45, 46.
6. *Ibid.* pl. XXIV, 48.
7. Cf. also the head of Pan on a fourth-century relief from Kyzikos in Istanbul, Mendel, *Catalogue*, no. 571; *Illustrated Guide*, 1956, p. 45, no. 35 — there, however, in profile view.
8. Cf. for the portraits of Tissaphernes and Pharnabazos now E. S. G. Robinson, *Numismatic Chronicle*, 1948, pp. 48 f.; Schwabacher, *Charites*, pp. 27 ff.

9. *Br. Mus. Guide*, pl. XXXII, 3.
10. Conveniently grouped in Imhoof-Blumer, *Porträtköpfe auf antiken Münzen hellenischer und hellenisierter Völker*, pls. VI, VII; cf. also Bieber, *The Sculpture of the Hellenistic Age*, figs. 243, 244, 247, 248.

CHAPTER 9

Jewellery

1. Madame Stathatos informs me that, as far as she knows, all these bands when found were straight, not bent into circular form as they would have been had they served as bracelets. For similar bands found at Narce, Etruria, cf. Amandry, *Les bijoux antiques, Collection H. Stathatos*, p. 45, fig. 25.
2. Minns, *Scythians and Greeks*, p. 195, fig. 88.
3. Minns, *op. cit.*, p. 199, fig. 1.
4. Segall, *Katalog der Goldschmiede-Arbeiten, Benaki Museum*, no. 28.

CHAPTER 10

Paintings and Mosaics

1. Fraenkel, *Antike Denkmäler*, I, pl. 8; Swindler, *Ancient Painting*, fig. 206; Richter, *Craft of Athenian Pottery*, p. 77, figs. 74–79.
2. Hall, *A.J.A.*, XLVIII, 1944, pp. 334f.
3. R. S. Young, *A.J.A.*, LX, 1956, pp. 255ff.
4. They will presently be published by M. Napoli, the discoverer, but are briefly mentioned in *Magna Graecia*, III, 5, Sept–Oct, 1968, p. 3, and by M. Bonini in *Atalante*, Feb. 1969, no. 50, pp. 38–43, with copious illustrations in colour.
5. For varying views on this much discussed subject see the bibliography on perspective p. 405. Some authorities, e.g. Beyen and White, have argued that, since in Euclid's *Optics* the convergence of lines is cited as a principle of seeing, and in several passages of Vitruvius' *De Architectura* (cf. White, *op. cit.*, pp. 45ff.) an exact knowledge of true perspective is implied (cf. also Lucretius, *De rerum natura* IV, lines 426–431, edn. Bailey), the painters could not have been ignorant of this knowledge. But, as has been pointed out (cf. Bunim, *Space*, p. 24), 'Euclid's *Optics* is concerned with the laws of seeing only, not with the bearing of these laws on representation as a specific problem of painting'. Nor was the theoretical knowledge of an architect necessarily shared by the practising painters. At all events, the fact remains that, though occasionally a considerable degree of co-ordination is obtained in *parts* of Pompeian paintings, 'the composition of the *whole* scene is not constructed with reference to a single point of view corresponding to the eye of the spectator' (Bunim, *op. cit.*, p. 34). The theory that the lost Hellenistic paintings may have shown true perspective (cf. White, *op. cit.*) can only be proved by the finding of such examples. Moreover, it would seem strange that such knowledge of true perspective should have been entirely lost until rediscovered in the Renaissance. The Greek artists—starting from the purely two-dimensional concept that had obtained in art for thousands of years—made great strides in the direction of optical representation. It was only the final step—that is, the production of a systematically unified composition—that seems to have been reserved for later times. Cf. also my forthcoming book *Perspective in Greek and Roman Art*.
6. Swindler, *op. cit.*, fig. 442.
7. *Ibid.* fig. 488; Renard, *Aquileia Chiama*, I, 1954, pp. 50ff., and *Collection Latomus*, XXIII, pp. 307ff.
8. On the interpretation of these much discussed paintings cf. now Herbig, *Neue Beobachtungen am Fries der Mysterien-Villa in Pompeji*, 1958.
9. Swindler, *op. cit.*, fig. 636.
10. Cf. Swindler, *op. cit.*, p. 290; Rumpf, *Malerei und Zeichnung*, pp. 117f.; Pfuhl, *Malerei und Zeichnung der Griechen*, figs. 633, 634.
11. Rumpf, *op. cit.*, pp. 123f., figs. 11, 12, and p. 13; Vanderpool, *A.J.A.*, LXI, 1957, pp. 284f., pl. 86, figs. 14–16, LXII, 1958, pp. 324f., pls. 84–86; LXVI, 1962, p. 390, pls. 109–110.

CHAPTER 11

Pottery and Vase Painting

1. Cf. Buchner and Russo, *Rendiconti dell'Accademia dei Lincei*, X, 1955, pp. 215ff.
2. Pfuhl, *Malerei und Zeichnung der Griechen*, fig. 59.
3. For a similar owl, cf. Szilagy and Castiglione, *Führer, Museum der bildenden Künste, Budapest*, 1957, pl. V, I.
4. Trendall, *The Felton Greek Vases*, 1958, pp. 5ff.
5. Karo, *Führer durch Tiryns*, 2nd edn., 1934, p. 17.
6. Daux, *B.C.H.*, LXXXV, 1962, pp. 854f., fig. 16, pl. 29.
7. *A.J.A.*, LXII, 1958, pp. 165ff.
8. Cf. Beazley, *Vases in Poland*, p. 8.
9. Cf. Mingazzini, *Arch. Anz.*, 1967, pp. 344ff.

10. *M.M.A. Bull.*, October 1956, p. 54.
11. Pfuhl, fig. 313. D. von Bothmer, *M.M.A. Bull.*, February 1966, pp. 201 ff., figs. 4, 11.
12. Pfuhl, figs. 383–384, 417, 418.
13. Pfuhl, fig. 401.
14. Neugebauer, *Führer durch das Antiquarium*, II, Vasen, pl. 55, 8.
15. Furtwängler und Reichhold, *Griechische Vasenmalerei*, pl. 49.
16. Pfuhl, fig. 424.
17. Cf. Beazley, *A.J.A.*, XLIX, 1945, pp. 153 ff.
18. Pfuhl, fig. 466.
19. Pfuhl, fig. 468.
20. Richter, *Greek Painting*, p. 12.
21. Beazley, *Der Kleophrades-Maler*, pls. 16–19.
22. *Ibid.*, pls. 3–6.
23. On the possibility that a kylix from the Athenian Agora signed *Gorgos epoiesen* is an early work by the Berlin Painter cf. Beazley, *A.R.V.*², p. 213, no. 242; but this would only give us the name of the potter.
24. Richter and Hall, *Red-Figured Athenian Vases*, *M.M.A.*, pl. 16.
25. Furtwängler und Reichhold, *op. cit.*, pls. 17–18.
26. Pfuhl, fig. 501.
27. Pfuhl, fig. 498.
28. Furtwängler und Reichhold, *op. cit.*, pl. 136, 2.
29. Richter and Hall, *op. cit.*, pls. 85, 86.
30. Pfuhl, fig. 543.
31. Lullies, *Eine Sammlung griechischer Kleinkunst*, 1955, pls. 39–41.
32. Beazley, *Attic Red-Figured Vases in American Museums*, p. 173, fig. 106 bis, and *A.R.V.*², p. 1045, no. 3.
33. Hoppin, *Handbook of Red-Figured Vases*, II, p. 475.
34. D. von Bothmer, *M.M.A. Bull.*, November 1949, p. 95, fig. 3.

CHAPTER 12
Furniture

1. Many different articles of furniture are listed by name in ancient literature and inscriptions, cf. Pritchett, *Hesperia*, XXV, 1956, pp. 201 ff.; but only those discussed in my short sketch can, I think, with confidence be equated with the relatively few and constantly recurring forms figured in Greek art.
2. On such furnishings, cf. Richter, *Archaeology*, XVIII, 1965, pp. 26 ff., and *Furniture* (1966), pp. 117 ff.
3. The stones that Pausanias mentions were probably glass, to judge by the pieces of glass inlay found in Olympia (cf. p. 55). The word ὕαλος, glass, was also used for transparent stones, such as alabaster and rock crystals (cf. references cited in Liddell and Scott's *Lexicon, e.g.* Herodotos, III, 24, and my p. 385).
4. Cf. Ventris, *Eranos*, LIII, 1955, pp. 109 ff.; Palmer, *Minos*, V, I, 1957, pp. 58 ff.
5. Cf. the actual wooden pieces of furniture found in Egypt, Bulgaria, and Olympia, Richter, *Furniture*,² figs. 216–218, 377, and Filow, *Die Grabhügelnekropole bei Duvanlji*, pp. 122 ff.
6. Ohly, *Ath. Mitt.*, LXVIII, 1953, p. 91.
7. Ransom, *Couches*, pls. IX–XVII; Hoffmann, *A.J.A.*, LXI, 1957, pp. 167 ff.
8. Richter, *op. cit.*, figs. 350, 351.
9. *Ibid.*, figs. 467, 468.
10. *Ibid.* fig. 387.
11. Richter, *op. cit.*, fig. 384; Clairmont, *A.J.A.*, LVII, 1953, pp. 92 ff.
12. Richter, *op. cit.*, figs. 403, 404.
13. Minns, *Scythians and Greeks*, p. 322, fig. 232.
14. Richter, *op. cit.*, 408–410.
15. For a theory that some of the large chests on the Locrian pinakes above mentioned are really cupboards, with openings at the side instead of at the top, cf. E. G. Budde, *Armarium und* Κιβωτός, Würzburg, 1940; and, *contra*, Pritchett, *Hesperia*, XXV, 1956, pp. 220 ff.; Richter, *Collection Latomus*, XXVIII, 1957, pp. 420 ff.
16. Amyx, *A.J.A.*, XLIX, 1945, pp. 508 ff.
17. On a Corinthian aryballos, cf. Weinberg, *Studies presented to Hetty Goldman*, p. 263, fig. I, and on an Attic kylix, cf. Richter and Hall, *Red-Figured Athenian Vases in the Metropolitan Museum* no. 51, pl. 47.
18. Cf. Birth, *Die Buchrolle in der Kunst*, 1907, pp. 244 ff.
19. Cf. the many examples illustrated by Budde, *op. cit.*

CHAPTER 13
Textiles

1. Pritchett, *Hesperia*, XXV, 1956, pp. 244 ff.
2. Stephani, *Compte-rendu*, 1878–79, pp. 111 ff., pls. III–VI; Minns, *Scythians and Greeks*, fig. 113.
3. Schaefer, *A.J.A.*, XLVII, 1943, pp. 266 ff.; *Illustrated London News*, July 11th, 1953, pp. 69 ff. (Roman period).
4. Beckwith, *Illustrated London News*, January 23rd, 1954, pp. 114 f. Now in the Victoria and Albert Museum.
5. On silk, cf. Richter, *A.J.A.*, XXXIII, 1929, pp. 27 ff.

CHAPTER 16
Epigraphy

1. Vanderpool, *A.J.A.*, LXVI, 1962, p. 390; cf. also Hood, *J.H.S. Archaeological Reports for 1961–62*, p. 15.

BIBLIOGRAPHY

In these bibliographies I have confined myself to listing a few fundamental works (where references to other writings will be found), and recent studies, especially those in which objects mentioned in my text are described at greater length. For accounts of recent discoveries, see Daux, *B. C. H.* in his Chronique des Fouilles et Découvertes archéologiques; Vanderpool and M. Ervin, *A. J. A.*, in their News Letters from Greece, and *J. H. S.*, Archaeological Reports; also *The Illustrated London News*.

CHAPTER 1
The Forerunners

Evans, *The Palace of Minos at Knossos*, 1921–35. Reprinted 1964.
Pendlebury, *A Handbook to the Palace of Minos*, 1933 (last edn. 1954); *The Archaeology of Crete*, 1939.
Wace, *Mycenae, An Archaeological History and Guide*, 1949; articles in recent numbers of the *J.H.S.*, in *Viking*, 1956, and in *Studies presented to Hetty Goldman*, 1956; etc.
Blegen and others, *Troy* I–IV, 1951–58.
Blegen, articles on the excavations at Pylos in recent numbers of *A.J.A.* and *Archaeology* and in *Proceedings of the American Philosophical Society*, vol. 101, 1957, pp. 379 ff.; A Guide to the Palace of Nestor, 1962 (with M. Rawson); Blegen and Rawson, *The Palace of Nestor at Pylos*, vol. I (1966), The Buildings; II (1969) The Frescoes, by M. L. Lang; III and IV forthcoming.
D. Levi, *Boll. d'Arte*, 1955, pp. 1 ff., and 1956, pp. 238 ff.; 'Gli scavi italiani in Creta' *Nuova Antologia*, 1956, pp. 1 ff.; and articles in recent numbers of the *Annuario*.
Ventris and Chadwick, *Documents in Mycenaean Greek*, 1956, with a foreword by Wace.
Beattie, 'Mr. Ventris' Decipherment of the Minoan Linear B Script', *J.H.S.*, LXXVI, 1956, pp. 1 ff.
Botsford and C. A. Robinson, *Hellenic History*, 4th edn., 1956, ch. II, 'The Bronze Age', pp. 9–33.
Platon, *A Guide to the Archaeological Museum of Heraclion*, 1956.
Forsdyke, *Greece before Homer*, 1957.
Mylonas, *Ancient Mycenae*, 1957.
Webster, *From Mycenae to Homer*, 1958.
D. L. Page, *History and the Homeric Iliad*, 1959.
Marinatos, *Crete and Mycenae*, 1960.
Hutchinson, *Prehistoric Crete*, 1962.
J. L. Caskey, 'The Early Helladic Period in the Argolid', *Hesperia*, XXIX, 1960, pp. 285 ff.; Excavations in Keos, 1960–61, *Hesperia*, XXXI, 1962, pp. 263 ff.
Boardman, *The Cretan Coll. in Oxford*, 1961.
Wace and Stubbings, *A Companion to Homer*, 1962.
Helen Wace, *Mycenae, Guide*, 2nd ed. 1962.
Blegen, *The Mycenaean Age*, 1962 (University of Cincinnati); *Troy and the Trojans*, 1963.
J. Alsop, *From the Silent Earth, A Report on the Greek Bronze Age*, with photographs by Alison Frantz, 1964.
Demargne, *Aegean Art*, 1964.
B.S.A., passim.

CHAPTER 2
Architecture

GENERAL WORKS

Stevens, in Fowler and Wheeler, *Handbook of Greek Archaeology*, 1909, ch. II, on Architecture.
Durm, *Die Baukunst der Griechen*, 3rd edn., 1910 (in *Handbuch der Architektur*, II, I).
Weickert, *Typen der archaischen Architektur in Griechenland und Kleinasien*, 1929; *Antike Architektur*, 1949.
Grinnell, *Greek Temples*, 1943.
D. S. Robertson, *A Handbook of Greek and Roman Architecture*, 1945.
Dinsmoor, *The Architecture of Ancient Greece*, 1950 (with full bibliography). A new edition is in preparation.
A. W. Lawrence, *Greek Architecture*, 1957.

SPECIFIC ASPECTS

Von Gerkan, *Griechische Städteanlagen*, 1924.
Paton and others, *The Erechtheum*, 1927.
Buschor, 'Heraion von Samos', *Ath. Mitt.*, LV, 1930, pp. 1 ff.; LVIII, 1933, pp. 146 ff. (with Schleif).

Dunkley, 'Greek Fountain Buildings', *B.S.A.*, XXXVI, 1935–36, pp. 142–204.

Shoe, *Profiles of Greek Mouldings*, 1936.

Payne and others, *Perachora*, I, 1940, pp. 27 ff. (on geometric temples).

Wycherley, *How the Greeks built cities*, 1949.

D. M. Robinson, and others, *Excavations at Olynthus*, VIII, 'The Hellenistic House'; also vols. X and XII; vol. XI, 1942, 'Cemeteries'.

I. T. Hill, *The Ancient City of Athens*, 1953.

The Athenian Agora, *A Guide to the Excavations*, 1954.

Kunze and others, *Olympia Berichte*, I–VIII, 1937–67, passim.

Stevens, *Hesperia*, V, 1936, XV, 1946, and Supplement XV, 1946 (articles on the Athenian Akropolis and the Parthenon).

Stevens, *Restorations of Classical Buildings*, 1955.

Bundgaard, *Mnesicles*, 1957.

F. Krauss, *Griechische Tempel in Paestum I*, 1959.

Berve, Gruben, Hirmer, *Griechische Tempel und Heiligtümer*, 1961.

Sjöquist, 'The Excavations at Morgantina', *A.J.A.*, LXVI, 1962, pp. 135ff.

Scichilone, Grecia, Architettura e urbanistica, in *Dizionario di Architettura e Urbanistica*, Vol. III, 1969.

Cf. also the articles on the various types of buildings in Pauly-Wissowa's *Real-Encyclopädie*.

CHAPTER 3

Larger Works of

Sculpture

GENERAL WORKS (on all periods)

Overbeck, *Die antiken Schriftquellen*, 1868.

Loewy, *Inschriften griechischer Bildhauer*, 1885.

Collignon, *Histoire de la Sculpture grecque*, 1892–97; *Les statues funéraires*, 1911.

Deonna, *Les statues de terre cuite dans l'antiquité*, 1908.

Winter, *Kunstgeschichte in Bildern, Das Altertum*, 1912.

Hildebrand, *Das Problem der Form*, 1918 (4th edn.).

Bieber, *Griechische Kleidung*, 1928.

Rumpf, *Griechische und Römische Kunst*, 1931.

Beazley and Ashmole, *Greek Sculpture and Painting*, 1932, 2nd edn. 1966.

Picard, *Manuel d'archéologie grecque*, I–IV, 1935–63.

Buschor, *Die Plastik der Griechen*, 1936.

Richter, *The Sculpture and Sculptors of the Greeks*, 1st edn. 1929, 3rd edn., 1950; new edn. in preparation.

Schuchhardt, *Die Kunst der Griechen*, 1940.

Matz, *Geschichte der griechischen Kunst*, I, 1949–50.

Giglioli, *Arte greca*, 1955.

Marcadé, *Recueil des signatures de sculpteurs grecs*, I, 1953.

Alscher, *Griechische Plastik*, I, 1954, III, 1956, IV, 1957; II, 1961.

Lullies and Hirmer, *Greek Sculpture*, 1957.

Schuchhardt, *Die Epochen der griechischen Plastik*, 1959.

Schefold, *Meisterwerke griechischer Kunst*, 1960, and *Klassisches Griechenland*, 1965 (applies also to other categories).

Carpenter, *Greek Sculpture*, 1960.

Hausmann, *Griechische Weihreliefs*, 1960.

Hafner, *Gesch. der griechischen Kunst*, 1961.

Zanotti-Bianco and von Matt, *Grossgriechenland*, 1961 (on all categories).

Langlotz, *Die Kunst der Westgriechen*, 1963.

Boardman, *Greek Art*, 1964.

Becatti, *Scultura greca*, 1961, *L'Età classica*, 1965.

Schefold, *Die Griechen und ihre Nachbarn*, 1967.

Hanfmann, *Classical Sculpture*, 1967.

Schuchhardt, *Griechische Kunst*, 1968.

ARCHAIC PERIOD

Furtwängler and others, *Aegina*, 1906.

Deonna, '*Les Apollons archaïques*', 1909.

Heberdey, *Altattische Porosskulptur*, 1919.

E. D. Van Buren, *Archaic Fictile revetments in Sicily and Magna Graecia*, 1923, and *Greek Fictile revetments in the Archaic Period*, 1926.

Picard and De La Coste-Messelière, *Fouilles de Delphes*, 1927 (archaic and later).

Buschor, *Altsamische Standbilder*, I–V, 1934–61; *Frühgriechische Jünglinge*, 1950.

Schuchhardt, 'Die Sima des alten Athenatempels der Akropolis', *Ath. Mitt.*, LX, 1935, pp. 1ff.

Payne and Young, *Archaic Sculpture of the Acropolis*, 1936. 2nd edn., 1950.

De La Coste-Messelière, *Au Musée de Delphes*, 1936; *Delphes*, 1943.

Kunze and others, *Olympia Berichte*, II–VIII, 1937–67; Kunze, *Neue Meisterwerke griechischer Kunst aus Olympia*, 1948.

Charbonneaux, *La sculpture grecque archaïque*, 1938.

F. R. Grace, *Archaic Sc. in Boeotia*, 1939.

Schrader (with Langlotz and Schuchhardt), *Die archaischen Marmorbildwerke der Akropolis*, 1939.

Rodenwaldt, *Korkyra*, II, 1939–40.

Akurgal, *Griechische Reliefs des 6. Jhts. aus Lykien*, 1942.

Richter, *Kouroi*, 1942, 2nd edn., 1960; 3rd edn., forthcoming. *Archaic Attic Gravestones*, 1944; *Archaic Greek Art*, 1949; *The Archaic Gravestones of Attica*, 1961; *Korai*, 1968.

Dunbabin, *The Western Greeks*, 1948.

Raubitschek, *Dedications from the Athenian Akropolis*, 1949.

Homann-Wedeking, *Die Anfänge der griechischen Grossplastik*, 1950.

Zancani Montuoro and Zanotti-Bianco, *Heraion alla Foce del Sele*, I, 1951, II, 1954.

E. Harrison, 'Archaic Gravestones from the Athenian Agora', *Hesperia*, XXV, 1956, pp. 25 ff.; *Archaic and Archaistic Sculpture, The Athenian Agora*, XI, 1965.

S. S. Weinberg, 'Terracotta Sculpture at Corinth', *Hesperia*, XXVI, 1957, pp. 289 ff.

Demargne, *Fouilles de Xanthos*, I, 1958.

Kontoleon, 'Theräisches', *Ath. Mitt.* LXXIII, 1958, pp. 117 ff.

C. Karouzos, *Aristodikos*, 1961.

FIFTH CENTURY

Conze, *Die attischen Grabreliefs*, 1893–1922.

Furtwängler, *Masterpieces of Greek Sculpture* (tr. Sellers), 1895.

Treu, *Olympia*, III, *Die Bildwerke*, 1894–97.

Bernoulli, *Griechische Ikonographie*, 1901.

A. H. Smith, *Sculptures of the Parthenon*, 1910.

Collignon, *Les statues funéraires*, 1911.

Kjellberg, *Studien zu den attischen Reliefs des V. Jh. v. Chr.*, 1926.

Paton and others, *The Erechtheum*, 1927.

Carpenter, *The Sculpture of the Nike Temple Parapet*, 1929.

Möbius, *Die Ornamente der griechischen Grabstelen*, 1929.

Diepolder, *Die attischen Grabreliefs*, 1931.

Binnebössel, *Studien zu den attischen Urkundenreliefs*, 1932.

Speier, 'Zweifiguren-Gruppen im fünften und vierten Jahrhundert', *Röm. Mitt.*, XLVII, 1932, pp. 1 ff.

Rizzo, *Thiasos*, 1934.

Ashmole, *Late Archaic and Early Classical Greek Sculpture in Sicily and South Italy*, 1934.

Bianchi Bandinelli, *Policleto* (Quad. 1), 1938.

L. Curtius, *Die klassische Kunst Griechenlands*, 1938.

Arias, *Mirone* (Quad. 2), 1940; *Pheidias*, 1944.

Schweitzer, 'Pheidias der Parthenonmeister', *J.d.I.*, LV, 1940, pp. 170–241.

Laurenzi, *Ritratti greci* (Quaderni 3–5), 1941.

Schefold, *Bildnisse der antiken Dichter, Redner und Denker*, 1943.

Karo, *An Attic Cemetery*, 1943.

Becatti, *Il Maestro d'Olimpia*, 1943.

Charbonneaux, *La sculpture grecque classique*, 1943.

Kunze and Schleif, *IV. Olympia Bericht*, 1944, pp. 143 ff.

Kenner, *Der Fries des Tempels von Bassae-Phigalia*, 1946.

Langlotz, *Phidiasprobleme*, 1948.

Rodenwaldt, *Köpfe von den Südmetopen des Parthenon*, 1948.

Eichler, *Die Reliefs des Heroon von Gjölbaschi-Trysa*, 1950.

Blümel, *Der Fries des Tempels der Athena Nike*, *J.d.I.*, LXV–LXVI, 1950–51, pp. 135 ff.

Richter, *Three Critical Periods in Greek Sculpture*, ch. I, 1951; *Greek Portraits*, I–IV, *Coll Latonus*, 1955, 1959, 1960, 1962; *The Portraits of the Greeks*, 1965.

Becatti, *Problemi fidiaci*, 1951.

Brommer, 'Zu den Parthenongiebeln', *Ath. Mitt.* 69/70, 1954–55, pp. 49 ff., 71, 1956, pp. 30 ff., 232 ff.; *Die Giebel des Parthenon*, 1959; *Die Skulpturen der Parthenongiebel*, 1963; *Die Metopen des Parthenon*, 1967.

Brunnsåker, *The Tyrant Slayers of Kritios and Nesiotes*, 1955.

Devambez, *L'Art au siècle de Périclès*, 1955.

Chamoux, 'L'Aurige', *Fouilles de Delphes*, IV, 5, 1955.

Dinsmoor, 'The sculptured Frieze from Bassae', *A.J.A.* LX, 1956, pp. 401–452.

Marcadé, *B.C.H.*, LXXX, 1956, pp. 161 ff., LXXXI, 1957, pp. 76 ff., LXXXVIII, 1964, pp. 623 ff. (on Parthenon pedimental figures).

Becatti, 'I Tirannicidi di Antenore', *Archeologia classica*, IX, 1957, pp. 97 ff.

Dohrn, *Attische Plastik vom Tode des Pheidias bis zum Wirken der grossen Meister des vierten Jahrhunderts*, 1957.

Bakalakis, *Proanaskaphikes ereunes ste Thrake*, 1958.

E. Simon, *Die Geburt der Aphrodite*, 1959.

P. E. Corbett, *The Sculpture of the Parthenon*, 1959.

H. A. Thompson, 'The Sculptural Adornment of the Hephaisteion', *A.J.A.*, LXVI, 1962, pp. 339 ff.

B. Ashmole and N. Yalouris, *Olympia, The Sculptures of the Temple of Zeus*, 1967.

FOURTH CENTURY

Johnson, *Lysippos*, 1927.

Süsserott, *Griechische Plastik des 4. Jahrh. v. Chr.*, 1938.

Rizzo, *Prassitele*, 1932.

Blinkenberg, *Knidia*, 1933.

Ashmole, 'Demeter of Cnidus', *J.H.S.*, LXXI, 1951, pp. 13–28.

Crome, *Die Skulpturen des Asklepiostempels von Epidauros*, 1951.

Arias, *Skopas*, 1952.

De Visscher, *Heracles Epitrapezios*, 1962.

E. Sjöqvist, *Lysippos*, 1967.

Cf. also the books by Conze, Bernoulli, Collignon, Diepolder, Binneboessel, Speier, Laurenzi, Schefold, Dohrn, listed under the fifth century, for they apply also to the fourth.

HELLENISTIC PERIOD

Altertümer von Pergamon, 1885–1937.

Roussel, *Délos, Colonie athénienne*, 1910.

Lawrence, *Later Greek Sculpture*, 1927.

Horn, *Stehende weibliche Gewandstatuen in der hellenistischen Plastik*, 1931.

Schober, *Der Fries des Hekateions von Lagina*, 1933; *Die Kunst von Pergamon*, 1951.

Zschietzschmann, *Die hellenistische und römische Kunst*, 1939.

Kähler, *Der grosse Fries von Pergamon*, 1948.

Adriani, *Testimonianze e Momenti di Scultura alessandrina*, 1948.

Bieber, 'Portraits of Alexander the Great', *Proceedings of the American Philosophical Society*, vol. 93, 1949, pp. 373 ff.; *The Sculpture of the Hellenistic Age²*, 1961; *Alexander the Great in Greek and Roman Art*, 1964.

Richter, *Three Critical Periods in Greek Sculpture*, chs. II and III, 1951.

Rostovtzeff, *The Social and Economic History of the Hellenistic World*, 1951.

Lauer and Picard, *Les Statues Ptolémaïques du Sarapieion de Memphis*, 1955.

Charbonneaux, *La Vénus de Milo* (*opus nobile*, 6), 1958.

W. Fuchs, *Die Vorbilder der neuattischen Reliefs*, 1959.

Magi, 'Il Ripristino del Laocoonte', *Mem. Pont. Acc. Arch.*, 1950.

Dohrn, *Die Tyche von Antiocheia*, 1960.

E. Schmidt, *The Great Altar of Pergamon*, 1962.

W. Fuchs, *Der Schiffsfund von Mahdia*, 1963.

Cf. also the books on portraits listed above.

SPECIFICALLY ON THE TECHNIQUE

Kluge and Lehmann-Hartleben, *Die antiken Grossbronzen*, 1927.

Blümel, *Griechische Bildhauerarbeit*, 1927. *Greek Sculptors at work*, 1955.

Casson, *The Technique of Early Greek Sculpture*, 1933.

Rich, *The Materials and Methods of Sculpture*, 1947.

Miller, *Stone and Marble Carvings*, 1948.

S. Adam, *The Technique of Greek Sculpture*, 1967.

In addition, for all periods, cf. the relevant entries in the various encyclopedias and lexicons, as well as the catalogues of sculptures in the various museums and private collections, especially those in the British Museum (by A. H. Smith and Pryce); Munich (by Furtwängler); Berlin (by Blümel); Athens, Akropolis Museum (by Dickins), National Museum, Guide (by Papaspiridi), and *Catalogue* (by S. Karouzou); Vatican (by Amelung and Lippold); Capitoline and Conservatori Museums (by Stuart Jones); Museo Mussolini (by Mustilli); Terme Museum (by E. Paribeni); Uffizi Gallery (by Mansuelli); Cyrene (by Rosenbaum); portraits in the Terme Museum (by Feletti Maj); Boston (by L. D. Caskey); New York (by Richter); Constantinople (by Mendel); Hermitage (by Waldhauer). Also Michaelis, *Ancient Marbles in Great Britain*, 1882; and the Helbig-Amelung Guide to the Museums of Rome (a new edition by Speier and others, in 4 volumes, in preparation; vols. 1, 2 and 3 appeared in 1963, 1966 and 1969).

FIRST CENTURY AND LATER

Lippold, *Kopien und Umbildungen griechischer Statuen*, 1923.

J. M. C. Toynbee, 'Some Notes on Artists of the Roman World', *Collection Latomus*, VI, 1951.

Richter, *Three Critical Periods in Greek Sculpture*, ch. III, 1951; *Ancient Italy*, 1955, pp. 34 ff.

CHAPTER 4
Statuettes and Small Reliefs

Furtwängler, *Olympia*, IV, *Die Bronzen*, 1890.

Walters, *Select Bronzes*, 1915.

Neugebauer, *Bronzestatuetten*, 1921.

Langlotz, *Antike Frühgriechische Bildhauerschulen*, 1927.

Dawkins and others, *Artemis Orthia*, 1929.

Lamb, *Greek and Roman Bronzes*, 1929.

V. Müller, *Frühe Plastik in Griechenland und Vorderasien*, 1929.

Buschor, *Altsamische Standbilder*, I–V, 1934–1961.

Jantzen, *Bronzewerkstätte in Grossgriechenland und Sizilien*, 1937.

Payne and others, *Perachora*, I, 1940, II, 1962 (applies also to other categories).

Kunze and others, *Olympia Berichte*, I–VIII, 1936–67.

Barnett, 'Early Greek and Oriental Ivories', *J.H.S.*, LXVIII, 1948, pp. 1 ff.

Jacobsthal, *J.H.S.*, LXXI, 1951, pp. 85 ff. (on Ephesian Foundation-Deposit).

Charbonneaux, *Les Bronzes grecs*, 1958.

Raven-Hart, *J.H.S.*, LXXVIII, 1958, pp. 87 ff. (on technique).

D. v. Bothmer, *Ancient Art from New York Private Collections*, 1961.

Cf. also the catalogues and handbooks of the various museums and private collections, especially those by de Ridder of the Akropolis Museum (1896), and of the Louvre (1913–15); by D. K. Hill of the Walters Art Gallery, Baltimore (1949); by Perdrizet of Delphi (*Fouilles de Delphes*, V, 1908); Schefold, *Meisterwerke griechischer Kunst*, 1960.

CHAPTER 5
Decorative Metalwork

Furtwängler, *Olympia*, IV, Die Bronzen, 1890.

Pernice and Winter, *Hildesheimer Silberfund*, 1901.

Puschki and Winter, *Oest. Jahr.*, V, 1902, pp. 112 ff. (on Trieste rhyton).

Rubensohn, *Hellenistisches Silbergerät in antiken Gipsabgüssen*, 1911.

Minns, *Scythians and Greeks*, 1913.

Walters, *Select Bronzes*, 1915.

E. Babelon, *Trésor de Berthouville près Bernay*, 1916.

Rostovtzeff, *Iranians and Greeks in South Russia*, 1922.

Pernice, *Die hellenistische Kunst in Pompeii*, 1926–41.

Filow, *Die archaische Nekropole von Trebenischte*, 1927.

Neugebauer, *Bronzegerät des Altertums*, 1927.

Lamb, *Greek and Roman Bronzes*, 1929.

Wuilleumier, *Le Trésor de Tarente*, 1930; *Tarente*, 1939.

Friis Johansen, *Acta archeologica*, I, 1930, pp. 273 ff. (on Hoby cups).

Kunze, *Kretische Bronzereliefs*, 1931; *Olympia Berichte*, I–VI, 1937–58; 'Archaische Schildbänder', *Olympische Forschungen* II, 1950.

Maiuri, *La casa del Menandro e il suo tesoro di argenteria*, 1933.

Filow, *Die Grabhügelnekropole bei Duvanlij in Südbulgarien*, 1934.

Hampe, *Frühe griechische Sagenbilder in Böotien*, 1936.

Rodenwaldt, *Arch. Anz.*, 1937, cols. 237 ff. (on Hoby cups).

Ippel, *Guss und Treibarbeit in Silber*, 1937.

Beazley, 'A Greek mirror in Dublin', *Proceedings of the Royal Irish Academy*, XLV, c, 5, 1939, pp. 31 ff.

D. B. Thompson, 'Mater caelaturae, Impressions from ancient metalwork', *Hesperia*, VIII, 1939, pp. 285 ff.

Richter, *A.J.A.*, XLV, 1941, pp. 363 ff., and LIV, 1950, pp. 357 ff. (on silver phialai).

Schefold, 'Griechische Spiegel', *Die Antike*, XVI, 1940, pp. 11 ff.

Züchner, *Griechische Klappspiegel*, 1942; 'Von Toreuten und Töpfern', *J.d.I.*, 65–66, 1950–51, pp. 175 ff.

Maryon, 'Metal Working in the Ancient World', *A.J.A.*, LIII, 1949, pp. 93 ff.

H. A. Thompson, *Hesperia*, XIX, 1950, pp. 333 ff.

S. Karouzou, 'Attic Bronze Mirrors', *Studies presented to D. M. Robinson*, I, 1951, pp. 565 ff.

Roes and Vollgraf, 'Le Canthare de Stevensweert', *Mon. Piot*, XLVI, 1952, pp. 39 ff.

Ohly, *Griechische Goldbleche des 8. Jhds.* 1953.

Brom, *The Stevensweert Kantharos*, 1952.

Joffroy, *Le Trésor de Vix*, 1954.

D. von Bothmer, 'Bronze Hydriai', *M.M.A. Bull.*, 1955, pp. 193 ff.

Tsonchev, 'The Gold Treasure of Panagurishte', *Archaeology*, VIII, 1955, pp. 218 f.

Jantzen, *Griechische Greifenkessel*, 1955.

Svoboda and Končev, *Neue Denkmäler antiker Toreutik*, 1956.

Kurz in Hackin, *Nouvelles recherches archéologiques à Begram*, 1954, pp. 110 ff.

R. S. Young, Articles on the bronze vases found at Gordion in recent numbers of *A.J.A.*

Willemsen, *Dreifusskessel von Olympia*, 1957.

Richter, 'Ancient Plaster Casts of Greek Metalware', *A.J.A.*, LXII, 1958, pp. 369 ff.; 'Calenian Pottery and Classical Greek Metalware', *A.J.A.*, LXIII, 1959, pp. 241 ff.

Kontoleon, 'The Gold Treasure of Panagurischte', *Balkan Studies*, 1962, pp. 185 ff.

Alfieri, 'Una phiale mesomphalos a stagno', *Coll. Latomus*, LVIII, 1962, pp. 89 ff.

Vanderpool, *A.J.A.*, LXVI, 1962, pp. 389 f., pls. 107 f.

D. v. Bothmer, 'A Gold Libation Bowl', *M.M.A. Bull.*, 1962, pp. 154 ff.

D. E. Strong, *Greek and Roman Gold and Silver Plate*, 1966.

Kunze, 'Waffenweihungen' and 'Helme', VIII. *Olympia Bericht*, 1967, pp. 83 ff., 111 ff.

Cf. also the Catalogues of the various museums and private collections.

CHAPTER 6
Terra-Cotta Statuettes and Small Reliefs

Pottier and Reinach, *La Nécropole de Myrina*, 1886.

Pottier, *Les statuettes de terre cuite dans l'antiquité*, 1890.

Hutton, *Greek Terracotta Statuettes*, 1899.

Winter, *Die Typen der figürlichen Terrakotten*, 1903.

Quagliati, *Ausonia*, III, 1908, pp. 136 ff. (on Locrian reliefs).

Orsi, *Boll. d'Arte*, II, 1909, pp. 406 ff. (on Locrian reliefs).

Zahn, *Arch. Anz.*, 1921, cols. 292 ff.

Jacobsthal, *Die Melischen Reliefs*, 1930.

Burr, *Terra-cottas from Myrina*, Museum of Fine Arts, Boston, 1934.

Jenkins, *Dedalica*, 1936.

Charbonneaux, *Les Terres Cuites Grecques*, 1936.

Bielefeld, *Ein attisches Tonrelief*, 1937.

Wuilleumier, *Tarente*, 1939.

R. J. H. Jenkins in Payne, *Perachora*, I, 1940, pp. 191 ff.

Van Ufford, *Les Terres Cuites Siciliennes*, 1941.

Kleiner, *Tanagrafiguren*, 1942.

Webster, *Greek Terracottas*, 1950.

Goldman, *Tarsus*, I, 1950, pp. 297.

A. N. Stillwell, *Corinth*, XV, 2, 1952 ff.

D. Levi, *Annuario*, N.S. XVII–XVIII (1955–56), pp. 1 ff.; *Boll. d'Arte*, 1956, pp. 270 ff. (on finds from Gortyna).

Zancani Montuoro, 'Note sui soggetti e sulla tecnica delle tabelle di Locri', *Atti e Memorie della Società Magna Grecia*, 1954, and 'La Teogamia di Locri Epizefiri', *Archivio Storico per la Calabria e la Lucania*, XXIV, 1955, pp. 283 ff.; 'Lampada arcaica...', *Atti*

e Mem. Soc. Magn. Gr., 1960, pp. 69 ff.;
'Il tempio di Persephone a Locri',
Rend. Acc. d. Lincei, 1959, pp. 225 ff.;
'Il corredo della sposa', *Arch. cl.*, XII,
1960, pp. 37 ff.

Young, *Terracotta Figurines from Kurion
in Cyprus*, 1955.

Boardman, 'Painted Funerary Plaques...',
B.S.A., L, 1955, pp. 51 ff.

Richter, 'Ceramics', in *History of Tech-
nology*, II², 1957, pp. 259 ff. (on tech-
nique).

D. B. Thompson, 'Ostrakina Toreumata',
Hesperia, Supplement VIII, pp. 365 ff.;
'Three Centuries of Hellenistic Terra-
cottas', *Hesperia*, XXI, 1952, pp. 116 ff.,
XXIII, 1954, pp. 72 ff., XXVI, 1957, pp.
108 ff.; XXVIII, 1959, pp. 127 ff.; XXXI,
1962, pp. 244 ff.; XXXII, 1963, pp.
276 ff., pp. 301 ff.; XXXIV, 1965, pp.
34 ff.

Graham, *A.J.A.*, LXII, 1958, pp. 313 ff.
(on Melian reliefs).

R. Stillwell, *A.J.A.*, LXIII, 1959, p. 169,
pl. 41 (on protomes from Morgantina).

Richter, 'Greek Portraits III', *Coll.
Latomus*, XLVII, 1960.

Lullies, *Vergoldete Terrakotta-Appliken
aus Tarent*, 1962.

Higgins, *Greek Terracottas*, 1967.

Cf. also the catalogues of the various
museums, especially the recent ones
of the important collections in the
British Museum by Higgins, and in
the Louvre by Besques-Mollard; also
Pedrizet, *Fouilles de Delphes*, V, and
D. M. Robinson, *Olynthus*, VII, XIV.

CHAPTER 7
Engraved Gems

Story-Maskelyne, *The Marlborough Gems*,
1870.

Imhoof-Blumer and Keller, *Tier- und
Pflanzenbilder auf Münzen und Gemmen*,
1889.

S. Reinach, *Les Antiquités du Bosphore
Cimmérien*, 1892.

Furtwängler, *Beschreibung der Geschnit-
tenen Steine in Berlin*, 1896; *Antike
Gemmen*, 1900; 'Studien über die
Gemmen mit Künstlerinschriften' in
Kleine Schriften, II, 1913, p. 147 ff.
(reprinted from the *J.d.I.*, III, IV, with
additions by Sieveking and L. Curtius).

E. Babelon, *Camées de la Bibliothèque
Nationale*, 1897; *Collection Pauvert de la
Chapelle*, 1899.

F. H. Marshall, *Catalogue of Finger Rings,
British Museum*, 1907.

Beazley, *The Lewes Collection of Ancient
Gems*, 1920; (Beazley), *Story-Maskelyne
Collection*, Sale Cat., 1921.

Lippold, *Gemmen und Kameen*, 1922.

Walters, *Catalogue of the Engraved Gems
and Cameos, British Museum*, 1926.

Eichler and Kris, *Die Kameen im Kunst-
historischen Museum, Wien*, 1927.

Fossing, *Catalogue of the Antique Engraved
Gems, Thorvaldsen Museum*, 1929.

D. M. Robinson, *Hesperia*, Supplement,
VIII, 1949, pp. 305 ff., *A.J.A.*, LVII,
1953, pp. 16 ff.

Richter, *Catalogue of Engraved Gems,
Metropolitan Museum*, 1956; *A.J.A.*,
LXI, 1957, pp. 263 ff.; *Ancient Engraved
Gems, Greek, Etruscan and Roman*, I
(1968), II (forthcoming).

Kenna, *Cretan Seals*, 1961.

Boardman, *Island Gems*, 1963; *The Ionides
Collection*, 1968; *Archaic Greek Gems*,
1968.

M.-L. Vollenweider, *Die Steinschneide-
kunst und ihre Künstler in spätrepublikani-
scher und augusteischer Zeit*, 1966.

S. Sena Chiesa, *Gemme del Museo Nazionale
di Aquileia*, 1966.

CHAPTER 8
Coins

Imhoof-Blumer, *Porträtköpfe auf antiken
Münzen hellenischer und hellenisierter
Völker*, 1885.

Imhoof-Blumer and Keller, *Tier- und
Pflanzenbilder auf Münzen und Gemmen*,
1889.

E. Babelon, *Traité des monnaies grecques et
romaines*, 1901.

Head, *Historia Numorum*, 2nd edn., 1911,
3rd edn. in preparation (by E. S. G.
Robinson and others).

Regling, *Die antike Münze als Kunstwerk*,
1924.

Hill, *Select Greek Coins*, 1927.

Head and Hill, *A Guide to the principal
Coins of the Greeks, British Museum*,
1932; new edition, 1959.

Newell, *Royal Greek Portrait Coins*, 1937.

Seltman, *Greek Coins*, 1933; 2nd edn.,
1955.

Rizzo, *Monete greche della Sicilia*, 1946.

P. W. Lehmann, *Statues on Coins*, 1946.

Lacroix, *Les Reproductions de statues sur les
monnaies grecques*, 1949.

J. Babelon, *Le Portrait dans l'antiquité
d'après les monnaies*, 1950.

E. S. G. Robinson, 'The Coins from the
Ephesian Artemision Reconsidered',
J.H.S., LXXI, 1951, pp. 156 ff.

Sutherland, *Art in Coinage*, 1955.

Schwabacher, *Das Demareteion* (opus
nobile 7), 1958.

Schwabacher, *Griechische Münzkunde*, in
*Handbuch der klassischen Altertums-
wissenschaft* (in preparation).

Franke and Hirmer, *Die griechische Münze*,
1964. English edn., with text by Kraay,
1966.

Cf. also the catalogues of the various
museums and private collections,
especially of the British Museum,
Sylloge Nummorum Graecorum (Eng-
land, Denmark, Germany, U.S.A.
etc.), and the Museum of Fine Arts,
Boston (by Brett).

CHAPTER 9
Jewellery

Hadaczek, *Der Ohrschmuck der Griechen und Etrusker*, 1903.

Minns, *Scythians and Greeks*, 1913.

Rosenberg, *Geschichte der Goldschmiedekunst auf technischer Grundlage*, 2nd edn., 1924–25.

Zahn, *Sammlung Bachstitz*, 1921; *Sammlung Schiller*, 1929; *Ausstellung von Schmuckarbeiten*, Berlin, 1932.

Alexander, *Greek and Etruscan Jewelry, A Picture Book*, 1940.

Reichel, *Griechisches Goldrelief*, 1942.

Bruns, *Schatzkammer der Antike*, 1946.

Wagner de Kertesz, *Historia Universal de las Joyas*, 1947.

Maryon, 'Metal Chasing in the Ancient World', *A.J.A.*, LIII, 1949, pp. 93–125 (pp. 110 ff. on granulation).

Amandry, *Les bijoux antiques, Collection Hélène Stathatos*, 1953.

D. M. Robinson, 'Unpublished Greek Gold Jewelry and Gems', *A.J.A.*, LVII, 1953, pp. 5 ff.

Becatti, *Oreficerie antiche*, 1955.

Coche de la Ferté, *Les bijoux antiques*, 1956.

Jacobsthal, *Greek Pins*, 1956.

Higgins, *Greek and Roman Jewellery*, 1961.

H. Hoffmann and P. F. Davidson, *Greek Gold, Jewelry from the time of Alexander*, 1965.

Cf. also the catalogues of the various museums and private collections, especially those of the British Museum, by F. H. Marshall, 1911; of the National Museum, Naples, by Breglia, 1941, and Siviero, 1954; and of the Benaki Museum, Athens, by Segall, 1938.

For recent extensive bibliographies cf. Becatti, *op. cit.*, pp. 229–34; Coche de la Ferté, *op. cit.*, pp. 105–10; Higgins, *op. cit.*, pp. 193–223.

CHAPTER 10
Paintings and Mosaics

Helbig, *Wandgemälde Campaniens*, 1868.

Brunn, *Geschichte der griechischen Künstler*, 1889, II, pp. 3 ff.

Hermann and Bruckmann, *Denkmäler der Malerei des Altertums*, from 1904.

A. Reinach, *Recueil Milliet, Textes grecs et latins relatifs à l'histoire de la peinture ancienne*, 1921.

Pfuhl, *Malerei und Zeichnung der Griechen*, I–III, 1923 (vol. III re-ed. by Schefold, 1940).

Swindler, *Ancient Painting*, 1929.

Rizzo, *La Pittura ellenistico-romana*, 1929; *Monumenti della pittura antica scoperti in Italia*.

L. Curtius, *Die Wandmalerei Pompejis*, 1929.

D. M. Robinson and others, *Excavations at Olynthus*, II, 1930, pp. 81 ff. and V, 1933 (on mosaics).

Beyen, *Die pompejanische Wanddekoration*, 1938.

Bianchi Bandinelli, 'Tradizione ellenistica e gusto romano nella pittura pompeiana', *Critica d'Arte*, VI, 1941, pp. 3 ff.

Richter, *Greek Painting, The Development of Pictorial Representation from Archaic to Graeco-Roman times*, 1944; 4th edn., 1952.

Lippold, *Antike Gemäldekopien*, 1951.

Coche de la Ferté, *Les Portraits romano-égyptiens du Louvre*, 1952.

Rumpf, *Malerei und Zeichnung, Handbuch der Archäologie*, IV, I, 1953.

Maiuri, *La peinture romaine*, 1953.

Schefold, *Pompejanische Malerei, Sinn und Ideengeschichte*, 1952; *Pompeji, Zeugnisse griechischer Malerei*, 1956; *Die Wände Pompejis*, 1957; *Vergessenes Pompeji*, 1962.

P. W. Lehmann, *Roman Wall Paintings from Boscoreale*, 1953.

Gabriel, *Masters of Campanian Painting*, 1952; *Livia's Garden Room*, 1955.

Adriani, 'Ipogeo dipinto della Via Tigani Pascià', *Bulletin de la Société archéologique d'Alexandrie*, no. 41, 1956, pp. 1 ff.

L. Richardson, Jr., *Pompeii: The Casa dei Dioscuri and its Painters*, 1955.

C. M. Robertson, 'The Boscoreale Figure-Paintings', *J.R.S.*, XLV, 1955, pp. 58 ff.; *Greek Painting*, 1959; 'Greek Mosaics', *J.H.S.*, LXXXV, 1965, pp. 72 ff.

Elia, *Pitture di Stabia*, 1957.

B. R. Brown, *Ptolemaic Paintings and Mosaics and the Alexandrian Style*, 1957.

Borda, *La pittura romana*, 1958.

Chéhab, 'Mosaïques du Liban', *Bull. du Musée de Beyrouth*, XIV–XV, 1958–59.

E. Schiavi, *Il Sale della Terra*, 1961 (on the technique).

Makaronas, *Arch. Delt.* XVI, 1960 (1962), pp. 73 ff. (on mosaics from Pella).

Von Blankenhagen and C. Alexander, *The Paintings from Boscoreale*, 1962.

See also the Catalogues of the collections in the various museums, especially those in the British Museum (by Hinks) and the National Museum, Naples (by Elia).

ON PERSPECTIVE

For early discussions cf. the references cited in my *Red-Figured Athenian Vases, Metropolitan Museum of Art*, 1936, p. 191, note 12. Among the more recent writings may be mentioned: Panofsky, 'Perspektive als symbolische Form', *Vorträge Bibl. Warburg*, 1924–25, pp. 266 ff. (1927); Bulle, 'Eine Skenographie', 94. *Winckelmannsprogramm*, 1934; Richter, 'Perspective, Ancient, Mediaeval, and Renaissance', *Scritti in onore di Bartolomeo Nogara*, 1937, pp.

381 ff.; Little, 'Perspective and Scene Painting', *Art Bulletin*, XIX, 1937, pp. 487 ff.; Kern, *Arch. Anz.*, 1938, cols. 245 ff.; Beyen, *Arch. Anz.*, 1939, cols. 47 ff.; Bunim, *Space in Medieval Painting and the Forerunners of Perspective*, 1940; Schweitzer, *Vom Sinn der Perspective*, 1953; White, *Perspective in Ancient Drawing and Painting*, 1956, and *The Birth and Rebirth of Pictorial Space*, pp. 236 ff.; Bianchi Bandinelli, in *Archeologia e Cultura* (1961), pp. 155 ff.; Richter, in *Furniture*,[2] 1966, pp. 130 ff.; *Perspective in Greek and Roman Art*, forthcoming.

CHAPTER 11

Pottery and Vase Painting

GENERAL

Furtwängler and Reichhold, *Griechische Vasenmalerei*, 1900–32.
Walters, *Ancient Pottery*, 1905.
Buschor, *Griechische Vasenmalerei*, 1925; *Griechische Vasen*, 1940.
Pfuhl, *Malerei und Zeichnung der Griechen*, I–III, 1923 (III, re-ed. by Schefold, 1940).
Swindler, *Greek Painting*, 1929.
Beazley and Ashmole, *Greek Sculpture and Painting*, 1932; 2nd edn., 1966.
Lane, *Greek Pottery*, 1948.
Trendall, *Handbook to the Nicholson Museum*, 2nd edn. 1948, pp. 240–336.
Rumpf, *Malerei und Zeichnung* (*Handbuch der Archäologie*, IV, I), 1953.
Villard, *Les Vases grecs*, 1956.
R. M. Cook, *Greek Painted Pottery*, 1960.
C. M. Robertson, *Greek Painting*, 1959.
Arias and Hirmer, *A History of Greek Vase Painting*, 1961.
Cf. also the *Catalogues* of the various museums and private collections; the fascicules of the *Corpus Vasorum Antiquorum*; and the *Bilder griechischer Vasen* (ed. by Beazley and Jacobsthal) on special classes and individual painters (by Beazley, Hahland, Schefold, Payne, Ducati, Rumpf, Diepolder, Smith, Trendall, Technau, Webster, S. Karouzou).

GEOMETRIC

Desborough, *Protogeometric Pottery*, 1952.
Cyclades: Dugas, *La céramique des Cyclades*, 1925. Buschor, 'Kykladisches', *Ath. Mitt.*, LIV, 1929, pp. 142 ff. Kondoleon, *Eph. Arch.*, 1945–47, pp. 1 ff.
Rhodes: Friis Johansen, *Exoki*, 1958.
Samos: Technau, *Ath. Mitt.*, LIV, 1929, pp. 6 ff. Eilmann, *Ath. Mitt.*, LVIII, 1933, pp. 47 ff.
Eretria: Boardman, *B.S.A.*, XLVII, 1952, pp. 1 ff.
Crete: Payne, *B.S.A.*, XXIX, 1927–28, pp. 224 ff. D. Levi, *Hesperia*, XIV, 1955, pp. 1 ff. Brock, *Fortetsa*, 1957.

Corinth: Weinberg, *A.J.A.*, XLV, 1941, pp. 30 ff.
Attica: R. S. Young, *Hesperia*, Supplement, II, 1939. Kübler and others, *Kerameikos*, I, 1939, IV, 1943, V, 1954. Davidson, *Attic Geometric Workshops*, 1961.
Aegina: Kraiker, *Aegina, Die Vasen des 10. bis 7. Jahrhunderts*, 1951.
South Italy: Dunbabin, *The Western Greeks*, 1948. Buchner, *Röm. Mitt.*, 60/61, 1953–54, pp. 37 ff., *Rendiconti dell' Accademia dei Lincei*, X, 1955, pp. 215 ff.
Brann, Late Geometric and Proto-Attic Pottery, *The Athenian Agora*, VIII, 1962.

ORIENTALIZING

In addition to the above books and articles, many of which treat of seventh-century wares as well as geometric, cf.:

EAST GREEK

Kinch, *Vroulia*, 1914. Price, *J.H.S.*, XLIV, 1924, pp. 180 ff. (Chios). Kunze, *Ath. Mitt.*, LIX, 1934, pp. 81 ff. (Ionian kylikes). Maximova, *Les vases plastiques*, 1927. R. M. Cook, *B.S.A.*, XXXIV, 1933–34, pp. 1 ff., and XLVII, 1952, pp. 123 ff. (Fikellura and Clazomenian). Rumpf, *J.d.I.*, XLVIII, 1933, pp. 69 ff. (Clazomenain). Friis Johansen, *Acta Arch.*, XIII (Clazomenian sarcophagi). Schefold, *J.d.I.*, LVII, 1942, pp. 124 ff. (Rhodian). Homann-Wedeking, *Ath. Mitt.*, LXV, 1940, pp. 28 ff. Schiering, *Werkstätten orientalisierender Keramik auf Rhodos*, 1957. Dikaios, *A Guide to the Cyprus Museum*, 3rd edn., 1961. Akurgal, 'The Early Period and the Golden Age of Ionia', *A.J.A.*, LXVI, 1962, pp. 369 ff.

CHIAN-NAUKRATITE

Price, *J.H.S.*, XLIV, 1924, pp. 180 ff.
Boardman, *B.S.A.*, LI, 1956, pp. 55 ff.

CORINTHIAN

Friis Johansen, *Les vases sicyoniens*, 1923. Payne, *Necrocorinthia*, 1931; *Protokorinthische Vasenmalerei*, 1933. Benson, *Die Geschichte der korinthischen Vasen*, 1953.

BOEOTIAN

P. N. Ure, *Aryballoi and Figurines from Rhitsona*, 1934; A. and P. N. Ure, *Arch. Anz.*, 1933, pp. 1 ff. A. Ure, *Metropolitan Museum Studies*, IV, 1932, pp. 18 ff.

ATTIC

J. M. Cook, 'Protoattic Pottery', *B.S.A.*, XXXV, 1934–35, pp. 165 ff.
Beazley, 'Groups of Early Attic Black-Figure', *Hesperia*, XIII, 1944, pp. 38 ff.
Kübler, *Altattische Vasen*, 1950.
Brann, *Late Geometric and Proto-Attic Pottery, The Athenian Agora*, VIII, 1962.

Brokaw, *Concurrent Styles in Late Geometric and Early Proto-Attic Vase-Painting*, *Ath. Mitt.*, 78, 1963, pp. 63 ff.

BLACK-FIGURE OUTSIDE ATTICA

CHALCIDIAN: Rumpf, *Chalkidische Vasen*, 1927, H. R. W. Smith, *The Origin of Chalcidian Ware*, 1932.
LACONIAN: Lane, *B.S.A.*, XXXIV, 1933–34, pp. 99 ff.
CAERETAN: Devambez, *Mon Piot*, XLI, 1946, pp. 29 ff. Santangelo, *Mon. Piot*, XLIV, 1950, pp. 1 ff. Callipolis, *Antiquité classique*, XXIV, 1955, pp. 384 ff.
BOEOTIAN: P. N. Ure, *Sixth- and Fifth-Century Pottery from Rhitsona*, 1927; A. and P. N. Ure, *Arch. Anz.*, 1933, cols. 1 ff.; *Bulletin of the Institute of Classical Studies, London*, 6, 1959.
For Boeotian red-figure cf. Lullies, *Ath. Mitt.*, LXV, 1940, pp. 1 ff.

ATTIC BLACK-FIGURE AND RED-FIGURE

Beazley, *Attic Red-figure Vase-Painters*, 1942, 2nd edn. 1963; *The Development of Attic Black-Figure*, 1951; *Attic Black-figure Vase-Painters*, 1956; and the references cited in these three fundamental books. Also *Paralipomena* (forthcoming).
Hoppin, *A Handbook of Greek Black-Figured Vases*, 1924; *A Handbook of Attic Red-Figured Vases*, 1919. Still useful for the illustrations.
Haspels, *Attic Black-Figured Lekythoi*, 1936.
Caskey and Beazley, *Attic Vase-Paintings in the Museum of Fine Arts*, Boston, I, 1931, II, 1954, III, 1963.
Schefold, *Kertscher Vasen*, 1931; *Untersuchungen zu den Kertcher Vasen*, 1934.
Richter and Hall, *Red-Figured Athenian Vases, Metropolitan Museum of Art*, 1936; Richter, *Attic Red-Figured Vases, A Survey*, 1946, 2nd edn., 1958.
Lullies, *Griechische Vasen der reifarchaischen Zeit*, 1953.
S. Karouzou, *The Amasis Painter*, 1956.
Kraiker, *Die Malerei der Griechen*, 1958.
Alfieri, Arias, and Hirmer, *Spina*, 1958.
Sparkes and Talcott, *Pots and Pans of Classical Athens*, 1958.
M. Robertson, *Greek Painting*, 1959.
H. Hoffmann, *Attic Red-figured Rhyta*, 1962.
Beazley, *The Berlin Painter*, Occasional Papers no. 6, Melbourne University Press, 1964.
See also works listed under GENERAL.

ATTIC WHITE-GROUND

Riezler, *Weissgrundige attische Lekythen*, 1914.
Fairbanks, *Athenian White Lekythoi*, I, 1914, II, 1917.
Beazley, *Attic White Lekythoi*, 1938; see also in his books on black-figure and red-figure.

OTHER ATTIC FIFTH- AND FOURTH-CENTURY WARES

Crosby, *Hesperia*, XXIV, 1955, pp. 76 ff. (on polychrome ware).
Talcott, *Hesperia*, IV, 1935, pp. 481 ff. (on black-glazed stamped ware).
P. E. Corbett, *Hesperia*, XVIII, 1949, pp. 298 ff. (on later fifth-century ware), XXIV, 1955, pp. 172 ff. (on stamped palmettes).
Sparkes, 'The Greek Kitchen', *J.H.S.*, LXXXII, 1962, pp. 121 ff., pls. IV–VIII; 'Black Perseus', Antike Kunst, XI, 1968, pp. 3 ff.
Talcott and Sparkes, on household wares and all-black, from the Athenian Agora (forthcoming).

ON THE PROPORTIONS

Hambidge, *Dynamic Symmetry*, The Greek Vase, 1920.
L. D. Caskey, *Geometry of Greek Vases*, 1922.

ON THE SHAPES

Richter and Milne, *Shapes and Names of Athenian Vases*, 1935.
Bloesch, *Formen attischer Schalen*, 1940.
Beazley, *A.B.V.*, pp. xi f., *A.R.V².*, pp. XLIX ff.

ON THE ORNAMENTS

Walters, *Ancient Pottery*, II, 1905, pp. 209 ff.
Jacobsthal, *Ornamente griechischer Vasen*, 1927.

ON THE TECHNIQUE

Richter, *The Craft of Athenian Pottery*, 1923; in *Red-Figured Athenian Vases*, *M.M.A.*, 1936, pp. XXXV ff.; *B.S.A.*, XLVI, 1951, pp. 143 ff.; in *History of Technology*, II, 1956, pp. 259 ff.; *Attic Red-Figured Vases, A Survey*, 2nd edn., 1958, pp. 23 ff.
Hussong, *Zur Technik der attischen Gefässkeramik*, 1928.
Weickert, *Arch. Anz.*, 1942, cols. 512 ff.
Schumann, *Berichte der d. ker. Ges.*, XXIII, 1942, pp. 408 ff.; *Forschungen und Fortschritte*, XIX, 1943, pp. 356 ff.
Beazley, *Potter and Painter in ancient Athens*, 1944.
Bimson, 'The Technique of Greek Black and Red Terra Sigillata', *The Antiquaries Journal*, XXXVI, 1956, pp. 200 ff.
Farnsworth and Wisely, 'Fifth Century Intentional Red Glaze', *A.J.A.*, LXII, 1958, pp. 165 ff.
A. Winter, Die Technik des griechischen Töpfers in ihren Grundlagen, in *Technische Beiträge zur Archäologie* I (Mainz 1959).
Farnsworth, 'Draw-pieces as aids to correct firing', *A.J.A.*, LXIV, 1960, pp. 72 ff.
U. Hoffmann, 'The Chemical Basis of Ancient Greek Vase-Painting', in *Angewandte Chemie* (International ed.), I, 1962, pp. 341 ff.

Farnsworth, Greek Pottery: A Mineral-
ogical Study, *A.J.A.*, LXVIII, 1964,
pp. 221 ff.
J. V. Noble, *The Technique of Painted Attic
Pottery*, 1965.
Cf. also, on modern pottery making,
Binns, *The Potters' Craft*, 1922;
Honoré, *Pottery Making*, 1950, 2nd
edn. 1954; K. Zimmerman, *Formende
Hände*, 1952; Hampe and Winter, *Bei
Töpfern und Töpferinnen in Kreta,
Messenien und Zypern*, 1962, and *Bei
Töpfern und Zieglern in Süditalien, Sizilien
und Griechenland*, 1965.
On Greek kilns of classical times cf.
Rhomaios, *Ath. Mitt.*, XXXIII, 1908,
pp. 177 ff.; Gebauer, *Arch. Anz.* 1937,
cols. 184 ff.; Kunze and Schleif, III.
Olympia-Bericht, pp. 33 ff.; Binns in
Richter, *Red-Figured Athenian Vases*,
p. xlv; *Not. d. Sc.* 1956, pp. 277 ff.;
R. M. Cook, *B.S.A.*, LVI, 1961, pp.
65 ff.

ON SUBJECTS OF ALL PERIODS AND
CLASSES

Walters, *Ancient Pottery*, 1905, II, pp. 1 ff.
Bieber, *The History of the Greek and
Roman Theater*, 1939 (new edn. 1961).
Hampe, *Frühe griechische Sagenbilder in
Böotien*, 1936; *Die Gleichnisse Homers
und die Bildkunst seiner Zeit*, 1952.
Clairmont, *Das Parisurteil in der antiken
Kunst*, 1951.
Bielefeld, *Amazonomachia*, 1951.
Vian, *Répertoire des gigantomachies*, 1951.
Index in Beazley's *A.R.V².*, 1963, pp.
1720 ff.
Beazley's Appendix II in *A.B.V.*, pp.
723 ff.
Webster, 'Homer and Attic Geometric
Vases', *B.S.A.*, L, 1955, pp. 40 ff.
Brommer, *Vasenlisten zur griechischen
Heldensage*, 1956.
D. von Bothmer, *Amazons in Greek Art*,
1957.
K. Schefold, *Frühgriechische Sagenbilder*,
1964.

ON INSCRIPTIONS

Kretschmer, *Die griechischen Vaseninschrif-
ten*, 1894.
Beazley, 'Some Inscriptions on Vases',
A.J.A., XXXI, 1927, pp. 345 ff., XXXIII,
1929, pp. 361 ff., XXXIX, 1935, pp.
475 ff., XLV, 1941, pp. 593 ff., LIV, 1950,
pp. 310 f., *A.R.V.*,² pp. 1553 ff.,
A.B.V., pp. 664 ff.
On kalos names cf. Beazley's *A.R.V.²*,
pp. 1559 ff.
On stamped inscriptions on wine jars
used as shipping containers cf. V. R.
Grace, *Hesperia, Supplement*, X, 1956,
pp. 117 ff.
On graffiti and dipinti see, in general,
Hackl, *Münchener archäologische Studien*,
1909, pp. 5 ff.; Talcott, *Hesperia*, V,
1936, pp. 346 ff.

SOUTH ITALIAN RED-FIGURE

Trendall, *Paestan Pottery*, 1936 (additions
in *Papers of the British School at Rome*,
1952); *Frühitalienische Vasen*, 1938;
*Vasi italioti ed etruschi a figure rosse,
Vaticano*, I, 1953, II, 1955; *Phlyax
Vases*, 1959; 2nd edn. 1967; Cassandra
Painter and his Circle, *Jb. Berl. Mus.*,
II, 1960, pp. 7 ff.; South Italian Red-
Figured Pottery, *Atti, VII Congresso
di Archeologia Classica*, II, 1961, pp.
117 ff.; 'The Lipari vases and their
place in the history of Sicilian red-
figure', in *Meligunis-Lipára*, II, 1965,
pp. 271 ff.; *South Italian Vase-painting*
(British Museum, 1966); *The red-
figured Vases of Lucania, Campania and
Sicily*, 1967; Greek vases in the Felton
Collection, 1968.
Trendall and Cambitoglou, *Apulian
Red-Figure Vase-Painters of the Plain
Style*, 1962.
H. Hoffmann, *South Italian Rhyta*, 1964.
Beazley, 'Groups of Campanian Red-
Figure', *J.H.S.*, LXIII, 1943, pp.
66–111.
Lidia Forti, *La Ceramica di Gnathia*
(Naples, 1965).

ON PERSPECTIVE

See bibliography for chapter 10, p. 396.

HELLENISTIC POTTERY

Pagenstecher, *Die calenische Reliefkeramik*,
1909. Courby, *Les vases grecs à reliefs*,
1922. H. A. Thompson, 'Two centuries
of Hellenistic Pottery', *Hesperia*, III,
1934, pp. 312 ff. Schwabacher, *A.J.A.*,
XLV, 1941, pp. 182 ff. S. Weinberg,
Hesperia, XVIII, 1949, p. 152. Züchner,
J.d.I., LXV–LXVI, 1950–57, pp. 175 ff.
Byvanck–Quarles van Ufford, 'Les
bols mégariens', *Bull. van der Vereeni-
ging . . .*, XXVIII, 1953, pp. 1 ff. Edwards,
Hesperia. Supplement X, 1956, pp.
86 ff. D. M. Taylor, 'Cosa, Black Glaze
Pottery', *Memoirs American Academy in
Rome*, XXVI, 1957. Richter, 'Calenian
Pottery and classical Greek Metalware',
A.J.A., LXIII, 1959, pp. 241 ff. Grei-
fenhagen, Beiträge zur antiken Relief-
keramik, *Ergänzungsheft. J.d.I.*, 1963.
Hausmann, *Hellenistische Reliefbilder*, 1959.
Libertini, *Centuripe*, 1926, *Nuove ceramiche
di Centuripe*, 1934. Trendall, *M.M.A.
Bulletin*, 1955, p. 161 ff.
Zahn, 'Glasierte Tongefässe im Anti-
quarium', *Amtliche Berichte aus den kgl.
Kunstsammlungen*, XXXV, 1914, cols.
277 ff., 81. *Berliner Winckelmannspro-
gramm*, 1923, pp. 5 ff.

ON GREEK LAMPS

D. M. Robinson, in *Olynthus*, II, 1930,
pp. 129 ff.; Graham, *ibid.*, V, 1933,
pp. 264 ff.; Broneer, *Corinth*, IV, 2,

pp. 31 ff.; Howland, *Greek Lamps and their Survivals, The Athenian Agora IV*, 1958.

Beckwith, *Illustrated London News*, January 24th, 1954, pp. 114 f. (on textile from Koropi).
Picard-Schmitter, 'Sur la chlamide de Démétrios Poliorcétès', *Rev. arch.*, XLVI, 1955, pp. 17 ff.

CHAPTER 12
Furniture

Blümner, 'Der altgriechische Möbelstil', in *Kunst und Gewerbe*, 1885.
Koeppen and Breuer, *Geschichte des Möbels*, 1904.
Watzinger, *Griechische Holzsarkophage aus der Zeit Alexanders des Grossen*, 1905.
Edgar, *Graeco-Egyptian Coffins*, 1905.
Ransom, *Couches and Beds of the Greeks, Etruscans and Romans*, 1905.
Minns, *Scythians and Greeks*, 1913, pp. 322 ff.
Richter, *Ancient Furniture, Greek, Etruscan, and Roman*, 1926; 'A marble Throne in the Akropolis Museum', *A.J.A.*, LVIII, 1954, pp. 271 ff.; 'Were there Greek armaria?', *Collection Latomus*, XXVIII, 1957, pp. 420 ff.; *The Furniture of the Greeks, Etruscans and Romans*, 1966 (*cited as Furniture²*).
Reincke, in Pauly-Wissowa, *Real-Encyclopädie*, Supplement VI, 1935, S.V. Möbel; also the single articles on the various types both in Pauly-Wissowa, *R.E.*, listed by Reincke on col. 508, and in Daremberg and Saglio, *Dictionnaire des antiquités*.
Deonna, *Délos*, XVIII, 1938, pp. 235 ff.
Pritchett, *Hesperia*, XXV, 1956, pp. 210 ff. (on the furniture cited in inscriptions).
E. G. Budde, *Armarium und* Κιβωτός, *Ein Beitrag zur Geschichte des antiken Mobiliars*, 1940.
Neugebauer and Greifenhagen, Delische Betten, *Ath. Mitt.*, LVII, 1952, pp. 29 ff.
Ohly, *Ath. Mitt.*, LXVIII, 1953, pp. 89 ff.
Piccot-Boube, Les lits de bronze de Mauretanie Tingitane, *Bulletin d'Archéologie Marocaine*, IV, 1960, pp. 189 ff.

CHAPTER 13
Textiles

Blümner, *Technologie und Terminologie*, I, 1875, pp. 89 ff.
Stephani, *Comptes rendus de la Commission impériale archéologique*, 1878–79, pp. 120 ff., Atlas, pls. III, 3, IV, V, 2–3 (on textiles found in the Crimea).
Minns, *Scythians and Greeks*, 1913, pp. 335 ff.
Bieber, *Griechische Kleidung*, 1928, pp. 1 ff.; *Entwicklungsgeschichte der griechischen Tracht*, 1934, pp. 10 ff.; 2nd edn. 1967.
Schaefer, 'Hellenistic Textiles in Northern Mongolia', *A.J.A.*, XLVII, 1943, pp. 266 ff.
Wace, 'The Cloaks of Zeuxis and Demetrius', *Oest. Jahr.*, XXXIX, 1952, pp. 111 ff.

CHAPTER 14
Glass and Glaze

Kisa, *Das Glas im Altertum*, 1906.
Richter, 'The Room of Ancient Glass', Supplement of the *Bulletin of the Metropolitan Museum*, June 1911 (on the *M.M.A.* collection).
Sangiorgi, *Collezione di vetri antichi*, 1914.
Zahn, 'Glasierte Tongefässe im Antiquarium', *Amtliche Berichte der preuss. Kunstsammlungen*, XXXV, 1913, cols. 277 ff., 309 ff.; *Galerie Bachstitz*, II, 1922.
Harden, *Roman Glass from Karanis*, 1936; *J.R.S.*, XXV, 1935, pp. 163 ff.
Fossing, *Glass Vessels before Glass-Blowing*, 1940.
Toll, 'The Green Glazed Pottery, with technological notes by Matson', *The Excavations at Dura-Europos, Final Report*, IV, I, 1943, pp. 1 ff., 81 ff.
R. W. Smith, *M.M.A. Bull.*, 1949, pp. 49 ff.
Vessberg, *Roman Glass in Cyprus*, 1952.
Hackin and others, *Nouvelles recherches archéologiques à Begram*, 1954, pp. 95 ff.
Coche de la Ferté, *Mon. Piot*, XLV, 1956, pp. 131 ff.
Isings, *Roman Glass from dated finds*, 1957.
G. Davidson Weinberg, articles in recent numbers of *A.J.A.*, *Hesperia*, *Journal of Glass Studies*, *The Corning Museum of Glass*.

CHAPTER 15
Ornament

Riegl, *Stilfragen, Grundlegung zu einer Geschichte der Ornamentik*, 1893.
Conze, *Attische Grabreliefs*, 1893–1922.
Walters, *Ancient Pottery*, II, 1905, pp. 209 ff.
Jacobsthal, *Ornamente griechischer Vasen*, 1927.
Möbius, *Die Ornamente der griechischen Grabstelen*, 1929.
Bakalakis, *Ellenika Trapezophora*, 1948.
Hermann, 'Bronzebeschläge mit Ornamentik', VI. *Olympia Bericht*, 1958, pp. 152 ff.
Bakalakis, *Proanaskaphikes ereunes ste Thrake*, 1958.
See also bibliographies for Chapters 1, 2, and 12.

CHAPTER 16

Epigraphy

Loewy, *Inschriften griechischer Bildhauer*, 1885.

Roberts, *Introduction to Greek Epigraphy*, I, 1887, II, 1905.

Kern, Inscriptiones Graecae, 1913.

Larfeld, *Griechische Epigraphik*, 3rd edn., 1914.

Tod, *A Selection of Greek Historical Inscriptions*, I, 1933, II, 1948.

Kirchner, *Imagines inscriptionum atticarum*, 1935.

Schubart, in Pauly-Wissowa, R. E., XVIII, 3, 1949, S.V. papyrus, cols. 1116 ff.

Raubitschek, *Dedications from the Athenian Akropolis*, 1949.

Marcadé, *Recueil des signatures de sculpteurs grecs*, I, 1953, II, 1957.

Ventris and Chadwick, *Documents in Mycenaean Greek*, 1956.

Klaffenbach, *Griechische Epigraphik*, 1957.

Woodhead, *The Study of Greek Inscriptions*, 1958.

Jeffery, *The Local Scripts of Archaic Greece*, 1961.

Meritt, *Greek Historical Studies*, 1962, pp. 16 ff.

Guarducci, *Epigrafia greca*, vol. I, 1966, vol. II, 1969, (vol. III forthcoming).

Cf. also the various *Corpora* of Greek Inscriptions.

TENTATIVE CHRONOLOGY
OF GREEK SCULPTURAL WORKS
from c. 850 to c. 100 B.C.

The references to pages in this book are inserted in the second column, after each item. The references in the third column are principally to recent catalogues and handbooks in which other publications are cited, e.g.:

W. B. Dinsmoor, *The Architecture of Ancient Greece*, 1950 (cited as Dinsmoor).

H. Diepolder, *Die attischen Grabreliefs*, 1931 (cited as Diepolder).

C. Picard, *Manuel de l'archéologie grecque, La sculpture*, I–V, 1935–66 (cited as Picard).

F. N. Pryce, *Catalogue of Sculpture, British Museum*, I, 1, 1928 (cited as Pryce).

W. Lamb, *Greek and Roman Bronzes*, 1929 (cited as Lamb).

G. Lippold, *Die griechische Plastik*, in *Handbuch der Archäologie*, III, 1, 1950 (cited as Lippold).

G. M. A. Richter, *The Sculptures and Sculptors of the Greeks*, third edition 1950 (cited as Sc. and Sc.); *Kouroi*², 1960 (cited as *Kouroi*²); *Archaic Gravestones of Attica*², 1961 (cited as *Gravestones*²); *Archaic Greek Art*, 1949 (cited as *A.G.A.*); *Handbook of the Greek Collection, Metropolitan Museum of Art*, 1953 (cited as *M.M.A. Handbook*, 1953); *The Portraits of the Greeks*, 1965 (cited as *Portraits*, 1965).

H. Payne and G. M. Young, *Archaic Marble Sculptures from the Acropolis*, 1936 (cited as Payne).

H. Schrader, with E. Langlotz and W.-H. Schuchhardt, *Die archaischen Marmorbildwerke der Akropolis*, 1939 (cited as Schrader).

M. Bieber, *The Sculpture of the Hellenistic Age*, 1955; 2nd edn. 1960 (cited as Bieber).

G. H. Chase, *Greek and Roman Antiquities, Museum of Fine Arts, Boston, A Guide*, 1950 (cited as Chase, *Guide*).

For Roman copies the date of the original is given. When the material is not mentioned the object is of stone.

c. 850–700 B.C.	Geometric bronze statuettes and groups (p. 186)	Lippold, pp. 9 ff.
c. 750	Ivory statuettes, Athens (p. 186)	Lippold, p. 10, pl. I, 1.
c. 700	Bronze statuette dedicated by Mantiklos (p. 186)	Picard, I, p. 137; Lamb, p. 74.
	Bronze shields from Idaean cave (pp. 210 f.)	Kunze, *Kretische Bronzereliefs*.
c. 700–600	Earliest bronze protomes of griffins (p. 211)	Lamb, pp. 70 ff.; Kunze, II. *Olympia Bericht*, pp. 104 ff.; Jantzen, *Griechische Greifenkessel*, pp. 13 ff., 84 ff.
c. 660–650	Statue dedicated by Nikandre (p. 60)	Picard, I, p. 570; Lippold, p. 43, pl. II, 2; Marcadé. *B.C.H.*, LXXIV, 1950, p. 182; Richter, *Korai*, no. 1.
c. 650	Earliest torsos of kouroi from Delos (p. 57)	*Kouroi*², figs. 20, 21.
c. 650	Bronze statuettes from Dreros (pp. 186 f.)	Marinatos, *Arch. Anz.* 1936, cols. 217 ff.; Lippold, p. 22, pl. 3, 1–3.
c. 630–600	Bronze breastplates from Olympia (p. 211)	*Olympia*, IV, pls. LVIII, LIX; Lamb, pp. 62 f.; *B.C.H.*, VII, 1883, pp. 1 ff., pls. I–III.
c. 640–610	Bronze statuettes from Delphi and Crete (pp. 186 f.)	Lamb, pl. XXI, b, XXV, b.
c. 650–625	Sculptures from Prinias (p. 62)	Picard, I, pp. 448 ff.; Lippold, p. 22, pl. 2, 1.
	Seated statue from Gortyna (p. 62)	D. Levi, *Boll. d'Arte*, 1956, pp. 272 f., fig. 58.
	Ivory group, New York (p. 190)	*M.M.A. Handbook*, 1953, pl. 20, a.

c. 640–620	Terra-cotta antefixes and metopes from temple at Thermon (p. 274)	Dinsmoor, pp. 51 ff.; Picard, I, p. 349.
	Figure formerly at Auxerre, now Louvre (p. 60)	Picard, I, pp. 450 ff.; Lippold, p. 22; Richter, *Korai*, no. 18.
	Female figures supporting vessels, from Olympia and Isthmia (p. 188)	Lippold, p. 31, pl. 9, 2; Broneer, *Hesperia*, XXIV, 1955, p. 129, fig. 1; Richter, *Korai*, pp. 27 ff.
c. 630–620	Reliefs from Mycenae	Dinsmoor, pp. 50 f.; Lippold, p. 25, pl. 4, 3.
c. 625–600	Pediments of lioness and calf and of Herakles and the Hydra from the Akropolis, Athens (p. 62)	Dickins, *Acropolis Cat.*, 1, pp. 76 ff.; Lippold, p. 36.
	Terra-cotta plaques with reliefs representing the prothesis (p. 233)	Boardman, *B.S.A.*, L, 1955, pp. 51 ff.
	Statues from Eleuthernai and Haghiorgitica	Lippold, p. 22, pl. 2, 2; Picard, I, pp. 499 ff.
	Wooden group of Zeus and Hera, and head of wooden statuette from Samos (p. 190)	Ohly, *Ath. Mitt.*, LXVIII, 1953, pp. 77 ff.
	Lions from Delos (p. 62)	Picard, I, p. 419; *A.G.A.*, figs. 47, 48.
c. 620	Gold bowl from Olympia, Boston (p. 211)	L. D. Caskey, *Boston Mus. Bull.*, XX, 1922, pp. 65 ff.; Payne, *Necrocorinthia*, pp. 211 f.; Chase, *Guide*, fig. 29.
c. 615–590	Lion Tomb from Xanthos (p. 62)	Pryce, B 286.
	Sounion group of statues of kouroi (from Attica, Boeotia, Delphi, Thasos, Delos, Samos, Thera, etc.) (p. 57)	*Kouroi²*, pp. 30 ff., figs. 25–131.
	Gorgon from the Akropolis	Schrader, no. 441.
	Sphinx from stele, New York (p. 62)	*Gravestones²*, no. 37, figs. 96–98, 105, 106.
c. 600	Head of Hera, Olympia (p. 62)	Picard, I, p. 505; Lippold, p. 26, pl. 8, 1; Richter, *Korai*, no. 36.
	Limestone sphinx from Kalydon	Payne, *Necrocorinthia*, pl. 49, 1; Dyggve, *Das Laphrion*, figs. 191 f. (a piece of the body has now been added).
	Pedimental figures from the temple of Artemis, Corfu (p. 62)	Rodenwaldt, *Korkyra*; Picard, I, pp. 475 ff.; Dinsmoor, pp. 73 ff.; Lippold, p. 28, pls. 6, 1, and 7, 1.
	Earliest seated statue from Didyma, London (p. 62)	Pryce, B 271.
c. 590–570	Orchomenos–Thera group of kouroi (from Boeotia, Attica, Thera, Actium, Delos, Samos, Rhodes, etc.) (p. 63)	*Kouroi²*, pp. 59 ff., figs. 132–207.
c. 575–550	Standing Goddess, Berlin (pp. 63 f.)	Lippold, p. 37, pl. 10, 2.
	Headless maiden, Akropolis, 593	Payne, pl. 12; Schrader, no. 2; Richter, *Korai*, no. 43.
	Rampin horseman (pp. 68 f.)	Payne, pp. 7 ff.; Schrader, no. 312; Lippold, p. 79, pl. 22, 3.
	Sphinx from Spata	*Gravestones²*, no. 12, figs. 40, 41.
	Lions from Perachora (p. 70)	Payne, Perachora, pp. 135 f., pl. 113.
	Calfbearer, Akr. 624 (p. 68)	Payne, pp. 17 f.; Schrader, no. 408; Lippold, p. 37, pl. 10, 3.
	Naxian sphinx, Delphi (p. 48)	Lippold, p. 44, pl. 7, 2.
	Metopes of Sikyonian Treasury (p. 71)	Picard, I, pp. 480 f.; Lippold, pp. 24 f., pl. 4, 1.
	Metopes from the Heraion, Foce del Sele (p. 74)	Zancani Montuoro and Zanotti-Bianco, *Heraion*, II.
	Statue from Samos, dedicated by Cheramyes, Louvre (pp. 64 f.)	Buschor, *Alt. St.* II, p. 24; Lippold, p. 56, pl. 14, 1; Richter, *Korai*, no. 55.
	Akropolis kore 677 (p. 66)	Schrader, no. 23.
	Tenea–Volomandra group of kouroi (from Tenea, Attica, Samos, Naukratis, etc.) (p. 63)	*Kouroi²*, pp. 75 ff., figs. 208–272.
c. 560	Metopes of temple Y at Selinus (p. 74)	Lippold, p. 50, pl. 4, 2; Dinsmoor, p. 80.
	Group of statues signed by Geneleos, Samos (p. 66)	Buschor, *Altsamische Standbilder*, II, pp. 26 ff.; Lippold, p. 57.

c. 560–550	Poros pediments from the Akropolis: Introduction; Three-bodied Typhon and Herakles; Lion and bull (p. 71)	Dickins, *Cat.*, pp. 62ff.; Lippold, p. 36, pls. 6, 2, and 8, 3.
	Relief from Samothrace, Louvre	Lippold, p. 72, pl. 18, 2.
	Hero relief from Chrysapha, Berlin	Lippold, p. 31, pl. 4, 4.
	Reliefs from Kyzikos with chariots	Lippold, p. 65, pl. 18, 3.
c. 550	Winged Nike from Delos (p. 69)	Picard, I, p. 366; Lippold, p. 63, pl. 7, 4; Marcadé, *B.C.H.*, LXXIV, 1950, p. 182.
	Ivories from Delphi (p. 197)	Lippold, p. 64.
c. 555–540	Melos group of kouroi (from Melos, Epidauros, Boeotia, Euboea, Delphi, Thasos, Samos, Delos, Paros, Rhodes, etc.) (p. 63)	*Kouroi*², pp. 90ff., figs. 273–390.
c. 550–540	Head of ex-Knidian karyatid, Delphi	*Fouilles de Delphes*, IV, 2, pl. XVI; Lippold, p. 64, pl. 15, 3; Richter, *B.C.H.*, LXXXII, 1958, pp. 92ff.
	Lyons kore	Payne, pp. 14ff.; Schrader, no. 253; Richter, *Korai*, no. 89.
c. 555–530	Parts of sculptured drums of the temple of Artemis, Ephesos, now in London (p. 74)	Dinsmoor, pp. 127ff.; Pryce, pp. 47ff.
c. 550–525	Friezes from temple of Athena, Assos	Bacon and others, *Investigations at Assos*, pp. 155ff.; Lippold, p. 65, pl. 17, 1.
	Relief of women dancing, from Teichioussa	Pryce, B 285.
c. 540	Metopes of temple C, Selinus (p. 74)	Dinsmoor, pp. 80ff.; Picard, I, pp. 351ff.; Lippold, p. 91, pl. 29, 1.
c. 540–530	Gravestones of brother and sister, and of warrior, New York (p. 70)	Richter, *M.M.A. Cat. of Sc.*, nos. 15, 16.
	Sphinx from stele, Boston (p. 70)	Chase, *Guide*, fig. 40.
	Peplos kore, Akr. 679 and kore 678 (p. 79)	Payne, p. 21; Schrader, nos. 4, 10; Lippold, p. 77, pl. 23, 2; Richter, *Korai*, nos. 113, 112.
c. 530–500	Later korai from Akropolis (pp. 79f.)	Payne, pp. 26ff.; Lippold, pp. 78f.; Richter, *Korai*, pp. 68 ff.
c. 540–515	Anavysos–Ptoon 12 group of kouroi (from Attica, Keos, Boeotia, Chalkis, etc.) (p. 75)	*Kouroi*², pp. 163ff., figs. 391–449.
c. 530–525	Pediment, frieze, and karyatids of Siphnian Treasury, Delphi (pp. 82, 88)	Dinsmoor, pp. 138ff.; Lippold, pp. 70f., pls. 15, 4; 16, 4; 19, 1 and 2.
	Kore by Antenor, Akr. 681 (p. 80)	Payne, pp. 31ff.; Schrader, no. 38; Lippold, p. 81, pl. 24, 1; Richter, *Korai*, no. 110.
c. 525–500	Seated statue from Branchidai, London	Pryce, B 280.
	Statue dedicated by Aiakes, Samos (p. 82)	Buschor, *Alt. St.*, I, pp. 40ff.; Lippold, p. 58, pl. 13, 4.
	Athena perhaps by Endoios (p. 82)	Picard, pp. 639ff.; Lippold, p. 75, pl. 21, 2.
c. 520–510	Pediment of Treasury of Megarians, Olympia (p. 88)	Lippold, p. 86, pl. 25, 2.
c. 520	Pediment with Athena and Zeus battling giants, from Akropolis (p. 88)	Schrader, nos. 464–470; Lippold, p. 75, pl. 21, 1.
	Incised stele, Louvre (p. 86)	*Gravestones*², no. 57, figs. 138–140.
c. 520–510	Pediments of temple of Apollo, Delphi (p. 88)	Dinsmoor, pp. 91f.; Lippold, p. 81; Schefold, *Mus. Helvet.*, III, 1956, pp. 61ff.
c. 520–500	Metopes of temple F, Selinus	Lippold, p. 91, pl. 29, 2.
c. 520–485	Ptoon 20 group of kouroi (from Boeotia, Attica, Euboea, Naxos, Samos, Cyprus, Italy) (p. 75)	*Kouroi*², pp. 126ff., figs. 450–563.
c. 510–500	Metopes of later Heraion at Foce del Sele (p. 92)	Zancani Montuoro and Zanotti-Bianco, *Heraion*, I.
	Relief of helmeted runner, Athens, N.M. 1959 (p. 83)	Lippold, p. 84, pl. 27, 4.
	Statue bases, Athens (p. 88)	Picard, I, pp. 628ff., II, pp. 20ff.; Lippold, p. 85, pl. 28.
	Aristion stele, Athens, N.M., 29 (p. 86)	Lippold, p. 84, pl. 27, 2.
	Metopes of Treasury of Athenians, Delphi (p. 88)	Dinsmoor, p. 117; Picard, II, pp. 24ff.; Lippold, p. 82, pl. 26, 1 and 3.

	Reliefs of mounting charioteer and Hermes, Akropolis	Picard, II, pp. 34ff.; Lippold, p. 83, pl. 26, 2.
	Pedimental statues of temple of Apollo Daphnephoros, Eretria	Dinsmoor, p. 91; Picard, II, pp. 42f.; Lippold, pp. 72f., pl. 20, 3 and 4.
c. 500	Bronze krater from Vix (p. 215)	Joffroy, *Le Trésor de Vix*, 1954.
c. 500–490	Harpy Tomb, London (p. 88)	Picard, I, pp. 552ff.; Pryce, B 287; Lippold, p. 67, pl. 17, 2 and 3.
	Stele by Alxenor, Athens, 139 (p. 86)	Lippold, p. 114, pl. 38, 1.
499–494	Head of Athena on coins issued during Ionian Revolt	Baldwin, *The Electrum Coinage of Lampsakos*, pp. 26ff.
c. 490	Daphni torso	Payne, p. 44.
500–480	Pedimental sculptures and akroteria of temple of Aphaia, Aegina (pp. 92f.)	Furtwängler, *Aegina*; Picard, II, pp. 73ff.; Lippold, p. 99, pl. 30.
Soon after 490	Nike, Akropolis, no. 690, dedicated after battle of Marathon (p. 86)	Raubitschek, *A.J.A.*, XLIV, 1940, pp. 53ff.
c. 490–470	Stelai, Villa Albani and from Esquiline (p. 107)	Lippold, p. 94, pl. 24, 4.
c. 500–475	Terra-cotta sculptures from Olympia (pp. 93f.)	Kunze, III. *Olympia Bericht*, pp. 119ff.; V. *Bericht*, pp. 103ff.; VI. *Bericht*, pp. 169ff.
c. 490–480	Euthydikos kore, Blond boy, Kritios youth, Akropolis, nos. 609, 689, 698 (pp. 79, 80)	Payne, pp. 38ff.; Schrader, nos. 37, 299, 302; Lippold, pp. 78ff.
	Sparta warrior	Picard, II, pp. 163ff.; Lippold, p. 105, pl. 32, 4.
c. 480	Running Maiden, Eleusis (p. 86)	Picard, II, p. 82; Lippold, p. 109, pl. 35, 3.
	Reliefs of sphinxes, Xanthos	Pryce, B 290.
	Seated goddess, Berlin (p. 83)	Picard, II, pp. 110ff.; Lippold, p. 101, pl. 21, 4.
	Head of goddess, Rome	E. Paribeni, *Cat.*, Terme Mus., no. 1.
479–478	Demareteion of Syracuse, struck after defeat of Carthage at Himera (p. 255)	Head, *Historia Numorum*, 2nd edn., pp. 172f.; Schwabacher, *Demareteion*.
477–476	Tyrannicides by Kritios and Nesiotes (p. 99)	Picard, II, pp. 11ff.; Lippold, p. 107.
c. 470	Reliefs from Thasos, Louvre	Picard, II, pp. 87ff.; Lippold, p. 116, pl. 40, 1.
	Bronze statuette of diskobolos, New York (p. 197)	Richter, *M.M.A. Handbook*, 1953, p. 66, pl. 59, c.
c. 470–460	Three-sided reliefs in Rome and Boston (p. 102)	Picard, II, pp. 144ff.; L. D. Caskey, *Cat. of Sc.*, Boston, no. 17; Lippold, pp. 118f., pl. 42.
	Charites, Vatican	Lippold, p. 112, pl. 35, 4.
	Procession of chariots, Xanthos	Pryce, B 309–314.
	Frieze from Doric temple, Marmaria, Delphi	Marcadé, *B.C.H.*, LXXIX, 1955, pp. 467ff.
	Metopes of temple E, Selinus (p. 109)	Picard, II, pp. 126ff.; Lippold, p. 128, pl. 29, 3 and 4.
476–461	Tetradrachm of Aetna (p. 257)	Head, *Historia Num.*, 2nd edn., p. 131.
c. 470	Bronze Charioteer, Delphi (p. 97)	Picard, II, pp. 133ff.; Lippold, p. 113, pl. 37, 4; Chamoux, *L'Aurige, Fouilles de Delphes*, IV, 5.
	Pollux, Louvre; Valentini torso; Boboli statue	Lippold, p. 125, pl. 49, 1.
465–457	Pedimental sculptures and metopes of Temple of Zeus, Olympia (pp. 97, 108)	Picard II, pp. 176ff.; Dinsmoor, pp. 151ff.; Lippold, pp. 120ff.; Kunze, IV. *Olympia Bericht*, pp. 143ff.; Ashmole and Yalouris, *Olympia*.
c. 470–450	Large bronze statuette of horse, Olympia (p. 198)	Kunze, III. *Olympia Bericht*, pp. 133ff.
	Relief of stephanephoros, Athens	Lippold, p. 110, pl. 35, 2.
	Bronze Poseidon–Zeus, Artemision (pp. 99f.)	Lippold, p. 131, pl. 37, 3.
	Mourning Athena, Akropolis (p. 107)	Lippold, p. 110, pl. 35, 1.
	Melian terra-cotta reliefs (p. 237)	Jacobsthal *Melische Reliefs*.
	Locrian terra-cotta reliefs (p. 237)	Orsi, *Boll. d'Arte*, III, 1909, pp. 406ff.; Quaglati, *Ausonia*, III, 1903, pp. 136ff.; Zancani Montuoro, *Atti e Memorie della Società Magna Grecia*, 1954, pp. 73ff.
	Pharsalos relief, Louvre	Lippold, p. 117, pl. 41, 3.
	Bronze hydria, New York (p. 217)	Richter, *M.M.A. Handbook*, 1953, p. 82.

	Youth by Stephanos	Lippold, p. 129, pl. 36, 3; Richter, *Ancient Italy*, pp. 112 ff.
	Apollo of Mantua (p. 97)	Lippold, p. 129, pl. 36, 2.
	Portrait of Themistokles (pp. 100 f.)	R. Calza, *Museo Ostiense*. no. 85; Becatti, *Critica d'Arte*, VII, 1942, pp. 76 ff.; Richter, *Coll. Latomus*, XX, 1955, pp. 16 ff.
	Stelai of athletes, Vatican, Delphi, Naples, Istanbul (p. 107)	Lippold, pp. 115, 123, pl. 38, 2 and 3.
	Bronze mirror-supports (p. 221)	Lamb, pp. 160 ff.; S. Karouzou, *Studies presented to D. M. Robinson*, I, pp. 576 ff.; Lippold, p. 105, pl. 33, 3 and 4.
	Herculaneum Dancers, Naples	Picard, II, pp. 166 ff.; Lippold, p. 112, pl. 35, 4.
	Hestia Giustiniani, 'Aspasia', and similar peplos statues (p. 102)	Lippold, pp. 132 f., pl. 47, 1 and 2; p. 102, pl. 32, 2; E. Paribeni, *Cat. Terme Mus.*, no. 89.
	Elgin Athena, bronze statuette (p. 200)	*M.M.A. Handbook*, 1953, pp. 81 f.
	Esquiline Venus	Picard, II, pp. 121 f.
c. 470–450	Spinario	Picard, II, pp. 172 f.
	Maidens from Xanthos, London (p. 102)	Pryce, B 316–318; Lippold, p. 123.
c. 460–450	Omphalos Apollo (pp. 97 f.)	Picard, II, p. 55; *Kouroi²*, no. 197; Lippold, p. 102, pl. 32, 1.
	Heads, Chatsworth and from Perinthos	Picard, II, pp. 124, 911.
	Diskobolos and Marsyas by Myron (pp. 109 f.)	Picard, II, pp. 225 ff., 232 ff.; Lippold, p. 137, pls. 48, 1 and 2, and 49, 4; E. Paribeni, *Cat., Terme Mus.*, no. 20.
	Protesilaos, New York	Richter, *M.M.A. Sc. Cat.*, no. 27; Lippold, p. 203, pl. 68, 4.
	Herakles, Boston, Oxford (p. 111)	Lippold, p. 139, pl. 49, 2.
	Athena 'Promachos' by Pheidias (p. 119)	Picard, II, pp. 338 ff.
	'Penelope', Vatican	Lippold, p. 134, pl. 47, 3.
c. 450–440	Frieze of Temple on Ilissos	Dinsmoor, p. 185; Picard, II, pp. 709 ff.; Lippold, p. 159, pl. 58, 1.
	Stelai of Philis, Louvre; Giustiniani, Berlin; Brocklesby, New York	Lippold, pp. 115–116, 176, pls. 38, 4; 41, 4; 64, 1.
c. 447–443	Metopes of Parthenon (p. 115)	Dinsmoor, pp. 169 ff.; Picard, II, pp. 401 ff.; Lippold, pp. 149 ff., pl. 52.
c. 442–438	Frieze of Parthenon (pp. 115 f.)	Picard, II, pp. 434 ff.; Lippold, pp. 150 ff., pl. 53.
c. 438–431	Pedimental sculptures of Parthenon (p. 113)	Picard, II, pp. 470 ff.; Lippold, pp. 152 ff., pls. 54, 55; Marcadé, *B.C.H.*, LXXX, 1956, pp. 161 ff.
447–439	Athena Parthenos by Pheidias (pp. 116 f.)	Picard, II, pp. 374 ff.; Lippold, pp. 145 ff.
435–430	Zeus, Olympia, by Pheidias (pp. 116 f.)	Picard, II, pp. 354 ff.; Lippold, pp. 142 ff.; *Sc. and Sc.*, pp. 220 ff.; Kunze, *Gnomon*, 1956, p. 318.
c. 460–440	Cassel Apollo	Picard, II, pp. 314 ff.; Lippold, p. 142, pl. 51, 1.
	Athena Lemnia (p. 118)	Picard, II, pp. 330 ff.; Lippold, p. 145, pl. 51, 3.
	Tiber and Cherchel Apollo (p. 97)	Picard, II, pp. 316 ff.; Lippold, p. III, pl. 36, 1; E. Paribeni, *Cat. Terme Mus.*, no. 13.
c. 450–430	'Sappho' Albani	Lippold, p. 154, pl. 56, 1.
	Dioskouroi, Monte Cavallo	Lippold, p. 156, pl. 56, 4.
	Athena Medici	Lippold, pp. 155 f., pl. 56, 3.
	Barberini Suppliant	Picard, II, pp. 692 ff.; Lippold, p. 162, pl. 57, 4.
	Diadoumenos Farnese	Picard, II, pp. 344 ff.; Lippold, p. 154.
	Zeus, Dresden	Lippold, p. 190, pl. 66, 3.
	Portrait of Perikles and Anakreon (pp. 122, 129)	Lippold, p. 172, pl. 50, 3; Richter, *Portraits*, 1965, pp. 102 ff.
	Niobids in Rome and Copenhagen (p. 134)	Picard, II, pp. 685 f.; Lippold, p. 177, pl. 65, 1–3.
	Goddess from Ariccia	Lippold, pp. 173 ff., pl. 62, 4.

	Eleusinian Relief, Athens (p. 131)	Lippold, p. 160, pl. 58, 3.
	Beneventum Head, Louvre (from Hercula- neum?)	Picard, II, p. 702, pl. XXV.
	Perseus	Lippold, p. 139, pl. 50, 2.
	Athena from Velletri, Louvre	Lippold, p. 173, pl. 62, 3.
	Herm by Alkamenes (p. 122)	Picard, II, pp. 554 ff.; Lippold, p. 186, pl. 67, 3.
	Hermes Ludovisi, Terme Mus.	Lippold, p. 179; E. Paribeni, *Cat. Terme Mus.*, no. 28.
c. 440	Metopes and friezes from temple of Hephaistos (p. 134)	Dinsmoor, pp. 79 ff.; Picard, II, pp. 714 ff.; Lippold, p. 158, pl. 57, 1 and 2.
	Sculptures from temple of Poseidon, Sounion (p. 34)	Lippold, pp. 158 f., pl. 57, 3.
c. 450–440	Doryphoros by Polykleitos (p. 120)	Picard, II, pp. 279 ff.; Lippold, p. 163, pl. 59, 1.
	Herakles, Barracco	Bianchi Bandinelli, *Policleto*, pl. IX.
	Bronze statuette, Louvre (p. 200)	Picard, II, pp. 266 ff.; Lippold, p. 164, pl. 59, 3.
	Westmacott Youth, London	Smith, *Cat.*, no. 1754; Lippold, p. 164, pl. 60, 1.
c. 440–430	Diadoumenos by Polykleitos (p. 120)	Picard, II, pp. 287 ff.; Lippold, p. 166.
	Polykleitan Hermes, Terme Mus.	E. Paribeni, *Cat. Terme Mus.*, no. 53.
	Amazons by Pheidias, Polykleitos, Kresilas, Kydon, and Phradmon (pp. 126 f., 394, ch. 3, note 15)	Picard, II, pp. 300 ff.; Lippold, pp. 171 ff.; *Sc. and Sc.*, no. 37; Aurigemma, *Boll. d' Arte*, 1955, pp. 19 ff.
	Prokne and Itys, Akropolis (p. 122)	Lippold, p. 185, pl. 66, 1.
c. 420	Diomedes, Naples, etc.	Lippold, p. 184, pl. 48, 4.
	Metopes and frieze from Temple of Apollo Epikourios, Phigaleia (p. 134)	Dinsmoor, pp. 154 ff., and *A.J.A.*, LX, 1956, pp. 401 ff.; Picard, II, pp. 802 ff.; Lippold, p. 201.
c. 440–420	Satrap sarcophagus, Istanbul (pp. 48, 131)	Lippold, p. 207, pl. 75, 1; Mendel, *Cat.*, no. 9; Kleemann, *Der Satrapen-Sarkophag.*
	Stele of Krito and Timariste (p. 131)	Lippold, p. 206, pl. 64, 3.
	'Aphrodite' herm, Naples	Lippold, p. 187, pl. 67, 4.
	Ares Borghese, Louvre	Lippold, p. 186, pl. 68, 1.
	Dioskouroi from Lokroi	Lippold, p. 177.
c. 420	Sculptures from Temple of Nemesis, Rham- nous (p. 122)	Dinsmoor, pp. 181 f.; Picard, II, pp. 536 ff.; Lippold, p. 188, pl. 69, 1.
	Sculptures from Argive Heraion	Dinsmoor, p. 183; Picard, II, pp. 816 ff.; Lippold, pp. 201 f., pl. 74, 3.
	Record relief, Eleusis, dated by inscription	*Ath. Mitt.*, XIX, 1894, pl. VII.
	Hera Borghese, Terme Mus.	Lippold, p. 188, pl. 66, 2; E. Paribeni, *Cat. Terme Mus.*, no. 94.
	Idolino, Narkissos, Dresden boy (p. 129)	Lippold, p. 165, pl. 60, 2 and 3.
	Engraved gems by Dexamenos (p. 248)	Furtwängler, *Ant. Gemmen*, III, pp. 137 ff.; Beazley, *Lewes House Gems*, p. 48; Richter, *Cat. of Gems*, *M.M.A.*, 1956, pp. xxxii, xxxv.
	Palatine Aura	E. Paribeni, *Cat. Terme Mus.*, no. 5.
	Demeter, Eleusis	Lippold, p. 191, pl. 70, 1.
412–410	Head of Apollo on tetradrachms of Chal- cidian League	Robinson and Clement, *Olynthus*, IX, p. 21, no. 18, pl. IV.
c. 420–410	Bronze boy, Munich	Lippold, p. 174, pl. 50, 4.
	Diskobolos attributed to Naukydes (p. 126)	Lippold, p. 199, pl. 68, 2.
	Gjölbaschi Monument (p. 137)	Picard, II, pp. 874 ff.; Lippold, p. 209, pl. 76, 3.
409	Record relief, Louvre, dated in archonship of Glaukippos (p. 134)	*Ath. Mitt.*, XXXV, 1910, pl. IV, 2.
412–400	Attic tetradrachms with portraits of Tis- saphernes and Pharnabazos	Bieber, figs. 243, 244; Head, *Historia Numorum*, 2nd edn., p. 597; E. S. G. Ro- binson, *Num. Chronicle*, 1948, pp. 48 f., pl. 8; Schwabacher, *Charites*, pp. 27 ff.
427–424	Frieze of Temple of Athena Nike (p. 134)	Dinsmoor, pp. 185 f.; Picard, II, pp. 760 ff.; Lippold, pp. 193 f.

420–413	Karyatids of Erechtheion (pp. 134f.)	Lippold, p. 192, pl. 70, 2.
410–407	Parapet of temple of Athena Nike (p. 137)	Picard, II, pp. 772ff.; Lippold, p. 194, pl. 69, 4; Dohrn, *Attische Plastik*, p. 24.
409–406	Frieze of Erechtheion (p. 137)	Paton and others, *The Erechtheum*; Dinsmoor, pp. 187ff.; Picard, II, pp. 738ff.; Lippold, pp. 192f., pl. 69, 2.
c. 430–420	Stelai of shoemaker, London; youth with birdcage; in Grottaferrata; horseman, Villa Albani (p. 131)	Diepolder, pp. 4, 6, 9; Lippold, pp. 195f.
c. 430–400	'Venus Genetrix' (p. 129)	Lippold, p. 168, pl. 60, 4; Picard, II, pp. 620ff.
c. 420–410	Nike by Paionios (p. 122)	Picard, II, pp. 587ff.; Lippold, p. 205; *Sc. and Sc.*, pp. 244f.
	Maenads attributed to Kallimachos; Kalathiskos dancers (p. 122)	Picard, II, pp. 625ff.; Lippold, pp. 222f.; Richter, *M.M.A.; Cat. of Sc.*, no. 58; Caputo, *Menadi di Tolemaide*; Rizzo, *Thiasos*.
c. 400	Nereid Monument (p. 137)	Picard, II, pp. 849ff.; Lippold, p. 208, pl. 76, 1 and 2; Dinsmoor, pp. 256f.
	Stelai of Hegeso, Phainerete, and Phrasikleia; from Lowther Castle; of Ktesileos and Theano (p. 131).	Diepolder, pp. 27, 26, 25; Lippold, p. 196, pl. 72, 2.
c. 425–420	Three-figured reliefs (p. 133)	Lippold, p. 202, pl. 74, 2.
c. 417	Akroteria from temple of Athenians, Delos	Lippold, p. 192, pl. 71, 1.
425–400	Dekadrachms signed by Eumenes, Euainetos, Kimon, etc. (p. 259)	Rizzo, *Monete della Sicilia*, pp. 203ff., 230ff.; Head, *Hist. Num.*, 2nd. edn., pp. 175f.
c. 420–400	Silver phialai, London and New York (p. 218)	Richter, *A.J.A.*, XLV, 1941, pp. 363ff.; LIV, 1950, pp. 357ff.
	'Lycian' sarcophagus, Istanbul (p. 131)	Mendel, *Cat.*, no. 63; Lippold, p. 210, pl. 75, 2.
406–405	Record relief, treaty between Athens and Chios	Svoronos, *Ath. N. M.*, pl. CCII.
403	Record relief, Athens, treaty with Samos	Lippold, p. 198.
400/399	Record relief, Athens	Svoronos, *Ath. Nat. Mus.*, pl. CCIII.
398/397	Record relief, Athens 1479	Lippold, p. 229, pl. 88, 1.
c. 400–350	Attic grave stelai (pp. 161ff.)	Diepolder, pp. 29ff.; Lippold, pp. 228ff.; Dohrn, *Attische Plastik*, pp. 127ff.
394/393	Stele of Dexileos (p. 162)	Diepolder, p. 26; Lippold, p. 229, pl. 80, 1.
	Ornament from gravestone of Athenians who fell at Corinth	Papaspiridi, *Guide*, no. 137; Möbius, *Ornamente*, p. 24.
c. 400–380	Acanthus Column, Delphi (p. 49)	Picard, III, pp. 223ff.; Dinsmoor, p. 253.
	Sculptures from temple of Asklepios, Epidauros (pp. 138f.)	Dinsmoor, p. 218; Picard, III, pp. 330ff.; Lippold, p. 220, pl. 79, 1 and 2; *Sc. and Sc.*, pp. 276ff.
	Leda, Boston, etc. (p. 141)	Caskey, *Cat.*, no. 22; Lippold, p. 209, pl. 70, 3.
375/374	Record relief, treaty between Athens and Korkyra, dated in archonship of Hippodamas (p. 166)	Rizzo, *Prassitele*, p. 7; Lippold, p. 230.
c. 375–370	Sepulchral lekythos, Munich	Diepolder, pl. 34.
	Stele of Chairedemos and Lykeas, Piraeus	Diepolder, pl. 16.
	Eirene and Ploutos, by Kephisodotos (p. 141)	Rizzo, *Prassitele*, pp. 4ff.; Picard, III, pp. 85ff.; Lippold, p. 224, pl. 83, 1.
	Hermes and Dionysos by Kephisodotos (p. 141)	Rizzo, *Prassitele*, pp. 7ff.; Picard, III, pp. 107ff.
362/361	Record relief with Athena, Athens	Picard, III, p. 103, fig. 27.
370–350	Sculptures from temple of Athena Alea, Tegea (pp. 149f.)	Dinsmoor, pp. 218ff.; Picard, III, pp. 150ff.; Lippold, pp. 250f., pl. 90, 3 and 4.
367–353	Head of Apollo and seated Zeus on tetradrachms issued by Maussollos	Head, *Hist. Num.*, 2nd edn., p. 629.
c. 355–352	Head of Apollo on tetradrachms of Chalcidian League	Robinson and Clement, *Olynthus*, IX, p. 81, no. 133, pl. XVII.

c. 350	Demeter of Knidos (p. 158)	Lippold, p. 260, pl. 93, 4; Ashmole, *J.H.S.*, LXXI, 1951, pp. 13 ff.
	Sarcophagus of Mourning Women, Istanbul (p. 166)	Lippold, p. 231, pl. 82, 1; Mendel, *Cat.*, no. 10.
	Pothos (p. 150)	Lippold, p. 252, pl. 91, 3.
	Lansdowne Herakles (now in the J. Paul Getty Museum, Cal.) (p. 153)	Lippold, p. 251, pl. 91, 1.
	Meleager, Vatican, etc. (p. 153)	Lippold, p. 289, pl. 102, 4.
c. 360	Satyr, Dresden, etc.	Rizzo, *Prassitele*, p. 17.
c. 350–330	Aphrodite of Knidos by Praxiteles (p. 141)	Rizzo, *Prassitele*, pp. 45 ff.; Lippold, p. 239; *Sc. and Sc.*, pp. 260 ff.
	Apollo Sauroktonos (p. 144)	Rizzo, *Prassitele*, pp. 41 ff.; Lippold, p. 240, pl. 84, 3.
	Eubouleus, Aphrodite of Arles, Artemis of Gabii, Apollo, Lykeios, Eros of Parion, Leconfield Aphrodite, Capitoline Satyr, Dionysos Sardanapalus (pp. 144, 147)	Rizzo, *Prassitele*, pp. 103 ff.; Lippold, pp. 238 ff.
	Hermes of Olympia (p. 144)	Rizzo, *Prassitele*, pp. 66 ff.; Picard, IV, pp. 250 ff.; Lippold, p. 241; *Sc. and Sc.*, pp. 259 f.
	Mantineia base (p. 144)	Rizzo, *Prassitele*, pp. 86 ff.; Lippold, p. 238; *Sc. and Sc.*, pp. 264 f., pl. 85, 1–3.
	Aberdeen Herakles (p. 147)	Rizzo, *Prassitele*, p. 74.
	Hermes of Andros; Farnese Hermes	Rizzo, *Prassitele*, pp. 75 f.
380–350	Portraits of Plato, Thucydides, Lysias (p. 156)	Laurenzi, *Ritratti*, nos. 20, 26, 18; Lippold, p. 273; Richter, *Portraits*, 1965, pp. 147 ff., 164 ff., 207 f.
c. 355–330	Sculptures from Temple of Artemis, Ephesos (p. 149)	Dinsmoor, pp. 223 ff.; Picard, III, pp. 108 ff.; Lippold, p. 254, pl. 89, 2.
	Sculptures from Mausoleum of Halikarnassos (p. 149)	Dinsmoor, pp. 257 f.; Picard, III, pp. 7 ff.; Lippold, pp. 256 f.
	Athlete from Ephesos, Vienna	Lippold, p. 218, pl. 78, 3.
347–346	Record relief honouring three princes of the Bosphorus	Lippold, p. 247, pl. 88, 4.
c. 340–330	Base signed by Bryaxis (p. 154)	Lippold, p. 258, pl. 94, 1.
	Sarapis (p. 154)	Lippold, p. 258, pl. 93, 3.
	Korai of Herculaneum	Rizzo, *Prassitele*, pp. 91 ff.; Lippold, p. 242, pl. 86, 1 and 2.
	Muses, Vatican	Lippold, p. 301, pl. 107.
	Bronze Marathon Boy (pp. 147 f.)	Lippold, p. 274, pl. 96, 3.
c. 320–280	Aphrodite of Capua, Capitoline, Townley, Ostia, Medici, etc. (pp. 149, 158)	Lippold, pp. 284, 290 f., pls. 101, 3, 104, 1; Felletti Maj, 'Afrodite pudica', *Archeologia classica*, III, 1951, pp. 33 ff.
c. 350–330	Portraits of Sophokles, Euripides, 'Aischylos' (p. 160)	Laurenzi, *Ritratti*, nos. 31, 32, 45; Lippold, pp. 215, 271.
	Apollo Patroos by Euphranor (p. 156)	H. A. Thompson, Εἰς Μνήμην Γ. Π. Οἰκονόμου III, 1953–54, pp. 30 ff.
c. 340–310	Portraits of Bias, Periander, Aristotle	Laurenzi, *Ritratti*, nos. 30, 44, 47; Richter, *Portraits*, 1965, pp. 87 f., 86 f., 170 ff.
335–334	Choragic Monument of Lysikrates (p. 49)	Dinsmoor, pp. 237 f.; Lippold, p. 271, pl. 94, 3.
c. 350–320	Asklepios of Melos and related types (p. 158)	Lippold, p. 259, pl. 95, 2.
	Apollo of Belvedere (p. 158)	Lippold, p. 269, pl. 98, 3; Bieber, p. 63.
	Artemis of Versailles (p. 158)	Lippold, p. 270, pl. 98, 2; Bieber, p. 63.
	Ganymede and the eagle (p. 155)	Lippold, p. 269, pl. 98, 1; Bieber, pp. 62 f.
	Ares Ludovisi	Lippold, p. 289, pl. 102, 2.
	Fragments of Altar of Kos (p. 154)	Lippold, p. 299; *Sc. and Sc.*, figs. 684–687.
c. 350–300	Later Attic stelai (p. 162)	Diepolder, pp. 43 ff.; Lippold, pp. 245 ff.
c. 325–300	Apoxyomenos by Lysippos (p. 153)	Lippold, p. 279, pl. 100, 1.
	Borghese Satyr	Lippold, p. 298, pl. 104, 3.
	Herakles Farnese (p. 153)	Lippold, p. 281, pl. 101, 1.
	Herakles Epitrapezios (p. 153)	Lippold, p. 283.

	Hermes adjusting sandal; Eros stretching bow	Lippold, pp. 280 ff., pl. 100, 2 and 4.
	Dionysos with satyr; seated Hermes in Naples; wrestlers, Naples	Lippold, pp. 281 ff., pls. 100, 3, 102, 1, 101, 1.
	Agias, Delphi (p. 153)	Lippold, p. 287, pl. 102, 3.
	Poulydamas base (p. 153)	Lippold, p. 284, pl. 94, 2.
	Portraits of Alexander (p. 153f.)	Bieber, *Proceedings of the American Philosophical Society*, XCIII, 1949, pp. 373 ff.; Lippold, pp. 267 f., pl. 97, 1 and 2.
	Alexander Sarcophagus (p. 154)	Lippold, p. 288, pl. 82, 2; Bieber, pp. 72 f.; Mendel, *Cat.*, no. 68.
321–317	Record relief, Athens	Speier, *Röm. Mitt.*, XLVII, 1932, pl. 29, no. 1.
c. 330–300	Dancer, Rome	Lippold, p. 284, pl. 101, 4.
c. 320–280	Medici Aphrodite (p. 149)	Lippold, p. 312.
	Head from Southern slope, Akr. (p. 158)	Lippold, p. 304, pl. 109, 3.
	Artemis Colonna	Lippold, p. 291, pl. 110, 4.
	Bronze Praying boy, Berlin	Lippold, p. 296, pl. 105, 2.
From 305	Portraits of Hellenistic princes on coins (p. 260)	Newell, *Royal Greek Portrait Coins*; Bieber, pp. 85 ff.; Seltman, *Greek Coins*, pp. 218 ff.
c. 320–280	Group of Niobids, Florence (p. 169)	Lippold, p. 309, pl. III; Bieber, pp. 74 ff.
	Head from Chios, Boston (p. 149)	Caskey, *Cat.*, no. 29; Lippold, p. 306, pl. 109, 4.
	Metope from Ilion	Lippold, p. 307, pl. 110, 1.
After 300	Tyche of Antioch (pp. 168f.)	Lippold, p. 296, pl. 106, 2; Bieber, p. 40.
	Group of Artemis and Iphigeneia	Bieber, pp. 77 f.
280/279	Portrait of Demosthenes (p. 177)	Laurenzi, *Ritratti*, no. 61; Lippold, p. 303, pl. 108, 2; Bieber; p. 66. Richter, *Portraits*, 1956, pp. 215 ff.
c. 320–270	Portraits of Aischines, Epikouros (p. 177)	Laurenzi, *Ritratti*, nos. 46, 65; Lippold, p. 314.
c. 300–250	Themis of Chairestratos (p. 169)	Lippold, p. 302, pl. 108, 1; Bieber, p. 65.
c. 250–240	Crouching Aphrodite by Doidalsas (p. 169)	Lippold, p. 319; Bieber, pp. 82 f.
	Sleeping Ariadne (p. 169)	Lippold, p. 347, pl. 122, 4; Bieber, pp. 145 f.
	Menelaos and Patroklos	Bieber, pp. 79 ff.; Lippold, p. 362, pl. 122, 2.
c. 280–230	Boy with goose	Lippold, p. 329, pl. 117, 2.
	Girl from Anzio, Terme Mus.	Lippold, p. 332, pl. 119, 3.
c. 240–200	Dying Gaul, Gaul and wife (pp. 170, 174)	Lippold, p. 342, pl. 122, 1 and 3; Bieber, p. 108.
c. 200	Statues of Gauls, Amazons, Persians, giants (p. 174)	Lippold, p. 353, pl. 127; Bieber, pp. 109 f.
	Portrait of Chrysippos (p. 177)	Laurenzi, *Ritratti*, no. 76; Lippold, p. 338; Bieber, p. 68; Richter, *Portraits*, 1965, pp. 190 ff.
	Nike of Samothrace (pp. 169f.)	Lippold, p. 360, pl. 126, 4; Bieber, p. 125.
c. 240–200	Market women, Fishermen, Sleeping Erotes, Jockey, Drunken Woman, Satyrs and Nymphs (p. 177)	Bieber, pp. 140 ff.; Lippold, pp. 320 ff.
	Boy from Subiaco; Wrestlers, Florence	Lippold, p. 347, pl. 121, 3 and 4.
	Castellani Spinario, London	Lippold, p. 331, pl. 113, 4.
	Draped female statues	Lippold, pp. 334 f., pl. 120.
	Nile and Tiber	Lippold, p. 326.
c. 220–170	Apotheosis of Homer (p. 181)	Lippold, p. 373, pl. 131, 3; Bieber, pp. 127 ff.
c. 197–159	Altar of Zeus and Athena, Pergamon (p. 175)	Lippold, pp. 355 f., pl. 128; Bieber, pp. 113 ff.
c. 200–150	Sleeping Satyr, Munich (p. 175)	Lippold, p. 330, pl. 118, 2; Bieber, p. 112.
	Hanging Marsyas (p. 177)	Lippold, p. 321; Bieber, pp. 110 f.
	Red Faun, Capitoline Mus.	Lippold, p. 330.
c. 200–100	Aphrodite of Melos (p. 170)	Lippold, p. 370, pl. 130, 3; Bieber, p. 159.
c. 180–140	Sculptures of temple at Lykosoura (p. 181)	Lippold, p. 350, pl. 124, 1 and 2; Bieber, p. 158.
c. 160–140	Laokoon (p. 175)	Lippold, pp. 384 f.; Bieber, p. 134; Richter, *Three Critical Periods*, pp. 66 ff.; Magi, *Mem. Pont. Acc. Arch.*, 1960.

	Some heads and torsos from Sperlonga	*Illustrated London News*, Oct. 26th, 1957, p. 711, figs. 1 and 3; Dec. 28th, 1957, p. 1133, figs. 5 and 6; Jacopi, *L'Antro di Tiberio a Sperlonga*, 1963; L'Orange, *Acta Inst. Rom. Norvegiae*, 1965, pp. 261 ff.
	Portraits of Homer, Pseudo-Seneca (p. 181)	Lippold, pp. 385, 387, pl. 133, 3 and 4; Laurenzi, *Ritratti*, no. 133, p. 138; Richter, *Portraits*, 1965, pp. 50 ff., 58 ff.
	Belvedere Torso (p. 177)	Lippold, p. 380, pl. 134, 1.
	Bronze Boxer	Lippold, p. 380, pl. 134, 2.
	Borghese Warrior, Louvre (p. 177)	Lippold, p. 382, pl. 134, 3.
	Farnese Bull, Naples	Lippold, p. 383, pl. 135, 1.
	Aphrodite and Pan from Delos	Lippold, p. 369, pl. 135, 3.
c. 150–100	Hermaphrodite	Lippold, p. 366, pl. 130, 1 and 2.
c. 167	Monument of Aemilius Paulus (p. 181)	Lippold, p. 351, pl. 125, 2.
c. 160–120	Frieze from temple of Hekate, Lagina (p. 181)	Dinsmoor, p. 282; Lippold, p. 375, pl. 132, 3; Bieber, p. 161.
c. 150–100	Frieze of Temple of Artemis Leukophryene, Magnesia (p. 181)	Dinsmoor, pp. 274 ff.; Lippold, p. 374, pl. 132, 2; Bieber, pp. 169 f.
	Head of Athena by Euboulides, Zeus from Aigeira, sculptures from Heroon of Kalydon (p. 183)	Lippold, pp. 365 ff.; Becatti, *Attica*.
c. 100	Exact Roman copies begin (cf. p. 183)	Richter, *Ancient Italy*, pp. 105 ff.

(For vase names see fig. 437)

Agora—The market-place in a Greek city.

Abacus—The uppermost member of a capital.

Akroterion—The ornamental finial of a stele or pediment.

Anathyrosis—The contact surface of a stone, of which the central portion is roughened and sunk, and the margin smoothed.

Anta—Pilaster slightly projecting from the lateral walls.

Antefix—Ornament terminating the covering tiles of a roof and concealing the joins with the flat tiles.

Architrave—The lowest member of the entablature, i.e. the lintel carried from the top of one column to another.

Bouleuterion—The Greek Senate house.

Cavetto—Concave moulding derived from the Egyptian concave cornice.

Cella—The enclosed principal chamber of a temple.

Chiton—The tunic, short or long, and generally of linen, worn by Greek men and women.

Chlamys—Short, woollen cloak, worn by men and Amazons, and fastened on right shoulder.

Chryselephantine—Combining gold (χρυσός) with ivory (ἐλέφας).

Cornice—The upper, horizontal member of the entablature.

Diazoma—The ambulatory or horizontal passage separating the several ranges of seats in a theatre or stadium.

Echinus—The convex moulding beneath the abacus of a capital.

Engaged column—Semi-detached (from wall or pilaster) and about semi-circular in plan.

Engobe—See Slip.

Entablature—The superstructure carried by the columns, consisting of architrave, frieze, and cornice.

Euthynteria—The top course of the foundation or levelling course of a building.

Filigree—Decoration with fine wire (used in jewellery).

Granulation—Decoration with tiny balls (used in jewellery).

Guttae—Small, pendent, tapering cylinders, placed under the mutules of a Doric entablature.

Heraion—Temple of Hera.

Herm—Pillar, usually square, surmounted by a head.

Himation—A Greek mantle, generally of wool.

Karyatid—Figure of a maiden (kore) taking the place of a column in supporting an entablature.

Kerameikos—Potters' quarter.

Komos—Revel.

Kore, Korai—Maiden, maidens; used specifically for the standing archaic statues of maidens.

Kouros, Kouroi—Youth, youths, used specifically to designate the archaic statues of youths in frontal attitude, bilaterally symmetrical, generally with the left foot advanced.

Krepidoma—The stepped platform of a Greek temple.

Kyma, Kymation—A wave-like moulding, i.e. of double curvature.

Leather hard—(of clay) consistency of leather, state between wet and bone dry.

Lesche—An informal meeting place, resembling a stoa.

Levigated—(of clay) freed of impurities, made smooth.

Little-Master—Term applied to a special type of black-figured cup with miniature decoration.

Megaron—The principal hall in a Mycenaean house.

Metope—Panel between the triglyphs of a Doric frieze.

Mutule—Projecting slab on the soffit of a Doric cornice.

Obverse—(opposite of reverse) the side of a coin bearing the principal emblem.

Odeion—Roofed building used mostly for musical performances.

Opisthodomos—Porch at the rear of a temple.

Orthostates—Bottom course of the walls of a cella, usually placed vertically.

Palaestra—Place for athletic training requiring restricted space, e.g. boxing or wrestling.

Parapet—A low protecting wall at the edge of a platform.

Parodos—One of the two lateral entrances to the orchestra of a Greek theatre (formed by the ends of the auditorium walls and the stage building).

Pediment—The triangular space forming the gable of a two-pitched roof, including the wall at the back (tympanon), the raking cornice above, and the horizontal cornice below.

Peplos—The woollen garment, also called the Doric chiton, worn by Greek women; often open on one side, and fastened on both shoulders.

Peptized—(of clay) with the heavier particles removed by means of a protective colloid.

Peristyle—The covered colonnade surrounding a building.

Petasos—Man's cap with broad brim.

Pilos—Conical felt cap.

Polos—Cylindrical headdress.

Pronaos—The front porch of a temple.

Propylaion, Propylaia—The gate-building or buildings of the sacred enclosure of a temple.

Prothesis—Lying-in-state of the dead.

Prytaneion—Meeting place of the Senate committee.

Ramp—Sloping approach to a temple.

Record relief—Relief with an inscription recording a historical event.

Regula—The narrow strip under the taenia of a Doric architrave.

Reserved—(of vase decoration) left in the colour of the clay.

Reverse (see Obverse).

Revetment—Applied, decorative facing.

Sakkos—Kerchief wound round head to serve as a cap.

Sima—Gutter.

Skene—Stage.

Slip—Liquid clay, applied as a coating on vases and terra cottas.

Sphyrelaton—technique in which hammered plates of metal are nailed on a wooden core.

Stele—An upright slab, often used for a gravestone.

Stoa—Roofed portico, walled at the back and with a colonnade in front.

Stylobate—Pavement or platform on which the columns are placed.

Taenia—Band or fillet crowning the architrave of a Doric entablature.

Telesterion—Hall of ceremonies, generally for initiation into Mysteries.

Temenos—Sacred precinct.

Tholos—A Greek circular building.

Tiara—Oriental cap with three flaps.

Treasury—A treasure house in a sacred precinct for housing valuables.

Triglyph—Rectangular, slightly projecting slab between the metopes in a Doric frieze, generally with two vertical channels and two chamfers.

Tympanon—The triangular wall at the back of the pediment.

Objects in the following museums are reproduced from official photographs, by courtesy of the museum authorities concerned: Walters Art Gallery, Baltimore; Staatliche Museen, Berlin; Museum of Fine Arts, Boston; Musées Royaux, Brussels; Fitzwilliam Museum, Cambridge; Musée archéologique, Châtillon; Ny Carlsberg Glyptotek, Copenhagen; British Museum, London; Antikensammlung, Munich; Metropolitan Museum of Art, New York; Pierpont Morgan Library, New York; Ashmolean Museum, Oxford; Kunsthistorisches Museum, Vienna; National Museum, Athens; and Dumbarton Oaks Foundation, Washington, D.C.

In addition, photographs from the following sources have been used for reproduction: Agora Excavations, Athens (figs. 43, 115, 417, 471); Alinari, Florence (figs. 18, 23, 39, 80, 106, 107, 117, 124, 127, 133, 144, 145, 152, 153, 155, 169, 174, 180, 193, 194, 202, 203, 214, 215, 216, 229, 231, 233, 394, 396, 399, 400, 441, 446); Anderson, Rome (figs. 77, 134, 163, 188, 232, 289, 393, 395); Archives Photographiques, Paris (figs. 71, 285, 292, 293); Bulloz, Paris (fig. 300); Chari-siades, Athens (fig. 326); Maurice Chuzeville, Paris (figs. 105, 424, 439, 453, 464); Deutsches Archäologisches Institut, Athens (figs. 59, 62, 68, 85, 89, 91, 92, 96, 99, 114, 123, 159, 183, 220, 253, 258, 263, 264, 267, 275, 276, 280, 297, 298, 305, 408, 409, 415, 500, 519); École française, Athens (fig. 251); J. Felbermeyer, Rome (figs. 239, 434); Alison Frantz, Athens (figs. 28, 53, 65, 72, 98, 103, 108, 116, 178, 192, 196, 211, 217, 241, 255, 262, 328, 416, 422); John R. Freeman, London (figs. 360–372); Gabinetto Fotografico Nazionale, Rome (figs. 119, 122, 135, 161, 179, 225, 402); Giraudon, Paris (figs. 67, 175, 456, 457); Istituto Archeologico, University of Rome (fig. 227); Kennedy (figs. 154, 197); G. Macworth-Young (figs. 52, 86, 90, 118); Foto Marburg (figs. 78, 79, 94, 97, 100, 207, 222, 250); Ilse Schneider-Lengyel (figs. 84, 95, 102, 109, 120, 121, 130, 156, 164, 168, 173, 184, 185, 190, 191, 195, 198, 199, 218, 224, 229, 230, 236, 242, 274); W. Stevers, Melbourne (fig. 423); Tombazi, Athens (figs. 413, 414); Vatican (figs. 131, 136, 157, 165, 189, 208, 212, 223, 245, 484); Wagner, Athens (fig. 64).

Buschor, *Frühgriechische Jünglinge* (fig. 83); Fowler and Wheeler, *Handbook of Greek Archaeology* (fig. 4); Furtwängler und Reichhold, *Griechische Vasenmalerei* (figs. 50, 429, 430, 438, 511–513); Grinnell, *Greek Temples* (figs. 1–3, 5, 6, 8, 10, 14, 19–22, 24, 25, 26, 27, 29–31, 34–37); Jacobsthal, *Ornamente griechischer Vasen* (fig. 517); Payne and others, *Perachora* (figs. 260, 271); Pfuhl, *Malerei und Zeichnung der Griechen* (figs. 425, 468); Rizzo, *Prassitele* (fig. 187); Rodenwaldt, *Korkyra* (fig. 9); Stevens, *Classical Buildings* (fig. 33); Zancani Montuoro and Zanotti-Bianco, *Heraion* (fig. 12); *Altertümer von Pergamon* (figs. 38, 505); *American Journal of Archaeology* 1957 (fig. 327); 1962 (fig. 407); *Antike Denkmäler* (fig. 390); *Bulletin de correspondance hellénique* (fig. 295); *Encyclopédie photographique* (fig. 428); *Römische Mitteilungen* (fig. 411); *Journal of Hellenic Studies, Archaeological Reports for 1961–62* (fig. 520). The drawings for figs. 75, 104 and 437 are by L. F. Hall. Figs. 5, 7 and the maps at the end of the book are reproduced from Dinsmoor, *The Architecture of Ancient Greece (1950)*, by courtesy of Messrs. B. T. Batsford, London. Figs. 1–4, 8, 10–12, 14–17, 19–22, 24–27, 29, 30, 31, 33–38, 40, 42, 44, 46–49 have been re-drawn by Lucinda Rodd.

Thanks are also due to the following for their help in providing photographs: Mr. Walter C. Baker; Mrs. Felletti Maj; Mrs. Karouzou; Miss J. Konstantinou; Mr. D. Levi; Mr. Maiuri; Mr. Marcadé; Mrs. Zancani Montuoro; Mr. Mylonas; Mr. V. Poulsen; Mr. Rhomaios; the late D. M. Robinson; Miss M. Santangelo; Mr. Sestieri; Mrs. Stathatos; Miss L. Talcott; Mr. A. D. Trendall; Mr. R. S. Young; and the late Mr. Zanotti-Bianco.

The numbers refer to the illustrations